Bringing Art to Life

McGill-Queen's/Beaverbrook Canadian Foundation Studies in Art History
SANDRA PAIKOWSKY and MARTHA LANGFORD, series editors.

Recognizing the need for a better understanding of Canada's artistic culture both
at home and abroad, the Beaverbrook Canadian Foundation, through its gener-
ous support, makes possible the publication of innovative books that advance
our understanding of Canadian art and Canada's visual and material culture.
This series supports and stimulates such scholarship through the publication of
original and rigorous peer-reviewed books that make significant contributions to
the subject. We welcome submissions from Canadian and international scholars
for book-length projects on historical and contemporary Canadian art and visual
and material culture, including Native and Inuit art, architecture, photography,
craft, design, and museum studies. Studies by Canadian scholars on non-
Canadian themes will also be considered.

BRINGING ART TO LIFE

A Biography of Alan Jarvis

Andrew Horrall

McGILL-QUEEN'S UNIVERSITY PRESS

Montreal & Kingston · London · Ithaca

© McGill-Queen's University Press 2009

ISBN 970-0-7735-3574-9 cloth

Legal deposit third quarter 2009
Bibliothèque nationale du Québec

Printed in Canada on acid-free paper that is
100% ancient forest free (100% post-consumer
recycled), processed chlorine free.

McGill-Queen's University Press acknowledges
the support of the Canada Council for the Arts
for our publishing program. We also acknowledge
the financial support of the Government of
Canada through the Book Publishing Industry
Development Program (BPIDP) for our publish-
ing activities.

Library and Archives Canada Cataloguing
in Publication

Horrall, Andrew
Bringing art to life : a biography of Alan Jarvis /
Andrew Horrall.

(McGill-Queen's/Beaverbrook Canadian
Foundation studies in art history; #2)

Includes bibliographical references and index.
ISBN 970-0-7735-3574-9

1. Jarvis, Alan, 1915–1972. 2. National Gallery
of Canada–History. 3. Art museum directors–
Canada–Biography. I. Title. II. Series: McGill-
Queen's/Beaverbrook Canadian Foundation
studies in art history; #2

N910.07H67 2009
708.11'384
C2009-902591-4

For Amy

Contents

Illustrations

Acknowledgments

I have accumulated many debts while working on this book. The first is to Jarvis' mother, Janet. Many of the rich personal details in this biography reflect the close relationship Jarvis had with his mother, to whom he wrote regularly during the fourteen years he lived in England. His letters were playful, joking, and boastful, and are the foundation on which I have erected this account of his life. In addition to these personal missives, Jarvis mailed her copies of his writings and the newspapers and magazines to which he contributed or in which he appeared. She kept them out of pride in her son's achievements. Unfortunately, few of her letters to Jarvis survived his periodic house cleanings. Material she collected forms the heart of Jarvis' extensive archives at the University of Toronto.

Secondly, I have a collective debt to Jarvis' friends, family, and admirers. Foremost among these is Elspeth Chisholm, a journalist who had known Jarvis as an undergraduate. Soon after his death in 1972, she interviewed key figures in Canada and abroad for a CBC radio documentary. The years have since silenced many of Chisholm's subjects, though their reminiscences are captured in fifteen hours of recordings that she donated to Library and Archives Canada. Like Jarvis' mother, Chisholm's collection is a testament to the deep impression he made on people. It is an absolutely vital resource for understanding Jarvis.

I have also had the great fortune to meet, talk to, or correspond with many people who knew Jarvis. I was continually struck by their warm hospitality and the eagerness with which they shared their memories. I quickly learned that the simplest anecdotes and stories were keys to unlocking reams of written words. No one was more helpful, gracious, or forthcoming than Jarvis' widow, Betty. She and Jarvis first met as young children and grew up together. Soon after university she married her first husband, while Jarvis moved to England. They reconnected after she was widowed and married soon after Jarvis' return to Canada in 1955. I was struck by her warmth, wit, and intelligence. I could see why Jarvis referred to her as his "Katherine Hepburn." Her life, some of which is detailed in these pages, deserves a book of its own.

A full list of people with whom I was in contact appears at the end of this book. In the meantime I would like to particularly thank David Silcox for opening many important doors, and Jean Sutherland Boggs for the enjoyable lunch over which we shared thoughts about Jarvis. Her perspective, as a former director of the National Gallery of Canada, illuminated Jarvis' Canadian career. Jarvis' younger days were recalled by Hamilton Southam, Norman Berlis, Mary Graham, and Mavor Moore. John Maize provided extensive information about Jarvis' high school years. Peter Cox, Peggy Appiah, Geoffrey Reeve, and Piers Nicholson helped me understand his time in England. Alex Colville, Kenneth Lochhead, Ronald Bloore, and Gordon Smith testified to Jarvis' impact on the Canadian arts community in the 1950s. Robert Fulford provided rich context about Jarvis, Norman Hay, and the Canadian cultural scene. While I have quoted many of them directly, I was constantly and subtly guided by their insights when interpreting other evidence. Similarly, I made contact with Richard Brennan in the very final stages of this project. He was unfailingly helpful in digitizing the letters that his mother, Fanny Myers, had received from Jarvis in the 1940s. These were invaluable in shedding light on the time that Jarvis spent in Toronto and New York City at the start of the war, as well as his emotional and romantic life. This book would have been far more sterile without the cooperation of all these people.

Less evident contributors also deserve my thanks. In 1996 Gibran van Ert gave me a copy of Robertson Davies' novel *What's Bred in the Bone*, which features a character based closely on Jarvis. In doing so, Gib unwittingly launched me on a quest to uncover Jarvis' story. The staff of the Thomas Fisher Rare Book Room at the University of Toronto were unfailingly help-

ful during many, many visits. Both the people and the physical surroundings make this one of the most pleasant places to do research. Cyndie Campbell and the staff of the National Gallery of Canada Archives provided unfailing support by identifying documents and answering my many questions. The Gallery's archives are a treasure. Lesley Whitworth shared her knowledge of the Council of Industrial Design and Jarvis' work there. Glenn Wright tracked down the Jarvis, McKay, Nottingham, and Hepburn family genealogies. Dan Somers used his tremendous knowledge of the collections at Library and Archives Canada to locate photographs. My colleagues Élizabeth Mongrain, Anne Goddard, Johanna Mizgala, and Jill Delaney provided introductions and pointed me to Jarvis-related material in Library and Archives Canada's holdings. As always, Bruce, Sue, and Imogen were great hosts on English research trips.

Permission to quote from Robert Graves' "The Devil's Advice to Story-Tellers" is granted by the Graves estate.

I have made every effort to identify, credit appropriately, and obtain publication rights from copyright holders of illustrations in this book. Notice of any errors or omissions in this regard will be gratefully received and correction made in any subsequent editions.

I would also like to thank Philip Cercone, Joan McGilvray, Brenda Prince, David Schwinghamer, Filomena Falocco, Jacqueline Davis, Susanne McAdam, Elena Goranescu, and Rob Mackie at McGill-Queen's University Press. Their support, guidance, and encouragement throughout the submission, editing, and publishing of this manuscript were immensely important.

My wife Amy deserves the most thanks of all. She listened to far too many stories about Alan Jarvis and commented insightfully on countless versions of the manuscript. You are my greatest help and my best friend. Your love and support meant everything. I could not have done this project without you.

Finally, no matter how much, or how subtly any conversation, letter, or e-mail shaped my views about Jarvis, the opinions expressed in this book are my own.

Selection of Work Acquired during Jarvis' Time as Director

The following plates show some of the major Canadian and European purchases made by the National Gallery of Canada while Alan Jarvis was director. Their consistent quality refutes accusations once made against Jarvis that he neglected Canadian works in favour of European art. They also illustrate Jarvis' understanding of art, his personal attachment, and the way he led the Gallery. As a young man, he had often sketched with David Milne. He was passionate about modern sculpture, an artistic career he longed to follow. He asked John Gould, an emerging artist he admired, to paint his official portrait. At the same time, the works by James Wilson Morrice and Robert C. Todd show Jarvis' considerable trust in the artistic judgment of the Gallery's staff. While many of the acquisitions made under Jarvis challenged the artistic tastes of 1950s Canada, they are now among the most familiar, admired, and enjoyed works in the Gallery's collection.

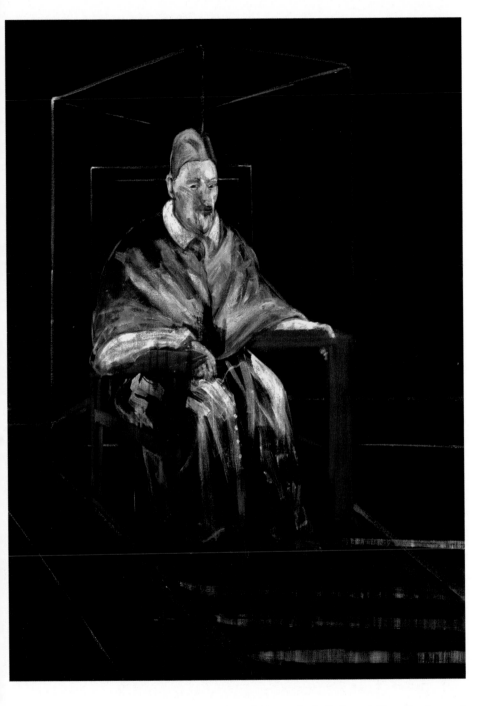

Francis Bacon, *Study for Portrait No. 1,* October 1956.
National Gallery of Canada, Ottawa.
Photo © National Gallery of Canada
Image © Estate of Francis Bacon / SODRAC (2009)

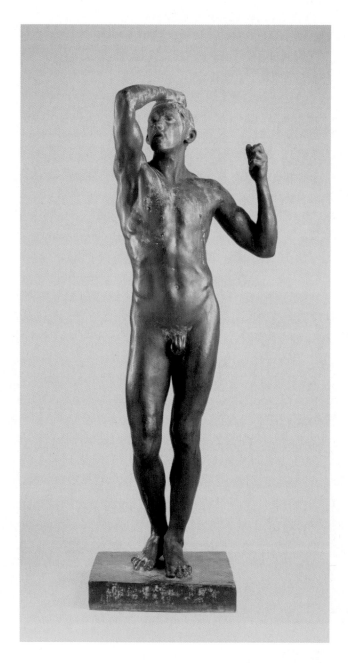

Auguste Rodin, *Age of Bronze,* 1875–76, cast in 1901.
National Gallery of Canada, Ottawa.
Photo © National Gallery of Canada

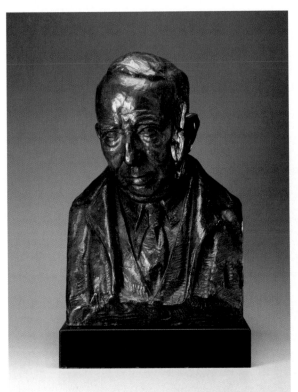

Florence Wyle, *Bust of A.Y. Jackson*, c. 1943.
National Gallery of Canada, Ottawa.
Photo and image © National Gallery
of Canada

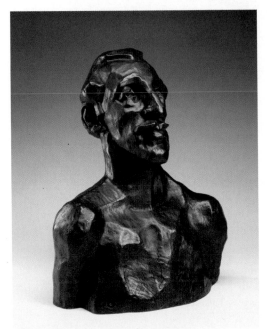

Henri Gaudier-Brzeska, *Horace Brodzky*, 1913.
National Gallery of Canada, Ottawa.
Photo and image © National Gallery of Canada

Jacob Epstein, *Rock Drill,* 1913–16, cast 1916.
National Gallery of Canada, Ottawa.
Photo © National Gallery of Canada
Image © The estate of Sir Jacob Epstein

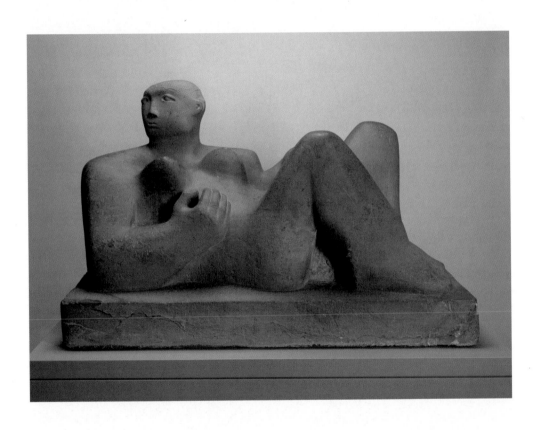

Henry Moore, *Reclining Woman*, 1930.
National Gallery of Canada, Ottawa.
Photo © National Gallery of Canada.
Image reproduced by permission of the
Henry Moore Foundation

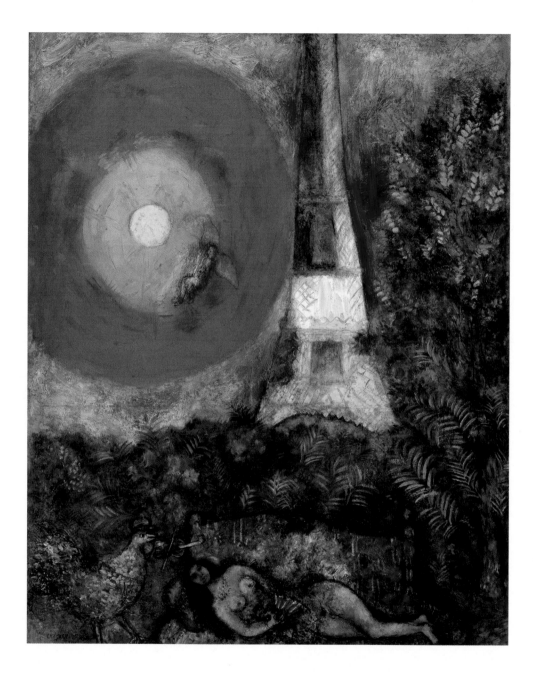

Marc Chagall, *The Eiffel Tower,* 1934.
National Gallery of Canada, Ottawa.
Photo © National Gallery of Canada

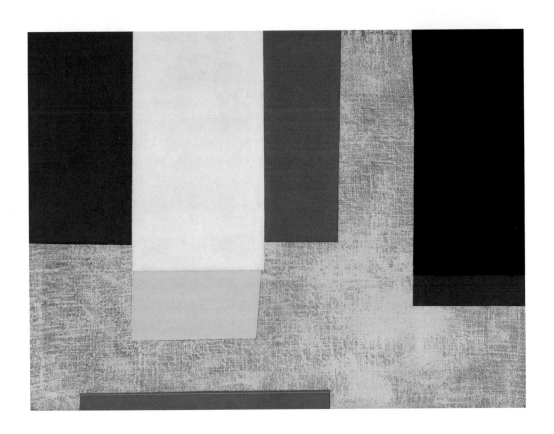

B.C. Binning, *Related Colour Forms*, 1957.
National Gallery of Canada, Ottawa.
Photo © National Gallery of Canada
Image © Ron Walsh

Jacques de Tonnancour, *The Clearing*, 1956.
National Gallery of Canada, Ottawa.
Photo © National Gallery of Canada
Image © Luc de Tonnancour

Robert C. Todd, *The Ice Cone, Montmorency Falls*, c. 1850.
National Gallery of Canada, Ottawa.
Photo © National Gallery of Canada

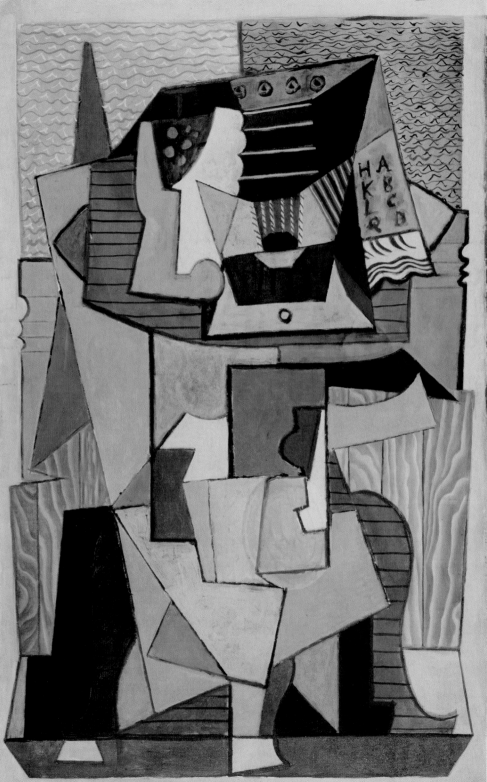

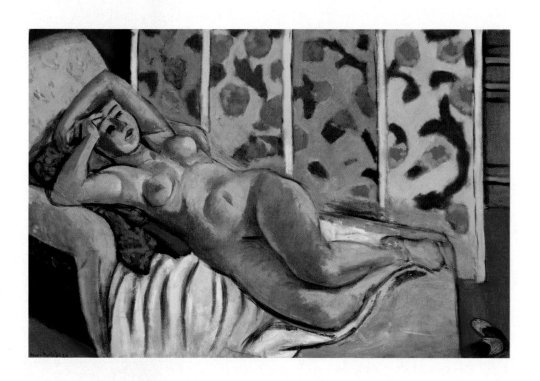

Henri Matisse, *Nude on a Yellow Sofa,* 1926.
National Gallery of Canada, Ottawa.
Photo © National Gallery of Canada
Image © Estate of H. Matisse / SODRAC (2009)

Opposite
Pablo Picasso, *The Small Table,* 1919.
National Gallery of Canada, Ottawa.
Photo © National Gallery of Canada
Image © Picasso Estate / SODRAC (2009)

James Wilson Morrice, *The Communicant*, c. 1910.
National Gallery of Canada, Ottawa.
Photo © National Gallery of Canada

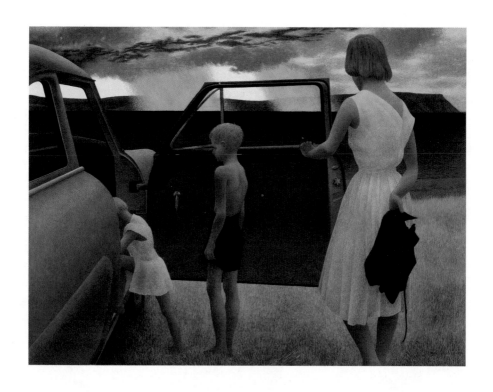

Alex Colville, *Family and Rainstorm*, 1955.
National Gallery of Canada, Ottawa.
Photo © National Gallery of Canada
Image © A.C. Fine Art Inc.

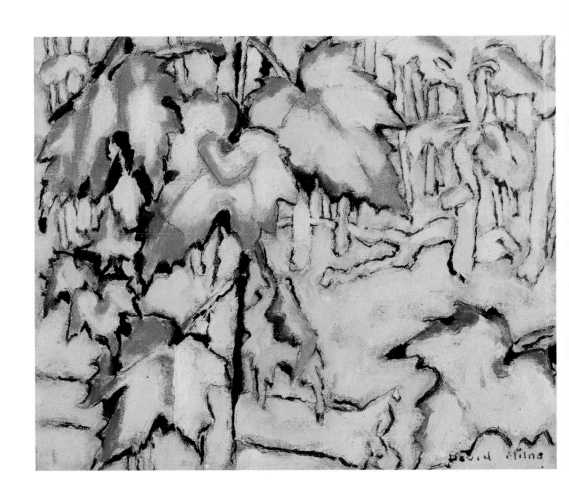

David B. Milne, *Maple Leaves*, 1936.
National Gallery of Canada, Ottawa.
Photo © National Gallery of Canada
Image © David Milne

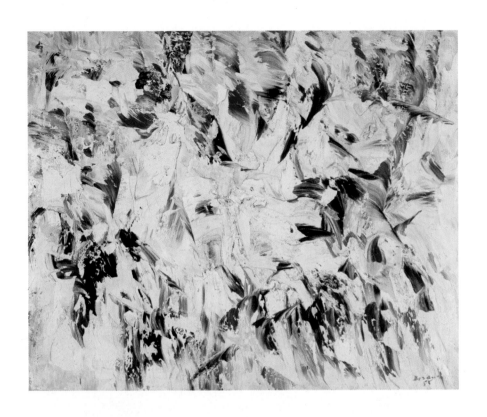

Paul-Émile Borduas, *Delicate Rustlings*, 1955.
National Gallery of Canada, Ottawa.
Photo © National Gallery of Canada
Image © Estate of Paul-Émile Borduas / SODRAC (2009)

John Gould, *Alan Jarvis*, 1962.
National Gallery of Canada, Ottawa.
Photo and image © National Gallery of Canada

Bringing Art to Life

Sigh then, or frown, but leave (as in despair)
Motive and end and moral in the air;
Nice contradiction between fact and fact
Will make the whole read human and exact.

Robert Graves
The Devil's Advice to Story-tellers

CHAPTER
ONE

"A Walking Work of Art"
Introduction

Civil servants are supposed to be dull and inconspicuous.

Alan Jarvis' triumphal return to Canada to head the National Gallery in May 1955 defied this acknowledged truth. He had been chosen to inspire and embody a far-reaching cultural initiative through which the government aimed to transform a complacent, conservative, dour country. Because Jarvis had spent the preceding thirteen years in England, the government hired public relations experts to help broadcast stories of his extraordinary beauty, wit, and polish. In an era when many Canadians venerated British ideals and institutions, Jarvis recounted anecdotes about that country's most prominent cultural, political, and religious figures in a graceful mid-Atlantic accent. For a little over four years, his distinctive voice prodded, provoked, and galvanized Canada in hundreds of lectures, on television, and in print.

The Liberal government that appointed Jarvis had been in power since 1935, had steered the nation through the war, and now watched as Canadians enjoyed victory's material rewards. The impact of veterans' benefits, social welfare programs, and a booming economy were easy to see. In virtually every city, older neighbourhoods of grid-bound streets and gabled brick houses were being ringed by winding drives of vinyl-clad suburban bungalows. On many of these lots, a carport sheltered the outsized, chrome emblazoned Chryslers, Buicks, and Cadillacs that symbolized modern life. Men drove to

work in the morning, while their wives stayed home and their children, the first baby-boomers, trouped off to school. Families reunited each evening in front of that marvellous black and white convenience, the television set. The Liberal government hoped to mirror this material success with a vibrant national cultural infrastructure.

Up until his return to Canada, Jarvis' life had presented an almost perfect narrative for an age wrapped in triumph, idealism, and romance. Born in the early days of the First World War, he was a golden child invariably described in superlatives and from whom great things were expected. Before turning thirty, he sketched and sculpted with some of Canada's foremost artists, earned a brilliant degree in philosophy, won a Rhodes Scholarship, lunched at the *New Yorker* "Round Table," weekended at Chequers with the British prime minister, and socialized with Noël Coward. Over the next decade, he wrote a best-selling book on design, helped revolutionize the British film industry, conducted pioneering social research, and sculpted portraits of London's high society. Barely middle-aged when he took over the National Gallery, he gave this small, insular institution nationwide force and inspired a generation of artists. He championed modern art and vaunted Canada's best painters and sculptors to the country and the world. He attacked complacency and derided the second rate. He dared Canadians to demand beauty in their daily surroundings. But Jarvis' successes concealed significant self-doubts. When he was publicly humiliated and dismissed at age forty-four, it set off a decade-long alcoholic denouement.

Jarvis' fall from public consciousness was quick. Though he was not yet sixty when he died in 1972, his Anglophile pedigree already belonged to a distant age. In the 1970s, Canada was led by a sandal-wearing, playboy prime minister who pirouetted behind the Queen and urged the young to drop out and hitchhike around their country. Culture competed with federal initiatives like bilingualism, wage and price controls, rapprochement with Red China, and the Montreal Olympics.[1] In this frosty climate, Elspeth Chisholm, a journalist who had known Jarvis at university, set out to remind Canadians of what he had done. She spent more than a year interviewing Jarvis' friends, admirers, colleagues, and detractors.[2] Chisholm's resulting 1975 radio documentary opened with an account of Jarvis' disgrace, before tracing his impressive achievements, to show that he had been martyred by a narrow-minded conservative ministry.[3] Her broadcast stirred people's memories. Three years

later, the Royal Society of Canada bestowed a medal on Jarvis as a posthumous tribute to his contributions to art and culture.[4]

Jarvis' canonization stopped there. Among the voices Chisholm captured with her tape recorder was that of the English art historian Sir Kenneth Clark, who may have been prompted by the interview to pen the most often quoted summation of Jarvis' life. In his autobiography, Clark described Jarvis as "the handsomest man I have ever seen, a good sculptor, with a wide knowledge of art." But Clark qualified this glowing memory by recalling that Jarvis' "face was his misfortune, and the last years of his life were a tragedy."[5] This somewhat cryptic emphasis on Jarvis' flaws has been influential.

The sense that Jarvis was a magnetic, though imperfect figure was cemented by Robertson Davies, a fellow Anglo-Canadian who explored the narrative possibilities of Jarvis' life. In Davies' 1985 novel *What's Bred in the Bone*, Jarvis appears in the guise of Aylwin Ross, a beautiful, young, ambitious, Oxford-educated art critic, whom the protagonist encounters while serving on a committee identifying looted art in post-war Germany. While Ross is younger and less erudite than his academic and intellectually prideful colleagues,

> he was brilliant; he had, in terms of his years and experience, extraordinary knowledge of art. Best of all, he had flair. His perception was swift and sure. But what especially endeared him to Francis [Cornish, the protagonist] was that Ross was light-hearted, and thought that art was for the delight and enlargement of man, rather than a carefully guarded mystery, a battleground for experts, and a treasure-house to be plundered by the manipulators of taste, the merchants of vogue, the art dealers.[6]

As this passage suggests, Ross is playful, egotistical, and hugely charming. His fellow committee members also detect a whiff of homosexuality about him. In the novel, Ross resurfaces a decade later as the conspicuous and celebrated head of the National Gallery. When a prolonged speaking tour shows that he is "a Canadian presence of a kind to which they [Canadians in general] were not accustomed," it breeds resentment and mistrust.[7] Soon this flawed character is fired over a misguided art deal and, to appease the demands of fiction, kills himself.[8]

In a review essay, Robert Fulford, who knew both the author and his model, wrote that "the relationship between Alan Jarvis and Aylwin Ross is so close that the Ross section of the book almost amounts to a biography."[9] Fulford enhanced readers' understanding of the novel by exposing Davies' building blocks. But a biographer must remain conscious that in creating Aylwin Ross, Davies submitted to fiction's imaginative process the Jarvis with whom he had enjoyed a wary relationship. While the outward shape of Jarvis' life survived this transformation, Davies invented, emphasized, and erased characteristics and events to fit the demands of his story. In doing so, he captured the essence of Jarvis' personality in a few pages.

Jarvis' literary metamorphosis was apposite because he wove stories throughout his life, turning himself into what the artist Jacques de Tonnancour called "a walking work of art."[10] The unprecedented publicity that accompanied his appointment to the National Gallery cemented a mythic version of his accomplishments in people's imaginations. He played up to this image for the rest of his life. Clark and Davies, who had both known Jarvis, had a balanced appreciation of his talent, charisma, flair, and faults. A far less charitable view was put forward recently by Douglas Ord, who argued that Jarvis deferred slavishly to English ideals while being fundamentally contemptuous of his home land.[11] The progression of views from Chisholm to Ord shows that Jarvis' "invented" persona has gradually distorted any understanding of his innermost motivations. Unlike a novelist, a biographer must crack these shells to expose the tender flesh within. This is particularly difficult because the only glimpses Jarvis left of his inner life are found in two tiny diary fragments, his friends' memories and memoirs, and some private letters that are scattered through many archival collections. Pulling together this evidence exposes a series of contrasts between Jarvis' inner motivations and their outward manifestations; sophistication concealed humble origins, levity covered serious intent, confidence disguised insecurity, and gaiety masked sadness and grief.

Two animating concepts can be distilled through this research.

First, Jarvis pursued several distinct careers in a working life that lasted only two decades, but the jobs were linked by a consistent, serious purpose. Coming of age during the Great Depression marked Jarvis profoundly. At university he was seduced by the promise of adult education – a radical, left-wing concept that differed greatly from adult education as conceived today.

In Jarvis' time, proponents of adult education wanted to change society. Drawing on ideas developed in psychology, sociology, history, philosophy, and other disciplines, their goal was to provide learning opportunities to people who had no access to traditional schooling in the hope that students would challenge precepts and demand a more just society. Between the wars, experiments in adult education spread across Canada, as universities broadcast courses over the radio, city schools offered night programs, and a national coordinating body was established. Adult education was Jarvis' intellectual canvas and is the most perceptive and rewarding one on which to paint his life.

Sex was the other animating concept. Despite being evasive about many of his innermost feelings, for most of his adult life Jarvis "wore his sexuality with ease."[12] The most sensitive and even criminal part of his life was the most open. He was bisexual. His predominant physical relationships were with men, but his attraction to women was real and withstands scrutiny and scepticism. Familial, legal, and social pressures certainly affected Jarvis' heterosexual relationships, but dismissing them outright as a sort of camouflage is unfair and inaccurate. So too is seeing the successful older men with whom Jarvis was associated as a coterie of homosexual protectors, because his closest male relationships were with "father-brother substitutes," in whose attentions he sought consolation for two tragedies in his youth. Some were gay and became Jarvis' lovers. Many were neither.[13]

I never met Alan Jarvis. In the course of researching this book, I have had the pleasure of meeting and communicating with many people who knew him well. Just as Elspeth Chisholm found three decades ago, Jarvis' friends were excited to share their memories of his talent, triumphs, and flaws. Many of them are artists who were encouraged and inspired by Jarvis and, in a sense, they and their works are his physical legacy. While biography imposes structure on life's inherently messy, freeform nature, and a biographer's relationship to his or her subject is at once more intimate and remote than anything conveyed by the term "friendship," I hope that, like Robertson Davies' portrait miniature, the Alan Jarvis who appears in this book bears some resemblance to the person so many people knew.

CHAPTER
TWO

"A Curiously Mixed Background"
Family and Childhood, 1915–1934

Lawren Harris, one of Canada's most renowned twentieth-century painters, once proclaimed that the three most important people ever to emerge from Brantford, Ontario, were himself, Alexander Graham Bell, and Alan Jarvis.[1] A modern wit would give third spot on this list to hockey legend Wayne Gretzky. So Harris' quip illustrates the esteem in which Alan was held during his lifetime, the oblivion into which he has fallen in death, and some fundamental misconceptions about his background.[2] Alan was at least partially complicit on each count. Few of his friends and acquaintances knew much about his early life, because he mentioned his family rarely and circumspectly. Glimpses of this period can be gleaned by trawling Alan's archives at the University of Toronto, and a small number of other sources, but it is difficult to fully pull back the curtain in which he enveloped his roots.

Unbeknownst to Harris, Alan had only slight ties to Brantford. The Jarvis line from which he descended was humble, as were his Hepburn, Irving, and McKay ancestors. They were all Presbyterian Scots who hailed from small towns in south-western Ontario like Guelph, Seaforth, and Winona. They may well have migrated to the rich soils of Wellington and Huron counties as Loyalists in the upheavals that followed the American Revolution. Like so many others, by the early years of the twentieth century, Alan's direct forebears had drifted to the city of Toronto in search of brighter economic opportunities.

Throughout his boyhood, Alan saw many aunts, uncles, and cousins, but he generally obscured or embellished his family story. It indicated both a lack of interest in, and embarrassment about, his extended roots. Of all his ancestors, he was most careful to conceal the details of his father, about whom he never really spoke, and of whom he probably had no memories. Charles Arthur Jarvis – Charlie to his friends – was born in Toronto on 5 April 1887. His father, Charles Henry Jarvis, had once been a police constable, an occupation that required little in the way of formal education but conferred lower middle-class respectability. Policing was a Jarvis family trade, with one relative becoming chief in Bowmanville, Ontario, and another serving with the Mounties. Around the time of Charlie's birth, his father retired from the force to become a grocer. Charlie's mother was born Isabel Hepburn in Guelph, a small industrial city that lies about 100 kilometres west of Toronto. She and her husband raised their children in a small house at 288 Clinton Street, just west of Toronto's downtown. Charles Henry Jarvis died when Alan's father was quite young, and sometime thereafter Isabel married Frederick Nottingham, who worked in a large commercial bakery. The new family lived together at 587 Shaw Street, a few minutes' walk from the house in which Charlie spent his earliest years.[3]

Charlie kept his father's surname and developed into an outgoing, ambitious, and intelligent young man at a time when only a very few people could aspire to a university education. He was not one of the fortunate few, as the Nottingham family's modest circumstances forced him to leave school in his teens and begin contributing to the household income. Rather than making the expedient choice of joining his stepfather at Toronto Bakeries, Charlie apprenticed as an optician. A coat and tie, rather than an apron, was the uniform of this congenial and socially elevated occupation. After initial training in Toronto, Charlie acquired more advanced skills in New York City and Philadelphia before returning at twenty-one to Shaw Street and a job at Eaton's, Canada's foremost department and mail order store. The Eaton's optical counter was headed by an experienced ophthalmologist and was likely the busiest purveyor of eyeglasses in Canada, and therefore an excellent place to hone one's skills.[4] Though Charlie would eventually adopt the title "doctor," he had chosen optometry because, unlike more established branches of medicine, it was largely unregulated in North America and so there was no prerequisite for a university education. Optometrists, who undertook

rudimentary training in ocular diseases, were only gradually demarcating the distinctions between themselves and the more humble opticians, who simply fitted and sold spectacles. A Canadian governing body for this new profession, the College of Optometry, would only be established in 1941, but Charlie was one of the "leaders" of its precursor, the Ontario Optometrical Association.[5] Whatever their training, optometrists, like similar quasi-professional occupations, enjoyed a respect and standing in the community that was far above Charlie's modest beginnings.

In contrast to the way Alan revealed little about his father, his mother was well known to many of his friends and was a central figure in his life. She was born Janet Stewart McKay on 10 April 1890 in Seaforth, an industrial town of some 3,000 people located near London, Ontario. She was one of the three children of Elizabeth Irving and William McKay, who listed his occupation as "engineer," a Victorian term for someone who ran a machine in a factory. By the early years of the new century, William had relocated his family to Toronto, where he eventually rose to the position of manager in a small industrial company. The McKays may have been marginally wealthier than the Jarvises, though the families lived only about two kilometres away from one another on the western edge of downtown Toronto.[6]

Charlie and Janet's first meeting has been lost in time, but, as with many couples in that era, it was likely at some church, school, or neighbourhood social function. They fell in love and were wed in Toronto on 28 December 1910. On the marriage certificate, the twenty-three-year-old groom listed his residence as Kansas City, Missouri, where he was undertaking advanced optometrical training. Shortly thereafter, Janet moved to her husband's adopted home and, almost exactly nine months later, on 29 September 1911, she bore the couple's first child, a son they christened Colin McKay.[7]

Photographs from Kansas City show a happy Charlie and Janet socializing with a large group of friends. The young couple project middle-class respectability, despite the evident contrasts in their personalities. A handsome, tall, dark-haired man who dangled his *pince-nez* from a silk ribbon, pomaded his hair, and favoured stiff celluloid collars, Charlie looked every inch the ambitious self-made professional and civic booster who belonged to both the Rotary and the Freemasons. Holiday photos show this gregarious, outgoing man's raffish side. He and his mates – self-described "live wires" – pose with

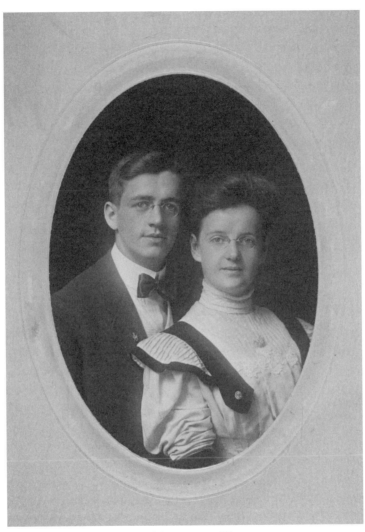

Jarvis' parents about the time of their 1910 wedding.
Alan Jarvis Collection, University of Toronto.

their automobiles or promenade dandyishly along a boardwalk, wearing straw boaters on their heads and the most up-to-the-minute drainpipe trousers.[8]

Janet Jarvis' striking good looks and appealing, gentle face are equally evident, but by all accounts she was deeply conventional. She was more reserved than her husband and never touched alcohol. Like many women of her time, she was married at twenty and had her first child the following year. As the wife of a man who aspired to professional status, there was no question of Janet taking a job. Instead, she kept the family home and socialized mainly with relatives, her husband's colleagues, and the local church women's group. Her physical appearance changed gradually as the years passed in reflection of her responsible, matronly, and supportive role. As a young woman, Janet pinned her long light brown hair up in the style of Edwardian ladies and, like her husband, wore *pince-nez* spectacles, though they made her look severe. This effect became forbidding in middle age as Janet coiled her hair into a tight bun and adopted rimless glasses. Unlike her husband, no photos have survived of Janet frolicking with her friends.

Having moved to the United States, a journey that Stephen Leacock called "that goal from which no traveller returns," Charlie and Janet made their way back to Canada after only two years.[9] Charlie's Kansas City training was over and it was time to go home. Rather than heading back to Toronto, the young family settled in Brantford, an attractive city that lies about 100 kilometres southwest of their hometown, but to which neither of them had any connection.

Brantford's architecture vouchsafed the stolid, imperial confidence of its Victorian and Edwardian residents and demonstrated that the Jarvises made an informed decision about where to live. The city was centred on a splendid Doric-columned courthouse that overlooked Victoria Park, "a Union Jack of gravel walks and neatly mown grass."[10] Like so many similar Ontario towns, imposing churches of several denominations ringed the other sides of the park. Porticoed banks anchored the main street, while yet more church spires poked above the adjacent avenues of handsome and substantial brick houses. Through the trees to the west of the courthouse could be glimpsed the crenel-

lated roof-line of the local armoury, which was home to Brantford's militia, a force of citizen soldiers who joined as much to parade in resplendent uniforms as to defend the country.

These confident buildings testified to an abundant wealth that derived from manufacturing. In this era, farmers throughout North America tilled their fields atop Brantford-built Massey-Harris machines, while passengers on the Grand Trunk Railway rode in carriages that had been assembled in Brantford. The daring men and women who took up cycling in the 1890s also likely did so astride machines that had been born in Brantford. Wealth spurred creativity. Alexander Graham Bell carried out his early research at his parents' Brantford house, and a few years later, Lawren Harris, an heir to the tractor fortune, took up his paint brushes. Literary-minded people in North America and abroad might well have attended one of Mohawk poet Pauline Johnson's immensely popular public readings.

Brantford's burgeoning industries attracted workers from nearby towns and rural areas, and ambitious young businessmen like Charlie, causing the city to grow greatly in the two decades before the First World War. Like most Canadian urban centres, Brantford's citizens were overwhelmingly of British extraction, though small groups of Armenians, Poles, Austro-Hungarians, and Jews worked in the factories. There was also a significant aboriginal community. Politically, Brantford swung between Tory and Grit, while its social mores encompassed both the adherents of the temperance society, that *sine qua non* of Ontario decency, and the more roughly hewn patrons of the city's many theatres and saloons.

Such a vibrant and booming centre was just the place for a go-ahead young man like Charlie Jarvis. He arrived alone in 1913, describing himself as an "optical expert" and boarding in a house with three other men. Janet and Colin stayed in Toronto with her mother-in-law for the first year, by which time Charlie had begun referring to himself as an "optometrist and manufacturing optician." Within another twelve months, he had adopted the grandiose title "Dr Charles A. Jarvis OptD" and opened his own business under the slogan "Where poor eyes and good glasses meet."[11] As befitted an ambitious man, Charlie joined the local Rotary club and Masonic lodge and raised funds for the war effort. A militia commission did not tempt Charlie, and though he was only twenty-seven years old when Europe's armies

mobilized in August 1914, there is no evidence that he tried to enlist in the Canadian Expeditionary Force.[12]

Charlie and Janet's second child was born in Brantford on 26 July 1915. He was christened Alan Hepburn at Alexandra Presbyterian, an imposing church within sight of the Jarvis' modest, two-story red brick house at 41 Peel Street. The young family was happy, as Charlie's prospering business moved to new premises at 52 Market Street, across from the courthouse. The building that housed Jarvis Optical has disappeared, but its location proclaimed Charlie's ambitions. An up-and-coming businessman must have an equally impressive home and so, in late 1917 or early 1918, the Jarvises moved to a substantial three-story brick house on a double lot at 172 Nelson Street, less than a kilometre from Charlie's work.

Charlie's ascent continued in 1918 when he moved to an even more elegant shop at 128 Colborne Street that was reported to be "some of the best premises in the province." Though a few blocks away from his original location, the new site was still in the heart of downtown. Everything seemed perfect as Charlie walked to work on the morning of 10 October 1918. However, just before nine, in the melodramatic phrases of the contemporary press, he was reported to have called out to an employee "Send for Dr Phillips, I have taken the wrong stuff!" before collapsing. Neither the doctor, nor the fire brigade could revive him. He was dead at age thirty-one. The *Brantford Expositor* suggested that Charlie "had been ill of late and kept medicine at the back of his store," which he had unfortunately placed next to a bottle of cyanide.[13] This might be a literal recitation of the facts. However, Edwardian newspapers reported on shameful issues elliptically, so the wording might also imply that Charlie had been depressed or, given that his home was dry, kept a bottle of alcohol in the workshop. The coroner was equally unable to determine if Charlie had taken his own life, or had had a tragic lapse in concentration. So he listed the cause on Charlie's death certificate as potassium cyanide poisoning.[14]

Moving letters of condolence from Charlie's colleagues and friends in Brantford, Toronto, and the United States demonstrated his impact on the profession and community. His estate, which he bequeathed entirely to Janet, included seven life insurance policies, which were worth a little more than $35,000. Charlie had purchased three of these policies, with a total value of $20,000, on opening his new premises a few months earlier. Jarvis Optical,

whose shares were worth $3,680, was Charlie's only other asset. Janet was not trained to carry on running the business and had two sons to rear. But she remained in Brantford for about a year, before selling the shop to one of her husband's assistants.

Having cut her sole tie to Brantford, Janet took her young family back to Toronto, where they once again moved in with Charlie's mother. The city blurs traces of Janet and her children, though it is almost certain that she lived very modestly on the small financial cushion that Charlie had left. Janet re-emerges in June 1925 when, at age thirty-five, she married forty-eight-year-old Edward Bee. Ed was the distinguished-looking, but not handsome, manager of Queen City Glass, a small manufacturer of window panes, mirrors, and "bent and fancy" glass.[15] He lived on his own in a small apartment near Janet's home. The devout pair almost certainly met at West Presbyterian Church, which was a short walk away from their front doors. Where Charlie had been the young Janet's passion, Ed was the reliable, financially secure partner of her middle age. Just as importantly, he proved his affection for Colin and Alan during a year-long courtship.[16] Janet took her new husband's surname, but her children did not. Nevertheless, Ed provided his new family with the stability and security they had lacked since Charlie's death.

Ed was much more like his new wife than her first husband had been. When relaxing, this non-drinking pipe smoker traded his dark suit for the cardigan in which he golfed and tended his aquarium. He also dabbled in painting, about which the young Alan was alternately supportive or scathing, calling some of Ed's more exuberant creations "chocolate box" work.[17] It was a term that Alan applied to maudlin creations for the rest of his life. One searches in vain for more exciting things to say about a rather phlegmatic man whose only recorded extravagance was to buy a diamond ring for himself at the age of sixty-two. If Ed was even-tempered to the point of dullness, the affection he felt for Janet's children was nonetheless reciprocated and the new family was very relaxed, happy, and close. Though Alan was ten years old when his mother remarried, he always treated Ed, whom he called "Pappy," as his father. His mother went by the name "Jinny," and the young Alan was known affectionately as "Jar Face" or "Ambrose."[18]

The Bee family settled into a comfortably large and relatively new house at 66 Marmaduke Street in Toronto's far west. They filled it with furniture and decoration that reflected their prosperous middle-class solidity. The

somewhat sombre dark wood mouldings, doors, and floors were covered with heavy drapes, brocade carpets, patterned wallpaper, comforting Victorian prints in mahogany frames, and thickly upholstered furniture with flowery slipcovers. Tea was served from a formal silver set.[19] The uninspired decor also reflected Janet and Ed's outlook. Like many Ontarians, they were moderately pro-British in political and cultural matters and softly anti-American. It was an essentially romantic connection to the Empire, because neither of them had ever crossed the Atlantic. The family's closest link to the old country was an Englishwoman named Maudie who kept house for them.

Marmaduke Street lies in what is now a much sought after neighbourhood, but in the 1920s the area lacked the social distinction of the Annex, Forest Hill, or Rosedale. Nevertheless, "66," as the family always called their home, was ideally situated. This neighbourhood of large and affordable houses attracted young families, making the streets echo with the sounds of children. The Bees worshipped less than a block from their front door at Howard Park United Church, while the children attended elementary school only slightly further down the street. Five minutes' walk in the other direction lay High Park, a huge concentration of ravines, marshes, and ponds in which children played, swam, fished, boated, skated, and skied. Ed's office was close by, as were the shops and street cars of Roncesvale Avenue and Bloor Street, the major route to downtown.

If the area around 66 was vibrant, this was not an adjective that could have been applied unreservedly to Toronto. In the 1920s and '30s, Montreal was Canada's largest city as well as its cultural and financial heart. Toronto was a dour cousin. The city was known, among other things, as "Toronto the good" because of its abundance of churches and the ubiquity of such guardians of morality as the Women's Christian Temperance Union. Many residents like the Bees had taken the pledge, and some public places, like High Park, remained "dry" well into the twentieth century. This public rectitude extended to sexual matters. At least as far back as the 1880s, the police morality squad and the city's judiciary had targeted and harshly punished homosexual men.[20] Polite society was dominated socially and politically by a small clutch of Protestant, Anglophile families of British descent like the Jarvises, with whom Alan was often, and incorrectly, linked. Most residents were of similar stock, though small communities of immigrants from continental Europe began settling in Toronto after the First World War.

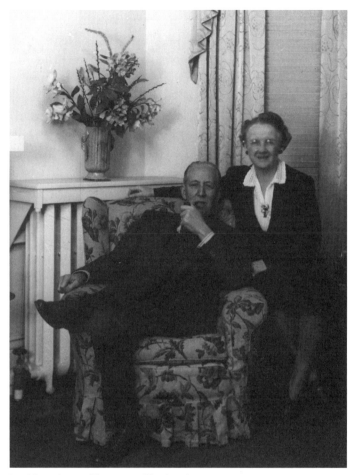

Jarvis' mother and her second husband,
Ed Bee, in the living room at 66 Marmaduke
Street, c. 1940. Alan Jarvis Collection,
University of Toronto.

Throughout Alan's youth, an artistic and cultural centre was emerging from beneath this gloomy patina. Painters, musicians, and the culturally minded congregated at the Arts and Letters Club, around whose lunch tables the Group of Seven, the most influential collective of Canadian painters, was founded. One of Canada's very finest accumulations of paintings, ranging from Old Masters to contemporary works, could be seen at the Art Gallery of

Toronto. During the 1920s, the gallery's director of education was Arthur Lismer, one of the members of the Group of Seven, who in his role at the gallery developed an extensive outreach program that targeted both schoolchildren and aspiring artists. Other cultural events took place at Massey Hall, which opened in 1894 as Canada's first purpose-built concert venue. The Toronto Conservatory of Music set the Dominion's standards for music teaching and performance. Its head, the internationally renowned conductor Sir Ernest MacMillan, championed symphonic music, while the London-trained actress Dora Mavor Moore pioneered Canadian theatre. Virtually all of this activity took place without arousing much interest from Janet and Ed Bee. They loved the movies, a passion they shared with both their children, but had only a passing interest in, and conventional, conservative views about the arts. This disinterest in the arts would prove to be problematic for both Colin and Alan.

The bond between the Jarvis boys transcended the four-year gap in their ages; by adolescence they looked so alike that it was sometimes hard to see that Colin was that much older than Alan. Throughout his life, Alan idolized and consciously emulated a brother whose achievements seemed effortless. Colin was the more naturally outgoing of the pair, and was a gifted runner, actor, and poet. Alan was an adept mimic who could capture voices and accents perfectly, but was slightly quieter, less obviously athletic, and more inclined to draw and sculpt. Though their personalities were markedly different, the boys were as inordinately good-looking as their father. They were very cute babies, who grew increasingly photogenic in adolescence as they struck nonchalant, charming, or swaggering poses, wearing their longish hair Brylcreemed straight back off their foreheads like matinee idols. Cinematic comparisons provide an effective shorthand with which to convey the brothers' physical appearances – Colin was a laconic Gary Cooper to Alan's Cary Grant. Or, as a friends' parents said as Alan swaggered down the street, "Look at that boy, he has such an air about him."[21] Alan never lost this beauty, keeping a full head of hair, standing 1.83 metres tall, and weighing a trim eighty kilograms until the end of his life. As for most teenagers of the boys' generation, cigarettes were a requisite part of this debonair pose, and judging by

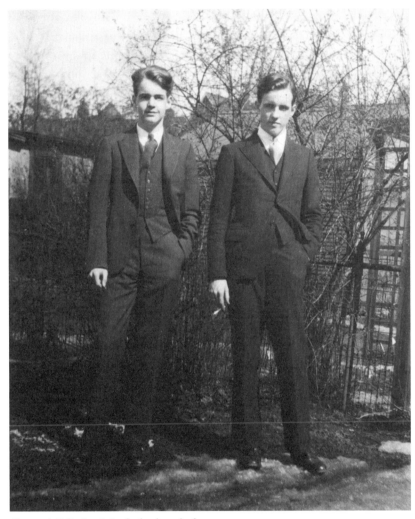

Alan and Colin Jarvis in the backyard of
66 Marmaduke Street, Toronto, c. 1930.
Alan Jarvis Collection, University of Toronto.

photographs, Colin and Alan were soon regular smokers. Janet urged her sons to quit – even though she smoked cigarettes and Ed enjoyed his pipe.[22]

In almost every other way, Colin and Alan made their parents immensely proud. Like that of many middle-class fathers, Ed's approach to child-rearing revolved around the muscular Christian sentiment of developing "sound minds in healthy bodies," and his stepsons took this message to heart.[23] They attended church regularly and Colin at least helped to run the Sunday School. They both joined youth groups sponsored by the parish and Ed's chapter of the Rotary Club. The brothers understood the effect they had on their peers. Colin's athletic skills and outgoing personality made him a natural leader among the local kids. Alan played the same role for a slightly younger crowd by imitating his idolized elder brother to overcome his natural shyness and introspection. Their gangs played in the streets and High Park, and attended the cinema. In contrast to these shared activities, in sports Alan and Colin were quite different. Colin excelled at track and field, while Alan, who was more frail and sickly, canoed, fenced, and played squash in his teens.

Ed's hope of raising well-rounded sons was also apparent in the boys' burgeoning artistic inclinations. At thirteen Alan set up a studio in the basement of 66, where he taught himself to sculpt, paint, and work in pewter. He was quite colour blind and so gradually settled on clay as his preferred medium. Away from his easel, Alan read nineteenth-century British novels voraciously. By fourteen he had finished the realist works of Thomas Hardy, and had decided that Anthony Trollope's immensely popular tales of clerical and political machinations were "too slow" for him. To these rather conventional choices, Alan added a healthy appetite for detective stories and the metropolitan wit and sophistication that was chronicled in the *New Yorker* magazine. His interest in music was an equally catholic mix of everything from classical to jazz.[24]

The first glimpse of Alan's fascination with celebrity is seen when he began collecting autographs at age fifteen. His correspondents ranged from Britain's war leader David Lloyd George, to the Scottish singer Harry Lauder, and the Canadian prime ministers Robert Borden and R.B. Bennett, while on the back of a card he received from the Duchess of Atholl, Alan penned a boastful "Mr Jarvis commands the respect of a duchess." The approaches were not always successful, with both the Prince of Wales and Duchess of York refusing Alan's

requests outright, while George Bernard Shaw sent a photo. A better augury of Alan's future career was the card from the painter A.Y. Jackson: "Dear Mr Jarvis, you have probably come to the conclusion that I have long ago forgotten that I promised to get you the signatures of the Group of Seven. I wrote to [Fred] Varley in Vancouver and to [Edwin] Holgate in Montreal last year, but neither of them have answered. So the best I can do is send you the Toronto signatures, with [Lionel] Fitzgerald of Winnipeg added, as he has quite recently become a member. If I can run down the other two members some time I will let you know."[25]

Alan's rather solitary interests did not prevent him from developing an adolescent romantic attachment to Betty Devlin, whom he christened "Betts-egg." Her family lived around the corner from the Jarvises, and her older brothers were chums with Colin and Alan. Betty soon became Alan's closest confidante. She enjoyed his wit and sense of fun and they engaged in harmless pranks like throwing confetti at Howard Park Church weddings and teasing its caretaker. Her parents were just as fond of Alan and they invited him to stay at the family cottage. Eventually Alan confessed to his brother that he had a crush on Betty. Like any adolescent, Alan was uncomfortable about revealing these emotions to her directly and so at one point Colin asked Betty whether his brother had "been romantic with you?" When she replied that he had not, Colin could only say "Oh, he will."[26] The pair remained inseparable until high school, when Betty's parents sent her to a private girl's academy.

As they grew older, the Jarvis boys proved that they also had formidable intellects. Colin attended the University of Toronto Schools, or UTS. Every year, academically gifted boys from throughout the city wrote entrance examinations for this exclusive institution whose curriculum stressed academics, sport, drama, and the arts. Having won a spot, for the next four years Colin travelled downtown to school every morning. Colin's UTS peers were among Toronto's most talented young men, and had no connection to the area around High Park. The school's environment encouraged Colin to develop considerable literary and athletic skills. In his last year, he was one of eleven Toronto high schoolers invited by the Canadian Authors' Association to read their verse to four of the country's most renowned poets: Charles G.D. Roberts, E.J. Pratt, Katherine Hale, and Constance Davies Woodrow. Coming from the doyen of Canadian letters, Roberts' praise for three of Colin's sonnets –

"Power to your elbow! Go ahead!" – inspired the would-be poet.[27] The triumph was repeated on the track at the end of the year when Colin set a record by winning four running events at the school's annual athletics meet.[28]

Colin's effortless academic and athletic successes continued in September 1930 when he entered University College at the University of Toronto. He enrolled in the program titled Philosophy with an Option in History or English, the college's most academically rigorous course, appeared regularly in leading roles with the University College Players, and sprinted on both the college and varsity track teams.[29] A couple of love letters to an unidentified sweetheart that survive from this period show that Colin was playful and happy.[30] He was also ambitious. In 1930, he chose the slogan "Just Call on Colin" to successfully campaign for the post of assistant secretary of the University College Literary and Athletic Society, the college's storied governing body. The Lit, as it was called, had been established to groom future Canadian political, business, and social leaders. The following year he ran, unsuccessfully, for the Lit's presidency under the banner "Colin Colin Again."[31] Failure to secure one of the most hotly contested college offices did not deter Colin, who served as president of the College Players' Guild in 1931, a position from which he issued a mock-splenetic denouncement of Hollywood as "Tommy-Rot" that could not compare to the quality of stage dramas.[32] A day after this interview was printed in the student newspaper, he added a Gilbertian clarification that "my true opinion of the Hollywood films is that they are drenched with eroticism. If your reporter finds eroticism to be the intellectual equivalent of 'tommy-rot' then it must be so because all reporters are endowed with Olympian omniscience in matters philological."[33] His literary and artistic ambitions resurfaced in the spring 1932 edition of the college literary magazine in the form of a pen and ink drawing of two nuns, and a rather pretentious poem that included the image "man with a magenta mind/walks in a desert/of white sand ..."[34]

Colin also spread his talents beyond the university campus. In the summer of 1930, he ran the drama program and edited the newspaper at a YMCA camp in the Muskokas, north of Toronto.[35] He moved the following year to Camp Onondaga, near Minden, Ontario, to supervise the youngest campers and once again organize drama activities. Onondaga's owners boasted to Janet Bee about how her son's "splendid work," cheery attitude, and never fading

zeal won the respect and admiration of both the staff and the boys.[36] His charges, among whom was a young Mavor Moore, scion of one of the country's foremost theatrical families, were inspired by Colin's talent and passion for theatre.

Janet and Ed were less enthusiastic about their son's artistic inclinations. Charlie's death had made Janet all too aware of her family's precarious perch in the middle classes. She and Ed worried that an artistic life was frivolous and unprofitable, so at some point during Colin's undergraduate days they made him agree to pursue a more traditional and reliable professional career.[37]

These auspicious accomplishments in academics, athletics, and leadership brought Colin to the attention of faculty members like Barker Fairley, who taught German and led Canada's emerging left-wing. He believed Colin was "one of the few students at Varsity who will really accomplish something."[38] Colin was firmly on course for a Rhodes Scholarship, the most coveted academic prize open to Canadian undergraduates.

There was far less obvious accomplishment in Alan's academic career, despite talents and enthusiasms that impressed his classmates.[39] Alan failed to win a place at UTS and enrolled in September 1927 at Parkdale Collegiate, the neighbourhood's public high school. This physical divergence highlighted some essential differences between the Jarvis brothers. Despite earning very good grades, Alan's quieter nature meant there is little trace of him in the yearbook. He was not a conspicuous athlete or member of the literary society, which were the most assiduously documented student activities. While Colin earned laurels at UTS, Alan withdrew from school in the spring of 1931 to convalesce from an appendectomy. He returned in September and graduated in the summer of 1932.[40]

Alan did not proceed directly to university that autumn. Instead, he stayed on at Parkdale to complete extra, self-directed coursework. In early 1933, he enrolled in the sculpture course at Central Technical School, where he hoped to hone the skills he had begun developing in the basement of 66, while also trying to emulate some of the artistic opportunities that Colin had enjoyed at UTS. This decision to explore sculpture was important for Alan, but one that his parents must have looked at warily, because the courses at the Central Technical School were designed to produce professional artists. The

school had been founded in 1915, and was headed in Alan's time by Peter Haworth, an English painter who had trained at the Royal Academy, while some of Canada's best painters and sculptors taught classes.[41] This was a truly remarkable collection of talents in a country that could boast very few full-time artists. Sculpture was taught in the school's modern clay modelling and casting rooms by Elizabeth Wyn Wood, one of Canada's finest artists. She was a gifted teacher who took immense pride in passing on her skills to young people. She initiated a popular series of lectures designed "to foster an appreciation of fine sculpture and architecture among the senior students of art, and in this way influence their work," which she would then arrange to have exhibited at Toronto's annual Winter Fair. By the mid-1930s, she had well over 100 day students and a further 15 in the evenings.[42]

Alan's decision to throw himself into sculpture classes was a reaction to the defining event of his life. The normally robust Colin began feeling unwell at the end of 1932. Leukemia was diagnosed early in the new year and, given the primitive cancer treatments of the day, there was little hope of recovery. The family concealed the nature of Colin's illness from outsiders, and he quietly withdrew from the university to be cared for at home. Professor George Brett, who ran the Philosophy with an Option in History or English program sent best wishes for the speedy recovery of his star pupil, while most visiting friends remarked that Colin was cheerful. Only a very few saw the despair that was evident in the lists he made of the foods he would miss or never taste.[43]

Colin died at home on 4 March 1933 at age twenty-one. Most of his contemporaries only learned how seriously ill he had been through the black-bordered, front-page death announcement in the student newspaper.[44] Condolences from the university's president, along with those from former teachers and friends, demonstrated how well-known and valued Colin had been.[45] The funeral was held at Howard Park United Church, where the Jarvises had worshipped since moving to the neighbourhood eight years earlier. Colin was interred at Park Lawn Cemetery, in a plot to which his father's remains were transferred two months later.[46]

Alan, who walked to the funeral with Betty Devlin, was shattered and angered by his brother's death. After the service, the two friends went to a soda shop that was favoured by the neighbourhood's young people. Alan's fury

would not abate as he blamed the minister and the United Church for accepting the death of his brother and idol too readily. Betty was shocked by these violent emotions from a fundamentally gentle spirit who wielded wit as his primary weapon. Alan's grieving tirade was the start of an estrangement from the United Church and Christianity itself that grew over the years.[47]

This angry break with religion was part of a bigger emotional rupture. Alan had lost his elder brother, idol, and closest and most intimate companion. Janet had buried a second member of her family. She and Ed had lost a beloved son of whom they were immensely proud and for whom they foresaw a life of unqualified promise. Ed was too retiring to have left much trace of how this affected his relationship with Alan, though it is clear that Colin's death fundamentally altered the way Janet looked on her surviving son. Colin's achievements had always been greater than those of his younger brother. But he was gone. For a short time many years earlier, Charlie Jarvis had given his family prosperity and public respectability. Having been dissuaded from an artistic career, Colin had seemed destined to fulfill his father's blighted destiny by cementing the family in the middle classes. All of these explicit and implied hopes now transferred to Alan, who would never again find it easy to divorce himself from his parents' aspirations, or his brother's legacy. He sensed this pressure acutely for the rest of his life and always measured himself against idyllic notions of his brother's potential. In candid and self-reflective moments throughout his life, Alan would state that Colin, who had seemed so much more talented, should have achieved all that he himself did. When Alan compared himself with his brother, he came out as less witty, intelligent, and handsome. Over time an obsession with what Colin might have accomplished became "an extraordinary fantasy" in Alan's life and a key to understanding his eventual descent into depression and alcohol.[48]

The pressure was so subtle, yet persistent, that at times Alan blurred the distinctions between himself and Colin. In a short autobiographical sketch almost twenty years later, Alan grafted Colin's sporting achievements into his own youth. At the same time, Alan wrote a more glamorous and wealthy role for Ed Bee, perhaps in an allusion to his dead father's potential, as "a leading Canadian glass manufacturer."[49] Alan was always cagey about his immediate and extended family, even if this sort of deliberate conflation and obfuscation was very rare. It spoke of his secret, life-long search for the approbation,

approval, and support of men he called "father brother substitutes."[50] Some of these relationships were physical, but seeing them as simple homosexual affairs risks trivializing their importance as a means of understanding Alan.

These feelings and relationships manifested themselves over many years, but Alan was shattered immediately. With his parents' blessing, he enrolled that autumn in full-time sculpting classes at Central Technical School. Immersion in art shielded Alan from the painful comparisons to Colin that would have been made if he had gone immediately to university, while providing a creative outlet for his grief and anger. Alan had always loved sculpting, but this experience gave the art form a deep, private, emotional resonance. He would turn to sculpting to deal with shock, stress, and disappointment for the rest of his life. But the art school was not a cocoon. In October, Colin's university friends offered their support to Alan by casting him in a production of John Drinkwater's play *Bird in the Hand*. Their compassionate gesture was ruined by a critic who said the play was the worst sort of failure; a comedy that garnered no laughs. Alan was singled out for having "rather spoiled his attitudes by unfamiliarity with his lines."[51] The experience brought Alan little solace, especially since Colin had been such a gifted actor. He never again appeared in a student production and entered the university the following year wary of being too readily identified with his illustrious brother.

CHAPTER
THREE

"Douglas Duncan Invented Me"
Undergraduate, 1934–1938

In September 1934, Alan Jarvis entered University College, or "uc," the largest and only secular institution affiliated with the University of Toronto. It was a key choice because much of an undergraduate's life revolved around his or her college. The University of Toronto had traditionally drawn students from throughout Ontario, though by the 1930s most of the 4 per cent or so of the province's young men and women who attended university did so in their hometowns. uc's undergraduates bore out this trend; about half hailed from Toronto and like Jarvis, a majority of them lived at home throughout their studies. Nevertheless, the student body was more diverse than this fairly narrow catchment area suggests. Half were women, while uc's secularity attracted a substantial number of Jewish students. Similarly, the students' socioeconomic origins encompassed the offspring of professional families with long traditions of university education, those like Jarvis, whose parents' success had propelled them into the middle classes, and a smaller group of scholarship students from more humble backgrounds.[1]

The English scholar Malcolm Wallace had been uc's principal since 1928, while the most redoubtable member of faculty was the Oxford-educated George Brett, who occupied both the University chair in philosophy and presided over a college department that had international stature. Its core included the corpulent, outgoing Fulton Anderson, who taught Plato, and the

lean, retiring Reid MacCallum, who covered aesthetics. UC's other departments were equally noteworthy. The Cambridge- and Courtauld-educated *connoisseur* John Alford ran the department of Fine Arts, while the German department was headed by Barker Fairley, the left-leaning Goethe specialist, founder of *Canadian Forum* magazine, and promoter of the Group of Seven. Imported stars worked alongside UC alumni who had returned to the college after graduate studies at some of the world's most renowned universities. The English department was riven politically between the Tory Arthur Woodhouse and the socialist Rhodes Scholar Norman Endicott, while the French faculty included the Sorbonne-educated poet and painter Robert Finch. Amid all this intellectual heft, the most conspicuous and controversial member of UC's staff was the historian Frank Underhill, who had co-founded the League for Social Reconstruction in 1931, authored the Regina Manifesto two years later, and provoked the Canadian Establishment from his office in the college's history department.[2]

In the mid 1930s, there were essentially three avenues via which an ambitious UC undergraduate could bring him- or herself to the attention of the college and university authorities. Firstly, UC's impressive faculty focused its teaching on Philosophy with an Option in History or English. Brett had modelled this honours course on Oxford's *Literae Humaniores*, the storied subject known as "Greats," whose students use an intensive study of Greek and Latin as a base for examining classical literature, history, and philosophy. UC students met in small tutorials to analyze texts in their original languages and explore the historical contexts within which they had been created.[3] Only the brightest young men and women were admitted, and those who attained the highest grades were identified in the faculty's eyes as Canada's future leaders. Among those of Jarvis' generation who bloomed in this academic hothouse were Arnold Smith, the founding secretary general of the Commonwealth, University of Toronto president Claude Bissell, and the champion of Canadian theatre, Mavor Moore.

An elected position on UC's student body was a second route to recognition.[4] The Literary and Athletic Society, or Lit, as mentioned previously, had been formed in UC's earliest days as a political debating club with the express purpose of being "a training ground for leaders in Canadian society, above and beyond any specific university training attained in lectures and seminar rooms."[5] Membership in the Lit was restricted to men in Jarvis' day, but its

officers were in effect UC's student government. At the same time, the Lit's original mission was passed on to new generations through the tradition of inscribing the names of each year's executive in gold paint on the walls of the college's main student lounge. This gilded memorial included men who had become senior politicians, judges, lawyers, businessmen, and Jarvis' brother Colin, who, as we have seen, had served as the Lit's assistant secretary in 1930. Among its newer activities, the Lit financed UC's annual student magazine, the *Undergraduate*, which, as one of its first editors maintained, was "serious, experimental, a witness to high standards in literature and art," though critics, perhaps justifiably, felt it was controlled by an artsy elite who published turgid imitations of the day's great writers.[6]

Finally, the university's – and much of Toronto's – cultural life was centred on Hart House, whose gothic arches, oriel windows, and vaulted timber ceilings made it appear as though a baronial hall had been deposited amid the university's oldest colleges. The House was the brainchild of Vincent Massey, a graduate of Toronto and Balliol, whose family fortune derived from one of the world's largest manufacturers of farm machinery. Massey had joined Toronto's history department just before the First World War. Regretting that the university lacked an equivalent to the Oxford Union, where students from all colleges could meet, Massey convinced the family foundation to erect one. The House, which opened for university use in 1919, boasted an Oxbridge-inspired dining hall, art gallery, gymnasium, library, debate and reading rooms, and a small chapel. The theatre, which occupied most of the basement, soon became the home to Toronto's most important stage company, while the resident Hart House String Quartet was Canada's first professional classical music ensemble.

In Jarvis' day, Hart House was headed by J. Burgon Bickersteth, a middle-aged English bachelor who hailed from a line of prominent Anglican clerics. Massey had selected Bickersteth personally because he embodied the "muscular Christian" ideals of athleticism, intellect, and public service that Hart House was meant to promote. Having been educated at Charterhouse School and Oxford, where he captained the soccer team, Bickersteth spent two years as a missionary in Northern Alberta, before twice winning the Military Cross on the Western Front. Hart House came into its own under the tweedy Bickersteth. He stocked the library with fine books and the gallery with canvases from the Group of Seven, introduced Oxbridge style debates, presided over

formal dinners in the great hall, and expanded the theatre program. Bicker-steth set the House's overall direction, but individual activities were run by a series of student committees. Much as with the Lit, election to one of these bodies brought young men – women could only attend a restricted range of Hart House events until the 1960s – to the attention of Bickersteth and other grandees within the university and in Toronto's social and political elite.

The air was laden with expectation when Jarvis first passed through UC's heavy wooden doors in the autumn of 1934. Colin Jarvis had died only nine-teen months before Jarvis began studying the same demanding course, Phi-losophy with an Option in History or English. Colin had also served on the Lit, published poems and drawings in the *Undergraduate*, and run track for the university. Many of his friends were now senior students at the college, while several faculty members wanted to help this lamented star's younger brother.[7] Jarvis had acted at Hart House with some of these people a year ear-lier, though familiarity did not quell his wariness about being too closely iden-tified with Colin. As Jarvis confided in a short-lived diary a decade later, "Colin was a legend at the U of T. I was in danger of being 'Colin Jarvis' little brother' I was right to fight against that and clever to avoid it. It meant that I was aggressive and very mistaken about much at that age."[8] These private anx-ieties also manifested themselves in the classroom. He studied psychology, English, French, history, and philosophy, but apart from a top grade in phi-losophy, his academic performance was unremarkable.[9]

Nevertheless, UC's safe and welcoming environment allowed Jarvis to hone the suave, theatrical persona that could be detected in adolescent pho-tos. This outwardly self-assured pose compensated for his quiet nature and insecurities about being identified with his brother. It made him formidable and emotionally distant, but his wit, charm, and essentially pleasant person-ality quickly drew fellow undergraduates and faculty to him. Few knew him intimately, but many contemporaries were impressed by the way he laced his conversation with an almost unlimited store of *bon-mots* gleaned from the *New Yorker* and other sophisticated sources. He also collected limericks that reflected his mild, if slightly *risqué*, sense of humour, including this favourite of his:

When Titian was mixing rose madder
His model posed nude on a ladder
Her position to Titian
Suggested coition
So he nipped up the ladder and had her.[10]

Jarvis' flair was evident in an age when male students wore jackets and ties to lectures. Fellow undergraduates confirm this image of a dominant and charming, if somewhat distant personality who "would swan about the campus looking ten feet tall, camel's hair coat draped gracefully over his shoulders, usually with some of his acolytes clustered amazingly around him."[11] Hamilton Southam, a well-heeled undergraduate at Trinity College, who hosted weekly teas for aesthetically inclined students, remembered Jarvis as a "witty, slightly cynical god-like figure that floated fourteen inches above everyone else on the campus" and whose innate artistic taste made him something of a hero to his peers.[12] Francess Halpenny, who worked with Jarvis at Hart House Theatre, recalled that his intellect, glamour, and beauty made him "a legend at campus," while he and a friend from UC brandished imaginary swords and shouted "*En garde!*" when they crossed paths, in reference to the fact that people bearing the same surnames as theirs had fought the last duel in Upper Canada.[13]

Jarvis was conspicuous, admired, and well-liked, but his cosmopolitan, light-hearted demeanour was really a carapace that protected an ambitious but fundamentally shy and insecure young man who had never ventured beyond southern Ontario, and whose abstention from alcohol showed that he had not questioned some of his society's narrow strictures. Because people relished Jarvis' wit, his irreverent and blithe attitude shielded him from close questioning or scrutiny. While he was highly visible on campus and had a wide circle of acquaintances, he was emotionally inscrutable to all but a few intimate friends like Betty Devlin, who was also at the university. Jarvis supported this image by playing up a connection, based solely on a shared surname, with the more illustrious Jarvis family that had dominated Toronto society for much of the nineteenth century.[14] To maintain this pretense, very few of Jarvis' college friends were allowed to see his ordinary, unremarkable parents.

Part of the reason for Jarvis' visibility on campus was that from the

moment he entered UC, he threw himself into extra-curricular activities. He joined the college philosophy club in his first year, though academic societies were never central to his social life. More importantly, within weeks of arriving at the university, Jarvis asked Burgon Bickersteth for permission to set up a studio at Hart House.[15] Jarvis' initiative coincided with the establishment of the House's Arts and Crafts Room, in which Carl Schaefer, one of Canada's finest landscape painters, led twice-weekly classes. About two dozen undergraduates were invited personally by Bickersteth and Vincent Massey to attend.[16] As poet and Carleton University English professor George Johnston recalled, he and Jarvis were among the four or five regulars who "ate lunches there and worked on various projects. Carl [Schaefer] came once or twice a week to give us instruction and encouragement. At the end of the year we exhibited with the [Hart House] Sketch Club."[17] In addition to lectures on the history of art, Schaefer showed his students how to work in media like watercolour, ink, and gouache and fundamental techniques such as drawing, form and weight, modelling, and "composition from the print collection and current exhibitions."[18] These lessons built on the training Jarvis had undertaken with Elizabeth Wyn Wood.

Jarvis distilled this comprehensive practical and theoretical instruction, which was relatively uncommon in an era when art history courses were in their infancy, into the reviews he wrote for the university newspaper *Varsity*. These short, almost weekly pieces demonstrated how Jarvis' formal training, keen descriptive abilities, and astute judgment vied with a strong tendency to interweave personal anecdotes and an undergraduate desire to tear down accepted opinions. If Jarvis' ideas were provocative, his knowledge was more limited. His first column roundly criticised the Art Gallery of Toronto for misrepresenting Pierre-Auguste Renoir and Edgar Degas, with an exhibition of canvases that had been painted when the men were well past their primes.[19] Jarvis could be simultaneously iconoclastic and fawning, as in the way he lauds an exhibition by his teacher Carl Schaefer – "especially after seeing the Royal Academy work … it [Schaefer's work] gives one new confidence in Canadian art." He was also provocative – by calling on Toronto's civic leaders to declare Eric Gill week in honour of an artist whose "pencil studies defy comment."[20] *Varsity* was a springboard to the 1935 edition of UC's annual *Undergraduate* magazine that featured an article by Jarvis titled "Sculpture of the Twentieth Century." Like Jarvis' earlier criticism in *Varsity*,

this longer article combined youthful audaciousness with a growing knowledge of art and a provocative turn of phrase. He declared that Rodin had rescued sculpture from the "marble pornography thinly veiled in a Greek costume" to which it had descended during the nineteenth century, pronounced, as many professional critics already had, that Ivan Mestrovich, Eric Gill, Barbara Hepworth, and Henry Moore were the greatest modern sculptors, and dismissed Alexander Calder's mobiles as "interesting only to people with a fondness for gadgets."[21]

Having made an auspicious start, illness kept Jarvis away from campus for a good part of his second year. One can only imagine how worrying this must have been for Janet and Ed Bee, who had lost Colin in almost identical circumstances such a short time before. There is no concrete evidence of what troubled Jarvis, though it was probably the sinusitis from which he would suffer for the rest of his life. As a consequence, Jarvis took little part in the university's social life that year and was awarded aegrotats in four courses, while managing to obtain first class standing in ethics.[22]

Jarvis returned to campus and soared both academically and socially for the first time during the 1936–37 academic year. He was elected art editor of the *Undergraduate*, in which he published two longer and more polished articles that displayed a surer critical sense than his *Varsity* work, even if he continued leavening his judgments with personal anecdotes. In the first, he called the painter David Milne – with whom he had a personal connection, as we will see – both "a man of great personal charm, witty and intelligent" and a master of line, pattern, and palette. And Jarvis' one-time teacher Elizabeth Wyn Wood was lauded as the only person to have successfully depicted the Canadian landscape in sculpture.[23] The essay was followed by a brash critique of shows by UC faculty members; Robert Finch painted exceedingly well within narrow parameters, while Barker Fairley's freer approach had been "the source of his defects as well as of his essential merits, for his work shows a lack of that respect for formal discipline which is the mark of the trained artist."[24] Such cheek demonstrated the comfortable relationship Jarvis enjoyed with UC's faculty.

Jarvis also triumphed academically, earning firsts in philosophy, ethics, and aesthetics. As a result, he returned in September 1938 enriched by the thirty-three-dollar Tracy Scholarship as top student in Philosophy with an Option in History or English, and the McDonald prize in philosophy, which

paid fifty dollars outright and one year's tuition.[25] He was also the conspicuous and opinionated editor-in-chief of the *Undergraduate* during his final year, securing offices for the staff and convincing the college to endow cash prizes for the best submissions. After obtaining this funding, Jarvis spoke to various groups on campus, encouraging their members to contribute prose, art, and poetry. In these talks, he held up the *New Yorker* as a model of style, adding that he intended to shake up the *Undergraduate* magazine by refusing imitations of fashionable contemporary authors like T.S. Eliot in favour of things based "on what the writers feel themselves" because students "are on a higher intellectual plane than most people, and should strive to educate their general reading public."[26] He played up his suave, cosmopolitan demeanour by informing the Women's Press Club that Canadian writers had a parochial outlook that ignored their own country as a source of inspiration. For his first issue, Jarvis penned an editorial which boasted that the amount and quality of submissions indicated that "there is room in University College for a 'cultural' magazine."[27]

Collegiate triumphs by an inscrutable, dandified, and conspicuous young man were only the most traditional part of Jarvis' undergraduate years. By choosing UC, Jarvis had placed himself at one of the centres of a reform movement in Canadian art. The Depression, the Spanish Civil War, and the rise of fascism had caused a group of younger Toronto painters, including Jarvis' teacher Carl Schaefer, to reject the stylized, nationalist landscapes of the Group of Seven in order to engage more actively with contemporary social issues. Many of them had studied at the Art Gallery of Toronto under Arthur Lismer, who encouraged his students to depict social conditions and to help the needy. Broadly speaking, these young men and women aligned with the political left, identified themselves as "workers," and in 1933 founded the Canadian Group of Painters as "an organization dedicated to uniting socially conscious painters from across the country."[28] In doing so, they reflected the wider growth of Canadian socialism that also witnessed the founding of the Cooperative Commonwealth Federation in 1932 and its intellectual blood relative, the League of Social Reconstruction.

Aesthetic justifications for this new movement were elaborated in large part by Jarvis' UC philosophy teachers George Brett and Reid MacCallum. They published essays in left-wing Canadian magazines that drew heavily on the ideas of the Oxford philosophers Robin Collingwood and Edgar Carritt,

arguing that art should depict the human condition and engage with contemporary social issues. MacCallum was especially active in disseminating his views through his friendship with Schaefer, as a stalwart of the Hart House Art Committee, and as a public speaker. Similarly, John Alford, who founded the university's fine art department, knew Jarvis from social events, public speaking, and Hart House. Alford was the embodiment of a socially committed aesthete. After Cambridge, he drove an ambulance in the First World War, took a graduate degree in psychology, spent time at the famous London slum settlement Toynbee Hall, and then completed a doctorate in art history at the Courtauld Institute. His experience in social work and aesthetics led the Carnegie Foundation to select him as the first occupant of a professorial chair at UC, whose incumbent was charged with fostering "a democratic ideal of art as experience," along the lines of American New Deal initiatives.[29] Finally, the Australo-Canadian art critic Graham McInnes, who was active in Hart House and various Toronto cultural projects, advanced similar ideas in his influential arts column in *Saturday Night* magazine. Echoes of what Jarvis imbibed at UC and Hart House can be heard clearly in what he said and wrote about art for the rest of his life.

Although the exact date is not clear, sometime in the fall of 1934, Jarvis met his first "father-brother substitute."[30] Douglas Duncan was a bookbinder and art collector from a wealthy family. In childhood, Duncan and his sister, Frances, regularly accompanied their arts-mad mother to the theatre and concerts. After graduating from the University of Toronto Schools, Duncan spent three uncongenial years at Victoria College and an equally depressing stint with his father's meat packing firm. Sensing Duncan's unhappiness, at the end of 1925 his indulgent parents sent him to Paris where he shared a small flat with his university friend Robert Finch, who was pursuing graduate research. Duncan also followed courses at the Sorbonne, before discovering his *métier*. By the time he returned home in 1928, Duncan was one of Canada's foremost bookbinders.

This Parisian sojourn also gave Duncan the freedom to explore his homosexuality. He frequented gay cafés, night clubs, and theatres and eventually, thanks to an affair with a young German art dealer, joined a clique of

flamboyant artists, intellectuals, and aristocrats. Despite the openness with which he lived his daily life in Paris, Duncan had to hide his sexuality from his parents who, like many in their social milieu, condemned homosexuals as "immoral." For instance, when a young Parisian he had "picked up" at a café moved in with him he felt the need to reassure his mother and father that this new friend was just a live-in French teacher.[31] He lifted the cloak slightly in the summer of 1927 when his sister's music teacher killed himself after being exposed by a young male lover. In a consoling letter, Duncan told his sister that her teacher had pursued increasingly reckless affairs after the breakup of his relationship with Duncan's one-time flat mate Robert Finch. Duncan then explained that his own exploration of the literature on "inversion," as homosexuality was then known, had convinced him that "like green eyes, it is not unnatural, but *less* usual."[32] Frances' grief for her friend and Duncan's all but confession helped her accept her brother's sexual orientation. She befriended and travelled in Europe with Duncan and his lovers in the 1930s.

Duncan's passion for collecting matured in Paris. As a young man he learned that by living with his parents, spending next to nothing on food, and wearing his clothes until they were threadbare, his trust fund could be stretched to purchase fine books, music, and art.[33] The money went even further in Paris thanks to an exchange rate of forty francs to the dollar. He was a voracious reader, who amassed an immensely valuable collection of published and manuscript volumes of *fin de siècle* aesthetes and modernists like Oscar Wilde, Aubrey Beardsley, Marcel Proust, and D.H. Lawrence. He indulged his passion for opera and Diaghilev's Ballets Russe with equal fervour. This self-described "magpie" photographed details of gothic and renaissance architecture as reference material for book designs. But he also took many pictures of young, semi-clad matelots, stevedores, and swimmers that reflected his more private interests. Both types of images were taken for the most part on the continental car tours Duncan made with a variety of visiting friends, and, in 1931 at least, a handsome young lover from Toronto.[34]

In the summer of 1929, Duncan rented a small flat at 8 bis rue Campagne Première, a short and narrow Montparnasse street distinguished only by the fact that it was where Picasso bought art supplies and Gertrude Stein garaged her car.[35] Though he was not rich enough to hobnob with the *quartier's* residents at Le Dôme café, which was a short walk away from his door, Duncan signed a ten-year lease in 1930.[36] The decoration at 8 bis, which was limited to

a modernist chair, bookshelf, bed, and gramophone, reflected its owner's ascetic tastes. By the time he and Jarvis met, Duncan was summering in Paris and binding books all winter in his equally spare Toronto studio.

Duncan, who was twelve years Jarvis' senior, was an unlikely match for the younger Adonis to whom he was soon lover, teacher, and patron. He was tall, bespectacled, emaciated, and in seemingly delicate health, in part because of a diet based around cigarettes and chocolate. Though Duncan was neither physically demonstrative nor sensual, he mined his interests and experiences into charming, witty, and ironic conversations. As Jarvis recalled years later, above all else Duncan valued "intense personal relationships," the mantra of London's Bloomsbury group.[37] Whatever their physical disparities, the two men adored lively banter and admired many of the same writers and artists. Their parents would have condemned the relationship, but Duncan and Jarvis moved in a social group that included men and women who were passionate about theatre, art, literature, and music. Many of them also adhered to the left-of-centre ideas being expounded by the academics, artists, and critics who were positing a new socially engaged purpose for Canadian art. Group members discussed the latest happenings and trends in Europe and New York, where several of them had lived. Gay men like Duncan and Robert Finch were prominent within this circle. The group's social, sexual and political attitudes distinguished it from Tory, introspective Toronto and made it a remarkably tolerant and private haven at a time when homosexuality's social stigma forced gay men into parks, laneways, and lavatories. As Duncan knew from the fate of his sister's music teacher, men who engaged in such public encounters risked criminal prosecution and social disgrace.[38]

Jarvis had to be extremely discreet about his new-found intellectual and emotional home. It gave him a safe social sphere within which to explore his homosexuality and relationship with Duncan, while concealing this part of his life from university friends. This added to the essential inscrutability of Jarvis' public persona. He knew many of the sportier undergraduates, though he himself was not much of an athlete. They noticed that he took little interest in women, but possible suspicions about his sexuality were allayed by his continuing close friendship with Betty Devlin.[39] Janet and Ed Bee got to know Duncan, who seemed to them to be a slightly unwordly, harmless artistic type. Moreover, the differences in age, personality, and physical appearance between Duncan and Jarvis led many people to assume that this was simply an

intense, mentoring friendship based on an interest in the arts. What they did not see was that Duncan was Jarvis' first male lover, even if the relationship was far more significant emotionally than physically. Unlike so many of Jarvis' contemporaries at the university, Duncan had never met Colin. This alleviated Jarvis' feelings of guilt and inadequacy about fulfilling his brother's destiny and allowed him to reveal himself freely. Duncan adored him in return. The pair built a loving relationship around a shared passion for the arts, which contrasted with the fundamental incomprehension of cultural endeavours that Jarvis found at home. In this sense, his relationship with Duncan was far more than physical and in later life Jarvis claimed that "Douglas Duncan invented me."[40] The phrase combined Jarvis' nostalgia for the way Duncan guided him in artistic and sexual matters, with self-deception. Jarvis had begun creating a public persona long before meeting Duncan.

Fittingly, their first significant meeting was inextricably linked to the painter David Milne. In November 1934, Jarvis reviewed an exhibition of Milne's work at the Mellors Gallery for *Varsity*. He subsequently raved to Duncan, whom he knew slightly from university arts circles, about this impressive and relatively unknown artist. Duncan was intrigued by both the painter and the young man who sang his praises. He decided to visit the show with Jarvis.[41] The affair began amid Milne's canvases and continued with a journey the pair made on a "dirty, cold, cold day" the following spring to the painter's isolated shanty at Six Mile Lake, some 160 kilometres north of Toronto. Neither of them knew exactly how to find the cabin, which could only be reached by boat, and so they enquired at the general store in the town of Big Chute. Its proprietor remembered that Jarvis and Duncan "came into the house. I forget how they came in. I mind of it being blustery. And stormy and cold."[42] After thawing out over lunch, the pair set off "very gingerly" in a rented canoe, for as Duncan recalled, "we sort of drew up to the shore and the man [Milne] affably said hello and in fact said he was just going to have his supper, come up and have supper. And we said thank you. We had our food with us and we were going to camp somewhere on the lake. And he said well you can eat your own food, but you might as well have some tea or coffee on the fire here. And we ended up by feeling our way, that it was alright, that we were welcome."[43] Jarvis and Duncan returned Milne's hospitality by inviting him to visit them in Toronto.

Milne, who was born in 1882 near the hamlet of Burgoyne, Ontario, was more cosmopolitan than his reclusive lifestyle suggested. He had studied art in New York City, taken part in the famous 1913 Armory Show, and been an official Canadian war artist. Long resident in the United States, Milne returned to Canada in 1929 determined to be recognized as one of the country's best painters. He was a genial character who enjoyed discussing ideas and art. For this reason, he was drawn to Duncan as someone who "outdistanced me in simplicity" and to Jarvis as a lively conversationalist with good artistic judgment.[44] From Duncan and Jarvis' first visit, Milne referred to his new friends affectionately as "the twins" and Six Mile Lake became a place where the two visitors spent time together as a couple.

Friendship deepened apace, and by December 1935 Duncan and Jarvis were Milne's main link to Toronto. In the spring of 1936, they brought a much needed lantern and books to Six Mile Lake, in return for which Milne gave them several works. Because Duncan summered in Paris, the trio did not meet again until they sketched together for the first three days of September on the rocks that fringed Six Mile Lake. Jarvis was fascinated to see a professional artist at work, so it is not surprising that the few paintings of his that survive from this period show a very strong likeness to those of Milne.[45] The long discussions about French art that Duncan and Milne held on these painting excursions deepened their friendship. It also became evident in January 1937 when Jarvis and Duncan regaled Milne with stories of a visit to the National Gallery, that the three men shared an iconoclastic desire to shake up Canadian art and society. The Gallery championed the Group of Seven as the apogee of Canadian Art, which Milne felt unfairly overshadowed his own work. So he appreciated hearing about the discussions that his friends had had with the Gallery's associate director Harry McCurry and the young art scholar Donald Buchanan. He also loved the fanciful plans Jarvis and Duncan had concocted during their visit, for one day turning the institution "upside down." Dreams of upending the art establishment increased Milne's affection for the pair, whom he dubbed "those majestic six footers."[46] As their conversations became more honest and confessional, Duncan discovered that Milne felt ill-used by Vincent and Alice Massey and Toronto's Mellors Gallery with whom he had signed a contract to sell his works.[47]

Visits to Six Mile Lake must be seen in relation to the way Duncan's life

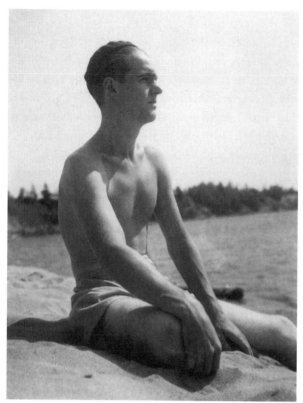

The Muskoka woods provided the privacy in which Jarvis and Douglas Duncan explored their love. An intimate photograph of Jarvis taken by Duncan, likely Six Mile Lake, c. 1937. National Gallery of Canada, Barwick/Duncan collection.

changed dramatically in the autumn of 1937 when he helped to found the Picture Loan Society. The organization had been suggested by Rik Kettle, an Oxford-educated art teacher at Upper Canada College. On an English holiday, Kettle and his wife had been impressed by London's Picture Hire Limited, which rented paintings for a set portion of their market value. On returning to Toronto, the couple spoke to friends about founding a Canadian version. Kettle then published a short essay on the subject in which he lamented Torontonians' preference for inexpensive copies of Old Masters

over more costly original Canadian works. He proposed remedying this by setting up "some form of picture library" that rented works on a monthly basis, believing that it would bring art within reach of those on fairly modest incomes. Kettle's idea tapped into the ferment in Toronto's arts community, and among the supporters he attracted was Norah McCullough, a colleague of Arthur Lismer at the Art Gallery of Toronto. She proposed bringing Duncan into the group.[48]

Interest in the project spread quickly and by the time the Picture Loan Society opened its doors on 14 November 1936, its board of directors included several of Toronto's emerging socially engaged painters. An annual two-dollar subscription allowed members to rent pieces of art for two percent of their value per month. For a similar membership fee, artists could submit as many as five works for sale. Ten dollars was the minimum price for any item and haggling was forbidden. The society received a 10 per cent commission on all sales, or about one third of what a commercial dealer would take.[49] Jarvis joined on the society's first day, while Milne followed a fortnight later.[50] Despite its founders' hopes, the society's first exhibition, of Carl Schaefer's work, which ran for two weeks in January 1937, produced only one sale, to Duncan.[51] Business grew gradually, so that by the end of the year the society's roster included about thirty artists and 140 members, who had spent almost $2,000 purchasing or renting paintings.[52] Collecting and promoting Canadian art soon became an obsession for Duncan, who gradually gave up bookbinding to spend the rest of his life running the society.

The Picture Loan Society occupied four small rooms above a dance and music school in a nondescript building just east of the University of Toronto. Paintings covered its walls from floor to ceiling. Though Duncan lived in his parents' house until almost the end of his life, he kept a small bachelor apartment that also served as a bookbinding room at the society. This became a bolt-hole for he and Jarvis, who, along with the young silversmith Harold Stacey, were given studios on the premises.[53] Customers passed by Jarvis' door as they entered the society, placing him literally at one of the hubs of Toronto's emerging arts community. Regular visitors like Rik Kettle were impressed by this "very good looking, confident in a quiet sort of way, person" who possessed "an elegant turn of phrase, again in a quiet sort of way" and who talked "in a way about the arts that I found impressive. I wouldn't use the word learned, I think, because it never applied to Alan." In an echo of

Jarvis' undergraduate contemporaries, Kettle felt that these qualities made Jarvis appear "un-Canadian in a sense," as though his speech and manners had already been polished by an Oxford education.[54]

Jarvis' exposure to these democratizing impulses convinced him that he could fuse his academic and artistic interests through adult education. As mentioned earlier, this radical discipline that drew on psychology, sociology, history, and philosophy was emerging forcefully in Canada in the early 1930s. Adult educators felt that they could bridge social and economic inequalities – many of which were worsening because of the Depression – by extending learning opportunities to far-flung rural areas and neglected urban slums. Pioneering Canadian adult-education ventures saw the University of Alberta deliver courses over the radio, while St Francis Xavier University helped Maritimers set up cooperative enterprises, and a national coordinating body, the Canadian Association of Adult Education, was established in 1935. The University of Toronto lacked an active adult education program, though the movement's ideals appealed to progressive faculty members like Frank Underhill and Burgon Bickersteth.

As there was no formal program of study, Jarvis used the summers, which Duncan spent in Paris, to explore his chosen field. These long separations did not dampen the relationship; even though Duncan was a notoriously dilatory and unreliable correspondent, he sent postcards, some with sexually playful messages like: "it's nice to know that age has not withered you and that you are still happy playing games like any youngster. Well keep it up: there's nothing like the farmers in the dell to make you fresh for Plato and Spinoza in the fall. I, on the other hand, will probably be skittish by fall, after all this solemn culture."[55] One can only assume that such messages appeared innocent to anyone who was not aware of the true nature of Duncan and Jarvis's relationship.

Nevertheless, as Duncan's pastoral allusion suggests, Jarvis spent the 1935 and 1936 vacations as a counsellor at Camp Glenokawa, on the Lake of Bays about 175 kilometres north of Toronto. The first wilderness camps in Ontario opened at the turn of the century as part of the same back-to-nature movement that produced the Boy Scouts. They allowed children from relatively wealthy families to spend several weeks learning faux-native rituals and practicing woodcraft. Glenokawa was part of a second generation of camps that rejected the rigid structure and high fees of earlier models.[56] It was set up in about 1932 by Glenn Allen, a one-time juvenile lead on the London stage and

a member of the wartime Dumbbells concert party. He envisioned Glenokawa as a place where children from all backgrounds studied the arts in an outdoor setting. The camp, which accommodated about two dozen boys in rudimentary cabins, was significantly cheaper and smaller than more established ones nearer Toronto, and attracted families that had been touched by the Depression. Many of them heard about Glenokawa through the advertising shows that Allen staged during the "camp week" that was held each spring at Eaton's department store.[57] Like its rivals, Glenokawa's physical activities revolved around swimming and canoeing, but staff members were encouraged to organize all manner of arts and crafts activities, while Allen himself oversaw the annual revue of songs, skits, and acrobatics that the youngsters staged at summer's end at the community centre in the town of Port Sidney.[58] By deciding to take a job as a camp counsellor, Jarvis was once again following in his dead brother's footsteps. Jarvis dealt with his lingering wariness by choosing Glenokawa, a camp at which Colin had never worked.

Jarvis' choice was not solely based on distancing himself from Colin, because Glenokawa's emphasis on teaching the arts in an unconventional setting had direct parallels with the ideals of adult education. Jarvis taught swimming, painting, sculpting, and general arts and crafts, in addition to leading the campers on long canoe trips. Ever the dandy, by pairing a flannel lumberjack shirt, the uniform of the Canadian bush, with a black beret that was almost certainly a gift from Duncan, he developed a compelling wilderness counterpart to the suave persona he had adopted in the city. Spending the summer out of doors gave Jarvis a bronzed and athletic though not overly muscled physique, while his flowing hair was bleached by the sun. Fellow counsellors saw heads turn as "this well tanned Blond Greek God" strutted through a nearby town on the weekly supply run.[59] Jarvis was equally conspicuous at camp, where he appropriated a fence post from an adjoining farm, installed it atop a high rock outcropping, and used it as a stand on which to sculpt clay portraits of his young charges. Posterity was denied these busts, because the local cows licked and nuzzled them until they looked like non-figurative works of modern art. The campers also provided an audience with whom Jarvis perfected witty pronouncements about the arts, such as declaring that Wagner's *Ride of the Valkyries* sounded "somewhat like a bathtub falling down stairs."[60] Each August he designed the sets for the Port Sidney show, and in 1936 he played an ageing chorus girl. The skit descended to farce

when Jarvis' costume slipped, revealing the pair of boxing gloves with which he had filled out the bosom.[61]

Jarvis had learned a great deal about non-traditional education during those two seasons at Glenokawa, so he jumped at an offer in the summer of 1937 to join a provincial government program that created the first syllabus for teaching health in high schools.[62] He worked directly with Ontario's chief medical officer of health while planning the course, and then helped train the teachers who would have to implement this new subject. But Jarvis was still drawn to the wilderness and at summer's end he and his Glenokawa friend Pat Fitzgerald paddled through Algonquin Park on an ill-fated trip that saw them fall behind schedule, run out of food, and become the subjects of an aerial search by the park rangers.[63]

At Camp Glenokawa, Jarvis' passion for teaching in a non-conventional setting emerged, c. 1935–36. Alan Jarvis Collection, University of Toronto.

Having thus primed himself for a career in adult education, Jarvis looked for practical ways to achieve his goal. He needed money to continue his studies and so the Rhodes Scholarship competition, on which much of his future rested, dominated his fourth year. Apart from the Rhodes Trust, only a very small handful of Canadian organizations funded graduate study at foreign universities in the 1930s. A scholarship that financed an advanced degree at a restricted number of institutions, mainly Oxbridge and the Ivy League, was the quickest way into Canadian academic life and the professional ranks of the federal civil service.[64] These prizes were often the only chance an ambitious but impecunious undergraduate had to avoid taking some fairly anonymous position in the workforce. For instance, having twice failed to win the Rhodes, future prime minister John Diefenbaker read law at the University of Saskatchewan and worked in provincial obscurity for decades. His more fortunate contemporaries made their marks at a much earlier age. If Jarvis failed to secure such a scholarship he would have to implement his adult educational ideals by training as a teacher or social worker at the University of Toronto. Less alluringly, he might have to join his stepfather at Queen City Glass.

By the 1930s, the Rhodes was the most prestigious and hotly contested academic award in the English speaking world. The scholarships had been created in 1902 out of the estate of the South African diamond magnate and Empire booster Sir Cecil Rhodes. His will laid out a scheme to send young men from throughout the British Empire and America to Oxford. Rhodes stipulated that these scholars, whom he envisioned as future leaders of the English-speaking world, should combine intellectual, athletic, and community achievements. George Parkin, the principal of Toronto's Upper Canada College and long-time proponent of imperial federation, was asked to set up the scholarship program and remained its guiding force for twenty years.[65]

Canada had originally been allotted two scholarships, but by the 1930s Ontario alone elected as many men each year. They were chosen in an open competition, in which Parkin's son-in-law, Vincent Massey, took a paternal interest. So too did Burgon Bickersteth, whose role was symbolized by the way the provincial competition was held at Hart House. Young men who had come to Massey's and Bickersteth's attention through such organizations as the Lit or student committees could expect significant support. It is not surprising then that the University of Toronto won an overwhelming number of the Ontario scholarships, causing rival institutions to argue that one of the

annual prizes should be reserved for their undergraduates.[66] Compounding the provincial outcry against Toronto's dominance, a University College student had won the Rhodes in each of the four years before Jarvis applied, leading principal Malcolm Wallace to gloat that this was "confirmatory evidence that the college remembers its primary function – the development of intellectual capacity in its members."[67]

The annual competition was launched with a November 1937 announcement in *Varsity* stating that candidates would be judged on "their school and college record[,] their literary and scholastic attainments, their qualities of manhood, their exhibitions of moral force of character, their instinct to lead and take an interest in their fellows, and their physical vigour."[68] Jarvis' academic record was certainly distinguished, and he had a long list of extracurricular attainments, but he had never excelled at college or university sports, nor had he been elected to any of the more competitive posts in student government. Pressure to distribute scholarships equitably throughout the province furthered his disadvantage. Fortunately, Jarvis' biggest impediment – his homosexual relationship with Duncan – for which he would have been disqualified on "moral" grounds, was concealed by the impenetrable persona that he maintained at campus.

Disregarding both overt and disguised weaknesses, Jarvis submitted an application that included academic transcripts, personal information, the names and addresses of five referees, a *pro forma* testimonial from the University of Toronto's president that the candidate had the necessary "combination of qualifications both in scholarship, art and athletics," and a statement from Jarvis on the "character of the work at which I aim in after-life." The record of Jarvis' candidature therefore contains succinct subjective and objective, personal and detached insights into how this twenty-two-year-old intended to weave the seemingly independent strands of academics, art, and adult education into a coherent career. Of this course he was certain, stating definitively that "my work with children and teachers, combined with my work in philosophy has lead [sic] to an increasing interest in the problems of education. Hence I propose to read for the degree of MLitt in Philosophy – as the subject for which I am best trained – and intend in after-life to devote myself to adult education and teacher training."[69]

Candidates who cleared the initial hurdle wrote a three-hour essay at Hart House on 27 November. The questions Jarvis faced have not survived, but

those set before Ontario scholars seven years earlier, which were likely similar, indicate that the committee explored the candidates personally, "Why I am making application for a Rhodes Scholarship"; academically, "Contemporary tendencies in my major subject of study"; in their knowledge of current affairs, "Causes of the present economic depression"; and their imaginative capacities through the open-ended "Wheat."[70] References were taken for those who passed this comprehensive test.

Jarvis' candidature was strengthened by how closely his references echoed his career plans. George Brett emphasized Jarvis' quiet demeanour, saying that though his undergraduate career had been "conspicuous[,] he has considerable reserve, pursues his course independently, and will carry through a project very efficiently without all the attention his achievement deserves."[71] Reid MacCallum, who was providing references for three candidates, said Jarvis was the "most remarkable of the trio," because of the "extraordinary sureness he shows about what he wants to be and do," while at the same time remaining "modest and very unassuming, and thoroughly sincere and free from any kind of pose." MacCallum added the lapidary prediction that Jarvis would "exercise a far-reaching and profound influence on the whole matter of art-education, which might well be nationwide in its results; a field in which Canada is still badly in need of the right man. I cannot overemphasise the way in which Jarvis impresses me as having ideas far beyond his years in this field, an infallible sense of what is needed, and practical judgement to affect it."[72] John Alford, the professor of fine art, focused on how the theatricality of Jarvis' public persona had at first deceived him into seeing a "dilettante with natural taste and some executive facility, and I was inclined to foresee the development of aesthetic learning of a not very profound or fruitful nature." However, after prolonged observation, Alford perceived "unusual natural aptitudes" in teaching the history and theory of art, in which he predicted an important and influential career for someone he thought was "amiable and influential rather than essentially intimate and cordial" in his relations with other students.[73] Alford's last comment was a perceptive appraisal of the public persona that this popular student had adopted.

Three further references addressed the way Jarvis had applied his knowledge outside the university. The shortest came from Ontario's chief medical officer of health, who had been very impressed by Jarvis' contribution to the previous summer's course on teaching.[74] A businessman and Marmaduke

Street neighbour noted Jarvis' "moral force of character and ... decided flair for leadership."[75] Finally, Betty Devlin's father, who was president of the Confederation Life Insurance Company, reported that during the fourteen years he had known Jarvis he had seen "a growing tendency to assert, guide and direct others" with the sole criticism being that "he takes everything, work and play, very seriously, but I am of the opinion that we need in this day and for the future, men who take their obligations seriously."[76] Burgon Bickersteth, whose imprimatur often helped decide the Rhodes competition, was not one of Jarvis' references. It was not a slight; Bickersteth was in England on extended leave.[77]

The competition's final and most important phase began on 4 December with a lunch at Hart House, in the course of which applicants were told that they would be interviewed individually that afternoon. A second lunch and round of interviews followed a week later. Only then did the committee, composed of former Scholars and other eminent citizens, select Ontario's two winners. The suitability of candidates who survived to the final rounds was roughly equivalent. Interviews tipped the scales. This was a daunting experience for Jarvis, given that his selection panel was chaired by the former Ontario premier G. Howard Ferguson and included Terry MacDermot, the principal of Upper Canada College and secretary of the League of Nations Society. Jarvis' performance in one of his interviews became something of a legend for his generation and indicated his confidence, provocativeness, and wit. As a way of breaking the ice, the committee asked Jarvis to expand on his desire to work in adult education. They followed up with a series of questions that probed for the candidate's weaknesses. Ferguson asked whether Jarvis played any sports, a rather obvious hole in his application. Jarvis, who had canoed at Glenokawa and fenced from time to time at Hart House, replied somewhat boldly "I'm not fond of participatory sports." Ferguson followed on by asking whether Jarvis cheered on any of the university's teams, to which he replied predictably that he was "no fonder of non-participatory sports." Bested in this exchange, Ferguson then asked what extra-curricular activities Jarvis did pursue. "Reading" was the reply. When asked what type of books he enjoyed, Jarvis shot back at Ferguson, who he guessed had not creased a spine in years, "what books would you like to know about?"[78] Jarvis' cheeky performance proved he was not cowed by his questioners and caught his persona perfectly.

On the day after the final interview, 12 December, Jarvis learned that he had succeeded.[79] The scholarship and a University of Toronto degree would allow him to enter Oxford with "senior standing," meaning that he could take a second bachelor's degree after two years. A third year of funding was available to Rhodes men who scored the highest grades in their Oxford exams.[80] A more cautionary correspondence carried on throughout the spring between Jarvis and the warden of Rhodes House, who looked after the scholars while they were at Oxford. He advised Jarvis that the scholarship's £400 per year was "a lot of money, but not huge" and that recipients should expect to supplement this sum by as much as £50 per annum.[81] Janet and Ed Bee were delighted to provide this for their surviving son, who had more than realized the hopes they had once attached to Colin.

Jarvis now had to choose a college and find a thesis supervisor. The decision to study with the aesthetician Edgar Carritt reflected the influence of UC philosophers George Brett and Reid MacCallum, who had drawn heavily on the English scholar's works when enunciating the new aesthetic for Canadian art. Carritt's college, coincidentally called University, was the one Jarvis intended to join. Brett, who knew Carritt slightly, introduced Jarvis to his prospective supervisor by recounting how "we [the Philosophy Department] sent up four strong candidates for the Rhodes: to say that Jarvis got an award is enough recommendation. In personality he is exceptional, a combination of serious interest without melancholy and efficiency without ostentation. In fact he hardly exhibits himself ('sells himself') enough. I feel sure he would be a gratifying person to have as a pupil and would reward any effort made to assist him."[82] Carritt and his college could hardly disregard such a highly-praised applicant, and Jarvis was accepted by both in the spring.

An avalanche of congratulations from friends and family began within days of the award. These ranged from the solemn: "there is a great future for you Alan … cultivate and make as sincere as possible that native modesty of yours. It will open otherwise closed doors and help you in attainments that with your many goals, are even now within reach."[83] To the comic: "I wish you three Gs – Grit, Grace and Gumption – to carry it through to great heights."[84] The happy, laudatory spirit carried over through Christmas when Janet gave her son money for his "on to England fund."[85] At the end of a short January visit to Toronto, David Milne claimed his own share of Jarvis' success by boasting to Alice and Vincent Massey "Did you hear that our boy Alan

(Douglas Duncan's and mine, Alan Jarvis) had got a Rhodes Scholarship?"[86] Students and faculty from UC offered their congratulations more formally the following month at a banquet hosted by the Lit.[87] At this dinner, George Brett applauded Jarvis publicly for the first time, while the philosopher Fulton Anderson "offered a toast to Jarvis as the man who had become a Rhodes Scholar without playing the traditional undergraduate role of a would-be Rhodes man."[88] In private, UC's French professor Robert Finch voiced the lighthearted sentiments of the gay artistic circle to which he, Duncan, and Jarvis belonged, by wondering how Jarvis could have been so gauche as to win the award.[89]

Though his future was settled, Jarvis' remaining term as an undergraduate was busy. In January he proposed the motion "That the study of science tends to narrow the mind" for his only Hart House debate.[90] The audience for this, the year's most heavily attended debate, included Sir Frederick Banting, the co-discoverer of insulin and painting companion of A.Y. Jackson. Banting would surely have demurred as Jarvis argued that "this is no mere question of highbrow against lowbrow or of the narrow mindedness of the absorbed scientist such as Charles Darwin, who confessed an inability to enjoy art." Nor could Banting have been placated when Jarvis followed on by asking "how is it that there has been technological advance but no cultural advance" in an attempt to prove that the narrow focus required by the scientific method limited a person's overall outlook. The judges were no more impressed by these arguments than Banting, and Jarvis lost resoundingly.[91]

That same month, Jarvis designed the sets for Hart House Theatre's production of *Miss Elizabeth Bennet*. What was advertised as the world premiere of this work by A.A. Milne formed the centrepiece of a university drama festival, which Jarvis also helped to organize. His contribution to the shoestring production reflected the rarefied, un-Canadian interests that Rik Kettle had already noticed. The Georgian-era sets imitated Cecil Beaton's sumptuous and precious stage designs, which Jarvis can only have seen in English books and magazines. The performance was accompanied by gramophone recordings of works by the Czech composer Wilhelm Gluck, to whom Duncan had almost certainly introduced Jarvis. Among the play's cast was Johnny Weingarten, an undergraduate who soon adopted the surname Wayne and later joined his UC contemporary Frank Shuster to

become the most important comedy team in Canadian history. This one-time collaboration was the genesis for the oft-told, if erroneous tale that Jarvis had "discovered" Wayne and Shuster.[92]

The following month, Jarvis organized a University Art Exhibition in the Hart House Gallery to which he contributed two oil paintings "in the style of David Milne." Recalling the way these had been created on sketching trips at Six Mile Lake, they hung alongside a group of Milne's own drypoints that came from the expanding collections of Duncan and Jarvis.[93] Milne's esteem for his young admirer was now so high that he asked Jarvis and Duncan for advice about a new direction in painting he wished to follow, but the pair "wouldn't have anything to do with" the idea.[94] Instead, on a mid-May visit to the cabin, Duncan and Jarvis disclosed their plans for a summer-long tour of European galleries and cultural sites. This prompted Milne to once again laud Jarvis to Alice and Vincent Massey, who was now Canadian high commissioner in London. He implored them to "keep an eye on him [Jarvis], a quiet, big boy, unusually intelligent and very wise in the ways of art."[95] Duncan and Jarvis were similarly protective of Milne. Knowing that they would not return to the cabin that summer, the pair told the owner of the Big Chute general store that "we're going for a trip and if anything happens to Dave, if he happens to get drowned or upset in a canoe, or something, he says you collect all his pictures, his sketches, lock the door, take his pictures and bring them over to your place. And collect them all up, and then when we come back, we will come" and retrieve them.[96]

At home over the May long weekend, Jarvis' interest in adult education drew him to the Third Canadian Youth Congress. This forum had been created in 1935 by a group of Toronto socialists as a way of bringing young people together to debate current social and political topics.[97] Over 500 delegates, representing church and political parties from virtually every province, gathered at the Central Technical School. After three days of discussion, they resolved to condemn the Quebec padlock law and the growth of fascism in Canada, urged the government to work more actively for international peace, and called for the establishment of cooperative manufacturing, a public works program, and a national unemployment insurance scheme. Of greater interest to Jarvis was the demand for "free facilities for (the) education of adults, both unemployed and employed wishing to continue studies."[98]

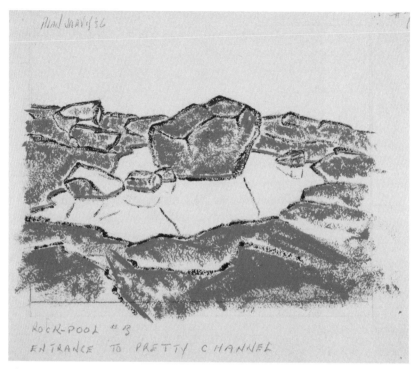

Alan Jarvis, *Rock Pool #3: Entrance to Pretty Channel*, 1 September 1936, National Gallery of Canada, Ottawa. Gift from the Douglas M. Duncan Collection, 1970. Photo © National Gallery of Canada.

A fortnight after the meeting, Jarvis interviewed the twenty-nine-year-old artist Gordon Webber for a CBC radio broadcast entitled *Youth and Art in Canada*. Webber, who was at the forefront of the leftward shift in Canadian art, shared Jarvis' interest in adult education; he was one of the founders of the Picture Loan Society and had taught evening art classes for the Workers' Educational Association. After introductory bantering, Jarvis contradicted what he had argued at Hart House, by declaring that the twentieth century had seen the reconciliation of science and art and that civilization was "learning to make our machine world beautiful as well as efficient."[99] Webber agreed by pointing out that factories now employed artists to design their products. This introduced a fifteen minute report on how the Youth Con-

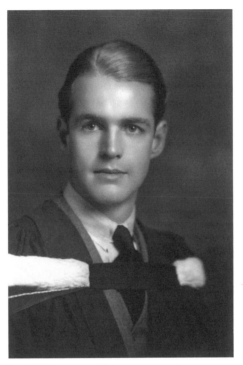

Jarvis' University of Toronto graduation
portrait, 1938. Private collection.

gress had tried to define a way for artists to help alleviate social problems.
These debates, which echoed Brett, MacCallum, and Alford's new aestheti-
cism, had culminated in a call for the development of formal training in
industrial design and a challenge to individual artists to seek audiences be-
yond the bounds of museums and galleries because Canada desperately
needed "Art Centres in every town and city where people who want to pro-
duce plays, dance, paint – anything, could all work on common ground and
above all where anyone – not just professional artists can come and partici-
pate."[100] Jarvis then stated, as he would repeatedly in the coming years, that
such improvements to daily life could be brought about if a sufficiently large
group of citizens demanded them."[101]

Two days later, Jarvis' undergraduate career officially ended at UC's commencement ceremony, during which he was cheered by fellow students.[102] Europe lay ahead. In late June, friends from Marmaduke Street and beyond who had attended school, church, and camp with Jarvis, and a couple of neighbours who had provided references for the Rhodes, came out to say goodbye as he and Duncan headed for New York City, where they were boarding a ship for France. Jarvis left Toronto in Duncan's convertible, garlanded with accolades and expectations for a brilliant career. To most of those present, the scene seemed innocent. Duncan was making his usual summertime trip to Paris, while Jarvis was going to experience Europe before taking up his Rhodes. What they could not see so clearly was that Duncan adored Jarvis and believed that he had found a man who "loved him enough in return," which he had once told his sister Frances was the secret to homosexual relationships.[103] The car took Jarvis' immense and unmistakable presence with it, causing Carl Schaefer to remark to David Milne wistfully at summer's end, "I am going to miss Jarvis, everyone seems to be going away."[104] Milne must have endorsed the sentiment.

CHAPTER
FOUR

"I May Come Home with an Accent – God Forbid"
Europe, Oxford, and Dartington, 1938–1939

The most crucial fifteen months of Jarvis' life began when he and Douglas Duncan drove out of Toronto in late June 1938, bound for New York City and Europe. During this period, he matured intellectually, socially, and sexually, distancing himself permanently from his family's narrow Sabbatarianism. In the process, he further refined the sophisticated public persona that his undergraduate acquaintances had encountered. The naive tone and immature language of Jarvis' letters home glossed over many of these emotional experiences, and especially helped conceal his sexual growth. For a biographer, the friendships he made during this period were like a painting's vanishing point: they established perspective and almost every subsequent opportunity in Jarvis' life could be traced back to this short interval. Landing in England as a distinguished young colonial committed to the worthy ideals of adult education, within one year Jarvis had begun forming the interrelated personal networks on which he would build his career.

This maturation was far from apparent at the outset of the transatlantic voyage, because Duncan was the dominant partner in the relationship and the one who set out the trip's itinerary. By contrast, Jarvis' eyes were wide with wonder from the moment he crossed the border at Niagara Falls, on through Buffalo, and in to New York City, the cultural centre he had long venerated. Though Jarvis was almost invariably described as looking like a matinee idol,

at this point he was far closer to a movie hero's overly eager, awkward sidekick – more Donald O'Connor than Gene Kelly. Once in New York, the pair took the car to be loaded aboard, before checking in to the Barbizon Hotel. Over the next couple of days, they went to the movies, saw Cedric Hardwicke in *Shadow and Substance* on Broadway, took in the rockettes at Radio City Music Hall, wandered the Museum of Modern Art's halls, and practised rudimentary French phrases in coffee shops.[1] In an age when international travel was restricted to those few who had sufficient leisure and money, Jarvis appreciated that Duncan was there to "cope with all the little things that áre absolutely new to me, such as *who* and *when* to tip, how to look after baggage checks, foreign customs and that sort of thing. I don't think I will worry from now on about going anywhere having once been shown through 'the ropes' and certainly it makes all the difference in the world being with someone you know. It would be awful to go away the first time alone."[2]

On their last day, the pair headed for the *Ile de France*, one of the most magnificent transatlantic liners. Jarvis' depiction of this short journey conveyed excitement and trepidation, noting that the "taxicab ride to the pier, as with any ride in New York was enough to strike terror into the heart of any poor Canadian."[3] At the wharf, their "bags were snatched by a dirty unshaven beachcomber who carried them the 50 ft [sic] and then impolitely instructed us to call a French Line porter, and then stood waiting for his tip."[4] Jarvis pushed his way through the crowds in pursuit, all the while clutching his trench coat and hat in one hand, while continually examining his pockets with the other in nervous fear of pickpockets or dropping some necessary travel document. Though it was mid-morning, the quay was crowded with first-class passengers clad in the dinner jackets and gowns they had worn the previous evening. If it is difficult to imagine Jarvis or the spare and inelegant Duncan as this scene's hero, then the gravel-voiced actor Burgess Meredith, one of those who had come straight from a farewell party, certainly lent it Hollywood panache. Romantic scenes set on ocean liners were common in the era's films, but there was little glamour to this trip, because the cabin booked by the innately frugal Duncan had to be shared with an Austrian man.[5]

Omens of war were unmistakable that summer. The *Ile de France* carried many Jews who could no longer travel on German liners. Hitler had annexed Austria in March, and the ship steamed into the Atlantic as France and Britain tried furiously to prevent him from seizing German-speaking areas of

Czechoslovakia. Janet and Ed Bee were uneasy that their son was leaving at a time when international relations were so fractured, but Duncan had planned the trip with the European situation in mind. To dampen Janet and Ed's fears, the travellers gave them a European road map on which they had traced their route.[6] Duncan chose the *Ile De France* because he knew it would arrive in time for the King and Queen of England's visit to Paris, an event both he and Jarvis wanted to see. The Royal tour was intended to signal Britain's confidence in France, whose government had collapsed in the spring, and to solidify the two countries' military and diplomatic alliance. In another nod to the political tensions, Duncan paid all expenses from his Paris bank account, so that he and Jarvis could use their American Express cheques if they needed to escape the advancing armies. Jarvis related these and other details in many letters and postcards home that brimmed with assurances of his and Duncan's safety and frugality.[7]

Ellis Island and the Statue of Liberty were soon astern and, after exploring the ship and getting his sea legs, Jarvis began reading the two books he had purchased in New York with birthday money from his step-father: *Technics and Civilization* and *The City in History*, by the American urban philosopher Lewis Mumford. The works introduced Jarvis to Mumford's critique of the modern belief that technological advancement had brought unrestricted social boons. Jarvis was engrossed by ideas that echoed the discussions in which he had taken part at the Canadian Youth Congress. He spent the better part of the crossing ensconced in a deck chair absorbing Mumford's tomes and discussing the author's ideas with Duncan. Mumford's thesis took an evergreater hold as Jarvis re-read the works continuously over the summer. When not engaged in this serious endeavour, the two men attended the ship's cinema, practised their French with the crew, and discussed medieval art with a fellow passenger who taught the subject at New York University.[8] Jarvis' budding intellectual maturity was offset by the naive excitement with which he tasted exotic new foods like "cheeses and what not," discovering in the process that French cuisine was not all greasy and rich, and that what he had always called crescent rolls were really "croissants."[9] These last experiences betrayed the narrow culinary horizons of 1930s Toronto.

Having visited Rouen on the way, the pair settled into Duncan's Paris flat. Any suspicions that might have been aroused in Toronto about two men sharing this tiny apartment were offset by the fact that Duncan's sister Frances

and her English husband Jack Barwick lived in the same building. The presence of married chaperones made Jarvis and Duncan's living arrangements seem utterly respectable. Jarvis spent his first days in the French capital strolling with Duncan like well-heeled *flâneurs* past the haunts of the Lost Generation, down the Champs-Élysées and through the Tuileries. They dined one evening at the Suckling Pig and followed on with coffee in the Latin Quarter, where they saw Picasso pass by, leading a Russian wolfhound on one arm and a "wild" looking woman on the other. Jarvis felt as though he had arrived in the centre of the arts world.

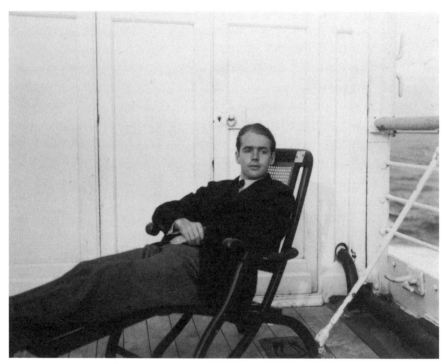

Headed to Europe for the first time aboard
the Ile de France, June 1938. National Gallery
of Canada, Barwick / Duncan collection.

The notion that the trip was part of a young man's cultural education rather than a lovers' holiday was further bolstered by the presence of Jarvis' undergraduate friend Hamilton Southam, who was summering with the Canadian ambassador. Southam was also avidly interested in the arts, but Jarvis had never introduced him to Duncan. By concealing Duncan from all but his closest friends, Jarvis created a haven in which he avoided uncomfortable or dangerous questions about the relationship, and felt no pressure to live up to his brother's memory. He continued this pattern by leaving Duncan behind when he and Southam visited the Musée Rodin, and lunched together at Le Dôme and at the ambassadorial residence. Touring Paris with people who knew it well bolstered Jarvis' confidence until the disastrous trim that resulted from a solo trip to the barber made him realize just how little command he had of the French language.[10]

For the rest of the summer, the Paris flat was a haven where Jarvis and Duncan carried on their relationship. Frances Barwick, who had been shattered by the suicide of her gay music teacher a decade earlier, had long accepted her brother's lovers and she and her husband Jack, an accountant who had been unemployed since the start of the year, befriended Jarvis during long country drives and many visits to the Louvre. Though the Barwicks worried about the ever-worsening European situation, they did not try to prevent Jarvis and Duncan from touring the Continent. Just after Bastille Day, the two men loaded their car with fruit and water and left Paris for Bavaria and Italy. The route Duncan chose was an advanced course in the history of European art and architecture that passed through Chartres, the Rhone Valley, the Riviera, Munich, Assisi, and Siena.[11] Along the way, the pair explored important sites, buildings, towns, and churches. Duncan emphasized his seniority and didactic role by directing Jarvis' eyes to the most exciting frescoes, friezes, and architectural features. In doing so, he also underscored Jarvis' appreciation of Lewis Mumford, because the centuries-old buildings and villages seemed to reflect an era when technology, art, and science had interacted harmoniously.

Idyllic notions about Europe and its history did not survive a short stop in Germany. In Munich the pair stayed with Kurt Wagensiel, a thirty-four-year-old writer, translator, and art dealer who had been Duncan's Paris lover a decade earlier. Duncan and Wagensiel shared a passion for opera, and together with Frances they had travelled and attended music festivals.[12] There

is no evidence that Jarvis was aware of these earlier trips or felt threatened by Wagensiel and Duncan's past, but confidence in a lasting peace was dissipated by the seas of Nazi uniforms, saluting, and anti-Semitic slogans that pervaded Hitler's Bavarian power base. The feelings were reinforced by Wagensiel's anxious desire to emigrate with his small collection of canvases by Picasso and Matisse and books by Jean Cocteau and Marie Laurencin, which he feared the Nazis would seize for being degenerate.[13] While Wagensiel lacked the permits needed to leave the country, he and Duncan decided that the items would be safer in Paris, where they could be reclaimed when the situation stabilized. So Jarvis and Duncan smuggled several of Wagensiel's pieces out of Germany in the first week of August. The threat that a technology-obsessed Nazi regime posed to art, literature, and sexual freedom contrasted starkly with the premodern marriage of science and art about which Lewis Mumford wrote.

From Munich, Jarvis and Duncan drove through the Alps to Venice where they intended to take in the film festival. After sunning themselves on the Lido, alongside Duncan Fairbanks junior, the pair spent several languid days sunbathing in the nude near Ravenna, where Duncan took homoerotic photographs of young fishermen. Duncan had made sexually charged portraits of Jarvis on their Muskoka canoe trips, but in Italy he did not have to hide his voyeuristic impulse. Unsurprisingly, Jarvis neglected to mention the photographs in his letters home. Instead, he wrote glowingly about the more traditional Renaissance attractions of Perugia and Florence, and how he found Italian fascism less repugnant than what he had witnessed in Munich. Jarvis' letters from this leg of the trip once again underline the naiveté of a young man who had barely left Toronto. Italy was a backward country of foul smells and inhabitants who were incredulous that Canadians would not drink even a single glass of wine with their meals.[14]

International tensions mounted appreciably in August when Hitler mobilized the German army against Czechoslovakia. As they had planned, Jarvis and Duncan returned to the relative safety of Paris at the end of the month, before embarking on one last excursion to southeastern France. The summer was waning and Oxford approaching, so Jarvis tried to deflect his parents' apprehensions about losing their son by summarizing his continental experiences: "the more I see and travel around Europe – by the way – the more I feel that I will never forsake Canada. I may come home with an accent – God forbid – but I'll come home. It is just too true that you don't know you have

a home until you leave it."[15] Though it was masked in many ways over the coming years, Jarvis' underlying sense of Canadianness remained remarkably constant for the rest of his life.

The pair were back in Paris when the Czech crisis peaked as a joint French and British diplomatic effort saw Prime Minister Neville Chamberlain twice fly to Germany for meetings with Hitler. Despite the exertions of Chamberlain, an elderly man who had never before been in an airplane, by the end of September, Czechoslovakia, France, and Great Britain had all at least partially mobilized their armed forces. War appeared to be only weeks away as, ever eager to document his experiences, Duncan photographed the crowds of armed French reservists who waited at the Gare de l'Est for the trains that would take them to the front. Faced with this evidence that Europe's armies were on the move, Jarvis reassured his parents that he would be safe at Oxford, where the Rhodes Trust would look after the scholars.[16] So many others hoped to find refuge in England that the boat trains chugged out of Paris packed with people. Not included in this number was Duncan, who disliked Britain and did not cross the Channel with Jarvis. Their parting at the Gare Saint-Lazare did, however, cause the normally undemonstrative older man to whimper, so he claimed, for the first time in fifteen years.[17] Once Jarvis was gone, Duncan shut up his flat as usual and sailed for home. Over the next ten months, the two men's physical separation was compounded by Jarvis' growing intellectual and emotional independence and Duncan's almost pathological aversion to writing letters.

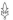

Jarvis went up to Oxford for the first time at the start of October 1938. And though he left without a degree ten months later, the acquaintances he made during this year proved to be the most important of his life. He already knew Allison Grant and Mary Greey, two friends from Toronto who were studying art in London, and a fellow counsellor from Glenokawa was completing his medical training in England. But the most obvious social group to which Jarvis was connected were the twenty-five or so Canadians already studying at Oxford.[18] Many of them were also Rhodes Scholars. Jarvis, however, had missed a first chance to meet his peers. He was already in Europe with Douglas Duncan on the day of the annual "sailing dinner" that Montreal-based former

Rhodes men threw on the eve of the current group's departure for England. Though it was not uncommon for individuals to skip the event, especially Maritimers who usually sailed from Halifax, one 1938 scholar felt that Jarvis' absence indicated that he had little interest in mixing with Canadians and intended to "go English" as soon as he reached Oxford.[19] Embracing British customs too warmly was a cardinal sin for many Canadians in an age when colonial students felt a strong desire to demonstrate that they were as capable as English undergraduates. There was some truth to this view of Jarvis. While he kept in touch with several compatriots at Oxford, he was never close to the other Canadian Rhodes Scholars in his year. Instead, he arrived at Oxford intending to use the many introductions that he had been given by University of Toronto faculty members, declaring that "it is terrible to come here and see only Canadians and Americans."[20]

Oxford in the 1930s differed substantially from the *fin de siècle* aesthetic posing of Max Beerbohm's prose and drawings, or the drunken public school antics of the 1920s that produced Evelyn Waugh and John Betjeman. By the time Jarvis arrived, the undergraduates were no longer divided into mutually antagonistic camps of sports-mad "hearties" and arts-minded, vaguely homosexual "aesthetes." Instead, the students had been increasingly politicized by the failed 1926 British General Strike, the Depression, the rise of fascism, and the Spanish Civil War. This new-found seriousness and the concomitant attractions of socialism were symbolized by the politically committed verse of W.H. Auden and Christopher Isherwood, and caused Maurice Bowra, a prominent and socially connected Wadham College don, to maintain that this generation of young men had to choose between joining the "Comintern" or the "Homintern."[21] Bowra's witticism rang true in an overwhelmingly male academic environment in which homosexuality was not uncommon and was, essentially, tolerated if carried on discreetly.

Despite these philosophical and political changes, Oxford remained a small, rule-bound, and decidedly elite institution that differed substantially from the University of Toronto, even if the latter aped many of its physical, institutional, and intellectual characteristics. Most strikingly, all but five of Oxford's twenty-nine colleges were exclusively male and though dons had long been permitted to marry, most were bachelors. Some lecturers were remarkable scholars, but they were under little pressure to research, publish, or teach, so long as they moulded their charges into gentlemen and future

leaders of the country and empire. This unreal atmosphere reflected the traditional educational path of English undergraduates who came to the university from single-sex boarding schools. At college, they submitted to a strictly enforced code of rules governing everything from major offences for which one could be expelled or "sent down," to the wearing of academic dress and walking on the college lawns. Colleges barred their huge wooden gates, which had originally protected the students from marauding townspeople, at midnight. University police, known as bulldogs, then patrolled the streets, forcing students who missed curfew to sneak back into college. Alternately, anyone spending the night in another undergraduate's bed had to be smuggled out of college the following morning, because such sexual activity, whether gay or straight, was one of the most serious infractions.

The unified university of Oxford is something of an administrative fiction, because its all but independent colleges have wide authority to admit and graduate students. The choice of college determined one's Oxford experience in a far more profound way than it did at the University of Toronto. Jarvis' college, University, was Oxford's oldest, counted Percy Bysshe Shelley among its alumnae, and was situated on the High Street in the city centre. The single-sex college was referred to as "Univ" in university shorthand and "The Pub on the High" by students, in recognition that it lacked the social exclusivity of Christ Church, Balliol's academic laurels, or the sporting prowess of Oriel.[22] Nevertheless, it had formidable left-wing credentials. The newly appointed master, Sir William Beveridge, was Britain's leading authority on poverty and unemployment. After overseeing the development of social policy during the First World War, he directed the left-leaning London School of Economics until being appointed to head Univ in 1937. The dons were equally intimidating; the expert on government John Maud was dean, while economics was handled by a young Yorkshireman named Harold Wilson, who moved into politics in 1945 and eventually became prime minister. Following Oxford tradition, Beveridge invited college fellows and select students to weekly intellectual gatherings where topics were dissected and discussed at an intimidatingly elevated level.[23]

Jarvis was one of sixty-four men who entered at Univ that year, about fifty per cent of whom had come from English public schools, while a further half dozen hailed from the somewhat less illustrious grammar schools. Six were Rhodes men.[24] Like all students, Jarvis had a servant or "scout," an elderly

man named Radford, whose deference, laconic humour, and Jeeves-like abil-
ity to anticipate his master's needs confirmed every stereotype about British
butlers. So too did the maids who cleaned rooms and did laundry, and the
porters who carried packages and delivered mail. Jarvis' physical surroundings
confirmed less romantic colonial conceptions of life in the mother country.
His draughty room in an aesthetically pleasing centuries-old stone building
made, so he informed his parents, sleeping in an Oxford bed "like crawling
into a frigidaire full of damp sheets," while the rest of the furniture was "old,
dark and without any spark of excitement."[25] A porcelain chamber pot nestled
under the bed because the communal facilities were in the basement. The
primitive sanitary arrangements caused Janet to forbid her son from touch-
ing the bathroom floor, instructing him to instead balance on one slipper-
clad foot while thoroughly drying the other so as to avoid contracting any
fungal complaint.[26]

Mitigating these rather drab physical surroundings was the romantic ring-
ing of college chapel bells that drifted over the rooftops. Jarvis also bright-
ened the room significantly with a couple of original works by David Milne
and one of his step-father's watercolours, and gave Radford standing orders
to supply fresh flowers. Jarvis then went up to London, where John Alford's
introduction to the head decorator at Heal's, the ultra-fashionable supplier of
simple modern designs, helped him choose vibrant, harmoniously coloured
table linens, china, and cutlery.[27] While Jarvis' shopping trip was aimed at
making Oxford more comfortable, it also underlined the sense of impending
peril thanks to the throngs of people he saw in Whitehall awaiting news of the
prime minister's third and final round of discussions with Hitler. This was
the weekend that Neville Chamberlain fatefully proclaimed that he had forged
"Peace in Our Time," even as the anti-aircraft batteries that dotted London's
parks and public spaces belied any confidence that war had been averted.[28]

An optimistic and confident Jarvis launched himself on Oxford in much
the same way he had done at Toronto. Much to the dismay of his hardwork-
ing and rather mundane parents, Jarvis and Univ's other Rhodes Scholars
were informed by the college dean that they had proven themselves academ-
ically and so they should not focus solely on Oxford's intellectual opportu-
nities. This was Jarvis' official introduction to the University pretence in which
even the most dedicated students act as though their successes come effort-
lessly.[29] Jarvis adapted quickly to the congenial rhythms of Oxford life and

added this insouciant dimension to his public persona. He was awakened by Radford each morning, who stoked the fire and made tea while Jarvis bathed. Academic work occupied him from breakfast until lunch, after which he cycled to one or another athletic event – Jarvis turned out for field hockey and squash – and then returned home for afternoon tea. An elaborate dinner was served in Univ's dining hall each night with a formal Latin grace, servants in white ties, and begowned students eating at the candle-lit wooden tables that ran the length of the room. For a small fee, Radford would also supply lunches, teas, and dinners so that Jarvis could entertain friends and acquaintances in his rooms. Though Jarvis did not form lasting friendships with any of his Oxford contemporaries, while in college, he hosted fellow Canadians, international Rhodes men and other acquaintances to lunch. The home-baked cookies that Jarvis' mother sent from Canada were always appreciated in these intimate gatherings.[30]

Jarvis explained his daily routine to his parents while reassuring them that it encompassed six or eight hours of study. The greater distractions, so he claimed, were the myriad political, musical, arts, and intellectual activities that took place each evening.[31] Jarvis joined Univ's art society the Martlets, which pleased him by being "the oldest and snootiest in college," and the Oxford Arts Club. He listened to eminent philosophers at the Jowett Society and took drawing classes at the Ashmolean Museum.[32] As a Rhodes Scholar, Jarvis was also invited to a more exclusive set of social events. Among the more notable were a December tea with the Queen, and an April dinner hosted by the Hudson's Bay Company, at which he sat beside the BBC's founding director general, Sir John Reith. Jarvis found this forbidding man, who had imposed his Presbyterian beliefs on a nation by shutting broadcasting down in the early evening so that people had time for bedtime prayers, "a rather dour old boy whose ears *badly* need washing!"[33] Fellow Canadian Rhodes men may have been suspicious of Jarvis' loyalties, but he was clearly not cowed by the British.

Though Jarvis' academic work revolved around self-guided research, he also attended lectures by some of his intellectual heroes. The 1930s was an exciting time for Oxford philosophy. The most notable philosopher in residence was the metaphysician Robin Collingwood, whose 1933 *Essay on Philosophical Method* had been one of the seminal texts of his generation. By the time Jarvis arrived, older dons like Collingwood, Edgar Carritt, and Gilbert Ryle

were being challenged by a younger generation that included Isaiah Berlin and Alfred Ayer. Jarvis' principal contact with the department was through his thesis supervisor Carritt, who seemed so "old and grey" as to be a caricature of an Oxford don. At their first meeting, the pair explored Jarvis' ideas and interests and set out a work plan for the year.[34] Carritt initially perceived an "intelligent and serious student," who lacked the background in philosophy to tackle his proposed thesis.[35] North American students often felt that their previous degrees were undervalued by an overly snobbish British educational system. Jarvis planned to fill his intellectual lacunae by hiding away in a London boarding house for part of the Christmas vacation and working in the Courtauld Institute and British Museum with scholars to whom he had been introduced by John Alford.[36]

The awed tone of Jarvis' summertime correspondence continued through the autumn as he discovered Oxford. Happily, the 1938 MGM film *A Yank at Oxford*, about the adventures of an American Rhodes Scholar, served as a shorthand with which he explained the university's many quaint customs to his parents.[37] Debts to tailors, bookmakers, and bookshops were among Oxford's best established undergraduate traditions, but anathema to Jarvis' pinch-penny Scots family. Therefore, having exhausted his extra money over the summer, Jarvis provided his parents with itemized lists of expenditures, pledging never to exceed his budget like the more roistering young men. Financial restrictions did not prevent Jarvis from boasting, as he would for years to come, about the "many new and delightful people" that he met like Franklin Roosevelt's cousin and Sir Stafford Cripps' daughter.[38] He also began adopting university slang, which he helpfully translated for Janet and Ed, while at the same time vouching "I haven't acquired an Oxford accent yet, and I don't think I will!"[39] Jarvis further assuaged his parents' fears that Oxford might alter his morals by telling them that though chapel was no longer compulsory, he, like many undergraduates, attended regularly.[40] Jarvis was not reconciled to religion, but he understood its importance to his parents and knew that they would be comforted by news of his churchgoing.

By contrast, the reassurances Jarvis made to his abstemious parents about himself being in an environment where alcohol was so casually served resound like a Greek chorus foretelling a future tragedy. He had not touched wine on his European holiday with Duncan, but Oxford was different. By beginning in boastful wonderment and concluding in the condemnatory

language of the Temperance movement, the following passage from one of Jarvis' first Oxford letters, evokes his ambivalence in bringing up the subject of alcohol with his parents:

> don't worry darling [Jarvis' mother] about the drinking at Oxford. There *is* lots of it around and beer is served in [the dining] hall to all who want it – and the college store sells wines and beer, but what drinking is done in *this* college is absolutely harmless. The English lads all drink beer or "shandy" after games and in hall but we Americans have started a milk-habit in hall and it's amazing how it's taking. One of the Oxford customs is to repay favours or kindnesses by sending someone in hall a mug of ale "with Mr … [sic] Compliments" so I do have an occasional mug, and I have had a glass of sherry before dinner at the other colleges. But you *know* you don't have to worry about me!
>
> And, there is never any "hard" liquor around the colleges. It is hard to describe, and hard to understand how casual and innocent English drinking is until you have seen it. All the English boys are brought up to consider beer with their meals as a matter of food so they just don't go in for pub crawling. All the dons of course serve sherry to their pupils if they have them in before dinner, and if a thing like the music club is held in a don's room they serve cider and beer at night, and the dons all have wine with their dinner in hall. So once you get used to Oxford you forget that there is a lot of drink around and never think of these colleges as wet places.[41]

The tone of surprise and disbelief lasted until January when Jarvis first admitted to seriously touching alcohol at a rather sodden black tie dinner thrown by Vincent Massey, the Canadian high commissioner, during which the hosts "served sherry before dinner and with the soup. Then champagne, then claret or port with the coffee and liqueurs if anyone wanted any. And they're Methodists too! It was a little funny perhaps to throw a spread like that for Rhodes Scholars, but there was nothing you could do but pretend to be enjoying all the alcohol."[42] Whatever worries such anecdotes generated in Janet and Ed Bee were offset by Jarvis' assurances that he rarely drank coffee, was giving up smoking, and stocked his room with fruit, brown bread, Ryvita crackers, and a daily pitcher of fresh milk.[43]

The looming war was the background to Jarvis' year at Oxford, and he may well have shared the sentiment recorded by an American at Cambridge that "Hitler hovered over all."[44] European tensions escalated throughout the autumn even as Britain and France tried to prevent Italy from siding with Germany. Jarvis saw the deep divisions in Britain between those who favoured appeasing the dictators and those who wanted the country to stand firm when he attended a by-election hustings – both Oxford and Cambridge universities had their own seats in Parliament – that was essentially a referendum on the issue. On one side stood the socialist master of Balliol College, Alexander Lindsay, who argued for a diplomatic solution to the crisis, while the Tory barrister Quentin Hogg favoured a robust military response.[45]

None of this deterred Jarvis from starting his winter holidays with a week-long Italian trip organized by the Oxford Ski Club.[46] From Sestriere he returned to Paris to spend Christmas with the Barwicks and a small group of friends that included Ted Manteau, head furrier at the ultra-fashionable couturier Molyneux. The group was augmented as Christmas dinner ended when two of Jarvis' Oxford friends dropped by for an evening of dancing. As Frances Barwick reported to her parents in Toronto, "Jarvis seemed to enjoy it all, and we most certainly did. He fitted in like a member of the family, and it really added quite a lot to that feeling of Christmas-tree-excitement!"[47] Shortly thereafter, the Barwicks, Manteau, and Jarvis set out on a spur of the moment tour of the Vosges. They had not gotten very far when bad weather forced them to take shelter in a café where they spent New Year's Eve playing billiards.[48] During this short time, Jarvis and Manteau discovered a shared love of jazz and much else. Manteau then expressed his infatuation with Jarvis by hosting an elaborate dinner *à quatre* in his honour at the brasserie Chez Francis. The menu consisted of oysters, roast pheasant, paté de foie gras, and soufflé. The refined dishes tested the adventurous palate of which Jarvis had boasted over the summer. He was not yet ready to brave oysters, and so Manteau ordered him soup. The meal was followed by dancing at the Bal Tabarin, the Erté-decorated haunt of the gypsy guitarist Django Reinhardt.[49] Normally scrupulous in reporting his activities, Jarvis neglected to mention this love feast to his family, indicating a growing furtiveness about his private life. After Paris, he spent several weeks researching in London.

Back in Oxford for the start of term in January, Jarvis submitted a detailed list of his vacation expenses to his mother to prove he was stretching his

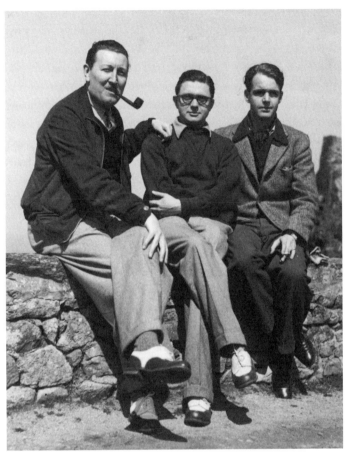

Jack Barwick, Ted Manteau, and Jarvis, France, 1939.
Alan Jarvis Collection, University of Toronto.

Rhodes money as far as it would go.⁵⁰ Though he purchased a typewriter with which to produce his thesis, Jarvis still filled many letters justifying his involvement in non-academic activities, like designing sets for a production of *The Duchess of Malfi* and reviewing an exhibition of paintings from Vincent Massey's collection.⁵¹ At a mid-February tea, Sir William Beveridge learned that Jarvis was an artist and offered him a room in the Master's Lodge in which to sculpt. Jarvis accepted and began working on a portrait of Beveridge,

a challenging model described by one contemporary as resembling "nothing so much as a gargoyle thatched with white hair."[52] The knowledge that Jarvis had once again taken up sculpting so alarmed his mother that she made him promise to finish his thesis first.[53] By early spring, Jarvis had worked around this stricture by convincing Carritt to sit for a portrait during their tutorial sessions, justifying this unusual teaching method to his parents by declaring that Carritt felt it would be "a very good idea for us to discuss aesthetics with an aesthetic object present."[54] Jarvis appeared to be carrying off this combination of creativity and scholarship, given Carritt's opinion that the draft thesis he submitted at the end of the second term was "too good: – on a scale of thoroughness in detail which could not be maintained on a thesis of reasonable length."[55]

War became inevitable just as Jarvis' intellectual and artistic efforts began bearing fruit. Italy attacked Albania in the first week of April, thereby declaring her support for the Axis Powers. Germany annexed the remains of Czechoslovakia a few days later and Britain introduced conscription at the end of the month. Initially undeterred by these developments, Jarvis returned to France to spend his spring vacation with the Barwicks, assuring his parents that they would cut short their planned motoring tour at the first sign of trouble.[56] He then settled in London for a second round of thesis research, and also began working on a book about the historical connections between war and art. The new project was inspired by the ideas of Lewis Mumford that Jarvis had digested on the Atlantic crossing. Several weeks in London clarified his thoughts about the future and he returned to Oxford determined to obtain a B.Litt, the most junior research degree, as the first step towards a doctorate.[57] He also resumed work on the Master's portrait to the consternation of Carritt, who warned Jarvis not to do too much, a concern he expressed more forcefully to the Rhodes Trust, by reporting that Jarvis' thesis was progressing slowly because of his "not having the training to distinguish easily what is important."[58] Carritt's assessment was the first of many subsequent indications that Jarvis lacked self-discipline and, in the absence of an imposed daily routine, took on too many simultaneous responsibilities. However, by the end of the academic year, Jarvis had done sufficient work to register his proposed thesis under the formidably erudite title "'Beauty without a Reference to the Feeling of the Subject Is Nothing by Itself': Kant's *Critique of Judgement*, Section 9."[59]

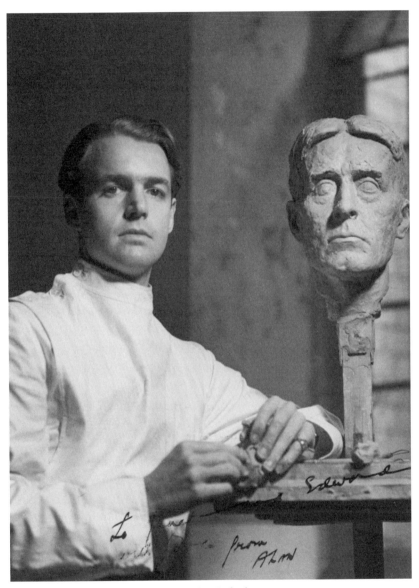

Jarvis with the bust of his tutor E.F. Carritt, Oxford, 1939.
Alan Jarvis Collection, University of Toronto.

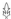

As Jarvis had claimed to his mother, many of the most important learning opportunities at Oxford took place outside of formal lectures and tutorials. It was a style of learning to which Jarvis adapted quickly and easily. His introduction to the wider world of English affairs was occasioned by the young Australo-Canadian art critic Graham McInnes, who appeared in Oxford during Jarvis' first week at college. McInnes wrote about the arts for *Saturday Night* magazine and belonged to the same Toronto circles as Douglas Duncan and Jarvis, and was now doing publicity work for a Tate Gallery exhibition of Canadian Art.[60] Thanks to introductions from McInnes' mother and Burgon Bickersteth, he and Jarvis were invited to lunch at the Oxfordshire home of Sir Michael Sadler, a retired diplomat and former master of Univ, who owned one of Britain's best collections of modern art.[61] Jarvis and McInnes were awed by these works. Art talk continued over lunch before giving way to a discussion of Australian and Canadian current affairs.[62] Jarvis charmed the Sadlers, who invited him and a group of friends to return for tea the following week. They exchanged Christmas cards and in the winter Jarvis arranged for Univ's art society to visit. Returning late from this last outing, an offence for which the individual miscreants were fined five shillings, was Jarvis' only run-in with college authorities.[63]

The friendship of an eminent collector and social figure like Sir Michael Sadler was a coveted prize, which resulted directly from the high esteem in which Jarvis was held by members of the Canadian establishment. He could boast of such accomplishments to his parents, but he had to write in the most cautious, benign terms when referring to a series of well-placed lovers in the British art world. Despite homosexual acts being criminal offences, at Oxford Jarvis enjoyed a greater sexual freedom than he had in Toronto, thanks to living on his own for the first time and the relatively commonplace nature of non-physical, passionate attachments between young men in English public schools and at the university.[64] Jarvis' relationship with Duncan had not formally ended that summer, but within a fortnight of arriving at Oxford Jarvis met Ian Robertson, the young assistant keeper of fine art at the Ashmolean Museum. Robertson, with whom Jarvis gardened and visited country houses and village churches, was his first English sexual conquest.[65] The brief rela-

tionship lasted long enough for Robertson to introduce Jarvis to many people in the British arts world.

Equally soon after arriving in England, Jarvis met Roger Hinks, who at thirty-five had already been assistant keeper of Greek and Roman antiquities at the British Museum for over a decade. Hinks fit the pattern for Jarvis' lovers that had been set by Duncan. Premature baldness prevented him from being classically handsome, but he was by turns erudite, urbane, austere, teasing, and witty. He loved good food and company and was a fastidious dresser who looked more suited "to the deck of an Edith Wharton yacht or to the cypress walk of a palazzo in Henry James" than to the modern world.[66] Hinks pursued Jarvis ardently, even though he felt that the younger man had erected an emotional "wall of glass" to deflect any but the most casual advances. The inscrutable shield that people had noticed in Toronto remained, though the relationship finally bloomed at the end of the Christmas vacation when Hinks helped Jarvis research his thesis at the British Museum. Throughout the rest of the winter, Hinks often visited Oxford, where the pair took romantic walks on Christ Church Meadow. When apart, they exchanged sexually charged letters and postcards.[67]

Hinks focused on Jarvis so tenaciously in part because his own career was in crisis. He had overseen the 1938 restoration of the Elgin Marbles, the frieze which had once crowned the Parthenon in Athens and was among the British Museum's most well-known artefacts. Public controversy erupted in the autumn of 1938 when it appeared that over-forceful cleaning had removed the last traces of the paint that had originally been applied to the figures. After several assessments by experts and a humiliating appearance before the museum's trustees, Hinks was informed in mid-December that, in effect, his career was over. He resigned at the end of February 1939 and retreated to the Continent. Before leaving, he wrote to Jarvis:

> I want you to know that I am deeply grateful for the way in which you received my advances. Of course you must have interpreted them in the obvious ways; and I did not even want to deny how much you attracted me. But what mattered to me infinitely more – especially at that moment – was the feeling that we understood each other through and through and could really help and comfort each other. That seems to

me the only way in which life makes sense; and it is so rare to find somebody radiant and warm (instead of opaque and frozen) that when the miracle happens, I want to lose my head for an instant. But I don't: I only feel a great glow of gratitude instead.[68]

It was almost impossible for such a new relationship to survive this kind of immediate stress. So Hinks and Jarvis drifted away from one another gradually.[69] Moreover, despite its passion, Jarvis never saw that his pairing with Hinks was exclusive. It followed closely on the heels of his Parisian flirtation with Ted Manteau and during his hedonistic exploration of new sexual opportunities. In February he picked up a dancer from Germany's avant-garde Ballet Jooss, when the company performed in Oxford. Throughout the rest of the year, this young man sent Jarvis long, passionate, but exceedingly trite letters. These missives did not ignite a sustained romantic relationship, though the young dancer, Jarvis, and an "explorer" identified only as "D," with whom Jarvis was also entangled, met that May at the seaside for a weekend-long sexual encounter.[70] For his part, Hinks bragged of the way he was consoling himself on the Continent: "We went to the club Liegois, where we picked up two Spahis who had gone there to earn a little pocket-money. They were quite nice boys, but the uniform seems to me merely grotesque and not at all aphrodisiac."[71] Such relationships, brief encounters, and frank talks about sex were important in cementing Jarvis' comfort with his attraction to men, as his close friends noticed he "played his sexuality with ease" for the rest of his life.[72]

Jarvis' most important sexual relationship began in April 1939, when, in an effort to help him gain more experience in adult education, Burgon Bickersteth introduced him to Christopher Martin, the youthful administrator of the arts programs at Dartington Hall, a radical co-educational experiment in the rural southwest of England.[73] Dartington had been founded in 1925 when Leonard and Dorothy Elmhirst purchased a dilapidated fourteenth-century manor. In India Leonard had befriended the Bengali philosopher Rabindranath Tagore, with whom he had set up a model agricultural settlement. Dorothy's father was one of America's richest men, while she inherited another fortune from her first husband. The Elmhirsts established Dartington to prove that education could liberate mankind, that the arts could transform a society that had been impoverished by technology, that urban and rural ideals could coexist harmoniously, and that a concern for the individual must be combined with industry and science.[74]

Dartington's school opened in 1926 with a handful of students, but within a dozen years it numbered just under 200 pupils. Among them were the children of prominent intellectuals Bertrand Russell and Aldous Huxley, artists Barbara Hepworth, Ben Nicholson, and Jacob Epstein, the publisher Victor Gollancz, and Sigmund Freud's grandchildren.[75] Left-wingers patronized experimental schools like Dartington because they believed that the jingoism and martial spirit inculcated by traditional public schools had caused the carnage of the First World War.[76] So Dartington lacked a formal curriculum, cadet corps, chapel, corporal punishments, or games. Instead, children were encouraged to discover and develop their personal interests. As the pioneering sociologist Michael Young, who had been among Dartington's first pupils, stated, its "essence was that it was not to be a school at all of the sort that most people would recognize. There were to be children in it, but it was not to be an institution of the book. Its classrooms were to be 'a farm, a garden, workshops, playgrounds, woods and freedom,' its main book the book of nature."[77] Young spent much of his time repairing and racing motorcycles, while others explored interests as diverse as chicken hatchery, small business, and ballet. Instead of rugby and cricket, the children practised eurythmics – the avant-garde system of music and movement – on the lawns or skinny dipped in the nearby river, to the consternation of local residents.

Bickersteth provided an introduction to Christopher Martin because he sensed that Jarvis would be attracted to Dartington's educational ethos and its idyllic setting in an untouched corner of England. He was right, though Jarvis' exposure to this unworldly community also deepened his awareness of the impending war, because the Elmhirsts were helping artists escape from Nazi Germany by employing them at Dartington. Among the dancers who had been saved were the futurist choreographer Kurt Jooss and the choreologist Rudolph Von Laban. Bauhaus founder Walter Gropius entered England thanks to a commission to design the studio and theatre in which Michael Chekov, a student of Stanislavsky, worked. Dartington also attracted idealistic artisans and designers who produced linens and furniture in a William Morris–like belief that such pre-industrial handicrafts could better the lives of the working classes. As arts administrator, Martin's job was to create a coherent program out of these disparate elements.

This dual identity as a school and professional arts department made Dartington one of Europe's most vibrant and challenging cultural communities and a well-endowed, practical experiment in the educational and

artistic theories to which Jarvis had been introduced at Glenokawa.[78] Jarvis felt comfortable there immediately in part because, like its founders, Dartington was a hybrid of transatlantic educational and artistic theories.[79] Jarvis was also drawn to Christopher Martin, an immensely charismatic man and passionate adult educator who "lit up quickly in response to certain people and to particular situations and had a great capacity for lighting up others."[80] Though written in another context, this is an apt description of why Jarvis was intellectually, emotionally, and sexually attracted to the bisexual Martin, who was married with two small children.

Given his personality, experience, and interests, it is not surprising that Jarvis was drawn to Dartington. Soon after they met, Martin offered him a fellowship to teach and study art at the school during the month of August. Jarvis spent several preparatory weekends at Dartington over the early summer, lunching with the Elmhirsts and befriending a number of staff members. He saw a great deal of Martin and his wife Cecily at their farmhouse, where guests read poetry and plays aloud, or at fashionable London venues like the Royal Opera House.[81] Martin and Jarvis began an affair and talked of collaborating on a number of arts projects in the coming years. But once again Jarvis remained emotionally distant from his lover.[82]

The pub was Dartington's social centre and reinforced Jarvis' growing conviction that alcohol was not entirely evil. In its relaxed and convivial atmosphere, Jarvis first met the group of young homosexual men who had gathered around the Martins. They included Jimmy Knapp-Fisher, who headed the publishers Hodder and Stoughton, Christopher Orpen, Bob Pelham-Borley, who was the secretary of London's St Thomas's Hospital, and Tony Harris, an "angelic" young jazz pianist with whom the entire group was infatuated.[83] Jarvis remained friends with many of these men until the very last years of his life.

For Jarvis, the most important member of this gay social circle was the manager of Dartington's mill, Arthur Hiram Winterbotham-Hague-Winterbotham, whose family's looms produced textiles that were used to make the most luxurious pink hunting jackets and ecclesiastical vestments. Mercifully, for author and reader alike, Jarvis always shortened his friend's Wodehousian name to the more manageable "Hi." One of the most striking things about Hi was how much he resembled Douglas Duncan, whom he soon replaced as a lover and father-brother substitute. He was tall, stoop-shouldered and sported round tortoiseshell spectacles. He loved gardening,

was passionate about music and the arts, and had a keen interest in Lewis Mumford about whom he had lectured at Dartington.[84] At the same time, Hi was far more carefree and bohemian than Duncan, while not expecting the level of emotional commitment from his lovers that Christopher Martin did. He had a tremendous sense of fun, declaring the things he most valued in life to be "beer, poetry, humour, understanding and love with a small l."[85] It was from Hi that Jarvis learned the habit of assigning friends and colleagues with monikers that punned with their names or reflected aspects of their characters, like the Dartington staff member Arthur Waley, whom Hi called "Waley Waley up the bank" in reference to an old English folk song.[86] When not at Dartington, Hi lived at Woodchester House, a comfortable Georgian residence near Stroud, Gloucestershire, whose extensive gardens gave way to stunning views over the Cotswolds, one of the most beautiful and bucolic parts of England.

Despite his enthusiasm for Dartington's programs, personnel, and accommodating sexual climate, Jarvis arranged interviews throughout the spring with the London County Council and other educational authorities in hopes of setting up additional opportunities to broaden his knowledge of adult education.[87] In the midst of this, Jarvis told his parents excitedly about the Dartington job, the car he had bought, and the prospect of staying in England indefinitely. Even this relatively innocuous announcement crystallized the increasing divergence between his and his family's views of the world.[88] Janet and Ed were unconcerned about the professional training their son might find at Dartington, but they worried about the fellowship's focus on the arts. Just as they had done with Jarvis' brother almost a decade earlier, they pointed out that a life in the arts was precarious and frivolous and lacked the social status of an academic post. But as an undergraduate Jarvis had known teachers like Robert Finch, Barker Fairley, and Reid MacCallum who had proved that the two could co-exist. Nevertheless, parental discouragement won out and was responsible, at least in part, for Jarvis' decision to stay at Dartington for only half of the time he had been granted. Even this reduced commitment was truncated when the tubercular Martin was hospitalized soon after Jarvis arrived at the start of August.[89]

A second event with unanticipated, but momentous consequences occurred in June when Jarvis' American friend Lloyd Bowers asked him to escort a young woman to the Univ Commemoration Ball. Bowers had

arranged for himself and Jarvis to squire a pair of New York debutantes, Fanny Myers and Honoria Murphy, who were spending the summer in Europe. Having purchased gowns in Paris, the young women arrived in Oxford on the eve of the party to be shown around the university by their suitors. The following night began with a formal dinner for fourteen, after which they joined the ball for dancing and champagne-fuelled fun. College servants remarked, as Jarvis gloated to his mother, that his date, Honoria Murphy, whom he would forever after call "Ho Ho," was the most beautiful woman at the event, though such claims are impossible to verify because both couples, depending on which account one reads, had either passed out from drinking, or were making out in their rooms when the traditional "survivors" photograph was taken at dawn. Both versions agreed that the four had recovered sufficiently to go punting on the river for breakfast.[90] Honoria's mother, Sara, who was the girls' chaperone, described Jarvis as "very attractive and no feathers anywhere" in a letter to her husband, who had stayed in the United States.[91] The foursome subsequently went nightclubbing in London, and at the end of June Sara Murphy took them all to dinner at the ultra-chic Café de Paris. The women were leaving for France and Sara Murphy invited Jarvis and Bowers to join them several weeks later for a cruise around Corsica on the family yacht. Bowers accepted, though Jarvis chose to remain in London, citing a need to research his thesis.[92] The young women's importance would not become fully clear to Jarvis for several months.

Skipping the Mediterranean cruise was part of a wider deception whose real purpose Jarvis concealed from family and friends in Toronto and confided to very few English friends. He had begun seeing a London psychiatrist on the ostensible pretext of conducting research into what he told his parents was the "psychology and psychopathology of the states of aesthetics."[93] Such a recondite description of his thesis prevented Janet and Ed from asking any detailed questions about the work or their son's real reason for staying in London. This was to undergo intensive psychoanalysis with Dr Oswald Schwarz, a Viennese refugee and disciple of Sigmund Freud, whose Harley Street practice specialized in sexual disorders. Schwarz believed that homosexuality was common in boys, but abnormal in adult men, whose desires could nevertheless be cured, or at least controlled, through willpower.[94] Oxford friends believed that Jarvis was in London working on his thesis and a book that examined the historical relationship between art and war. This

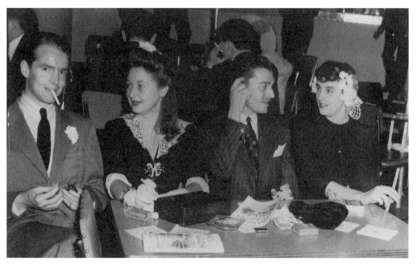

Jarvis on the town with (left to right) Honoria
Murphy, Lloyd Bowers, and Fanny Myers, 1939.
Alan Jarvis Collection, University of Toronto.

was at least partly true, because when he was not meeting with Schwarz, Jarvis
made steady progress on this topical research. A few members of Jarvis' Dart-
ington circle knew the real reason for these sessions, because they were also
Schwarz's patients. Though they lived fairly open gay lives, they could not
fully escape the era's social pressures.

The summer of 1939 was the only time in Jarvis' adult life when he ques-
tioned his sexuality or sought a psychological "cure." The introspection
followed a hedonistic, but exhausting year in which he had taken a series of
lovers and begun drinking regularly.[95] That he was secretly questioning and
exploring his attraction to men was another instance of how Jarvis' carefree
public persona concealed his emotional life. The serious way in which he
approached these sessions was demonstrated by the fact that one of only two
very brief fragments of diaries in his archives dates from this period. This
single sheet of paper, written on the first of May 1939, contains random im-
pressions of Jarvis' day, ranging from tangible events like "to the college, the

portrait [of Sir William Beveridge]," to physical sensations such as "the full bowels," and a dream of "the image of Betty, of Pat – Lloyd's face," before ending on a down note with "(long) morning of world, of failure, the anguish."[96] There is too little information in this document to draw telling conclusions, but therapy appears to have strengthened Jarvis' overall acceptance of his attraction to men. As the sessions progressed, Jarvis pondered the idea of training as a psychologist, and briefly looked on Schwarz as a father-brother substitute. A flattered Schwarz responded that "your idea of becoming a sort of professional psychologist wants careful consideration. Occasionally I have thought myself of you as a possible pupil of mine," though nothing came of this suggestion.[97]

In the middle of Jarvis' introspection, Douglas Duncan announced his intention of spending six weeks in Europe in July and August 1939. The waspish letters he and Jarvis exchanged while setting up this trip showed that neither was completely certain about the state of their relationship, despite each having taken lovers over the previous year. Indeed, Duncan toyed with the idea of showing Europe to a new young beau, while at the same time feeling

very unhappy about the prospect of that quartet [Alan, Hi, Douglas, and his new lover]. There might be friction, there might not: there's the rub. If it were just the two of us, there is nothing that I want more. But last summer was so happy for me; and I couldn't bear that there should be any trouble or strain between us. I feel about you exactly as I always have; but since this last year has meant a convenient breaking off for you, I suspect that in spite of any polite protestations, you would really prefer to leave it at that. It might be awkward with your explorer friend, it might well be very hard for you; and in that case it would be *terribly hard* for me. So hard that I just can't face it. If possible, I don't intend to be hurt any more, or much more, by you. Not an adventurous frame of mind, certainly, but it has its justification, I think. So, I am afraid, it is again up to you. I am complacent enough to accept that you would like to see me, etc, but at the same time I am humble enough not to be a bit surprised if you feel Toronto and last summer are so far away that they might much better not be resuscitated. And I could hardly go over to Paris and come back blandly saying I had not seen you.[98]

In the end, Duncan crossed the Atlantic alone and Jarvis met the ship at Southampton. Tensions invaded the reunion during the pair's first night together, which they spent with Hi at Woodchester. Once in London, they moved into a boarding house, where the strains increased as Duncan grew jealous of "Dartington," which he felt had come between himself and Jarvis. Duncan saw that Jarvis wanted to discuss art and education with his new mentor Martin, and spend the weekends with his new lover Hi. The rejection seemed complete when Duncan learned the reason for the sessions with Dr Schwarz. He left abruptly for Paris, after which a series of bitter letters did little to heal hurt emotions.[99] Duncan returned to Canada at summer's end, though he worried that his own sexual orientation would be exposed if Jarvis' lies about Dr Schwarz were uncovered. At the same time, when Duncan discovered that Jarvis was funding the sessions with the last of his Rhodes money, he insisted on paying the bills. The gesture reflected his continuing affection and concern for Jarvis.[100]

Jarvis returned to Oxford in late August to find that the university was preparing for a war that had now become inevitable. Like many students, he made little effort to resume his studies. Instead, after checking the latest news at Rhodes House each morning, Jarvis headed to the Ashmolean Museum to help pack its treasures and blacken the windows of the room in which he had taken drawing classes one year earlier. Once languid weekends at Woodchester were now devoted to preparing the house to accommodate evacuated children. Finally, Jarvis planned his own war service by volunteering to drive a London ambulance, because it was clear that civilians would not escape the coming conflict.

These activities signalled that an era in Jarvis' life was closing. It is worth quoting one of his last English letters at length because it demonstrates explicitly how he tried to rationalize the experiences of Oxford, Dartington, and Dr Schwarz with his parents' rather unimaginative, middle-class aspirations:

> I've meant to say for a long time that I know that I must decide which of the many things I am interested in I am going to do well and this summer has been devoted to that. I came here with an interest in philosophy, art education and psychology, not to mention a desire to write and act and so on and I've had the usual "forty days in the wilderness." I've had to recognize that art and sculpting must come second, that I

have a great deal of work to do to become an educationist, and that I must grow up. I think I know now the sort of work I want to do and that I never will be an artist, tho' I'll always have that side, that I am now twenty-four, and therefore must run my own life. It is hard, darling for you to think of me as no longer the baby, and you'll be surprised when I come home that I'm not a baby, but it must [be] done. I don't mean that I'll ever give up asking and wanting your help, simply that since I am detached from home my life must be my own to run. And, that is why I've faced the ideas of deciding my career, ordering my work, and settling down. I shall have changed a lot for I've come into contact with too many people and too many ideas not to have been affected, and I'm going thru' the conflicts over religion and "ultimate things" that every person must do before thirty if he is going to become mature. I've seen from the [Christopher and Cecily] Martins that I most certainly want to marry and have children as wonderful as theirs, and how vital it is that one keep clean and wait for the right girl. I know I've admitted all these things but in an abstract way and suddenly one realises their truth. And, I realise clearly that what one *is*, not what one does is the thing that matters, and that humble service is the real career. Gee I sound like a hell of a prig, but you will understand what I mean. Your wonderfully understanding notes fell upon good soil as you can see, dear. I *know* that I have a good mind and strong personality, for which I owe more to my Ma than ever I can say, and that neither means a damn thing if it isn't put to good use. So, darling, you see before you an educationist and psychologist – not an artist or philosopher! It's not conceit – just the self-esteem founded on just and right that Milton saw was the key to living![101]

The confident tone masked sexual experiences that Jarvis could never disclose to his parents, an evasiveness that was familiar to many gay men. The letter also glossed over his discomfort about foregoing a career in the arts. Nevertheless, he heeded his parents' pleadings, stored his books and art equipment at Woodchester, gave the car he had only recently purchased to the Martins, and returned to Canada at the end of September 1939. He was one of a minority of Canadian Rhodes men who went home; several of that year's recipients

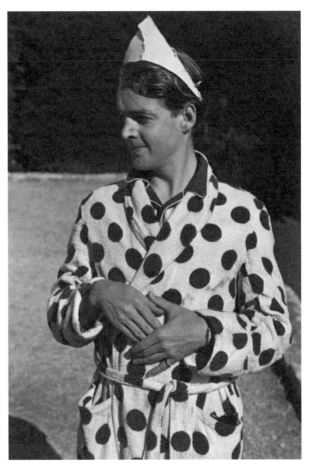

A gay kaleidoscope personality, Jarvis at
Woodchester, c. 1942. Alan Jarvis Collection,
University of Toronto.

entered Oxford, as did Hamilton Southam, the friend with whom Jarvis had
toured Paris the previous summer. Southam was surprised to find that Jarvis
was no longer around.[102]

In keeping with the leadership qualities the selectors had assessed in can-
didates, the Rhodes Trust advised scholars who wished to join up that they
belonged in the officer corps. Because those who interrupted scholarships to
enlist would be welcomed back at war's end, leaving Oxford in 1939 was not

an irrevocable decision.[103] Jarvis had no desire to join the military, but was "certain I can get work of national importance in Canada – education in the army for one thing, so I am not going to stew until I can get to Ottawa."[104] Such practical experience in adult education would further Jarvis' professional development and put him in an excellent position to resume his studies, or start a career when the fighting was over. Having declared his ambitions, Jarvis sailed for New York, where he intended to visit the Canadian pavilion at the World's Fair, which was staging an art exhibition that included several Milnes from Duncan's collection.[105]

CHAPTER
FIVE

"The Dead Days"
Toronto and New York City, 1939–1941

The twenty-seven months between Jarvis' departure from Oxford and his return to England in January 1942 are the most obscure part of his life. Jarvis left almost no written traces of this period and excluded at least one key set of correspondence from his voluminous archives at the University of Toronto.[1] Nevertheless, shards of information from printed sources, interviews, and a few letters in Jarvis' and other collections can be pieced together to create a picture of a frustrating and protracted, but nonetheless critical, interregnum between his youthful study and the mature application of his ideals. Broadly, Jarvis lived at home in Toronto from October 1939 until the following September when he entered New York University's Institute of Fine Arts. He spent nine months at the Institute, before once again returning home in the summer of 1941, where he remained until leaving for England at year's end. At the risk of mixing metaphors, this period was like a symphony's middle movements, wherein the leitmotifs of adult education, philosophy, and art that had been stated clearly at earlier points in Jarvis' life became fragmentary and jumbled, and fought for dominance as he struggled to find a useful way of both implementing his ideals and contributing to the war effort.

Although it was not immediately apparent, the sense of purpose with which Jarvis had left England was affected significantly by a chance encounter.

In early October 1939, Jarvis disembarked in New York City, intending to spend a few days visiting the World's Fair and catching up with his Oxford friend Lloyd Bowers. While touring the Flushing fairgrounds, he was spotted by Fanny Myers, or "Fa Fa," one of the American debutantes that he and Bowers had escorted to the Univ Commemoration Ball four months earlier. Jarvis and Myers had not kept in touch over the summer, but their chance encounter in New York was the start of a deep friendship that would last until his death. It is easy to see why Jarvis was soon attracted to her emotionally, intellectually, and physically. Myers was born and raised amid the American expatriate arts community in Paris. She was a talented painter with a great sense of humour, and a striking raven-haired beauty to boot. Honoria Murphy, the fourth member of that Oxford group, was also in New York and so Myers arranged for them all to reunite.[2]

Jarvis, who had won the approval of Honoria's mother in Oxford, now met her father. Gerald Murphy was the fifty-two-year-old head of his family's upscale department store. He had attended an elite New England boarding school and Yale, where he swam, acted, and was tapped for the Order of Skull and Bones. At graduation in 1916, he was voted both "Greatest Social Light and Thorough Gent," and "Most Brilliant" student. Unbeknownst to most of his friends, Murphy was bisexual, though he was deeply uneasy with any physical intimacy.[3] He nevertheless married the heiress Sara Wiborg, and spent uncongenial stints in the Army and at Harvard, before moving to Paris in 1921 to study painting.

Americans were drawn to France in the early 1920s by extremely favourable exchange rates, cultural opportunities, and the availability of alcohol, which was prohibited at home. The Murphys soon joined the louche, bisexual circle that surrounded the Russian ballet impresario Serge Diaghilev. Murphy began creating the huge modernist canvases he showed at the Salon des Indépendents and that have since convinced some scholars that he was one of the great American painters.[4] Murphy was an immaculate dandy with a trim swimmer's physique, imperious manner, and impeccable English who favoured capes, spats, and a sword-concealing walking stick. The many parties and artistic events that the Murphys sponsored soon placed them at the centre of American expatriate life. At their apartment, the cocktail hour, that symbol of 1920s decadent modernity, was an elaborate production in which Murphy mixed the most obscure and inventive drinks with a theatrical flour-

ish. It was in such raffish surroundings that he and Cole Porter became intimate friends and artistic collaborators. The Murphys also befriended and financially supported emerging American Lost Generation writers like Archibald MacLeish, John Dos Passos, F. Scott Fitzgerald, and Ernest Hemingway, and they were substantial patrons to the painters Pablo Picasso and Georges Braque.

In 1924 the Murphys bought an imposing house with extensive terraced gardens at Cap d'Antibes, which they named Villa America. A constant stream of friends stayed there, and some eventually bought properties nearby, lending credence to the myth that the Murphys had "created" the modern Riviera. Fitzgerald seized on this idea for his 1934 novel *Tender Is the Night*. His protagonist, Dick Diver, an American doctor who symbolically rakes the stones and weeds from an undiscovered stretch of Mediterranean beach, was based on Murphy. Criticisms of the couple's sybaritic lifestyle were dismissed by Murphy with his oft-quoted personal creed that "living well is the best revenge." When the *New Yorker* writer Calvin Tomkins appropriated this saying as the title of a 1971 profile of the Murphys, he fixed it as a hallmark of the Jazz Age.[5]

The Murphys' fortune survived the 1929 Wall Street crash and unlike many Americans they remained in France. But the new decade was not so happy. They returned to New York permanently in 1932 to run the family business. By the time Jarvis met them seven years later, they had lost both their teenaged sons to disease, and a grieving Gerald had stopped painting. The deaths heightened the sexual tensions in the couple's marriage, which their most recent biographer characterized by saying "silence, and its cousin denial, were familiar members of the Murphy family."[6]

Physically unsatisfied by her husband, Sara had a number of affairs and travelled frequently to Europe with their remaining child, Honoria, and it was on one of these trips that they met Jarvis. Gerald rarely accompanied them, preferring to remain in New York, where a succession of handsome and promising young men became his surrogate sons. The relationships were not physical, but they allowed Gerald to sublimate his sexual attraction by using his social and business contacts to promote these men, while instructing them personally in recondite aspects of wine, gastronomy, and culture. Separate interests and *amours* seemed to ease the tensions in the Murphys' marriage; neither contemplated divorce and by all accounts the family remained demonstrative and loving.

The Murphys' importance to 1920s Paris was not widely known until much later, so it is unlikely that Jarvis would have recognized their names. Gerald, though, had heard of this good-looking Canadian thanks to Sara's written account of the Oxford ball, which he had read aloud to "a roaring public" that included MacLeish and Dos Passos.[7] This positive reaction was confirmed when the two men first met soon after Jarvis' arrival in New York and discovered their shared passion for Bach, T.S. Eliot, and Gerard Manley Hopkins.[8] Murphy's attraction to this handsome, accomplished, and ambitious young man was immediate. To Jarvis, Murphy was an even more well-established father-brother substitute.

The two men were immediately captivated by one another, though neither Jarvis nor Murphy was looking for a sexual relationship. Murphy valued intense friendships, while Jarvis was returning to a home where he would have to once again hide his sexual preferences, curb his drinking, and spend Sunday mornings in church. Moreover, he was still coming to terms with his sexuality, having swayed during the preceding two years from Toronto's deception and concealment to casual acceptance of homosexuality at Oxford and Dartington, and finally searching for insight with Dr Schwarz. Jarvis' discomfort was heightened by his imminent departure for home, where, without any immediate prospect of employment, he was returning to his parents' house. While living there, he would not be able to entertain lovers, nor pay for further psychoanalysis, even if he could find a suitable Canadian specialist. Moreover, he and Douglas Duncan, who had parted in London with such acrimony, needed to resolve their relationship, if for no other reason than to prevent people asking uncomfortable questions about why they were no longer as close as they had once been. Having spent several days in New York, during which he and Murphy laid the basis for a strong, admiring friendship, Jarvis boarded the train for Toronto.

Jarvis and Murphy grew closer over the following year through a series of letters that the former kept for almost three decades before excluding them from the archives he bequeathed to the University of Toronto. Murphy addressed these missives to "A. Amatus," Latin for "beloved," and declared that Jarvis was the soulmate for whom he had searched since having his first adolescent homosexual feelings.[9] Such letters reminded Jarvis that there was an exciting, accepting, and supportive world outside of Toronto.

In contrast to the way Jarvis excised virtually all of these letters from his archives, he turned over those he received from Hi, Christopher Martin, and other English acquaintances who wrote regularly to keep him abreast of events in that country. Hi, jokingly if appositely, called his gossipy missives from Dartington Jarvis' "catechism," and over time their repeated injunctions about events in Britain helped convince the recipient that he had made a mistake in returning to Canada so hastily. Jarvis' sense of isolation was exacerbated by pledges of love from Hi that were as moving as they were dangerous, given that a postal censor could not have failed to understand the – illegal – homosexual declarations that ranged from "I miss you more than you know" and "Woodchester seems very empty without you," to the simple "I love you."[10] Martin was equally ardent in his love, while Tony Harris, the gay circle's *beau idéal*, beckoned Jarvis back to his spiritual home at Dartington.[11] Jarvis' sense of isolation was further heightened in the early months of 1940 by threats to idyllic Dartington. Hi's hand was mangled in an industrial accident, Martin's health continued to decline, and Harris was called up by the Marines.[12]

Little of this turmoil was perceived by Jarvis' Toronto friends, who encountered an apparently busy, focused, and ambitious young man. The deception was eased by his reacquaintance with Duncan, even though the relationship was not as scintillating or pleasurable as it had once been. Jarvis was no longer so obviously the junior partner, thanks to his English intellectual, cultural, and sexual experiences. Duncan's affection had survived these buffetings and he tried to help his friend, but in private he referred to Jarvis as "my refugee problem," a barbed witticism at a time when many governments struggled to accommodate populations who had been displaced by the war.[13]

The pair's initial uneasiness had disappeared by the end of October 1939 when they made one last trip to Six Mile Lake in order to help David Milne clear out the cabin. The relationship between Duncan and Milne had also changed radically while Jarvis had been in Europe. Milne's popularity with Canadian collectors had increased significantly, causing the artist to resent the prices he received for his canvases under an earlier deal with Vincent and Alice Massey and Toronto's Mellors Gallery. Duncan had become aware of Milne's feelings during their conversations on pre-war visits to the cabin. Before leaving for Europe, he and Jarvis had instructed the local storekeeper to secure Milne's possessions in the event of an accident, and in late 1938

Duncan had become Milne's exclusive dealer. Jarvis was in England by then, though he was aware of the impact of business on Duncan and Milne's friendship. The few letters he had received from Duncan at Oxford detailed the latter's attempts to catalogue Milne's works, trips he and the artist had made to Ottawa, and the paintings purchased by the meat packing millionaire J.S. McLean.[14]

Commerce underpinned the trip to Muskoka, where Jarvis and Duncan intended to identify and destroy sub-standard works, so as to limit the number, but increase the quality and monetary value of Milne's surviving paintings. That Jarvis was a full partner in the enterprise that consigned works to a small fire near the cabin was a measure of how fully the other two men trusted his artistic judgment. Two out of three votes determined the fate of what Milne described somewhat exaggeratedly as "thousands of dollars worth of oils, a million of watercolours and some chicken feed of etchings." Whatever the works' commercial value, Milne's biographer, to whom Jarvis related the details of this episode many years later, shuddered at the loss of so many canvases.[15] This was almost certainly the last time Jarvis and Milne saw one another. Milne, who was separated, but not divorced from his wife, had fallen in love with a much younger woman during Jarvis' year at Oxford. The couple lived together and eventually had a son, causing Duncan to fear that the relationship would scandalize middle-class art buyers. So, over the following years, Duncan became increasingly protective and proprieterial about access to Milne, concealing even the name of the town in which Milne lived.

Like the stay in New York City, the trip to Six Mile Lake was only a short diversion from Jarvis' search for a way of contributing to the war. Though he found it "depressing" that Toronto's streets were "crowded by night with nothing but soldiers and flyers – Canadian, Norwegian, Polish," it was not yet critical for him to enlist, because Canada still enjoyed the relative peace of the "phoney war" that lasted from the end of the battle for Poland in September 1939 until Germany's assault on Western Europe the following May.[16] Many young men in Jarvis' position, including the majority of Canadian Rhodes Scholars, had chosen to continue their studies. The country as a whole took its cues from Liberal Prime Minister MacKenzie King, who mapped out a moderate response to the war. Wage and price controls and rationing of select consumer goods had been instituted in the last days of the peace, but King refused to establish other mechanisms of "total war,"

such as conscription, and a propaganda agency, preferring instead to speak directly to the press.[17]

Relative calm on the battlefields, little domestic propaganda, and the government's resistance to instituting conscription gave Jarvis time to explore the possibilities of more congenial work with the civil service or army education. As his final letters from Oxford had indicated, he hoped to find a position with the federal government that drew on both his adult education expertise and the radical aesthetic to which he had been exposed in pre-war Toronto. This idea was timely because the government and adult educators had been discussing a program to teach the public about the country's goals since the start of the war.[18] Jarvis set his personal plan in motion in early November by travelling to Ottawa to see Harry McCurry, who had taken over the National Gallery that April. The meeting was brokered by Duncan, who had introduced Jarvis to McCurry during a brief visit to the Gallery three years earlier. In Ottawa, Jarvis explained his idea of establishing an arts program for the Canadian forces under the Gallery's aegis. He proposed that this should begin with a comprehensive, albeit ambitious survey of

> the possibility of the Gallery providing art-as-recreation and an art education programme for the men in Canada's fighting services; an investigation into the ways in which professional artists might do national service and the ways in which their special abilities may be utilized by the government in such fields as publicity, camouflage, war-records and art-instruction in the camps; finally a consideration of civilian wartime conditions affecting such groups as art teachers, wives and families of enlisted men, below-enlistment age students and the extent to which the Gallery might meet possible demands for special educational and recreational services.[19]

Jarvis hoped to do all this while crossing the country speaking on topics drawn from research he had done the previous summer for his book, which he was now calling *War in Western Art*. McCurry was noncommittal, though he was impressed by Jarvis' research and indicated that it might be furthered at the Gallery on a Carnegie fellowship. McCurry and his predecessor, Eric Brown, had used such short-term positions since the mid-1930s to encourage promising young Canadian art scholars. To date, Donald Buchanan had

written a pioneering biography of the Montreal painter James Wilson Morrice and Graham McInnes had produced his equally path-breaking *Short History of Canadian Art*. As secretary of the Carnegie Committee for Canada, McCurry's recommendation would have virtually guaranteed the funding.[20]

Despite knowing McInnes well, and thereby understanding that the Carnegie Foundation was almost the sole means of funding academic research in Canada, Jarvis was committed to developing his educational project and had little interest in pure art scholarship or gallery work. So he interpreted McCurry's enthusiasm as a licence to begin discussing the army project with Ned Corbett of the Canadian Association for Adult Education (CAAE), the country's main body for adult educators, and Wilfrid Bovey of the Royal Canadian Legion. He had never met Corbett, though Bovey was a key selector for the Quebec Rhodes Scholarships, a connection that Jarvis intended to exploit.[21] The CAAE and the Legion were already discussing joint educational programs with the government, and Jarvis hoped to sway McCurry's support by including them in his own plans. As a first step, he began revising an undergraduate essay about his sculpting teacher Elizabeth Wyn Wood into what he intended to be his inaugural lecture. He was soon devoting all his time and meagre savings to the work.[22]

Preparations aside, Jarvis' role in such an endeavour depended on the Gallery's endorsement. He had heard nothing by the start of January 1940, prompting Duncan to ask McCurry whether any firm decisions had been made about the plan. McCurry replied unenthusiastically that Jarvis should continue researching his book and pursue any other opportunities that presented themselves, because it was unlikely that the Gallery would soon sponsor a program along the lines Jarvis envisaged. It was a sign of how doggedly Jarvis believed in his idea that he continued meeting with Corbett, Bovey, and other educators in hopes of pressing McCurry to adopt the project. Faced with McCurry's evident misgivings, in late January Jarvis announced to him that Canada's adult educators were "very glad to know that there is some likelihood of the field of art being covered and that the National Gallery will have charge of the work," before asking for permission to introduce the Gallery's "general proposals" at an upcoming joint planning meeting of the Legion and the CAAE.[23]

This last suggestion from an unemployed, but tenacious and increasingly bothersome young man affronted McCurry's dignity as the head of a national

cultural institution. He cabled Jarvis not to make a proposed trip to Ottawa and followed up with a letter in which he made it clear that the responsible government officials had not discussed Jarvis' idea, that the Legion had decided not to endorse the plan, and that therefore "the National Gallery is not prepared to authorize you to attend that meeting in Toronto on our behalf although no doubt it would be valuable for you to be there unofficially."[24] Soon after the Toronto meeting, the Canadian Army put the Legion and CAAE in charge of its wartime education program, without any input from the Gallery, or Jarvis.[25] Aware that he was losing ground, Jarvis attempted to explain away the misunderstandings that he felt had prompted McCurry's rebuke.[26] At the same time, he complained to his friends in England about his frustrations and unhappiness in trying to organize such an undertaking with "fatminded" Canadians.[27]

After waiting ten days for McCurry's response, Jarvis pressed the issue by writing once again. By this time the go-ahead confidence of his earlier letters had been replaced by the abasement of asking whether the aforementioned Carnegie funding might still be available for work on his book.[28] McCurry replied dismissively three days later that "we do not award Carnegie fellowships unless the recipients have a desire to and a fair chance of entering the museum services of Canada in some capacity. I think you said you do not wish to take up gallery work and I received the impression that you wished some congenial employment in the gap in your Rhodes work," and thereby effectively closed the door on Jarvis.[29] McCurry could not have known that Jarvis was broke and desperately needed the money. Moreover, living in his parents' house and conforming to their rules was becoming an "undeniable and inexplicable trial."[30] So McCurry's rejection left Jarvis thoroughly "disgusted with Canada," a feeling that manifested itself physically in insomnia and a recurrence of sinusitis that he could not shake off for months.[31]

A ray of hope appeared just as these negotiations stalled, Hi and Christopher Martin, who knew of Jarvis' frustrations, began laying plans for him to undertake exactly this sort of work in Britain under Sir Kenneth Clark, the director of that country's national gallery. At the start of the war, Clark had advocated for an educational program similar to Jarvis' idea, and in late 1939 he had taken over the Film Division of the Ministry of Information. Clark was already one of the most influential art scholars, administrators, and cultural critics in the English-speaking world, while his new post gave him even

greater powers to develop national cultural initiatives. Within months he turned the ministry into a haven for artists, writers, and filmmakers like Henry Moore, Graham Sutherland, John Betjeman, and Humphrey Jennings.[32] Jarvis had never met Clark, but the opportunity for Hi to present his friend's case came about when, in order to protect their three children from the London blitz, the Clarks rented a house near Woodchester. Hi was soon a regular visitor and became one of Clark's closest friends. When people recall Clark's oft-repeated description of Jarvis as "the handsomest man I have ever seen," they overlook that it was an aside in a longer reminiscence about Hi, whom he called "a character who did so much to cheer us up, for he himself was always cheerful."[33] While Hi tried to muster Sir Kenneth's endorsement for Jarvis, Martin made a similar approach to Lady Jane Clark, who had been his girlfriend at Oxford.[34]

None of these efforts bore fruit, leaving Jarvis feeling trapped in Toronto, because civilians could not travel to England except on vital work for the war effort. His desperation was deepened by the March election, in which the cautious prime minister won an increased mandate. It was clear that opportunities in adult education would not soon appear in Canada. So Jarvis despondently gave up on the country, making neither further approaches to the civil service nor using university and Rhodes contacts to find a job. Wearing a uniform had no allure either. He now had no money or prospects of interesting employment and was denied the sexual licence he had enjoyed in England. This was the start of the depressing, aimless period that he called the "dead days."[35]

These feelings and restrictions on transatlantic travel caused Jarvis to attach new emotional importance to the time he had spent in New York City on his way home. Manhattan supplanted England as the place to which he hoped to escape even if the way to get there was equally unclear. His parents would only support him financially if he secured a publishing deal or some other concrete prospect before leaving.[36] He had neither, and so he looked for grants and scholarships that would fund a writer's life or study at a New England university. Earning the money himself was just as difficult because the only paid employment he could find was doing odds and ends for the CAAE, former professors, and the provincial Department of Health, for which he had worked during the summer of 1937. Frustrations were constant and growing,

as is evident from a springtime letter to Fanny Myers in which Jarvis dreamed of getting "fired so I can go to New York!"[37] Neither wish was granted.

The sense of gloom, failure, and purposelessness deepened when it became clear that his most exciting and long-term employment prospect was to spend the summer at Camp Glenokawa, at which he had worked while an undergraduate. The time at Glenokawa had fired Jarvis' passion for adult education, but returning there after his English experiences was a depressing admission of retreat and failure. Moreover, it was a student's job that paid very little and only lasted a couple of months. It would at least take Jarvis out of Toronto, but without getting him any closer to New York. And so the prospect did little to change his mood. In June, on the eve of leaving for Glenokawa, the normally well-spoken and witty Jarvis underlined his frustrations with a "Gdammit!" in a letter to Fanny Myers.[38]

Just as Jarvis reached this point, Toronto's isolation from the war was eroded by frequent newspaper stories and CBC radio broadcasts from Canadian military camps in Britain. It looked as though the young men interviewed on these shows would soon be sent into battle because German forces ended the phoney war by overrunning Denmark, Norway, the Netherlands, Belgium, and France in April, May, and June 1940. Axis advances pushed almost 300,000 British and Allied troops back to the Channel beaches at Dunkirk, where they were rescued by a hundreds-strong flotilla of naval ships, fishing trawlers, and pleasure boats. The summer-long Battle of Britain followed as the Royal Air Force staved off a German invasion by jousting with the *Luftwaffe* for control of the British skies. Reports of these events subtly hardened Canadian views about young men like Jarvis who still wore civilian clothes.

The end of the phoney war had immediate personal, familial, and social repercussions. Legislation bringing in conscription for home defence was passed by the government in the spring of 1940 and was due to take effect in July. This unnerved Jarvis, who dreaded being forced to undergo military training and knew that his age group would be the first to be called up.[39] His apprehensions increased in mid-June, when a "desperately anxious" Christopher and Cecily Martin, who feared that England was about to be overrun, begged him to become the guardian for their two young children, so that they could be evacuated to the United States.[40] The personal effect on Jarvis of this clear evidence that English friends were in danger was com-

pounded by his parents' growing worries about what to say when asked which military service their son had joined.[41] Janet and Ed were happy that he had not enlisted. There was no family military tradition; neither Charlie Jarvis nor Ed Bee had fought in the First World War. Nevertheless, Jarvis could not escape being challenged directly at a party by an Englishwoman to explain why he was not yet in uniform.[42] Threats to idyllic Dartington and mounting social expectations about young men's duty robbed Toronto of any remaining congeniality.

By the spring of 1940, Jarvis had scuppered his chances for cultural war work and Carnegie funding and so he focused on his book *War in Western Art*. As the series of lectures he had proposed to Harry McCurry indicated, Jarvis hoped the book would establish him as a commentator on current affairs. One of very few letters from Gerald Murphy that survive in Jarvis' archives shows that Murphy encouraged the work from New York: "I feel so strongly that the thing you know is valuable and of the future. To me, since the present is being telescoped historically, your art historical aspect is the one which should prove the most illuminating."[43] He then put Jarvis in touch with Manhattan literary agents and publishers and provided an introduction to Archibald MacLeish, the Librarian of Congress, whom he asked to assist this young researcher's "most intelligent and (self-imposed) task."[44] Those who encountered Jarvis in Toronto also saw a seemingly busy and focused researcher. He explained to them that he had only taken the job at Glenokawa in order to complete the manuscript in the quiet of the forest.[45] This was all window dressing, because, like Reverend Casaubon who beavers away on a universal theology in George Eliot's novel *Middlemarch*, he was secretly incapable of completing the book that was expected of him.

Only five manuscript pages of *War in Western Art* survive. These are dedicated to "Janet, Edward and Douglas" and declare the author's belief that

> What has not yet been done – and what this work attempts to do – is to take the art of an historical period *and* its warfare as institutional expressions of a total cultural complex and to see in what way they are related and how they are each woven into the general pattern of culture.

To do so will, I believe, throw light upon the actual nature both of art and war, as well as make their inter-relationship more intelligible. And, if we are prepared to grant any importance to cultural history, the relationship may not be only intelligible but valuable to the individual in a world at war. Still more important, an increased understanding of war – or of art – may be not only a means of understanding our-selves and society but a means of re-orienting our civilisation. This is especially necessary in a world which has twice in a generation descended into war.[46]

This passage was followed by a statement of the book's timeliness, which quoted Hitler's dictum that in wartime people's minds and opinions are in-fluenced much more quickly by pictures than words. The introduction, along with the few notes and scraps of text that survive in Jarvis' archives, shows that the work was to have been heavily inspired by, if not derived directly from, Lewis Mumford. Jarvis had absorbed Mumford's theories about the impact of technology on society during his 1938 European tour. To these Jarvis intended grafting shoots of art analysis derived from Roger Hinks, and his-torical insights from Oswald Spengler, Arnold Toynbee, and Richard Tawney, three scholars who had attempted to identify universal historical forces in the aftermath of the First World War. Chapters were to have progressed chrono-logically from "The Thriving Earthworm" about ancient Greece to an explo-ration of the nineteenth-century French romantic painter Eugène Delacroix called "Tiger in an Ivory Tower." There would then have followed two chap-ters on the contemporary international laws that were needed to prevent armed conflict entitled "The Moral Equivalent of War and Peace" and "The Right Forms of War and Peace," before ending with a chapter examining "The Chivalrous Ideal."[47]

War in Western Art never progressed further and Jarvis began referring to it privately as a "life-work" that he could not accomplish easily.[48] As the project ground to a halt, Jarvis became enthralled with the idea of producing a book about the "enjoyment of sculpture" that would be "decently illustrated" with pieces from American collections. In it, he wanted to explain the process by which sculptures are created from the earliest paper sketches to the final castings. He hoped that by doing so he could equip people to critically analyze works in galleries and museums and to recognize sculpture's influence on the

everyday world, like the shapes of cars and buildings. The project, of which nothing survives, would have heavily reflected Jarvis' adult educational ideals.[49]

Dreaming about such projects heightened Jarvis' overriding desire in the first half of 1940 to escape Toronto. Since returning home, he had confided his frustrations in letters to Fanny Myers and Gerald Murphy, who were fast becoming his most important confidantes, but whose glamorous Manhattan lives seemed out of reach. Fanny Myers' parents offered to put Jarvis up while he finished his books, but Janet and Ed insisted that the works must be completed before he left home. Murphy also encouraged these literary efforts and sometime in the spring they decided that Jarvis should make the move to Manhattan by enrolling at New York University's Institute of Fine Arts.[50] Money was still an obstacle, because in mid-1940 there was little chance for an able bodied young man to get graduate funding from a Canadian source. Hope glimmered in early summer when the university awarded Jarvis a scholarship. It was nothing as prestigious as the Rhodes and did not cover his expenses. He had no money of his own, but his parents agreed to provide a little, as they had done during his year at Oxford, in the hopes that a further degree and book would launch their son's career. A crippling exchange rate, however, meant that Janet and Ed's contribution would not go far at all.[51] The situation was finally resolved in the early summer when Murphy offered to give Jarvis $100 per month for the length of his course.[52] Murphy was coming close to declaring his love for Jarvis, and wanted him in New York. For Jarvis' part, accepting Murphy's money was a private admission of how desperate he was to get out of Toronto.[53]

So, when Jarvis left for Glenokawa, his future was somewhat more clear, even if it was still not certain that he could get a visa to leave the country. He did virtually no work on his books while at the camp, and returned home in mid-August to spend a fortnight working at the Canadian National Exhibition's temporary art gallery.[54] He left the city shortly afterward, with the best wishes of John Alford, the University of Toronto's professor of fine art. Alford was impressed with what Jarvis told him about *War in Western Art*, in part because he believed the book would bolster the socially committed aesthetic he had been advocating since his arrival in Canada. As he told Jarvis:

> I can't help expressing a wish that you will be able to do something new and useful on the art-propaganda "gestalt" relationships, or on the dual,

public and private, personal and social functions of art. It's all very timely, with the overdue decline of "art for art's sake" creating a danger that the "still small voice" will be drowned out by art-as-pageantry-à-la-Goebbels, art-as-planning-à-la-Bauhaus, and art-as-exposition-à-la-WFA. Can you set out to formulate a theoretical reconciliation? It implies a social philosophy as well as a theory of art, and that is why your training and interests are apposite. And I can't help also adding a hope that the love of personal wisdom, which you have, won't entirely lose out in the struggle with the claims of pure scholarship which it will certainly meet.[55]

The encomium showed that Alford, like the rest of Jarvis' Toronto friends, believed that this young man was leaving confidently for New York City, where he would make an important contribution to art scholarship. None of them had seen the frustration, gloom, and inertia behind Jarvis' effortless public demeanour. It was an early sign of the way Jarvis deteriorated physically and emotionally when he had no daily structure or routine.

Now that they were living in the same city, Murphy and Jarvis' relationship developed apace. Murphy advised his charge about food and wine, and took him to Broadway, the symphony, and the ballet, an art form that Jarvis adored for the rest of his life. Jarvis' sexual appetite returned during these evenings as he developed a crush on a young man from Brooklyn who danced for George Balanchine. With his knack for accents, Jarvis loved mimicking the dancer's ungraceful voice, including one night at the theatre when, during a musical diminuendo, he was heard distinctly throughout the auditorium saying in a proud but amazed New York accent "Look at me, I'm dancing!"[56] Jarvis could have assumed the same awed tone when talking about his own circumstances. He was finally living the glamorous life that his persona had long aped. Central to this was a devotion to the *New Yorker* magazine, and so one can only imagine Jarvis' excitement when Murphy took him to lunch with its writers at the Algonquin Hotel. It is easy to picture Jarvis seated alongside Dorothy Parker, Robert Benchley, and others as they traded the wisecracks and witticisms that exemplified the *New Yorker's* sophisticated metropolitan whirl.[57]

Murphy's role as a surrogate parent, rather than a sexual partner, was emphasized by the way Jarvis referred to this sophisticated, aristocratic man

in private as "the ideal father he had never had."[58] Jarvis' personal fantasy was reinforced by the weekends he spent swimming and sunbathing at Swan Cove, the Murphys' East Hampton beach house. Comforting as this must have been to someone who barely remembered his own father, photographs from Swan Cove show that the sexual element was ever-present. Pictures of Jarvis and the Murphys relaxing on the patio collide with homoerotic images of a still athletic Gerald in a shockingly small swimsuit. The starkly different messages conveyed by these photographs show that Jarvis was not a blood relative and allude to an intense relationship with Gerald that unnerved Sara in a way that earlier protegés had not. She became "rather edgy" about the threat this "Byronic" young man posed to her marriage.[59]

Jarvis and Murphy's relationship was as equivocal as these family scenes suggest. Their physical proximity rested at least in part on Murphy's monthly stipend. Nevertheless, Jarvis cut the same glamorous pose as he had in Toronto and Oxford. He earned top grades in his courses and began work on a thesis entitled "*David Hume – The Delicacy of Passion*," which he envisaged as an intellectual biography of the Scottish Enlightenment philosopher.[60] His endless witticisms and limericks made him a popular member of the Institute of Fine Arts, where he reconnected with several Toronto friends. One of them, Alan Armstrong, with whom Jarvis had designed sets for Hart House Theatre, remembered how he always brought a beautiful and socially connected woman to parties. This was Fanny Myers, for whom Jarvis had fallen hard and began hoping to marry one day.[61]

In less frenetic moments, Jarvis lazed on the weekends drinking coffee, smoking cigarettes, reading the *New Yorker*, and listening to classical music. Armstrong's wife recalled the Sunday breakfasts the couple hosted for fellow students. Jarvis would arrive at the last such gathering of each month, having just received his allowance from Murphy, with a bottle of hard liquor that he would place on the counter with a flourish while calling out for "ice water for the baby."[62] We have seen that Jarvis forsook his family's teetotal beliefs while at Oxford, but no matter how blithely he dressed it up, this monthly reaction to Murphy's financial support signalled a deep discomfort with their relationship. Superficially, Jarvis' time in New York mimicked the year he had spent at Oxford by combining academic work with an impressive social life. But in England the Rhodes had marked him as an important young man and enabled him to pay his way. In New York, he was no longer independent. Every

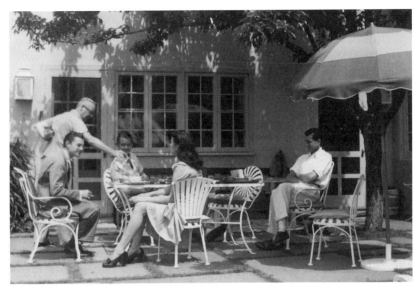

On the terrace at Swan Cove, the Murphy's
estate at Southampton, New York, c. 1941.
© Estate of Fanny Brennan.

four weeks he had to convince himself that he belonged in the United States
and that he was not being kept by an older man. Work on the books remained
stalled, as Jarvis discovered that Manhattan did not resolve the frustrations he
had felt in Toronto. A drink with breakfast may have dulled the sensation
temporarily, but by the end of 1940 Jarvis was telling friends at home that he
was busy, but not happy.[63] Duncan, who never wrote, was not one of these
confidantes and the two men's relationship petered out.[64]

Jarvis was also feeling increasingly guilty that he had run away from the
war. He exposed his private unease in a letter to Hi, in which he asked how
the British perceived American neutrality. Hi responded rather blandly that
domestic propaganda supported America's stance. Hi obviously knew little
about Whitehall's massive campaign to bring the United States into the war.[65]
From the autumn of 1939, the British government sent prominent writers
on speaking tours of the States, where they tried to dispel the image of England as an effete, nineteenth-century relic. Throughout his time in New York,
Jarvis was bombarded by increasingly intense British efforts to counter
America's well funded and organized isolationist and pro-German movements. His arrival in Manhattan also coincided with the first of fifty-six

straight nights of bombing raids on London. Reports of Britain's stoic resolve were soon being beamed across the Atlantic by American journalists who had been evacuated from the Continent as France fell. The most famous of these newsmen, Edward R. Murrow, began broadcasting live from London rooftops in late September. Realizing that the sympathetic portrait painted in these radio reports might sway American public opinion, British authorities produced a series of immensely popular monthly documentary films which were distributed across the United States by Warner Brothers. At the same time, Hollywood studios rushed out British-themed features. These efforts shaped an image of an embattled and resolute people who could withstand the enemy's pounding.[66]

Whitehall's propaganda efforts increased after the November 1940 presidential election. American reporters were supplied with information and photographs that documented Nazi atrocities in Poland, the iconic image of St Paul's Cathedral under attack and others that had been withheld at home, like those showing the civilian casualties of the massive raid that levelled Coventry in November. The first signs of success appeared at the start of 1941 as President Franklin Roosevelt pledged to support Britain, Congress debated supplying the country with material, and the Anglophobe ambassador Joseph Kennedy was recalled from London. The BBC responded by setting up a North American Service that broadcast sympathetic news, documentaries, and dramas to American listeners.[67]

Britain had to seal these efforts by showing that it was fighting back. In a February speech hailing the first Allied successes in North Africa, which was aimed squarely at American listeners, Prime Minister Winston Churchill declared, "Give us the tools and we will finish the job."[68] His vow that the country would no longer passively "take it" became Britain's rallying cry. Further evidence of the country's new-found aggression was seen over the following two months in the Allies' spirited defence of Greece. By the time the London blitz ended in mid-May 1941, England was fighting back on several fronts.

Jarvis, who adored books, newspapers, magazines, radio, and the cinema did not escape this propaganda. It had a strong impact on his thoughts about the future and increased his drinking. By the spring of 1941, he was overtly concerned that he had shirked his duties by going to New York. As he told Toronto friends, if he wanted to do something of "national importance," pre-

sumably in the field of education, then he had to return to England.[69] At first, Murphy resisted the idea because, as a friend of Jarvis recalled, "he couldn't bear to lose Jarvis when he had only just found him – it was like suffering through the boys' [the Murphys' sons] deaths all over again – and he could not fully express his grief."[70] But he eventually understood. Jarvis remained at the Institute until the end of the academic year, but he did little work on his thesis and never earned his degree.

By the time he quit New York in early summer, Jarvis had decided to join the Royal Canadian Navy as an expedient way of going overseas.[71] In Toronto, he solicited the dean of Canadian Rhodes Scholars, Roland Michener, to help him enlist only to be rejected because of the decidedly unheroic sinusitis from which he had long suffered, and the colour-blindness that left him unable to distinguish between red and green, which, because they are used to identify port and starboard, are the most important shipboard hues.[72]

The war entered a new phase as Jarvis laid these plans. Hitler invaded the Soviet Union in June and in August Churchill and Roosevelt met in the waters off Newfoundland to negotiate the Atlantic Charter, which proclaimed a common set of Allied aims for a post-war world. America was all but in the war, while Jarvis was once again marooned in uncongenial, depressing Toronto.

His frustrations continued until September when Hi made a definite job offer. He had been appointed head of the personnel department of Parnall Aircraft, whose 20,000 workers made Lancaster bombers at factories in Bristol and throughout Gloucestershire. Hi's mandate was to oversee the labour supply, staff welfare, catering, and transport. Startlingly mendacious as it may seem, Hi had convinced Parnall that Jarvis was an "American" expert on Taylorite "time-motion study systems," and thus ideally qualified to help run the factories. He buttressed this lie by warning Jarvis that "anything you can get to know about them [time and motion studies] will be useful" before showing up at the factory.[73] Jarvis was so desperate to leave that he complied. The salary for an assistant controller of personnel was £400, or about what the Rhodes had paid, but Jarvis could economize by living with Hi at Woodchester. Whatever the attractions of the job itself, Parnall was willing to secure a transatlantic passage for Jarvis.

Hi then approached Vincent Massey through Sir Kenneth Clark in hopes of arranging an official Canadian government backing for Jarvis' voyage.[74]

Though he had long heard of, and even met Jarvis, Massey refused to endorse the idea of a young man coming to England to take up work for which he had little training. So, almost immediately after Jarvis was hired officially by Parnall on 17 October, Hi, Murphy, and the Elmhirsts, who had moved to New York at the start of the war, began smoothing the way with various American and British officials. Parnall, meanwhile, agreed to Jarvis' request to start early in the new year so that he could submit a finished manuscript of *War in Western Art* to the Anglo-American literary agency Curtis Brown before sailing.[75] This last bit of optimism was misplaced – Jarvis missed the deadline and abandoned the book.

Amid this very focused activity, Christopher Martin wrote a frank and perceptive letter in which he quite rightly questioned why Jarvis had accepted a job for which he had no apparent qualifications or aptitude, citing an "awful fear that it isn't the important thing at all which gives you your mid-Atlantic Oliverisms but what Hi would call the hey-hey life which somehow we all encourage you to live; Hots and his sex wagon, Tony swinging hymns, Hein's studio, darts at the George, Jimmy's parties; all holiday stuff like a very prolonged sojourn at Cap Ferrat." This idealized, sexually charged vision of Dartington was immensely attractive to Jarvis, but as Martin pointed out "all the rest, the high flown things like culture and art and philosophy, you take about with you anyway because they are qualities of mind. If you externalise them or think of them as something which can be found in Europe but not where you happen to be at the moment then I should be afraid of Europe crashing badly when you come back to it. All of which is extremely pious and probably quite valueless but I come back to my original question of what is it that you want to find in one place but miss in the other?"[76] This honest judgment had no impact on Jarvis, who was desperate to leave.

Jarvis spent Christmas 1941 in New York with the Murphys, being loaded down with food, cigarettes, socks, candies, lipstick, and clothes by friends who knew he was setting out for a country under strict rationing.[77] A few days later he sailed for England, where he would spend the next thirteen years.

"Up to My Ears in the Business World"
England, 1942–1945

Bob Borley and Jimmy Knapp-Fisher, two of Jarvis' Dartington friends, met his ship as it docked on New Year's Day 1942. This was the first sign that, despite Martin's warning, the social and professional networks that Jarvis had begun building while at Oxford remained relatively intact. They provided Jarvis with a sense of support and offset the challenges he was about to face in helping to run an aircraft factory. Such fellowship was doubly important because the immensely heavy workload at Parnall Aircraft jolted Jarvis out of the inertia and frustration that he had experienced for the preceding two years, and left him with few windows for relaxation. During what little free time he had, Jarvis devoted himself to learning how to manage personnel. In doing so, he created opportunities to employ adult education techniques and set the course he followed for the rest of his career.

All of this unfolded slowly. On the morning after arriving, Jarvis went down to Woodchester, where many of his possessions had been stored for the previous two and a half years. Neither the Gloucestershire countryside, nor the house itself appeared to have been touched by the conflict. Hi's house-keepers still ran the estate, whose gardens teemed with flowers and produced such exotic foods as asparagus and strawberries that were otherwise almost impossible to obtain. This unusually varied diet was further enriched by shipments of butter, jams, juices, cookies, and other luxuries from Jarvis' parents.

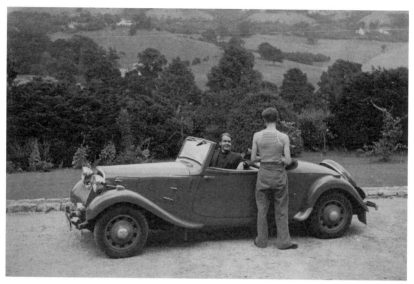

Jarvis in the car he drove throughout the war,
talking with a male admirer (possibly Tony Harris),
Woodchester, c. 1942. Alan Jarvis Collection,
University of Toronto.

Jarvis was also significantly more mobile than most people because his
responsibility for a workforce that was scattered across the west of England
entitled him to a precious petrol ration that fuelled the ragtop two-seater in
which he travelled through the country. In fact, Jarvis' and Hi's fuel allowances
were so generous that they filled the tanks of the painter Graham Sutherland
and other less well-supplied friends.[1]

The Cotswold idyll disguised the bleakness of Britain's position at the start
of 1942. Even though Winston Churchill proclaimed that the Allies had taken
the offensive, German submarines prowled North American coastal waters,
while Axis armies had overrun the Balkans and Greece, penetrated deep inside
the Soviet Union, and harried the Allies across North Africa. In the Far East,
the Japanese had sunk much of the American Pacific fleet at Pearl Harbour
and attacked or captured Hong Kong, Singapore, Malaya, the Philippines, and
Burma. Australia and India were threatened. At home, morale was ebbing and
it was not certain that Churchill would survive as prime minister. Though

Britain had been spared a land invasion by the Royal Air Force in the summer of 1940, this had touched off the German blitz campaign, during which cities were repeatedly bombed. The most intense period of raids lasted until the middle of 1941, by which time over 40,000 people had been killed and more than one million been made homeless.

Parnall Aircraft was based in southwestern England around Bristol, a railway hub, industrial centre, and port. The city was first blitzed in the summer of 1940 and over the following year hundreds of residents died and the medieval town centre was razed. The most intense bombing had ended by the time Jarvis arrived, allowing him to claim that, though he often heard attackers in the distance, he never had to use an air raid shelter.[2] Whether he spotted the bombers or not, the destruction and fear they left behind were all too evident.

The war had marked England just as tangibly. Even with a generous petrol ration, travelling through the country was not as easy as it had once been, because much of the British Isles was partitioned into military encampments for the tens of thousands of Allied troops who had been stationed there since 1940. A steady stream of Americans was arriving thanks to Washington's declaration of war in December 1941. Air force personnel were deployed constantly on bombing and defensive missions, while huge armies trained in preparation for a land assault on Europe. The number of troops in Britain grew steadily towards an October 1943 peak of about a quarter of a million, where it remained until after the Normandy landings the following June.[3] Service personnel alternated between frenetic, dangerous combat and long bouts of boring drill and inactivity. As Jarvis arrived, interrelated programs encompassing entertainment and education were being put in place to meet the enormous challenge of sustaining their morale.

The war also placed huge pressures on the British aircraft industry, which had no tradition of mass production. In the years before the war, the Royal Air Force struggled to replace obsolete biplanes, while the Germans produced thousands of modern fighters.[4] British manufacturers increased production overnight by reverting to techniques that had first been seen in the early days of the industrial revolution. Tens of thousands of precision parts, ranging from the most delicate navigational instruments to the largest sections of fuselage, were manufactured by an elaborate, country-wide web of contractors and sub-contractors stretching from large factories into individual

homes. Because so few parts were produced on assembly lines, the aircraft industry employed a disproportionately high number of skilled workers, who understood that they could not be easily replaced. Their sense of power led them to demand higher wages and a share in running individual factories through committees that oversaw management–labour relations and production.[5] Managers in turn had to meet government-imposed production targets, appease demands from the shop floor, and oversee the smooth integration of thousands of adolescents and women into factories and workshops of all sizes.

Such dispersed manufacturing also required an exceptional level of oversight and direction to maintain labour harmony and coordinate production. Soon after taking office in May 1940, Churchill, who had long argued that Britain needed to build more planes, created a Ministry of Aircraft Production under the Anglo-Canadian industrialist Lord Beaverbrook. While this was an important step in regularizing the industry, many of its experienced managers had already entered military service, causing immense problems. Parnall, for example, expanded thirty-fold in the first two years of the war, while at the same time losing all of its managers from non-technical areas.[6] To make up for this deficit, aircraft manufacturers looked to experienced businessmen from other industries, like Hi – who ran textile mills for his family and at Dartington – to coordinate these increasingly attenuated, interdependent manufacturing steps and control the potentially problematic workforce.

These new managers were also responsible for sustaining employee morale. The combination of strident and politically committed workers with the strategic need to control the skies in modern warfare meant that aircraft factories were subjected to intense propaganda campaigns. Military and political leaders toured factories, proclaiming that aircraft production was vital to the war effort, while visiting airmen recounted their stories about the value of the planes the plant was building. Factory walls were plastered with patriotic posters and the workers were barraged with leaflets that all reinforced the importance of a steady supply of planes to the Allied cause.[7] In other words, this comprehensive program of educating aircraft workers made Parnall an ideal place in which Jarvis could develop and implement the ideas he had proposed to the National Gallery of Canada two years before. Jarvis

clearly perceived the relevance of his earlier experiences, telling his parents later on in the war, "I've often thought too what a lot of good training and experience I got at Glenokawa which helps with educational work now."[8] Opportunities to implement these ideals came Jarvis' way because Hi, who he now referred to as "Hire-em and Fire-em," had very sensibly retained the traditional managerial duties of supply, training, and administration, while giving his less experienced associate the more social and educational topics of welfare, housing, and entertainment. The two shared responsibility for liaising with Whitehall.[9]

Though the work was congenial and exciting, its unrelenting pace shocked Jarvis out of the frustrating inertia of the previous months in Toronto. From his first week on the job, Jarvis was out of bed at seven – quite an accomplishment for someone who was never an early riser – worked until late evening, and spent most weekends writing reports for various government bodies. He tried to develop his almost non-existent management skills by attending conferences and seeking the advice of Oxford acquaintances like Sir William Beveridge, the master of University College, who had been commissioned by the government to study ways of eradicating poverty in postwar Britain. Beveridge's report, which was tabled in Parliament in November 1942, became the blueprint for the British welfare state.

Even as he developed these skills, Jarvis pondered the concrete adult educational measures he could introduce to Parnall's factories. Throughout his first six months, he worked with the existing management committees to organize concerts, sports events, and art exhibitions, and helped to set up communal vegetable gardens.[10] The responsibilities energized Jarvis, who announced to his parents after only a month in his new career, "never did I think I would be so up to my ears in the business world or that I would start off with Management with a capital M, but there I am!"[11] Soon after, he set up classrooms at the factories for the adolescents who were joining Parnall in large numbers. Then he and Christopher Martin attended a management conference at Nuffield College, Oxford, and as Parnall began hiring masses of women towards the end of 1942, he studied the impact of their introduction for the government.[12] This intensive training paid off in the spring of 1943 when Hi's responsibilities began taking him to London for long periods, leaving Jarvis in charge of most facets of personnel management for Parnall's

West Country operations. In Hi's absence, Jarvis became the squire of Wood-chester and spent the following year working feverishly, while living a de-cidedly gentrified war.[13]

Throughout the war, Jarvis' and Hi's social lives were hectic, glamorous, and tied closely to adult education. They often weekended with the Martins at Dartington, which was relatively close by. Several of the young gay men who Jarvis had befriended before the war were no longer in residence, though the community remained the cultural, spiritual, and sexual oasis that he remembered. Days at Dartington were passed swimming in the river, while evenings were spent with the Martins and other guests, like the scientist Julian Huxley, the painter John Piper, the poet Stephen Spender, and the young barrister Michael Young. Everyone was seeking a brief escape from the war. Jarvis' duties at Parnall left him with almost no other leisure time. Even so, he flirted briefly with completing the portrait bust of Sir William Beveridge that he had begun at Oxford. And a February 1943 letter to the *Times*, in which he argued that the government's official war artists would almost certainly produce some great works, was a final evocation of his un-finished book *War in Western Art*.[14] Other than this, Jarvis' personal artistic and literary endeavours ceased.

An important and exciting social network opened for Jarvis soon after he returned to England, when Hi introduced him to Sir Kenneth and Jane Clark, who had rented a house near Woodchester. The Clarks had heard of Jarvis thanks to Hi's and Christopher Martin's attempts to have Sir Kenneth hire this young Canadian in early 1940. They were soon charmed by Jarvis, whom they invited to a succession of dinners, plays, concerts, and films as part of a group that included Laurence Olivier, Vivien Leigh, Leslie Howard, Noël Coward, T.S. Eliot, Graham Sutherland, and the society hostess Sybil Colefax. In addition to attending chic London events, Hi, Jarvis, and the Clarks spent quieter weekends together at various country retreats, while Sir Kenneth often wrote in Woodchester's garden.[15]

Working at Parnall and socializing with some of Britain's most influential cultural figures caused Jarvis to alter the public persona that he had adopted in adolescence to conceal his inner thoughts and self-doubts. Canadian friends who were stationed with the forces in England, like Pat Fitzgerald with whom Jarvis had worked at Camp Glenokawa, noticed that the mask was

solidifying evermore concretely into that of a "British" aesthete. Fitzgerald recalled that after meeting Hi and Jarvis in London in the fall of 1942:

> we embarked on a delightful pub crawl with dinner at a charming French restaurant. Alan was looking the ultimate tweedy Englishman. His accent was flawless Oxonian but without the slightest trace of affectation. I kidded him about this to which he replied that it was good for business and also effectively established that a Canadian could also be mistaken for a gentleman! I asked what his formula was for business success in England. He recommended wearing odd combinations of clothing, affect total indifference as to salary and to do everything with exquisite good taste.[16]

Jarvis had changed his accent, despite having once promised his parents that he would always speak like a Canadian. Nevertheless, Fitzgerald and other Canadians were amused at the way Jarvis mimicked upper-class English speech and dress. His manner of speaking further obscured his humble roots and added another layer to his protective shell.

Jarvis was prevented from transforming himself into an entirely flippant caricature of an English dandy because at about this time Hi introduced him to Sir Stafford Cripps, one of the most formidable politicians of his generation. Cripps was a brilliant and devout aristocrat's son who worked obsessively hard and was Britain's best-paid barrister. After being rejected for military service in 1914, Cripps drove an ambulance – donated by his wife's wealthy family – in France, and then applied his scientific knowledge to help run the Ministry of Munitions. And though he was just thirty at war's end, Cripps was already suffering from severe digestive ailments and insomnia.

Cripps' political and religious views fused into an adamant Christian socialism that led him into the governing Labour Party in 1929. He was quickly appointed solicitor general and knighted, though the government was disintegrating by the time he entered the Commons as Member for East Bristol, one of Britain's poorest constituencies. In the summer of 1931, Prime Minister Ramsay MacDonald shattered the Party by forming a coalition government that Cripps refused to join. Instead, he veered into Labour's radical socialist wing and set about building an extra-parliamentary power base.

Throughout the 1930s, Cripps toured the Empire preaching his vision of a socialist future and promoting himself as the embodiment of British radicalism. The billing for a 1934 appearance at Toronto's Massey Hall touted Cripps accurately as "Britain's most challenging personality."[17] Socialists throughout the Empire sought his support and advice and subscribed to his newspaper. But Cripps' radicalism was at odds with the temperate course being steered by Labour's leaders and he was thrown out of the party in 1939.

One of Cripps' most fervent beliefs was the need for comprehensive social and economic planning. Because of this, he helped Dorothy and Leonard Elmhirst establish the independent policy research group Political and Economic Planning (PEP) at Dartington in 1931. This pioneering think tank was composed of public servants and industrialists who aimed to furnish political leaders and senior bureaucrats with accurate facts on topical social issues. Among PEP's eight founders were the rising journalist, civil servant and conservationist Max Nicholson, the scientist and public intellectual Julian Huxley, and the liberal newspaperman Gerald Barry. PEP soon became the most important advocate in Britain for the study of national issues.[18]

Cripps' promotion of left-wing ideas on the lecture platform and in print meant that he could not be ignored, but he was easy to mock, because he attempted to control the serious intestinal disorders that resulted from his war service with an ascetic, teetotal, vegetarian diet that was decidedly uncommon in the 1930s. This slight, gaunt, and bespectacled man's more noticeable peculiarities, like a preference for specially made flat-soled shoes, reinforced the notion among his critics that he was a sanctimonious, do-gooding crank. Winston Churchill expressed this sentiment most memorably by declaring when he espied Cripps, "There but for the grace of God, goes God."[19]

Whatever his eccentricities, Cripps' public profile and aura of rectitude virtually guaranteed him a prominent role in Churchill's May 1940 coalition. He served as ambassador to the Soviet Union until early 1942, when he was promoted to the seven-member War Cabinet with responsibility for informing Parliament about Britain's domestic and external situation. Cripps was immensely visible in this role, but he was increasingly frustrated by the way national morale, especially among factory workers, declined following the military defeats in North Africa. As discouragement set in, Churchill sent Cripps to New Delhi to secure the Indian National Congress' support for the war. The mission failed and Cripps pondered resigning until in late 1942 when

he became minister of Aircraft Production. It was a demotion from the War Cabinet, but ideally suited Cripps' interests in planning, morale, and the condition of the working class.[20]

Jarvis met Cripps almost as soon as he took over this new post. Cripps became the champion of adult education for whom the young Canadian had been searching since the start of the war. Cripps was convinced that adult, or "current affairs," education was vital in a "total war," in which the state's entire human and industrial resources were focused on the military effort. Such a program would explain government decisions and military strategy to civilians and service personnel alike and thereby plant the idea that they had a personal stake in the victory. Jarvis had been frustrated two years earlier by the Canadian government's unwillingness to implement such a program, but things had moved with more determination in Britain. In 1939, a group of people loosely connected with the Labour Party and the YMCA had begun putting together a plan for army education, which faltered over government and military leaders' fears that unsupervised discussions would be taken over by socialist "barrack room lawyers." Meanwhile, Burgon Bickersteth, the warden of Hart House, who had returned to his homeland before the war, became a central figure in Canadian army education. He shared this responsibility with the educationalist Bill Williams, who ran Britain's Army Bureau of Current Affairs (ABCA), which came into being after the Dunkirk evacuation in 1940. Both organizations taught young officers how to lead their men in weekly discussions on current affairs in the hope that such debates would boost morale and fighting efficiency by explaining the nation's war aims.[21]

Military programs alone did not meet the needs of current affairs, because the government was also making *de facto* promises for its post-war domestic intentions through, most notably, Beveridge's study of civilian conditions. Sensing this supportive climate, in early 1942 a pair of army officers approached Cripps and William Temple, the dynamic, socialist Archbishop of Canterbury, who had long advocated for the creation of a post-war "welfare state." These young men envisaged a program with the overtly political, non-military goal of "the inculcation of the idea that the first requirement of a citizen of a democracy is a belief in the faith and practice of democracy."[22] Twinning army education with wider current affairs was argued in academic journals throughout the middle of 1942 and came to be seen as an important means of reviving home front morale. To bowdlerize the debate, the Left

supported these ideas as a way of addressing social inequalities, while Tories were uneasy about equating the war with citizens' stake in the state.[23] Right wingers worried especially about participatory discussion groups, which were central to current affairs education, because they felt these would be harder to control than lectures. The caution with which the first "civilian" discussion groups were introduced in 1942 reflected these differing opinions. Initially, discussions were limited to organizations with vaguely military structures like Civil Defence and the National Fire Service. In little time, about 200 volunteers from these organizations had been trained as discussion leaders, and by September of that year, some 15,000 people were meeting nightly in London alone.[24]

While these debates about the role and shape of current affairs programs were underway in the spring of 1942, Jarvis and Hi began working on a practical factory education scheme. By the end of the year, Jarvis was discussing how to put it into practice with Herbert Agar, a Pulitzer Prize winning writer he had met through Gerald Murphy. Agar was working at the American embassy and the preliminary talks with Jarvis soon caught the ear of the society hostess Sybil Colefax, who socialized with the Clarks. She arranged "some interesting contact" between Jarvis and British educational leaders, the somewhat prosaic outcome of which was that Jarvis was asked in December to report on his Parnall ideas for the president of the Board of Education.[25] The report had little official impact, but by the start of 1943 Jarvis, who was still substantively employed by Parnall, was spending an increasing amount of time with Cripps, who had convinced PEP to sponsor educational work. Jarvis began devoting his precious spare time to developing educational ideas, writing speeches for Cripps, broadcasting and speaking to various groups around the country.[26] This brought him into contact with Isobel Cripps, who he saw "was very sure in her grasp of the human factor in industry; quick to assess the 'morale' of any shop, and to sense the mood of the work people."[27] Isobel's humane instincts complemented her husband's political skills and made her an obvious ally for Jarvis' educational experiments.

Jarvis glossed over this preliminary step in the romanticized account he penned of the way he became involved in British adult education. According

to Jarvis' version, at the end of March 1943 he was driving down West Country lanes with a guest speaker on the way to one of Parnall's factories. As the men chatted, he had an epiphany about how far the provisions for education in industry lagged behind those in the armed services. Meanwhile, personal experience had shown him that factory workers mistrusted propaganda as a government "line," and that they needed some more effective and inclusive means of illustrating the purpose and importance of industrial production.[28] Jarvis' description of this conversation and sudden awareness of the need for industrial discussion groups glossed over the work he had done with Sir Stafford Cripps since the start of the year. What is more certain is that existing commitments to Parnall and Cripps made it difficult for Jarvis to see how he could achieve this vision on his own, so he mobilized his network of sympathetic friends and acquaintances. Within very little time, the Elmhirsts provided money, while the Crippses got PEP involved and approached the movie mogul J. Arthur Rank for further support. In London, Sybil Colefax arranged a meeting with the textile magnate Samuel Courtauld, who she felt would be sympathetic to such a program, before trying to generate publicity for the new venture by introducing Jarvis to the American journalists William Shirer and Edward R. Murrow.[29]

The Elmhirsts had the greatest impact on the project, because their support included the writer Amabel Williams-Ellis. She was a member of the Stracheys, one of Britain's foremost literary families, while her husband, the architect and critic Clough Williams-Ellis, had helped found PEP. The couple counted the Crippses and Elmhirsts among their closest friends and their daughter taught art at Dartington. Williams-Ellis was a well chosen addition to the team because she had already published some two dozen popular volumes on poetry, history, science, and architecture, while her most recent book had been an examination of women's war work. The Elmhirsts also suggested that Michael Young, a twenty-eight-year-old Dartington-educated barrister and pioneering sociologist, whom Jarvis had met through Christopher and Cecily Martin, join the project.[30]

By June, Cripps was sufficiently impressed by the trio's work to approve a summer-long pilot project. Now that they had the minister's backing, Jarvis, Williams-Ellis, and Young christened their undertaking the Industrial Discussion Clubs Experiment (IDCE) and settled in to offices at Bristol University.[31] Cripps backed the IDCE because he sensed that encouraging workers

to actively debate the war and current affairs might be more effective than traditional aircraft factory propaganda. Just like the existing army discussion schemes, the IDCE aimed to train a small group of workers to run the meetings, to whom a central office would supply discussion materials. By doing so, the IDCE would achieve its aim of helping "to educate the young wartime entrant to industry whose knowledge not only of current affairs but of their own work and possible futures is pitifully inadequate. It could arrange for talks on production problems – 'you and your job' – and for Brains Trusts with 'Great Brains' from outside the factory. It might, indirectly, help to raise production."[32] Brains Trusts were popular military and civilian current affairs events in which panels of "experts" on various subjects were questioned by audiences of workers or servicemen. These had obvious utility as teaching tools and over the previous year Jarvis and Hi had participated in several such trusts on military bases in the west of England.[33]

Jarvis spent a week-long shutdown at Parnall helping to get the IDCE up and running, after which he contributed in his spare time, which he felt was all "a little more than can really be coped with, it means working all weekends and just not getting any [free] time at all."[34] He persevered in hopes of attaining IDCE's goal of determining the feasibility of discussion groups for a civilian workforce who, unlike the men and women in uniform, could not be compelled to participate. The study also sought to determine if specific places needed to be designated as discussion rooms, who should lead the talks, and whether these generated fruitful exchanges or party political speeches and general grumbling.[35]

Initial reactions to the IDCE closely resembled those that had occurred in the military, with managers predicting that discussions would be co-opted by socialists, and the unions suspecting that management controlled the experiment. Nevertheless, the first so-called "jam sessions" were held in July at Parnall's Bristol factories. These meetings generally took place in a corner of the canteen during the lunch hour and attracted from six to about fifteen participants. A typical activity began with a thirty-minute "Programme Parade" of Ministry of Information films, which were intended to provide subjects for discussion. The most popular titles were the self-explanatory *Health in War*, followed by *New Towns for Old*, an introduction to the social changes that might be realized in the peace, and then *Common Cause*, which explained Britain's alliances with China, America, and the Soviet Union. When the last

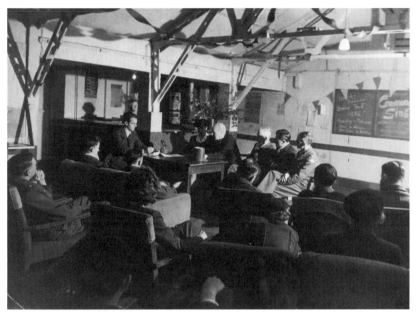

Jarvis leads a wartime Brains Trust, the discussion
group in action, c. 1944. Alan Jarvis Collection,
University of Toronto.

film ended, discussions were kick-started by one of the IDCE leaders, who
asked which film had made the biggest impression. Though the numbers of
participants were relatively small, in July a group of Parnall workers began
realizing the IDCE's goal of sparking a self-directed initiative, supported by a
central office that supplied films, briefs, and other background information.
Representatives from ten Bristol factories began meeting in rooms above a
fish and chip shop and by August they had formed a committee that contin-
ued the experiment until the end of the year.[36]

Having turned the IDCE over to local workers, the three directors pro-
duced a report on the experiment, which Jarvis hoped would be "world shat-
tering" for people and agencies with an interest in adult education, including
Cripps, the Ministry of Information, ABCA, and Burgon Bickersteth.[37] Like
almost all such policy documents, the report gestated after its submission,
though the IDCE's unmistakable momentum was captured that October in a

short, laudatory article in *Picture Post* magazine.[38] Sensing success, in late autumn Cripps withdrew Jarvis from his daily duties at Parnall in order to scope out a national version of the experiment that was christened the Industrial Bureau of Current Affairs (IBCA).[39] Cripps' ulterior motive for setting up IBCA in late 1943 reflected the military victories in North Africa, Italy, the Soviet Union, and the Pacific that had swung the war's momentum decisively towards the Allies. Though the political parties had agreed to a wartime electoral truce, Cripps and other leaders realized that it was time to start preparing citizens, however subtly, for the political choices they would be asked to make during the peace.[40]

Jarvis' new brief was to investigate how to transform the Bristol experiment to meet the IBCA's mandate, and the overall usefulness of such a body in helping people readjust to peacetime life. This was a terrific responsibility, but one that also put Jarvis, so he said, in "a most enviable position of meeting all of the leaders in the education field," and created the opportunities for which he had first approached Harry McCurry four years earlier.[41] Soon after a December 1943 weekend at the Crippses' country house, during which the details of Jarvis' new assignment were finalized, he wrote home with typical enthusiasm that "it is of course immensely thrilling and gratifying to be sponsored by such a great and good man – the only other 'Brains Trust' one would want to be in is FDR's! Bickersteth and the [Vincent and Alice] Masseys are, incidentally, a bit pleased about it all too."[42] Among the other members of the trust that Jarvis had joined were Cripps' secretary, the Canadian Rhodes Scholar Graham Spry, and his political protégés, future cabinet minister Woodrow Wyatt, and future prime minister Harold Wilson, whom Jarvis had first encountered as an Oxford economics don. Even though Jarvis could now devote himself almost wholly to educational tasks, since his responsibilities at Parnall had been greatly reduced, the workload was daunting. Firstly, Jarvis prepared a report on the IDCE that Cripps intended to submit to cabinet by the end of the year. This was well received and in early January 1944 Jarvis could boast of "real recognition at long last."[43]

Working full-time for Cripps also meant moving to blitz-pounded London, where accommodation was scarce. Nevertheless, Sir Kenneth and Lady Jane Clark helped Jarvis find and furnish a flat in a converted Victorian barracks at 3A Sydney Close, a row of low brown brick buildings with classical porticoes that lie a stone's throw from the Victoria and Albert Museum. The

small studio, in which the bed rested on a platform above the bathroom, remained Jarvis' home until he returned to Canada in 1955. Living in an artist's studio prompted Jarvis to sculpt for the first time in years, and reignited his youthful artistic ambitions.[44] Not long after unpacking his modelling tools, he proposed doing the "head of a young Chinese boy or girl" that could be auctioned to help a charity run by Isobel Cripps, though with rather false modesty he declared to his family that "such a scheme might look as if I thought I was [Jacob] Epstein."[45] While this jokey comparison to one of the world's greatest sculptors was self-serving and facile, Jarvis was a competent artist and completed a bust of the official war historian Sir Keith Hancock that is now in the Institute of Commonwealth Studies. On the strength of this commission, he was asked in August 1944 by Sir Kenneth Clark to sculpt the heads of his three children.[46] This apparent benediction by Britain's greatest arbiter of taste ended with Jarvis feeling a sense of "defeat rather than of anger, bitter disappointment or frustration in spite of the illusion which I had allowed to grow up around the portrait and what might result from it" when Clark expressed his dislike of the bust of his youngest son.[47] Jarvis recorded his hurt privately, but remained friends with Clark, who was simply too powerful to alienate.

Another boon to living in London was that Jarvis could entertain friends from home like Carl Schaefer, who was a Canadian war artist, and Mary Greey, who had moved to England soon after graduating from the University of Toronto.[48] The reunions were generally convivial, like the one recalled by Kendrick Venables, an undergraduate friend who was serving in the Canadian navy. When his corvette docked in Bristol in the autumn of 1944, Venables met the Crippses, who inspected the ship. He recalled:

> Sir Stafford with his head in the asdic cabinet asking very, very searching questions of the operators and Lady Cripps opined that I was a Canadian and wanted to know what Canadians I knew and one of them I said was Alan who had been apparently a friend of theirs, who talked a great deal about them and this sparked a great light in her eyes, Sir Stafford was summoned from the asdic cabinet while we talked about Alan, um, and his weekend habits of coming down to stay with Hiram Winterbotham-Hague-Winterbotham … and all I said was that unfortunately I wasn't going to have time to get away from the ship during

the weekend, but that I hoped to be in London on the Monday and expected to see Alan at that time. Fine. At three o'clock that afternoon we got a signal from the local admiral saying that all the repairs and modifications to the ship that we had hoped for had been approved, having been disapproved the day before. This was tremendous as far as we were concerned. Unfortunately, I left the ship before the repairs were completed, but I do believe that my successor and his colleagues had a rather more comfortable berth until the war ended thanks to, perhaps, I really believe, thanks to the fact that I could talk warmly about Alan to Sir Stafford who obviously had a great regard for him and the sequel to the thing was that I did get to London on the Monday. I went round to a mutual friend's for drinks at the appointed time, Alan came in, as breezy as always, dropping names wherever he went and said I knew you were in town, I just had tea with Stafford and Isobel and they said you were in town.[49]

The anecdote demonstrates the way Isobel softened her husband's matter of fact approach to such events. Venables reached London to find Jarvis acting like the cock of the walk, and referring casually to his new protector and promoter as the "minister of treats and surprises."[50] While Venables was awed by Jarvis' prominence, not all such meetings were free of tension. John Devlin, the elder brother of Jarvis' adolescent love Betty, who flew spitfires – one of the most glamorous wartime jobs – bristled during a similar encounter at the way Jarvis made it clear that his civilian job was far more important than that of a fighter pilot.[51]

The set on which Jarvis staged much of this entertaining was the Churchill Club, an institution in the precincts of Westminster Abbey that had been founded by a group of political and social luminaries to foster understanding among English-speaking nations. Unlike many other such facilities, Canadian service personnel in London had to apply for membership, which entitled them to use the library and dining rooms and attend various lectures, concerts, films, and discussions on topical subjects. Jarvis revelled in the club's air of exclusivity as much as its affinity to adult education, and declared it "*the* place for finding boys from home these days."[52] The club was a genteel stage on which Jarvis flaunted his British connections to friends from Toronto. One of them recalled standing at the bar just after a debate about

music between the composers William Walton and Ralph Vaughan-Williams when "he [Jarvis] sort of slapped Walton on the back and said 'Willy I hear you were marvellous.' And Willy turned to him and said 'Oh, hello Alan.'"[53] By holding such reunions in the Club's relaxed and convivial atmosphere, Jarvis could show off a public persona that exuded effortless success, while concealing the relentless demands of working for Cripps.

Now that the IBCA had been tentatively endorsed by the government, it leased offices in Bloomsbury and hired a small staff that included Mary Nicholson, a novelist and industrial specialist who was married to one of PEP's founders. She launched a national marketing campaign that proclaimed "a discussion club gives its members an opportunity to compare experiences, to question slogans; it is an antidote to mental stagnation, it gives a chance to 'put your word in' to see if others think there is anything in a fresh idea."[54] The national office's role was to train discussion club organizers and equip them with facts, pamphlets, and other materials and identify local, regional, or national organizations that were interested in hearing the results of the discussions.[55]

Jarvis' role directing this national program led to an invitation to attend the Archbishop's Conference on Adult Education, which was held in Oxford in January 1944. He stayed at the university with Maurice Bowra, the socially connected don who was the prototype for Mr Samgrass in Evelyn Waugh's *Brideshead Revisited.* Among the other delegates to the conference were the economic historian George Cole, Sir William Beveridge, Burgon Bickersteth, and Balliol's master, Alexander Lindsay, all of whom headed important government social welfare initiatives that were focusing evermore concretely on preparing citizens for the peace. In private, Jarvis found the proceedings "depressing, serious, worthy and dehumanised," but nevertheless boasted to his parents that he had greatly impressed the other delegates.[56]

By March 1944, Cripps was very satisfied with the way the Bristol experiment had been retooled into a national program and declared to Jarvis "that there was a direct relationship between the liveliness of these groups and the general spirit of the factories with which they were associated, and it confirmed my belief in the value of your work. Both the IDCE and Parnall Aircraft are to be congratulated on this experimental work in a new field which is likely to produce important results both for industrial relations and for the general quality of responsible citizenship."[57] The following month,

Jarvis' Toronto friends got a glimpse of his war work thanks to a short article that appeared in *Magazine Digest*. Its British author had taken part in numerous IDCE discussions and concluded that the success of the program, which she praised Jarvis for creating, could be gauged by "the emergence of a new type of worker-leader; a leader matured by self-education and self-analysis and attuned to the thinking of the great mass of the people."[58] Jarvis was flattered to know that his parents had read this complimentary article, though he undercut any sense of his growing importance by reverting in a letter home to the childish "doesn't HB [the article's author] make Lambie Pie sound like a big shot, t'aint true."[59]

However comfortable Jarvis felt about reporting on these events, it was clear by mid-year that he was developing a national profile in adult education. This growing stature brought him to the attention of Alexander Lindsay, the Christian socialist master of Balliol College who helped run army education, created short residential courses at Oxford for allied service personnel, and produced the standard army current affairs text. More importantly, Lindsay administered the Nuffield Bequest, which had been established to bridge the gap between academia and wider society. During the war, Lindsay had funded a series of meetings at which influential social leaders discussed and directed the foundation's national investigation into the needs of the peace.[60] In August 1944, Jarvis and Christopher Martin received one of these coveted invitations. Their brief stay in Oxford took place amid a whirlwind round of lectures on industrial discussion that Jarvis was delivering to uniformed and civilian groups throughout England. At the conference's end, he headed to the Lake District and then to Scotland where he talked about Cripps' vision for post-war Britain, and on his return confessed wearily that "I'm getting so that I make speeches in my sleep." Such rest would have to wait, as Jarvis spent the last part of 1944 criss-crossing the country on Cripps' behalf, proselytizing about industrial discussion to various civilian and military groups.[61]

Discussing the IBCA at meetings and conferences was fun and easy for Jarvis, but industrialists remained suspicious about the program because they sensed that wartime labour conditions would disappear in the peace.[62] Therefore, much of Jarvis' efforts were focused on convincing factories to sponsor discussion groups. It looked briefly in the summer of 1944 as though International Chemical Industries, one of Britain's biggest corporations, would

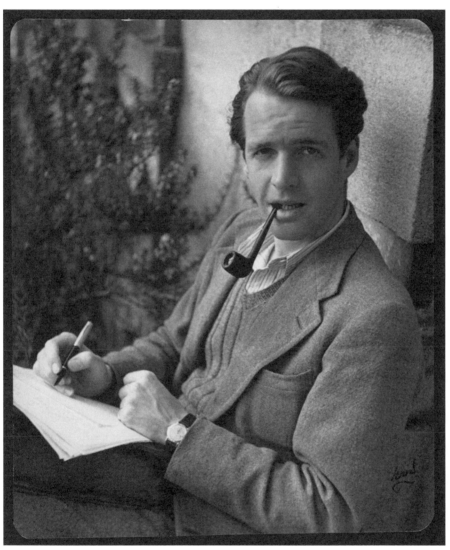

An important young man. Jarvis works
on plans to rebuild post-war Britain at
Woodchester, c. 1945. Alan Jarvis Collection,
University of Toronto.

host discussions in its plants, but negotiations broke down.[63] The IBCA was dealt a further blow at the start of 1945 when the Carnegie Trust rejected Jarvis' request for £100,000 with which to develop the program. Though the Carnegie Trustees were quite sympathetic to the aims of adult education, they decided to back a more well-established outfit.[64] Carnegie's refusal meant the IBCA lost a similar sum in government funds and was forced to effect a major retrenchment. And so, in April 1945, over a year after moving to London to develop the IBCA, a forlorn Jarvis once again turned to the Elmhirsts, who had financed the initial Bristol experiment. Their offer to test the new discussion program at Dartington hardly fulfilled Jarvis' expectations.[65] Just as the IBCA seemed doomed, at the start of May 1945 Jarvis left Parnall, technically still his employer, and abandoned the Dartington trial in order to accompany Cripps as "chauffeur-handyman" on a pre-election tour of the Midlands. Jarvis has been captured in this role in a photograph that was published in an early biography of Cripps.[66]

The IBCA was gone, but Jarvis soon had a new objective. Many of the people he had encountered in adult education, like the Cripps, saw socialism as a political manifestation of their Christianity. Working alongside them in an atmosphere that fostered debate and questioning reignited religious feelings that had been dormant since the death of his brother Colin, twelve years earlier. Hints that Jarvis had begun linking adult education with Christianity were apparent as early as September 1942 when he organized a prayer day at Parnall.[67] He then spent New Year's Eve 1943 reading the Bible that his mother had given him when he left for Oxford in 1938.[68] She had underlined Luke 12:48, which reads "for unto whomsoever much is given, of him shall be much required: and to whom men have committed much, of him they will ask the more," which Jarvis now interpreted as validating his desire to build an egalitarian post-war Britain.[69] Religion and adult education were fused completely by February 1944, when Jarvis worked directly for Cripps and thought about his own peacetime employment. Isobel Cripps, whom Jarvis described to his mother as "the only practising Christian I know beside you," recognized, fostered, and guided this growing spirituality.[70] Whether she had had a role in it or not, in early 1944 Jarvis announced to his parents that "I concentrate (I'm

afraid as usual) on a career and think more and more about the Church, (in which respect returning to Oxford for a divinity rather than a philosophy degree is the key)."[71] Such sentiments grew throughout the autumn as Jarvis and the Crippses met "Christian frontier people" in an attempt to map out "a big programme of religious education."[72]

The most important influence on Jarvis' inchoate Christian socialism was the charismatic Bristol slum priest Mervyn Stockwood, whom he met at the Crippses' country house during a November 1944 planning session. Their attraction was mutual, immediate, intellectual, and physical, causing the thirty-one-year-old cleric to confess, "I felt I had known you for ages. Of course that is a dangerous reaction, because I know myself so well in such circumstances!"[73] A commitment to adult education drew them together, but they soon realized that they shared the same playful sense of humour and had both lost their fathers in early childhood. Stockwood exuded confidence and passion and, like Jarvis' earlier father-brother substitutes, appeared to offer an entry into an attractive new world. Stockwood was not conventionally handsome, but his extrovert personality made him a caricature High Anglican cleric. He dressed well, loved food and wine, acted in pantomime, played the piano, danced the conga, and flashed an acid and irreverent tongue. He referred to the Church of England as the "Comedy of Errors," dubbed his female choir "The Stockwood Follies," and when informed late in life that a gay newspaper intended to "out" him, Stockwood, who was then a bishop, shot back with the decidedly unepiscopal "Tell them I've had a lot of women as well!"[74] Stockwood's theatrical personality also made him passionately attached to traditional Anglican vestments, liturgies, and rituals and the belief that "the Holy Communion was basically a passion play, a drama based on the birth, death and resurrection of Christ."[75]

Exhibitionism concealed Stockwood's deep faith and passion for social justice. He had been a Conservative and high-living Cambridge undergraduate before being radicalized by the hunger marches of the 1930s. On ordination in 1937, Stockwood was sent to one of Bristol's poorest areas, where the social and physical manifestations of poverty – unemployment, disease, and birth defects – were endemic. From his arrival, Stockwood explored adult education as a way of resolving these problems. He involved the locals in running the parish, put the children in charge of the Sunday School, turned the church into a weekday rehabilitation centre, and sponsored a youth centre

that was governed by a "parliament" of adolescents. Most radically, he held joint ecumenical services with the local Methodist minister and used his pulpit equally for sermonizing and for denouncing the shopkeepers he felt were gouging his parishioners.[76]

Daily experience of East Bristol poverty and the example of the local member of parliament, Sir Stafford Cripps, drew Stockwood into the Labour Party in 1938.[77] This political affiliation was quite unusual in the Church of England, which was often mocked as "the Conservative Party at prayer." On the heels of his political conversion, Stockwood began holding short Sunday evening "People's Services" at which hymns and Bible readings were followed by addresses from prominent left-wing figures such as Cripps, Stephen Spender, and the socialist politician Sir Richard Acland. Guest speakers covered "consideration of contemporary happenings" and the social implications of the Gospels alongside traditional topics like doctrine and prayer.[78]

Stockwood's identification with his parishioners deepened during the war when the vicarage was requisitioned, forcing him into two spartan, bug-ridden rooms above a shop.[79] This priest-hole was not his only lair; as an air raid warden, Stockwood spent many nights ministering to parishioners in underground shelters. His political views hardened in 1941 when he helped found the Society of Socialist Clergy and then explained his actions in the iconoclastic magazine *Horizon*. The article resulted in invitations to preach throughout the country and in 1942 Stockwood was part of a group who quit Labour to join Acland's socialist Commonwealth Party.

Stockwood was never tempted to leave the Church of England, because it seemed poised to champion social causes through adult education. The Church's head, the Archbishop of Canterbury William Temple, had been appointed in 1942, the year that his book *Christianity and the Social Order* had sold well over 100,000 copies. In this work, Temple explained the gentle socialism that Labour intended to implement after the war and proved that he was a natural ally for Cripps and Stockwood. But those who embraced the message and looked to the Church for leadership were shocked by Temple's sudden death in October 1944. He was succeeded by the staid, conservative Geoffrey Fisher.[80] Fears of losing the leftward momentum within the Church caused Cripps to convene the fall 1944 meetings at which Jarvis first encountered Stockwood.

Cripps' initiative also reflected an increased British focus on post-war reconstruction, because by the middle of 1944, victory, if not yet assured, was very probable. The Allies landed in Normandy at the start of June, were on the Champs-Élysées at the end of August and soon after entered Greece, Czechoslovakia, and Germany itself. These symbolic territorial gains were offset by an arduous and bloody European campaign that lasted the winter. Meanwhile, the Pacific war swung towards the Allies; General MacArthur made good his famous promise and returned to the Philippines in mid-October 1944, and the Japanese mainland was bombed late the following spring.

General optimism was greater still for Jarvis as he foresaw that adult education would play a prominent role in the post-war world. Similar sentiments directed the evolution of his father-brother relationship with Stockwood. Jarvis made his first definitive political gesture by joining Labour in June 1944, just as Stockwood and Cripps were reconciling with the party.[81] While this personal political statement earned the respect of British friends, Jarvis hid it from his family for almost a year, before announcing it with a defensive "I belong to the Labour Party not only because of Stafford but because I am convinced it is *the* party which is in the interest of the common men and women and I've seen too much of the Tories during the past three years to trust them at all."[82] The decision was a fairly natural outcome of Jarvis' war work, but his February 1945 declaration that he intended to become an Anglican "worker priest" who tackled social issues, rather than pastoral duties, took Stockwood by surprise. The honesty of Stockwood's response to Jarvis demonstrated his strong faith and the points at which friendship and pastoral responsibilities intersected. He began by stating "I always pour cold water on the suggestion of ordination because if a man can be put off the priesthood he ought to be," before addressing Jarvis' specific points. Jarvis worried that he was attracted to the cloth because of "egoistic impulses." Stockwood replied "if you were to be ordained, it is quite likely that you might have a brilliant ecclesiastical career, crowned perhaps by a mitre; but supposing God decided that you should spend your years in obscurity, and apparent failure … that is the test," because a priest should ask for "no privilege other than that I may be like the donkey who carried his master on his back to Jerusalem." Stockwood was more suspicious about Jarvis' vision of a career as a worker priest – a type of clergyman that did not yet exist in the Anglican

Church – with "the field of human relations as my parish."[83] Such responsibilities might allow Jarvis to complete the managerial and educational work he had begun at Parnall, and though Stockwood shared this sentiment, he explained the fundamental facts of a clerical career to his friend:

> my real work is done here in Bristol with a comparatively small number of people, trying to understand them, talking over their problems, guiding them, standing by them in their failures, encouraging them in their disappointments, picking them up when they are knocked down – and praying for them as I stand at the altar. It's easy enough to flit from place to place dealing with personal problems in a general sort of way, but it is not very permanent. The real work begins when you settle down in one place and try to get to know your people and to love them as *persons*. Even in one's parish, it is the armchair in the study rather than the pulpit in church which constitutes the priest's operating theatre.

Having revealed the depth of his faith, Stockwood ended with the self-deprecating statement "What a pious letter I have written. I had better post it straightaway otherwise I shall be so ashamed of it that it will never reach you."[84]

This long, honest epistle became the basis for a theological correspondence that the two men exchanged throughout the spring to prepare Jarvis for confirmation. They explored the meaning of conversion, and whether facing "temptations and corruptions" strengthened a person's faith.[85] Stockwood's inclusive, if uncommon belief that there is "not one road but many" to Christ assuaged Jarvis' feelings, which stemmed almost certainly from his childhood, sexuality, and English experiences, that Protestantism was "life denying" and "represented darkness and inflexibility."[86] This instruction was carried out mostly by correspondence, but the two men also spent many spring weekends together. During a visit to Bristol, Jarvis tried on one of Stockwood's clerical collars, proving that his struggle with spirituality encompassed a very worldly and egoistic desire to see how he would "look" as a priest.[87] In this sense, Jarvis saw clerical vestments as a costume in which to play the role of a caring and nurturing educator. It would also be a kind of armour for his emotions, because social conventions prevent people from delving too deeply into a priest's personal feeling and inner life. Jarvis' actions also showed that

talking with Stockwood had made him question whether he had a clerical vocation. Stockwood was certain that Jarvis could offer something to the Church and so he drew him into parish life by having him deliver the sermon one Sunday in late April and run social events with the local youngsters, who, so Stockwood claimed, thought he was a "'bloody good bloke' OK for St M[atthew]'s – but perhaps not for the chapel! So you see they have got you tapped" as an adept worker priest, rather than a traditional religious figure.[88] Finally, Stockwood introduced Jarvis to one of his closest friends, Neville Gorton, the bishop of Coventry. The bishop, whose cathedral and diocese had been smashed by bombs, was extremely impressed by Jarvis' desire to fuse Christianity with social action. In March he offered a "very big job" to Jarvis, whom he felt could "not only raise money, but get local groups and organizations going everywhere, to plan something in the nature of a nuclei of Christian confidence and attack" that would help to rebuild his shattered city.[89] Jarvis discussed the position with Stockwood and Cripps, who both counselled him to decline a job that would tie him up for at least three years. He heeded their advice. By this point, the Cripps had other plans for Jarvis.[90]

Shortly before taking his first communion, in Stockwood's church, on 3 June 1945, Jarvis reassured his parents, who came from Presbyterian families and who were now stalwarts of the United Church, that his new-found religion did not betray their beliefs. He told them, "I always think of you and Pop most vividly in church. I always think very clearly of you folks in Howard Park [his parents' parish] and it seems very close. That's what one means by the church being a community I suppose. And I wanted you to know that I do go a lot now." He went on to explain his motivation:

> now that peace is nearly upon us I'm overwhelmed by a recognition of how much more is needed if it is all not to be a pitiful waste again – than merely fighting outward physical bother, we who are likely to survive *owe* so much and must *give* so much … My own feelings now are focused around the desire to serve God and one's fellow men in any way possible – and humbly. It's a tough fight to withstand the temptations of power and personal gain and you'd be willing to do anything – I hope I've reached that state. I've got over, I hope, any interest in personal glory (and it's a real temptation for I'm afraid your child is becoming quite well known in this country) and have now, not the faintest interest

in money or jobs as such. At the moment I feel the major duty is to help Stafford get into the position where he and Isobel can bring a Christian and wise influence to bear on British politics and international relations and then use the gift of speech and writing wherever possible. However if one cannot predict what will work out and if I were ordered to some African or Chinese mission I think I would go![91]

The letter closed with "Bless you, darling mother, and believe me that the *greatest* challenge I have to live up to is to be the son you want me to be and the one you *deserve*."[92] This single missive captured the strands of Jarvis' personality by weaving the attractions of high office, his continuing need to meet his family's expectations, and his genuine religious motivations. At the same time, the declaration concealed private thoughts, which he recorded in a roughly contemporary entry in his short-lived diary:

> An hour or two with Isobel [Cripps] is a great thing. Not only does one realise that the world is a big and important and busy place but a human one. Her sense of people is much stronger than her sense of political – if only Jane Clark could borrow a bit of it! … IC [Isobel Cripps] is meeting a terrific emotional need in me, no doubt, and it is of course unfair that she should have it and that it should be denied to Janet [Jarvis' mother]. Yet where, and more important, what would I be if I had not so arranged life so that I am in contact with people like IC more often than with Janet: here is a good and timelier test of selfishness. How far is a vicarious life adequate for Janet and Edward [Jarvis' father]. Too little fulfillment for them: this is a price paid for my survival but why should they pay it?[93]

The fantasy in which Isobel was a mother-substitute was facilitated by the way that she and her husband took Jarvis into their home and treated him like a son, while the Crippses' children looked on him as "a member of the family" and "an extra brother."[94] His most recent memories of Toronto life were redolent with frustration and depression. Jarvis' relationship with the Crippses differed significantly from what he had experienced with the Murphys, because there was no sexual attraction or tension between he and Sir Stafford. Indeed, the welcome and support he found in this aristocratic home

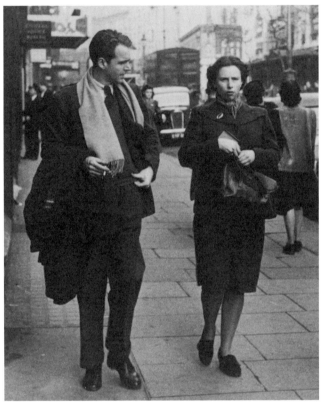

The end of the war. Jarvis and Peggy Cripps,
London, November 1945. Alan Jarvis
Collection, University of Toronto.

engendered more traditional feelings, as Jarvis considered proposing to the
Crippses' youngest daughter Peggy. Their union would have sealed Jarvis'
position in the British establishment, but he never carried through on the
impulse, fearing it would alter his relationship with her parents.[95]

Another significant reason that Jarvis preferred the Cripps to his own par-
ents was that their patronage did not restrict his sexual freedom. The Cripps
were aware of Jarvis' homosexuality and accepted it because they hoped to
found a world where people could be "honest" with one another.[96] Jarvis had

resumed his relationship with Hi on landing in England and it lasted for almost two years. But he chafed increasingly at Hi's unbending opinions and almost reclusive attachment to Woodchester. Stockwood and Jarvis became lovers at about this time, though neither saw the relationship as exclusive. In London, Jarvis joined a gay clique headed by yet another father-brother substitute, David Webster, the General Administrator of the Covent Garden Opera. Gay men had to be circumspect, so Webster's circle employed a series of codes in public that would not have required Bletchley Park's resources to decipher. When members were introduced to a good-looking young man, they would ask, "Is he a friend of Mrs King?" The possible answers ranged from a curt "No!" to "He says he is dying to meet her," "He used to know her before he married," and the rather obvious "They see each other only in Marrakech."[97] In this discreet circle, Jarvis drifted casually through many lovers. He was no longer interested in trying to investigate or "cure" his sexual orientation as he had been in 1939. Instead, he matter-of-factly recorded a dream "of considerable vividness with realistic fellatio, element of seduction of young, yet well equipped boy" in the diary that he kept at war's end.[98]

One cost of a relatively open and easy gay life were the lies this only child, who was nearing thirty, was forced to tell his parents in order to explain why he had not yet married. Jarvis was attracted to both sexes. He had dated Fanny Myers in New York City and Peggy Cripps more recently. Gerald Murphy was an example of a married bisexual man and Jarvis could certainly have found a wife who was willing to accept his sexuality. However, since returning to England, Jarvis had lived an almost completely gay life. He could not share this with his parents and so he told them about the women he knew, like an unnamed earl's daughter, for whose hand he claimed that he and Hi intended to fight a duel. Such romanticized claptrap, and references to women like Peggy Cripps to whom he was genuinely attracted, continued to conceal Jarvis' lifestyle from his parents.

But there was something fundamentally different about his feelings for Fanny Myers. They had been very close during Jarvis' year in New York and had corresponded throughout the war. He showed her brother Dicky, who was serving with the Royal Air Force, around London and her parents sent him care packages.[99] Though Jarvis and Myers had never talked seriously about marriage, he was very upset when she became engaged to someone else

in early 1944. A couple of fraught letters he wrote her show how he had hoped that they might somehow recapture their time in New York.[100] The sentiments mixed the anger and sadness that marks the end of a romantic relationship, with Jarvis' increasing thoughts about how to resume his pre-war life and career. While he explained his feelings honestly to Myers, and their friendship lasted until the end of his life, he masked his disappointment from his parents with a glib "Isn't it terrible the way all my old girlfriends marry off. Guess I'd better take some time off from politics and look around! Still, I can't imagine any poor girl keeping up with me and liking it!"[101] The emotional bruise was more evident when he wrote to his mother two weeks later:

> I wouldn't have expected Fanny to wait for me: nor could I feel it was either sensible or fair to marry in haste and go away to England at a time when it was difficult for wives to follow (it is easier now of course). I must admit I did have some tall thinking to do just before I left New York. But, with the war at such an uncertain stage then – as it is even now – and not knowing what I would be wanting to do post-war I don't know even now, whether I will want to finish my doctorate at Oxford (where wives have a hell of a life and where extra money is needed). Even getting engaged seemed unfair at that stage so maybe baby missed the bus. Now I feel pretty grim about the situation … But, I do hope Fanny is feeling happy about things: certainly Tom is a very good match for her and maybe it will be for the best. Isn't it a crazy world? (A thought I've had often recently looking at people's possessions of a lifetime blown into the tree tops).[102]

Jarvis had once again concealed these feelings behind a "charming, light-hearted and agreeable" mask that April when he was best man for his Glenokawa friend Pat Fitzgerald.[103] In the run-up to the ceremony, Jarvis informed his mother, who knew the groom's family well, that he would "have to think up a new version of always the bridesmaid, never the bride for the speech."[104] The writing was as casual as Jarvis' earliest letters home, though the wedding photograph, in which he sports a signet ring and a chalk stripe suit, attests that his persona was now, as the groom had already noted, explicitly "British."[105]

Commitments to work were another convenient way for Jarvis to deflect his parent's questions about whether he intended to marry. In October 1944 he declared jauntily,

> Well I say it will be either marriage or the church for me by 30. And I don't know which! Somehow I can't escape the enormous feeling of gratitude or being spared the worst of this war and a great feeling that if one is spared that "socially useful work" (I'm not sure whether that means religion or politics or both) and no sparing of one's self is the only way to repay the debt. Therefore I work like a crazy thing (I hope pretty unselfishly) and seem no nearer to settling down than I ever was. However I do see ways in which I can be (and have been) useful to society, especially as a teacher, preacher and writer. I wish I could tell you a great deal more about all that I've learned in the last three years. But all that doesn't make Jinny [Jarvis' mother] a grandmother does it?[106]

The passage's levity masked significant soul-searching of the type one does when nearing a milestone birthday. Jarvis spent New Year's Eve 1945 at Sydney Close with Bob Borley, a gay friend from Dartington, "appropriately, discussing sex, ambition, personal influence." Further ideas were recorded by Jarvis at the start of a "notebook" of "works, articles, journals and thoughts" whose few dozen surviving loose leaf pages are filled with analyses of his sexuality, friendships, spirituality, and meditations about whether to return home at war's end. Jarvis confided his sense that a "Jarvis myth" had taken hold in England, while he had lost touch with Canada, the country that had shunned him in 1939.[107] Once again, he modified these private musings for his family in the last days of the war:

> Well dears this has been a hectic time and a searching one, for me, I've been seeing a lot of Stafford and Isobel Cripps and have decided – for a while at least – that my wagon is hitched to their star … that means vows of poverty and obedience for me – at least until after the general election and then we'll see who Stafford is and what's next. I shudder to think of the work ahead but then I'm personally convinced that it is a cause which is just and more Christian than any other and I'm delighted and flattered to be able to make a few gestures of help toward. I wish I

could tell you a lot more about it but the answer, in a nutshell, is that I'm working, after June, for the "Cripps General Staff" and not for Parnall. Nuff said.[108]

Jarvis' sense of purpose and the accepting gay world in which he moved boded well for the future, but one last break from his family's mores was not so happy. The long, hard, endless work that Jarvis had done to meet the demands of Parnall, the IDCE, and Cripps left him exhausted. It is hardly surprising then that he was drawn to the dazzling, if somewhat louche, social circles that revolved around Dartington, Sir Kenneth Clark, and David Webster. Cocktails and champagne were props for this new social life, but Stockwood, who was no mean tippler himself, witnessed a far from glamorous side to Jarvis' drinking. In March he reported rather jokingly about a conversation with a woman who asserted "that a person attending my parish hall used her garden and front door as a public urinal etc. I have just discovered that it happened last Friday week – the day *you* were staying here. So I intend to preserve the peace and to avoid local blame by expressing my apologies and stating that it is a good old trans-Atlantic custom!"[109] And even though, as he later joked that "not even Jarvis' greatest enemy would accuse him of the vice of Puritanism," Stockwood noted, ominously, that his friend was the only person he knew who could stomach a drink with breakfast.[110] The heavy drinking for which Jarvis had been noted in New York had not abated. If Stockwood hoped the story would act as a warning to Jarvis, it had no effect.

"To Build a New Kind of Society"
The Council of Industrial Design, 1945–1947

The general election of 26 July 1945, in which Labour trumped the Conservatives by more than 150 seats to win its first majority government, was one of the biggest political upsets in British history. Fighting in Europe had ended in early May and even though Japan's surrender was still three weeks away, voters looked to the peace as they marked their ballots. In doing so, they shunted the aristocratic war leader Winston Churchill aside in favour of a Labour Party that they believed would champion wholesale social reform. The new government's goal of establishing an equitable society was embodied in the title of its electoral platform "Let us Face the Future," which had been written largely by Jarvis' Industrial Discussion Clubs colleague Michael Young. This heady declaration promised to build a new Britain that venerated the sacrifices of individual men and women, who "deserve and must be assured a happier future than faced so many of them after the last war." It was couched in the language of the left: a new "Socialist Commonwealth of Great Britain" could be built by putting collective "national" and "community" ideals above the "sectional interests" of capitalists and war profiteers. These goals would be attained through social and economic planning of the type that Labour supporters had championed over the preceding decade; "analysis" of the current situation would underpin a "national plan" of public ownership and regulation of key industries.[1]

The Labour and Conservative leaders personified competing visions of Britain. In contrast to Churchill's corpulent swagger, everything about the incoming prime minister, the balding, pipe-smoking Clement Attlee, from his given name to his horn-rimmed spectacles and dark three-piece suits, suggested the upright stolidity of a suburban bank manager; a reassuring presence in an economically shattered country. Appearances aside, Attlee was no neophyte. He had led the Labour Party for a decade and spent much of the previous five years as deputy prime minister in Churchill's coalition. He now headed a capable and experienced ministry whose key members had held similarly important wartime posts. Chief among this group was Sir Stafford Cripps, whose Christian Marxism had been replaced by left-leaning economic liberalism that rested on the new religion of planning. This prepared Cripps ideally to be president of the Board of Trade, a ministry responsible for overseeing general economic welfare, regulating industry, and protecting consumers. While the presidency was not traditionally one of the most important ministerial posts, Cripps' profile and charisma made him the government's public face and a dominating force at the cabinet table. Colleagues and the general public assumed the job was a step on the way to 10 Downing Street.[2]

Attlee's government immediately set out on a sometimes messianic quest to fulfill its election promises, despite unmistakable evidence of Britain's weakness. The cities were scarred by bombs that had damaged or destroyed hundreds of thousands of homes, the merchant fleet was decimated, and many overseas investments had been sold to pay for the war. At home, basic foodstuffs and commodities continued to be rationed. Abroad, the Empire was disintegrating, with India, the "Jewel in the Crown," moving inexorably towards independence, and liberation movements springing up elsewhere. Traditional markets for British goods shrank along with the Empire's borders. More immediately, the domestic situation worsened significantly and unexpectedly two weeks after the fighting ended in the Pacific. On 2 September 1945, President Harry Truman cancelled the wartime Lend-Lease agreement through which American materiel had been provided to Britain on deferred payments. Calling in the loan threatened to cripple Britain's economy just as industries retooled for peacetime production. A surprised and desperate Attlee dispatched the economist John Maynard Keynes to Washington to negotiate a $3-billion loan, which only postponed Britain's economic reckoning until it came due in the summer of 1947.

The government did what it could to implement its goals within these restrictive parameters. It fell to Cripps to convince British financiers that the new cabinet was not filled with radical socialists intent on nationalizing wealth. In order to do so, he insisted on tying British expenditures to available resources so that the country stood on its own feet. By emphasizing the export of British goods, Cripps hoped to generate hard currency abroad, which could be reinvested at home.[3] At the same time, the government heeded its socialist ideals by nationalizing important industries like railways and coal, while Cripps spent much of the summer of 1947 in India trying to negotiate an agreement on independence.

Jarvis pledged himself to the Crippses in 1945 and became one of their favourite protegés. Wartime work had convinced Sir Stafford and Isobel that Jarvis had an innate "Canadian" ability to cut through British reticence.[4] The relationship was sealed on election night when the Crippses produced a huge pink cake to celebrate Jarvis' thirtieth birthday. They had got the date slightly wrong, but the gesture nonetheless showed that the Crippses were taking a very personal interest in this young man.[5] The Crippses knew that Jarvis' skill at managing projects made him an invaluable asset in the task of creating a new Britain, and so they looked for a position in which his talents could best be employed. In the meantime, he continued drawing a wage from Parnall, though he worked as Cripps' companion, with vaguely defined duties that ranged from chauffeuring to writing speeches, and delivering personal messages to political colleagues. The workload was punishing, as Cripps put in one twenty-hour day after another and drove his staff just as hard. But he was also an inveterate Whitehall intriguer with whom Jarvis loved gossiping over cups of tea or hot milk.[6] The new relationship confused Janet Bee who expected, quite reasonably, that like other Canadians, her son would return home now that the war was over. But Jarvis had already said he intended to stay, a wound he now rubbed raw by asking her to "approve of her [Isobel Cripps] as a step-mother while I am in England."[7] The request can hardly have consoled Janet, given her son's claim that work for the Crippses prevented him from visiting Toronto for the foreseeable future.[8]

The letter also demonstrates that by the summer of 1945 the Crippses were the dominant figures in Jarvis' life. Sir Stafford was a professional sponsor, while Isobel was an intimate confidante. They assumed these roles in part because the men with whom Jarvis had his most intense sexual and emotional relationships were rooted in the West Country and so he did not see

them often. At war's end, Hi returned to the family textile business and his gardens at Woodchester. He and Jarvis had spent long periods apart during the previous two years. On rare visits to London, Jarvis found Hi insufferably conceited and stubborn.[9] Physical separation eased the transition from love to friendship; Jarvis spent occasional amicable weekends at Woodchester in the coming years, and continued to see the house as a sort of refuge.

Mervyn Stockwood, with whom Jarvis had become ever more intimate during the war, was different. In spite of his increasing prominence within the Church and wider public, Stockwood was destined to remain in Bristol until 1955. All the same, as a member of the Crippses' inner circle, he saw Jarvis at political, social, and religious events. Physical passion was balanced by shared religious and political views, while they bridged the geographical separation through sexually playful letters. When Jarvis began working for Cripps, Stockwood advised him that "in the interests of legitimate and natural expression, you should greet your boss with a raw carrot in your hands and a smacking great kiss on the lips!! It would, of course, be a gorgeous picture and of tremendous electioneering value, but the lady might object."[10] Risqué confidences aside, this was a serious, busy time for both men and so they saw little of one another before sharing a cottage on Exmoor for a brief August break. When Japan surrendered in the middle of the holiday, the pair headed for Bristol, where they toured the parish throughout the night, joking, laughing, and dancing in the streets.[11]

In London, Jarvis continued moving in David Webster's gay circle. In the late spring of 1945, Webster introduced him to an architecture student from Liverpool with whom he soon became besotted. The two men spent time together in London and when they were apart they exchanged flirtatious love letters, photographs, and drawings of one another. Despite this obvious attraction and the foolhardy explicitness of their correspondence, which could have led to criminal proceedings, the relationship lasted a little less than one year. It failed in part because Jarvis shielded his emotions and refused to commit himself just as he had done with earlier lovers.[12] Nevertheless, casual romances and affairs with the men in Webster's circle were important because the long and unrelenting hours that Cripps and those close to him worked prevented Jarvis from developing other significant attachments.

The first place that the Crippses deployed Jarvis was in the Church of England, an institution they believed might help to bring about an egalitarian Britain. Jarvis had worked on social issues for the Archbishop of Canterbury

in the early part of 1945, after which he had been offered the job of building the community centre at Coventry Cathedral. Neither of these opportunities had led to full-time employment, so the Crippses steered their protégés Jarvis and Stockwood into a series of meetings over the summer that were chaired by a dynamic forty-year-old priest named Lewis John Collins. He had been a bibulous and high-living Cambridge student, teacher, and chaplain. Stockwood had been one of his students, and in this role had helped Collins realize that his vocation was for social action, not theology or conventional pastoral duties. Collins summarized Stockwood's influence on his life by saying "if ever a master owed more to his pupil than the pupil to his master, I was that man." They drifted into the Labour Party together in the 1930s and Collins often visited Stockwood in Bristol, where he was impressed by the way his former student challenged parishioners to become politically active.[13] Collins was equally impressed by Cripps' vision of an equitable post-war Britain.

Seeing the misery of the shattered army and plummeting morale in the wake of the Dunkirk evacuation, Collins enlisted as a chaplain in the Royal Air Force. He was posted to a base in the west of England, where he was given the responsibility of leading mandatory discussions of current affairs. As a Christian, he was distressed at the number of communists he encountered in uniform, and so he founded a religious group in camp that followed a quasi-monastic rule. Members addressed one another by their given names – a radical informality in 1940s Britain – prepared communal breakfasts on Sundays, and discussed the social implications of the gospels. Over a period of several months, guests like Cripps, Sir William Beveridge, Foreign Secretary Anthony Eden, and Clement Attlee spoke at the camp and explained that the war was being fought for a better and more just British society, as much as against Nazism.[14]

This wartime work showed the Crippses that Collins was a formidable social force and in the spring of 1945 they introduced him to Jarvis. In July, with Sir Stafford Cripps' blessing, Stockwood and Collins began planning a conference of clerics and lay people that would discuss how to reform the Church of England along the class-levelling, socially involved principals that all three men had championed during the war.[15] It was hoped that such a national body would sustain the momentum that the late Archbishop William Temple had created in reorienting the Church toward a social, scriptural, and

missionary public dialogue. Though Stockwood and Collins inspired the Crippses to set up the committee, it was chaired by the bishop of Chichester, George Bell. Bell's episcopacy gave him significant influence within the Church, while his opposition to Nazism made him "the outstanding English Christian of the Second World War" and earned him significant moral authority.[16] Several other left-wing clerics were asked to take part, as were prominent political voices like Sir Richard Acland, who had founded the socialist Commonwealth Party, and the philanthropist Lord Hambleden. Jarvis, who had only been baptized into the Anglican Church a few weeks before, was appointed for his interest in social change. Peggy Cripps was considered as a representative of youth and the Oxford English don C.S. Lewis as a public figure, though in the end neither took part.[17]

This core group believed deeply that the Church had to be reformed in order to morally regenerate Britain. Their summer meetings resulted in a six-point manifesto that September that mingled the theological stridency of would-be Luthers, the political expectations of post-war Britain, and Comintern tactics.[18] The declaration read:

1. The function of the Church is to be the Church. i.e. God's instrument for establishing his kingly rule.
2. Our main task is to increase the number of Christians
3. Reformation outside the Church Building
 (a) Cells in industry
 (b) A non-parochial priesthood
 (c) An active participation in politics
 (d) A church newspaper
4. Reformation inside the Church Building
 (a) A new type of clergy
 (b) Revision of ordination training
 (c) A drastic overhaul of the services, with the exception of the Holy Communion
 (d) A considerable increase in the number of services for the young instructed
5. The need for cooperation with other denominations
6. The need for a spiritual challenge.[19]

The group followed up a month later with a first statement of intentions, declaring that the Church was marginal in the modern world, but could be revitalized by establishing "virile Christian communities or 'cells' wherever Christians are to be found, not only in the churches but also in the homes, the factories, the places of leisure," whose theological training would be directed at discussing and refuting the claims of science and Marxism. In practical terms, a new order of worker priests in these cells would groom people to serve on local and national elected bodies, and as officers in professional associations and trade unions.[20] Such practical, pastoral social work echoed almost exactly what Jarvis had, only a few months earlier, told Stockwood he aspired to do.

Discussions about implementing these grand schemes carried on throughout the autumn, though by January 1946 it was clear that the massive public rally at the Albert Hall, with which the committee hoped to launch the new crusade, would never take place. Having so easily elucidated their basic tenets, the group had foundered over a combination of Acland's insistence that capitalism be denounced explicitly as "evil," cold feet on the part of several ecclesiastical members, and a growing sense that their ideas were a patronizing "attempt to work from the top downwards, to gather together the few who had already achieved at least some distinction in their own professions to work out a blue-print for the unqualified many."[21] The committee had failed to agree politically and spiritually, and on the question of inclusiveness and equality.

Unless one is a priest or teaches in a seminary, theological reformation rarely constitutes full-time employment. Luckily for Jarvis, the Crippses found a more substantive position for him during the initial meetings of Collins' committee. This was in the important, emerging field of industrial design. As early as January 1943, the British government had begun investigating ways of capturing the inventive spirit in which the country's scientists and manufacturers had met the war's technical challenges. These men and women had created synthetic materials and developed manufacturing processes that now had to be adapted for the production of consumer goods. The government understood that this type of planning was necessary to ensure that Britain emerged from the war in a competitive position with the United States, where the production of civilian goods had continued almost unabated since 1939.[22] Manufacturers had similar concerns about the transition to peacetime pro-

duction and in 1944 the Federation of British Industry argued that the government should establish a central agency mandated to encourage new and innovative designs in individual industries. They suggested that such work could best be achieved through the establishment of government-funded design centres, and it was on this model that the Council of Industrial Design was established by the Board of Trade in late 1944.[23]

The Council was composed of government-appointed intellectual, aesthetic, and industrial experts. They were drawn from a fairly narrow group of men and women with similar cultural and intellectual beliefs. As a body, they possessed a Henry Higgins–worthy desire to educate the public with their rarefied aesthetic tastes. This, they hoped, would divert the working classes from their traditional Eliza Doolittle–like fascination with maudlin sentimentality, cheap ornamentation, and outrageous colours. Arbiters of taste like Sir Kenneth Clark and the book designer Sir Francis Meynell sat alongside industrialists like the furniture maker Gordon Russell and Josiah Wedgwood, who ran the family ceramics business. Sir Thomas Barlow, a Yorkshire woollen magnate with strong Labour ties chaired the Council, while the staff was headed by Clement "Clem" Leslie, a middle-aged Australian Rhodes Scholar with a doctorate in philosophy. He had forsaken an academic career before the war for a post in private industry, and was now a fast-rising civil servant. He knew little about design or aesthetics, causing Barlow to worry that it might be disastrous if "he were to turn out to have bad taste."[24] Leslie had, however, demonstrated his administrative talents during the war and was now a protegé of the Home Secretary Herbert Morrison, one of Cripps' main rivals within the Labour party.

At its first meeting, the Council adopted a two-pronged strategy of proving to industry that good design was essential to make British manufactures competitive overseas, and for creating a home market for these products by teaching consumers how to recognize well-made objects.[25] The Council's mandate to educate public taste was controversial and prompted questions in Parliament about the government's intentions. This criticism forced the body to act circumspectly because the future relationship between the government and industry was likely to be a hotly contested election issue. Moreover, as Council members perceived, their urban, educated, aesthetic views might not be appreciated by manufacturers or consumers in less cosmopolitan areas.[26]

Cripps inherited responsibility for the Council when he became president

of the Board of Trade in the summer of 1945. He had never been noted for his attachment to material things, but the Council's idealistic desire to ameliorate everyday life through the provision of better consumer goods appealed to his left-wing sensibilities. Moreover, Cripps knew that Jarvis was the perfect personal representative for this initiative. No sooner had the election been won, than the two men discussed the possibility of Jarvis' joining the Council. In exchange for a promise to remain for at least two years, in August Cripps recommended his protegé to the Council's director.[27] Jarvis was an attractive addition to the staff, given that his unquestioned aesthetic sensibilities were now, thanks to the war, backed by significant managerial experience. Additionally, his work with discussion clubs might be valuable for a program whose very nature skirted accusations of elitism and condescension.

Fixing his sights on the Council was the first step towards a post-war career for Jarvis, who had left Parnall Aircraft permanently on 30 June. Over the summer, he worked variously on the church reformation committee, and the languishing bureau of current affairs, about which he continued speaking to groups around the country. He was also active in Political and Economic Planning, the body that had been established at Dartington in the 1930s.[28] In his spare time, he edited a small collection of Cripps' speeches, which was published in 1946 by his Dartington friend Jimmy Knapp-Fisher.[29] The diversity of Jarvis' undertakings during these months was reminiscent of the way he had applied himself to many things simultaneously while at the University of Toronto and at Oxford. These successes convinced Jarvis that he could turn his hand to almost any endeavour. But he fundamentally lacked the discipline and dedication needed to work at and perfect any single activity. This became a significant problem in later life.

Nevertheless, the Council appealed to Jarvis because it drew together the egalitarian impulses that underlay his wartime endeavours, and seemed like an agreeable place to work. Jarvis was already on friendly terms with several of its members, and Leslie, who had jokingly replied to the Council's request for personal information at the time of his appointment, "My hobbies are nobody's business and my habits unspeakable," was a sympathetic personality.[30] However well they got on personally, Jarvis and Leslie were the protegés of competing Labour grandees. Once installed in the Council's offices at Tilbury House, Jarvis sensed it was shrewd to downplay his connections to

Cripps for whom he nonetheless knew he was "trouble shooting" in this new job.[31] Even so, he could not hide the relationship. Female co-workers, with whom Jarvis was exceedingly popular, kidded him about how often he took Peggy out or escorted Isobel Cripps to functions hosted by the prime minister and other equally eminent people.[32]

Jarvis joined the Council on 10 September 1945, at an annual salary of £750. He was one of three people charged with establishing design centres for various industries. The practical experiences of Jarvis' two more senior colleagues complemented his academic and theoretical training. Design centres were key elements in the government's efforts to retool industry for peace – by awarding prizes, scholarships and fellowships, encouraging good design and the development of new products – and to stimulate public interest through exhibitions.[33] Jarvis was responsible for setting up centres for the printing, leather, and jewellery industries.[34] The work was very often frustrating, because many manufacturers mistrusted the Council's elite, metropolitan bias, but during 1945 the staff grew from about 10 to 100 people as the government set about achieving its design goals.[35]

Educating industry and the public through design centres and cadres of informed discussion leaders would only happen gradually and by using time-honoured techniques like fairs and exhibitions. Therefore, cabinet had begun discussing a major post-war industrial exhibition in 1942.[36] Ministers felt such a public assertion of confidence in British industry, which had traditionally been small, undercapitalized, scattered, and lacking in advertising and sales expertise, would be a major counter to the global industrial hegemony that America had secured during the war. The importance that the government attached to this long-expected exhibition made it the Council's priority during its first year. As planning advanced over those twelve months, the show's target audience switched from producers to consumers. As a result, exhibits would have to emphasize wartime design innovations to demonstrate to domestic and foreign consumers that British industry was strong and focused on modern design.[37]

It was not clear that such an ambitious exhibition could be prepared on short notice. At least two Council members feared there would not be enough goods to display and lobbied instead for an historical overview of British design.[38] Cripps disregarded their objections and approved the show officially

in late August 1945 on the explicit instructions that it was to feature manufactured goods and not "precious" or handmade items that would be too costly for most consumers.[39] The machines and manufacturing processes that created these new goods were to be featured at a second exhibition in 1947.

The still-unnamed show was announced publicly at the start of October 1945, less than a month after Jarvis joined the Council. It would be, so the government claimed, a way of demonstrating the "vigour, freshness, originality and skill with which our manufacturers are setting about their tasks of serving the home consumer and capturing a great share of the export trade."[40] These stirring words, coupled with Cripps' earlier injunction to display democratic goods, shaped subsequent thinking about the exhibition. The Council debated whether it should rely on the advice of a "snob committee" to select items, before deciding that it would be dangerous to ignore experts in design, education, and industry. The final panel, announced in late spring, was a hybrid of aesthetes and educationalists, including Jarvis' wartime discussion group collaborator, Bill Williams, Barnett Freedman, an artist who had sketched at Parnall, and the ubiquitous Sir Kenneth Clark.[41]

In late October, the Council debated more than thirty blatantly patriotic possible names, including the stirring "Power for Peace," "British Made," "The Lion on the Label," "Britain Creates," and "Design for Reconstruction" before settling on the succinctly confident "Britain Can Make It."[42] Having chosen a title that declared that the nation itself, as well as her manufacturers, could emerge from the war, the Council chose the Victoria and Albert Museum, whose contents had been moved out of London in the early days of the fighting, as the venue. From then until the spring of 1946, Council staff worked out the means by which items would be selected for the exhibition. Trade papers in many industries were approached in an effort to get their readers to participate in the exhibition. Some members wanted to include only the best designs, while it was eventually decided that all manufacturers would be allowed to submit designs to local panels, which would send the best ones on to London for the final vote. The exhaustive list of items and commodities they had to consider ranged from binoculars, baby carriages, carpets, and cutlery to pottery, packaging, wallpaper, and watches.[43]

Planning the exhibition was very taxing, but it was not the only Cripps-sponsored program in which Jarvis was implicated. The resumé he had sub-

mitted to the Council had referred to work on what he called "Canadian Forces education and recreation." It was a considerable stretch for Jarvis to claim that he had done any important wartime work in Toronto. On the other hand, he had accomplished a great deal with the industrial discussion clubs, even if they had lost their way at war's end. The Crippses wanted to ensure that this was not lost, and so Jarvis spent a considerable amount of time collaborating with Bill Williams and the Carnegie Trust, developing a peacetime Bureau of Current Affairs. The Bureau was established in early 1946 when the Trust agreed to fund an organization led by Williams, with Jarvis as "Travelling Organiser" at an annual salary of £1,000.[44] Jarvis had helped to write the submissions that secured Carnegie financial support and considered abandoning the Council to work full-time in adult education. As he explained to his mother, one of the attractions of helping Williams was the possibility of obtaining a doctorate from Oxford on the basis of accumulated expertise and publications.[45] The post would have fulfilled many of Jarvis' aspirations for the wartime industrial discussion clubs, but he was indecisive, telling his parents that the Carnegie job would force him to settle in Britain, where he might become "a successful and untranslatable or untransplantable Englishman."[46] The statement was meant to mollify his parents, because Jarvis never considered himself "English" and was always ambivalent about settling in Britain.

A further incentive to leave the Council was the frustratingly prolonged, difficult, and inconclusive negotiations with industries over the establishment of design centres. Whether or not Clem Leslie was aware that Jarvis thought about leaving, he transferred increasing authority over the Council's public relations to Jarvis throughout the autumn and winter. Finally, in March 1946 Jarvis was promoted to head the Council's twenty-seven member publicity and propaganda section at a salary equivalent to the Carnegie offer. The promotion helped Jarvis make up his mind, because he felt he could not pass up this opportunity to manage the Council's education, press, radio, television, film, advertising, and publications. The job was very attractive because, as Jarvis explained, it was "completely new experimental educational work (with enough cash and staff to carry it out)" that drew on his adult education and wartime discussion clubs experiences.[47] Moreover, as an internal assessment of this post argued, propaganda's potential to inflame the at times contradictory aims of industry and design called for

sensitive political instincts.[48] Selecting Jarvis for the role was a testament to the esteem in which he was held at the Council, and set the course for the next fifteen years more concretely than anything he had yet done.

In the meantime, Jarvis' section developed plans for explaining the principles of design to both industry and consumers. The work had strong echoes of his earlier projects in that a "leadership group" drawn from professional societies and discussion groups was to be supported with pamphlets and other material, while the Council would reach out to a larger number of "uninterested" people by way of "the normal arts of publicity" such as films, broadcasts, and entertaining, practical publications.[49] Jarvis felt that his new responsibilities made him effectively the Council's deputy director and the head of its international relations, in which role he promised his mother to visit Canada, consoling her further by declaring that he would almost certainly be knighted before he turned thirty-five.[50] Whether or not he was heading for such an honour, Jarvis' staff appreciated his open and relaxed North American demeanour, the care he showed for others, and the gently iconoclastic sense of humour he displayed by such things as dictating speeches for Council chair Sir Thomas Barlow in the latter's flat, northern accent.[51] Jarvis' eventual successor recalled a generous and exceedingly good public speaker with an immense circle of friends.[52]

Jarvis developed an advertising and promotional campaign for *Britain Can Make It* based around posters that were displayed on the wooden fences surrounding London's many bomb sites, at railway and tube stations, and in cinemas.[53] He allied this with his mandate to oversee publications by working out a deal with Penguin Books in January 1946 to bring out eighteen titles on design, under the collective heading *The Things We See*. Jarvis was to edit the series. The discussions with Penguin rekindled an interest in writing that had lapsed on his return to England, and in March he agreed to produce the introductory volume, subtitled *Indoors and Out*, which aimed to raise readers' critical understanding of design. Subsequent titles discussed particular items like houses, furniture, pottery and glass, public transport, ships, and gardens.[54]

To some degree, *Inside and Out* realized Jarvis' aborted ambitions for *War and Western Art*. Though less weighty and erudite than what he had once envisioned, this sixty-two page book relied heavily on Lewis Mumford's ideas, while its dedication to "Janet, Edward and D.M.D. [Douglas Duncan]" was

identical to the one found on the earlier manuscript. Given that Jarvis now had virtually no contact with Duncan, this was a wistful acknowledgment of a lost era. In the book, Jarvis juxtaposed photographs of natural and man-made objects, slums and suburbs, grand vistas and intimate close-ups, to demonstrate that good design reflected an object's function. Architecturally, he explained that the aphorism "An Englishman's home is his castle" was not a licence to bedeck modest urban terraces with feudal ornamentation. In a nod to Labour policies, he stressed the need for national planning of roads, railways, and new towns. Finally, he mixed Mumford's and the Council's dictums to argue that if consumers refused to purchase goods that were not well-designed, they could force mass producers to create ones that ameliorated modern life. This last point was almost exactly the same as the one he had made on CBC radio in 1938. The book was promoted at the Council's public events and eventually sold more than 75,000 copies, thereby fulfilling John Alford and Gerald Murphy's long-ago predictions about Jarvis' talent for popularizing erudite concepts.[55]

Jarvis' next idea for a *Britain Can Make It* publication, tentatively entitled *Design in a New Democracy*, was intended to explore basic design concepts from the perspective of consumers and manufacturers, before culminating with a reverie on the "programme for the new democracy" in which Jarvis intended to mix an explanation of Labour's political and social goals with ideas about the "assimilation of the machine" that once again echoed Mumford.[56] A short proposal is all that exists of this idea; it appears that publishers had little interest in what may well have seemed like a reworking of Jarvis' existing book into a far from compelling political tract.

Other, less celebrated writing projects grew out of the Council. Throughout the spring and summer of 1946, Jarvis' section worked on a monthly compendium of news, reviews, and current events entitled *Design Digest*, which was first published to coincide with *Britain Can Make It*. The following April, Jarvis began writing a regular column on broadcasting for the short-lived magazine *Further Education*, which had been established to advocate for government involvement in adult education programs. Jarvis' four articles were rather banal discussions of radio plays: "no make-up artists can help the actor who is incapable of realizing character through voice alone"; the use of music in radio plays (a "need for experiment"); productions ("excellent material *is*

being broadcast"); and the "general policy of the BBC to raise public taste."[57] Jarvis' column was then dropped, although this "monthly review of planning and progress" lasted until 1951.

Broadcasting, in which Jarvis had dabbled since his undergraduate days, now re-emerged as a career path. Throughout the summer of 1946, he worked on a series of six twenty-minute BBC radio programs entitled *Design in Industry* that were to be broadcast during *Britain Can Make It*. These talks answered "the kind of questions the practical, though relatively ignorant, person asks" about design.[58] Their structure reflected Jarvis' book in that the general introduction entitled "Why Should We Know About Design?" was followed by various experts discussing furnishings, curtains, carpets, kitchens, pottery and glass, and decorating with colour. Jarvis had polished his presentation skills by giving a great number of similar speeches since his days with the Industrial Discussion Clubs.[59]

Amid this activity, in June 1946 Jarvis made his first trip home in over five years. He was stopping in New York City on the way, and so before leaving he wrote to Gerald Murphy, the "ideal father" and mentor with whom he had had a sexually-charged, but physically chaste relationship at the start of the war. Murphy, who had been hurt by Jarvis' decision to return to England, responded that he could not bear "the reopening of relationships (even after a three day absence) [because they] are more trying than termination, – commensurately with one's affection" and asked him not to visit. Jarvis defied this injunction by spending an afternoon at the Murphys' home with their daughter Honoria. Gerald Murphy returned in the early evening to hear a familiar though unexpected voice. He felt it would be too painful to enter the room, however, leaving Jarvis unaware of Murphy's presence until he received a touching letter sometime later: "You laughed and sounded well," Murphy wrote, "I was very glad of it," but an overriding desire to "protect the past from the present" had, Murphy explained, kept him away. "Life may one day allow of my being proven right. I hope so. It all seems to me so sad. Unutterably, I feel it."[60] The melancholic note showed that Murphy hid behind his own emotional shell, and provided a final coda to a relationship that had once been played with great *brio*.

Jarvis then headed to Toronto to stay with his parents. Their greatest shock on welcoming him home after half a decade of written contact was the pronounced accent with which he now spoke.[61] This was their first glimpse of

the public persona that Jarvis had adopted in England. Like so many people who change their elocution in adulthood, Jarvis' new accent was not flawless, though it was sufficiently "English" and affected to conceal his modest Canadian roots. British friends felt that Jarvis' speech reflected a privileged childhood, while many North Americans had quite negative reactions to the "phoney" way in which he now spoke. Janet and Ed knew that their son had become, in effect, part of the Cripps family. This was underlined by his British clothing, voice, and sensibilities. Though they did not understand their son's choices, they remained immensely proud of him and his achievements. During this business trip, Jarvis spoke about his work to the Canadian Manufacturers' Association in Toronto, and travelled to Ottawa where he discussed design issues with the federal minister of Trade and Commerce. This last meeting had been brokered by Donald Buchanan, an old acquaintance who felt that Jarvis might be an important ally in his own attempts to establish a design section at the National Gallery of Canada.[62]

On returning from this short trip, Jarvis plunged into the unrelenting final preparations for *Britain Can Make It*, excited by the knowledge that the show "really is going to make the reputations of some of the post-war generation."[63] The King and Queen opened the exhibition on 24 September 1946. It ran for fourteen weeks, during which almost one and half million people passed beneath the six enormous British flags that flanked the Victoria and Albert Museum's entrance. Nowadays, museums compete for blockbuster shows, so it is difficult to appreciate the exhibition's overwhelming sensory effect. Its chief designer was James Gardner, who had only just been released from camouflage duty in the military. He had obscured the walls and ceilings of every room with draped, gaily coloured fabrics. Within these fanciful billows were equally whimsical display cases that evoked cubist paintings, circus tents, and the fantasy architecture of MGM musicals. Unlike most British shops, the exhibition was strikingly bright, well laid-out and visually pleasing. Items were displayed in mocked-up rooms, cases, or suspended on wires from the ceiling. While each item was supposed to convey a precise message about design, functionality, and beauty, the Council did so without resorting to the overt propaganda to which the British had been subject during the war.[64] Instead, visitors were handed a set of tokens on entering the exhibition which they were invited to deposit in Quiz Banks placed at strategic points throughout the show. Pictures of several different designs were displayed at each of

these stations, and, in a nod to Jarvis' experience with participatory wartime discussion clubs, visitors were invited to actively indicate their preferences by inserting tokens in the slots underneath. Participants could similarly compare their views with those of professionals through a printed *Design Quiz*, which came complete with wall charts and photographs and was sold at a stall along with Jarvis' book, *The Things We See*.[65]

The British public, who had been deprived of many basic goods since the start of the war, and would have to endure five more years of rationing, embraced the show. In doing so they were taken on a thirty-room journey that started in a transitional "War to Peace" gallery, which explained how everything from newly developed materials like Perspex to large manufacturing plants were being adapted to produce consumer goods. The idea that wartime advances in design and manufacturing could be adapted to the peace was emphasized by the sleek, aerodynamic beauty of a spitfire fighter's tail section. When the Royal Air Force, which was actively trying to rid itself of surplus aircraft, delivered a working plane to the Museum, James Gardner simply cut off the part he needed and threw the rest on the local rubbish dump.[66] On leaving this introductory section, visitors passed through rooms displaying furnishings for modern offices and kitchens. Mockups of living rooms and bedrooms for houses in mining villages, the suburbs, and the cities were then presented. The popular poet of middle-class suburban life, John Betjeman, wrote the guide to this section, in which, with the help of the cartoonist Nicholas Bentley, he gently parodied the class and social differences of the types of families that might live in each room. Only after passing through this section did visitors enter the main exhibition, which celebrated bold and utilitarian fabrics, clothes, and furniture. Basic concepts were explained through a display by Misha Black, one of Britain's foremost designers. He had chosen to illustrate the design and manufacture of the simplest of household items, an egg cup. A speculative display of futuristic designs, such as had long been a staple at world's fairs, surrounded the exit. This included a double-decker railway sleeping car and not yet seen gems like an aerodynamic, folding, air-conditioned bed. To counter critics who called the show "Britain Can't Have It," every item on display was identified by manufacturer, where it was obtainable, and in cases where only prototypes existed, when a consumer version would be marketed.[67]

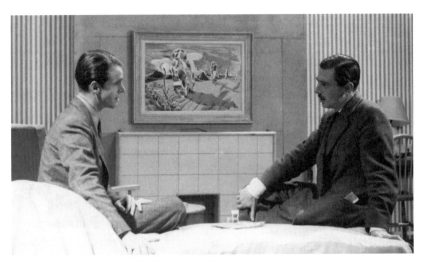

Jarvis takes part in a BBC television discussion
about interior design, 16 September 1947.
© Design Council Archive, Design Archives,
University of Brighton.

In an effort to measure the impact of *Britain Can Make It*, the Council
hired the pioneering sociological research group Mass Observation to com-
pare the opinions of people at the Victoria and Albert Museum with Lon-
doners at large. The fourteen investigators then compiled a report that
underlined some of the essential difficulties of moulding public taste. Chief
among these was that the audience was drawn from the same reasonably
educated portion of the population who were likely to visit museums. In
contrast, almost half of the unskilled workers polled declared that they had
no interest in the show. Of those who had actually toured the Victoria and
Albert's halls, most had been drawn to Shopwindow Street, in which such
long-rationed articles as shoes, hats, and nylons were displayed. Lusting after
hard to find basics hardly presaged a revolution in consumer tastes, but in a
more revelatory portent of the future, television was the single item that most
visitors wanted for their own homes.[68]

Britain Can Make It had dominated the Council's first year. It was, there-
fore, almost inevitable that the exhibition's end ignited debate about Council

activities and longer-term strategy. In this new atmosphere, already scheduled projects like the 1947 British Industries Fair and negotiations to set up design centres received increased attention. One important activity that had so far languished was film and television, through which the Council had hoped to reach consumers. A specific budget was allocated for such projects, although little was spent until the autumn of 1946, when film became the responsibility of Jarvis' public relations area.[69] The prospect was exciting for a life-long cinephile like Jarvis, who envisaged presenting "design as it affects ordinary people in their own homes."[70]

Two short films were produced under Jarvis' authority, with widely differing results. The first of these was made during the winter of 1946–47. It was written by the comedian Stephen Potter, whose book *Gamesmanship,* a guide to winning games through a liberal interpretation of the rules, was then an international success. Potter was a lecturer at the University of London and broadcaster who travelled in the city's literary and artistic circles, in which he befriended several people associated with the Council. The film's star was the popular comedian Joyce Grenfell, whose best friend was Jarvis' assistant at the Council.[71] Hiring this pair to create a film about design seemed like a good idea, given that they had recently written and starred in a very successful series of parodies of the era's highbrow, didactic broadcasting, with such titles as *How to Listen* and *How to Throw a Party*.[72] Potter's and Grenfell's mix of erudition and levity appealed very much to Jarvis' sense of humour, while he recognized that the stars' popularity was exactly what the Council needed.

Their project, entitled *Designing Women,* was a twenty-two-minute film that was made on a budget of £8,500. It opens with a newly married couple unpacking wedding gifts as they set up home for the first time. The boxes divulge a succession of gaudily ornate knick-knacks, but the couple disagree on which pieces are appropriate for their tiny flat. Their call for help is followed by a knock at the door, which they open to find a pair of toga-clad goddesses presenting visiting cards. Grenfell's reads "Miss Arty, assistant in helping you know what she likes," while the one offered by the beautiful starlet Audrey Fildes says "Miss Design, assistant in helping you know what you like." Once inside, this ethereal duo take turns decorating the flat, with the older, rather plain, and shrill Miss Arty filling it chock-a-block with an extravagant parody of high Victorian tassels, prints, frills, flounces, and cluttering bric-a-brac.

The effect is overwhelming and unsuited to a small mid–twentieth century apartment. Next, the attractive and elegant Miss Design magically reduces the number of pieces in order to demonstrate how to position objects rationally. She then chooses particular items to demonstrate simple rules. The suitability of one particularly unattractive gift is demolished by the question "Why should a heater look like a peacock?" The newlyweds respond to this gentle, participatory lesson with a rational conversation about the three basic tests that, according to Miss Design, any well-designed product should meet: "Does it work? Is it genuine and well made? and Is it attractive?"[73] They then decide to exchange any gifts that cannot withstand such scrutiny. A commercial distributor supplied *Designing Women* to British cinemas in early 1947, where it was incorporated into a longer bill. But audiences were not interested and the film failed to get "as wide theatrical showing as had been hoped" by the Council.[74]

The other notable Council film venture under Jarvis' scrutiny was less successful and far more controversial. In December 1946, Jarvis and Clem Leslie approached John Grierson and Basil Wright, two pioneers of the British documentary movement. The Council hoped that the partnership would promote British design abroad thanks to Grierson's ties to American distributors. The filmmakers were intrigued by the project and at the end of January Wright's company, International Realist Films, began developing a program of films about design for both theatrical and non-theatrical release that would target the public, housewives, adolescents, and children.[75] In early spring, International Realist submitted treatments for two films, which invoked the spirit of *Designing Women* by suggesting roles for the cadaverous Scots comedian Alistair Sim and the blimpish society cartoonist and clubman Osbert Lancaster.

Not surprisingly, the pairing was rejected, and over the spring International Realist and Jarvis worked on a succession of treatments, but he sensed that none presented "telling cinematic situations" centred on "human situations and stories." Instead, Jarvis feared that the scripts skirted dangerously close to "long doctrinaire harangues" about design of the sort that the Council was studiously avoiding.[76] He favoured a much simpler concept, suggesting that they film the "Birth of an Egg Cup," Misha Black's explanatory exhibit from *Britain Can Make It.*[77] The reservations were shared by Leslie, who nonetheless decided that it was more important to begin making films, even

if they proved to be failures, than to wait for the perfect scenario.[78] Mindful of this injunction, a shooting script that distilled scenes from several rejected treatments was approved in late summer and a budget of £14,729 was set aside. This sum, which was equivalent to about one tenth of the Council's total annual budget, necessitated a special dispensation from the Board of Trade.[79]

The opening scene of this thirty-minute film, which was given the ominous title *Deadly Lampshade*, takes place in the lighting department of a fashionable West End department store, where a woman is seeking a lamp as a birthday present for her husband. She tells the shop assistant, who has the clipped moustache and officious demeanour of a superannuated major, that she wants something simple. He dismisses this as a silly female notion of masculine taste, and shows her a desk lamp that is shaped like a Viking longboat. The bulb of this "Kosi-Glim" sits atop the mast, while the ship's prow doubles as that most necessary feature, a pipe rest. Owners of such an elaborate contraption, which would not have passed Miss Design's scrutiny, required a set of instructions to replace the bulb.

The introductory scene established the film's premise that there is a discrepancy between what consumers want, and what manufacturers and sellers tell them they should have. To drive home the point, the film cuts away to Kosi-Glim's midlands factory. Here the self-satisfied proprietors are preparing a companion for this immensely successful product. In a bow to feminine tastes, this is a Venetian "gondola lamp for the ladies' boudoir," whose body conceals a jewellery box, while the seats double as pin cushions. But not everyone is happy at the triumph of profits over beauty and utility. A young designer, who Jarvis insisted should not look like "a long-haired eccentric," tries to convince his bosses that a simple, modernist lamp is a far more honest design.[80]

The final scene, which takes place in a modern airliner, is a disjointed relic of an aborted earlier concept. Its underlying idea was that passenger planes were so new that viewers were unencumbered by a weight of tradition and familiarity when assessing their design. Moreover airplanes, like the spitfire from *Britain Can Make It*, were sleek and sexy modern icons. The scene is incongruous and added to the unfinished quality of the final product.

Deadly Lampshade was first shown to Council members privately at the start of February 1948. Several of them left the screening uneasy about the focus on bad design, which as sales of the Viking lamp showed, appeared to

mean good business. An internal Council report revealed that many employees had also failed to grasp the film's point. Hoping to clarify the situation, the Council ordered that the film be screened to a large test audience in Manchester at the end of June. Their reactions confirmed that *Deadly Lampshade*'s message was at best unclear and might even send audiences out looking for lamps shaped like Viking ships. The report touched off discussions with the filmmakers about editing a shorter, more focused version under the title *The Things We Buy: Table Lamps*. The work was never finished and the project was abandoned in mid-1949.[81] References to the film were rarely made thereafter, and despite the Council's order to destroy every print, a copy survives in the Design Archives at the University of Brighton.

Much of Jarvis' post-exhibition Council work took place amid rumours that Clem Leslie was leaving. These proved true when Leslie was recalled to the Home Office in May 1947. Jarvis worried that the loss of such a capable and pragmatic director would significantly affect the Council's funding and orientation. The two-year commitment that he had given the Crippses on joining the Council was also reaching its end and so he began discreetly looking for new options. He hinted to his parents about the unlikely idea that he might be appointed chair of the Royal Fine Arts Commission, or even succeed Leslie. It is hard to know how seriously Jarvis believed his many optimistic statements to friends and family, but the application for the Council's directorship that is found in his archives shows that he harboured some hope of leading the institution. Such a promotion might have secured the knighthood that he had promised his parents. Hopes had evaporated by the end of June when an annoyed Jarvis resigned from the Council, declaring, "I've burned that ill-paid bridge behind me." Jarvis' ire suggests that he had been passed over for the directorship. But, there was no dramatic rupture and he remained on staff until the end of September, during which time he was consulted about Leslie's replacement.[82]

Jarvis' final days at the Council were overshadowed by sadness. His colleague Jean Stewart assumed responsibility for *Deadly Lampshade* over the summer while Jarvis returned to Canada unexpectedly. Ed Bee had begun a series of heart tests in the autumn of 1946, and though his condition did not seem

grave, he died at the age of seventy on 3 July 1947.[83] Ed's death was so sudden that Jarvis only arrived home for the funeral. Janet Bee was widowed for the second time. Her only surviving child had just quit the job that had kept him in England since the war and was ambivalent about how long he wished to remain in that country. Jarvis spent several weeks at home, during which he spoke to the Rotary clubs in both Toronto and Brantford, explaining Labour's mission and his own work for Cripps.[84] While this was an opportune moment for him to move back, the Crippses had already begun grooming him to help lead Labour's next crusade. Film.

CHAPTER
EIGHT

"A Break in a Million"
Pilgrim Pictures, 1947–1950

From the autumn of 1946 until early the following year, Jarvis lived with Sir Stafford Cripps at Whitehall Court, an imposing, grey French Renaissance block of flats that overlooks the Thames. Jarvis had been asked by Isobel Cripps to act as Sir Stafford's confidante and companion while she and Peggy were on a prolonged humanitarian mission to China. Healthful considerations may have been part of Isobel's motive for suggesting the arrangement, because she knew that Jarvis would have to adopt Cripps' habit of getting to his desk before dawn to put in several hours work, followed by an ice cold bath, a brisk walk in St James's Park and then breakfast.[1] The ascetic, vegetarian regimen was good for Jarvis because, as Mervyn Stockwood saw, it forced him to cut back, even if only temporarily, on the drinking that had not abated with the end of the war.[2] It also gave the two men ample opportunity to discuss current events, and where Jarvis might now be most usefully employed.

Apart from this interruption, Jarvis' drinking was substantial because he continued moving in circles where heavy consumption of alcohol was common. He cemented his place as a dashing member of London society by joining the salon of Lady Sybil Colefax, who had befriended him during the war, and continuing to move in David Webster's artistic gay circle. Jarvis was also

a popular companion for his many female friends, whom he often escorted to serious plays, musical comedies, concerts, or dance clubs.³ As transatlantic travel became easier, he also played host to a number of old Toronto friends like Rik Kettle, Betty Devlin's parents and, most importantly, his mother. Other boyhood chums like Frank Starr, who had moved to London to launch a singing career, lived for long periods with Jarvis in the small Sydney Close studio. In his little spare time, he sculpted portraits of people in his social circle, remained a welcome guest at Woodchester, and made a point of spending religious holidays in Bristol with Stockwood.⁴

Otherwise, Jarvis' life was more peaceful, dedicated, and happy than the national situation might have warranted. The *Britain Can Make It* exhibition had been intended to demonstrate that British industry had survived the war and was retooling for peacetime production. Nevertheless, few in the crowds that had flocked to the Victoria and Albert Museum were blind to the country's precarious position. While Whitehall focused on replacing preferential imperial trade ties with bilateral agreements, globalization, as embodied by the General Agreement on Tariffs and Trade, was the emerging international economic model. The Agreement threatened Britain's privileged access to traditional markets and exacerbated the problem of generating hard currency with which to repay the $3-billion American loan that came due in August 1947.

Rebuilding the economy remained Labour's priority, and film was part of this strategy. Movies had been a contested cultural and economic arena ever since Hollywood began dominating world cinema at the end of the First World War. British critics feared cinema's Americanizing influence, particularly because audiences loved Hollywood's long, expensive, and entertaining films. The huge cinema chains controlled by the major American studios guaranteed that production costs were recovered at home. Significant profits were earned in overseas markets, of which Britain was the most important.⁵

Many of the Britain's most recognizable talents, from Charles Chaplin and Stan Laurel to Cecil Hardwicke and C. Aubrey Smith, lived in California because British studios turned out few high quality pictures. Instead, a myriad of small, undercapitalized companies produced low-budget films for home audiences. Their weak production values, incomprehensible accents, and parochial stories made the films virtually unmarketable in America. British

audiences also greatly preferred American movies, groups of which were booked into cinemas for months at a time.

The British government responded by passing the 1927 *Cinematograph Films Act*, one of the country's earliest pieces of protectionist legislation. The *Act*, which had to be renewed every ten years, imposed a minimum quota of domestic titles that rose over the first decade from 5 to 20 per cent of all films screened in British cinemas. Guaranteed access to the nation's screens attracted investors to Britain and a number of major companies were established in the late 1920s.

Though the *Act* was intended to protect domestic industry and safeguard national culture, it lowered the quality of British films, as producers churned out hundreds of forgettable "quota quickies" to meet cinemas' legal requirements. One notable exception was the Hungarian immigrant Alexander Korda, who produced lavish films with big stars. Even so, he had trouble finding American distributors until 1933 when *The Private Life of Henry VIII*, which promised a prurient look at one of history's most notorious figures, became wildly successful in America. Box office receipts for the New York opening set a world record and the film eventually made about five times its £100,000 cost. Though Korda's subsequent films fell short of this mark, he convinced some people that the industry should concentrate on expensive, British-themed pictures.

Just as Korda triumphed, the wealthy industrialist J. Arthur Rank founded the Religious Film Society to promote his Methodist beliefs through the movies. Rank's evangelical experiment soon awoke a more general desire to raise the quality of British films. Within a decade, he controlled over half the country's studio space, its largest supplier of cinema equipment, and some 600 movie houses. Rank intended this as a base from which to take on the American studios.[6]

These developments were set against the first renewal of the *Cinematograph Films Act*. In early 1937, a government study of the British industry called for the establishment of a national film office, a quality test for domestic studios, and restrictions on foreign investment. American producers, who had been shut out of the lucrative Italian and German markets, opposed these suggestions and pressured for greater access to British screens. Independent British producers balked at Rank's control over the domestic indus-

try. The war set the issue aside, until 1943, when a government commission began investigating "monopolistic tendencies in the British films industry," and reported a year later that the dominant British firms skewed the industry in favour of distributors and exhibitors at the expense of art and quality.[7]

Despite international and domestic pressures, the Second World War was a golden age of British film. Patriotic actors like David Niven and Leslie Howard returned from California to meet an emerging generation of filmmakers that included Peter Ustinov and David Lean. At the same time, audiences of blitz-weary citizens grew significantly until 1945, when about 30 million Britons went to the movies each week.[8] Many of the films they watched had baldly patriotic messages; none more so than *In Which We Serve*, Noël Coward's thinly disguised hagiography of Lord Louis Mountbatten. This was followed by Laurence Olivier's Technicolor *Henry V*, which included the king's Churchillian exhortation to his "band of brothers" on the eve of the battle of Agincourt, which served as a far from subtle call for Britons to remain steadfast against the Nazis.[9] The immense success of these two films in the United States seemed to confirm the idea that expensive, "quality" British films could triumph there.

Cinema was not among the industries targeted for nationalization in Labour's 1945 election manifesto, though the vocal young MPs Woodrow Wyatt and Michael Foot, whose wife was a filmmaker, decried Rank's monopoly and the Americanization it represented. The threat these industrial and cultural forces posed to Labour's most cherished shibboleths was magnified by the fact that the working classes attended the cinema in disproportionately large numbers.[10] Like other industries, cinema was overseen by the Board of Trade, and the young generation's demands became one of the most pressing issues facing Cripps when he took over the department in July 1945. The pressure led to his November 1945 "very preliminary decision" to establish a "Films Corporation" that would secure money from banks, insurance companies, and similar institutions to finance production and distribution of independent films, while a subsidiary body would "supervise and encourage all educational and documentary production."[11] The memorandum in which this idea was sketched out assumed that the films financed under the scheme would project traditional British values, a vision that underlay subsequent government plans for film.

Cripps' project foundered in 1946 on the twin horns of the Treasury's aver-

sion to guaranteeing long-term funding for films and a parliamentary agenda that was already packed with the nationalization program. On top of this, it was decided that any substantive changes would have to await the scheduled 1947 review of the *Films Act*. In the meantime, American studios saw that their access to the British market was threatened and began courting Labour leaders. At the start of 1947, Warner Brothers invited Foreign Secretary Ernest Bevin, Cripps, and other ministers to a London banquet at which the studio announced its intention of spending almost £2 million producing films in Britain, a budget that no domestic studio could match.[12] Hollywood's opening move was followed up in May when the biggest American industry lobby opened offices in London.[13]

The pressure was intense, though the government's actions reflected larger economic realities. At the end of June, the chancellor of the exchequer announced curbs on the import of what were considered to be semi-luxuries like petrol, newsprint, tobacco, and film. When repayments to the American loan began in August, the Treasury faced huge pressure and Cripps was forced to announce a wide-ranging "austerity" program that combined higher taxes with reduced domestic consumption in order to ensure that a large portion of British goods could be sold for hard currency in foreign markets.[14] Cripps, whose strict diet and moral rectitude had already made him the object of public bemusement, has forever been linked in the British imagination with this new government-imposed asceticism.

This economic retrenchment included a 75 per cent tax on all film revenues that came into effect in August 1947. The government hoped that the tax would force studios in America, where attendance had plummeted dramatically, to make concessions to protect their biggest export market. But cabinet had badly misjudged Hollywood, which immediately refused to send movies to Britain, lobbied the State Department to intervene officially, and hoped to pry open the international market by including films in the General Agreement on Tariffs and Trade.[15] Fairly high-level diplomatic meetings failed to rescind the duty that was just as unsuccessful domestically because British studios could not produce enough pictures to supply the country's screens. When Cripps was promoted to chancellor of the exchequer in November 1947, he no longer had the remit, or the time, to attend to the film industry, but as American negotiators knew, he retained a personal interest in this issue.[16]

This is the immediate background against which Jarvis became managing director of Pilgrim Pictures in October 1947. Pilgrim was a revolutionary production company headed by one of British cinema's most colourful characters, Fillipo Del Giudice. "Del," as he was always known, was a middle-aged Italian lawyer and anti-fascist refugee, who co-founded Two Cities Films just before the war. The company released a couple of moderately successful films before Del and his partner were interned in 1940 under the sweeping powers of the *Defence of the Realm Act.*

On Del's release a few months later, a mutual acquaintance introduced him to Noël Coward and they were soon collaborating on *In Which We Serve*, a film that earned huge American profits and an Academy Award.[17] Del then produced a hit for Leslie Howard, who joined the board of Two Cities. Back-to-back successes persuaded J. Arthur Rank to recruit Del, who insisted on retaining the right to sell his productions in the United States.[18] Now that he had access to the Rank organization's funding, Del gave Laurence Olivier a huge budget with which to make *Henry V*. But, when spending on the film got out of hand, Rank feared that its failure might endanger his empire, so he took direct control over Two Cities.[19] Such decisive action was justified, given that Del had spent huge amounts on African locations for one film, raced through £100,000 before abandoning another, and promised Winston Churchill four times that amount to secure the film rights to his *Life of Marlborough*.[20]

As these projects suggest, Del was an imperious and profligate mogul who might have come straight from a studio casting department. He was a portly man who favoured double breasted suits, oversized horn-rimmed spectacles, and smoked such enormous cigars that they would have made Churchill blush. Equally in keeping with that stereotype, he was an arrogant, fragile, and unctuous sybarite who surrounded himself with pretty starlets, while his unsure command of English lent a grandiloquent and comic air to his passionate, verbose, and self-flattering declarations about cinema.

His three residences were as overwhelming as his personality. First there was Sheepcote, an eight-bedroom Tudor house with a thirty-five seat cinema set in expansive grounds just outside London. He also had a flat in Grosvenor House on Park Lane, one of London's most fashionable addresses, and berthed a fifty-ton yacht on the Thames. It is hard to imagine the effect that the gourmet delicacies at Del's endless black market-supplied parties had on

his guests, many of whom had hoarded ration coupons and queued for basics since 1940. While Del's guests were adept at patching and darning threadbare clothes, his carpets were plush and his walls were lined with tapestries and exotic animal skins. There were also humidors stuffed with expensive cigars, huge bowls of fresh flowers, and even a machine that wafted exotic scents into every room.[21]

Del's wartime successes had convinced him that British cinema could only take on the Americans by making small numbers of large budget films. But rather than relying on the big chains for distribution, Del favoured showing films initially in only one or two urban cinemas for as long as a year, so as to generate publicity by word of mouth.[22] The idea contradicted the way Rank and the American studios released hundreds of copies of a single film simultaneously, drummed up interest through advertising, and turned a profit in a few weeks.

Equally novel was Del's feigned modesty in proclaiming himself a "butler," with the self-effacing duty of facilitating the work of the actors and directors he referred to as "talents."[23] These artists were not always credulous about Del's motives. While a grateful Laurence Olivier entrusted Del with one of the Academy Awards from *Henry V,* Peter Ustinov felt he was "a kind of Diaghilev of the English cinema."[24] This less than flattering comparison to the legendarily mercurial and spendthrift impresario of the Ballets Russe was echoed by the director David Lean, who was wary of someone he found to be "very smooth."[25]

Lean was right, because soon after Labour came to power in 1945 Del rather unexpectedly announced to an assistant, "I've always been a socialist deep down."[26] He then set about ingratiating himself with party leaders by feting them lavishly in London, on the Thames, and at Sheepcote in hope of being appointed to head a nationalized film industry. While the socialist documentary maker Jill Craigie felt that Del had no political opinions, he charmed Foreign Secretary Ernest Bevin, and Sir Stafford Cripps, whom he first met at the end of 1946 while Jarvis was living at Whitehall Court.[27] Del consummated his courtship during an early December visit to Sheepcote by Jarvis and Cripps. He expounded on the film industry's increasing economic importance, and underscored the message by screening portions of movies that vaunted his patriotic credentials and the fact that he was one of very few British movie makers who had succeeded in America.[28]

These meetings convinced Del that Jarvis was in effect Cripps' personal representative at the Council of Industrial Design. So he offered Jarvis a job with the independent film production company he was setting up, in hope of gaining Cripps' favour. Jarvis, who had just completed the Council film *Designing Women* and was now working on *Deadly Lampshade*, was immediately enthusiastic about an offer that seemed like the invitation to a fantasy world. Meanwhile, an ever more confident Del continued charming senior Labour officials by throwing a weekend-long birthday party for Isobel Cripps at Sheepcote the following January. He screened David Lean's epic *Great Expectations* and Charlie Chaplin's political satire *The Great Dictator*, a double bill whose patriotic and political messages found a sympathetic audience. As the campaign progressed, Del again offered a job to Jarvis, whose participation he realized was central to securing Cripps' support.[29]

Now that he had the government's ear, in April 1947 Del quit the Rank organization. Leaving Rank, who was at the top of his powers – having recently expanded into Canada, Australia, and South Africa – was courageous, if not foolhardy. Del's new venture, Pilgrim Pictures, was announced in June amid boasts that he had secured £100,000 in capital.[30] The company's name proclaimed Del's conviction that he was embarking on a mission to rescue British film. In case anyone missed this message, the firm's trade mark, which was shown at the start of all its films, was a shield on which was displayed a medieval pilgrim. Scrolled beneath this unworldly image was "Fillipo Del Giudice," who was identified with the self-effacing title of "administrator." The creed for this quest was Del's oft-repeated goal of "the divorce of production from the sales organisation," which was a shot across Rank's bow and a rallying cry for independent movie makers.[31]

Three interdependent branches of Pilgrim had to be put in place to realize Del's dream. In a nod to his new-found leftist ideals, a "Management Company" would be centred on a residential artistic community, described by Del as "a university of film art," and located in the decidedly unegalitarian surroundings of the Sheepcote estate. Here, a company of artists would live communally whilst working on a particular picture, but in small cottages, rather than the main house, which was to remain Del's lair.[32] Secondly, directors in the Pilgrim stable would develop scenarios and shooting scripts through individual production companies. Underpinning all this activity would be a finance corporation, which required £1 million in initial capital to

A pilgrimage to save British Film, (left to right)
Fillipo Del Giudice, Isobel Cripps, Sir Stafford
Cripps, Jarvis, c. 1947. Alan Jarvis Collection,
University of Toronto.

underwrite the four films that Del planned to make in 1948. Little else was
needed, because Del believed that the expensive, high quality films his
organization produced would sell themselves through word of mouth.[33] Apart
from the modest salaries that were to be paid to Del and other permanent
staff, profits would be reinvested in films, thereby ensuring Pilgrim's financial
self-sufficiency.

By rejecting the extravagance that traditionally accompanied film-making,
and insisting on tying the new organization's budget to its profits, Del at-
tempted to reflect Labour's fundamental economic beliefs. Equally appealing

to the government was Del's promise that the films made under his system would project innately British ideals and appeal, at least initially, to a select audience who had not been misled by what he dismissed as the "hysterical idolatry" for movie stars. However, Del predicted that as Pilgrim's films gained popularity and educated an ever greater share of the British population, they would elevate film into a national art.[34]

Del drew Jarvis into the film business gradually over the middle of 1947. As we have seen, Jarvis was increasingly frustrated at the Council of Industrial Design, for whom he still worked. When it became clear that he would not succeed its outgoing director, he decided to leave. Though Jarvis remained with the Council for several more months, at the end of June he secretly committed to joining Pilgrim. Shortly thereafter, a paragraph appeared in the leading film industry journal announcing that Del "had made what would be tritely but accurately known as a spectacular offer for a man who worked extremely closely with the present government, and has offered him the job of general manager of his London office," without ever mentioning Jarvis by name.[35] The announcement showed that Del saw Jarvis as his conduit to Whitehall.

While the new post's £1,500 salary was a hefty raise over Jarvis' Council pay, it was not quite as grandiose as the press release proclaimed. Nor was money the job's sole attraction, for as Jarvis admitted privately, he agreed wholeheartedly with Del that Britain needed films that influenced public taste and he believed moreover that "this may be the chance of a lifetime to combine creative work with earning some cash and doing some good all rolled into one."[36] Jarvis' seduction was completed at a series of dinners thrown by Del in the summer of 1947. Looking radiant in his dinner jacket, Jarvis reacquainted himself with Sir Laurence Olivier, Vivien Leigh, and William Walton, whom he had first met during the war. He was soon elected to the Savile Club, an exclusive Pall Mall gentlemen's establishment that had long been a gathering place for artists and literary types. In more casual moments, Jarvis lightened the drabness of post-war London by sunning himself on Del's yacht.[37] Alcohol was ever-present in this new professional and social milieu and Jarvis continued drinking heavily. A press profile intended to create an air of cosmopolitan sophistication for Jarvis did so by claiming that "a painting by Michael Stringer and a bottle of Gordon's gin [we]re almost the sole decoration of" his office in Pilgrim's Hanover Square headquarters.[38]

As cocktails and champagne became central to Jarvis' new career in the notoriously convivial world of film, he saw few people regularly who might urge temperance. Sir Stafford Cripps was working fiendishly to stave off national bankruptcy, while Isobel was immersed in charitable work and monitoring her husband's increasingly precarious health. Hi and Stockwood, who had been happy that Jarvis cut down his consumption while living with Cripps, were uncomfortable in the film world and only saw him during rare short breaks from Pilgrim. So, like the Crippses, they could not tell if he needed help.[39] Jarvis' alienation from the friends on whose support he had relied over the previous half decade was in turn very isolating. While the urbane, artistic world of film was seductive, Del was too volatile, egotistical, and capricious for Jarvis to look on him as a father-brother substitute. This meant that Jarvis also lacked the kind of close, authoritative mentoring that he had enjoyed since before the war. He believed passionately in Pilgrim's educative ideals and wanted to learn the movie trade, but he was always somewhat wary of Del. Ministers held similar feelings, which Cripps tried to assuage by planting Jarvis in the company with orders to curb Del's extravagances and ensure that Labour's film plans were achievable.[40]

Across the ocean, Jarvis' mother, who had just lost her second husband, was concerned about the abruptness with which Jarvis appeared to be abandoning adult education for the unstable artistic life she had always opposed. Janet understood from what Jarvis had told her on his trip to Toronto in 1947 that this new job would keep him in England at a time when she could reasonably have expected him to return home. After all, many of his contemporaries had long since begun careers in Canada. A couple of them had unintentionally emphasized Jarvis' absence, by boarding with Janet at Marmaduke Street. Even after returning to London, Jarvis reassured his mother that he had sound reasons for exchanging the Council's idealism and respectability for the film industry's haphazard life: "Pilgrim's affairs," he wrote her, "are so good by now that I just can't bear to hear you worrying. Del is being extremely kind and generous and says to everyone that he's training me to be his successor and that in 1950 he plans to leave me to run Pilgrim and go himself on a world cruise! Really, sweetie, I know you won't be convinced until you see the cash at the bank but you must take my word for it."[41] In other words, Jarvis claimed that he was finally embarking on the monetarily rewarding career that Janet and Ed had always hoped their children would follow.

Superficially, Jarvis' boast also echoed the optimistic comments he made on joining the Council of Industrial Design in 1945 – except that at war's end he had been focused on rebuilding British society, and now he called the 5,000 £1 shares in Pilgrim he had just been given a reward for "all the years of underpaid loyalty to Stafford's ideals."[42] The last frustrating months at the Council had left a slight cynical tinge to Jarvis' idealism. The declaration was also too blithely optimistic because finding stable funding was Pilgrim's greatest challenge. British banks had traditionally refused to invest in films, forcing big organizations to use real estate as collateral, but Del, whose ideas would have tied all his capital up in ongoing projects, could not offer such guarantees.[43] Enthralled as he was by Del's grand dreams, Cripps tried to ensure Pilgrim's financial and administrative stability until his hoped-for national film financing scheme was in place. He secured a seat on Pilgrim's board for Jack Keeling, an Eton-educated Labour supporter who had spent the war with the Ministry of Aircraft Production and now headed a Trust Company.

The appointment was Jarvis' cue to begin working on Cripps' film plan, although he was still nominally employed by the Council.[44] Throughout the summer and autumn of 1947 Jarvis, Keeling and Isobel Cripps asked a slew of Britain's most prominent business leaders and bankers to help float the company until the government could take over.[45] Their search became something of a crusade. In a July letter to Lord Hambleden, with whom Jarvis had worked on the 1945 Church of England committee, Isobel Cripps explained that she and her husband believed that Pilgrim's success was "of vital importance to the future of British films particularly in their industrial aspect."[46] Nevertheless, Hambleden turned them down, as did Dorothy and Leonard Elmhirst, who had worked closely with Jarvis and the Crippses on social projects since before the war.[47]

This reluctance partly reflected Rank's position as one of Britain's richest and most powerful men. Like Del, he had entered the movie business out of a desire to heighten public taste, and his company was now so dominant that challengers had to be cautious and discreet. Del was also his own worst enemy. Several otherwise sympathetic people who had been inclined to back him in return for pledges of absolute anonymity shied away because of his incessant bragging to the press about political connections.[48] Weeks of negotiations could be scuppered instantly by Del's ego, even though he blamed these untoward disclosures on his unnamed enemies.

Jarvis and Keeling were very soon frustrated. By mid-autumn they had yet to secure ongoing financing for Pilgrim, even though the company was already £25,000 in debt and needed substantially more cash to begin making pictures.[49] To Cripps and other senior Labour figures, these setbacks were to be expected in what they believed was a class struggle, and so they were not terribly worried. Instead, they promised to support Pilgrim once the government erected its funding infrastructure. Jarvis had a more intimate view of the movie world's lavish unreality than his political colleagues, and saw clearly how Del's outwardly egalitarian venture accumulated debts so quickly. On his first day, Del handed Jarvis the equivalent of a fortnight's Council wages to pay for a single business lunch, and the sumptuous black market meals he regularly enjoyed at the Park Lane flat meant that Janet Bee no longer needed to send her son the care packages that had supplemented his diet since 1942. Pilgrim's office was as overstuffed as Del's kitchens; the two men shared five secretaries and, having never received the car he had been promised repeatedly at the Council, Jarvis was chauffeured in an enormous Chrysler. Finally, after working flat out for five years, Jarvis now reported to a man who insisted that strenuous days be followed by lazy ones.[50]

Movie industry moguls had always flaunted their success through ostentatious living and Del was no exception. However, Jarvis could see that Del's lifestyle was out of step with Pilgrim's ideals, reflected his increasing ego, and scared off investors. Del's feud with Rank also imperilled the company. The fight began in the early summer when Del had tried to acquire his most valuable asset, the rights to the films he had made while working for Rank. With no cash at hand, Del offered Rank 65 per cent of all revenues generated by re-releasing the films. It is not surprising that Rank refused, given that he had financed the movies in the first place, owned hundreds of cinemas that were crying out for things to show, and had been publicly and incessantly derided by Del. The subsequent series of "long and unfriendly" letters from Del closed off any future cooperation between the two men.[51]

Their associates had to pick up the pieces. Jack Keeling intervened with senior members of Rank's staff in September 1947 in fear that the squabble might cause the government to withdraw its support for Pilgrim. He then asked Jarvis to make Del understand that his childishness was threatening the new company. Instead of heeding the cautions of this young ambassador, whom Keeling described as a "very intelligent and real friend," Del responded with

a melodramatic denunciation of the many anonymous "enemies" conspiring against him.[52] Thereafter, Del's outbursts and threats to accept equally unspecified "offers" to make films in other countries were a feature of working for Pilgrim.[53] Jarvis' unenviable duty was to mediate between Del, the government, and financial backers. Whenever criticized, Del's monomaniacal self-belief surfaced in such statements as "I do hope that Jarvis will tell you of the great moral impact my scribblings have produced on hundreds of the leading minds," which he believed should silence any questions about his methods.[54] While Jarvis had the onerous chore of translating Del's histrionics into lucid prose, Del grew increasingly convinced that he was being martyred for art, and harboured paranoid suspicions about the loyalties of close colleagues.

Despite sometimes being the focus of Del's illogical fears, Keeling and Jarvis worked throughout October putting together a corporate structure for Pilgrim that hinged on convincing an investor to put £500,000 into the company. With that secured, Jarvis and Keeling intended to offer seats on the board of directors to subsidiary investors. As was the practice at many British firms of the era, Keeling and Jarvis hoped to project an aura of stability by loading the board with Labour-friendly aristocrats. With their titles adorning the masthead, daily operations could be overseen by a management company headed by Del, with Jarvis as joint managing director, and Keeling and a clutch of artists like Sir Laurence Olivier and David Webster.[55] Though he had been working on Pilgrim since the summer, Jarvis only officially joined the firm when it came into being on 1 November 1947. By that time, he knew that his chief responsibility was "trying to modify or limit" Del's extravagances and self-congratulatory public statements in order to ensure that the company did not immediately sink.[56]

This was no small or placid task. However, within a few weeks of joining the company, Jarvis and Keeling believed they had found a backer, whose insistence on being referred to as "Mister X," showed that he had seen a detective film or two.[57] His cloak and dagger financial guarantee helped secure promises of a further million pounds, on the strength of which Del signed a contract with the directors John and Roy Boulting to begin shooting a film called *The Guinea Pig* in January 1948.[58] The project satirized Labour's attempts to break down class barriers through the fairly predictable story of

a tobacconist's son, played by Richard Attenborough, who earns a scholarship to an exclusive public school. He is bullied by the upper class students before finally earning their respect and romancing the headmaster's daughter. No sooner had the film been approved than Mister X had cold feet, and the other investors shied away. Pilgrim was in danger of collapse. So with the Cripps' blessing, Jarvis wrote a humbling personal letter to Dorothy Elmhirst explaining that "we [he, Keeling, and Del] have searched every street in the city and every avenue of private finance but completely without luck simply because of the poisoned atmosphere which now pervades the film world as a result of Arthur Rank's unfortunate and calamitous mis-management of the business," before unceremoniously begging her for an immediate donation.[59] Once again, she refused to help. Jarvis had leveraged an old friendship for Del, to no avail.

So Mister X remained Pilgrim's main investor. He was Bill Riley, a left-leaning Christian who owned a Birmingham glass factory and was a close friend of both Stockwood and the Crippses. Riley was convinced that Britain was "fighting a war more insidious than the 1918 or the Hitler war – a war of economy" and agreed to become Pilgrim's chairman in December 1947.[60] He believed it was a patriotic duty to support the nation's film industry, and as such he offered £30,000 that he had set aside for factory repairs to guarantee a loan of £150,000. The money was nothing like what Del, Jarvis, and Keeling had hoped for, but it stabilized Pilgrim sufficiently for the Boultings to start making their film. Despite Del's boasts about the fortune he had secured and press speculation over the identity of his backer, Riley was not sufficiently wealthy to finance the company alone. Instead, he believed, as Jarvis, Keeling, and the Crippses undoubtedly reassured him, that he had to keep the company going until the government could fund films directly.[61]

Riley agreed to chair Pilgrim's board because he was confident that a government structure for film financing would soon be erected. His instincts were validated almost immediately, as Cripps became chancellor of the exchequer, the most senior ministry, whose incumbent occupies the house next door to the prime minister on Downing Street. Cripps' promotion also prompted Del to start claiming in private that his crusade was supported by the highest economic office in the land, even if this inveterate self-promoter continued playing brinkmanship in public. In a December interview with the *New York*

Times, which was intended to publicize an upcoming American visit, Del announced that he might move Pilgrim to the United Sates because British financiers did not understand his insistence on quality.[62] He later boasted in the same newspaper that this plea had prompted "industrialists, clerks, housewives and labourers" to pledge £500,000 to his cause in a single day. Needless to say, he also claimed to have turned down this money on the point of honour that, despite its name, Pilgrim was a business, not a charity.[63]

In a bid to find American partners, Del, Jarvis, and Noël Coward sailed to New York in first class cabins in January 1948. Their arrival was documented by the *New York Times* in a long article intended to elicit sympathy for Del in a country which thought of itself as a nation of hard-working immigrants. The writer portrayed Del as a political refugee whose determination had earned him a fortune. This success was now imperilled because, as Del lamented, he was "down to his last limousine" and about to be evicted from his luxury flat.[64] It was a rather unusual proof of penury that demonstrated Del's inflated self-belief, while also casting him as a once-great moviemaker. Privately, Del knew that he had to convince the American studio bosses that Pilgrim's ties to Whitehall meant that he and Jarvis could broker a new film deal. To fortify the claim, before setting sail Del had asked the Treasury to endorse a scheme whereby Hollywood paid half the costs of Pilgrim's films, in return for all the profits from American screenings, and the right to repatriate the British profits from two films each year. The government refused to sanction a plan that would have made Del the gatekeeper to the British market. So he and Jarvis sailed away carrying little besides charm and bluff with which to convince the Americans that they were Labour's unofficial ambassadors.[65]

During the few days they spent in Manhattan, Jarvis and Del met Morris Ernst, a lawyer who was preparing a Supreme Court case that challenged the Hollywood studios' right to own monopolistic chains of cinemas. It was a legal critique of the way production and sales had been fused that spoke directly to Del's artistic idealism. The three men got on very well and eventually Ernst became Pilgrim's American eyes and ears. Jarvis also slipped away from Del to spend time with Honoria Murphy and Fanny Myers, the woman he had once considered marrying. She was now married to Hank Brennan, whose background in graphics and design had led to an executive position at *Time* magazine. He liked Jarvis and would prove to be a useful supporter.

Unlike during his visit the previous year, Jarvis did not attempt to meet Gerald Murphy.[66] The two men were never again in contact.

New York City was only a stopover on the way to Los Angeles, where Del and Jarvis spent a month in a bungalow at the Beverly Hills Hotel. Noël Coward introduced his companions to a number of influential studio executives, before setting off on his own business.[67] Jarvis and Del adapted quickly to Hollywood's rhythm. They gloried in southern California's sunshine and marvelled at the unaccustomed prosperity, symbolized by a dinner at Romanoff's, the Rodeo Drive celebrity haunt, which consisted of "more food than we eat in a week."[68] When not dining so fulsomely, Jarvis and Del discussed ventures with Spencer Tracy and Frank Capra and visited the sets of Alfred Hitchcock's *Rope* and John Huston's *Key Largo* to see how American movies were made. After this last excursion, a bedazzled Jarvis reported to his mother that "Bogey is nice, Bacall is sexy as hell," his words attesting to how he was living out a childhood fantasy.[69] The encounters beguiled someone who had been obsessed with celebrity and the movies since childhood; however, Jarvis' left-wing beliefs deepened during his California sojourn. Studio bosses were "men virtually without education and certainly without culture" who had been corrupted by success and produced nothing but frivolous movies. Jarvis compared them to a "spoiled child suddenly placed in a school environment where it can't have its own limitless supply of candy all day long: when teacher says no you mustn't its first reaction is to lie on the floor and scream and kick its heels. That's exactly what the Hollywood boys have been doing ever since the 75% tax" had been levied against them in Britain in mid 1947.[70] In contrast, so Jarvis claimed to his mother, the deals that he and Del were brokering would earn millions of dollars with which Britain could purchase food.[71]

Despite Jarvis' dramatic and dismissive descriptions of the American industry, Del enjoyed considerable respect in Hollywood because of his earlier financial successes and his oft-mentioned government connections. American executives, who were officially united in their refusal to deal with Britain, saw individually that Del might be able to break through the tax impasse. Harry Warner, in whom Jarvis detected a "mixture of childishness and vanity with pontificating on everything," was the first to negotiate with these English emissaries. He invited them to make a discreet visit to his Palm Springs estate, where they decided on a plan to film Coward's play *Peace in Our Time*. It would be the first production in a deal in which Warner Brothers would

underwrite Del's films, and make Pilgrim effectively a British subsidiary. Much like the scheme that Del had outlined to the Treasury before leaving London, Warners agreed to supply half the cost of pictures that were made in England. The domestic revenues from these productions would remain in Britain to finance other films, while the Hollywood studio recovered its outlay from American screenings.[72] Louis B. Mayer expressed similar, confidential interest, while refusing to commit himself because of what he called the "unfortunate [75 per cent tax] block" that made American pictures economically unviable in Britain. Independent producers like David O. Selznick, whose *Gone with the Wind* had been one of the greatest hits of all time, and the directors George Cukor and William Dieterle were also interested in working with Del, though they could not provide any financing. The filmmakers and studio executives with whom Jarvis and Del met were canny businessmen, who dangled these deals in the hope that such close allies of Cripps could reopen the British market. Their subsidiary message was that American studios would only invest in Britain in return for significant reassurances that the government would not nationalize the film industry.[73] In February, Del and Jarvis sailed home with their briefcases full of promises, impressions, and messages, but no firm deals.

Once at home, Jarvis submitted a report to Sir Stafford and Isobel Cripps arguing that the major studios' ownership of cinema chains had destroyed the artistic standards of American movies, which pandered mainly to adolescent bobby soxers. While unofficial ambassadors such as he and Del fostered goodwill, the film crisis could only be resolved through high-level diplomacy. Most importantly, no matter how the dispute was settled, Jarvis argued that it would favour those British producers like Del who turned out top-quality pictures. There was a small market in the United States for these typically English works, as Jarvis had discovered, whereas low-budget melodramas and imitations of Hollywood films were dismissed outright by American audiences. These two facts led Jarvis to conclude that British producers should market high quality films to the smaller American cinema chains.[74] The report had no official weight, but it influenced Cripps' decisions throughout the spring.

Del and Jarvis had kept in touch with Bill Riley, who ran Pilgrim in their absence, but they returned to face a new crisis. As with previous investors, Riley had barely begun working with Del when the London press unmasked

him in January. He was incensed, and believed that Del had let the news out, despite being on the other side of the Atlantic. Riley was astute enough to understand that Del's American negotiations might be smoothed by such public confirmation of Pilgrim's close ties to the chancellor.[75] But the knowledge did not prevent him from advocating financial retrenchment. The mortgage on Sheepcote was in arrears and an outstanding loan from Jack Keeling, who had already quit the company in frustration, was in little better shape. By February, Isobel Cripps, who was convinced that the situation was dire, unsuccessfully lobbied Warburgs Bank to invest more than a million pounds. Pilgrim wobbled on, but Del alone refused to acknowledge the situation and so, like Keeling, Riley called on Jarvis, whom he lauded as having "the most mature ability and understanding far in excess of his years" to try to convince Del to scale back spending in order to save the company.[76]

These stressful and unpleasant discussions between Jarvis and Del took place just as British cinema owners, trade unions, and their American counterparts began pressuring Harold Wilson, who had succeeded Cripps at the Board of Trade, to rescind the 75 per cent tax.[77] In the spring, it became clear to British legislators that the impasse might hinder the passage of the Marshall Bill, under which the United States intended to invest heavily in European reconstruction. This prompted Foreign Secretary Ernest Bevin, Cripps, and Harold Wilson to meet in London with an equally distinguished American delegation. As Jarvis had predicted, the negotiations culminated at the start of March with a new Anglo-American film agreement. Under this treaty, American studios could repatriate a large portion of the money their films earned in Britain without paying taxes. All other revenues were placed in an account that was managed by representatives from both countries, and earmarked for financing British pictures.[78]

Pilgrim survived the winter and saw the end of the 75 per cent film tax, while a new addition to the staff gave the company's supporters further reason for optimism. In early 1948, Rank's chief accountant, Barrington Gain, resigned and, having already worked with Del, joined Pilgrim. Jarvis believed that a financial manager who was so well trusted by the industry and the banks increased Pilgrim's stability and gave him a vital ally in his attempts to curb Del. He looked to Gain as "the one person in the world who can best control Del's expenditure" and thereby broker a peace with Riley, who was now so uneasy with the way money was spent in the movie business that he

barely spoke to his partner.[79] Buttressing this feeling of relief was the late spring completion of shooting for *The Guinea Pig*.

Riley, who had never expected to be in the film business for long, hoped that this was his moment to withdraw. But he worried in a letter to Harold Wilson that the government had backed away from a national film financing corporation in favour of working directly through the Hungarian-born director Alexander Korda's company.[80] Internal Treasury memos bolster Riley's assessment, showing that the government was not willing to give money away without significant safeguards. Civil servants felt that working with an existing corporation, headed by an experienced administrator like Korda's chief executive Sir Arthur Jarratt, was the surest way to proceed.[81] In order to ascertain Pilgrim's place in this new structure and explore possibilities for cooperation, Riley and Jarratt met at the end of March.[82] At the same time, Foreign Secretary Ernest Bevin, Harold Wilson, and Woodrow Wyatt began conferring with Jarvis on ways to implement the new Anglo-American agreement.[83] It seemed to Jarvis as though the strife and stress of Pilgrim's first six months had paid off.

Even as Pilgrim demarcated a place for itself in the new film world, Del remained too self-important to be tractable. It was only when Pilgrim's financial woes became acute that he was convinced to ask Alexander Korda for money to finish editing *The Guinea Pig*. The discussions deteriorated almost immediately as Del refused to heed Korda's advice about the film's script and cast. Del was further insulted when asked why 10 per cent of the budget had been devoted to his personal expenses, believing that he deserved his perks. Jarvis and Jarratt watched helplessly as the moguls argued. The pair bickered through the spring, convincing some senior government officials that the men who hoped to champion British films did not abide by their adopted country's gentlemanly code. An exasperated Riley, who, like Jarvis, was on good terms with Jarratt, emphasized this point in a letter to a senior Treasury official, by describing "an unrepentant situation, the kind which you and I would have resolved behind the cricket pavilion before leaving our prep school."[84] When this civil servant in turn forwarded a précis of the feud on to a colleague at the Board of Trade, he remarked archly "this correspondence will entertain you."[85] In a single meeting, two of Britain's most successful filmmakers had recast themselves as the type of petulant continental martinets

that could be seen in so many of the era's films. Remarkably, Del remained completely unconcerned by the political situation and continued believing that the new *Film Act* would guarantee him financing without any controls. So he was surprised and annoyed by the speech that Harold Wilson made in the House of Commons when introducing the new *Film Act* on 29 April. Del sent Wilson a seven-page critique of his oration that reprimanded him for not specifically endorsing Pilgrim's distribution model.[86]

This ill-judged attack on the minister responsible for the film industry came as Pilgrim's fortunes were once again in crisis. Del, who had mortgaged his property and Riley's investment, now had to sell the *Guinea Pig* at advantageous terms in order to pay for the films that Peter Ustinov, Noël Coward, and Carol Read were anxious to shoot.[87] As the Boulting brothers edited their work, Columbia Pictures offered Del $1 million for the *Guinea Pig*, and a number of future films, provided that Parliament passed the new Anglo-American agreement.[88] In the meantime, Del worked out a deal that secured fifty British screens for the film.[89]

Del's refusal to acknowledge reality caused Jarvis to think that Pilgrim might not need its founder. With Riley on the board of directors and Gain responsible for the accounts, outside investors would surely feel comfortable about placing their money in the company. Furthermore, these two men had proved they could work within the government's new financing scheme.[90] Jarvis, Riley, and Gain were seen by outsiders as restraining influences on Del and this made it easier to find funding for Peter Ustinov's film *Private Angelo*, the story of a young Italian soldier's attempts to avoid the war, which began shooting in London and Italy in late summer.[91] Del remained in charge nominally, but he was no longer the company's heart.

Renewed confidence in Pilgrim settled just as Jarvis' mother made her first visit to England. Janet Bee arrived in early May and stayed until the end of July 1948. Her itinerary showed the interest and pride she took in her son's achievements. Jarvis had always been assiduous in telling her about his friends, whom Janet now met for the first time. The trip began with a visit to Fanny Myers, Jarvis' one-time love, who showed Janet around New York City before taking her to the pier. Much as her son experienced on his first visit to Europe a decade earlier, Janet's culinary horizons were expanded by travel. On her first night in London she was introduced to Italian food, "which was very strange,"

by Jarvis and Mary Nicholson, with whom her son had worked on the wartime discussions clubs. Thereafter, this simple but sociable woman dined at many of the city's most exclusive restaurants. On a short jaunt to Paris, Jarvis showed her the building in which he and Duncan had spent the summer of 1938. A more animated witness to those pre-war days was Jarvis' one-time admirer Ted Manteau, who charmed Janet. In Oxford, she looked over the University College rooms that her son had occupied. The war years were represented by several long stays at Woodchester, and she saw Jarvis' new spirituality by accompanying him to church, though as a Presbyterian she waited outside while he took the Anglican Communion. Jarvis' work since 1945 was attested to by a lecture he gave about his book *The Things We See* and by the way Woodrow Wyatt secured a seat at Westminster, from which Janet watched parliamentary debate. Most compelling of these events were the parties at

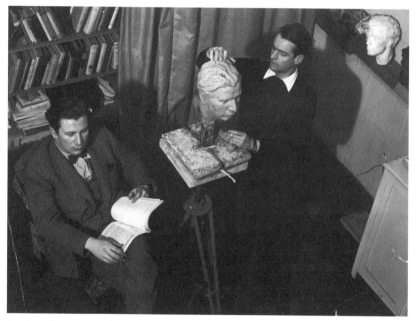

Jarvis sculpts Peter Ustinov in the studio at
3A Sydney Close, c. 1948. Alan Jarvis Collection,
University of Toronto.

Sheepcote and in Del's London flat, where Janet met the Crippses along with many of Britain's biggest stars, including John Mills, John Gielgud, Ronald Colman, and Bernard Miles. But her trip diary also records frequent instances when Jarvis travelled alone to Sheepcote, attesting to his protracted struggle to bring Del into line.[92]

Jarvis worked under huge stress as a businessman, government mediator, and Del's babysitter. It was hard to reconcile this unending toil with an idealistic crusade. Despite the government's new commitment to film financing, Del continued arguing that he deserved special treatment. He lobbied Isobel Cripps directly in the hope that she could make her husband force Rank to turn over Two Cities' films, which Del could then re-release to generate cash for Pilgrim.[93] When this failed, he tried equally unsuccessfully to sell the British rights to *Private Angelo*, a second Boulting brothers' project, and Noël Coward's film, before sending out an over-long, self-congratulatory "Cri de Coeur" to his contacts in Whitehall. It swayed no one.[94]

At the start of the summer, Del turned his charms on Harold Wilson, whose ideas about film he now claimed were "a tonic to my brain," and Woodrow Wyatt, whom he called "such a brilliant advocate of this art in Parliament."[95] They were more sceptical than the Crippses, and Wyatt's confidential aside to Wilson – "I gather that we are both the most remarkable people to have been in the House of Commons. I am a little irritated to note, however, that you appear to be even more distinguished than I am" – showed that they were unmoved by Del's effusiveness.[96] Moreover, his mercurial changes of tack made him seem unhinged and unreliable, though it was his behaviour at a couple of meetings in mid-July 1948 that doomed Pilgrim at the moment when it might have become a success. At the first of these, Wilson, Wyatt, and the Treasury urged Del to reconcile with Korda and Jarratt because the government had decided that it would only invest in films through the latter men's company.[97] Bill Riley helped negotiate a truce despite Del's "violent objections to having to get money through distributors," unless they gave him absolute authority over production, advertising, and worldwide sales. In return for these unheard of concessions, Del would split any profits equally. Korda and Jarratt showed more patience than could reasonably have been expected by announcing that they were willing to work with Del as long as he stopped crusading against the industry's business arm.[98]

Once again, Del failed to see that he had been thrown a life ring and he threatened that Pilgrim would "come to a dead halt" within two weeks if he did not immediately receive £150,000.[99] Wyatt and Wilson were suspicious of these claims and inquired secretly into Pilgrim's finances, only to find that the company was more solvent than its temperamental head let on.[100] Bill Riley tried to diffuse the impact of Del's behaviour with a July speech in the unlikely venue of the Imperial Defence College. He chose a suitably militaristic allegory by claiming that cinema would be a weapon in the coming world war, which he believed would be waged with culture.[101] Despite public and private attempts at conciliation by Jarvis, Riley, and various government officials, the rupture between Del and Korda was complete.[102]

The result was that Pilgrim received none of the money from the Film Finance Corporation that was announced on 22 July 1948. By this time, Del was ever more marginal to government plans, though he continued to shout from the sidelines.[103] In August he begged Harold Wilson to reconsider a policy that disregarded independent producers and advocated a month later for a £5-million "Film Production Fund" staffed by cultural experts who would sponsor films that "the educated brains of the country would appreciate from the moral and aesthetic point of view."[104] The idea was politely dismissed on the basis that voters would not condone using tax money to make elitist pictures.[105]

Del's increasing estrangement from the government put Jarvis, who had always been an unofficial cabinet representative at Pilgrim, in an ever more difficult and stressful position. He got some respite in September by sailing to New York to work out an American distribution deal for *The Guinea Pig*. He arrived to find that Morris Ernst, who was now Pilgrim's American representative, had hired the extremely successful public relations man Benjamin Sonnenberg to act for the company. This was very auspicious for a film that had no major studio support. But Del had insisted on a distribution plan that did not compromise Pilgrim's oft-repeated ideals. We can only guess what Sonnenberg, whose most famous advertising campaign had turned the small New England bakery Pepperidge Farm into an international concern, would have felt about Del's suggestion that Harvard University was a suitable spot for a premiere, or that the tag for the movie's poster should read "Those who are not interested in culture and taste are advised not to buy tickets."[106]

In London the following month, Jarvis reported to his mother that Pilgrim was "just ticking over" until its next film, *Chance of a Lifetime*, went into production. In the fallow, he relaxed at Woodchester and in London with his old Canadian friend Frank Starr, who had moved to London to pursue a singing career and lived for a time in Jarvis' studio flat at 3a Sydney Close. The tranquillity was shattered within a few weeks, as Riley and Del's relationship collapsed. Lloyd's Bank, which had a substantial investment in Pilgrim, tried to calm the situation by buying out Riley. Having done so, Lloyd's agreed to continue financing Pilgrim on condition that it appoint a new director, and that Jarvis remain in place.[107] This recognition of Jarvis' importance was of little lasting comfort. The situation worsened again in December when the right-wing *Daily Mail* began investigating whether the government had given an unnamed businessman permission to spend £750,000 in America, on condition that part of it was "siphoned off" into Pilgrim, a company in which Isobel Cripps and Bill Riley were believed to be substantial investors. Reporters from the newspaper tried to find out if Jarvis and Del had opened a secret – and illegal – American bank account during their trip to the States. Riley, who had originally wished to remain anonymous and was now trying to get away from Pilgrim, was forced to deny this rumour, stating that the Crippses had no financial stake in Pilgrim, which also "had the blessing of the Board of Trade, but not its official backing."[108]

By the time this furor broke, Del was little but a bothersome crank in the government's eyes. Politicians and bureaucrats had wearied of the pages-long rambling and insipid memos in which he attacked the national film policy and defended his system.[109] Jarvis, who still believed that the artistic merit of British pictures was under threat, had the unenviable task of writing more balanced synopses of these screeds, in hopes that their circulation would be less damaging to the company. Editorial duties were only part of Jarvis' struggle to keep Pilgrim afloat. When the film finance bill came up for vote in the Commons in late December, he banged on doors in Whitehall out of fear that Pilgrim "might fall between two stools."[110] It was of no avail.

An opportunity to wrest control of the company presented itself when Del left for New York at the end of the month to finalize details for *The Guinea Pig*'s Manhattan opening. Unlike on the trip that he and Jarvis had made a year earlier, Del was now completely broke and had no prospects of government

support. To dissipate this aura of desperation he spread the rumour that Paramount Studios had agreed to settle Pilgrim's debts in order to secure his services.[111] The hollowness of this grandiose claim was revealed a few months later by a *New York Times* reviewer, who found *The Guinea Pig* "highly parochial," and stated that "the attitudes of the characters are strangely stiff, the accents and idioms are hard to fathom – and the exposition is involved and tedious," before conceding that Del "had spared no expense in bringing forth a quality job."[112] The production on which Del had pinned his artistic revolution now warrants little more than a footnote as the first British film whose dialogue included the word "arse."

No brighter review could have been written about the situation Del found when he returned to London. His relationship with Jarvis deteriorated completely during three days of arguing at Sheepcote about personal expenditures.[113] By mid-March, Del was refusing to discuss anything until his reforms were adopted. In his place, Jarvis wrote a tempered report arguing that the "kiosk man" in sales had too much control over the artistic integrity of films. A neglect of quality was unacceptable in any other industry, and could be rectified in film if huge cinema chains were banned and Britain developed American-style "art theatres."[114] Internal bickering at Pilgrim continued until mid-March when Del went once again to the United States, leaving Jarvis in charge of the company.[115]

By June 1949, the Crippses had lost faith in Del, to whom Isobel pleaded "Please, please don't go and do anything which will leave its mark on us all. We have stood by you and battled for you all this time, and *now* just when all that's good is ahead, it seems you just *don't* understand. Big things require equally big behaviour to meet them and at this moment the damper inside you needs working. The other way is so *small*, and I have thought you *big*."[116] Her cautions coincided with a plan to restructure Pilgrim by abandoning Del's original vision, because it was "essential that the commercial and artistic policy should temporarily be subservient to finance." Jarvis was dispatched to America to convince Del that this could save the company. Del assented, though he only comprehended the revolution's scope on his return. Jarvis had dismissed Del's domestic staff, packed up his belongings, and put the £25,000 this had saved the company towards a film. Del's humiliation was compounded by the way investors would no longer give any money to him directly, and insisted on a very tight leash.[117]

This "New Look for Pilgrim" effectively sidelined Del and put Jarvis in charge of the company, which now had more than £86,000 in debts. In an attempt to balance the books, various types of existing shares were converted into a single series that Jarvis was entitled to buy at preferential rates. Sheepcote, which had drained away more money than anyone cared to admit, was put up for sale. Del's role was restricted to selecting scripts, scouting talent, and developing international contacts. In return for this, Pilgrim continued honouring the rent on the Grosvenor House flat and paid him a salary of £7,500. Substantial economies were also made in the office budget. Financial retrenchment still required Pilgrim to produce at least three medium-budget movies in the coming year. In line with the company's new ethos, "such films, however, must be based rather on financial considerations than from the point of view of their artistic merit or their suitability for special exploitation and distribution."[118] Jarvis would oversee contracts and spending on productions that looked on paper like pre-war quota quickies. Nevertheless, he bragged to his mother that Harold Wilson lauded his "reforming influence in British films," before remarking teasingly, "I'm afraid I'll have that knighthood if I'm not careful."[119] Lloyd's Bank was equally pleased and put off liquidating the company. It looked as though Pilgrim might survive, even if *Private Angelo* was released soon after to modest reviews.[120]

Del could not abide his reduced responsibilities and quit England permanently for Rapallo, Italy, where he styled himself Pilgrim's Italian managing director.[121] But this was not an international branch of his cherished company. Instead, Del seethed on his hotel terrace about Jarvis' betrayal and denounced this immature "student of psychology" in a series of letters to once-sympathetic Labour Party grandees. He found little understanding. Woodrow Wyatt chastised Del in mid-October, implying that Pilgrim's troubles resulted from his refusal to be "more agreeable in some of the measures which your best friends proposed." Del responded by heaping further blame on Jarvis, whom he accused of stealing the company. In spite of this treachery, Del claimed to have forgiven Jarvis, whom he would happily rehire "on the artistic side of production, but never again as an administrator."[122] In a subsequent, less magnanimous letter to Jarvis, Del claimed to have lavished £90,000 on his unfaithful young assistant.[123] Jarvis formally quit this once idealistic cinematic venture when Del asked him to help set up an Italian film company. The emotionally exhausted, exasperated, and disillusioned Jarvis

replied, "I cannot see how I can set out, again, with you in another country again, on a battle doomed to defeat from the outset."[124] The work at Pilgrim had left him frustrated and dispirited.

On a more positive note, Del was gone and Jarvis was in charge of a company that might still succeed. His first duty was to market the gentle comedy *Chance of a Lifetime*, which had been shot that spring. It was Pilgrim's most controversial film and the one with which Jarvis was most deeply involved. He explained his attachment in a third-person profile of himself: "This production happens to be Jarvis's special 'baby.' He fought for the project and won his partner Del Giudice's support for the bold decision to make the entire film in 'actuality.' Once the scheme was under way, Jarvis's close acquaintance with industrial affairs and his knowledge of the English countryside enabled him to pin-point in the Cotswolds the salient industrial and rural features to provide the living setting for the picture."[125]

Chance of a Lifetime explored industrial conditions in post-war Britain by following a group of disgruntled workers whose boss gives them an opportunity to run their factory. After a series of mistakes threatens to splinter the workforce, the owner is recalled and the two groups cooperate in running the plant. The "actuality" in which *Chance of a Lifetime* was filmed was an empty wing at the textile plant that was owned by Hi's family. The film was financed by Alexander Korda, with whom Pilgrim now enjoyed good relations, and completed in September 1949.

Trouble began when British cinema owners balked at showing a film that they felt was too political.[126] Without distribution, there was no chance of the film recouping its £150,000 cost. So, in the first week of January its writer and star, Bernard Miles, appealed to the government's new Film Selection Committee, which could compel cinemas to show films.[127] The committee had five independent members and representatives from each of the three main cinema chains. In debating Miles' petition, industry representatives argued that the film "had no entertainment value at all" and that they had lost a considerable amount of money on *The Guinea Pig*, which they had felt pressured to show. They further argued that it was better not to screen bad films, because they damaged a cinema's reputation. The independent representatives countered that *Chance of a Lifetime* might find a decent audience if given the opportunity.

While the committee refused to compel cinemas to show two films with the marvellous names *Torment* and *High Jinks in Society,* they recommended that *Chance of a Lifetime* be screened.[128] The Ministry of Labour and National Service then tried to block the film in the belief that it might incite workers to seize the newly nationalized industries.[129] When this plea was ignored the debate transferred to the cabinet table, where Harold Wilson argued that the political consequences of disregarding the Committee's decision were worse than showing the film.[130]

Eventually, test screenings were held at four London cinemas to which were dispatched the sociological investigators from Mass Observation. They found that fully 10 per cent of ticket buyers disliked the film, while half loved it. About one third understood that the makers were arguing for a new understanding between employers and workers.[131] By contrast, Jarvis was very proud of a film whose message crystallized the cooperation between managers and employees that he had first advocated in the wartime industrial discussion clubs. He had even considered removing Del's name from the credits and inserting his own. With such an emotional stake in the project, it was difficult for him to accept its failure. Once the government ordered its release, he penned a long letter that was published in a major industry journal in which he invited moviegoers to write similar letters in order to "indicate that the exhibition side may be sometimes wrong when it says 'we *know* what they like.'"[132] The statement echoed Del's loftiest pronouncements, but the call was not taken up by the public. When the government refused to give the film a gala West End premiere, it became clear to Jarvis that Pilgrim was slipping into inconsequence.[133]

Pilgrim's fortunes reflected those of the Labour party. Having overseen Indian independence, nationalized key industries, and steered foundational social welfare legislation through Parliament, the Labour government waited until its mandate had almost expired before going to the polls in February 1950 under the banner "Let Us Win Through Together." On election night, the conservative press revived the story of Pilgrim's too-close relationship to Labour, which they claimed was forcing cinemas to show a politically charged film that no one wanted to see. Jarvis seethed at the indignity of publicly defending his relationship with the Crippses by stating that he was not their adopted son and neither was their money and influence behind the film.[134]

Such attacks weakened Labour, which returned to power with a five-seat majority, but little coherence or vision. Pilgrim's relationship with the party had proven to be a public liability, and this further undermined the political alliances that Del, Jarvis, and Bill Riley had used to keep Pilgrim going. Even so, Jarvis' duties at Pilgrim continued. On the advice of Lloyd's Bank, he established a personal publishing and film company under the name Alan Jarvis Limited. Through this new firm, he tried to initiate film projects in France, Canada, and England. The shares that Jarvis owned in Pilgrim were now virtually worthless and so he financed the venture by selling a set of Canadian stocks that his lover Douglas Duncan had given him before the war.[135] All his meagre financial resources were now committed to his precarious film career.

Just as Jarvis had predicted on joining Pilgrim, he had eventually come to lead the company. However, Del had swept away the efforts of Jarvis, Jack Keeling, Bill Riley, Isobel Cripps, and others, leaving a moribund company in 1950, and Jarvis' hopes of reanimating the firm with *Chance of a Lifetime* had fallen flat. Though now emotionally exhausted by the experience, Jarvis forged on. A short press release from about this time was intended to emphasize his importance, and thus distance the company from Del. While depicting Jarvis as an "artist" and filmmaker who was "a little out of the common groove," the pen portrait stressed that he was also "truly a back room boy. Much of the spade work which built the reputation of Pilgrim Pictures as the leading and most audaciously successful innovators in British film production was performed by Jarvis without the spotlight of publicity ever being focused on him."[136] Neither potential investors nor Jarvis could have believed much of this ornate prose. He no longer held idealized notions of using film as an educational tool and understood that Pilgrim had to adopt a more classically commercial outlook. But, stripped of its mission, Pilgrim became little more than a small, underfunded, and partially successful firm. Jarvis had struggled with Del to no avail. Carrying on in the film world meant forsaking adult education and art in favour of business. He was extremely dispirited and did not know what to do.

"I Certainly Hope 1950 Will Be Different"
Oxford House, 1950–1955

Jarvis had tried to save Pilgrim Pictures from Del's erratic leadership in the hope that this young venture would grow into a swan whose golden eggs would reform public taste, please the Crippses, and earn him a fortune. But the company's disintegration in 1949 proved it to be the goose its critics had predicted. Pilgrim's demise also interrupted Jarvis' ascent, which, with the exception of the frustrating months in wartime Toronto, had been almost unbroken in the twelve years since he had won the Rhodes Scholarship. As Sir Stafford Cripps' personal emissary, he had played small but important roles in reconfiguring British society. Thus, 1950 dawned with great uncertainly about Jarvis' future, a situation that he summed up in a letter to his mother: "1949 has been funny and I certainly hope 1950 will be different. I certainly am not complaining but I'd like to spend less time fussing and more doing some practical work, and I'd like to spend more time in Canada."[1]

Jarvis' uncertainty about his future increased after Labour secured a very slim minority in the February election. The government limped along until forced to go to the polls again in October 1951. After a campaign that revolved around Cold War peace and security issues, Labour captured virtually half of the popular vote, but the senescent Winston Churchill was returned to office

with a seventeen-seat Conservative majority.[2] The new government flexed its diplomatic and military muscles to prove Britain's global power and eliminated rationing, though it maintained the basic framework of Labour's welfare state. The new government was able to focus on reasserting British prestige because domestic consumption edged gradually upwards as the country began enjoying the prosperity of peace. Churchill, who embodied this resurgent spirit, suffered a severe stroke in June 1953, but its effects were hidden from the public and he remained in office for a further eighteen months.

So, in January 1950 when Jarvis made his wish for the dawning year, he could not have known that his film career was finished, Labour was spent, and Sir Stafford Cripps was dying. This compounded the effect of Pilgrim's demise, because until now, as a young, able, and keen man with a wide circle of influential friends and colleagues, Jarvis was confident that new challenges and opportunities would present themselves. But working with Del had been frustrating, stressful, and dispiriting. Jarvis' only reliable income was the small retainer that Lloyd's Bank paid him to wrap up Pilgrim's financial affairs. His personal publishing and film company soon started to founder. He was nearing thirty-five, and it seemed certain he would pass this milestone without unequivocally achieving artistic and intellectual success. Feelings of despair and failure grew. Jarvis drank very heavily – another ongoing effect of his Pilgrim days – and drifted from the Church. Friends sensed a despair that they had not noted before.[3]

Middle age was in sight, and though in the parlance of the day Jarvis had had a "good war," many of his contemporaries had rows of medals to show for their service. They had subsequently taken advanced degrees, started families, and assumed ever more senior professional posts. Jarvis could not take strength from any of these, nor had any of his post-war hopes been fulfilled. Despite repeated boasts, he had never been dubbed Sir Alan, had not returned to Oxford for a doctorate or theological training, and held no qualification other than his undergraduate degree. Moreover, although friendship with the Crippses had brought him close to the centre of Labour power, he had never been seen as a future party grandee. His ties to Canada were equally uncertain. As we have seen, Pilgrim business had enabled Jarvis to visit his widowed mother in Toronto fairly regularly – he had been to the city three times in 1949 alone – meaning that the company's demise increased his physical

isolation. If he did cross the Atlantic, he would find that Janet Bee had donated his books to the University of Toronto and rented out his bedroom. The small studio in Sydney Close, which Jarvis had leased since 1947, was his only home.[4]

This inability to see his future depressed Jarvis, whose drinking was now very heavy. From this point on, alcohol was a constant and increasingly debilitating addiction. Worries about Jarvis' mental, physical, and spiritual state dominated a substantial correspondence that Mervyn Stockwood and Isobel Cripps exchanged from February to April 1950. Stockwood had few illusions about Jarvis, though even after his friend's death, he was discreet about his problems. As he explained with jokey euphemism to the CBC journalist Elspeth Chisholm: "Not Alan's greatest enemy would accuse him of the vice of Puritanism … well, I wouldn't say that personal self-discipline was the thing that automatically springs to mind when one thinks of Alan" and his relationship to alcohol.[5]

Witty descriptions of Alan's problems aside, Stockwood and Isobel agreed in their letters, much as they had in the past, that Jarvis' core problem was that he was "like a child … [l]acking much <u>self</u> discipline with no routine to help" now that he was effectively unemployed.[6] From his home in Bristol, Stockwood argued that the cure could be found by encouraging Jarvis "to lay a solid spiritual foundation, [and] in his case it means an outward discipline to obtain inner peace."[7] Stockwood believed that the first step was for Isobel to take Jarvis to communion as often as possible. She complied, but questioned the efficacy of her actions, feeling, as many others had when trying to probe Jarvis' emotions, that "there is a constant something which is difficult to fathom. I can discuss every kind of thing with him and all his plans, but then I come up against something on which I feel it would be an intrusion if I probed deeper, so I get a sense of failure at times."[8]

Isobel laid these spiritual foundations, however hesitantly, until Stockwood came up to London in mid-March with a more comprehensive plan for rescuing their friend. Stockwood knew that the governors of Oxford House, an Anglican mission in East London, had been searching for a new Head for more than a year, and he felt that Jarvis was the ideal candidate. Far from seeing this as a sheltering sinecure, Stockwood believed that the post approximated the duties of a "worker priest" of the type that he, Jarvis, and others had tried to introduce to the Church of England in the spring and

summer of 1945. As such, Stockwood felt his friend could find spiritual and physical redemption through this quasi-clerical post, because it would compel him "to give everything he's got to make it a success."[9]

Stockwood sounded Jarvis out about the job, appositely enough in the dining room of the Athenaeum, the extremely exclusive Pall Mall gentleman's club associated with intellectuals, academics, and senior Anglican clergy. With Jarvis' somewhat half-hearted consent, Stockwood then approached John Collins, another veteran of the 1945 Church reform committee, who was now a canon of St Paul's Cathedral. Collins in turn discreetly discussed the possibility of Jarvis' candidature with the dean of Westminster, who headed the Oxford House search committee.

Of more immediate importance for Jarvis, his meeting with Stockwood touched off a protracted discussion that the pair carried on in London, Bristol, and through letters. Stockwood reasserted the "father confessor" role he had assumed when preparing Jarvis for confirmation in 1945. He did this through a combination of pastoral experience and personal friendship that enabled him to penetrate the emotional barriers Isobel had found so daunting. These intimacies further convinced Stockwood that Jarvis needed order and structure in his daily life and definite longer-term goals. At the same time, Jarvis admitted that he was unhappy in what he termed the "political life," and that his greatest passions were for the arts and film. Having guided his friend this far, Stockwood was excited to see the dedication with which Jarvis finished three portrait sculptures for the Royal Society of British Artists in March 1950.[10]

While it was a promising sign, completing a handful of pieces was not a sure indication that Jarvis had overcome his depression. In fact, this immediate, atavistic focus on sculpture was exactly the way Jarvis had coped with his brother's death in 1933. It also demonstrated that Jarvis had never fully abandoned hopes of an artistic career, despite his 1939 pledge to his parents. Moreover, his simultaneous declaration that films were a "mission" that he intended to accomplish through a new production company seemed equally impulsive, given Pilgrim's disastrous last days. Stockwood worried that both paths lacked formal, daily structures. While in 1939 Janet had urged her son to take up a respectable career in academia, Stockwood now helped his friend explore the ways in which inner self-discipline, not necessarily of an overtly Christian cast, "could prevent himself from deteriorating."[11] Isobel supported

Stockwood's plan, though she confided that "Alan is always wrestling between Heaven and earth, and I really sometimes think that he is much nicer and more attractive when he is dealing with the earthy things."[12]

Jarvis' deterioration reflected his deepening sense of having failed to live up to his own and his dead brother's early promise. Confiding such insecurities had always been extremely difficult, but concealing them behind a public persona became harder for Jarvis and his dependency on alcohol grew apace. The teetotal Janet, who had seen her son regularly since the war's end, was shocked at how much he smoked and drank and asked him to cut back. Relaunching his career as a sculptor was unlikely to help, because Jarvis kept several cigarettes alight simultaneously while working in his studio. Janet was not the only one who could see how these addictions were taking hold. The joy Isobel and Stockwood felt when Jarvis renounced nicotine for Holy Week in 1950 showed that they were prepared to measure his victory over his vices in inches.[13]

Heavy smoking was commonplace in Jarvis' generation, and while physically damaging, it did not impair a person in the way alcohol could. Stockwood and Isobel, who were accustomed to British drinking habits, were nevertheless worried about their friend. Isobel sensed that Jarvis' drinking, refusal to reveal his emotions, and the film industry's continuing allure might scupper his chances of winning the Oxford House job. So she urged him, before his meeting with the dean of Westminster at the end of March, to "give it something of your real self and *why* you want to go into films, *apart* from all those 'frivolous' reasons! That you *have* this deep urge because of their potentialities for good or Evil."[14]

She need not have worried about the interview, because Jarvis and the dean were predestined to like one another. Alan Don was an urbane sixty-five-year-old Trollopian cleric who combined pastoral experience in Britain's slums with passions for fishing and art – he would be named a trustee of the National Portrait Gallery in 1951 – and had held such socially prominent posts as chaplain to the King, to the Archbishop of Canterbury, and the House of Commons. Their meeting was not simply an amicable discussion, because unlike the almost casual way in which Jarvis' suitability for posts had been accepted in the past, Don had to evaluate the candidate's abilities in "Christian leadership," "teaching," "social work on modern lines," and "social life in the locality."[15] Jarvis' considerable experience in these areas was neither

conventional nor readily apparent, but Stockwood vouched for Jarvis, who he felt could master this tremendously challenging job through dedication, self-discipline, and commitment. Doing so might also cure Jarvis' depression.

Despite what Stockwood, Isobel, and John Collins were doing on Jarvis' behalf, he did not immediately recognize the need for redemption through Oxford House. In describing the job to his mother as "an 'honorific' post, attaching to Oxford [University], Rhodes House and the Church which really will make your heart as well as mine burst with pride," Jarvis demonstrated an initial attraction to the trappings, rather than the substance of the work.[16] Moreover, even as his friends lobbied for his appointment, Jarvis announced a number of pie in the sky plans for his future, like becoming director of the Group Theatre at a salary he predicted would be £1,000 per year. There was something desperate in the way Jarvis looked for salvation in the revival of this impecunious 1930s troupe that had produced experimental and commercially unviable plays by the likes of W.H. Auden, Christopher Isherwood, and T.S. Eliot. Jarvis and Eliot discussed plans for the theatre over dinner, and he was eventually named one of two executive directors, but at nothing like the hoped-for salary.[17] A more impartial witness and dinner companion from this era was Mary Greey, with whom Jarvis discussed his theatrical prospects. She had a strong sense that her old friend was running short of money, options, and hope.[18]

Oxford House was Jarvis' one realistic prospect and, in return for a two-year commitment, he was appointed head in June 1950 on the understanding that he would assume his duties that September.[19] The post provided daily structure and responsibility and a secure, socially prominent position. It was also a promotion in responsibility and marked the first time that Jarvis had undivided control of an institution, much as he had hoped for at both the Council of Industrial Design and Pilgrim Pictures.

Jarvis became deeply committed to his work at Oxford House, but he had not conquered his problems with depression and alcohol by accepting the position. He was still very drawn to, and welcome at, West End parties and country estates. His film career was over, but he had ambitions to become a professional sculptor and a figure of some stature in English cultural circles. He had taken the post at Oxford House in part because he saw that its duties would not prevent him from chasing his other ambitions. In this sense the decision reflected earlier periods in which Jarvis' family and colleagues had

worried that he was trying to do too much all at once. When in residence at Oxford House, Jarvis lived a sedate, sober life that was not unlike the times he had spent living with Sir Stafford Cripps. Those who had lobbied for him to get the job were happy to see this, but Jarvis' life outside of the House was less ordered.

The Oxford House in Bethnal Green was a product of Victorian middle-class fears that endemic unemployment blighted Britain's rapidly expanding cities. Writers like Charles Dickens set novels there, while social reformers and clerics decried how unending poverty detached people from moderating social forces like religion and the class structure. The problem was most acute in London, where an enormous pool of casual labour surrounded the east end docks, whose "outcast" inhabitants became associated in the popular imagination with vice and violence.[20] These fears were confirmed in the late summer and autumn of 1888 as Jack the Ripper gruesomely butchered five prostitutes in this area. Though they were not direct responses to the Ripper hysteria, Oxford House and similar "settlements" tried to reintroduce the moderating influences of an ordered social hierarchy by sending undergraduates from privileged homes to live in these impoverished districts.

Bethnal Green, which lies in the heart of the Cockney East End, had once been a fashionable residential area on London's outskirts, but by the early nineteenth century the district had become a centre of weaving and shoe-making, whose workers were among Britain's poorest and most vulnerable. Their wages were driven down by mass production, while overcrowded, warren-like slums replaced the genteel houses of old. In only a few decades, Bethnal Green was transformed into one of London's poorest districts, whose inhabitants lived, as one Victorian civic reformer sermonized, in "a vast moral corruption of heartbreaking misery and absolute godlessness."[21]

Public conceptions of life in Bethnal Green had changed little by Jarvis' day. The gritty 1947 film *It Always Rains on Sunday*, which was shot in the area, refuted wartime images of a resilient, cohesive, and ever cheeky Cockney community. Instead, viewers are shown a bombed-out, miserable district of flophouses and depressing pubs, peopled by predatory spivs, fences, petty criminals, bookies, and bullying police. The Salvation Army fights for their souls in the streets, while the only middle-class accent belongs to the Anglican priest who runs a community centre, which has obviously been modelled on Oxford House. However, even he is corrupted by the toxic environment by

unwittingly accepting ill-gotten money. Such unremitting hopelessness causes the heroine to declare, "I wish there wasn't such a place as Bethnal Green," a sentiment with which the audience has to agree.[22]

As its name implies, Oxford House was affiliated with the university, having been founded in 1884 by the fellows of Keble College, one of the most important centres of Victorian High Anglicanism. So it is not surprising that the House had a specifically evangelical mission that was carried out by undergraduate residents and overseen by a council on which sat senior clergy, the heads of several Oxford colleges, and other equally eminent lay people. House activities revolved around religious services, lectures, sports, and cooperative endeavours that provided an alternative to the public house, booze-sodden music halls, and other vices.[23]

The head of Oxford House was responsible for leading religious services, recruiting undergraduates and publicizing the settlement from pulpits in wealthier parishes. Successive heads and most residents were priests, or at least studying for holy orders, until the 1930s, when a reformer began re-modelling the House into a secular community centre. His ambitious program was slowed by the war, during which Bethnal Green was heavily and repeatedly bombed. The blitz forced its own reforms on the House. Women were admitted and House activities became more practical and recreational; in the day it operated a small bar with table tennis, ballroom dancing classes, and music rooms, while area residents sheltered there at night. After 1945, Labour's social welfare programs and local initiatives made the House's mandate to provide "religious, social and educational work in East London" less critical and its middle-class do-goodism, which was never terribly popular, became increasingly anachronistic. Thus, two years after the war, the House applied successfully to the London County Council to be named an official community centre, which its governors felt was a "natural development of our work." The municipal grants that came with the new status were distributed by the newly formed Oxford House Community Association.[24]

The House's realignment also reflected a popular disinterest in religion. East End churches had trouble finding curates, and the House often had no chaplain. Given this atmosphere, the first post-war head admitted that "the work of the House will always be fundamentally Christian work, but we cannot say that all we do at the House is part of a plan to spread the Word of God."[25] Twice daily chapel services continued, though clinging to an evangel-

ical mandate would have made the House irrelevant, for as one local resident remembered about this period, "there was nothing religious about it, but there was a communion service every week. A few residents went."[26] Faced with this sentiment, the Oxford House Council decided in 1948 that the head should strengthen ties to the university and "maintain and show Christian leadership," though it was most important for him to be "an ordained layman" with experience in business and "organizing large social and club centres."[27] That the head's new role fit with Jarvis' post-war desire to create "worker priests" was confirmed by the way the House had almost been turned over to John Collins as a headquarters for Christian Action, the Anglican social movement he had built out of the ashes of the 1945 committee.[28]

As local residents took greater responsibility for running the community association, it became the heart of Oxford House. A vocal constituency emerged whose motto was "for Bethnal Greeners, by Bethnal Greeners," implying that outsiders should retire into the background.[29] The association was physically centred around a canteen and billiards room, while it hosted monthly dances, whist drives, music, and discussion nights.[30] Under its auspices, the Royal British Legion and clubs for pensioners and the blind all met at the house, as did a mutual loan society, football teams, a drama club that produced three plays per year, and scooter, motorcycle, painting, boxing, and badminton clubs.[31] The aims of Oxford House and the association diverged gradually and by 1952 the latter had become an autonomous entity that rented space in the house.

In order to meet these new challenges, responsibility for House activities was split between the head, whose duty was "to maintain the Oxford House on its traditional basis of Christian social work" and a warden who led the association and took care of day to day administration.[32] It was hoped that a single energetic person could fill both roles, but the work proved too onerous. Neither post was filled until a warden was appointed in early 1950 and only when Jarvis arrived that September were both of the House's leaders in place.

The separation between the House and the association left Jarvis free to shape the head's role. But running a community centre with an uncertain future meant switching from the alternating gales and glamour of the film world to the minor key of inner-city obscurity that Stockwood had cited when testing Jarvis' desire to join the priesthood five years earlier. And while the relative calm of a life without Del was appealing, it could not have been clear

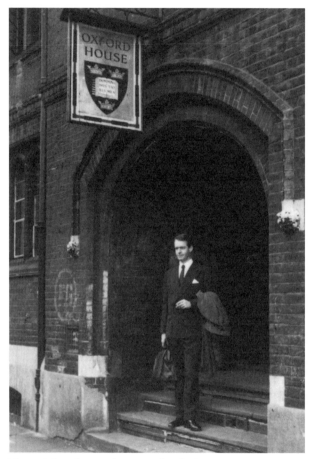

The social worker, on the steps of Oxford House, c. 1950.
Alan Jarvis Collection, University of Toronto.

to Jarvis how any achievement at Oxford House would lead him back to prominence. He only had to look at Stockwood, who despite his national profile was still the vicar of St Matthew Moorfields, to see that he too might be slow to advance

Nevertheless, the work suited Jarvis perfectly at this point in his life. First, it provided structure. Jarvis lived predominantly at Oxford House from his arrival until the end of 1951, during which time, with the help of Sir Kenneth Clark, he rented out the Sydney Close studio.[33] When in residence, Jarvis' days

revolved around early morning and evening chapel services that replicated the ascetic times he had spent with Sir Stafford Cripps. His religious convictions strengthened gradually.[34] Much of what could be accomplished depended on funding, which was a perennial problem. Money was raised through rummage sales and renting facilities for wedding receptions and meetings. Jarvis organized pantomimes and concerts and asked the actor Bernard Miles, with whom he had worked at Pilgrim Pictures, to perform a music hall act at the house in late 1951.[35]

Soon after arriving, Jarvis set out his agenda by deciding that the House should concentrate on working with young people. To this end, he joined the London and National Federations of Youth Clubs, the National Council on Mental Health, and a student exchange scheme that was run by the American embassy. He also began pulling tried and tested adult education activities out of his quiver. He set up a discussion club at which local politicians and other guests were questioned on topical issues such as race relations – Bethnal Green was one of London's most ethnically diverse areas – current affairs, the family, and films. This last topic was one of Jarvis' favourites because he believed that people's curiosity about the movie stars he knew personally would stimulate discussion.[36]

Jarvis was helped in his mission by a variety of friends. Frank Starr from Camp Glenokawa was enlisted to organize a music appreciation group. Jarvis mined his Glenokawa experiences more explicitly on the "Commando Weekends," during which he led groups of young boys and girls on treks through the forests of southern England and taught them how to read maps. About a year into his mandate, Jarvis set up a studio on the top floor of the house, where he led classes in clay modelling and the book illustrator Antony Lewis taught drawing.[37] He strengthened longstanding ties with Berkhamsted, a public school located just outside London, whose pupils helped with Oxford House activities. One of the students, Geoffrey Reeve, recalled a visit Jarvis made in 1951 to see the school's production of *The Bourgeois Gentilhomme*. Jarvis lauded the play and in a subsequent discussion that Reeve rated as "the biggest moment" in his childhood, inspired the young boy to believe that a career in theatre and movies was possible.[38] Another Berkhamsted pupil, who boxed against the House's best fighters, found it "remarkably easy to converse with Alan" and they stayed in touch until the young man was at Oxford.[39] Many of these activities were coordinated and supported by Jarvis' secretary

Susan Allison, who had followed him from Pilgrim, and by Peter Duke, a young civil servant who began working at the House in late 1951 and was soon being groomed to lead the institution.

People close to Jarvis saw that this hectic activity revivified him. He proclaimed to his mother within two months of arriving that "I do love the life here so much that I sleep like a baby (no more trouble with my hands for ages) and adore all the busy-ness. And love being surrounded by the bishops and the parsons! I really feel very much at home in the ecclesiastical world. More so I think than in films!!!!"[40] Reawakened religious feeling increased stability in Jarvis' life and he slowly paid off the debts he had accumulated in the desperate months before joining Oxford House. Links with the movie industry were severed when Pilgrim Pictures was officially dissolved in March 1953. The forty pounds Jarvis received for his shares was a welcome amount, but nothing like the fortune he had once hoped to earn.[41]

Mervyn Stockwood and Isobel Cripps saved their friend just in time, because Sir Stafford's health collapsed at almost the same moment that Jarvis took the job at Oxford House. Chronic illness and decades of unceasing work and stress earned Sir Stafford several long convalescent visits to a Swiss sanatorium, where Isobel and Stockwood nursed him. He died there on 21 April 1952.

While Isobel and Stockwood attended to Sir Stafford, an increasingly confident Jarvis looked for opportunities outside Oxford House through which he could develop his interest in helping young people. Such opportunities could also boost his national profile. Foremost among these was the 1951 Festival of Britain.[42] Shortly after the war, the left-leaning journalist Gerald Barry, whom Jarvis had known slightly through Dartington, proposed a festival to mark the centenary of the Great Exhibition of the Works of Industry of all Nations. This brainchild of Prince Albert had drawn together a panoply of machines and manufactured goods under the glass-roofed Crystal Palace in Hyde Park. The Victorian spectacle had proclaimed Britain's industrial dominance, while Barry hoped that a modern version would launch a new era of national greatness. Sir Herbert Morrison, one of the most senior Labour ministers, began championing what he called "a tonic to the nation" and construction of the festival's principal site on the south bank of the Thames was soon underway.[43]

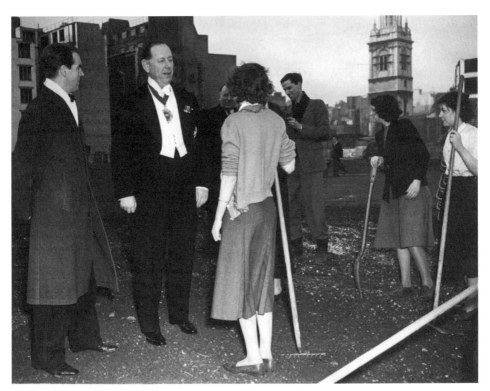

A somewhat overdressed Jarvis and the Lord Mayor of
London, talking to young people clearing a bomb site for
the Festival Fires, 1951, Alan Jarvis Collection, Univeristy
of Toronto. © Graphic Photo Union

Though Jarvis had not been party to the festival's initial planning, he
worked through a national youth group to organize a series of opening night
bonfires throughout the country around which young people would sing
patriotic songs. There was little time to prepare and Jarvis referred to his hec-
tic schedule as "a steady crisis for six months."[44] In addition to coordinating
some 2,000 local fires, Jarvis personally oversaw the groups of girls and boys
who cleared a bomb site adjacent to St Paul's Cathedral, in the middle of which
they then assembled an enormous pyre of scavenged wood. On the festival's
first night, the bbc broadcast a 1,000 voice choir singing a specially commis-
sioned dedication, which was the signal for localities to light their blazes.
Organizers chose songs that suited their communities, while the national fire

at St Paul's mixed tunes from throughout the Commonwealth with traditional British favourites.[45] After the flames had been extinguished, Jarvis helped set up the Festival Centre for Youth, which provided contacts and advice for visiting young people from a Soho church hall during July and August.[46]

The festival provided an excuse for Janet Bee to make her second visit to England, in May and June 1951. Three years earlier, Jarvis had plunged his mother into a whirl of film parties and trips to Oxford, Paris, Woodchester, and other places he had lived. The program was more sedate this time, but Janet once again met Jarvis' friends and colleagues and saw his work, including spending the evening at the Festival Fires and a dedicatory service at St Paul's Cathedral. The glimpses she got on this trip of Jarvis' work and the state of his health ignited a number of ongoing concerns.

After the festival, Jarvis continued his commitment to youth by becoming "hideously busy" planning a six-week-long exhibition that was to be held at the East End's Whitechapel Art Gallery.[47] The show, entitled *For Bill and Betty – Or Setting Up Home*, was a scaled-down version of *Britain Can Make It* that aimed at teaching East Enders about good design and giving them what Jarvis called "shopping confidence."[48] Where the 1947 exhibition had targeted British consumers as a whole, Jarvis was inspired to aim this version at youth by basing it on a couple who had married at Oxford House. They became the models for the fictional Bill and Betty around whom the show was built. The Oxford House Council agreed to sponsor this wholly unprecedented activity in January 1952, after Jarvis convinced them that it might help alleviate local conditions by teaching newlyweds how to choose well-designed home furnishings. The costs of this resolutely local undertaking were shared between the House and the Gallery, while neighbourhood stores lent the merchandise that was displayed. In organizing the show, Jarvis relied on contacts he had made during two previous careers in that the Council of Industrial Design provided support and movie mogul J. Arthur Rank furnished the props and fittings on which the goods were displayed. The show harkened back explicitly to Jarvis' Council work by combining the concept of the film *Designing Women* with the popularity of *Britain Can Make It*'s home furnishings section.[49]

Oxford House staff and volunteers from the Community Association installed the exhibition, which as Jarvis wrote in the visitors' guide, attempted to display everything from "carpets to curtain rails and from sinks to

saucepans."[50] He hoped that Britain's most glamorous couple, the Queen and Duke of Edinburgh, would open the show on 4 July 1952, but Court mourning – George the Sixth had died at the start of the year – prevented their attendance. So he once again turned to his Pilgrim Picture days to secure the husband and wife actors Richard Attenborough and Sheila Sim.[51] Their presence at the Gallery gave the Cockneys a rare glimpse of West End glamour.

The more fanciful displays and futuristic products from *Britain Can Make It* had been dropped in favour of a practical arrangement of items in a kitchen, living room, dining room, and bedroom. Didactic panels explained how to recognize good design and manufacture, match colours and textiles, and reuse and adapt old furniture. Even the exhibition catalogue, which Jarvis penned as a comically illustrated personal letter to the newlyweds, captured the spirit of the one that John Betjeman had done for *Britain Can Make It*. While the booklet's tone was relaxed, the author's assertion "that an ill-chosen piece or suite of furniture has broken up as many homes as a bad mother in law" was arch.[52] Whatever subtle differences there were in emphasis and aim between the two shows, *Bill and Betty's* catalogue restated several of *Britain Can Make It's* key themes, like the power that consumers have to dictate their desires to manufacturers. It also steered people who wanted to explore design more deeply to *The Things We See*, the series of books that Jarvis had edited while at the Council. But unlike the way some products in the earlier exhibition were not yet available, *Bill and Betty's* catalogue listed local shops that sold the things on display. East Enders flocked to this show of aesthetics with a practical edge, forcing the gallery to prolong its hours.[53]

The most fertile ground in which Jarvis planted his interest in young people was "social work on modern lines," something he was mandated to encourage as head of Oxford House. This was especially important in Bethnal Green, where tower blocks of flats were replacing the terraced houses that had been destroyed in the war. In the process, residents were pushed out to distant new suburbs, piquing the interest of social scientists, who wondered about the effects of such a massive demographic transformation, which was linked in the popular imagination with a sharp rise in youth crime. This seemed the perfect issue for returning Jarvis to national prominence. He began researching the subject in the autumn of 1951 thanks to a grant from the Carnegie Trust for a survey of the area's working mothers that aimed at determining whether, as was commonly believed, their absence from the home

caused juvenile delinquency.[54] The study was inconclusive, but its results convinced Jarvis that local teachers, doctors, clergymen, and government officials, among whom responsibility for social services was divided, knew so little about one another that it was impossible to set up discussion groups on the problem. Therefore, as an initial, practical step in coordinating these disparate resources, Oxford House published in November 1951 the first ever directory of Bethnal Green's social services.[55]

During this period Jarvis read widely on youth, social work, and juvenile delinquency and collected statistical evidence from sources as diverse as Chicago's Hull House and Scotland Yard.[56] A second Carnegie grant underwrote this research, while a leave of absence from Oxford House allowed Jarvis to spend from November 1952 to the following January discussing the topic with professionals in New York City, Chicago, and Toronto. While ostensibly gathering comparative data, Jarvis used the trip to his personal advantage by lecturing at Hart House. At some point on the trip, he learned that the directorship of the National Gallery of Canada might soon come open. So he went to Ottawa and took his first, discreet steps in lobbying for a job that would use both his love of art and his adult education skills, and would also provide an attractive and stable base from which to launch a Canadian sculpting career. Running the Gallery was a distant dream, but the thought that such a job might come about one day planted a growing desire in Jarvis to return home. More realistically, because Jarvis' Oxford House salary was small, and the law prevented him from taking much money out of the United Kingdom, his mother funded these Canadian detours by "hand[ing] out dollars by the hundred," which cannot have increased her confidence in her son's present career.[57]

Based on what he had learned during the trip, Jarvis reported that whereas British social workers were trained to focus narrowly on specific problems, their North American counterparts tended to be "sentimental rather than objective." He argued that a "middle way" should be staked out in which social workers were recruited for a combination of academic skills and vocation. In a by now familiar adult education technique, he also called for a central coordinating body of experts who would develop and distribute pamphlets on current concerns. This two-pronged approach would bridge academic, practical, and geographical distances.[58] The ideas and coordinating structure

through which they would be implemented were almost identical to the ones Jarvis had developed for the wartime Industrial Discussion Clubs Experiment.

Jarvis expanded his vision of social research activities in a second Carnegie report in the summer of 1953 by setting out concrete ways of marrying Oxford House–type social work with professional research. Citing the London School of Economics, Political and Economic Planning, and Michael Young, with whom he had worked on the Industrial Discussion Clubs Experiment and who had since become one of Britain's foremost sociologists, Jarvis argued that the daily problems faced by social workers prevented them from following academic developments. As such, since "the task of social research, however modest, presents difficulties, to a unit of the size and character of Oxford House, so great as to be insurmountable, then the obvious answer is to admit defeat and stick to practical local work and to training, jobs which this settlement at least is well equipped to do." However, by recruiting formally trained social workers and strengthening links with the universities, Jarvis believed that Oxford House could be transformed into "a living centre in which and from which the researcher can operate." The goal of such an institution would be to help mould a new type of social scientist who would "be most needed in the welfare state of the future," because he or she would be equipped with practical "blunt instruments."[59] The ideas were reminiscent of the abortive work Jarvis had done in 1945 to introduce worker priests to the Church of England.

In a more concrete sign that Jarvis' ideas were rooted in his wartime experiences, Michael Young, who as mentioned previously had also worked on the Industrial Discussion Clubs, was independently mining this same vein. He had secured funds from Dorothy and Leonard Elmhirst and the Rockefeller Foundation to establish an Institute of Community Studies, that was mandated to undertake sociological investigations of East London.[60] In August 1953, Jarvis proposed that Young's group join Oxford House for a year or two in order to create a "workshop" of complementary practical and theoretic resources that could focus on "questions of why one class of people seem capable of solving their own problems while another class seems to always look for help outside themselves."[61] The merger would also fulfill Jarvis' goal of transforming the House into a social research institute and promoting himself as one of the national leaders in this burgeoning field. At the start

of September, Young and Dorothy Elmhirst visited Bethnal Green to discuss the plan, but it foundered when the Oxford House council refused the merger and instead agreed only to rent space to the Institute, of which Jarvis became treasurer.[62] The blow was followed almost immediately by the Carnegie Trust's decision not to renew Jarvis' grant. It was clear that Oxford House would never become an important social research institution.[63] Nonetheless, soon after taking up residence, Young and his team embarked on a three-year study of life on East End council estates that is a classic British sociological text.[64]

Even if Oxford House had evolved along Jarvis' ambitious lines, he was already preparing to leave. From his 1952 Canadian trip onwards, his letters show a deepening, well-reasoned desire to return home. He also intimated to family and friends, including the dean of Westminster, that the trip had "underlined" his decision to go back to Canada permanently. Jarvis' feelings were strengthened by the death of Sir Stafford Cripps, Labour's failure, his widowed mother's pleas and the possibility of heading the National Gallery. Because such a move could not be made immediately, Jarvis pulled away from the House little by little, by giving up his small salary in September 1953, and handing an ever greater number of daily duties over to Peter Duke. At the end of the year, he told the Oxford House Council of his intention to resign in the coming autumn.[65] He seemed very self-confident and capable of appreciating all that he had accomplished, for as he told his mother at about this time "what a terrific amount has happened in 10 years – in [19]43 I was a very obscure industrial psychologist and that year met Stafford and everything changed. I still can't get used, in this big city, of being introduced as 'the' Alan Jarvis. It's been a funny life, but a fairly productive one for these ten years and I do owe so much to the Cripps for all their support."[66]

So the decision to leave Oxford House was not precipitate. As we have seen, Jarvis took the post in 1950 out of interest in the work, a belief that it could return him to national prominence, and a sense that it would allow him to simultaneously pursue a couple of new career paths. While Jarvis himself was very confident, these outside activities worried his mother, Stockwood, and Isobel, who had hoped that concentrating on his duties at the House would give his life order and structure. Instead, they fretted about whether another period of dissipation was beginning.

This was not immediately apparent as the income generated from sculpting, writing, and broadcasting supplemented the small honorarium that

Jarvis earned at the House and eventually raised his income to about what he had been making since the war. Outside endeavours also heightened Jarvis' profile in artistic circles and re-established him as a dashing man about town. He spent many evenings at glamorous parties and premieres, appeared in the society magazine *Tatler*, and was elected to the Athenaeum, Britain's most intellectually prestigious gentleman's club.[67] He saw Hi and Stockwood sporadically, but met yet another father-brother substitute through the gay community that was centred on the Covent Garden opera. He was Burnet Pavitt, a wealthy businessman, Royal Opera House board member, and eminence grise of the London arts scene. Jarvis spent many weekends at Pavitt's estate outside London, chopping trees and listening to his host, who was a very accomplished pianist, and other visiting musicians. Another of Pavitt's frequent guests was the immensely popular young contralto Kathleen Ferrier, whose sudden death in 1953 cemented Jarvis' romantic attachment to her singing.[68]

As we have seen, Jarvis had become a director of the Group Theatre just as he joined Oxford House. The Group sputtered along for three years, hosting cocktail evenings and readings of plays in theatres, private homes, and institutions.[69] By contrast, the Mermaid Theatre, to whose council Jarvis was elected, kept growing. The Norwegian diva Kirsten Flagstad and the actor Bernard Miles, with whom Jarvis had worked at Pilgrim and Oxford House, founded this company in the garden of Miles' London home in 1951. Flagstad launched the venture with seventeen performances of *Dido and Aeneas*, and Jarvis made a bust of her for the theatre's foyer the following year.[70] As Janet saw during her 1951 trip to London, these theatre jobs were glamorous, but time-consuming and paid little to nothing. At the end of the year, she warned her son not to neglect his duties at the House. He responded by reassuring her that he was dividing his time "very carefully and giving almost none to the Group Theatre and absolutely none now to the Mermaid and certainly no money to either!"[71]

More than anything, sculpting was the focus of Jarvis' energies outside of the House as well as his greatest source of income and personal satisfaction. He relied on charm, self-promotion, and a network of friends in and out of the art world to find commissions for which he charged between £200 and £400. As was usual, he boasted to friends that he secured these jobs by telling potential sitters, "For 500 guineas I'll do you as you are. For 1000 I'll make you look handsome. For 2000 I'll make you look honest."[72] The impish tone was

pure Jarvis, even if he inflated his prices for effect. Nevertheless, he soon built a reputation as a reliable artist. The Wildenstein Gallery, one of the world's foremost dealers, became his agents, while friends like the Mayfair gallery owner David Gibbs also sent him clients. Isobel Cripps ordered a bust of Sir Stafford, which Jarvis hoped would be used as a national memorial.[73] Even Janet Bee was pleased. During her trip to England that year, she realized, as she had done after Colin's death, that sculpting helped Jarvis deal with emotional crises. So she was cautiously supportive and made him an artist's smock for Christmas in 1951.[74]

Jarvis responded to this encouragement by completing seven portraits over the winter – which he declared to his mother moved him "out of the amateur and Sunday sculptor class" – and by the spring he was working in pewter, a material he had not touched since adolescence.[75] During the rest of the year, he did a portrait of one of the editors of the *Observer* newspaper, the artists John and Myfanwy Piper, and, thanks to his New York friend Fanny Myers, one of the editors of *Time* magazine.[76] Jarvis' career hit its stride in 1953 when he entered a figure of a dancer in the Royal Academy show, sculpted an aristocrat, and made portraits of an Irish family at their country estate.[77] When his friend the dealer David Gibbs married that summer, Jarvis sculpted the bride. Gibbs reciprocated by taking over as Jarvis' agent.[78]

Jarvis initially fit sculpting work around his duties at Oxford House, but he began working part-time at the House in September 1953 in order to devote three days per week to art. The decision to relinquish the tranquil stability of the House and to launch himself more fully into such a "precarious" occupation revived the worries that Jarvis' mother had so recently put to rest. In response to her fears, Jarvis pledged that he would be more than a simple sculptor, as would be demonstrated by the show he wanted to have before leaving England.[79] Jarvis' prominence in his new craft was signalled in October when he was elected to the Royal College of Art, an exclusive club in which he could dine and socialize with fellow artists. Belonging to the College also allowed Jarvis to reassure his mother that he would not exchange Oxford House for the life of a starving artist.[80] Membership in the College was an acknowledgement of Jarvis' talent, but his mother continued to worry that a lack of daily structure and routine would harm him. In early 1954 she confronted him by suggesting he join Alcoholics Anonymous, a support group that already had several Toronto branches. In a refrain that is all too familiar

to those attempting to help an addict, Jarvis dismissed this as a teetotaller's overreaction, joking that "smokers anonymous" would be more useful, before pledging to his mother that he would give up drink, some day.[81]

Her fears were not immediately realised, as commissions followed apace and seemed to be leading Jarvis back to Canada. In late 1953, the *Montreal Star's* publisher, John McConnell, hired Jarvis to sculpt Cyril James, the chancellor of McGill University.[82] The following year Jack Keeling, with whom Jarvis had worked at Pilgrim Pictures, arranged for him to do a portrait of the Anglo-Canadian industrialist Sir Eric Bowater, which evolved into an £800 commission for two giant portrait medallions for the prows of company ships.[83] Such well-paid jobs convinced Jarvis that sculpting could bridge the distance between London and Canada, a possibility he explored through a network of friends and acquaintances on both sides of the Atlantic.

Jarvis hoped to lay permanent foundations for a Canadian career during an August 1954 trip to Toronto, the ostensible purpose for which was to present a paper on "mental health in community organizations" at an international conference.[84] In fact he did not intend to spend much time in academic surroundings, preferring to meet with the "VIPs" he wished to sculpt. Before leaving he assembled a portfolio of his work that he called his "travelling sales book," which he was going to use to entice Canadian sitters.[85] Keeling also gave Jarvis an introduction to the Montreal financier Isaac Walton Killam, while the prominent Canadian lawyer Leonard Brockington opened Samuel Bronfman's door.[86]

Jarvis met McConnell in Montreal and oversaw the unpacking of the James bust at McGill before heading to Toronto. There he attended the conference, told the Rotary Club about his English career and saw Rik Kettle, who had helped to found the Picture Loan Society in the 1930s and was now a business executive. Jarvis hoped that Kettle, whom he had not seen in several years, might put him in touch with Canadian customers. The trip led to a couple of commissions, though, as Jarvis discovered, restrictions on exporting currency would make it hard for him to bring his Canadian earnings back to England.[87]

The visit thus taught Jarvis that if he was going to sculpt Canadians, he had to settle there. Much as she wanted her son to come home, Janet aired her fear that there was a very limited Canadian market for such services. Jarvis agreed in part: "[Janet was] perfectly right [to be sceptical] about anyone in

their right mind wanting to be just a sculptor in Canada (I decided that one at about 17 before I went to the University) but I decided this last trip or two that old Rhodes scholars don't have to worry too much, whether in Ottawa, Toronto or Montreal! I do *not* think that a conceited remark either."[88] Outward confidence reflected Jarvis' hope of finally living off his artistic vocation, in his homeland.

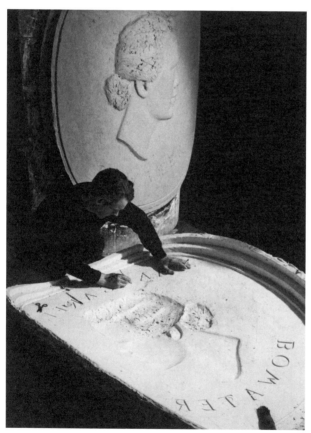

Jarvis sculpts one of the Bowater medallions, 1954.
Alan Jarvis Collection, University of Toronto.

Radio and television broadcasting provided a second prominent, if slightly less profitable career. BBC producers felt that Jarvis was a "very pleasant and presentable character," and paid him fifteen or twenty guineas – the choice of currency indicating that this was gentleman's work – per appearance.[89] They also knew that Jarvis could speak confidently and eloquently on subjects ranging from a two-minute interview about Oxford House, to taking part in a panel that selected the best scripts written by young people, or simply reminiscing about his voyage from the film world to social work.[90] Given his long experience with adult education, discussion programs were Jarvis' forte. Between September 1952 and May 1954, he appeared on six episodes of *Question Time*, in which a panel of experts were grilled by a live audience on such topics as "Where is science leading us?" and repeated instalments on teenagers under the title "The Younger Generation."[91] He twice hosted transatlantic versions of the program, whose producers instructed him to lead the panel, "intervene and to contribute, in particular on your film experience," and to begin "turning the tables" on the experts at the halfway mark.[92] As Jarvis boasted, "it is the easiest way I know of earning £15. You don't even have to write anything. Just sit in front of a microphone and be bright."[93] He continued with the BBC's International Service by twice appearing on Alistair Cooke's *Transatlantic Quiz*, in which panels of experts in New York and London answered questions about one another's countries.[94] This was followed by appearances to discuss the *Bill and Betty* exhibition, the Commonwealth, and film censorship.[95]

Other responsibilities filled out Jarvis' days. He collaborated on an official biography of Sir Stafford Cripps, published a short book on furnishing, and thought about becoming a full-time author.[96] In early 1954, he was appointed North American director of a fundraising appeal for the restoration of Westminster Abbey. This took him to Manhattan in May, where he recruited Morris Ernst, Pilgrim Picture's one-time American lawyer. They met with donors privately, while Jarvis publicized the appeal through a series of lectures. At these he talked about the Abbey's deteriorating roof, while joking in private that the most effective way to get Americans to open their wallets was to dangle the possibility of a knighthood before their eyes. The tongue in cheek tactic was illegal, but effective.[97]

Just as Isobel Cripps and Mervyn Stockwood had hoped when encouraging Jarvis to take the job, his confidence and optimism was boosted by the work at Oxford House. Even though Jarvis was unable to control his drinking for long during this period, he was more content than he had been for several years thanks to a supportive environment that nurtured his social research while also giving him enough free time to pursue activities like sculpting and broadcasting that filled his pocketbook and boosted his public profile. From mid-1953, he lived for part of the week at 3a Sydney Close, where he sculpted. Jarvis' playfulness returned with his contentment. He did not own a car, and so made the crosstown journey between Oxford House and his studio by bus, amusing himself along the way with a little game. The route passed many of London's most important monuments and imposing buildings. Jarvis and a friend would sit atop the double decker making exaggerated and nonsensical, but seemingly learned statements about the buildings they saw or the activities that took place within them. A triumph was scored if the pair heard other riders repeating the information.[98]

The most unexpected thing about Jarvis' time at Oxford House was the romantic relationship in which he gradually lowered the emotional barriers that lovers and friends had found so difficult. He first alluded to the reason for his growing contentment by declaring in an otherwise unremarkable March 1952 letter to his mother, "I've got some very good new residents [at Oxford House] including a very nice Canadian schoolmaster from Vancouver."[99] This was the first time he mentioned Norman Hay, an affable, tall, dark-haired twenty-seven-year-old who had left a teaching career in British Columbia to become a designer in London. He had arrived in London in 1951 with an introduction to Jarvis, about whom he had heard legendary stories. Jarvis, who winced at the number of Canadians sent to him, was cool and remote at their first meeting, but Hay was intrigued by this man who "was very glamorous and he seemed to me to be kind of key to a world that I wanted very much to experience." More than two decades later, Hay laughed, recalling how his suspicions were justified by a visit that was continuously interrupted by telephone calls from celebrities like the photographer Cecil Beaton. As with so many others, Hay employed superlatives to describe Jarvis

Norman Hay at about the time he met Jarvis, c. 1952.
Alan Jarvis Collection, University of Toronto.

to the friend he was staying with. Hay felt he had encountered "the most intelligent, the most charming, the most beautiful, the most talented, the most phoney person I've ever met."[100] But Hay also saw through Jarvis' grand persona to find an attractive, charming, and witty man who "played his sexuality with ease," something he himself was striving to do.[101]

Hay was a garrulous raconteur, who was happily bouncing through a series of jobs that included selling furniture and Christmas toys and performing in, of all things, a square dance troupe. Like Jarvis, he was physically beautiful and witty. Their sexual relationship began in the autumn of 1952 and carried on through the winter as Hay posed in his new lover's studio. Once Hay settled into teaching in an East End school, he frequently visited Oxford House and eventually became one of its residents. The phoniness that he had detected on first meeting Jarvis became increasingly charming as Jarvis hinted constantly about the famous and important people who sought his

advice. Hay and Susan Allison (Jarvis' secretary at Oxford House) bonded in bemusement at Jarvis' name dropping, which they knew was an endearing indicator that behind this illustrious persona was a fundamentally kind and insecure man. It took many years before Hay realized that Jarvis' fascination with celebrities was a psychological prop by which he tried to measure himself with his deceased brother.[102]

Hay and Jarvis were soon spending most of their time together. Jarvis was very comfortable with Hay and let down many of his emotional barriers as he committed himself to the relationship. But it was a struggle, as one day in the Sydney Close studio Hay declared that he loved Jarvis, whose rather cold and unemotional response was "I accept the responsibility for that."[103] Nevertheless, the relationship deepened as the two men attended various cultural events, and travelled in Britain. They were almost certainly not monogamous, but had become so attached to one another by the spring of 1954, that when Jarvis and two male friends took the classic gay men's holiday in Morocco, where they stayed with David Herbert, the aristocratic social maven who was known as the "the Queen of Tangier," Jarvis sent a postcard to the Sydney Close studio with the simple message "I long for 3a and NH."[104]

Jarvis used only Hay's initials on this missive, because their relationship had evolved against a sharp rise in criminal prosecutions for homosexual offences. The trials, convictions, and sentencing of prominent men like the actor John Gielgud, the novelist Rupert Croft-Cooke, and Lord Montagu of Beaulieu fascinated the public, while tabloid newspapers sought to expose "hidden" homosexual cells.[105] Like many gay men, Gielgud was caught soliciting sex in a public lavatory. Croft-Cooke and Montagu were convicted of "cottaging," or meeting discreetly in a private residence. Cottaging traditionally carried less risk of arrest, but the new emphasis on uncovering and prosecuting this behaviour placed significant pressure on gay men to conceal or deny their sexuality. There is no evidence that Jarvis was ever targeted or felt threatened, but he had cottaged with lovers since arriving at Oxford, belonged to a prominent homosexual artistic circle, and most riskily of all, lived relatively openly with another man. He and Hay had to be extremely discreet.

The relationship was further complicated by one another's bisexuality. Jarvis had thought seriously of marrying on a couple of occasions. Hay was perhaps less sure of his sexual identity. At some point, he met Audrey Fildes, the beautiful dark-haired actress who had appeared in Jarvis' film *Designing*

Women, but who is best remembered as the vengeful, disinherited mother in the 1949 comedy masterpiece *Kind Hearts and Coronets*. She and Hay began dating while he was involved with Jarvis. The trio seem to have accepted this rather complicated emotional arrangement, and Jarvis was the best man at their January 1955 marriage.[106]

The wedding's timing suggests it facilitated the newlyweds' departure for Ottawa where Jarvis had arranged an exciting new job for his friend. Almost a year earlier, Donald Buchanan from the National Gallery of Canada had asked Jarvis to recommend someone to help set up the institution's industrial design division. Buchanan clearly hoped that Jarvis would put his own name forward. The two men had known each other slightly for years; it was Buchanan who had arranged for Jarvis to discuss design issues with senior government officials in Ottawa in 1946. Buchanan also knew that Jarvis had started lobbying for the directorship of the Gallery, a post he himself hoped to fill. If Jarvis accepted the design job, he would be ruled out of the other competition, while Buchanan, the obvious internal candidate, would gain an associate with impressive industrial design qualifications. Jarvis' mother urged him to take the job and come home, but he aimed to head the institution, and informed her that the offer was "too poor pay for *me*. I *might* consider Don's [Buchanan] job, but nothing less."[107] Instead, he convinced Buchanan to hire Hay, based on the latter's talent for design and contributions to the *Bill and Betty* exhibition. This was not an entirely altruistic action, because by the time of Hay's wedding, Jarvis was almost certain that he himself was also heading to Ottawa, as director of the National Gallery.

There was remarkably little friction between Jarvis and Hay as their physical relationship ended, in part because Jarvis was also thinking about marrying. He and his childhood sweetheart Betty Devlin had corresponded intermittently over the years. Their romantic attachment had ended when they were undergraduates, as Jarvis and Douglas Duncan became lovers and she met a young mining engineer named Charles Kingsmill. Betty and Charles had married soon after graduation and moved to northern Ontario, where he was killed in an accident in 1948, leaving her with three children. Jarvis rekindled their friendship on his regular trips home, and by the early 1950s he and Betty were very close, though they had not talked explicitly of marriage.[108]

By 1954 Canada was beckoning for personal and professional reasons, but England would not let go of Jarvis so easily. Early that year, the government

asked Jack Keeling, Pilgrim Pictures' first financial backer, to reorganize the British film industry. He and Isobel Cripps tried to draw Jarvis into the venture. Jarvis reported to his mother that Keeling "could think of only one man in the UK who could boss the new show. ME! Would I consider the job? NO Would I consider it, just supposing I didn't get what I wanted in Canada … WELLL … very interesting dialogue, eh? I wouldn't want to go back to the slaughterhouse, but how very flattering."[109] Jarvis' mother, to whom he confided these thoughts, must have been alarmed that her son would be lured back into the movie industry from which he had emerged with such difficulty four years earlier. She need not have worried, however, as Jarvis was cautious about heading down that road again and only agreed to join a small team that held infrequent and inconclusive meetings throughout the autumn.[110] The film world held so little appeal because Jarvis was determined to return home.

"A Museum without Walls"
The National Gallery of Canada, 1955–1956

Canada had changed significantly in the thirteen years that Jarvis had spent in England, thanks in no small part to the Second World War. Just over 1 million Canadians – about one tenth of the population – served in uniform between 1939 and 1945. In order to equip the forces and steward an expanding and diversifying national economy, experts were lured from the private sector to the civil service, which tripled in size. At the same time, the country was drawn more closely into the American orbit through cooperation in defence, strategy, and the development of the atomic bomb. At war's end, returning men and women were reintegrated to civilian life through a comprehensive series of social benefits, known as the "Veterans' Charter," that helped urbanize Canada and laid the basis of the modern welfare state. At the same time, immigrants from shattered European nations poured into this surging and confident country, changing its ethnic and linguistic makeup and further loosening the cultural ties to Britain. Nothing symbolized the dawning era better than the 1948 retirement of Prime Minister William Lyon MacKenzie King. He had entered the House of Commons before the First World War and led the country for almost all of the previous twenty-five years. Hopes of power passing to a younger generation were scuppered when King was replaced as Liberal leader and prime minister by the elderly and avuncular Louis St-Laurent.

The city of Ottawa belied these changes. Giant booms of pine logs floated under Parliament's windows, much as they had done since Yankee lumbermen had first settled at the confluence of the Ottawa, Gatineau, and Rideau rivers a century and a half earlier. The area had assumed strategic importance in the 1820s as the entry way to a canal providing a safe route between Montreal and the Great Lakes. A town then gradually emerged on a neat grid of streets along the canal banks until it was chosen by Queen Victoria to be the national capital in 1858. By the time Jarvis arrived, a perceptive pedestrian strolling along Wellington Street, Ottawa's most important thoroughfare, could take in an architectural panorama of Canada's past. The east end was anchored by the French romanticism of the Chateau Laurier Hotel and the railway station's classical portico that attested to the train's importance in opening up and binding the country. Imperial solidity was symbolized by Parliament's gothic arches, in the shadow of which stood the 1930s modernism of the Supreme Court and Bank of Canada, institutions that vouched for more recent juridical and financial autonomy. Nestled among these stone structures, and elsewhere throughout the city, were acres of wooden "temporary buildings" that had been thrown up during the war to house the expanded civil service – Ottawa's main employer.

The city's post-war aspirations were embodied in the civic improvements overseen by the Federal District Commission. Its Baron Haussman, the French urban planner Jacques Greber, was hired in 1945 to turn this upstart lumber town into a city that was, in Mackenzie King's words, "worthy of Canada's future greatness."[1] From his Paris studio, Greber directed a team of Canadian architects, who reported in 1950 that industry and railways should be banished from the city core and replaced with boulevards, parks, and monumental public buildings, among which would be a new National Gallery.[2] Despite these grand designs, by the time Jarvis arrived the city could not boast a first class concert hall, let alone a professional theatre company or symphony orchestra. The National Library had only just been established, while higher education was provided at a century-old Catholic, Francophone university, and Carleton College, a small liberal arts institution that had opened during the war to offer courses to civil servants and military personnel.

In 1955, Ottawa's population was about 200,000, or three times smaller than Toronto, and five times less than Montreal, Canada's biggest city. The capital's more cosmopolitan residents were keenly aware of this diminutive

stature. The urbane, Oxford-educated diplomat and diarist Charles Ritchie, who gravitated towards London's literary circles, wrote in 1952 that Ottawa's population was "mewed up, like the animals in the ark," and especially on Sundays when smothering Sabbatarianism prevented much from happening.[3] Five years later, Ottawa native Norman Levine, who had lived in England since the war, made a short trip home in which he wrote caustically that the city had an aura of "nothing important really happening, of indifference, dullness, and boredom" caused at least in part by the mundane concerns of unimaginative civil servants.[4] And, on the eve of Jarvis' return, his lover Norman Hay, who had already settled in Ottawa, reported it to be "quite the ugliest city I've *ever* seen."[5]

Calvinistic austerity and lack of social amenities concealed two decades of dynamic achievement by the civil service. Originally an instrument for rewarding political cronies, the civil service had professionalized between the wars as Canada assumed ever greater control over international and domestic affairs. In 1925, Oscar Skelton, a professor of political science at Queen's University, was appointed undersecretary of state for External Affairs, an extremely powerful post he held for sixteen years. He recruited a mandarinate of young men who oversaw national development. If Skelton was the group's professional head, then its spiritual leader was Vincent Massey, whose patrician demeanour was leavened by ideas that he had imbued at Balliol College about steering the best young minds towards public service. This idealistic group had generally pursued graduate degrees at Oxbridge, the Ivy League, and a handful of other elite institutions. Most of them found that international experiences heightened their sense of Canadian identity, and on returning home the civil service offered opportunities to implement the ideas they had absorbed abroad. Their political affiliations ranged from Tory to socialist, but were disguised by a uniform of tweeds, flannels, college ties, and Savile Row tailoring. They lived near one another in Ottawa's leafier neighbourhoods, lunched at the Chateau Laurier Hotel, gossiped over afternoon drinks on the veranda of the members-only Rideau Club, and weekended at the even more exclusive Five Lakes Fishing Club.[6]

By the mid-1950s, such professional and social opportunities had lured seventy-five Rhodes Scholars to Ottawa, a significantly larger group than could be found in any other Canadian city.[7] Three of them had gone to Oxford in Jarvis' year; Gordon Robertson was a fast-rising deputy minister,

Edgar Ritchie was a senior diplomat and Davie Fulton was an energetic Conservative MP whom many commentators tipped as a future prime minister. These men socialized and networked through the Ottawa chapter of the Canadian Rhodes Scholars Association, which was headed by James Gibson, a former secretary to the prime minister and history lecturer at Carleton College. Jarvis' many visits to Canada, and especially to Ottawa, in the decade after the war had convinced him that he could rely on this network of well-placed men once he returned home.[8]

It is harder to write a similarly triumphalist history of the National Gallery, which had been founded in 1880 under the patronage of the governor general, the Marquis of Lorne, and his artistic wife, Princess Louise. The Gallery had few staff, a tiny budget, and was housed successively in a hotel, alongside the Supreme Court, and above a fish-breeding exhibit. Its two or three rooms filled up gradually with diploma work from the Royal Canadian Academy and a few modest purchases, while the municipal galleries of Toronto and Montreal, which benefited from the largesse of socially ambitious businessmen, had incomparably better collections.

Things began brightening in 1907 when a small Advisory Arts Council was empanelled to oversee the Gallery and three years later Eric Brown was appointed its first full-time curator. Though Brown had only emigrated from England a short time earlier, he had already worked for the Montreal Art Association and the Art Gallery of Toronto. He was a dynamic head, who was responsible for the Gallery's early growth. In 1911, the Gallery moved to a suite of rooms in the Victoria Memorial Building, a Scottish baronial castle that loomed over the south end of Ottawa and also housed the Geological Survey's collections of fossils and rocks. The institution took on truly national ambitions in 1913 when the first *National Gallery Act* charged the board of trustees with "the encouragement and cultivation of correct artistic taste and Canadian public interest in the fine arts," promoting the arts generally, and staging exhibitions. To meet these objectives, Brown set up a modest system of extension services, while using almost the entire operating grant to purchase new works. Progress halted abruptly when the Centre Block of Parliament burned down in early February 1916, forcing the House of Commons to decamp to the Victoria Building.[9] In a single weekend, the Gallery was packed away into storage, where its collections remained for five years. The ever

resourceful Brown took this as an opportunity to initiate a program of travelling exhibitions in 1919.

The Gallery's early momentum did not return immediately once the collection had been unpacked in 1921, but Brown increased the institution's staff, budget, and influence little by little. In 1922 he hired as his assistant Harry McCurry, a statistician in the Department of Customs, and four years later lured the young English scholar Kathleen Fenwick to Ottawa to start the print collection. Contracts were also signed with European advisors, who looked for art that the Gallery could afford. Though Brown's tastes were never particularly *avant-garde*, he was one of the very first people to recognize the genius of Tom Thomson, the Group of Seven, and Emily Carr. His support for these artists drew protests from academicians who believed the Gallery was primarily a repository for their works. Tensions erupted most notably over the selection of canvases for the 1924 British Empire Exhibition. Brown was not shaken by the calls for his resignation and concentrated on expanding his institution's extension services, with lecturers, films, and postcard-sized reproductions of Gallery works. The number of visitors increased substantially over the years, and though a permanent home was discussed time and again, every project was aborted. The Gallery's evolution was virtually halted by the economic crisis of the 1930s, during which its annual acquisitions budget declined to as little as $5,000.[10] Only the most modest works could be acquired with these sums.

Eric Brown died suddenly in April 1939. Prime Minister King, who had little if any interest in art, was preoccupied by the impending war and so he took the expedient step of promoting his friend, and Brown's long-time assistant, Harry McCurry. He proved extremely able, steering the Gallery through such brutal budget cuts that by 1941 there was no money for purchases. Even if funds had been available, quorum could not be achieved for a single meeting of the board of trustees between December 1939 and October 1946.[11] The trustees were simply preoccupied by the war. Like his predecessor, McCurry made the best of his situation by meeting with artists throughout the country, and heading the Carnegie Foundation's program to train Canadian museum professionals. In 1943 he used Carnegie money to hire Walter Abell, the Acadia University art scholar who had founded *Canadian Art* magazine to develop the Gallery's extension services.[12] As we have seen, McCurry

had been in charge of the Gallery for a little over six months when Jarvis, on his return from Oxford, enquired about starting up a war art program. Though McCurry had turned down Jarvis' suggestion, and also refused to award him a Carnegie grant, the Gallery eventually launched a project in which reproductions of contemporary Canadian works and iconic images were distributed to military barracks.[13]

The National Gallery's plight did not prevent a couple of important wartime developments in the arts in Canada. First of these was the June 1941 Queen's University gathering of about 150 artists, administrators, and teachers who had long envied the funding available for American New Deal arts projects. The so-called Kingston Conference – the first such meeting of Canadian artists – was envisioned as a "kind of weekend house party" under the aegis of the Carnegie Foundation. American arts administrators spoke about their experiences in hopes of making the event a forum in which Canadians "suggested, gained tacit approval for, and began to implement strategies to bring about a permanent relationship between artists and the state."[14] The Federation of Canadian Artists, the country's first cultural lobby group, was founded at Kingston under a small executive that included Rik Kettle, who had established the Picture Loan Society with Douglas Duncan.[15]

The Federation was one of sixteen groups that gathered in Toronto in May 1944 to develop a comprehensive cultural brief for the parliamentary Special Commission on Reconstruction and Re-Establishment. Participating bodies hoped that a coordinated appeal from the arts community might induce the government to include culture in post-war planning. Some of the core ideas had esoteric roots, like Lawren Harris' quasi-spiritualist call for seventy-five "cultural community centres," comprising galleries, libraries, and auditoriums, to unite an ethnically, linguistically, and geographically diverse country. At the same time, demands for a *dirigiste* federal ministry of arts sailed too close to the cultural control exercised by the fascist regimes with which Canada was at war.[16] These disparate impulses were distilled into the comprehensive, pragmatic argument that Canadian industry would flourish with better designed products. National identity would be enhanced by a federal body funding and directing the arts, a concomitant national adult education program, and an exposure to international artistic currents by tying culture to foreign relations. The vision required an enhanced National Film Board, Canadian Broadcasting Corporation and, most importantly, a National

Gallery working under an explicit mandate to coordinate country-wide activities.[17] Newspapers across the country embraced these ideas, and some advocated that the proposed cultural centres should be war memorials, in which European art would be exhibited to show the culture and civilization for which Canadians had fought and died.[18] Others wanted the arts included in veterans' training programs in order to ensure that wartime innovation and creativity carried over into the peace. Politicians were most taken with the argument that the arts could help to unify the country by fostering a distinctly Canadian national culture.

Commission members seemed enthusiastic about both the presentations and the submissions they received in June, and the following month the minister of Public Works announced that a new National Gallery would be erected after the war.[19] As it turned out, government interest soon flagged and the Gallery remained in the Victoria Building, while McCurry stayed on as director. Nevertheless, he accomplished a great deal with a small staff and limited budgets. The collections increased in size and importance. In 1948 alone, the Gallery was given the McCallum collection of works by the Group of Seven and Tom Thomson, Vincent Massey donated over 100 canvases by modern British artists, and it purchased a group of top-notch Cézannes. An industrial design division, about which Jarvis had advised the government, was inaugurated under Donald Buchanan in 1948. The division promoted good design through awards and a national index as a concrete reflection of the arguments made to the Reconstruction Committee. Its programs grew in importance as Canadian industry flourished in the post-war boom, though there was no permanent exhibiton space and Buchanan's staff occupied cramped quarters at the Gallery and elsewhere.[20]

A national cultural program along the lines of the presentations to the Reconstruction Commission gradually resurfaced in the government's imagination. Renewed interest was shaped largely by Vincent Massey, who had written and spoken at length about Canada's vulnerability to American cultural domination, since returning from London in 1946. Massey could speak freely because he was no longer Canadian high commissioner, but he needed a public office in order to lead a wider cultural campaign. To create a role that reflected Massey's influence, his supporters in the Liberal Party campaigned for the establishment of an official investigation into the state of Canadian culture. Their efforts bore fruit in 1949, when the government empanelled

the Royal Commission on National Development in the Arts, Letters and Sciences, under Massey's chairmanship.[21] Few Canadians had such a sophisticated knowledge of the interrelationship between government and culture as Massey, who now had a body through which to achieve his aims.

Over the following months, Massey and his fellow commissioners held some 200 meetings across Canada in which they heard presentations from over 400 institutions and interest groups. As the commission's historian pointed out, the National Gallery was one of several federal cultural institutions that came under the commission's lens, because there was a wide consensus that they required reform to adequately serve modern Canada.[22] These hearings galvanized Canada's cultural elite into something of a sustained arts lobby and so the 1951 *Report of the Royal Commission on National Development in the Arts, Letters and Sciences*, popularly known as the "Massey Report," was a watershed in Canada's cultural development. It included an overview of the country's arts and a series of recommendations for the future. Most importantly for Jarvis, the report stated that of all cultural institutions "the National Gallery has perhaps the most universal appeal, and has certainly achieved the widest contacts with the Canadian public." The commissioners then called explicitly for a Gallery budget that would allow it to acquire a representative group of Old Masters, champion Canadian art, hire more staff, and erect a permanent home in which to display its collections. In order to carry out this ambitious program, the commission recommended that the Gallery's legislation be rewritten and that it report to Parliament through a specific minister.[23] This call to increase the Gallery's role was not surprising, given that Massey had been one of its trustees since the 1920s and had chaired the board since 1948.

By 1951, the increasingly strident arts lobby, the Greber plan, and the Massey Report had all concluded that an expanded National Gallery was a key component of Canada's cultural development. As a result, soon after the report's publication, the government decided to make the Gallery the centrepiece for a series of far-ranging initiatives. Because these could not be accomplished under existing legislation, creating a new *National Gallery Act* was the first step in achieving this dream. Under this December 1951 law, the Gallery was transferred to the "control and supervision" of the catch-all department of Citizenship and Immigration, the board of trustees was increased from five to nine members in order to ensure regional representation, and

the institution's mandate, to promote interest in the arts and "applied and industrial design," was given an equally national scope.[24]

No sooner had these changes been made than Massey resigned from the board of trustees in February 1952 on his appointment as the first Canadian-born governor general. His enthronement appeared to legitimize an elitist, Liberal vision of the Canadian state and signalled that culture was one of the government's prime concerns. However, as the Queen's personal representative, Massey could no longer lead a cultural campaign. Even if he had been free to champion such an undertaking, Massey was preoccupied with redefining his post and dispelling public perception that he was an Anglophile snob. To do so, this small, skeletal man, who invariably wore a sober Savile Row suit and homburg, travelled more often and widely than any previous governor general. He visited cities, towns, and hamlets throughout the country, telling everyone from school children to senior citizens about the Crown's role and national identity.[25]

Despite many recommendations, a great deal of rhetoric, and some action, the National Gallery was still bursting out of its quarters in the Victoria Memorial Building. Exhibition rooms were partitioned to make offices, and there was no place to house the industrial design division. The lack of space crystallized demand for the new Gallery that had been promised in 1944. In November 1951, Prime Minister Louis St-Laurent authorized a formal architectural competition under the chairmanship of the American modernist Eero Saarinen.[26] Over the next year, Saarinen's committee evaluated more than 100 designs for a Gallery that would stand, as the Greber plan had indicated, on Cartier Square in the heart of downtown.[27] Partway through the process, it became clear that the site, which was occupied by the Department of National Defence, was unavailable, and so the finalists were told to modify their designs so that the building would fit a much smaller plot at the foot of Sussex Street.[28] A Winnipeg firm was chosen in early 1954, but the Federal District Commission, the government body charged with beautifying the capital, almost immediately began re-thinking the Gallery's location. Through the summer and autumn, Harry McCurry lobbied for either Sussex or Majors Hill Park, in the shadow of Parliament, because he sensed that the project would die if an alternative to Cartier Square was not found.[29] When it became clear in February 1955 that no suitable sites were available, federal and local officials decided to erect an office building on Elgin Street, one of the

city's main arteries. It was foreseen that the Gallery would be housed here for a decade or so. As a concession to art, the building would be named after the Gallery's founder, the Marquis of Lorne.[30]

One of the pressing reasons for a new Gallery building was to house the fruits of the ambitious acquisition strategy that marked McCurry's directorship. Just after the war, McCurry devised an innovative response to the Gallery's financial neglect, wherein Canadian funds that were blocked in Europe could be used to purchase works of art.[31] By allowing the Gallery access to money that could not otherwise be withdrawn from foreign accounts, the government could buy art without having to increase the institution's purchase budget. This was a politically delicate initiative because, as McCurry confided about one transaction to the British art historian Anthony Blunt, the government was "very anxious *not* to appear to be depleting the cultural heritage of the Netherlands to balance war accounts."[32] McCurry's scheme trained the Gallery's eyes on Europe in order to spot the few such opportunities that might present themselves. Eventually, McCurry focused on the tiny alpine principality of Liechtenstein, whose ruling family owned vast estates throughout central Europe. Vienna had been their main residence until the Nazi Anschluss had forced them to flee with their treasures to a mountaintop castle at Vaduz, the capital of their neutral principality. The armistice saw the Soviets annex most of the family's eastern lands and threaten to seize Austria and Liechtenstein itself. With the security of his aerie threatened, in the late 1940s Prince Franz Josef began looking to shelter significant assets abroad. His most valuable and easily convertible possession was his art collection, which as head of state, he had an unfettered right to sell and export. It is important to understand the details of the relationship between the prince and the Gallery, because it would prove to be pivotal for Jarvis' career and personal life.

The National Gallery of Canada had known about this fabulous collection since a visit by Eric Brown in 1927, and his annotated catalogue remains in the institution's library. The Gallery's next contact with the collection came in January 1950 when trustee Cleveland Morgan looked over the prince's works. The timing of Morgan's trip makes it clear that the trustees had heard the murmurs in the international art scene. These were confirmed in the spring of 1951 when the ruling family began whispering about exhibiting their paintings in the Americas in return for assurances that they would retain complete

ownership in the event that the Soviets annexed the principality.[33] Seizing on this development, the trustees authorized McCurry to investigate the possibility of purchasing some or all of the Liechtenstein paintings, while noting that because their prices would be so far and above anything yet spent on art by a Canadian institution, blocked funds could not be used. Any purchases would require cabinet's approval and a special vote from Parliament.[34]

The negotiations that took place over the coming years were never easy, because the prince had an aristocratic aversion to commerce that made him likely to walk away if he felt that his dignity was impugned. However, by working through picture dealers to cultivate a personal relationship with Franz Josef, the Gallery hoped ultimately to convince him to sell one of art's holy grails, *Ginerva di Benci* by Leonardo da Vinci. Works by da Vinci virtually never came on the market, and the only comparable one in private hands had recently been seized by the Soviets from a Polish collection.[35] Purchasing this single painting would make the National Gallery of Canada the only North American home to a da Vinci, and thereby one of the world's great collections.

The Gallery's ambitious strategy was launched rather tentatively in October 1952 when the trustees wrote to the prince's curator to say that they might be interested in purchasing part or all of the collection. The curator was informed moreover that "many of our cabinet ministers are favourably disposed to such a project," and to prove the government's cultural resolve the trustees enclosed a copy of the Massey Report, pointing out the sections that called for the beautification of Ottawa and the erection of a new National Gallery building.[36] Having sent this message, the trustees worked on fostering cabinet support by canvassing Vincent Massey and hiring William Constable – the English-born chief curator of the Boston Museum of Fine Arts and a long-time Gallery advisor – to vouch for the scheme's soundness. Constable did so in a December 1952 memorandum in which he argued that acquiring the prince's collection would make the National Gallery of Canada the second most important art museum in North America, and also achieve the Massey Report's recommendation that the institution acquire Old Masters.[37]

Meanwhile, the trustees adopted a less direct approach to negotiations with the prince by hiring the prominent New York picture dealer William Schab as their agent. Schab was first asked to put a value on the prince's 218 paintings, which he reported might be purchased for slightly more than $13

million.[38] The trustees knew that cabinet would be scared away by an initial monetary demand of this size, and that the prince would also likely get cold feet, but their gambit was remarkably successful. In a fit of largesse, Walter Harris, a Toronto lawyer with no especially profound interest in the arts, whose post as minister of Citizenship and Immigration made him responsible for the Gallery, convinced his colleagues not to miss the opportunity. So at the start of February 1953 cabinet gave the trustees $276,000 to spend on three Old Testament scenes: Rembrandt's *The Toilet of Esther*, and a pair of works by the fifteenth-century Florentine, Fillipino Lippi – *Esther at the Palace Gate* and *The Triumph of Mordecai*. Along with the money, the Gallery received permission to continue negotiating with the prince, on the understanding that $2 million was earmarked for acquiring portions of the collection. Critically, as it later turned out, only the money for the immediate purchase was set aside. The larger amount was not entered into the Supplementary Estimates, the official mechanism by which the government asks Parliament to authorize unforeseen expenses.[39] The public took little notice of this rather expensive purchase, which was unprecedented, but not extravagant.

Hoping to sustain the momentum, the Gallery dispatched Cleveland Morgan to Vaduz with a letter in which ministers informed the prince of their desire to continue the negotiations. Before leaving, Morgan, who favoured buying the entire collection outright, had been instructed to make a "selection of the outstanding paintings," without committing the government to any deal.[40] McCurry simultaneously asked the London picture dealers Thomas Agnew and Sons, who knew the collection well, to advise Morgan on the best way of approaching the prince. The meetings convinced Morgan that Geoffrey Agnew, one of the most experienced English dealers, should be employed as the Gallery's agent because he could travel to Vaduz more easily than Schab and appeared to be an adept bargainer who would "keep prices down." More importantly, according to Morgan, this urbane Cambridge-educated connoisseur would be "a British representative [which] will find favour with a large section of the [Canadian] public," who might otherwise balk at the sums the government planned to spend on art.[41]

The decision to employ Agnew hurt Schab's pride and his pocketbook, given the commissions that could be expected from future deals. He tried to regain the Gallery's support in October 1953 by informing the government

that the prince now wanted to invest the profits from art sales in Canada.[42] Unbeknownst to the New York dealer, Prime Minister St-Laurent was at that same time personally endorsing the trustees' plan of working towards the da Vinci through a series of deals, and agreeing that $2 million should be earmarked for purchases.[43] The institution's triumph was sealed in December when McCurry sent Agnew a cheque for the canvases the Gallery had taken possession of at the start of the year, saying "here in record time is the cheque for the Prince ... I hope the Prince will not insist on such haste again because the Canadian government is not accustomed to responding to such pressure."[44] The prince understandably wanted to be paid when he handed over his canvases. But, despite the prime minister, cabinet, and the trustees all pursuing an aggressive purchase policy, bureaucracies do not move at the art market's pace. As a consequence, Agnew had been unable to tell the prince exactly when he would be paid for any sales, making it difficult to negotiate on the Gallery's behalf.[45] The length of time that it took the Gallery to give the prince his first cheque was not a promising sign. In future, the Gallery needed to move quickly, discreetly, and decisively if and when deals emerged.

In order to expedite the Gallery's negotiations, by the start of 1954 Agnew and McCurry had identified the individual plums they wished to purchase as they worked towards the da Vinci.[46] The plan was put into effect in April when the Gallery offered $360,000 for Hans Memling's *Madonna and Child with St Anthony of Padua and a Donor*, Quentin Masys' *The Crucifixion*, Bartel Beham's *Portrait of a Prince of Bavaria*, Francesco Guardi's *Santa Maria Della Salute in Venice*, and *The Lacemaker* by Nicolas Maes.[47] Art journals and critics lauded the Gallery's entry into "the company of the world's more important collections," but despite the large expenditure, the public only expressed mild interest in a deal for artists they did not recognize.[48] Geoffrey Agnew attended the trustees' meeting at which the sale was finalized in order to discuss the overall strategy. He argued that the prince's desire to invest in Canada and his growing comfort in dealing exclusively with the Gallery gave the institution a unique opportunity. Moreover, so Agnew said, the booming art market would make even the most extravagant purchases seem like bargains in a very short time. Agnew boarded the plane for home with the trustees' permission to continue negotiations.[49] For their part, the buoyant board of trustees approached the government at the end of April for an annual

$500,000 purchase fund, only to be once again told to assume they had $2 million with which to keep negotiating.[50]

The momentum created by these negotiations also caused friction, just as the laws of physics say that it must. In Ottawa, several ministers were "a little restive" at the prince's demands for payment as soon as the paintings changed hands.[51] Cabinet's reticence seemed of little consequence, because on 1 July 1954 the Oxford-educated, Liberal backroom boy Jack Pickersgill, who had "a reputation of being an active supporter of the National Gallery and art affairs generally," took over the department of Citizenship and Immigration.[52] Walter Harris, the outgoing minister who had been such an eager early supporter of the Liechtenstein purchases, was promoted to the Finance portfolio, a perch from which he oversaw all government spending. An even more auspicious augur was read that October when Agnew signalled that the prince might be open to a big deal. The trustees instructed Agnew to offer $1.6 million for three paintings, in return for which they expected a firm option on the da Vinci.[53] Agnew approached the prince the following month only to find that the family was debating whether to sell any more of the collection. Liechtenstein's future brightened as it became clear that the Allies' post-war occupation and partitioning of Austria would end in 1955. The political climate caused Agnew to advise letting the discussions lie fallow, while speculating that the prince would want at least $2.5 million for the da Vinci.[54]

The abrupt break in negotiations was perfectly normal in the art market, where dealers often work for years convincing collectors to part with valuable pieces. But the rhythm was anathema to Jack Pickersgill's go-ahead nature. He felt he could personally reanimate the discussions by sending the prince a telegram that professed the government's eagerness to acquire the da Vinci. Luckily, aides persuaded the minister to withhold this missive, which would undoubtedly have been looked upon as *infra dignitatem* by the head of one of Europe's grandest families. The new year dawned with the Gallery and the government awaiting a signal from the prince. Instead of hearing from Vaduz, the government received a letter from their one-time agent, William Schab, demanding a portion of all commissions paid for Liechtenstein purchases on the basis that he had first brought the collection to the Gallery's attention.[55] Cabinet's lawyers dismissed the claim privately, but the government's strategy was questioned publicly on 4 February, when Wally

Nesbitt, the Conservative member for the rural riding of Woodstock, Ontario, asked Pickersgill in the House of Commons if the Gallery "intended to make larger purchases than usual of works of art during the coming year?"[56] The negotiations were at a standstill, even if their first political repercussions could be detected.

These at times frustrating attempts to create a national cultural infrastructure, erect a modern Gallery, and amass a collection of Old Masters were well underway as Jarvis began looking to leave England. Frequent trips to Canada since the war had allowed him to keep close tabs on the country's cultural developments and maintain a network of friends and contacts. He could also tell from what he read in his London studio that the Massey Report, the Liechtenstein purchases, and the new Gallery had changed the Canadian arts scene immeasurably. And the sculpting commissions he received on his trips home in the 1950s were further proof that it might now be possible to make a living as an artist in Canada. Jarvis was also fairly well-informed about what was happening in Ottawa, and so he was aware very early on about Liberal plans for the National Gallery. He had been awaiting the right opportunity to return home, and sensed that this might be it.

The search for a new Gallery director was entrusted to Jack Pickersgill, who had steered the *National Gallery Act* through Parliament in 1951, before assuming formal responsibility for the institution when he became minister of Citizenship and Immigration in mid-1954. Pickersgill made the Gallery competition his most important task, because he believed that the sexagenarian Harry McCurry lacked the authority and charisma to transform and lead the institution.[57] Pickersgill's vision was shared by Toronto accountant Charles Fell, who had succeeded Vincent Massey as chair of the board of trustees. Fell's mandate, vouched for personally by the prime minister, was to oversee the construction of a permanent Gallery, reorganize the institution to carry out its new role, and replace the director.[58] Minister and chairman worked in tandem. Soon after taking office, Fell raised McCurry's salary substantially in order to attract a first-rate replacement.[59] Meanwhile, Pickersgill, Fell, and the Civil Service Commission, the central agency responsible for government hiring, discussed the recruitment process. Pickersgill and Fell believed that the trustees had explicit authority to choose the director, but such a clause had been omitted from the 1951 *Act* in the rush to get it through

Parliament.[60] The oversight meant that the government, the trustees, and the public service had overlapping and unclear jurisdiction over the appointment, and laid the foundations for several of the problems Jarvis would encounter at the Gallery.

McCurry sensed that ousting him was the ultimate goal of these machinations and by the spring of 1954 he had all but stopped communicating with the trustees, who in turn expressed their "general dissatisfaction with the way the Director's office is functioning," which they felt had created an "intolerable" situation.[61] The trustees recognized that the only obvious internal successor to McCurry was Donald Buchanan, the forty-seven-year-old, Oxford-educated son of a wealthy Liberal senator. Buchanan had long been at the centre of cultural projects. As a scholar at the Gallery in the 1930s, he had made a pioneering contribution to Canadian art history with his biography of the painter James Wilson Morrice. Since then, he had held important jobs in film, radio, and wartime propaganda before founding the Gallery's industrial design section in 1947. As a relatively young and accomplished scholar and administrator with a wide range of contacts, Buchanan had many of the qualities the new director would need. However, the art critic Graham McInnes had remarked in the 1930s on Buchanan's "knobby lopsided face," a physical impediment that was compounded by creeping deafness. Pickersgill, trustee Dorothy Dyde, and others believed that hardness of hearing would make it difficult for Buchanan to acquire the broad public appeal that would be essential for the next director.[62] Private reservations on the part of those responsible for selecting the Gallery's new head aside, Buchanan's presence at the institution exacerbated tensions with McCurry.[63] Such worries were misplaced, because Buchanan was quite sympathetic to the director, who he believed was being shunted aside largely because he and Fell did not get along. As morale ebbed, staff focused their disenchantment on McCurry. For his part, Chief Curator Robert Hubbard wearied of the moralistic atmosphere the teetotal Christian Scientist McCurry had created at the Gallery.[64]

By coincidence, Jarvis was visiting Toronto at the end of his North American social science research trip when the government started overhauling the Gallery. So in January 1953 he began enquiring cautiously and discreetly about the directorship in an attempt to determine whether the revamped position would have sufficient scope to lure him back to Canada. He travelled to

Ottawa to stay with Frances and Jack Barwick, who he had known since 1938 when he and Douglas Duncan, Frances' brother, had toured Europe. The Barwicks had since settled in Ottawa and were prominent members of the city's musical scene. They recruited Norman Berlis, a diplomat with whom Jarvis had attended the University of Toronto, and who had inside knowledge of government affairs. Berlis then approached Walter Herbert, the head of the Canada Foundation, a small arts lobby with significant ties to the Liberal Party. Nothing concrete resulted from these conversations, but Jarvis' interest in the job was piqued during this short stay. Before leaving, he drafted a *curriculum vitae* for his supporters to circulate around Ottawa, while declaring to them that he had the backing of Sir Kenneth Clark, a long-time friend of Massey's and probably the most influential figure in the English-speaking arts world. According to Jarvis, Clark's endorsement would "knock Vincent [Massey] for a loop" and almost certainly trump any other aspirants.[65]

This subtle campaign lasted until the start of January 1954 when Jarvis contacted Charles Fell, stating coyly that he understood the post might become vacant in the near future, before penning a startlingly honest analysis of his aptitudes:

> As I understand it, the directorship will be principally concerned with public education of a Dominion-wide scope, with "external affairs" on behalf of Canadian art and with the administration of the Gallery programme, rather than with curatorship in the strict sense, for I can not pretend to be suited either by training or temperament for the latter work. You will see from my *curriculum vitae*, which is enclosed, that I have had a wide experience in the arts, industrial design and education – especially from the point of view of public relations – and I believe it is of a kind which would qualify me for consideration for the National Gallery post.[66]

An impressed Fell passed the letter along to his then minister, Walter Harris, who was casually keeping track of people who expressed interest in the post. At the same time, Fell advised the minister that "there was no urgency" in finding a new director, and suggested that the government try to attract well-qualified applicants by advertising widely in Canada, the United States, and

Britain.[67] Jarvis was also aware of the factors that would influence the government's decision, but he was undeterred. As he explained to his mother: "I sure hope I do get the Gallery job (but the odds are high that it will go to a French Canadian for political reasons) but even if not, I haven't a worry in the world about prosperity in Canada. Think what a pal I have in J.W. McConnell and do you think he's been making friends with me for nothing? O no!"[68] McConnell had arranged several Canadian sculpting commissions for Jarvis in the previous couple of years.

As we have already seen, Donald Buchanan had a more decisive reaction to the start of Jarvis' subtle campaign, about which he must have been aware. In the spring of 1954, he tried to hire Jarvis, whom he knew had unparalleled experience in the field, as his assistant at the design centre.[69] In doing so, Buchanan hoped to neutralize a serious rival, and strengthen the staff of the Gallery that he himself aspired to head. Jarvis deflected the move by proposing Norman Hay for the post. It was a clear sign that Jarvis intended to lead the Gallery.

Jack Pickersgill had a short interview with Jarvis sometime soon after an active search for a new director got underway in mid-summer 1954. In August the trustees excluded Buchanan formally, informing him gently that they were looking for someone "who will perhaps be enabled to circulate more than you have been able to do, and meet the other important gallery officials here and abroad, do a considerable amount of speaking, and in fact BE the National Gallery in the eyes of the public."[70] While Buchanan's physical impediments precluded his promotion, the trustees realized that he was an important part of the institution's future. They therefore made him assistant director, with responsibility for the Gallery's daily operations so that the new head could focus on public relations and outreach.[71]

Having launched the competition, Pickersgill and Fell were surprised to learn that the *National Gallery Act* required that the director be hired through the Civil Service Commission. This brought a greater level of scrutiny to the proceedings, which now had to be advertised formally in the *Canada Gazette*. Most importantly, it meant the trustees would be involved in the hiring process, without necessarily being its final arbiters. Fell reassured Jarvis that the government and Gallery would find "ways and means of simplifying this procedure!!" because he had made a very strong impression on Pickersgill

during a summertime interview.[72] Fell's note convinced Jarvis that he would get the job.[73]

It is not surprising then that the statement of qualifications in the official notice that first appeared in the *Canada Gazette* on 30 October 1954 had suspicious echoes of Jarvis' profile. According to this posting, the successful applicant required at least some post-graduate studies in the liberal arts, extensive knowledge of the fine arts along with speaking and writing skills. These were meant to underpin the director's duties to encourage public interest in the arts through purchases, loans, exhibitions, and lectures. Finally, the poster called for proven business and administrative skills, and especially recent experience running an art gallery. Six days later, in order to respect the letter of the regulations, the trustees sent Jarvis the civil service application forms. Jarvis completed them, citing that he had specialized knowledge of "the philosophy of art and in art history and museology; has considerable experience with large scale exhibitions (particularly Britain Can Make It, The Festival of Britain and the Bill and Betty – Setting up Home Exhibition) and in the field of industrial design; has written, lectured and broadcast widely on the arts and education; has first-hand knowledge of film and television production; business and administrative experience in both government and private enterprise."[74]

About ten people applied for the job, foremost among whom were Robert Hubbard, the Gallery's chief curator; Geoffrey Andrew; Vincent Massey's Balliol-educated nephew who taught English at the University of British Columbia; and Jarvis' most serious rival, Archibald Day, a diplomat who had been secretary to the Massey Commission.[75] As impressive as the list of applicants was, Fell recalled almost twenty years later that as soon as Jarvis entered the competition, he was far and away the first choice.[76]

Without so much as waiting for the application deadline to pass, Fell contacted Sir Kenneth Clark for Jarvis' reference, while Pickersgill, who wanted to "triangulate" by gathering his own information, asked his friend Norman Robertson, a 1923 Rhodes Scholar who was Canadian high commissioner in London, to "make some discreet enquiries and see what you can discover about him [Jarvis]. He is a Canadian who has been living in England ever since he went to Oxford about 1939. Saul Rae and Donald Buchanan both know him quite well and both think very well of him. I was very favourably

impressed by a short interview I had with him … I have no doubt you will find all kinds of people who know him or know of him, once you start making enquiries."[77]

Sir Kenneth Clark was the first to reply:

> I have known Jarvis for about fifteen years during which time I have seen him fill a number of different posts, some of them of great difficulty. In all of these he has shown remarkable administrative ability. He has a clear head, sound commonsense, keeps calm, and is outstandingly good at getting on with people. Throughout all his jobs he has continued his work as a sculptor and has kept in touch with modern art. I consider that he has sound judgement in art and considerable knowledge of its history. He would bring to the building up of a great gallery a freshness, energy and administrative ability rare among professional museum directors, and I would strongly recommend him for the post.[78]

By forwarding this unequivocal endorsement to Pickersgill, Fell increased the momentum behind Jarvis' candidacy. Jack and Frances Barwick followed suit by planting a story in the Liberal-leaning *Ottawa Citizen* announcing that Jarvis had been appointed.[79] Jarvis then furthered his own cause with a casual, gossipy letter to Fell: "[I have] had a congenial chat with the High Commissioner here. I believe the minister had written asking Mr Robertson some questions about me and (Frederic) Hudd, the deputy High Commissioner whom I have known for years, very sensibly suggested that the High Commissioner should talk with me personally – which we have done. In fact, we mainly gossiped about the late Sir Stafford Cripps!"[80] During their chat, Jarvis told Robertson that additional testimonials could be obtained from Isobel Cripps and the dean of Westminster, neither of whom appears to have been contacted. On the other hand, Ken Andras, a stock broker who headed the Toronto Rotary club at which Jarvis had often spoken, raved to Fell about the candidate's abilities as a public speaker.[81]

Praise ultimately overrode a very contradictory assessment of Jarvis' suitability. Norman Robertson, who had met Jarvis occasionally at Canada House functions, reported on a straw poll he had taken among mutual London friends. Allison (Grant) Ignatieff had reserved judgment on the grounds that

she was related to one of the other candidates. Mary (Greey) Graham had endorsed her old friend, as had Frederic Hudd. Positive views from Jarvis' friends and associates were qualified significantly by Graham Spry, one of the most accomplished Canadians of his generation. He was a Rhodes Scholar who had been secretary of the Canadian Clubs, campaigned for a national radio service, co-founded the League of Social Reconstruction, and helped write the Cooperative Commonwealth Federation's Regina Manifesto before taking a business position in England. He had spent the war as one of Cripps' personal assistants and had since served as Saskatchewan's agent general in London. Robertson contacted Spry when he learned that Jarvis too had been a close friend of the Crippses and was involved with aircraft production during the war. Robertson related Spry's response: "Graham, whose judgement I would not disregard, had obviously reservations. He did not particularize them but they left the feeling in my mind that the candidate perhaps lacked the weight and displacement you would like to find in the man you appoint to what should be a very central and responsible position in the new scheme of things."[82] Robertson underlined his reservations by urging Pickersgill to advertise the post widely, because he believed that with Buchanan in charge of the institution's daily operations the government could attract almost anyone it wanted as director.[83]

Because they shared these letters with one another, Pickersgill and Fell were very aware of the vastly different views of Jarvis' suitability. They alleviated doubts by informally consulting Vincent Massey, who knew about Jarvis' connections to the English art world and the positions he had held under Cripps; and Douglas Duncan, who was now one of Canada's foremost art dealers. Duncan could vaunt Jarvis' Canadian credentials by talking of his involvement in the Picture Loan Society and the "discovery" of David Milne.[84] Massey and Duncan might also have pointed out that the Council of Industrial Design and Oxford House had about the same number of staff as the Gallery, and reported to governing bodies with similar powers to those of the trustees.

In England, the notoriously snobbish Sir Kenneth Clark was convinced that the job was Jarvis', a sentiment that elevated him from the status of social acquaintance and friend to that of colleague. Such esteem earned Jarvis an invitation to spend the weekend at Saltwood Castle, the Clark's art-filled

estate near Folkestone, where the two men walked on the beach discussing the possibilities of the directorship. Emboldened by Clark's advice, Jarvis returned to Ottawa for an interview at the end of December.[85]

Jarvis was very excited about the job, which he clearly sensed could fulfill the ambitions he had harboured through almost two decades of work in the field of adult education. A few very sketchy and often indecipherable entries in a notebook that he wrote over the winter of 1954–55 capture these hopes. He planned to borrow the phrase "Is Art Necessary?" from Clark for a series of public lectures, and considered reworking the Bloomsbury art historian Roger Fry's seminal 1920 text *Vision and Design* for a contemporary Canadian audience. What appeared to be the reward for many years of dedication also caused Jarvis to reflect on the journey he had taken since first leaving home. To this end, he roughed out a couple of scenes for a *Bildungsroman* chronicling "the stylish times of the young homosexual in NYC for which there is no exact English equivalent, except perhaps Peter Prim and Johnny Dust. But the NYC standard of living is so much higher. Develop into the 'new kid' scheme nice kid based on Dicky Myers for e.g. but developed in terms of Kenny and his success." There would follow a "scene of boredom e.g. with Alan Jarvis, [illegible] of cupidity. Alan Jarvis vs. DMD [Douglas Duncan]." Later on he intended to "develop a scene or indeed a novel on the combination of Gerald M[urphy] and Al G[Jarvis], the crack of which is the seduction of boy or girl – is it [illegible] to work out the [illegible] of Gerald's [illegible] children and the devastation of say having his daughter (or step daughter) e.g. Alistair Cooke, seduced. A[lan] like me, the perfect American man, but what sort of sons in law does he find in Hank and [illegible]. The second daughter married to an alcoholic. Fanny and Hank and his [illegible] craziness."[86] If Jarvis had produced a novel along these lines, it would have been a very thinly disguised, raunchy Restoration trip through his life. It would also have required a writer of considerable skill.

In the meantime, Jarvis and his mother fretted about the competition until the first of February 1955 when he was offered a five-year contract at a starting annual salary of $12,000.[87]

The appointment thrust Jarvis into the tensions gripping the Gallery. The trustees sent him a list of London dealers with whom to meet before returning to Ottawa. The most important of them was Geoffrey Agnew, who was brokering the Liechtenstein negotiations, about which the trustees had almost

no up-to-date information, because McCurry had ceased communicating with them.[88] The fractures in this relationship were further revealed one month later when an aggrieved McCurry sent Jarvis a letter that opened with a frosty "I have not yet been officially informed of your appointment as my successor but the newspapers throughout Canada have been featuring the news widely," before becoming more cordial, congratulatory, and welcoming.[89]

From the outset of his time at the Gallery, Jarvis reported to different masters in the realms of politics, bureaucracy, and art. The pressures and demands they placed on Jarvis would sometimes contradict one another. The least problematic of these was the Civil Service Commission which, after overseeing the hiring process, administered Jarvis' career. Despite repeatedly declaring in the coming years that he had refused to be a civil servant, because such a position would restrict his ability to speak his mind in public, Jarvis was a regular government employee who contributed to the pension and health plans.[90] Nevertheless, Jarvis had to convince the public that he was a free agent in order to interpret the role that he and the government had written for the head of the National Gallery. He would not deliver a comforting government "line" about the arts. Instead, he was going to educate people by provoking them into critically examining the world. In this sense, Jarvis' ideas were deeply rooted in his English experiences with discussion clubs, worker priests, industrial design, film, and social work. Each of these projects had been overseen by Sir Stafford Cripps, an immensely powerful political figure. It remained to be seen whether Jack Pickersgill or Charles Fell could or would fill a similar role in Canada.

At the outset of Jarvis' Gallery career, one might have believed that his position as an intermediary between the trustees and cabinet would prove to be more problematic than his public profile. Fell and his colleagues relied on Jarvis' judgment and stature within the international art world, while Pickersgill was responsible politically for the Gallery at a time when it was set to assume an unprecedented national profile. When the minister's instincts had caused him to "triangulate" information about Jarvis' suitability, he had done so through the Oxbridge-educated civil service mandarinate. Norman Robertson and Graham Spry clearly believed that Jarvis was unsuited for the job. However, in arguing that so long as Donald Buchanan was associate director almost anyone could safely be chosen to lead the Gallery, Robertson unwittingly gave Pickersgill the comfort with which to choose this relatively

unproven candidate. Senior civil servants such as Jarvis constantly juggle competing political and bureaucratic demands, but the separate and potentially divergent aims of the two authorities to whom Jarvis reported ultimately weakened his position.

Preparations for the most misunderstood event in Jarvis' life, his marriage, were underway as he sailed for home in late April 1955 aboard the same ship that he and Douglas Duncan had taken to Europe seventeen years earlier. Far from being a simple cloak for his homosexuality, this was a match of longstanding mutual attraction, which had been building in intensity for several years. Betty Devlin and Jarvis had been inseparable as youngsters. Their families had lived close to each other and Jarvis had attended summer camp with Betty's two brothers. Betty and Jarvis' adolescent crush had evolved into a close friendship by the time they were at university, where Jarvis began his homosexual relationship with Duncan, and Betty met an engineer named Charles Kingsmill at a football party. She and Charles married soon after graduation. Jarvis attended the wedding, but left the reception early because, so his mother explained, he was a little jealous that his childhood sweetheart was marrying someone else.[91] Jarvis' actions show that he remained very emotionally attached to Betty, and that he had not yet fully understood his own sexuality. All the same, Betty's father, a prominent Toronto businessman, wrote a reference for the Rhodes Scholarship that took Jarvis to England, while she and her husband moved to a northern Ontario mining town, where they had two daughters and a son before Charles was killed in a workplace accident in 1948.

Betty and Jarvis corresponded sporadically as she raised the children on her own. The frequency of their letters increased as the years passed and by the summer of 1954, when Jarvis was invited to the Devlin's cottage during his Canadian trip, it was clear that he and Betty were contemplating marriage.[92] Many of Jarvis' friends, like Jean Gunn from the Council of Industrial Design, who had tea with Betty during a brief stop in Toronto, warmly endorsed this courtship. These supportive friends knew that Jarvis wished to return home and that Betty did not want to live in England. Moreover, the Gallery directorship would give Jarvis the financial stability to marry and provide for three growing children. He and Betty began discussing marriage soon after he won the job, and they became engaged in mid-March.[93]

Jarvis' decision to marry did not shock friends and acquaintances like Gunn, who had never thought of him as exclusively homosexual. Over the years, they had seen him accompany desirable young women like Fanny Myers and Peggy Cripps to social functions. But gay friends and lovers felt more threatened and were correspondingly more critical. Burnet Pavitt, to whom Jarvis had become close in England, was heartbroken about a decision he felt was "altering in every way and so much more separating than 10,000 miles."[94] Another factor was Betty's three children, in whose lives the long-time bachelor Jarvis was expected to play a fatherly role. Jarvis' former lover Norman Hay, who had just himself married, counselled that a wife and ready-made family required a great adjustment.[95] Norman's caution echoed that of Jarvis' mother, who met her son's boat as it docked in New York. She declared elatedly that the engagement was "the best Mother's Day [present] I have had since Colin and Ed left us," while at the same time urging Jarvis to move slowly by saying, "I am so proud of you dear and I know you can do anything you set out to do, but some things you are not too realistic about."[96] Janet knew that Jarvis always had a strong tendency to take on too many responsibilities all at once, so she implored him to get to know Betty's children gradually, as her own second husband had done. In this way, they would feel comfortable in the new family and look on Jarvis as a father. Building such a relationship could only be done very gradually, because it was already clear that Jarvis was going to spend much of his first year at the Gallery travelling around the country, and that even while at home he was going to be preoccupied learning his new job.

Despite his mother's urging, Jarvis was anxious to marry Betty, whom he called his "Katherine Hepburn" in reference to her wit, laugh, and the strength that she had exhibited as a widowed mother. Jarvis and Betty were wed by a Presbyterian minister who was a friend of the Devlin family on 23 July in Hart House chapel at the University of Toronto. The groom wore a plain dark suit and the bride a simple white dress to the very informal service. The only guests were Jarvis' mother, the Bees' housekeeper Maudie, and the Devlin family, who were all very happy about the union. The equally relaxed reception was held in the back garden of Betty's brother's house in Forest Hill. Among the presents they received was an Augustus John sketch from Jarvis' friend and former agent David Gibbs. After honeymooning at Niagara Falls

and the Stratford Festival, the couple and their three children moved in to 125 Manor Avenue in the oldest part of Rockliffe, a neighbourhood favoured by Ottawa's senior civil servants. Jarvis and Betty had been taken instantly by this large house with white clapboards, a barn roof, and huge gardens. They transformed it into a family home by turning part of the garage into a studio for Jarvis, and filling the rooms with cherished items, contemporary new furniture and, gradually, canvases from some of Canada's finest artists, like Gordon Smith and Jacques de Tonnancour.[97] The three children played in the quiet streets and attended the local schools.

Marriage to a woman for whom he had such deep, long-standing affection enriched and expanded Jarvis' personal life, but taking the Gallery job forced him to give up the professional sculpting career he had been developing since the collapse of Pilgrim Pictures in 1950. He had originally hoped to head the Gallery and work as an artist simultaneously, but in the earliest stages of the selection process the trustees had informed him that the head of the national art institution could not accept payment for such work.[98] So Jarvis would only sculpt for pleasure in his home studio. The network of professional contacts with Canadian grandees like J.W. McConnell that Jarvis had developed over the previous years had apparently come to nothing. So too had his English sociological work. Michael Young told Jarvis that he could not remain on the executive of the Institute of Community Studies if he no longer lived in the country.[99] Links with over a decade of London life were then further weakened when Jarvis rented his small studio at 3A Sydney Close.[100]

None of these significant personal sacrifices and changes was apparent to the public, because once the trustees decided on Jarvis, they commissioned a Bay Street advertising agency to craft a public persona for this new face of Canadian culture. Unlike with the appointments of other senior civil servants, newspapers across the country reprinted the firm's ecstatic press release that lauded a returning cultural star. The publicity helped to create a mythic image of Jarvis that was based on his association with renowned figures like Sir Stafford Cripps, T.S. Eliot, and Sir Kenneth Clark. The firm's potted biography spoke of a man who would bring equal measures of style, political common sense, organizational acumen, speaking ability, art world connections,

A walking work of art – Jarvis in the National Gallery.
Weekend magazine, 19 May 1956. © Library and
Archives Canada. Reproduced with permission. Louis
Jacques/*Weekend* magazine collection/E010745913.

and a keen eye to the job. The personal, psychological effect of this media
campaign was to further solidify Jarvis' emotional shield by creating an
urbane, cosmopolitan "character" for him to play. People who met him in his
first days in Ottawa found that he radiated this role thanks to Mayfair man-
ners, a mid-Atlantic accent, a confident knowledge of the English arts world,
and abundant charisma, charm, and enthusiasm. His conversation was pep-
pered with references to Cripps, Clark, and his own wartime work. These were
impressive connections to vaunt at a time when the war had defined many
people's lives, and Canadians still deferred to British expertise on many sub-
jects.[101] The young art critic Robert Fulford found "the impression of a man
at that time totally in command of himself, totally knowledgeable about what
he was doing, and what he wanted to do."[102] Ever the actor, Jarvis was playing
up the "official myth" that the government-sponsored publicity had begun
entrenching in the public imagination. At the same time, this blurred the
essentially Canadian identity of a man who spoke like a barrister but had
spent over half his life in Toronto and paddled a canoe like someone who had

been raised in the bush.[103] Jarvis had consciously adopted an English persona during the war in order to fit into his adopted country. Now that he had returned home, it made him stand out.

Private impressions like that of Fulford were spread widely through the interviews that Jarvis began giving as soon as he arrived. He declared that his priority was to build the new Gallery, to whose collections he wished to add sculpture and Spanish works.[104] *Canadian Art* magazine clearly understood why Jarvis wanted the job, because "throughout his career he has been concerned with bringing the achievements of art and culture to the busy man – or woman – in the street."[105] An admiring profile in *Time* magazine that lauded Jarvis' mandate to "sweep the cobwebs out of the tomb-like National Gallery and introduce overdue showmanship into its operations" caught something of the new director's *élan*.[106] The article had been suggested by Jarvis' wartime love Fanny Myers and her husband Hank Brennan, a *Time* executive, who had hosted a cocktail party in New York City as Jarvis passed through on his way to Ottawa.[107]

Hubbard, Buchanan, and a few other senior Gallery staff members had met Jarvis over the years, though none knew him well, and so they were both excited and apprehensive. Norman Hay reported exaggeratedly that "the talk is rarely off you in the salons of Ottawa," while the Barwicks hosted a cocktail party to which they invited Gallery staff, senior cultural bureaucrats, and politicians who they felt should meet the new director.[108] George Hulme, the Gallery's business manager, and Fell tried to organize a more official institutional welcome, only to find that they could not serve drinks because "government frown on two things – liquor and rugs for civil servants."[109] If Jarvis' introduction to Gallery personnel was less convivial than hoped for, his private revelations, such as "in the normal course of buying I am *very* much against medium price pictures, and very cagey about cheap pictures," showed them that he was not interested in running the institution on a shoestring.[110] More ominously, on his first day at work Jarvis asked Hulme to buy a bottle of gin for the office.[111] This small request marked both the end of the McCurry's moralizing and Jarvis' continuing addiction.

Regulations about rugs and alcohol foreshadowed trouble as Jarvis began his Gallery career at a breathless pace. Two months after Jarvis arrived, Hay was put in charge of the industrial design division, thereby freeing Buchanan to take over the Gallery's daily affairs and allowing Jarvis to shape the insti-

tution.[112] Jarvis addressed morale problems by ensuring for the first time that senior officials attended meetings of the board of trustees, soliciting their opinions on any number of topics, and leaving his office door open, both literally and figuratively, so that even the most junior staff members could discuss ideas. Unlike in McCurry's last days, Jarvis trusted his well-educated staff, lauded them publicly, and looked for consensus on decisions that affected the Gallery. He did so by employing discussion group techniques, like guiding staff through problems they thought were insurmountable. After hearing the reasons why an employee felt that a course of action could not be taken, Jarvis helped him or her discuss, dissect and dismiss each point until a way forward became apparent. Staffers were stunned by the new director's patience and the concern with which he helped them. In return, as he had done throughout his life with people he admired and befriended, Jarvis gave the staff playful nicknames, like "Old Mother" for Robert Hubbard.[113]

The heretofore unheard of responsibilities that Jarvis gave his employees were most evident in the way he prompted them to travel internationally. The era of reliable and inexpensive transatlantic flights was dawning and Jarvis, who had spent so many years in Europe, seized on it. Chief Curator Robert Hubbard took part in the Liechtenstein negotiations, helped set up the Canadian exhibitions for the Venice Biennale, and arranged loans with foreign galleries. These annual trips, and the introductions to European officials that Jarvis provided, exposed Hubbard to the international art world for the first time.[114] Kathleen Fenwick was similarly encouraged to search for prints in England. Jarvis' trust in his staff was evidence of his innate humility, for though he had a natural eye for judging art, he had virtually no experience of purchasing gallery-quality works. Consequently, acquisitions from the era reflected the enthusiasms of the individuals who chose them. Where Jarvis selected several important sculptures and a group of canvases by his old friend David Milne, Donald Buchanan acquired works by James Wilson Morrice, whose biography he had written two decades earlier, and Robert Hubbard indulged his passion for early Canadian oils.[115] Jarvis also dove into exhibitions eagerly, helping Buchanan choose the works for the Canadian pavilions at the 1958 Brussels World's Fair and the Venice Biennale.

Much of what the Gallery undertook during Jarvis' first two years had been planned before his arrival. His impact on the collections was more immediate as he focused on purchasing modern art and sculpture. As a result,

the Gallery acquired its initial cubist works – André Derain's *Still Life* and Guido Severini's *The Black Cat* – while at the same buying Canadian paintings at a rate that was five times greater than the annual average since the war. The largest group of these canvases were by Milne, but there were also substantial numbers of works by Ozias Leduc, Maurice Cullen, and Morrice. In 1957, the Gallery announced that it was looking for a first-rate work by both Pablo Picasso and Henri Matisse, two of the most important and influential modern painters. Neither of them was yet represented in the collection. In that same year, the British collections were enhanced by a Joseph Wright of Derby and the startlingly modernist *Head* by Graham Sutherland, an artist Jarvis had known since the war. Once again, the bulk of purchases were for the Canadian collection. Many of these were by emerging talents whose works were included in that year's Biennial. Refocusing purchases also meant forsaking some areas, and so in early 1956 the trustees decided not to pursue works by American artists, which were increasing in value exponentially. They defended the decision on the grounds that most Canadians had fairly easy access to the best American galleries.

Sculpture had always been Jarvis' greatest artistic love and it was the area in which he had the most dramatic impact on the collection. On his arrival, the Gallery owned about one hundred minor works. This changed dramatically in late 1955 when Jarvis bought Jean Arp's *Cyprian Sculpture* and Jacques Lipchitz's *Seated Figure* from the estate of New York dealer Curt Valentin. These were soon joined by Alberto Giacometti's *Portrait of Diego* and busts of A.Y. Jackson and Fred Varley by the Toronto artist Florence Wyle. The most impressive acquisitions were Auguste Rodin's *L'age d'Arain*, a brilliant life-size nude of a young man, Henry Moore's *Reclining* Woman, and Jacob Epstein's *Rock Drill*. All three were first-class, challenging pieces by important modern artists.

The Gallery also hosted an equally impressive succession of month-long exhibitions that exposed Canadians to many different artists and styles. The year 1955 saw shows devoted to Albert Robinson, the Canadian Society of Graphic Art, pre-Columbian Peru, David Milne, Jacques Villon, Henry Moore, and Ozias Leduc. These were followed in 1956 by shows devoted to the Canadian Group of Painters, the Mendel collection, Chinese painting, Canadian abstracts, Osip Zadkine, the Zacks collection, and Currier and Ives.

Equally impressive were the dozens of travelling exhibitions that the Gallery sent out across Canada.[116]

Meanwhile, the industrial design division awarded prizes to manufacturers, published educational pamphlets, and sponsored travelling shows of aluminium products, furniture, and textiles. The division's 1956 show of well-designed wedding gifts, entitled *For the Bride*, borrowed directly from Jarvis and Norman Hay's work in London on *Bill and Betty*.[117]

This last exhibition, and the way Jarvis treated his staff, were signs that he approached his work at the Gallery from the perspective of an adult educator. Fifteen years' experience in the field had given him the confidence to see that the Gallery's extension services were the foundation on which to build a national cultural network. Doing so would reposition the Gallery as a centre of expertise supporting more broadly based, local initiatives of the type Jarvis had tried to create through the Discussion Clubs Experiment, the Council of Industrial Design, and Oxford House. To do this, he enlisted the trustees in an ongoing struggle with the government to hire more and better trained staff. Among the most impressive was Jean-René Ostiguy, one of Canada's finest young art scholars, who became the Gallery's information officer in 1955. As the first bilingual member of staff, his presence alone expanded the possibilities for outreach. In a further commitment to serving both linguistic communities, Jarvis insisted that the Gallery's signs and interpretive panels be produced in both French and English for the first time. Existing senior staff were given the task of writing a multi-volume illustrated catalogue of the collections, while the graphic designer Paul Arthur was lured home from Switzerland to ensure that these books would be as beautiful as they were scholarly. Nathan Stolow was hired to develop a robust conservation and scientific research section in order to both safeguard the collections and advise other institutions. And finally, a pair of extension field officers, one based in the Maritimes and the other in western Canada, gave the Gallery a permanent presence outside the capital.[118] To publicize the Gallery's collection in Ottawa itself, Jarvis employed inexpensive, but innovative adult educational techniques like hanging a single painting in the Chateau Laurier hotel's lobby.

These endeavours underpinned Jarvis' dream of creating "a museum without walls," a phrase that summarized ideas he had been formulating for almost twenty years.[119] As he had first stated on CBC radio in 1938, he believed

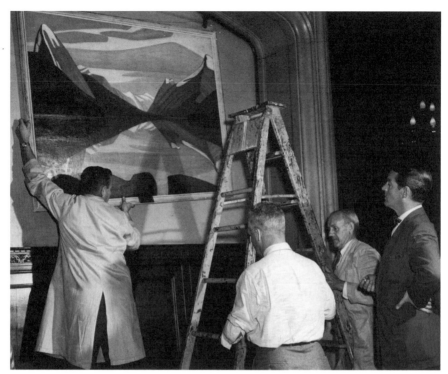

Making art accessible. Jarvis looks on as
Lawren Harris' *Maligne Lake, Jasper Park* is
hung in the lobby of the Chateau Laurier
Hotel, Ottawa, c. 1956. Alan Jarvis Collection,
University of Toronto.

it was important to erect art galleries and auditoriums in towns across the
country. Lawren Harris had presented the idea to Parliament's 1944 Special
Commission on Reconstruction and Re-Establishment and it had also been
echoed in the Massey Report. As the face of a national arts movement, Jarvis
now encouraged communities to build these venues to National Gallery stan-
dards in order to create a countrywide infrastructure for travelling exhibi-
tions and lecturers.[120] Jarvis' democratic idealism was evident in the first
annual report that he wrote as director, in which he stated that "whatever
pattern the future extension activities of the Gallery may take, it must never
conflict with, nor attempt to supersede this local activity."[121]

Similar beliefs underpinned Jarvis' championing of the new Gallery build-ing, which he envisioned as the concrete centre of a wider national cultural network. Achieving this aim was not always easy, as the civil service wanted to apply standard design for the interior, while Jarvis, who knew that the building was only a temporary home, refused to allow it to look like a quotidian, low-ceilinged office complex. To this end, he insisted on adequate conservation labs and storage facilities, and a library and offices for the staff. Above all, he wanted the design to encourage public appreciation of the national collection. The exhibition rooms had to be inviting, while he insisted on a large cafeteria in which weary Gallery-goers could refresh themselves.[122] When civil servants objected to this unprecedented amenity for a govern-ment building, Jarvis told them bluntly "no restaurant, no Jarvis," a threat he knew would carry the day.[123] Such relatively minor confrontations highlighted the differences between federal bureaucrats, who followed pre-existing regu-lations, and Jarvis, who refused to allow anything that seemed slipshod or second rate.

Not content to wait for the new building, Jarvis closed the Gallery for two months at the start of 1956 to replace the wiring and lighting, paint the walls a lively yellow, and turn some of the precious exhibition space into offices for the expanding staff. When the "dazzling" renovations were unveiled in mid-March, visitors discovered that the beloved Tom Thomson collection had been sent on tour. In place of these iconic interpretations of the Canadian Shield, the walls shimmered with modern works that Jarvis had recently pur-chased. Surreal green, orange, and mauve images of the Russian Shtetl mixed with those of contemporary Paris in Marc Chagall's masterly *Eiffel Tower*, and Takao Tanabe's abstracts challenged viewers, as did drawings by Picasso and Paul Klee, and a sculpture by the Dadaist Jean Arp. This was no longer a familiar, staid, or comforting collection. It now loudly proclaimed Jarvis' be-lief that art "should move you [and] upset you, bringing anger or tears."[124]

Extension and education services were the most marked features of Jarvis' tenure at the Gallery, because they were closest to his adult education ideals. They also supported his mandate to embody and publicize the arts in Canada, something that he and the trustees realized could not be done from behind a desk in Ottawa. A strategy to achieve this aim began to form even before Jarvis reached home. At the start of March 1955, Walter Herbert, the head of the Canada Foundation, an organization that fostered cultural

interests, approached Jarvis on behalf of Carleton College – Ottawa's Anglo-phone university – with an offer to give that year's commencement address.[125] James Gibson, a Rhodes Scholar and lecturer at Carleton, lay behind the invitation. Herbert seconded the idea, telling Jarvis it would be a "good thing" for him to make his first appearance "in the modest role of a scholar, rather than as an art pundit" and that the occasion would also help him reconnect with his Canadian roots.[126] The trustees agreed that this was a suitable inaugural venue and so in mid-May Jarvis told Carleton's seventy-five graduands that a liberal arts education equipped them to challenge ideas and overthrow societies.[127] Carleton's request was imitated by Queen's University, the Ontario College of Art, the Canadian Manufacturers' Association, the Canadian Association of Adult Education, and the Maritime Art Association.[128]

The success of these speaking engagements led Jarvis, Pickersgill, and Fell to hatch a plan in July to increase the Gallery's national profile by getting it in the press as much as possible. Fell had been frustrated by Harry McCurry's unwillingness to generate the kind of publicity that "keeps the name of the Gallery before the public and makes it more conscious that the institution exists."[129] From Jarvis' perspective, such attention would promote his vision of a Gallery at the centre of a national cultural movement. So the trio sketched out a national speaking tour for Jarvis that was endorsed heartily by Vincent Massey, who had made several similar trips as governor general.[130] Jarvis warmed up by delivering eight speeches in Ottawa and Montreal during the summer and early autumn, before setting out in late October on a three-week tour of Ontario, Quebec, and the Maritimes. Because no network of local cultural venues existed, the Gallery partnered with the Canadian Clubs, a nationalist society that had long sponsored speakers on contemporary issues. Individual clubs hosted many talks, while also identifying small galleries, classrooms, hotels, municipal halls, and private homes in which others were held. The informality of the venues deflated the stuffiness and pretension that had long been associated with the arts, and suited Jarvis' style and objectives perfectly. He shone at the rostrum, and was even more charming, flattering, and amusing at post-lecture receptions. Many of those who heard him talk were amazed by the way he intertwined anecdotes about Canada, London's social whirl, and fundamental artistic ideas.

After a few days' break in Ottawa, Jarvis set out on a tour of the West that initiated the almost unending travel he came to see as "idiotic." The schedules

were so hectic that he barely alighted anywhere before leaving again, meaning that he could not always visit local galleries, museums, libraries, and studios, let alone meet their staff.[131] Jarvis was especially frustrated because the tour was his first chance to see most parts of the country. His appointment as director rested largely on English cultural credentials that were understood and looked up to by a generation of Canadians. He was a Rhodes Scholar and friend of Sir Kenneth Clark, had been involved in a wide range of significant British cultural activities, and spoke like a gentleman. This glossed over a deep but narrow knowledge of Canadian art. Before joining the Gallery, Jarvis had never been to the West or the Maritimes, and had only briefly visited Montreal. While he had extensive knowledge of what had been painted, sculpted, sold, and exhibited in Toronto, he could not really claim a comprehensive knowledge of the Canadian art scene. As head of the National Gallery, he needed to develop a feeling for the country in order to identify, understand, and collect its best art.

As he soon discovered, reaching out to the West was a particular geographical and cultural challenge. In Regina he visited the newly opened provincial museum, which had been decorated with a frieze of ducks and other local wildlife. Jarvis was annoyed by what he took to be pompous imitations of classical models and joked that local hunters should get out their shotguns. The painter Kenneth Lochhead, one of the leaders of an emerging prairie school, adored Jarvis' comment because it showed "that this man was for real," and that his presence plugged local artists into a broader national movement.[132] Lochhead and friends showed their admiration by presenting Jarvis with a child's pop-gun so that he could blast away at the metaphorical "ducks" that hampered Canada's artistic development.[133] Another admirer was Doris Shadbolt of the Vancouver Art Gallery, who recalled "he [Jarvis] wanted to see at first hand you know. Get the feeling of what was going on" in the regions and to find out "what are our problems? How do we function? How can we relate to the larger central body in Ottawa?"[134] In doing so, Jarvis cut passes through the Rocky Mountains, which had historically been a cultural barrier separating the coast from the rest of the country.

Every such success with arts-minded people was bookended by rockier receptions. A stop in Calgary showed that the city had other priorities. Jarvis' arrival was timed so that it did not conflict with the Grey Cup championship football game in which the Stampeders were appearing.[135] In Vancouver a few

days later, proud citizens asked for Jarvis' opinion of their new main post office. He replied that the best thing to do with this rather uninspired modern box was to make a giant slipcover for it. Artists and arts supporters loved the unpretentious way in which Jarvis talked to them and his cheeky delight in tweaking the noses of powerful artistic philistines. Even as he extended his and the Gallery's reach across the country on this tour, the experience showed that there was a relatively small audience for his message.[136]

Jarvis was a very experienced and confident public performer who always spoke extempore, so we do not have full texts of what he said. Fragments can, however, be pieced together to recreate the speech he gave most frequently, "*Is Art Necessary?*," whose title had first been used by Sir Kenneth Clark in a wartime speech.[137] In this talk, Jarvis drew on Sigmund Freud, his wartime adult education colleague Bill Williams, Harry Truman, and public opinion polls to explore "what is art," "art and democracy," the government's role in patronage, and the need for a Canada Council, before concluding with his core idea "What is true of our day and age; a museum without walls."[138] By closing on this note, Jarvis hoped people would seek beautiful things outside of formal institutional settings, and understand his "chief ambition ... to bring the National Gallery to *every* part of Canada."[139]

Most audiences were awed by Jarvis' physical beauty and immaculate presentation, and seduced by the chatty way in which he conveyed complex ideas. He was by turns whimsical, anecdotal, cajoling, prodding, and provocative as he insisted that Canadian art had to be judged by international standards.[140] The effect that Jarvis had on those who were interested in the arts was summed up in the wake of a 1956 lecture to the Canadian Club of Montreal when the painter Jacques de Tonnancour raved that "Jarvis was absolutely magnificent on Monday the 5th. He is a walking work of art!"[141] Another commentator, who detected an evangelical fervour in Jarvis' speeches, dubbed him "the Billy Graham of Canadian Art," in reference to the crusading American preacher.[142] In short, Jarvis was as challenging and provocative as the modernist art he adored and persuasive enough to argue at the end of the year that the government's pursuit of the Liechtenstein collection was a sign that "Canada had come of age."[143] Speaking tours turned Jarvis into the face of the arts in Canada and made the country's painters, sculptors, and designers feel as though they were part of an important, national cultural awakening. There was tangible excitement when Jarvis entered a studio or attended a *vernissage*,

and walked about grandly selecting works for the Gallery.[144] In between such visits, Jarvis was regularly approached by aspiring artists and the owners of what they thought were important works that they felt should be added to the national collection. Over time he learned to deflect expectations by proclaiming "Now *that's* a painting," a statement that could be equally arch or flattering depending on the work in question.[145]

Nothing showed the success of Jarvis' speaking tours as much as the cover of the January 1956 edition of *Saturday Night* magazine. It captured the hope embodied in this rising cultural star by superimposing Jarvis' photo over a model of the new National Gallery, whose construction had just been approved.[146] Inside, an admiring profile ran in "Persona Grata," a regular column that featured prominent and influential men and women from around the world. In this interview Jarvis boasted that the arts were about to boom as never before, because new cultural industries would be needed to fill the "incredible leisure hours" that people would enjoy in the future.[147] The article showed that the man, the institution, and the mission had become inexorably intertwined.

At the same time, Jarvis' audiences were drawn from a rather small, sympathetic portion of the population. The effect that his message might have on a much wider swathe of Canadians was seen in May, when *Weekend* magazine, a colour insert that was distributed in newspapers across the country, ran a long interview entitled, appropriately enough, "*Is Art Necessary?*" The piece intended to glean what Jarvis had learned about the state of the arts in Canada after one year in office. He tried to be as provocative in print as he was to live audiences, by dismissing the "chocolate box" tradition of pretty and inoffensive pictures, because "art is not beauty. It should move you." This was followed by a declaration that though art will never appeal to everyone, it should be neither highbrow nor exclusive, because an active participation in the arts promotes a greater desire for good design. Such statements were rooted in what Jarvis had said about the arts since his undergraduate days. However, around the halfway mark, the interview shifted to architecture, a subject on which Jarvis had often spoken since returning home. He argued that Canadian public buildings were timid and nondescript, before demonstrating the inherent conflict between his official role as a senior civil servant and his adopted one as a provocative public figure. He called Saint John, New Brunswick, "probably one of the ugliest cities in the world. It is a shanty town

in effect." The new Provincial Museum in Regina was "a contemporary mockery of what was fatuous enough when they built the Montreal Museum of Fine Arts." Eastern Canada was not spared as Jarvis declared that little art was produced in the Maritimes, and snobs monopolized the arts in Toronto and Montreal, while the inferior "pocket grade" galleries they erected were being emulated in other cities.[148]

When asked such potentially explosive questions by a national publication, more seasoned civil servants would have recited reassuring bromides about Canada's artistic development. Not Jarvis, who had repeatedly proclaimed that his role was to be provocative. This caused him to misjudge the need to temper his remarks for the magazine's readership. What he said also betrayed his limited understanding of the country's diverse regions and the sensibilities of their inhabitants. The reaction was quick and predictable, and affected Jarvis' relationship with three key constituencies: the government, the arts community, and the public. The deputy minister of Public Works, who was responsible for all government buildings, demanded that Jarvis clarify his comments on architecture.[149] Tommy Douglas, the socialist premier of Saskatchewan, took a populist stance on the provincial museum, telling the press that "most modern paintings look like scrambled eggs and if Mr Jarvis wants the building to look like that I think I'd prefer the museum the way it is."[150] In the House of Commons, the member for Saint John insisted that the government investigate Jarvis' right as a civil servant to make such derogatory statements in the press.[151] Arts administrators, whose cooperation Jarvis had courted in his effort to build a museum without walls, were no happier. John Steegman, the director of the Montreal Museum of Fine Arts, was furious, while Martin Baldwin of the Art Gallery of Toronto would not accept that Jarvis had been misquoted.[152] Similarly, aggrieved private citizens from throughout the country wrote Jarvis to defend the beauty of their localities.[153] Among the few supportive voices was that of the editor of the Fredericton *Daily Gleaner*, who told Jarvis that "as long as the future of Canada's fine arts lies in the hands of someone awake to the spirit of originality and validity of achievement, the promotion of the arts can not go too far wrong in this country."[154]

The swiftness of the reactions reflected the way that Jarvis had become one of Canada's most visible public figures. The government-endorsed speaking tours he had undertaken since arriving in Ottawa had also created a

demand for Jarvis as a lecturer, a service for which he realized many organizations were willing to pay. So in November 1955 Jarvis asked the trustees' permission to accept a fee from the Art Gallery of Toronto for a talk on "Modern Sculpture and Some of Its Origins." The board agreed to this unforeseen consequence of their lecture program on the understanding that Jarvis could not be paid for speaking about the National Gallery, because any such speeches would continue to fall under the rubric of the ongoing publicity scheme.[155] However, as the cross-country tour wound up the following spring, Jarvis sought an ongoing permission to charge fees for lectures and television appearances that were not directly related to his Gallery work. Jack Pickersgill felt that Jarvis could accept money for events that required "scholarly work and special preparation over and above the call of" his Gallery responsibilities, but the trustees were unenthusiastic about this blanket permission and asserted their right to approve any such engagements. Over the course of his first year in office, Jarvis had become a public personality as well as a civil servant, and while his bosses knew under which guise he appeared, the public did not.[156] Confusion about whether Jarvis was a government representative or a private citizen would, as the *Weekend* magazine article showed, cause trouble. The government's plan to make Jarvis the face of the Gallery, and the relentless pace at which he delivered well over 100 speeches in his first year, also left him confused about the intersections between his role and responsibilities as a civil servant and as a public personality.

Missteps aside, Jarvis' inaugural speaking tour planted his desire to create a museum without walls in the public imagination. The most tangible evidence of this was the National Gallery Conference at the University of British Columbia in August 1956. The Vancouver painters B.C. Binning and Lawren Harris had proposed the idea for such a meeting to Jarvis on his western tour in the autumn of 1955. Over the following months, Jarvis convinced the trustees to fund a conference exploring how the Gallery could develop its role as a "servicing organization" that supported local endeavours.[157] About forty delegates, representing galleries from across the country, university art departments, the CBC, and a couple of arts-minded foundations attended this three-day meeting, which took place a decade and a half after the watershed Kingston Conference. As befitted the Gallery's increasingly national role, and Jarvis' commitment to extension and educational services, the discussions focused on the need for leadership from Ottawa.[158] Jarvis' keynote address set

the agenda by outlining the Gallery's current and projected national activities, and stimulated a discussion in which regional representatives argued that the Gallery's collections should tour more frequently, and that the institution's professional staff should also give lectures throughout Canada. The trustees, three of whom had attended the conference, digested these proposals before deciding that autumn to look for a Pearsonian "middle way" in which the Gallery's national role sat between ivory tower elitism and paternalism.[159] This fit Jarvis' vision perfectly, while arts administrators believed that they had forged professional connections with the Gallery, and mutually agreed on the fundamental ideas about how to steward the arts over the coming decade.[160]

The discussions in Vancouver had also pointed out that the Gallery had a role in coordinating art education throughout Canada. The concept was not new, but demonstrated the ways in which Jarvis built on the work of his predecessors. In the 1930s, Eric Brown and Harry McCurry had used Carnegie Foundation money to sponsor art projects and a few individual scholars. McCurry had more recently helped to establish the Canadian Museums Association as a body that provided national coordination for cultural institutions. By the time Jarvis took over the Gallery, the Association was conducting a survey of "opportunities for museum workers in Canadian museums" as a first step towards developing a national training program.[161] The educational aspects of this initiative appealed to Jarvis, who began discussing potential roles for the Gallery with his senior staff and trustees almost as soon as he took office.[162] The gradual development of a more systematic approach to national initiatives took place against the government's decision to launch the Canada Council in 1957. Such a national funding agency for the arts, humanities, and social sciences had been called for in the Massey Report.

But it was only in the wake of the Vancouver Conference that the trustees fixated on education as a means of charting a "middle way." As a consequence, they instructed Jarvis to call an informal weekend meeting of representatives from university art departments in early January 1956. Delegates from eleven institutions braved Ottawa's notoriously harsh winter. A couple of them had attended the 1941 Kingston Conference, and several more had been in Vancouver. As on this previous occasion, Jarvis opened the discussions by explaining that education was central to the Gallery's mandate for promoting interest in the arts, and later detailed the institution's work with the Canadian Museums Association. While differing opinions were expressed about

exactly how to teach art history, the meeting formally resolved that robust undergraduate and graduate level programs were needed across the country. Before heading home, the delegates founded the Universities Art Association of Canada, which remains the country's foremost professional body for art scholars.[163]

In order to accomplish all that he did in his first eighteen months, Jarvis worked at a clip that he had not experienced since the most hectic days of the Festival of Britain, half a decade earlier. Jarvis' lack of confidence about many aspects of his new job compounded the almost endless demands on his time. Though he looked to the outside world like an unflappable English gentleman, he fretted all night before Princess Margaret's visit in October 1955, out of fear of embarrassing himself. The pace and the pressure increased his drinking gradually until it mirrored the worst English days. He openly kept gin at the office as he had done in London, while his family discovered bottles hidden about the home.[164] In time, alcohol and the directorship's daily challenges caused a number of public and private slips that undermined Fell's confidence in Jarvis. In the summer of 1955, the trustees ordered him to publish a monthly newsletter to inform them of Gallery happenings. Jarvis agreed but, like Harry McCurry before him, failed to carry out this simple task.[165] The relationship was further strained by Jarvis' mishandling of the trustees' decision to terminate the contract of long-time Gallery advisor Sir Anthony Blunt. In April 1956, Jarvis lied to the board when he told them that he had communicated their intentions to Blunt. When Blunt learned of his dismissal sometime later, he sent Fell an angry letter, with which the recipient chastised the director. A sheepish Jarvis apologized at the board's October meeting, before admitting that he had mishandled another of their instructions about Gallery advisors.[166] It had been less than two years since Norman Robertson and Graham Spry had warned the government that Jarvis did not have the experience to lead the institution.

Hairline cracks began appearing in Jarvis' relationship with the trustees just as a new round of negotiations got underway with the Prince of Liechtenstein. The potential for these protracted discussions to rebound on Jarvis was great, given that he had very little experience with purchases. The public danger was at least equal, because government publicity had identified Jarvis so strongly with cultural initiatives. Almost as soon as this "English" gentleman had arrived at the Gallery, the Conservative party, which was eager to

be seen opposing elitist culture, began questioning the government in the House of Commons about the amount of money it was spending on art. On the first of June 1955, Conservative backbencher Joseph Murphy demanded a list of all the paintings purchased by the Gallery during the past twenty years, their prices, and how many were in permanent storage. Jack Pickersgill fended off the challenge by saying that records were inadequate to allow him to answer the first two parts of the question, while the final point only underlined the government's plans to build a new gallery.[167]

The Gallery negotiated its biggest purchase from the Liechtenstein collection despite this opposition. In the summer of 1955, Agnew warned the trustees that the prince might no longer be willing to give them an exclusive option on the da Vinci. Jarvis was shocked, because as he explained to William Constable, on whom he relied heavily for advice about prices and quality, the Gallery was planning to make a generous offer for four pictures solely in order to get the da Vinci. Constable urged Jarvis to keep negotiating so that the prince would not lose face and to secure a group of paintings that would be defensible in Parliament.[168] By November the prince was convinced that the Gallery could not meet his price, so he formally withdrew the da Vinci and cancelled the negotiation plan that had been laid out by Agnew the previous October. The rebuff shocked the trustees, but they heeded Constable's advice and immediately instructed Agnew to offer $2 million for a group of paintings. The prince countered with four less expensive works: Jean-Baptiste-Simeon Chardin's La Gouvernante and La Pourvoyeuse, an early fourteenth-century St Catharine by Simone Martini, and a dramatic Entombment of Christ by Peter Paul Rubens. The board's anxiousness was aggravated by increasingly protracted negotiations, though Constable steadied their nerves and vowed to personally defend any purchases before the House of Commons.[169] In return, the trustees hired Constable in February 1956 to revise a report he had made about the Gallery twenty-five years earlier. They asked him to chart how the Gallery collection had increased in value over time "as a background and justification for present and future purchases, especially" those from the prince. The report's publication would also give the trustees an excuse to throw a dinner in Constable's honour, to which they planned to invite members of the cabinet and influential Conservatives. In this convivial atmosphere, they would make the case that the Gallery needed a further $5 million for purchases.[170]

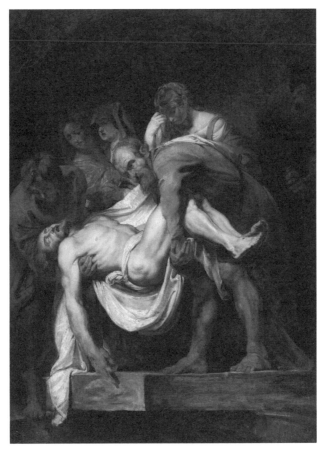

Peter Paul Rubens, *The Entombment of Christ.*
National Gallery of Canada, Ottawa.
Photo © National Gallery of Canada.

Although it was not immediately apparent, the strategy demonstrated that the common ground between art and politics was unstable. Moreover, the requirement to hold a parliamentary vote on each Liechtenstein purchase gave the Opposition a public forum in which to dig up this soil. So it is not terribly surprising to see that just as Constable was hired, a persuasive political argument began taking shape in the House of Commons. During the debate on funding the new purchase, on 8 February 1956, Joseph Murphy repeated his request for the full list and prices of purchases during the last twenty years. This time Jack Pickersgill agreed to produce a total amount spent, but refused

to break it down by individual painting.[171] The Conservatives digested this answer for a few minutes before party leader George Drew asked why Pickersgill had once again refused to answer the question.[172] The trustees held firm in the face of this political pressure, arguing that divulging the prices they had paid for individual pieces would jeopardize ongoing negotiations.[173] Pickersgill agreed and on 5 March he told the House only that the Gallery had spent about $90,000 on Canadian art and close to $1.5 million on European pieces since the war.[174]

Art scholars and critics at home and abroad lauded the coup through which Canada secured four exquisite Old Masters, though the wider reaction was far less sympathetic. Rubens was the only one of the artists whose name was recognized by the general public and, more importantly, the MPs who had to approve the purchase appropriation. So, in strictly political terms, the sum being asked for was out of kilter with the political value of the canvases. Moreover, the Gallery had just reopened after its renovation, with a display of surreal and vibrantly coloured – some might say jarring – new works in place of old favourites. The atmosphere in and out of the House was rife with charges that abstract works were "artistic garbage," a situation Jarvis worsened by quipping to a Montreal audience that the Gallery's critics had the aesthetic sensibilities of "hardware merchants."[175]

The public debate on these prices gave Saskatchewan MP John Diefenbaker, the most formidable parliamentary debater of his time, the material with which to begin articulating an argument that was as politically powerful as it was spurious. Namely, that the National Gallery was neglecting Canadian artists to buy elitist foreign works. In the House on 14 March 1956 he dismissed the trustees' concerns about the effect on negotiations and demanded that the government provide a list of prices paid for every painting the Gallery had purchased in the last five years.[176] The argument about profligacy and elitism broadened one week later when Wally Nesbitt, a young Conservative MP, asked how much Geoffrey Agnew was earning in commissions on the Liechtenstein sales. Nesbitt claimed he did not understand why the Gallery continued using an agent after several years of dealing with the prince, rhetoric that was strengthened by the revelation that Agnew had received some $60,000 for his work, a sum that almost equalled the amount spent on Canadian art in the previous decade. Finally, Nesbitt objected to the high prices paid for artists like

Chardin or Martini, who were little known to the public, and suggested that the Gallery should focus on acquiring the prince's da Vinci, whose value could be grasped by even the least arts-minded taxpayer.[177]

Nesbitt's challenge touched off a motion to rescind Agnew's commission that was argued in the House on the following day. During the debate, Nesbitt made grandstanding demands to know how the government could be sure that these paintings were not forgeries. Diefenbaker then repeated his claim that the Gallery was neglecting Canadian art for elitist foreign works. In his view, the National Gallery should encourage Canadian artists above all, especially in light of government efforts to make a grand capital out of an old lumber town. An independent member from Saskatchewan then pilloried Jarvis by reminding the director rhetorically that it was hardware merchants who paid for Gallery purchases. To drive home this democratic point, he equated the purchase price to 650,000 bushels of wheat, 6,000 steers, or the output of 125 prairie farms.[178] His comments touched off a very lengthy debate in which one Liberal called objections to the Liechtenstein deal a "hillbilly approach" to art, while socialists advocated spending the money on farm relief, others demanded that the collection be put on tour, and yet another group sought reassurances that the Gallery would not buy such "artistic garbage" and "grotesque things" as abstract art.[179] Once all this hot air had been expended, the money was approved. More ominously, the press accused Jarvis and art critics of arrogantly disregarding public sensibilities.[180]

At the same time, the debate showed the Conservatives how to construct a politically decisive argument on voters' long-standing objections to any hint of misspending. The enormous discrepancies between the prices paid for European and Canadian canvases reflected the inchoate demand for the latter, not the quantity or the quality of the individual pieces. There was a global market for European works, and top-quality Old Masters, which hardly ever came up for sale, were most expensive of all. Thus the Conservatives planted a seed in the public imagination that the Gallery was buying European art at the expense of Canadian works. It was far harder for the government to find an equally persuasive defence. Trustees and the minister looked disingenuous when they hesitated in divulging the prices paid for individual works. So they took a different tack in April by revealing the prices that had been paid for individual works, on the principal that these had been bought with public

funds. The trustees furthered this transparent stance by inviting parliamentarians to admire their expensive new paintings at a private viewing on 11 April 1956.[181]

Little more than one week later, Constable tabled his report, which was an articulate defence of Gallery endeavours. He advocated hiring a European agent and pursuing Old Masters before they became too expensive, while at the same time pointing to the Gallery's outstanding post-war record of purchasing Canadian works. He further argued that the sculpture collection should be increased, and called on the director and senior staff to travel regularly throughout the country in order to turn the Gallery into a facilitator for local arts endeavours. While Constable generally stayed away from politically sensitive issues, he argued that the trustees should have a clear indication of their budgets before they began negotiating for works. A strictly limited number of copies of the report were circulated to grandees of both parties.[182]

The strategy appeared to mollify the Conservatives, who lost interest in art. No sooner had the furor abated than the prince signalled that he was once again ready to deal with the Gallery. He still refused to discuss the da Vinci, but in April Agnew learned that he was willing to part with *Madonna Annunciate* by the fourteenth-century Florentine master Lorenzo Monaco. Flush from their success with Canada's largest-ever art deal, Jarvis, Fell, and Constable were convinced that this relatively inexpensive single painting should come to Ottawa. The Gallery was resurgent, and Jarvis suggested that Fell use an upcoming European visit to discuss future Liechtenstein purchases with Sir Kenneth Clark.[183]

Just as these delicate and confidential negotiations for the Monaco were getting underway, Jarvis gave an ill-advised interview to the *Toronto Telegram*, in which he alluded to the new deal and reanimated the political debate over art. Jarvis' comments reverberated when, as Parliament prepared to rise at the start of July, Nesbitt asked Pickersgill whether there were any ongoing negotiations with the prince. The question caught the government and the Gallery off guard. The minister admitted in the House that preliminary "conversations" were underway, while Fell hastily drafted a statement for the press, which said that Nesbitt's enquiry was based on groundless rumours.[184] To bolster this position, Fell instructed Chief Curator Robert Hubbard, who was in London, to avoid journalists and, if cornered, to admit only to having passed

through Liechtenstein on a train.[185] In private, Fell rebuked Jarvis for so stupidly jeopardizing the Gallery's private negotiations by opening "the door wide to all this political claptrap and speculation."[186] The storm abated just as quickly when MPs returned to their ridings for the summer and focused on local affairs, though it placed a small wedge in the crack that had begun opening between Jarvis and the trustees.

Jarvis established himself as the most important and widely quoted Canadian cultural leader during his first eighteen months in office. In doing so, he achieved the government's objective of making him the Gallery's public face, and thereby the embodiment of Canadian culture. But the strategy's negative effects could not be controlled by the government or the trustees. These resulted largely from the teasing, provocative quips Jarvis made during speaking engagements. Lecture tours had turned Jarvis and the Gallery into the focus of equal respect and anger. This was most noticeable after Jarvis' first Liechtenstein purchases, which were lauded by critics and questioned by politicians.

All of this made Jarvis the focus when things began going wrong at the Gallery.

"A Chamber of Horrors"

The National Gallery of Canada, 1957–1959

An optimistic National Gallery annual report – written by Jarvis and illustrated, for the first time, under Paul Arthur's direction – was tabled in the House of Commons in early 1957. The report rebutted Conservative charges of snobbery and elitism by proclaiming that the Gallery had moved beyond the cautious "interregnum" of Jarvis' early days to a period of "expansion" as it evolved "from a relatively minor institution into a truly national one."[1] Jarvis used the report to address the public debate over the latest Liechtenstein purchases, while defending the Gallery against accusations that it ignored Canadian works.

The confidence was ill-timed. In the general election of 10 June 1957, John Diefenbaker's Conservative minority ended twenty-two years of Liberal rule. Diefenbaker had only been Tory leader for six months, while the party had occupied the opposition benches for so long that his fourteen cabinet ministers were all novices. Like all minorities, they had to manage Parliament skillfully in order to remain in power. Ministers thus introduced a spate of vote-generating wage, price, and subsidy bills at a breakneck pace, while their equally tireless leader toured the country endlessly, belying his sixty-one years and embodying the change and reform about which he spoke. The most significant challenge bedevilling the government was the economy, which had boomed almost continuously since the war, only to sputter soon after the

Conservatives took power. Unemployment began to rise and the future looked troubled.

The prime minister's public appearances projected an image that was as deliberately crafted as Jarvis' persona. Though nicknamed "The Chief," Diefenbaker was a farm-born populist with a genuine desire to help society's less fortunate. To prove these credentials, he was often photographed fishing, a folksy passion that concealed decades of thwarted ambition. Having twice been passed over for a Rhodes Scholarship, and missing the First World War because of an inglorious training accident, Diefenbaker spent decades in the obscurity of Saskatchewan, gradually building a reputation as one of Canada's ablest defence lawyers. All the while he was defeated in bids for municipal, provincial and federal office, before finally being elected to the House of Commons in 1940. Diefenbaker's slow rise to power bred a deep mistrust of Ottawa's cadre of foreign-educated senior civil servants, whom he called "Pearsonalities," a snide reference to his political nemesis, the Nobel Prize winning diplomat Lester B. Pearson. Cabinet was equally convinced that the bureaucrats with whom they needed to work closely had strong Liberal sympathies. Diefenbaker extended Vincent Massey's term as governor general, but it was clear that the Liberal civil service mandarinate was no longer in the ascendant. Many of its most capable members left for the private sector or academia. These troubles were foreseen by the painter A.Y. Jackson and the National Gallery trustee Dorothy Dyde, who agreed a few days after the election that both Jarvis and the institution were in for substantial headaches because there was no support for the arts in the new administration. Jarvis' English friends also feared he would not survive long in this new climate.[2]

If Ottawa's political atmosphere was suddenly threatening, Jarvis' personal life was more settled than it had been in the previous two years. In the spring of 1957, the trustees instructed him to curtail his speaking engagements and concentrate on day-to-day duties in Ottawa.[3] In doing so, they ended the campaign to advertise the Gallery that they, Jarvis, and Jack Pickersgill had developed in 1955. A less frenetic work schedule allowed Jarvis to explore his parental roles and responsibilities as never before, something, he confided to family and friends that he wished to do. This was wonderful news for Jarvis' mother, who had urged him to concentrate on his family duties when he first returned home in 1955. She herself had remarried when Jarvis was ten and his brother fourteen. The Jarvis boys had soon looked on Ed Bee as their

father, which convinced Jarvis and his mother that Betty's children might one day feel the same.[4]

Now that Jarvis was rooted in Ottawa, a comfortable pattern emerged. On winter weekends, the family skied together in the Gatineau hills, while there were summertime visits to the Stratford Festival and shared cottage vacations with Betty's brother and his family. Jarvis was increasingly devoted to these domestic affairs, and tried to schedule his professional commitments around them. For instance, he curtailed a Toronto speech in February 1957 in order to get back home and "be one of the boys" on his stepson's birthday. He attended school concerts, and spoke at his elder stepdaughter's high school commencement.[5] He and Betty were very close and enjoyed one another's company. They spent part of the summer of 1958 motoring around Europe, as Jarvis helped set up Canada's pavilions at the Brussels World Fair and the Venice Bienale. The trip was Betty's first opportunity to see the places in which Jarvis had lived and worked, and to meet many of his English friends, like Sir Kenneth Clark, with whom they spent the weekend.

Parties, vacations, and graduations, no matter how grandly they are marked, are only dots in the continuum of parenthood and family life. Despite Jarvis' desire to act as a father to Betty's children, his complete inexperience and continued drinking made him impatient. He was a hopeless disciplinarian who plaintively requested a misbehaving youngster to "please stop being such a bore." The children, quite naturally, repeated this phrase mockingly behind his back.[6] Betty looked after household finances and other quotidian chores that Jarvis found equally mundane. All the while, Jarvis' mother was a very difficult, meddling, and at times physically intrusive presence as she tried to ensure the success of her son's marriage. Few of these tensions were apparent to the friends with whom Jarvis and Betty socialized, like Norman and Audrey Hay, Jack and Frances Barwick, and people from their undergraduate days, such as Norman and Oriel Berlis and Kendrick Venables.

The professional, family and social ties that were transforming Ottawa into Jarvis' home were strengthened at the start of 1957 when he was elected to the board of governors of Carleton University. This seemed like a perfect fit, given Carleton's mandate to educate students from non-traditional backgrounds and that its president, Claude Bissell, had worked with Jarvis on an undergraduate literary magazine.[7] Jarvis had given his first Canadian speech at Carleton's May 1955 commencement and his aesthetic expertise would be

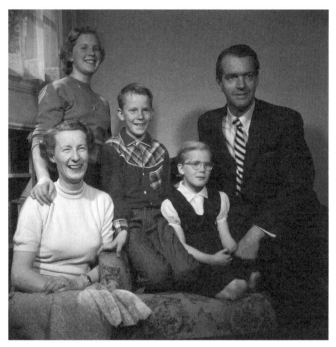

Jarvis, Betty, and the children, at about the time that he tried
dedicating himself to family life. *Weekend* magazine, 19 May 1956.
© Library and Archives Canada. Reproduced with permission.
Louis Jacques/*Weekend* magazine collection/E010745914.

particularly useful as the university built its permanent campus. As it turned
out, Jarvis was rarely able to attend the board's meetings, though his appoint-
ment helped to cement him to the local community in the way that his speak-
ing tours had done on a national level. He remained on the board until 1961.[8]

The Gallery trustees decided to keep Jarvis in Ottawa because they sensed
that it was no longer necessary to advertise the institution. Moreover, the staff
had increased substantially in a little over two years and required greater daily
stewardship than it had when Jarvis was hired.[9] No one foresaw the way Jarvis'
presence in the capital would exacerbate several minor irritants that had
grown up between him and the trustees. In mid-1957, they questioned his
right to authorize the foreign trips on which he sent senior Gallery officials.

The trustees feared that long European sojourns would breed a sense of entitlement, even if Jarvis saw travel by Robert Hubbard and Kathleen Fenwick, in particular, as key to their professional development.[10] No sooner had Jarvis been questioned on this issue than he was informed that the trustees intended to manage other business affairs more strictly.[11] But the lack of a regular newsletter hampered their attempts to scrutinize the Gallery's daily operations, and so they instructed Jarvis to rewrite the institution's bylaws in hopes of clarifying responsibilities and lessening internal tensions.[12] Little of this was apparent to the public, who visited the Gallery as never before, forcing it to stay open on Wednesday evenings.[13] People could also tell from the construction site on Elgin Street that the new building was well on its way.

Gallery purchases in 1957 continued to combine tradition and challenge. The first cubist masterpiece, Picasso's 1919 *Le Gueridon*, was added to the collection, as was Francis Bacon's *Study for Portrait Number 1*. They were balanced by the understandable, comforting image of Dante Gabriel Rossetti's *Salutatio Beatricis*, the Gallery's first Pre-Raphaelite work. A head by Henri Gaudier-Brzeska was added to the sculpture collection. The same philosophy underlay the following year's acquisitions, which included Henri Matisse's odalisque, *Nu au Cape Jaune*, and works by contemporary Canadians as diverse as Alex Colville, Alfred Pellan, Jacques de Tonnancour, Jean-Paul Riopelle, Paul-Émile Borduas, Harold Town, Kenneth Lochhead, B.C. Binning, William Ronald, and Kazuo Nakamura. More conservative tastes were assuaged with works by Group of Seven members Fred Varley and Franklin Carmichael, and the academician Charles Comfort.

Jarvis' Gallery exhibitions also hit their stride that year, beginning with a gala at which the governor general opened a show of the Joseph Hirshhorn collection, a fabulous accumulation purchased with the profits from Northern Ontario mines. This was the first Gallery show to have been wholly developed under Jarvis' leadership, and as such it resonated with his previous careers. It had first been discussed as Jarvis returned to Canada in 1955. During his brief stop in Manhattan, he was approached by the legendary public relations agent Benjamin Sonnenberg, whom Jarvis had first met through Gerald Murphy and had subsequently employed as an advisor to Pilgrim Pictures. Sonnenberg envisaged an exhibition that would redefine Hirshhorn as a cultured patron and benefactor. Soon after arriving in Ottawa, Jarvis broached the idea with Jack Pickersgill, who was immediately enthusiastic,

and they travelled to New York to sign a formal agreement. Pickersgill, who was no wallflower, was astounded by Hirshhorn, whom he described as a total extrovert with "a lot of discernment and a lot of appreciation, but who also tended to buy art by the yard."[14] The minister was equally impressed by the way Jarvis was not intimidated by the mogul. Their respect was based on a shared instinct for publicity. When Jarvis and the Gallery's chief curator, Robert Hubbard, subsequently selected works from among Hirshhorn's New York and Toronto caches, they were trailed by a photographer from *Weekend* magazine.[15] Unfortunately, the article these photographs were meant to illustrate was never published.

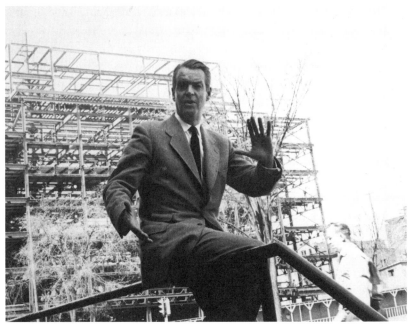

Jarvis expounds about art as the new National
Gallery building rises behind him, c. 1958.
Alan Jarvis Collection, University of Toronto.

The Hirshhorn show was followed by colour woodcuts, the second Biennial of Canadian art, an inaugural national fine crafts exhibition, mural designs for the Canadian pavilion at the Brussels World's Fair, Pablo Picasso's works, and a group of eighteenth-century British paintings. In 1958, there were shows of contemporary Australian and Italian art, the collection of Greek shipping magnate Stavros Niarchos, a memorial to the Winnipeg painter Lionel Fitzgerald, a look at younger British and European painters, prints by Henri Matisse, a retrospective look at the National Gallery's early years, Henri Cartier-Bresson's photographs, and the Massey medals for architecture. The governor general returned to the Gallery in June 1959 to open an exhibition of works drawn from Ottawa collections. Once again the Gallery sent dozens of exhibitions across the country.[16]

The effect of the purchases made under Jarvis' directorship was dramatic. Younger Canadian talents like Harold Town, Gordon Smith, and Jean-Paul Riopelle, who were "making an impact in the post-war world," were fostered at home through the 1957 and 1959 Biennials, and abroad at the 1958 Brussels World's Fair, and the Venice Bienale.[17] This recognized their talents and boosted their careers. However, not everyone appreciated the Gallery's increasing taste for modern works, and one senator proclaimed that the institution was becoming a "chamber of horrors."[18]

Nevertheless, as the collections grew, Gallery staff set about developing the skills to meet Jarvis' vision. Jean-René Ostiguy went to Paris to study how adult education could be applied in museums, Robert Hubbard and Kathleen Fenwick continued travelling to Europe, and William Constable came up from Boston to teach a new generation of professionals under the auspices of the Canadian Museums Association.[19] The staff's experience was acknowledged in January 1959, when Ryerson Press suggested that Jarvis, Hubbard, and Donald Buchanan select the subjects for a comprehensive series of short books on Canadian art. Jarvis was then asked to write the entry on David Milne, the one artist about whom he could claim to be an expert.[20]

Jarvis' proselytizing about "a museum without walls" also inspired a small band of well-heeled supporters, led by the Ottawa newspaper proprietor, diplomat, and patron Hamilton Southam, who had known Jarvis since their undergraduate days, to found the National Gallery Association at the start of 1958. These socially and politically prominent men and women wanted to cement Jarvis' work in popularizing the Gallery, by hosting bilingual lectures,

discussions with artists, films, and musical evenings in its auditorium. Prospectuses outlining their plans were sent to museum directors across the country in hope of creating an association with national reach. When the regions preferred their own local groups, the organizers decided to model themselves on similar committees in Toronto and Montreal, and turn the National Gallery itself into a vibrant museum without walls.[21]

The *Globe and Mail*'s art critic Pearl McCarthy, who was eager to see the Gallery become a "live place," was one of over 900 people who paid the $2 membership fee. A.Y. Jackson, whose niece, Naomi Jackson Groves, had helped launch the Association, lent his support by giving the inaugural lecture in December 1958, and was followed shortly by Jarvis' great admirer, Jacques de Tonnancour. Chief Curator Robert Hubbard led audiences through the history of Canadian painting in a series of talks over the spring, while on Sunday afternoons the Gallery echoed with chamber music.[22] Apart from being its guiding spirit, Jarvis had no formal role in the association, which was entirely independent of the Gallery, even if it embodied his adult education ideals and aim of creating similarly vibrant cultural community centres across the country.

More than anything, the association showed that Jarvis had begun creating popular support for the Gallery. His encouragement of grass roots endeavours had also helped to put in place much of the museum without walls that he had championed. But if, like the peers in Gilbert and Sullivan's *Iolanthe*, the Gallery was afflicted with an annual blister, it was Queen Mary's Carpet, a three-by-two-metre floral needlepoint. Queen Mary had sewed the first of over one million stitches in 1941, and when the carpet was completed nine years later she decided to sell it to help ease Britain's post-war debt. The sale was facilitated by the redoubtable ladies of the Imperial Order Daughters of the Empire (IODE), a charitable organization that had been established at the turn of the century to foster connections with Britain. They organized an immensely popular, if more than faintly absurd, travelling exhibition. When the carpet was displayed at the National Gallery in March 1950, a squad of Mounties in red serge stood guard as 14,000 people filed past in only two and a half days. This success inspired the IODE, who chose Toronto's Canadian National Exhibition as the venue from which to launch a fundraising drive to secure the carpet for the nation. At the end of August, it was flown to Toronto airport and handed over to the lieutenant governor of Ontario and a retinue

of civic and provincial dignitaries, who escorted it to the fair grounds. There the IODE had persuaded Simpson's, one of the city's swankest department stores, to decorate the hall in which the carpet was shown on a floodlit stage. A small army of volunteers manned the display, while regular announcements over the public address system reminded pleasure seekers on the midway to visit the carpet. The IODE had hoped that the Queen herself would record a similar radio address encouraging all Canadians to admire her handiwork during a thirty-six stop national tour, but Mary, whose Germanic *hauteur* was legendary, refused.[23]

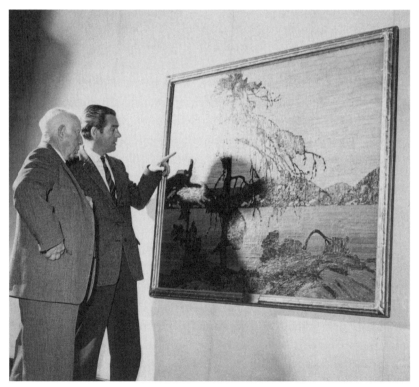

Old and New in Canadian art, Jarvis and the painter A.Y. Jackson examine Tom Thomson's *The Jack Pine* at the National Gallery. © Government of Canada. Reproduced with the permission of the Minister of Public Works and Government Services Canada (2008). Source: Library and Archives Canada/ Credit: G. Lunney/National Film Board fonds/PA-122726

As befitted their mission, the IODE invested this tour with the pomp and trappings of monarchy. In each city and town, the carpet was ceremonially handed over to a royal, consular, or similarly august municipal official who escorted it to the local museum. The totals that were raised in each centre the carpet visited over the next six months are a topographical atlas of mid-twentieth century royalist sentiment. Almost $25,000 was raised in Toronto, though Montrealers only gave some $4,000, about two thirds of which came as a single donation from someone identified only as "a very elderly gentleman."[24] For their part, Vancouverites coughed up a little over $1,000, which was only about three times the sum raised by the small industrial city of Sudbury.[25] In the midst of this folly, the IODE secured the carpet's copyright in hopes of reproducing it as wallpaper for those who wanted to add a cosy royal touch to their dens and bedrooms.[26] Local IODE chapters also sold colour postcards and brochures that explained the carpet's history and, in the end, some $200,000 was collected.[27]

By the tour's last stop, it was clear that the carpet would remain in Canada. Where it should be housed was more vexing, because Queen Mary, believing no doubt in the salutary effects of royal handicrafts, had stipulated that her creation be displayed in a public institution. With this in mind, the IODE sought and received the prime minister's assurance that it would be hung in the National Gallery.[28] In October 1951, therefore, when head trustee Vincent Massey formally accepted the carpet from Princess Elizabeth, it became one of the most valuable items in the collection.[29] At the same time, it was far from clear whether this piece of royal memorabilia belonged in an already cramped national art institution, especially as it came with thousands of surplus brochures that clogged the Gallery's storerooms in the coming years.

Individual works of art in public collections rarely have vocal champions, though the IODE had an understandably strong proprietary interest in the carpet's long-term care. They first complained in June 1952 that the carpet was improperly hung and not protected by glass or a crowd barrier.[30] The following January, the IODE's president threatened to repossess the carpet, and demanded that Vincent Massey personally ensure that a suitable glass display case was going to be embedded in the floor of the new Gallery building.[31] A harassed Harry McCurry replied with both hope and diplomacy that he would happily lend the carpet to any suitable museum in the country.[32] Unsurprisingly, none stepped forward. The IODE's request that the carpet be

shipped to England for repairs found its way onto the agenda of the trustees' meeting in March 1953.[33] The saga continued the following July when the IODE, having discovered that the carpet was no longer on permanent display, yet again appealed to Vincent Massey to repair what they described melodramatically as the Gallery's "breaking faith with the people of Canada."[34] The governor general could hardly disregard these vocal royalists and so Massey urged the trustees to retrieve the carpet from storage.[35] Charles Fell, the newly installed chair of the board who actively sought Massey's advice on Gallery affairs, agreed to investigate the matter, though he warned Massey that "I am sure I shall have some difficulties in dealing with [McCurry about] this particular problem."[36] This short phrase summarized the Board's strained relations with McCurry, who resisted on the grounds that hanging the carpet meant removing at least one important Canadian painting. He relented very grudgingly.[37]

The issue remained unresolved at Jarvis' appointment. In anticipation of his arrival, the IODE wrote to acquaint him with the carpet's history, and to ask where it was to be permanently displayed. Jarvis conferred with Fell, who advised him that this was a "National Gallery headache and we shall have to bear with it until we find the best solution."[38] So, one of the first letters to bear Jarvis' signature as director informed the IODE that the Gallery intended to keep the carpet only until such a suitable place could be found for it on Parliament Hill or in a museum. No other institution wanted the annoyance and eventually Jarvis hung the carpet behind a set of heavy gold curtains that were opened by security guards on request. He explained to any enquiring members of the IODE, that this arrangement protected the carpet from light and dust.[39] The compromise made it seem that the Gallery was hanging the carpet with sufficient reverence, while also appeasing artistic purists by keeping it out of sight. Jarvis brokered a ceasefire, only to have this particular rug pulled out from under him at a very inopportune time.

Jarvis' speaking tours had turned him into Canada's most well-known advocate for the arts and culture. Now that he was rooted in Ottawa, he decided to reach a national audience through television. He had appeared on the BBC several times, and returned home at the dawn of Canadian broadcasting. In late 1952, the CBC launched television stations in Montreal and Toronto, and expanded to Halifax, Ottawa, Winnipeg, and Vancouver within two years. Viewership rose in both absolute numbers and as a proportion of the popu-

lation over the same period, as the cost of purchasing a set dropped dramatically. By 1955, the majority of Ontario households were tuning in, though it took rural areas longer to catch up.[40]

Jarvis understood from his British career that the new technology was an important tool for creating a museum without walls, because, as he proclaimed to *Saturday Night* magazine at the start of 1956, "What a magnificent ally art is going to have in television! Art and television together are naturals."[41] He ventured into broadcasting that summer by leading a half-hour tour of the Gallery for the CBC series *This Is Ottawa*.[42] The Gallery was one stop on this six-episode exploration of federal institutions, which was broadcast on Tuesday nights at ten. Hosting the tour inspired Jarvis to get permission from Penguin Books to reuse *The Things We See*, the title of the best-selling book he had written a decade earlier, for his own CBC television series.[43]

A jazzy theme played as the title credits rolled over the shadows cast by a revolving mobile when the first instalment of Jarvis' show aired in July 1957. Viewers then saw Jarvis standing in one of the National Gallery's main exhibition rooms, where he set out his aim of demonstrating the difference between "looking" and "seeing," in order to train viewers to critically assess the world around them.[44] This aesthetic objective was captured in the words Jarvis spoke at the start of subsequent episodes:

The things we see
The things we see
People and places, things and faces
The world is so full of a number of things,
That I think we should all be as happy as kings.[45]

The poem and the up-tempo music over which it was recited set an informal tone. At the same time, Jarvis was an elegant host who wore an immaculate white shirt and striped club tie, even during the episodes in which he drew or sculpted. As in his public appearances, he eschewed a formal lecture style for a casual, extempore discussion that never relied on erudite ideas or specialist language. Instead, Jarvis used innovative, interactive techniques, many of which he drew directly from his discussion group days. He began with the most basic idea by encouraging viewers to look though a camera lens or a simple homemade cardboard viewfinder in order to "frame" what they saw in

their daily lives. By doing so, he hoped that they would be able to see art and beauty in the everyday world.

The lack of script made the episodes slightly uneven, as Jarvis paused for thought or repeated himself, and their pace is sometimes ponderous to a modern viewer. But they were quite stirring and radical in the context of 1950s Canadian television. More than anything, the thirteen shows demonstrated Jarvis' vast experience and ideas about art and adult education. He recounted anecdotes about sketching with David Milne to explain how a painter captures light, and drew random shapes on paper as various types of music played in order to show that moods can be expressed equally strikingly in charcoal. In a particularly interesting sequence, Jarvis rearranged the trees, sky, and snow on a full-size wooden model of Lawren Harris' iconic painting *Above Lake Superior* to demonstrate how artists compose and balance their work. Removing a single element made the composition fall apart figuratively.[46] An architect friend of Jarvis appeared on another episode to explain how a simple suburban bungalow reflected fundamental concepts of shelter and peace.[47]

Nothing was more compelling than the eighth episode, during which Jarvis demonstrated sculpture. His younger step-daughter Julie joined her father in the studio so that he could model her portrait in front of the camera. As Jarvis measured and moulded Julie's features in clay, he explained how sculptors must "see around the corner," or work in three dimensions in order to capture their subjects. He further demonstrated the techniques used to build up a portrait by applying heavy daubs of clay to Jacob Epstein's bust of George Bernard Shaw from the Gallery's collection. While the institution's conservators winced at this casual attitude to such a valuable piece, it underscored Jarvis' desire to deflate the stuffy pretensions of art and gallery-going.[48]

Jarvis brought his interrelated ideas together in the episode that covered industrial design. Unbeknownst to the viewers, what Jarvis said distilled his work on the *Britain Can Make It* and *Bill and Betty* exhibitions and the films *Deadly Lampshade* and *Designing Women*, by using simple techniques to describe profound ideas. The balanced pattern on a bolt of fabric was contrasted with a spilled inkwell that represented "accident," which Jarvis called the "exact opposite of design." He challenged the idea that everything old is beautiful by juxtaposing overly ornate Victorian forms with sleek, modern, mass-produced items. And in a direct nod to his English work, Jarvis used

two inexpensive sets of salt and paper shakers to show how to evaluate designs by asking simple questions like "What is it?," "Is it well made?" and "Will it last a long time?"[49]

While teaching viewers to critically assess the world around them, Jarvis was more subtly vaunting the Gallery's role as a national coordinating or "servicing organization" of the type that the Vancouver Conference had called for the year before. He encouraged viewers to find, photograph, and describe public sculptures and memorials in their hometowns in order to help the Gallery compile a national index. At the end of each episode, he asked the audience to send him a dime, in return for which they would receive a set of postcards of Gallery works. The cards had been created originally to advertise the collections, but Jarvis, whose show was broadcast in black and white, used them to explain how painters use colour. In the final episode, he explained most explicitly how the Gallery was engaging with the country, by walking through its rooms, extolling the collections, the staff who had amassed them, and enumerating the various Ottawa-based and touring exhibitions that the audience might wish to visit.[50] This was a final, concrete attempt at breaking down the museum's walls and making the collections accessible and understandable. Having been equipped with critical tools, Jarvis hoped the public would see that art was meant to elicit emotional responses, not be comforting or beautiful. Critics, like the *Globe and Mail's* Pearl McCarthy, who lauded Jarvis' plain language and his "national leadership in encouraging looking," loved the show.[51]

Jarvis' use of television to teach people to critically assess art and beauty made it apposite that the first significant public challenge to the Gallery was made on the same medium. In December 1957, he appeared on the CBC's *Close-Up*, which labelled itself as "a program with opinions." An announcer introduced the segment demanding to know whether the National Gallery was "filling up with junk," before cutting away to a shot of Pierre Berton and Jarvis facing one another in a darkened studio. The two men embodied opposing ideals of Canadian culture. Jarvis exuded Anglophile urbanity in a dark suit, gleaming shoes, and an accent to match. The heavier, balding Berton's checks, bow tie, and thick horn-rimmed glasses epitomized a new group of populist, nationalist critics who refused to ape English sensibilities.

The ensuing interview, which revisited Jarvis' missteps, was as confrontational as the show's premise. When asked about a senator's claim that he was

buying junk, Jarvis responded with what he termed a "very violent reaction" to the idea that the Gallery was misusing public funds. Berton, who was a more skilful television performer than his guest, then provoked Jarvis into admitting that he was always involved in controversy, before offering him the chance to justify the $885,000 Liechtenstein purchase. Jarvis did so by once again insisting that international reactions to the sale had been overwhelmingly positive. Such an apparently elitist reply was hardly likely to appease Berton, who then asked Jarvis to clarify the statements he had made the previous year about the cultural backwardness of the Maritimes. His rather half-hearted apology cited statistics to prove there were fewer professional artists on the east coast than elsewhere in the country. Finally, Berton echoed the prime minister by demanding to know why the Gallery purchased so few Canadian paintings, a nettlesome charge Jarvis tried to rebut by showing off works from his own collection by David Milne, Gordon Smith, and Jacques de Tonnancour.[52]

Jarvis mounted a more robust defence against such allegations the following month when he published the first of nine short columns that each explained a single Canadian painting from the Gallery's collection. These were widely circulated to a general audience through the *Toronto Star's* weekly magazine. Each column was accompanied by a large full-colour reproduction of the work Jarvis described. The paintings he chose ranged from Emily Carr's familiar *Indian Church* to the more challenging automatism of Jean-Paul Riopelle. There was nothing particularly revelatory in what Jarvis wrote, but that was never the point. He was demonstrating that the Gallery had long collected Canadian works, that many of these had become national icons, and that the institution continued to buy from the country's best artists.[53]

More positively, Jarvis' appearances on *The Things We See* showed that he was an engaging television performer. This was noticed by the young CBC producer Vincent Tovell, who eventually signed Jarvis to appear as an expert on a February 1959 program publicizing an exhibition of ceremonial masks at the Royal Ontario Museum.[54] Not long after the program's start, it became clear why Tovell had chosen Jarvis. His two co-panellists were tweedy academics with awkward voices and an inability to explain abstract ideas in plain language. Jarvis looked far more like the program's handsome and polished host in a well-cut, dark three-piece suit with a huge white handkerchief blooming from his breast pocket. As the group moved through the exhibition discussing

the origins and meanings of various masks, Jarvis made points in fluid, long sentences that contrasted with his co-panellists more ethnologically insightful, but less elegant contributions. The difference was so marked that by the time the trio had finished discussing the first set of masks, Jarvis had effectively assumed control of the program and begun leading the group around the studio.[55]

Jarvis' comfortable and compelling performances convinced the CBC to exploit his talents. Soon, Jarvis was asked to appear on a springtime children's series about Canadian artists. The series was never made, but Tovell approached Jarvis about presenting a more serious show on the Renaissance.[56] Tovell wanted to inject creativity into Canadian broadcasting by developing thoughtful, educational, "pure television" that combined images, music, and words to capture the spirit of what he explicitly called the "museums without walls."[57] Having encapsulated his democratic vision for the National Gallery with these same words, Jarvis was a natural choice. The Renaissance was selected as the inaugural topic because it was the spring from which modern artistic and intellectual currents flowed. Equally importantly, its core ideas could be covered in three half-hour programs as long as Jarvis, who appeared alone on camera, used a script. Having agreed to the format, Jarvis earned $1,500 out of the shoestring budget for travelling to Toronto throughout the spring to work out the shows with Tovell and the writer Ronald Hambleton. The trio decided that the series would be called simply *The Renaissance*, with each of the three episodes having a subtitle that reflected its focus on the concepts of "the mind, the body and the spirit."[58]

The first program, subtitled "The Window," began with a shot of Jarvis seated on a stool, reading a passage from the Book of Genesis about Man's dominion over the earth. He then used Leonardo da Vinci's notebooks to show how the artist had gone beyond religious doctrine to look critically and scientifically at the physical world. A week later came "The Mirror," in which Jarvis tackled Michelangelo's fascination with the human body, and described the *Last Judgement* from the Sistine Chapel as an allegory for the public's fears in the nuclear age. The final instalment explored the Renaissance spirit through Botticelli's sensual, "hedonistic" canvases and the Florentine leader Savonarola's public denunciations of moral corruption. Watching Jarvis' television appearances today, one is struck by how closely he modelled his posture, accent, and manner of speaking on his English hero Sir Kenneth Clark.[59]

But unlike the latter's *Civilisation*, which would be an international sensation a decade later, *The Renaissance* was broadcast between *The Loretta Young Show*'s domesticity and the music and comedy of *Here's Duffy*, a timeslot that only emphasized how different the program was from normal Canadian television fare.

Tovell and Hambleton enjoyed working with a man they found to be poised and confident, even though, as they later discovered, the series coincided with growing tensions at the Gallery.[60] At the end of 1956, Jarvis had boasted to Toronto's Empire Club that the Liberal government had spent almost $1 million on Liechtenstein works and created the Canada Council. Both were signs that culture would never again be neglected, and were a "symbol or symptom of Canada's coming of age."[61] Nothing could have been less prescient.

Though the Conservatives controlled fewer than half the seats in the House of Commons, the opposition parties had been in no haste to bring the government down. An increasingly infirm Louis St-Laurent was replaced as Liberal leader in January 1958 by the sixty-year-old Lester B. Pearson, who had served as minister of External Affairs since entering politics a decade earlier. Everything from Pearson's given name to his bow ties projected a meekness that contrasted with Diefenbaker's deep-set eyes, down-turned mouth, fulsome jowls, and impassioned speech. These differences were most pronounced on the floor of the House, where the Conservative leader's oratory was withering. The public saw their inequalities thanks to Pearson's first speech as leader of the Opposition, in which he blamed the Tories for the country's mounting economic ills, before demanding that they hand power to the Liberals. Diefenbaker seized on his opponent's misstep and spent over two hours throwing out quotes from a leaked Liberal economic document to prove that the party's pre-election forecasts had misled the public. He dissolved Parliament ten days later, and when the ballots were counted on 31 March 1958, the Conservatives had secured the greatest majority in Canadian history. Looking on these events from Montreal, John Steegman, the English-born director of that city's Museum of Fine Arts, lamented in his diary, "I am sorry, as the parties are now too unbalanced."[62]

Steegman's fears were well-founded, because the new government's manifesto emphasized agricultural reform, social justice, the inclusion of First Nations and the North, and reaffirming ties to the Commonwealth as a bul-

wark against American domination. The Liberal conception of cultural development that had been enshrined in the 1951 Massey Report was invisible in a political platform where mending the troubled economy was a far more pressing issue than acquiring a world-leading art collection. Diefenbaker himself had questioned the Gallery's commitment to Canadian artists in the House, while his supporters could well have pointed to the Liechtenstein deals and many of Jarvis' public statements as indications of Liberal profligacy, snobbery, and entitlement. This dramatic political shift coincided with the emergence of a group of younger, nationalist cultural critics and the establishment of Canadian history and literature as distinct fields of study in universities throughout the country. These broad social changes coupled with the abrupt political upheaval to make Jarvis' accent and apparent deference to English sensibilities seem anachronistic.

It was in this atmosphere that Jarvis and the trustees published the Gallery's annual report in the spring of 1958. Such reports are normally rather staid accounts of how a particular department spent its budget. But this one directly refuted Diefenbaker's charge that the Gallery neglected Canadian works. It was quite clear to anyone who read the document that the prime minister was one of "those who examine one isolated annual report ... [and] complain that the National Gallery has purchased too many European works and not enough Canadian" ones.[63] This strident claim was almost certainly drafted during Diefenbaker's parliamentary minority, but by the time it was published he had become the most powerful prime minister in Canada's history. There were bound to be consequences.

The new political atmosphere was further darkened by the fact that no member of the Conservative administration understood the years of elaborate negotiations that had been undertaken with the Prince of Liechtenstein. Furthermore, the two senior Treasury Board officials who had been responsible for the Gallery's financial affairs had left, taking with them their knowledge of existing informal funding arrangements.[64] But, no matter which party was in power, the Gallery had to keep negotiating with the prince if it wanted to one day secure his Leonardo da Vinci.

The Liechtenstein purchases had also come to symbolize the Gallery's ambitions in the public eye, though an attempt to buy a single painting from a German aristocrat would ultimately prove to be far more damaging. On his trip to Europe during the summer of 1956, Robert Hubbard first saw Peter

Brueghel the Elder's *Calling of St Peter* at the Austrian estate of Baron Gerhard von Polnitz. The baron was aware of the prices that the Liechtenstein works were fetching and hoped to realize a similar sum. He also knew that his picture was very marketable because Brueghel was one of the most renowned sixteenth-century Flemish painters and, like da Vinci, an artist whose works were familiar to the public. While such name recognition alone might induce cabinet to bid, Hubbard reported excitedly that the painting was "most beautiful and desirable," and assured the trustees that it could be acquired for "$400,000 or less" through the baron's Manhattan agent.[65] Kathleen Fenwick reinforced this assessment by reporting that the canvas was "of the beauty of which the photographs had given no idea."[66] The trustees knew that only six Brueghel's remained in private hands and so they decided to pursue the painting at the start of 1957 by instructing Jarvis to check with Treasury Board, which controls the government purse, about whether it could be purchased out of the remaining Liechtenstein funds.[67]

The trustees made the decision just as the new government took power and the relationship between the two bodies began to change. The new dynamic was more subtle than the intransigent opposition summed up snobbishly by Jack Pickersgill as "the Diefenbaker government felt that there were more votes in the Saskatchewan dam than in the National Gallery."[68] The Conservatives' lack of interest in culture was signalled that June when Justice Minister Davie Fulton, the energetic British Columbian who had been a Rhodes Scholar in Jarvis' year, was given temporary responsibility for the Gallery. Fulton was focused on legal reforms, and admitted to not paying a great deal of attention to the Gallery or questioning Liberal commitments to the institution.[69] In the absence of any unequivocal signal to desist, in the autumn the trustees had decided to keep purchasing from the prince in order to maintain the momentum they had built up towards a deal for the da Vinci.[70] Though the evidence is far less clear, it appears that the trustees also felt they could start negotiating in earnest for the Brueghel.

It was at this point that Jarvis appeared on Pierre Berton's television show. Unbeknownst to either man, reactions to Gallery affairs were coming to a head. As part of the plan to buy into the Liechtenstein collection gradually, Geoffrey Agnew had contacted the Gallery in April 1956 about *Madonna Annunciate* by the fifteenth-century Florentine monk Lorenzo Monaco, which Jarvis, Fell, and Constable soon wanted. However, negotiations with the

prince lay fallow until the start of 1958 when Jarvis asked for a $100,000 option on the painting, which the trustees were anxious to purchase with the last of the Liechtenstein money. They believed that such a relatively small sale would bring the Gallery closer to the da Vinci, a deal that would in any event require a new vote of money. The strategy derailed almost immediately. In what must have been a tremendous shock to the Gallery, the Conservative cabinet rejected the trustees' request for $400,000 for the Brueghel in early February on the grounds that "a transaction of this sort was bound to become known to the public and was unlikely to be looked on with favour under the present unemployment situation."[71] The Gallery had little recourse, because the Liberals had never regularized the Liechtenstein purchase fund. In their private correspondence, the painter A.Y. Jackson and the trustee Dorothy Dyde took the rebuff as a strong sign that Jarvis was "in for a rough ride" in a turbulent political atmosphere.[72] Little more than one month later, the Conservatives won their majority.

Rather than accept cabinet's decision, Jarvis tried to guide the powerful new government. In a mid-April 1958 letter to Fulton, he explained that the Gallery was committed to championing Canadian art, but swiftly rising prices in the international market meant that the institution would soon be unable to buy foreign works. Having made this argument, the Gallery parcelled the Brueghel and Monaco deals together, saying that if the Brueghel could be bought for $350,000 and the Monaco for $95,000 then the total would come within what the trustees believed had been earmarked for Liechtenstein purchases.[73] This was the first purchase that the Conservatives oversaw, and even though they could have annulled the Liberal's unwritten agreements, ministers accepted the Gallery's argument and on 2 May they authorized the trustees to use the Liechtenstein funds to buy both works.[74]

On 7 May, Jarvis therefore telephoned Geoffrey Agnew in London to say that the Gallery would take the Monaco for $95,000 and guarantee to pay the prince by 15 June. Unbeknownst to Jarvis as he spoke to Agnew, Fulton had discovered that there had never been a formal Liechtenstein account and so there was no money for the purchase. Once the minister realized his misstep, he ordered Jarvis to cease negotiations, before humiliatingly revealing the mistake to his cabinet colleagues.[75] Having set the purchase in motion before receiving the order to desist, Jarvis' reaction could not be so measured and Fulton found it difficult to convince the director to cancel the

deal.[76] Jarvis conceded on the following day by ringing Agnew to say that the money was not available, all the while reassuring the dealer that this was a temporary, political impasse. Soon after, the trustees conferred about the issue and they too agreed that the funds would almost certainly become available once the Supplementary Estimates were tabled in the House in mid-June. These reassurances convinced Agnew that he had a firm commitment from the government of Canada, and so he borrowed the money with which to buy the painting on the Gallery's behalf.[77] While the evidence is again less clear, Jarvis' actions with the baron convinced the latter that he too had a deal with the Gallery.

Just as the strands in the skein began tangling, on 12 May cabinet responsibility for the Gallery passed to the red-baiting Hamilton accountant Ellen Fairclough, who was identified as far and away the least competent minister in a famously critical assessment of the Diefenbaker government.[78] Jarvis did not immediately perceive the significance of this change, telling friends that Fairclough's control of the purse strings made her the "minister of treats and surprises."[79] Jarvis had first given this name to Sir Stafford Cripps, from whom he had received many treats. As it turned out, Fairclough offered more, but mostly unpleasant, surprises. She and Jarvis were like chalk and cheese; she felt he was a Liberal, whose romantic notions about art, especially the nonchalant way he leaned paintings along his office walls, showed a complete lack of administrative ability. She was equally suspicious of the Gallery because professional training told her that no matter how sensationally a painting's value soared, this could not be realized, because top-class works were never sold. To this end, she dismissed the previous government's unwritten commitments to buy Old Masters that were rapidly increasing in price and favoured once again putting the Gallery on a strictly monitored annual purchase account. Finally, as a long-time member and former vice-president of the IODE, Fairclough cannot have been impressed by the Gallery's disrespectful treatment of Queen Mary's Carpet.[80]

Cabinet's attitude towards the Gallery began hardening at a late May cabinet meeting during which Fulton explained that Jarvis had made firm offers to purchase the Brueghel and Monaco. The government's legal advisors stated that any claims brought by the agents would be unlikely to hold up in court, sparking a debate about whether cabinet could extricate itself by buying and immediately reselling the canvases, or even asking the owners to take them

back. While the discussion demonstrated ministers' ignorance of the international art trade, they agreed that Jarvis, who was in Venice with Betty setting up the Biennale exhibition, "should be asked to return to Canada immediately to help clean up what could only be described as a 'mess.'" In addition, he was to be stripped of all financial responsibilities, and made subordinate to a deputy minister. Cabinet also agreed to dismiss Jarvis if he refused this last sanction, which was effectively a demotion.[81]

Like Jarvis' collaborators on *The Renaissance* television series, the friends who had joined him in Venice did not realize that the situation had suddenly deteriorated. George Ignatieff, Canada's ambassador to Yugoslavia, who had first met Jarvis as an undergraduate, recalled the frequency with which he excused himself to answer long distance telephone calls from Ottawa – a rare and expensive occurrence in 1958. Jarvis did not share the reason for such close contact with home, but Ignatieff sensed that he was troubled, all the while recalling nostalgically years later that, even in a moment when he needed support, Jarvis never allowed such mundane things "to put any cloud over his relationship with his friends."[82] Jarvis' former lover Burnet Pavitt had an equally blithe, if catty memory of a group chatting over drinks "on the piazza, while you [Jarvis] were being plagued by that horrid ministress on the telephone."[83] It was romantic for Jarvis' friends to think that he could simply brush off these pressures, but the exigencies of running a government department had smacked up against the insouciant emotional shell that prevented him from asking for help and support when he most needed it.

During their telephone conversations, Jarvis and Fairclough decided that he should travel directly to Zurich to inform Baron von Polnitz that the deal for the Brueghel was off. Unfortunately, the baron and his agent arrived at the meeting on 7 June expecting to receive $350,000 for the Brueghel. When he realized that Jarvis was breaking off the negotiations, he sent the trustees the first of an increasingly indignant series of demands for money. These arrived in Ottawa each month for the rest of the year.[84]

Meanwhile, the relationship with Geoffrey Agnew was strained, though not quite so dramatically. The Gallery's long-time London dealer had initially been quite conciliatory, and even offered to find a buyer for the Monaco, in return for his $4,500 commission. Cabinet refused to meet this demand. Their intransigence annoyed Agnew, who cited wholly unprofessional behaviour from a national art institution, before informing ministers that Canadian

lawyers had advised him he could sue both Jarvis personally and the government for breach of contract.[85] In spite of this warning, the refusal to meet Agnew's terms turned the Monaco deal into a political issue. On 10 July, Fairclough told her colleagues about Agnew's claim, and in the ensuing discussion it was agreed that Jarvis "appeared to have no administrative talent and, in fact, had played a questionable part in the whole affair." Having recorded this opinion in the minutes, ministers reaffirmed their refusal to allocate funds for the Brueghel, while rather understandably postponing a response to Agnew.[86]

Firm as this decision appeared to be, at the next cabinet meeting four days later Fairclough asked her colleagues to revisit their views, given that government lawyers had informed her that a lawsuit launched by either dealer could only be defended on politically unpalatable legal technicalities. Instead, she said that ministers might want to look on this as a rare – not to mention politically expedient – opportunity to acquire two important paintings.[87] The reflective mood lasted until August when a new letter from Agnew, in which he argued that he had bought the Monaco in good faith and was prepared to sue if he was not paid for it, caused Fairclough to advocate honouring the transaction. She said that Agnew's history of buying pictures from the prince on the government's behalf had assured him that he was acting once again as Canada's official agent. Her colleagues were more adamant and refused to allocate any funds, blustering that Agnew should sue, before conceding that his commission might be paid at some future date.[88]

Though Jarvis exuded his usual gaiety in public, there were tangible signs he could see that his future was precarious. One of the few people in whom he confided was John Steegman, the British connoisseur who headed the Montreal Museum of Art. He and Jarvis were not close friends, but they had often lunched or met for cocktails over the previous three years. Steegman was also at odds with his institution's trustees and a shared sense of peril may have led to the September meeting he summarized in his diary as "Alan Jarvis came in for a drink – discussed with him my affairs: also his own, with anxiety on both sides."[89] Both men knew that the autumn would not be pleasant for Jarvis.

The drama's final act began in mid-September when Fairclough sent Agnew a letter whose wording had been carefully reviewed by government lawyers, because cabinet no longer trusted Jarvis with these communications. She informed Agnew that because there had never been a deal, money would

not be allocated to complete the sale. Two weeks later, the trustees instructed Jarvis to inform the baron that the government believed he had never had a contract with the Gallery and that no funds were available with which to purchase his Brueghel. They ensured the message was conveyed precisely by insisting that Jarvis copy the "legally correct" wording of Fairclough's earlier letter to Agnew.[90]

This mid-October missive was staid, formal, and legalistic, but a letter in Jarvis' archives at the University of Toronto that is ripped in half, undoubtedly by Jarvis, attests to his intense emotions as the situation deteriorated. It was written by Charles Fell two days after Jarvis drafted the trustees' letter to the baron. In it, Fell expressed his desire to discuss "the fault to be found in the actions which you [Jarvis] took" in the negotiations, a rebuke he compounded by pointing out that because the Civil Service Commission had hired Jarvis in 1955, any possible punitive action "would be between you and the Government rather than you and the National Gallery Board [of Trustees]," to whom the director could no longer look for protection.[91] In Fell's eyes, both Jarvis and the government were to blame for this bungled affair, and he considered resigning in protest. Whether Fell stayed or not, Jarvis now faced an unsympathetic cabinet without the sure support of the trustees, and the worst professional crisis in his life without friends to confide in. This left him professionally and emotionally alone as government and Gallery interests diverged completely.

The public remained largely unaware of Jarvis' isolation until November when *Maclean's* magazine published an article whose title asked the leading question "Is Jarvis Mis-spending Our Art Millions?" No answer was proffered, because, after stating that Jarvis was a "spectacular exception" to the rule that senior government officials say as little as possible in public, Peter C. Newman recounted a litany of the director's most outrageous and challenging remarks, like calling soothing pictorial works "the chocolate box" school of art, or that viewing Queen Mary's Carpet behind its curtains "should be accompanied by a hidden phonograph playing God Save the Queen, and that all IODE ladies should be charged twenty-five cents a peep."[92] The bulk of the article retraced Jarvis' life and career in a way that made him seem like a silly dilettante who dismissed Canadian sensibilities. It is not surprising that the article enraged Norah McCullough, the Gallery's extension officer for western Canada, who had known Jarvis since the 1930s when they had worked together on the

Picture Loan Society. She had called on her substantial Toronto contacts in an effort to prevent the publication of the article, whose title alone seemed to her to be "dangerous considering the general level of voter intelligence."[93] Once Newman's piece appeared, a "boiling mad" Joseph Hirshhorn chastised the magazine's editor for printing in the guise of serious journalism a trifling story that was "more appropriate to a teenage movie magazine."[94] McCullough and Hirshhorn defended an extremely vulnerable friend, but when the Montreal publisher Gilles Leclerc privately praised Jarvis' "'je m'en foutiste' audacity" to provoke Canadian sensibilities, he articulated the views of a wider circle of admirers. They were largely unaware of just how bad things had become at the Gallery for this embodiment of Canadian culture.[95]

From the publication of Newman's article onward, Gallery affairs were constantly in the government and public's eye, putting Jarvis under unremitting pressure and stress. On 5 December, Geoffrey Agnew once again demanded his commission, to which he now added $2,500 in interest and expenses. The letter included a very pointed jab at the whole affair, for as Agnew wrote: "I imagine that Mr Fell, the Trustees and yourself [Jarvis] have not carried out your threat of resignation, probably because you fear that reactionaries would step into your shoes. I can sympathize with your decision and have no wish that you should all resign on my behalf."[96]

Agnew caught the spirit of the moment, because Ottawa buzzed with rumours that Jarvis and the board planned to quit *en masse* unless the government honoured the deals. Each side tried to curry public favour as the stories spread. In mid-month the *Toronto Star* published an accurate account of how the deals with the prince and the baron had evolved, suggesting that the paper had a source in the Gallery. This may well have been Jarvis, who made his first attributable comments that same day when, under a banner headline, he told the *Ottawa Journal* that Davie Fulton's inattentiveness, when he was the cabinet minister responsible for the Gallery, was to blame for the botched deals. It was startlingly brazen for a civil servant to make such a public charge, and showed that things were seriously amiss between the Gallery and the government. Even so, Jarvis, Fell, and several other trustees refused to comment on their springtime intentions.[97]

These accusations prompted reporters to confront ministers as they arrived at the following day's cabinet meeting. Fulton defended himself by saying that "nobody had told the gallery they could buy the paintings," to

which Ellen Fairclough added "you can't expect to buy $500,000 worth of paintings when we need the money for other things" like economic programs. Prime Minister Diefenbaker once again played his populist trump in saying that he refused to spend so much money on what he dismissed as "two paintings from Europe."[98] While the trio had never been especially sympathetic to the Gallery, they were hardly likely to be won over by being questioned as they entered a meeting whose agenda was the "crisis" that had gripped the economy. Over 400,000 people were out of work and cabinet was splitting into a faction that advocated fiscal retrenchment and a balanced budget, and one that favoured spending as a way out of the recession.[99]

Now that the basic facts of the dispute were public, people evaluated the actions of both sides.[100] In London, Geoffrey Agnew defended himself in *The Times*, while closer to home, A.Y. Jackson, one of the most astute observers of Gallery affairs, saw the government's decision to argue the issue in public as a big setback for Jarvis. The Gallery's relationship with the government was not helped by a *Toronto Star* editorial that lambasted Diefenbaker as an uncultured cretin, and a *New York Times* piece that predicted the Opposition would wield the deals like a cudgel in the upcoming parliamentary session.[101] Only the *Toronto Telegram*'s young critic Paul Duval defended the prime minister, though with unintended irony, by arguing that the Gallery should not spend its money on these paintings and instead focus on buying the prince's da Vinci.[102] As these reactions were published, Jarvis again lunched in Montreal with John Steegman, whose diary on this occasion recorded that the "situation between the National Gallery and Ottawa and the Finance Minister is appalling – Alan's post of Director is certainly in jeopardy."[103] This short note barely captured a whiff of the *Sturm und Drang* into which Jarvis had been thrust.

The storm hit, just as the *New York Times* had predicted, in January 1959 on the first day of the new parliamentary session. Opposition leader Lester Pearson used his reply to the Speech from the Throne to upbraid the administration for equivocation, miscommunication, and indecisiveness on trade, agriculture, wages, and defence spending, to which he added, in a rare fit of rhetorical eloquence, "this ill-starred venture of the government into the field of art which has brought a measure of humiliation to our country and some very bad publicity."[104] By including the deals in his opening challenge to the government's legislative agenda, Pearson equated them with quotidian

economic policy and turned them irrevocably into a public, partisan political affair. Privately, Charles Fell believed that the outcome of all this posturing remained "up in the air."[105]

The first blow came from the government benches. On 11 February, Joseph Murphy, who represented a rural Ontario riding and was a long-standing critic of the Gallery's acquisitions, demanded the names and prices of all paintings purchased since 1950, along with the commissions paid on these sales and the identity of the agents who had brought the canvases to the Gallery's attention.[106] There was no immediate response, but Jarvis refused to hide as the fight intensified, taking part in a public debate on the potentially inflammatory question "How much of modern art is junk?" that was held in the auditorium of the building that housed the Gallery.[107] The Liberals counterattacked in Parliament at the end of the month when Jack Pickersgill asked whether Jarvis had received "authorization from the government or any member of the government or anyone authorized to speak for a minister, either in writing or orally" to make an offer for the Brueghel.[108] Pickersgill hoped to use his knowledge of the Gallery's inner workings to expose Conservative incompetence in handling the latest deals.[109]

Despite Jarvis' apparent indifference to the fight, the political jabs from both sides of the floor were hitting home. While deciding on how to respond to Pickersgill's question, cabinet discussed the Gallery situation and Jarvis' future for the first time on 24 February. Ministers conceded that their "moral position" with respect to Agnew, who had bought a painting from the prince in the belief that he was acting as the government's agent, meant that they should pay his commission. Acknowledging their potential liability hardened cabinet's attitude towards Jarvis. He had often boasted of having refused to be hired as a civil servant, in order to preserve his right to speak his mind, and to enable the government to dismiss him if the things he said were too controversial. However, it was precisely because the director *was* a civil servant that cabinet had such trouble getting rid of him. The government knew that it would be difficult to fire him outright, and that he was further protected by the high reputation he enjoyed in artistic circles. Even with this restricted ability to punish Jarvis directly, ministers nonetheless reprimanded him and told him "to look for another job."[110] The decision to pay Agnew and punish Jarvis gave Fairclough the ammunition with which to respond to Pickersgill.

So on the following day Fairclough told the House that cabinet had authorized the trustees to negotiate for the Brueghel, based on the latter's assurance that there were sufficient funds, but that "no authority existed to make a firm offer or enter into a contract for this purchase by the National Gallery or the government of Canada or anyone on its or their behalf."[111] The minister's short speech quieted the issue for a fortnight, when an opposition member forced her to produce the Gallery's budget for the previous twenty years, identify every trustee who had served since 1913, and explicitly state Jarvis' roles and responsibilities before reading a lengthy portion of his biography into *Hansard* to prove that he was qualified for the job. At the end of this laundry list, Fairclough distanced the government from the Gallery, stating that it was an independent institution and that there was no relationship between the board of trustees and the department of Citizenship and Immigration.[112] Jarvis was isolated and publicly repudiated by the government, which was as yet too unsure of its position to take the customary next step and fire him. He could no longer rely on the trustees' support, thanks to the increasingly fractious relationship he had with them.

On the following day, Fairclough tried to diffuse the situation by telling the House that the new Gallery, which was slated to open at the end of the year, would include the most modern facilities and sufficient space to exhibit all the important works in the collection. Lester Pearson could not abide this platitude and once again defended Jarvis in a long speech about cabinet's "sorry record of mishandling" negotiations with the prince. In her reply, Fairclough refused to apologize for the government's actions, before reaffirming that Jarvis had never been permitted to purchase the works.[113] The pair sparred until Parliament adjourned for the evening. A good sleep fortified Jack Pickersgill, who on the following day accused Davie Fulton of incompetence – through dismissive Conservative taunts of "oh, oh" and "utter rubbish" – because the minister claimed to have been ignorant of whether funds were available for the purchases. This sparked a long debate that pitted Fairclough and Fulton against Pearson and Pickersgill. Both sides had girded themselves before entering the House with transcripts of earlier debates from which they quoted extensively.[114]

Cabinet's deliberations and the political posturing crippled the Gallery's daily operations. Jarvis and his senior staff were occupied explaining the deals

at length to officials from the Privy Council in hopes of convincing them that the institution had acted properly. The strategy only deepened the conviction in the heart of government's senior department that Jarvis' personal actions had bound Canada in a moral "gentleman's agreement" with Agnew and the baron.[115] The Conservatives reacted by reducing the annual purchase budget to a bare minimum. Robert Hubbard and Kathleen Fenwick, Gallery curators who had enjoyed unprecedented autonomy under Jarvis' directorship, felt paralyzed about suggesting additions to the collections. There were no purchase funds, and even if there had been money, only the most reckless staffers would have bought anything.[116]

As Jarvis worked behind the scenes, he was quoted in the right-wing *Toronto Telegram*, saying that Queen Mary's Carpet, a spectre that had troubled no one for quite some time, was a phenomenon but not a work of art and should therefore be housed in a museum.[117] His drinking was very, very heavy at this point and may well have caused him to make this spectacularly ill-judged comment.[118] His views, which were certain to cause offence in some quarters, came as Ontario royalists were preparing for Queen Elizabeth's impending visit. The IODE also happened to be holding its annual convention, and when members objected to the dismissive tone of Jarvis' remarks, it was reported on the front page of the *Toronto Star*.[119] The *Times* of London, which had earlier reported on the broken deal with Agnew, carried an article about the new carpet controversy. Written rebukes arrived at the Gallery from the IODE, private citizens, British women's groups, and even one of the Queen's Ladies in Waiting.[120]

As the carpet story drew its last breaths in the media, a Liberal backbencher tabled motions demanding that the government produce all correspondence and minutes concerning the Brueghel negotiations, while in his reply to the budget, Lester Pearson once again cited the broken deals as evidence of Conservative financial mismanagement.[121] What looked like the start of another campaign to discredit the government was actually the story's denouement, because little else was ever said in the House and the government now only had to find the right lever with which to oust Jarvis. But getting rid of him would not resolve the deals, as cabinet heard personally from the Canadian high commissioner to London in mid-May. He had been approached by Britain's secretary of state for the Commonwealth about the

Agnew situation. Their conversation convinced the high commissioner that the affair was "causing a great deal of embarrassment" and affecting business relations between their two countries. This information prompted Fairclough to again ask her colleagues to buy the Liechtenstein painting from Agnew, which she felt could be done stealthily and without Parliament's knowledge, by using money from the Gallery's administrative account.[122] They refused.

The situation with the baron, who was now threatening to sue for $21,000 of interest on the purchase price, had taken on similar diplomatic dimensions.[123] He travelled to Ottawa in early 1959, forcing the German ambassador to personally prevent him from confronting the prime minister.[124] Having calmed the baron, the ambassador demanded that Fairclough explain why Jarvis remained in office when the government refused to honour a deal that it had told the House he had authorized. Ministers were not swayed, believing that, unlike Agnew, the baron's dealer had not been acting on the government's behalf and so they had no obligation to pay. Nevertheless, they were split between a faction who felt that Jarvis' esteem in the international art world meant that firing him would create a huge storm and reignite public interest, and those who wanted a decisive move to prevent the Opposition from ever reopening the issue.[125] Fulton then sealed the debate by stating what Fairclough had only implied – Jarvis had to go.

Charles Fell was the first casualty. He had been contemplating his response to the situation between the Gallery and the government since the previous autumn and on 29 June he sent the prime minister a polite letter of resignation.[126] In a subsequent interview, he told Fairclough that Jarvis had often acted without the trustees' consent. The conversation convinced the minister that Jarvis was to blame for the situation and that he could not remain in office once Fell had been replaced. However, when she sought authority to fire Jarvis at a cabinet meeting three weeks later, her colleagues were confused about his employment status and, consequently, how to remove him.[127] The following morning, ministers questioned whether the Civil Service Commission had the authority to make limited-term appointments such as that of Jarvis. Fearing that they might be bound to wait until his contract expired in 1960, cabinet instructed Fairclough to see whether Fell would permit her to discuss his criticisms with Jarvis. She hoped the humiliation would force him to quit. As a sign of their resolve, ministers declared that they would

"welcome" the resignations of any trustees who disagreed with this course of action.[128] The hard line towards the trustees reflected the government's belief that these Liberal appointees should have supervised Jarvis more closely.

It is not clear whether Jarvis ever learned what Fell had said, but the end came on 30 July when Fairclough told him to step down.[129] He did not give her a formal reply before leaving to spend a month in Algonquin Park with Betty, the children, and her brother's family. Incapable of sharing his troubles, and feeling a noble obligation to preserve the holiday, Jarvis kept the news from his wife, though he told her brother and Joseph Hirshhorn, who had so strenuously defended him in the previous autumn.[130] Betty knew something was wrong, but he rebuffed her questions. So she asked Norman Hay to visit, in hope that he might have more luck. Hay found that Jarvis was setting out in a rowboat each morning, spending the day alone and drinking heavily.[131] It is not clear exactly how Jarvis broke the news to his wife and family, but neither the *pro forma* letter of resignation that he wrote on 24 August, nor Fairclough's equally innocuous response, reflected the preceding two years of bitterness and accusation. His only request was to break the news to his mother, so that she would not learn of his dismissal through the media. Fairclough consented, and they decided mutually that Jarvis would leave at the end of September.[132] At the following cabinet meeting, Fairclough declared that a Civil Service Commission competition, such as the one in which Jarvis had been hired, was not the appropriate way to select his replacement, because it limited cabinet's ability to choose a particular candidate. With Jarvis gone, the government paid Agnew's commission with interest.[133] The baron never received any money.

Reflecting on their relationship fifteen years later, Fairclough summed Jarvis up as a "dreamer" who fell in love with pieces of art, all the while believing that the government would somehow find the money with which to purchase them. These emotional responses led him to act hastily, which in turn forced cabinet to "either honour the commitment because he is a servant of the government, or you say he had no right to commit the government and consequently we repudiate the deal and we have to repudiate him. There's no two ways about it."[134] For his part, Jarvis could not publicly admit that he had been forced out or that he and Fairclough had parted on anything but the best of terms.[135] She was convinced by Jarvis' insouciant public attitude that there were no hard feelings. In fact he was shattered.

Next to leave was Cleveland Morgan, the trustee who had helped inaugurate the Liechtenstein negotiations. He did not go quiescently. On 2 October, he sent the prime minister a stinging two-page letter of the sort that national leaders are not accustomed to receiving. In it, he railed against the government's "studied discourtesy" in repudiating the purchases, making Jarvis' departure appear to be voluntary, and appointing new trustees without consulting the board.[136] Diefenbaker's placid reply glossed over Morgan's criticisms, but the *Montreal Star* captured the trustee's bile by calling his resignation a clear sign of the government's contempt for quasi-independent institutions like the Gallery.[137] Nor was it easy to ignore the seventy-three-year-old painter Lawren Harris, who was the best known trustee thanks to his membership in the Group of Seven. He attacked the government over its treatment of the Gallery, but refused to quit, lest the Tories appoint someone who had no interest in art.[138]

Other onlookers began spreading the idea that Jarvis was a victim of political pettiness who had been martyred for art, and this point of view has largely dominated subsequent thoughts about his Canadian career. Lady Jane Clark, who learned of Jarvis' fate in the London newspapers, wondered how "the National Gallery of a great country like Canada would have had such petty and politically minded trustees – when we [she and her husband Sir Kenneth] were in Canada Vincent [Massey] was so happy to have you – your staff loved you – you had bought marvellous pictures."[139] In a subsequent note, an equally surprised Sir Kenneth, whose backing had secured the directorship for Jarvis, added that it was "a disaster you have had to leave. I was afraid that these local characters would do you in."[140] Norman Berlis, who had helped Jarvis in the earliest stages of his campaign for the directorship, confided that "I know it has been far from an easy job, but you have done so much and I have such faith in you that – for the Gallery's sake – I am very sad indeed that you are leaving."[141]

Many arts-minded Canadians, a community that Jarvis had brought together and inspired, told him that his departure robbed the country of an important champion. Among them were the modernist architect Watson Ballharrie, who lamented the silencing of "a public scourge to the second rate," to which the sculptor Marius Plamondon added, "Until you came along, no one had managed to shake us out of our national complacency. You have convinced many, awakened others and made the rest uneasy, artists and public

alike."[142] From her Toronto studio, the sculptor Frances Loring wrote "I am very sorry to hear that the National Gallery is no longer to have you as head. It will be a great loss. However, I do not doubt that you are doing the right thing, I don't see how you have stood it as long as you have."[143] Maud Brown, the aged widow of the Gallery's founding director, declared "you haven't been given a fair chance to show what you can do – or rather, have been doing for the Gallery – for it takes time for all the new developments you have initiated to bear fruit."[144] From New Zealand, where he was serving as Canada's high commissioner, Jarvis' one-time companion Graham McInnes said simply "that I regard your departure from the National Gallery as a cultural calamity," especially because Jarvis had "forced people to sit up and think" about the arts.[145] The keenest insight into the forces that had driven Jarvis out was conveyed by his former lover Burnet Pavitt, who wrote sardonically that "to have Dr Fell and the shade of [Queen] Mary Teck up against you must have been most tiresome."[146]

The public outcry largely supported Jarvis and lambasted the government, cementing his martyrdom in the wider imagination and in his own psyche. Richard Gwyn told a CBC audience that this was "a personal tragedy in the career of a man who must rank among the most brilliant of contemporary Canadians."[147] Robertson Davies, as editor of the *Peterborough Examiner,* denounced the dismissal as the first step in a "war of attrition" in which culture would be robbed to pay off deficits, while a languishing Gallery displayed "fancy beadwork and Queen Mary's needle point carpet."[148] Blair Fraser, the most astute and influential journalist in Ottawa, used his national column to attack the government. In an article that was illustrated with a cartoon of Diefenbaker and Fairclough pulling a rug out from under Jarvis as he was about to take delivery of the Brueghel, Fraser asked whether the director's "resignation" was a "euphemism." Having posed the question about whether or not Jarvis had left voluntarily, Fraser retraced Jarvis' Gallery career in order to put the fault squarely on a Conservative cabinet that refused to trust anyone whom the Liberals had appointed.[149] The *New York Times* echoed this assessment by blaming the Diefenbaker government's meddling and duplicity.[150]

Jarvis' dismissal was a huge blow to the Gallery staff who had flourished under his direction. Their surprise and shock was deepened because Jarvis confided his troubles to so few people. He spent a considerable amount of

time in his last weeks advising Lord Beaverbrook about the establishment of an art gallery in Fredericton, New Brunswick. Jarvis participated eagerly in the project, because the new gallery helped realize his vision of well-endowed art institutions in every province. The interesting work with Beaverbrook's convivial art experts was also insulated from the huge tensions at the National Gallery. Beaverbrook's staff were unaware of the extent of Jarvis' troubles, because in the safe harbour of their work he continued to radiate an immense aura of confidence and achievement, while retaining "great humour and great humanity and he was just fun to be with."[151]

The unexpectedness of Jarvis' departure from the National Gallery is best captured in a note that Richard Simmins, the head of extension services, sent Jarvis on the eve of the latter's summer holiday:

> Things seem to be moving along fairly well at the Gallery but perhaps this is just a brief lull before another storm. At least with another few months we will all have the new building to divert us and this should boost morale all round; and, for a year or so, we will be so preoccupied with novelty, that petty things will receive only their just treatment.
>
> It has been quite a tough year for you and I do hope you, in the quiet of the woods, are girding your loins for the new season. So rest assured that you have the support of your staff. No institution is free of faults and weaknesses, trivial irritations and a Philistine control agency which tries to make life hell. On the whole the National Gallery is doing a good job and – with luck – we have a great future.[152]

Before looking forward, the Gallery staff had to bid Jarvis farewell. At an autumn reception, the staff presented him with a typewriter as a sign that they expected to read his opinions about art for years to come.[153] At the same time, a letter from Robert Hubbard to Sir Anthony Blunt, the Gallery's long-time London agent, conveyed the staff's trepidation for their own futures:

> I am afraid that the situation here is rather chaotic. Three new Trustees quite unknown to us were appointed the other day, but there is no director yet. The great fear is that some unqualified or otherwise unsuitable person might be appointed. For myself of course I hope the

situation does not become impossible, or I shall have to think of going somewhere else. I have already investigated Canada Council fellowships, and might possibly turn up in London on one. All this comes just as we are getting ready to move into the new building in November.[154]

Having vented his fears and frustrations, Hubbard urged many acquaintances in the art world to apply for the directorship.[155] But the government was taking no chances. In January 1960, cabinet appointed Charles Comfort, a genial fifty-nine-year-old grandfather. He had been a war artist and was now one of the country's foremost portraitists, a University of Toronto professor, and president of the Royal Canadian Academy. Comfort was unlikely to challenge cabinet's or the public's ideas about the arts.[156]

Bathos closed Jarvis' year. Having been forced out of the Gallery over his supposed misjudgment, he awarded one of the prizes in a student art show to a young man who had sent-up abstract works by filling a canvas with "jam, a huge gob of plaster, the odd piece of hi-fi equipment, a cigarette box, and a few toothpaste tubes." Journalists, and no doubt many readers, delighted in Jarvis' self-justificatory claims that he had spotted the hoax, but rewarded it nonetheless "for amusement value."[157] The episode confirmed many people's suspicions that non-representational art was bunk and that Jarvis' snobbish judgment clashed with Canadian sensibilities.

CHAPTER
TWELVE

"Canada's Most Outspoken and Witty Man About the Arts"
Toronto, 1960–1968

Ottawa, which had only just dug out from one of the heaviest snowfalls in memory, hummed on the evening of 18 February 1960. Red-coated Mounties and local constables controlled the traffic that choked Elgin Street on that Wednesday night as some 2,500 invitees, led by Prime Minister Diefenbaker and his wife, were deposited at the new National Gallery. Once inside, guests to the building's inauguration discarded their overcoats and galoshes – as the cloakroom filled, outerwear was dropped unceremoniously in the Design Centre's new exhibition space – to reveal white ties and tail coats, gowns and satin gloves. The mid-winter glamour, rare enough in a staid country like Canada, was evanescent. The capital's haberdashers had done a brisk business in formal wear in the previous days, but scuffed shoes, long-unworn waistcoats, and business suits were easy to spot.

Less visible were members of the Liberal Party, who had sparred with the government over Gallery issues for much of the previous year, and denounced the event's dress code as an "undemocratic white tie curtain around the Prime Minister."[1] In the face of this last political stand, Conservative members and senators, foreign ambassadors, civil servants, Ottawa socialites, and representatives of Canadian and international art institutions mingled amid the exhibition of European paintings that Donald Buchanan had assembled for the occasion. The gala's climax was Diefenbaker's pointed speech, in which he

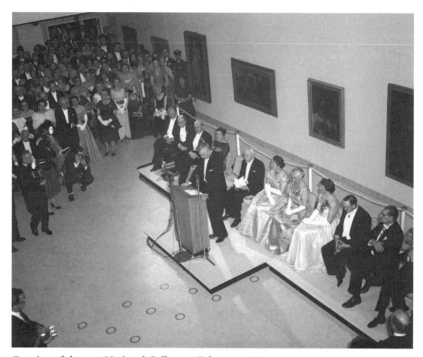

Opening of the new National Gallery, 17 February 1960.
© Library and Archives Canada. Reproduced with the permission
of Library and Archives Canada. Source: Library and Archives
Canada/Credit:Duncan Cameron/Duncan Cameron fonds/
Accession 1970-015/Item no. 8422

boasted of a populist "major step forward – a gallery for all Canada" that
would foster "Canadianism."² Anyone who had followed Gallery affairs knew
that this was a shot at Jarvis and the Liberals, whom Diefenbaker had long
accused of neglecting the country's artists. Ellen Fairclough, the minister who
had dismissed Jarvis, was next at the rostrum, though she and the eight re-
maining speakers were drowned out by the chatter that echoed through the
building's cavernous atrium. Once the speeches were done, the guests repaired
to the top floor restaurant that Jarvis had insisted be included in the Gallery's
temporary home, where they enjoyed a suitably parsimonious array of sand-
wiches and coffee.

Even the most casual onlookers – and many people had pressed their noses to the Gallery's ground floor windows on that wintry night – perceived the tensions about Jarvis that underlay the thrift-store elegance. Charles Comfort, who was making his maiden appearance as director, had set out his unobtrusive style in an interview the day before by refusing "with a touch of asperity to be drawn into any 'provocative' statement, such as whether he thought art in the Maritimes was backward."[3] The new Gallery's democratic ideals were further signalled by the way Queen Mary's Carpet, which had dogged the institution for a decade, was laid out on a wooden dais amid works by British artists.[4] Most pointedly, Jarvis, who had done so much to popularize the arts in Canada, was absent. He had not been invited. Neither his name, nor his contributions were mentioned in any official speech. He, Betty, and a small group of friends had assembled across town at the home of Norman Berlis, who had been among the very first people to campaign for Jarvis' appointment.[5] Dining with supporters and admirers heartened Jarvis into batting away questions about whether he had been snubbed by saying that he had not attended the ceremonies, because he did not "like large, noisy crowds."[6]

Problems within the Gallery could not be brushed aside so easily, however. Prior to the opening, all but two of the institution's sixty-five staff members signed a letter to the prime minister threatening to quit unless Jarvis was invited. Diefenbaker had to be dissuaded from firing them.[7] The morning after the opening, Cleveland Morgan's angry letter of resignation from the board of trustees was tabled in the House of Commons, and newspapers jumped on the first public accusation from a Gallery insider that Jarvis had been fired and had not resigned, as the government had made it appear the previous autumn.[8] Four days later in the House, the Liberals forced Diefenbaker to explain that omitting Jarvis from his speech was "neither intentional, nor an extraordinary circumstance."[9] At the same time, a still-simmering Charles Fell, who had also quit the board of trustees the previous summer, lamented to Donald Buchanan:

It was a great misfortune in my opinion that reference was not made at the formal opening ceremonies, to the very fine job which Alan Jarvis did during his tenure of office as Director. Such omission is inexplicable. It is not for me to suggest, of course, what should be done now, but

it would be an extraordinary thing if the Trustees did not place themselves on record in respect to this. No matter what faults any man in his position had, it cannot be denied that he made a very fine contribution to the gallery and he should receive full marks for this at the appropriate time.[10]

Jarvis had to wait for such recognition. In the meantime, the closest he came to publicly voicing anger about his exclusion in body and spirit was to say that the ceremony was "not fitting of a democratic country ... art is for everybody – black tie or no tie" in an interview he gave three months later.[11]

The Gallery remained a political touchstone for much of the following year, causing Comfort to work at lowering its profile. According to the critic Robert Fulford, Comfort's deliberate "anti-publicity campaign" soon made the institution as "unobtrusive and unambitious" as the new government's cultural agenda. The anaemic environment prompted some of the people who had worked most closely with Jarvis to leave the Gallery. Paul Arthur and Norman Hay went quietly, though Donald Buchanan's resignation at the end of July 1960 sparked renewed Liberal attacks in Parliament. The furor soon abated and there was no mass exit; Robert Hubbard and Kathleen Fenwick stayed on for much longer.[12]

The building's inauguration cut Jarvis' last ties to the Gallery and the government while opening, as his many supporters believed, tremendous opportunities for a man who appeared to be at the top of his powers. In order to realize their expectations, Jarvis needed a platform from which to advocate for the arts. This was challenging, because no position comparable to the directorship existed in the private sector, and Jarvis lacked the sort of personal fortune that permitted his heroes Douglas Duncan, Gerald Murphy, and Sir Kenneth Clark to act as patrons and philanthropists. Nor was he likely to follow the example of Rik Kettle, who had been an important promoter of Canadian culture since helping to establish the Picture Loan Society in the 1930s, while earning his living as a business executive. In short, without a position that carried daily responsibilities and structure, Jarvis risked relapsing into the self-destructive depression he had experienced after the collapse of Pilgrim Pictures in 1950.

The danger was soon clear to Jarvis' friends and family, who saw him react to the deep humiliation of being fired by retreating into his blithe public per-

sona. To the world he appeared confident, witty, and happy, though long-time friends saw a diminishing reflection of what he had been in his prime. He never came to terms with the dismissal and declined precipitately; from about 1961 onwards, apart from short attempts at sobriety, Jarvis sank ever more deeply into drink. He ate very little and his health slipped. His shame and depression, exacerbated by alcohol, honed a new, unpleasant, and spiteful edge on Jarvis' wit, with which this essentially gentle man began hurting people.[13] When he did, it was unintentional, because most of his anger was self-directed, like the superficially jocular way he introduced himself at parties by saying "I'm Ellen Fairclough," or described John Diefenbaker as "the voice of God speaking through Bugs Bunny," long after the events of 1959 had faded from public memory.[14]

The public caught occasional glimpses of the way Jarvis' witticisms had become tinged with sadness and failure. Among the most memorable was a 1965 article for a Liberal party magazine in which he wrote that while directing the Gallery "I was forced to spend a good deal of time explaining [to the Conservative government] that these pictures are expensive because they are all painted by hand," a Whistlerian quip he had often made to friends. Having fired this shot at Diefenbaker, Fairclough, and Davie Fulton, Jarvis detailed his dismissal, before quoting a supportive letter he had received in 1959 from Sir Kenneth Clark. He noted that Clark had been knighted in the aftermath of a similar controversy, by a country with greater artistic feeling.[15] It was an ill-judged comparison to English events, but showed how deeply Jarvis felt that Canadians' philistinism had caused his failure. The article's motif of a public honour bestowed on a cultural official also showed that Jarvis felt his contributions had never been officially acknowledged.

As the article demonstrated, when Jarvis' outward facade is removed, it becomes clear that he saw the rest of his life through the prism of humiliation, shame, failure, and lost status. Consequently, these are the most perceptive lenses through which to examine his remaining years. Even if he had picked himself up, embarking on a new career as he had done so often in the past was a greater challenge at forty-five than it had once been. He was now supporting a wife, three adolescent stepchildren, and a large family home, as well as facing an equally heavy weight of public expectation. Jarvis needed to be at the top of his powers to fulfill his ambition of combining curatorial work, sculpting, editing, writing, film-making, and broadcasting to become Canada's "man

about the arts."[16] Professional work in each facet of this career was virtually non-existent in Canada and therefore required a prodigious, pioneering effort to establish and sustain. The ambitious plan was especially daunting for a middle-aged man who had not practised these skills regularly for several years, let alone a depressive alcoholic. Moreover, the stress of the last year at the Gallery and the enormous challenge presented by these new undertakings made the freshness and vitality that Jarvis once radiated hard to see in his face, which was never fleshy, just more creased and full. Grey now streaked the full head of hair that he continued wearing in the long, flowing style he and his brother Colin had adopted as adolescents. Though still handsome and lean, Jarvis had traded the looks of a romantic leading man for Ronald Colman's weathered elegance.

The first step in his new career was leaving Ottawa, which is essentially a government town, for Toronto, Canada's emerging cultural centre. So in early 1960 the Jarvises sold the house on Manor Avenue and moved to the city in which they had grown up and still had many friends and family. Jarvis' mother, who was almost seventy, was especially delighted to see him return, twenty-two years after setting out for Oxford.[17] At first it looked as though Jarvis' dismissal would not affect the comfortable lifestyle the family had enjoyed in Ottawa. Their new home at 472 Russell Hill Road was in an upper-middle-class neighbourhood of winding, tree-lined streets and substantial houses just north of the university. As befitted Jarvis' intention to launch careers as a cultural personality and working artist, the house was big enough to accommodate both a study and a studio.

Toronto was familiar and welcoming ground. Jarvis soon became a regular visitor at Hart House, where he had spent many days as an undergraduate. Here he found a community of young people who had been inspired to study the arts by his example at the Gallery. Jarvis loved mentoring this new generation and they were struck by his "considerateness, the concern for the educational side of the activity" that he was leading. Most importantly, he helped the students on the Art Committee decide about acquiring particular paintings. He did so by using adult education and discussion group techniques; as one student recalled, "instead of being conventionally authoritarian he [Jarvis] asked me questions and he asked other students who were in the room at the time, what their impressions were of the painting," in order to guide them towards their own decision.[18] He planted firmer roots in June

1961 by setting up Alan Jarvis Associates to manage his "sculpturing [sic], film production, painting, [and] writing" from a small downtown office.[19] It was necessary for Jarvis to establish a formal business structure because the income generated by these activities – about $16,000 in 1961 – was slightly greater than he had earned at the National Gallery.[20] By all indications, Jarvis would be able to make a comfortable living.

Toronto, where political machinations were of little consequence, should have been a tonic to Jarvis' spirits. But his depression, despair, and drinking increased at the moment when he most needed focus. Betty and others begged him to get help, to no avail. Within a year of settling in Toronto, Jarvis confided to a friend that his marriage was faltering because of his alcoholism.[21] Sobriety proved elusive and tensions in the house heightened until mid-1962 when Jarvis and Betty played out an abject final scene to their lifelong relationship as he left the family home in a stupor in the pouring rain. Thereafter Jarvis drank incessantly and became convinced that what he termed the "facades," or shielding personas that he had adopted throughout his life, were responsible for his misery.[22]

There were few friends or family in Toronto who knew Jarvis intimately enough to help him build on this moment of enlightened self-perception. Jarvis' mother still lived in his childhood home, but she was too elderly to save her son. Mervyn Stockwood, who had helped Jarvis overcome similar alcoholic depression in 1950, visited Toronto at about this time and was shocked to see how little gaiety was left in his friend's life.[23] Shared religious beliefs had brought them together at the end of the war, but it now magnified how far apart they had drifted. Once a regular Anglican communicant, Jarvis was rarely seen in church, while as Bishop of Southwark, Stockwood was implementing many of the ideas about "worker priests" that the two men had helped develop in 1945. Another former lover, Burnet Pavitt, wrote from England urging Jarvis not to drink, while newer Toronto friends like the businessmen Arthur Gelber and Philip Torno, who could see what was happening, were no more successful in convincing him to stop.[24]

Jarvis, who had never been materialistic, took few possessions when he left the family home and moved in with his old flame Norman Hay, whose own marriage had failed a year earlier. Hay, who had seen Jarvis drink heavily at Oxford House and watched the problem grow during the National Gallery years, hoped that it would abate. Instead, he was shocked that the sharp-witted,

beautiful man was now articulate for no more than two or three hours per day. In place of meticulous suits, gleaming shoes, and a radiant aura, Jarvis moped about the apartment in a dirty, shapeless dressing gown and, because he bathed sporadically, began to smell. Prolonged "work" soon became a euphemism for Jarvis, who arrived at his office in late morning, if at all, shuffled some papers and made a few phone calls to people he knew would not be in, before leaving once again. Jarvis and Hay spent many afternoons drinking together. As they did, Hay became so concerned for his friend that he contacted a support group for alcoholics, only to be told that admitting the problem was the first step to recovery. Jarvis never faced his addiction.[25]

The public was largely unaware of the speed with which Jarvis' life collapsed, because he roused himself for appearances by having his shoes shined and his hair trimmed in order to don the well-known persona of an irreverent gentleman.[26] But it was now a costume in which he played a familiar character. He had never spoken from notes and so he was usually able to shine by reviving the chatty, anecdotal talks about the necessity of art that he had first delivered during the war, and perfected at the Gallery. Sustaining the lighthearted persona took increasing effort, and cracks inevitably appeared. In one of the first such slips, in November 1961 Jarvis' "rude, irresponsible attitude towards the obligations of membership" earned the rather singular honour of expulsion, by unanimous decision, from the Sordsmen's Club, a *louche*, heavy-drinking society presided over by the publisher Jack McClelland.[27] Financial chaos also enveloped Jarvis' life, despite a substantial income with which he continued supporting his family. In late 1962 he sold an Alexander Calder sculpture, a memento of Gerald Murphy, just as lawyers for Eaton's department store pressed him to settle an overdue account. That debt was paid, but he soon owed money to the television performers' union, which suspended him in the autumn of 1963.[28]

None of this convinced Jarvis that he was in trouble. Instead, his concern for others showed a deep-seated self-deception about his own life. When Camp Glenokawa's founder fell on hard times that year, Jarvis organized a charitable fund for his one-time mentor.[29] Friends offered similar support and compassion to Jarvis in the early 1960s, but he turned them away.

Toronto friends watched Jarvis slip over several years, but an invitation to take a free trip on Scandinavian Airlines' inaugural Toronto to Copenhagen flight in November 1963 showed English friends how far he had deteriorated

since leaving the Gallery. Jarvis tacked several weeks in London onto this unexpected jaunt in the hope that revisiting the sites of his earlier triumphs and happier days would lend perspective to the events of 1959.[30] He wrote sheepishly to Burnet Pavitt, who had been heartbroken at Jarvis' departure and marriage in 1955, admitting that "if anyone ever had a right to say 'I told you so' it is you."[31] This declaration aside, a few traces of the trip that are found in Jarvis' archives show he enjoyed it immensely, from an infant goddaughter's comment that "You look very grand," to the evening he spent with his Design Council colleague Jean Gunn watching Flanders and Swann in *At the Drop of Another Hat*, the most popular revue in London.[32]

Those who met Jarvis had different reactions. The trip's most important result was the confrontation by three friends who knew that a short stay in England was not a cure. First among them was Norman Hay, who posted a letter to London in which he explained that he had opened his apartment to Jarvis in hopes that "you would gradually pull your life into order. We must admit that just the opposite happened. At first it broke my heart but gradually, out of self-preservation, my attitude became harder and colder. It isn't that I love you less, but that I was forced to switch off." Hay had realized they could not recapture their London idyll.[33] The former lovers remained friends, but their break-up severed one of Toronto's few stabilizing bonds for Jarvis and robbed him of a real home. When he returned, he moved his meagre possessions into the first of a series of hotel rooms. Here Jarvis received letters from two English friends who had been shocked by the man they had met in London. Jean Gunn and her best friend, the comedian Joyce Grenfell, who both knew Jarvis from the Council of Industrial Design, believed that faith might cure him, much as Mervyn Stockwood and Isobel Cripps had once done. Gunn twice tried to convert Jarvis to Christian Science, while the devout Anglican Grenfell sent him a touching letter that was deeply imbued with her faith.

> You are one of the special people, Alan, and that is why so many people mind how things are for you and with you. You have a responsibility to be all we who love *know you are* and that's why I fun about your weight and your cigarettes etc it's not necessary to use crutches, you are equipped to soar and rejoice and be glad and good! So *there*. You are so gifted and this is a power from your original source – *le Bon Dieu* – you

aren't a "miserable sinner" even if you think you are! You are never less than the "magic and Likeness of God."[34]

Three honest, loving declarations made the trip to London a watershed in Jarvis' later life. Like Stockwood, however, Gunn and Grenfell could do little to help their friend from afar.

Living alone in the impermanent atmosphere of a hotel further robbed Jarvis of daily routine and structure that he needed in order to recover. His life became increasingly listless and bohemian as younger leaders of Toronto's art scene, like the art gallery owner Dorothy Cameron, invited him to exuberant parties that spilled out into the streets.[35] His constant companion was Barbara Moon, a journalist a decade his junior whom he met when she was researching an article on David Milne. She had revered Jarvis during the Gallery years and now they dined, went to the theatre, the ballet, cinema, or simply watched movies on television. Jarvis acted like a gentleman in this surrogate courtship; smoking her brand of cigarettes, telling witty stories, and reciting playful fantasies about marrying Moon. But, the facade remained inviolate; he refused to see her when he was depressed or drunk.[36] At the parties Jarvis and Moon attended together, he reconnected with Johnny Wayne, the television comedian with whom he had been an undergraduate. The pair would escape to a corner of the room, adopt plummy English accents, and play a game of one-upmanship with Bertie Woosterish comments.[37] Wayne had taken courses at Oxford during the war, and found these interludes amusing. But Jarvis' part in such set pieces was maudlin, because he played up a caricature of himself as an out of touch English snob. Unlike Wayne, Jarvis' role was no longer simply put on for amusement at parties.

Whatever his personal problems, Jarvis' flair and profile was unmatched in Canadian cultural life. He was the hero of a younger group of arts-minded people whom Robert Fulford called "the Jarvis Generation."[38] With their help, the career he launched in 1960 wove the strands of several different, interdependent activities together. Many of these undertakings took place simultaneously and so they overlap in time and space. But, from a biographer's perspective, it is confusing to explore and explain them all at once. Therefore, it is most clear to trace them individually. At the same time, these endeavours can be split roughly into two groups according to the emotional impact they had on Jarvis. The directorship of the Canadian Conference of the Arts,

editing *Canadian Art* magazine, and freelance curatorial work were quasi-institutional, administrative positions that were intended to replace the national platform Jarvis had lost on leaving the Gallery. By contrast, public speaking, writing, television, and sculpting were Jarvis' attempts to fulfill his long-frustrated artistic ambitions. Ominously, neither type of work provided the daily structure and responsibility that had prevented Jarvis from dissipating his energies in the past, while the sum of these endeavours did not force him to work for as many hours as a single full-time job. He was lauded by admirers and had ample time to fulfill his many commitments, but was not working towards an identifiable, tangible goal.

More than anything, Jarvis' many supporters believed he was an incomparable champion of Canadian art who had been martyred by a reactionary, retrograde government. They hoped he would continue cajoling the country from some new perch. To this end, in the month following Jarvis' dismissal, the architect John C. Parkin launched a discreet, but unsuccessful campaign to have him named director of the Art Gallery of Toronto.[39] Parkin's fears that Jarvis would be lured to a foreign institution were realized in November 1959, when the Minneapolis Museum of Art offered him its directorship. No sooner had Jarvis turned Minneapolis down than the North Carolina Museum of Art launched an aggressive courtship that lasted through the first half of 1960. And just as these discussions wrapped up, the organizers of the 1962 Seattle World's Fair asked Jarvis to help design their project.[40] The approaches were flattering, but Jarvis was not free to leave Toronto since his marriage was troubled but not yet irreparably broken and his stepchildren were settling into schools. Moreover, two years of tension, aggravation, and attack from trustees, the cabinet, and the general public had stripped Jarvis of his nerve and self-belief. He could only perceive that a similar job in a regional institution was a further public humiliation for the former head of a national art gallery.[41]

Jarvis' openness to such approaches changed significantly after the failure of his marriage in mid-1962. He was very attentive that June when Gordon Washburn, the outgoing director of Pittsburgh's Carnegie Institute, encouraged him to apply for the job. Jarvis' interest in the post was heightened by the very enthusiastic encouragement of Evan Turner, the director of the Montreal Museum of Fine Arts.[42] He applied formally in late June, telling the selection committee to contact Jack Pickersgill about his achievements at the National Gallery, while Washburn could give a more general reference.[43]

Whether it was simple absentmindedness, or a sign of the disorder in Jarvis' life, he forgot to enclose his *curriculum vitae* in the package he sent to Pittsburgh. When Jarvis finally submitted the document, a full month later, it included a lucid explanation of how he believed the various strands of his career were woven together. It echoed the statements he had made to the Rhodes Trustees and to the National Gallery of Canada. Jarvis declared that "administration apart, the central core of all my work has been a deep interest in adult-education through almost every medium – the written word, lecturing, broadcasting, film, television and, perhaps most relevant, making exhibitions and the museums play a more vital role in our communities."[44] Tellingly absent from this application was any mention of what Jarvis had accomplished since leaving the Gallery almost three years earlier. The way he presented himself to the Carnegie Institute showed that in his alcoholic depression he believed everything he had done since 1959 had been tainted by his failure at the Gallery.

Nevertheless, Jarvis was still a very attractive applicant, and he flew to Pittsburgh for an interview in October, only to learn within a fortnight that he had not been selected.[45] The rejection reinforced his feelings that he could never overcome his failure at the National Gallery, and ended his hopes of heading another cultural institution. He was passed over by the Dallas Art Gallery without an interview in the autumn of 1963 and, smarting from this rebuff, ignored a friend's suggestion a few months later that he try for the directorship of New York's Frick Collection.[46] Each rejection further cemented Jarvis' feelings of humiliation and failure, and anchored him ever more concretely in Toronto.

Jarvis' Canadian friends hoped that he would stay in the country. So they arranged for him to head a prominent cultural advocacy group. The early 1960s was an important era in the history of modern Canadian culture because the momentum that had begun a decade earlier with the Massey Report had increased with the founding of the Stratford Shakespeare Festival in 1953 and the Canada Council for the Arts in 1957. Moreover, the federal government was beginning plans for another wide-ranging series of cultural activities to mark Canada's one hundredth birthday in 1967. These were going to

revolve around "Expo 67," the Montreal World's Fair. Jarvis' time at the National Gallery had linked him inextricably with Canadian culture and it was clear to his supporters that he had a role to play in ongoing initiatives.

To this end, in February 1960 Jarvis was named the National Director of the Canadian Conference of the Arts (CCA), a cultural lobby that had been formed at the 1941 Kingston Conference. Once again, John C. Parkin, whose attempt to secure the directorship of the Art Gallery of Toronto for Jarvis had only just been thwarted, orchestrated the appointment. He first raised the idea to the Toronto businessman and philanthropist Arthur Gelber at a conference. Over cocktails, Parkin and Gelber decided that a post at the CCA should be created for Jarvis in order to give him a significant national platform such as Jack Pickersgill and Charles Fell had put in place at the National Gallery in 1955.[47] The pay was small, but the part-time work was agreeable, lacked administrative responsibilities, and freed Jarvis to develop his role as a national spokesman for the arts.

Jarvis had barely taken up his duties before the CCA announced that he was organizing an international conference for Toronto in early May 1961. Initial ideas for the meeting reflected Jarvis' personal artistic and intellectual development. He hoped to secure the participation of Lewis Mumford, the American urban philosopher who had influenced his early thoughts on art and society, UNESCO's founding director Sir Julian Huxley, whom he had known at Dartington, and Alastair Cooke, the New York City based BBC journalist with whom he had worked in the 1940s.[48] When it became clear that a full-time organizer was required to pull the ambitious program together, Jarvis poached David Silcox, a fine arts student who chaired the Art Committee at Hart House. It was an inspired idea because Jarvis had always loved helping and guiding younger people in the arts and, as Arthur Gelber, who also worked closely on the conference, recalled, "David came and joined us and, if anything David was the hardest working member of the team. To put the whole thing together."[49] Jarvis and Silcox were witty extroverts who soon formed a deep friendship. When Jarvis gave his assistant the playful nickname "Pillbox," it was a sure sign of affection and respect. In return, Silcox called him "Uncle Bottles" or "Ali Jar."[50] Friendly banter cut through the formality of what might otherwise have been a deferential teacher-student relationship. While Silcox worked on the conference, Jarvis used speaking engagements to publicize his vision of assessing "Canada's cultural maturity."[51] This implied

weighing the impact that the Massey Commission, the National Gallery, and the Canada Council had had on the country. The conference cost some $75,000 and dwarfed previous Canadian cultural get-togethers.

It was a very impressive event. Claude Bissell, who was president of both the Canada Council and the University of Toronto, and that institution's star professor, Northrop Frye, gave the first plenary addresses. Over the following two days, sessions on visual arts, literature, drama, music, and the arts in society ran from lunch until just before dinner. The conference attracted many of Canada's most important cultural figures, including Harold Town, Jacques de Tonnancour, Isamu Noguchi, the writers Mordecai Richler, Hugh McLennan, and Morley Callaghan, the dramatists Gratien Gélinas and Mavor Moore, and the composer Louis Applebaum. Daytime sessions at the O'Keefe Centre were open to the public, though the doors were shut during the informal dinners and receptions that ended each day. Jarvis and Silcox wanted these to be intimate gatherings at which delegates mingled, conversed, and exchanged ideas.[52] Evening entertainment included readings from a clutch of poets including Irving Layton, Anne Hébert, Earle Birney, and Leonard Cohen and a private concert by the CBC symphony orchestra. The whole thing wrapped up with "A Meeting of Minds" between Sir Julian Huxley, the Quebec cabinet minister René Lévesque, who would soon become the champion of independence, and the Toronto historian and social activist William Kilbourn. A committee headed by Jarvis had also selected works by artists who had received Canada Council grants for a show at the Av Isaacs Gallery, whose owner was one of the biggest champions of modern Canadian art.[53]

The country had never seen such a large and lavish gathering of artists and arts administrators. Jarvis chaired the sessions on the visual arts, though the entire event radiated with his personality and, as the following passage shows, it was deeply rooted in his adult education beliefs and English experiences. According to one of the participants,

> there was a sense of occasion a sense of opening out the Canadian future in the arts. This was the biggest bash that had ever been held and Jarvis was in his element on this occasion absolutely at home and enjoyed himself hugely ... He was so concerned that we not waste the opportunity. He had worked as you know in London in 1951 on the Festival of Britain and he talked of this a great many times and he felt

that coming out of the terrible experiences of the war people had dis-
covered what is possible, again coming back to the beautiful, discovered
that you could create a kind of public joy, that you could put beautiful
things around and people would respond and have a good time and he
wanted that to happen here. He wanted architects, he wanted sculptors,
he wanted painters, he wanted musicians, he wanted all kinds of people
including athletes, all kinds of people to celebrate. And again there were
not so many people who knew how to think that way in Canada, who
knew how to translate the dream into some kind of reality. Alan could
get these people together and ideas would fly around in all directions
and before you know it you had some kind of consensus about how
to start.[54]

Not everyone was so impressed. Among the dissenters was Mordecai Rich-
ler, the iconoclastic Montreal novelist who had lived in London for a decade.
He gave a curmudgeonly lecture to the conference in which he proclaimed
that only practicing artists could discuss art, and that his well-dressed audi-
ence had little to add on the subject.[55] Richler's views were largely echoed by
Saturday Night magazine, which published an editorial arguing that a lot of
money had been wasted on yet another tired "jamboree" at which people be-
moaned Canada's cultural poverty, and most gallingly, deferred to the views
of Huxley, an Englishman who knew virtually nothing about Canada.[56] The
increasingly nationalist sentiments that could be discerned in some of this
rhetoric underlined the growing anachronism of Jarvis' "English" persona.
Nevertheless, he continued working on various CCA projects after the
conference, while David Silcox moved on to graduate studies at London's
Courtauld Institute.

The conference re-established Jarvis as a cultural commentator and facil-
itator, and he received renewed official backing when the Liberals returned to
power in April 1963. Party leaders were abundantly sympathetic to Jarvis
because they felt he had been sacrificed for political reasons. So they asked
him to speak on "Policies and Plans for Urban Development and Land Use"
at their 1960 policy conference in Kingston.[57] Once the party was back in
power, Prime Minister Lester Pearson and Secretary of State Jack Pickersgill,
who had defended Jarvis over Gallery purchases, were keen to help. They
appointed him to the advisory panel for the 1967 Montreal World's Fair.[58] The

job seemed grandiose, though the committee's only meeting, for which Jarvis was paid $350, took place that May at the Seignory Club in Montebello, Quebec. About one month later, Jarvis attended a gathering of senior government officials to further develop the Fair's concepts, themes, activities, and general program. This meeting and an autumn follow-up were chaired by Hamilton Southam, whom Jarvis had known since undergraduate days. The work appealed to Jarvis and ignited hopes of finding a permanent job with Expo, even though his pre-existing commitments would not allow it. Instead of a fulltime post, in February 1964 Jarvis was named to the Visual and Literary Arts sub-committee of the Centennial.[59] He attended meetings over the coming two years, for which he received a small per diem.

Official appointments like this gave Jarvis the government's imprimatur. His greatest satisfaction came in 1965 when the Liberals sought his advice about new National Gallery legislation and who should succeed Charles Comfort as the institution's director.[60] That same year, Maurice Lamontagne, the federal minister responsible for the arts, asked Jarvis and the CCA to help the government plan post-Centennial arts projects. The resulting conference, known as *Seminar 65*, drew about 125 representatives from various arts groups, government and private funding bodies, and the media to Ste-Adèle, a resort town in the Laurentian hills north of Montreal. The "Quiet Revolution" was rapidly transforming Quebec from a Church-dominated introspective society into a modern, secular one in which the first signs of separatism could be detected.[61] The choice of Ste-Adèle as the conference site therefore reflected the Liberals' ulterior motive of discerning if arts programs could cross the linguistic divide and help unify the country. Four days of closed-door study groups and discussion sessions worked through topics ranging from the roles of national bodies, to training for young artists and using the mass media. On the first day, Jarvis elaborated on the seminar's general theme of capturing the country's artistic spirit, in order "to make 1967 of lasting value."[62] His message largely repeated what he had said at the Toronto Conference four years earlier, but this was of little consequence, because his personality was still very effective. As one participant summed it up, "Jarvis was the sort of chairman and organiser" who brought people together in order to have "an enormous argument about how the public money should be spent for [19]67 and please would the government get on with it because

it was getting awfully late and there did not seem to be any big plans that people could understand."[63] This was translated into the stolid language of an official report that called on the government to cooperate with private funding agencies in order to ensure the continuing development of a national arts policy, which culminated in Centennial year activities.

About 100 people attended a follow-up conference in Toronto in March 1966. The Canada Council footed the bill and Lamontagne's successor, Judy LaMarsh, attended several sessions. Once again, talks focused on the relationship between artists and funding bodies, the need for investment in art teaching, and the future of the National Gallery. One participant recalled that "Alan was a very important person in that process. He had that ability to bring them [artists, the government and funding agencies] together to talk to them, with them. Listen, and often very amusingly, harmonize people who might have differed, might have quarrelled even."[64] Consensus was harder to find in an era when the counter-culture famously mistrusted people, like Jarvis, who were older than thirty. In hopes of creating an inclusive team spirit, delegates were issued badges whose colours indicated the type of art they practiced. They were also told not to speak to the press until the official report was released. Nevertheless, seventeen dissenters issued a manifesto questioning the seminar's right to speak for Canadian artists. Other participants held romantic notions of Jarvis returning to the National Gallery, an idea that LaMarsh broached with him. "I'd need danger money" was Jarvis' only public response to this improbable suggestion.[65] Jarvis remained an important, catalyzing figure in the arts, but he was a fifty-year-old alcoholic. The community needed younger leaders. Jean Sutherland Boggs, who had a doctorate in art history from Radcliffe, was appointed to head the Gallery in May. She was not much older than Jarvis had been when he took over the institution in 1955. He advised her to wear a bullet-proof girdle.[66]

The Toronto Conference was Jarvis' valedictory CCA project, though he continued on as national director. Expo dominated the cultural scene in 1967, and that December Lester Pearson announced his resignation as Liberal leader. The party's Anglophile era ended when he was succeeded by the self-consciously hip and youthful Montrealer Pierre Trudeau.

Another core strand to Jarvis' new career was created at a lunch he shared with Paul Arthur and the Toronto philanthropist Philip Torno on the day in 1959 that his resignation from the Gallery was announced. The trio drafted a press release announcing that Jarvis had been appointed chairman of the Society for Art Publications, which published *Canadian Art* magazine. Once again, the position paid little, but provided an important bi-monthly platform for broadcasting ideas and shaping opinions. The magazine had been founded as *Maritime Art* in 1940 and taken over by the National Gallery three years later. Under Donald Buchanan's editorship, it became the country's leading arts periodical, though like so many similar ventures, revenues never reflected the magazine's impact, and it relied heavily on Gallery subsidies.[67] The Gallery now wished to rid itself of the money loser, so Jarvis, Torno, and Arthur concocted a plan to create "a more effective and a more widely appealing magazine" that stood on its own financial feet.[68]

The trio's ambitions were difficult to satisfy because removing the magazine from the Gallery exacerbated its financial difficulties. When advertising sales and large grants from the Canada Council failed to cover the operating expenses, the Canada Foundation, a nationalist advocacy group, was brought in to administer a charitable account.[69] Thereafter, identifying and cultivating private patrons was the magazine's greatest challenge. It was one that Jarvis knew well, given the way he had continually appealed to British investors to keep Pilgrim Pictures afloat in the late 1940s. This became his primary role at the magazine, as Paul Arthur handled its daily operations. In December 1959, Jarvis signed the first of a seemingly endless series of pleas to various philanthropists and corporations.[70] At the same time, he tried, unsuccessfully, to raise the magazine's profile by having Robertson Davies join its editorial board, and soliciting articles from Sir Kenneth Clark.[71]

The magazine was an important beacon for the arts even if Arthur and a bookkeeper were its only fulltime employees and they worked out of the spare room of Arthur's Ottawa home. It publicized artists with lavish photos of their works, well-written portraits, and critical appraisals, but it struggled to find an audience. In the early 1960s, the magazine had about 6,000 Canadian subscribers and 400 in the United States, a circulation that made it difficult to sell many advertisements. So the magazine lurched along in constant financial worry, publishing thin issues from time to time, and missing the odd one altogether.[72] Various promotional ideas were tried to increase pub-

lic interest, like inserting a free 45 RPM recording of a conversation between Roloff Beny and Jarvis. It lured few new subscribers, but showed that even after a decade in Canada, Jarvis' accent remained resolutely mid-Atlantic.[73]

Canadian Art lost $15,000 in 1962 alone and insolvency loomed early the following year when both the Hudson's Bay Company and Eaton's department store cancelled their advertising contracts and the Toronto collector Samuel Zacks reduced his subsidy.[74] The crisis prodded Jarvis and Arthur to launch a public appeal for funds, and reduce the number of expensive colour reproductions in each issue, in order to concentrate on paying for top-notch writers.

After significant effort, they persuaded John G. McConnell, owner of the *Montreal Star*, to rescue the magazine. Jarvis got on well with McConnell, who focused his newspaperman's marketing sensibilities on the magazine and in mid-1964 sent free copies to hundreds of "prominent Canadians" as a way of drumming up new subscribers and patrons.[75] McConnell's money and flair for publicity stabilized the situation and by the following spring circulation had grown to about 8,000 copies per month. The happy times were short-lived, however, as McConnell also had a businessman's eye for bookkeeping. The chronically chaotic financial records he found in the magazine's offices led to a series of disputes with Arthur. Only two years after joining, an angry and frustrated McConnell quit, and the magazine continued on its fitful way.[76] The Canada Council stepped in with funding, only to itself withdraw in 1967 over concerns about fiscal administration. Arthur finally had enough and resigned that August.[77] *Canadian Art's* constant search for money and stability was a tale that is very common in Canadian publishing. Even so, the magazine consumed Jarvis' attention, while offering very little in the way of tangible repayment.

The final quasi-institutional way that Jarvis hoped to replicate his success at the Gallery was as a freelance exhibition curator. This paid very well, considering it required only a few weeks of work per year, though it took slightly longer to establish than his other 1960s endeavours. In early 1963, he was hired by the cigarette manufacturer Rothmans – which was headed by his brother-in-law John Devlin – to set up the company's art program.[78] Jarvis held many

discussions with the company's executives before they decided to begin by asking artists to submit works on the theme of the "Joy of Living." The best won a $1,000 prize and four paintings were chosen as the "nucleus" of Rothmans' collection.[79] Soon after, Jarvis was awarded a $5,000 annual retainer as the company's art advisor. He had a small purchase budget and travelled across the country doing interviews about the various exhibitions that Rothmans sponsored.[80] The position put Jarvis in an enviable position from which to influence the corporation's spending on the arts, as he did when he convinced it to underwrite an outdoor sculpture show in Toronto in March 1965.[81]

Just as this work for Rothmans got underway, in May 1963 Jarvis was asked to curate a large exhibition of contemporary Canadian works for New York's Museum of Modern Art.[82] He jumped at the project, which had a scope and scale comparable to what he had done at the National Gallery. He was rejuvenated. He assembled a selection committee with Toronto collector Samuel Zacks in the chair, and used his arts world contacts to borrow paintings and sculptures. Significant financial support arrived in July in the form of a Canada Council grant.[83] The show, entitled *Fifteen Canadian Artists*, aimed to introduce American audiences to major post-war developments in Canadian art. To do so, the organizing committee scoured public and private collections before settling on works by such artists as Paul-Émile Borduas, Jack Bush, Alex Colville, Toni Onley, Sorel Etrog, and Harold Town. In his initial excitement, Jarvis told his American counterparts that he and Paul Arthur would design and write the catalogue. This never happened. Instead, the task was given to the Montreal Museum of Fine Art's Evan Turner and William Withrow from the Art Gallery of Toronto.[84]

Jarvis took on a second, more stable curating job at the start of 1963 when he accepted $1,000 to oversee the annual exhibition of Canadian works that accompanied the Stratford Shakespeare Festival. The Festival set aside an unprecedented $19,000 for the show in the hope that Jarvis' involvement would increase the number of visitors.[85] He was excited by the prospect, declaring that "I am very anxious to make this Exhibition 'off beat' in a reverse way. I would like to show the Pre-group of Seven as well and the group and our contemporaries."[86] Friends sensed his excitement as he asked them for pieces to include in what Norman Hay suggested should be called "This Land – This Canada."[87]

As he had done with the 1961 conference, Jarvis hired a University of Toronto fine arts student to help with the shows. Paul Russell found Jarvis very friendly and interested in other people, even as he was increasingly ravaged by drink and often supervised work in the gallery from a wheelchair, which he claimed was an ideal vantage point for mounting exhibits. He seemed happy and focused, though the partnership with the festival was difficult from the outset.[88] Budgets were never sufficient to secure first-class touring exhibitions, leaving Jarvis to cajole galleries, private collectors, and artists to lend him their works. Few were willing to risk displaying their treasures in a converted hockey rink. One-time supporters like Joseph Hirshhorn, who had exhibited his enormous collection at the National Gallery in 1957, turned Jarvis down flat. The rebuff was a stark, personal indication of the reduced scale on which Jarvis now operated. When he was unable to secure his preferred pieces for the inaugural show, Jarvis assembled a collection of portraits he called *Faces of Canada*.[89] He talked the exhibition up to the press as best he could. But at least one critic saw that Jarvis' claims that this was a "fun" and not an "academic" show were really attempts to explain away the number of unexceptional works he had included. The same critic lauded the "wry, malicious, funny, angry and always affectionate" way Jarvis had hung these items. All but the last of these rubrics described Jarvis' decision to include a portrait of Ellen Fairclough, the minister who had fired him from the Gallery.[90] It was further proof that he could not forget that her actions in 1959 had reduced him to running art shows in a sports arena. By including her portrait, Jarvis was hinting that she deserved that same sort of derision from Canadian art lovers.

The Stratford exhibitions were always interestingly laid out and well-received, though as an adjunct to the festival's core theatrical activities, they were vulnerable. In 1965, Stratford's directors scaled back the program, and asked Jarvis to reduce his personal fees and provide full documentation of all expenses.[91] It was a further blow to Jarvis, but he responded by placing sculptures on theatre lawns as a way of fully integrating the art into the festival. At the same time, he declared to the *Toronto Star* that air and space travel had created an awareness of form and depth that was going to make sculpture the most popular art.[92] Despite such lofty pronouncements, Stratford officials were concerned about costs and at summer's end it was clear that sculpture's

day had not yet arrived. As one festival official told Jarvis, "we seem to be accumulating expenses and responsibilities like a burr" without much to show in return.[93] In his younger days, Jarvis might have been able to reorganize and reinvigorate the program, but his crumbling personal life now prevented him from this kind of effort and thereby closed down yet another professional avenue. The 1966 show went ahead only after Rothmans agreed to pay for renovations to the buildings in which it was held.[94]

The Stratford shows were far smaller than the exhibitions Jarvis had overseen in London and Ottawa. Nevertheless, they strongly reflected his long-expressed desire to create a "museum without walls." He and Paul Russell presented works of art innovatively in the hope of showing people how to find beauty in the everyday world. Costs prevented them from truly exploiting their ideas, however, and Russell left to study art in London. Jarvis continued working for Rothmans, though it is hard not to believe that his brother-in-law kept paying his large salary because he knew it helped support Betty and the children.

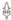

The remaining three post–National Gallery activities that Jarvis undertook were more traditionally creative and reflected his life-long artistic ambitions. He had always possessed considerable natural artistic talent and flair, though a combination of parental pressure, the war, and subsequent daily responsibilities had prevented him from developing it fully. He now set out to become a public commentator on the arts, a sculptor, and a writer.

Jarvis' exposure to the media at the National Gallery had made him the country's best-known authority on the arts and one of its most accomplished and opinionated public speakers. He was extremely talented and compelling on the podium and loved all aspects of lecturing, from travelling, to engaging with audiences and socializing with them over drinks afterwards. On leaving the Gallery, Jarvis knew that speaking was a tremendously valuable currency that he could spend to keep his name and work in the public eye. At the same time, he could only increase his value as a lecturer by minting fresh ideas, anecdotes, and witticisms.

It soon became apparent that abundant natural talent had subtly undermined Jarvis since adolescence, because he had always lazily relied on his gifts,

rather than developing them in any consistent way. Instead, he had only ever scratched a few notes on the back of an envelope for any talk, confident that he could play the oft-rehearsed role of an opinionated arts-booster extempore. This was no longer sufficient, and drink prevented him from adopting a more rigorous approach. As a result, he said almost exactly the same things he had in 1955, though the frequency of his speeches was nothing like his first year at the Gallery. His wit still flashed in the description of Toronto's Yonge Street as "ten miles of outhouses leaning up against Eaton's [department store]," or saying that "I should like to die in Toronto, because the difference between here and where I am going is indistinguishable."[95] But because the core message and method of presentation had not changed since 1955, Jarvis transformed himself fairly quickly into a caricature and fodder for Toronto's satirical revue the *Bohemian Embassy*, which lampooned his "salesmanship approach to art" as boring and repetitive.[96] It was another sign that a new generation of artists and performers, who had often been heavily inspired by Jarvis, were passing him by.

On a more practical level, public speaking paid very little. For every well-remunerated occasion, Jarvis spoke to several small audiences, or charitable organizations. This had not mattered in the 1950s, when lecturing had been part of a more comprehensive scheme to advertise Jarvis' Gallery work. Jarvis loved talking to groups, but he needed to focus this energy in a way that he had never done before so that it would provide a significant income and publicize his new endeavours. A brief and incomplete list of Jarvis' speaking engagements conveys how broadly he travelled, the sizes of his audiences, and the demands such engagements placed on his time.

At the start of 1960, he discussed "spheres of Christian influence" in art at an Ottawa church.[97] Then he addressed the Canadian Clubs of Woodstock, West Durham, Kirkland Lake, Temiscaming, and South Porcupine – Ontario towns that could hardly be called arts hubs.[98] Over the rest of the year, he judged murals in Montreal, chaired art competitions for Bishop's University and the Canadian Opera Women's Guild, auctioned works for World Refugee Year, spoke about sculpture at the Art Gallery of Toronto, and advised UNICEF on the design of its Christmas cards.[99] The year's highlight was a lecture on "The Plastic Arts in Canada" at a management seminar exploring Canadian and American relations at Vermont's Goddard College.[100]

Jarvis repeated his Goddard lecture to a colloquium on the role of the arts

in Canada and the United States at the start of the following year.[101] He then returned to the Canadian Opera Women's Guild, told the Young Men's Hebrew Association of Toronto about "abstract painting – art or fraud," and spoke to the city's board of trade.[102] He judged an art contest at Carleton University and headed the committee organizing Toronto's first outdoor art show before judging a show in Saskatchewan, and heading to the Vancouver Festival, where he called on the "anti-uglies" to unite against Canada's lamentable urban architecture.[103] In the fall, he flew north as part of a federal government committee on Inuit art.[104]

In 1962 Jarvis' marriage foundered, his drinking increased, and the quality of the events at which he appeared began varying greatly. At the start of the year, he helped Queen's University fill a vacancy in the art history department and then in the summer dedicated a memorial plaque to David Milne in Paisley, Ontario. Douglas Duncan, with whom Jarvis had barely communicated in years, was not present.[105] In October, he opened the Art Loan Society of Port Credit, just outside Toronto.[106] And when Waterloo Lutheran University conferred an honorary doctorate on Jarvis that same month, he rehashed "Is Art Necessary?," the speech that he had given time and again since arriving at the Gallery.[107]

Public speaking culminated in March 1966, when the Toronto travel agent Frank Starr, who was one of Jarvis' oldest friends, having worked with him at Camp Glenokawa and Oxford House, hired him to lead a European "Art Odyssey for Connoisseurs." The Starr family had offered Jarvis support and hospitality since the failure of his marriage, and Frank well knew how engaging his friend could be when talking about art. That spring, fifteen well-heeled guests from as far afield as New York, Newfoundland, and Winnipeg paid close to $2,500 per person – a price that was equivalent to almost half Jarvis' annual income – for the privilege of having him escort them from the "centres of southern Europe following the spring northwards to" Germany, the Netherlands, and Leningrad.[108] Thirty years earlier, the teetotal Jarvis had made a similar pilgrimage under Duncan's tutelage. Contrasting that journey's frugality, the elderly "connoisseurs" stayed in top hotels and dined in choice restaurants. Jarvis, the one-time leader of a national cultural initiative, was now paid to "perform" in his public persona for rich retirees.

As a small consolation, he stopped in London for several days on the way home. Here he caught up with Paul Russell, the student he had employed on

A subdued, but stately Jarvis leaves the Casa
El Greco, Toledo, Spain, during the 1966 Art
Odyssey for Connoisseurs. Alan Jarvis
Collection, University of Toronto.

the Stratford exhibitions. They saw *Suite in Three Keys,* Noël Coward's final
West End triumph.[109] After the curtain fell, Jarvis suggested going backstage
to visit Coward. Like many others, Russell was not always convinced that
Jarvis knew as many people as he claimed. However, when the pair were ush-
ered into the dressing room, Coward and Jarvis exchanged warm hugs and
reminisced affectionately. As he and Russell left the theatre, Jarvis boasted
that "I never drop a name I can't pick up."[110] It was one of his standard quips,
and it still awed his audience.

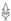

Television was another means by which Jarvis hoped to recapture his Gallery-era success. There were enormous opportunities in Canadian television in the early 1960s as the government legalized private broadcasting, and new stations screamed for shows with which to fill their schedules. In December 1959, he was hired at $500 per month by Ottawa's Crawley Films – best known for producing the police drama *RCMP*. The firm's head, "Budge" Crawley, felt that Jarvis' experience at Pilgrim Pictures and his Ottawa connections would make him useful in "seeing people on our behalf, and developing film projects and writing film outlines for us."[111] Crawley's hunch was rewarded within a month when he and Jarvis agreed to make a film about the use of stainless steel in modern design, a subject reminiscent of Jarvis' earlier English work.[112]

More novel was Jarvis' April 1960 idea for a program that would weave photos, news clippings, and live interviews to explore what he termed "biographies of personalities." Jarvis envisioned himself as the editor-in-chief of a team that researched, wrote, and produced the programs.[113] An interested Crawley agreed to split the profits equally with Jarvis. So in July Jarvis hired Ronald Hambleton, with whom he had written the *Renaissance* series, to help develop what he now called *Look Who's Here*. The show's potential for vitality and freshness was dissipated quickly by the ninety-five people Jarvis identified as possible subjects. The list was a road map of his past, with Claude Bissell and Vincent Massey reflecting his youth; Archibald MacLeish and John Dos Passos standing in for the days with Gerald Murphy; Sir Kenneth Clark, Peggy Cripps, Peter Ustinov, and Morris Ernst recalling the English years; and Benjamin Sonnenberg, Gordon Washburn, and Sam Bronfman representing what he had done since returning to Canada.[114] Almost every candidate was well into middle age, while only a very few, like Glenn Gould, Jean-Paul Riopelle, and Harold Town, whose careers had begun after the war, could have been called contemporary. Underlining this anachronism, several of Jarvis' subjects were almost unknown to the general public, indicating that his interests and obsessions were increasingly personal and retrospective.

Even so, Crawley gave the project a tentative green light and agreed that the industrialist Joseph Hirshhorn should be the first subject. Hambleton, who had warned Jarvis that it would be difficult to coordinate visuals with an extempore interview, completed a script in August 1960.[115] But Jarvis put it aside and dropped Hirshhorn in favour of re-editing an existing interview

As Jarvis' 15 March 1960 appearance on *Front Page Challenge* dramatically illustrates, he could not escape the humiliation of the end of his Gallery career. © CBC Still Photo Collection: Roy Martin.

with Lord Beaverbrook.[116] The test was uninspiring and Crawley backed out that autumn on the pretext that the program would be too expensive.[117]

Jarvis then worked briefly developing a show called *Strictly for the Birds*, of which only the name remains, and at the start of December he appeared in a program about war art, which was yet another throwback to his work on the aborted book *War in Western Art*.[118] In mid-March, he was a mystery guest on *Front Page Challenge*, the CBC's long-running current affairs quiz in which the panellists had to guess the identity of a public figure.[119] The appearance

kept him in the public eye, but focused on the controversial aspects of his Gallery career and thereby further linked him with snobbery and failure. Throughout these appearances, Jarvis was trying to revive *Look Who's Here*. With Crawley's help he looked for financial backers until a rejection by the CBC effectively killed the project in June.[120]

Crawley was not Jarvis' only television contact. In March 1960, he appeared before the government's regulatory agency on behalf of a group headed by the newspaper publisher John Basset that was hoping to operate Toronto's first private station.[121] That July the station, CFTO, repaid Jarvis by agreeing to produce thirteen new episodes of *The Things We See*. Jarvis was paid $25 per week, a pitiful salary that reflected the impecuniousness of early private broadcasters, who made their money by selling shows to other stations. His contract reflected this business model by calling for his pay to increase to $300 per show in future years.[122] The show's renewal depended on CFTO's ability to sell the show to other broadcasters. So, the new series was much more ambitious than its namesake and vowed to range widely through the arts, while drawing heavily on the National Film Board and other existing resources. It was touted as "a sort of baby *Omnibus*," in reference to Alistair Cooke's immensely popular American variety show.[123] The first episodes were aired in January 1961 when, in an early example of cross-promotion in a competitive media market, Jarvis also began writing a weekly column for Basset's newspaper, the *Toronto Telegram*.[124]

Critics paid little attention to the new show, even though Robert Fulford found that "Jarvis has turned out to be an urbane and confident host: he seems ill at ease only when he's reading bits of prepared text."[125] The judgment was seconded privately by Vincent Tovell, the CBC producer with whom Jarvis had worked on the *Renaissance* series. The pair spent several lunches discussing broadcasting ideas, but Tovell felt Jarvis lacked the breadth of experience and knowledge needed to host an *Omnibus*-style program. The comedian Johnny Wayne also believed that Jarvis' natural talent before the camera was best suited to unscripted shows about art.[126]

Even so, the first episodes of *The Things We See* were sufficiently successful and inexpensive – at a time when there was relatively little competition for timeslots – that a second season began in October 1961. Jarvis was now simply the principal performer in a series that ranged from "Rembrandt, Van Gogh and Picasso, to industrial design and racing cars."[127] As predicted, the

series suffered because Jarvis did not perform well when reading from a script, and this made it difficult for CFTO to find advertisers or sell the series to other stations. At the same time, the *Toronto Telegram's* editor complained that Jarvis' companion column was "dull."[128] Jarvis might have survived this critical and commercial drubbing by dedicating himself to writing and learning how to perform on television, but he was too enfeebled by alcohol, which ended his broadcasting career, just as it destroyed his marriage.

The Things We See was cancelled at the end of the second season, after which Jarvis tried launching several film and television projects. He and Ronald Hambleton worked on a screenplay of a novel by his Industrial Discussion Clubs colleague Mary Nicholson in the hope that Richard Attenborough, another acquaintance from Jarvis' English days, would direct.[129] When the project collapsed in the summer of 1963, Jarvis tried to secure the film rights to Stephen Crane's *The Red Badge of Courage*.[130] He then returned to the building in which he had once directed the National Gallery, to present a short piece entitled *The Fantasy of the Print* at a UNESCO-sponsored art festival.[131] Jarvis' confidence and interest drained away with each proof of failure and decreasing stature. It was at this point that he stopped paying his dues to the television performers' union.[132]

In a last romantic attempt at television stardom, in February 1964 Jarvis tried to enlist Sir Kenneth Clark's thirty-year-old son, who was working at a New York City television station, to help find a buyer for *The Things We See*. Jarvis hoped American producers would see the show's potential to rival Alistair Cooke's *Omnibus*.[133] Clark circulated copies of the show, but no one was interested and Jarvis' television career sputtered to a halt.

Sculpture was the creative endeavour in which Jarvis had always had the greatest emotional investment. He had turned to it as a way of coping with every crisis since his brother Colin's death in 1933. He had abandoned this vocation reluctantly at Oxford to appease his parents, and returned to it fervently in his last London years, only to be ordered to put down his tools as a condition of accepting the Gallery job in 1955. True to this pattern, one month after leaving the Gallery he bought a load of clay, and then joined the Sculptors' Society of Canada.[134] Jarvis had not practiced his art regularly in five years, and so

he protected himself from the knowledge that his skills had diminished by adopting a seemingly insouciant attitude in which he claimed that he was only a minor talent.[135]

Reverting to sculpture, as he had done during his first alcoholic depression in 1950, was not necessarily a good sign, because a career in sculpting was as challenging as it was emotive. Jarvis' attempts to set up a practice in the early 1950s had shown him that there was a very small Canadian market. However, his profile as the former director of the National Gallery launched his new career with great panache. In the spring of 1960, he received $2,000 to sculpt the Stratford Festival's Tom Patterson, was approached to do a statue of Lord Beaverbrook for the latter's newly opened gallery, and was asked to create a decorative piece for the men's residence at Dalhousie University. All the while, Ottawa friends like Kendrick Venables and Louis Rasminsky, the head of the Bank of Canada, supported him by commissioning portraits.[136]

Jarvis made his most important connection in February 1961, when Max Stern, the Austrian émigré art dealer who with his wife owned Montreal's Dominion Gallery, arranged a portrait of Sam Bronfman.[137] Jarvis asked for $4,000 to sculpt the patriarch of the wealthy distilling family, with the caveat that "there is no established Canadian scheme for this, as there is in England." He and "Mr Sam" got on well during a couple of sittings, but the family grew weary as deadlines slipped and the bust was only finished in November.[138] Despite the delays, the Bronfman commission led directly to a year-long agreement between Jarvis and the Dominion Gallery that was sealed in September. Under the contract, Jarvis received $500 per month in return for which the Sterns were guaranteed 25 per cent of all revenues generated by portraits, and half of any money paid for all other sculptures. With this financing, Jarvis leased a studio in an abandoned Toronto factory and took on the outward trappings of a professional artist.[139]

Another enormous boost came from Dorothy Cameron, one of the emerging champions of Canadian art. In October 1960, she asked him to think about working towards an exhibition at her Toronto gallery, feeling that "it would cause a great deal of interest" in his works and lead to further commissions.[140] He also hoped to drum up business through such events, declaring "I would like on this occasion only to show portraits and to keep other works for a bigger showing later on."[141] The exhibition ran for a week at Cameron's gallery in January 1962 before the Sterns hosted it in Montreal,

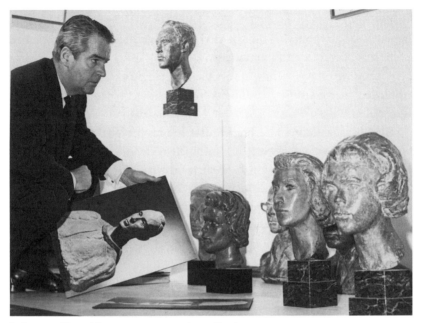

In hopes of launching a career as a sculptor, Jarvis
sets up a show of his works, 1962. Alan Jarvis
Collection, University of Toronto.

after which it moved to Ottawa's Robertson Gallery.[142] At each stop, the exhi-
bition was advertised by "one big photograph in the show window with a big
facsimile signature" by Jarvis. This promoted Jarvis as a personality, while
camouflaging the fact that he had relatively few completed pieces to show.
Once inside, patrons passed a display of small photographs of Jarvis' English
sitters, before entering a room with seven sculptures of Canadian personali-
ties and twelve large photographs of Jarvis' English works.[143] It was a rather
sparse accumulation for a year of effort.

Nevertheless, the Toronto opening hummed with the glamour that Jarvis
had brought to the Canadian arts scene, and the serious purpose that had
always lain behind his endeavours. Philip Torno, the wine company execu-
tive who had helped to establish the Society for Art Publications, supplied the
champagne for a black-tie event that raised funds for *Canadian Art* maga-
zine.[144] Among the crowd of philanthropists, artists, Liberal insiders, and
University of Toronto professors was the cultural critic Robert Fulford, who

remembered Jarvis playing his expected public role and deflecting criticisms of his skills with a witty "I'm not very good, but I'm very fast and I'm very, very expensive."[145] As was now always the case, the happy and confident shell concealed chaos; Jarvis' accountants fumed about the woeful state of his financial records.[146]

Also as usual, Jarvis' inscrutable mask hid his personal troubles and allayed doubts. The Sterns mailed him his final cheque in September 1962, believing that their partnership had been launched. From Montreal, they were simply unable to see Jarvis' disintegration. So they began arranging a follow-up show for their gallery, through which they hoped to drum up commissions for Jarvis.[147] When they enquired about the number of works to expect, Jarvis admitted that because his marriage had failed "for about eight months I have gone off sculpture and worked on a kind of painting (it is, perhaps, close to the modern Spanish, using plaster, sand etc, but with brighter palette)" and that in regards to sculpture he claimed to have "made a breakthrough as important and as original as Calder's 'mobiles' but I would like as many more weeks as possible to develop this. If it is as good as I think it is, then it is fantastic. I cannot describe the concept adequately in words, I must *show* you."[148] Only someone who had no regular contact with Jarvis could believe this piffle.

Jarvis prevaricated into December when he asked the Sterns for another postponement on the grounds that nursing his ill mother had prevented from pursuing his new discoveries. The letter closed with the optimistic proposal that the Dominion Gallery should anticipate hosting separate springtime shows of paintings and sculptures, which Jarvis now called "variables."[149] The Sterns held off, only to learn in March 1963 that "domestic reasons" had once again prevented Jarvis from sculpting. By agreeing to wait, the Sterns showed more patience than can reasonably have been expected given their investment. They were repaid a fortnight later with Jarvis' casual declaration that "Les jeux sont fait," by which he meant that he had shattered his arm in an alcohol-related accident on an arctic trip, and begun to "reassess" his artistic breakthrough.[150] Jarvis never showed again at the Dominion Gallery.

Sculpting commissions dwindled quickly without the sponsorship of a gallery or agent and Jarvis' career petered out. In the spring of 1963, he made an abstract mural entitled *The Four Elements* for the National Trust building in downtown Toronto. The following February, the Royal Canadian

Armoured Corps paid him $2,500 to sculpt General Frederic Worthington for a public park in Borden, Ontario.[151] With this, Jarvis' professional career was over, but a desperate, romantic attachment to art outlived his slide and showed his psychological fixation on its redemptive powers. By this point, there was little else in which Jarvis could put his faith. So in August 1965 he enquired about enrolling in London's Central School of Art, and was "delighted to know there is some possibility of entering the etching course – a discipline which is of the greatest interest to me. I do hope, as an ancillary it will be possible to do some drawing from life."[152] Whatever hopes this ignited of re-establishing his former life at 3A Sydney Close were moot. He never enrolled. Like the break-up of his relationship with Norman Hay, it was a sign that Jarvis could never recapture those heady, successful days.

Writing was the last strand in Jarvis' post-Gallery career. The Gallery staff had given him a typewriter when he left, signalling their hopes of reading his cajoling opinions for years to come. They knew that Jarvis' lectures were an almost effortless combination of spontaneity and intellect, anecdote, and wit, but they did not know that he had never written as easily or fluently. Nor could any but his most intimate friends have known that writing was the craft at which his elder brother Colin had excelled. The psychological pressures of trying to live up to Colin's memory were immense. Jarvis' theses at Oxford and New York University had been abandoned, while *War in Western Art* had been stillborn. His one published success, *The Things We See*, was a very slim volume. There were other occasional pieces, but Jarvis had never completed any written work that required extensive research or sustained effort. Moreover, like sculpting, Jarvis had not practiced his craft for many years.

In spite of this history, the belief that Jarvis could write well was widely held. At the end of 1959, the *Montreal Star* began carrying a column entitled "The Things We See," which it hoped to syndicate across the country. The newspaper was owned by John G. McConnell, whose father had helped Jarvis find Canadian sculpting commissions during his last years in London. Jarvis had similarly grand hopes for the column in which he intended to discuss aesthetics, much as he had on television. He secured the rights to collect the instalments into a book, but the largest newspaper chain in western Canada

cancelled the column after a single week.[153] McConnell was exasperated. He had expected the provocative, even infuriating opinions that came so naturally to Jarvis on the podium. However, apart from consecutive columns about the new National Gallery, Jarvis produced fairly uninspired pieces on architecture, airports, and the arts in general, which the critic Pearl McCarthy praised for dealing "with the rare thing in daily print – discussion of the bases."[154] She was one of his few admirers.

The column got renewed life in June 1960 when Jarvis convinced John Bassett, the owner of Toronto's CFTO television, to publish "The Things We See" in his newspaper, the *Toronto Telegram*. The series and column would appear in tandem and publicize one another.[155] It was clear from an October announcement in the *Telegram*, promising that Jarvis would "tee off on everything from shoddy public housing to compact cars, from toilet bowls to jet airports," that Bassett expected him to be provocative on screen and in print.[156] Jarvis missed deadlines from the outset, which he blamed on his having taken on too many commitments.[157] The content of Jarvis' columns did not make up for his lapses and it was dropped. He continued to hope that it would be revived and had an implicit agreement in the fall of 1962 that the *Montreal Star* would run it if Jarvis became director of Pittsburgh's Carnegie Institute.[158] Even though he was not selected, two years later the *Star* gave him another chance, which Jarvis quickly repaid by being two hours late with his first column.[159] By this time he could no longer fulfill a weekly writing assignment.

Book publishers were just as convinced that Jarvis could transfer his voice to the page. He was approached by Marsh Jeanneret from the University of Toronto Press in the spring of 1961 to write a major history of Canadian art for publication during the 1967 Centennial year. As Canada's most prominent spokesman for the arts, it was fitting that this ambitious, nationalist project should be offered to Jarvis. A generous grant from the Canada Council funded a book that was supposed to incorporate scholarly texts about the country's French and English artistic traditions with high-quality, full-colour illustrations. It would also be produced entirely in Canada to show off domestic publishing and printing skills.

Jarvis signed on for a fee of $1,000, and recruited Paul Arthur to oversee the layout and design.[160] Deadlines were extremely tight and, as was now commonplace, Jarvis began missing them almost immediately. By mid-June, the

press was threatening to cancel the project, and was only slightly more optimistic when Jarvis brought the National Gallery's Robert Hubbard, Kathleen Fenwick, and Jean-Paul Morriset on board that autumn.[161] The project survived into 1962, though little work was done. When Hubbard backed out that November, Jarvis suggested that he be replaced by J. Russell Harper, a younger member of the Gallery staff, whose "scholarship is equally good."[162]The departure of one of the most noted authors on Canadian art sent a clear signal to the press that the book was in serious trouble. When Jarvis failed to submit the first manuscripts and editorial reports at the start of 1963, the book was cancelled. A revived project was then entrusted to Harper, and this appeared as planned in 1967 as the groundbreaking *Painting in Canada*.[163]

Jarvis was incapable of completing sustained writing projects. At the same time, he published occasional, short, general pieces on Canadian art. He earned as much as $500 from widely circulated magazines like *Harper's* and *The Atlantic*, though many of the journals were obscure and his work was uninspired.[164] For instance, in 1960 he wrote an article on Canadian painting for the *Student's Guide to Canadian Industry*, and a similar piece for the University of Alberta's engineering society journal the following year, while his contributions to the *Canadian Annual Review* were criticized for a Gradgrind-like devotion to "the facts and little else."[165]

At the same time, an appearance of productivity clung to Jarvis thanks to the November 1962 publication of four slim volumes entitled *Gallery of Canadian Art* that he had edited for McClelland and Stewart during his last days at the Gallery. This included his booklet on David Milne.[166] Such small signs of productivity kept alive the belief that Jarvis could write well. Among those who were fooled was the London publisher Weidenfeld and Nicolson, who approached Jarvis in 1965 to write a full-scale biography of Sir Stafford Cripps. Jarvis grasped at this as "just the kind of challenge and tough work which I have needed for sometime," and rumours abounded in Toronto the following year that Jarvis was turning his recent European art tour into a comic novel.[167] But he did not even start either project.

When Alan Jarvis Associates closed down in February 1965, it signalled that his post-Gallery career was all but over.[168] He was not yet fifty, but had

systematically deceived or disappointed everyone who had extended their hands to help in his interconnected endeavours. The consequences of these individual failings rippled through a small cultural community in which the same few people supported many projects. For instance, after letting Max Stern down as a sculptor, Jarvis had to convince him to advertise in *Canadian Art*. Many people still hoped Jarvis would rebound, though they were unwilling to give him any major responsibilities.

A further blow to his ambitions fell that September, when Dorothy Cameron was forced to close her gallery because of financial troubles resulting from a prosecution over an exhibition's supposed obscenity. She had been one of Jarvis' biggest boosters, a favour he returned two months later by emceeing a dinner in her honour in one of the ballrooms at the swanky Park Plaza Hotel. According to the speaking notes that were written for him by the publisher Jack McClelland, the occasion was supposed to be a fun and lighthearted protest at Toronto's narrow morality. In this spirit, Jarvis regaled the audience by imitating Lester Pearson's tortured French, donning a set of false teeth to impersonate John Diefenbaker, and joking that the head of the morality squad, for whom a place had been reserved at the head table, had not shown up. This last quip was the cue for an actor dressed in police uniform to burst through the doors and "raid" the premises. The jocularity floated on a sea of wine provided once again by Philip Torno, and the well-oiled guests danced into the early morning to the music of the vibraphonist Peter Appleyard.[169]

But Jarvis' gaiety was not spontaneous. The comprehensive speaking notes and instructions that the party's organizers prepared for him demonstrated that they no longer trusted him to talk off the cuff, while his Diefenbaker impersonation, which he had often done in private, showed he was still pursued by the spectre of 1959. Soon after, Jarvis' charitable instincts took over as he tried to hire Cameron as a consultant on the 1966 Stratford show, but her fees could not be covered within the tight budget.[170]

All the same, Jarvis retained the cachet of a former head of a national institution and a significant public profile as a champion of the arts. This brought opportunities that were, at least superficially, impressive. He was made a director of the cash-strapped Dominion Drama Festival, the once-important theatrical event that had become increasingly marginal in recent

decades.[171] He was also invited by the Israeli government to attend the official opening of the Israel Museum in Jerusalem. At the ceremony, he was mistaken for a British diplomat, at a time when the Foreign Office was still home to urbane, Oxbridge-educated members of the grandest families.[172] The confusion showed that Jarvis' pose remained engaging, but it was now little more than a thin veneer that could be easily rubbed away, exposing the underlying feelings of humiliation and failure.

The most telling such occasion happened during the Royal Ballet's North American tour in the summer of 1965. Toronto balletomanes hosted a reception for its legendary choreographer Sir Frederick Ashton and soloists Lynn Seymour and Rudolph Nureyev. Norman Hay and Dorothy Cameron were invited and asked Jarvis, who loved ballet, to come along. He was outwardly excited, though Hay and Cameron sensed him grow uneasy as they approached the party. When he froze at the door, Hay concernedly encouraged him to enter and talk to Ashton, whom Jarvis had known in London's artistic and homosexual circles. But Jarvis would not budge, offering the maudlin excuse, "What am I supposed to say; hello Sir Frederick, do you remember me? I'm Sir Alan."[173] Memories of London now increased Jarvis' sense of failure.

Equally telling was Expo 67, the Montreal fair that Jarvis had helped conceive and that had been designed in large part by the artists, bureaucrats, and arts administrators whom he had inspired. Everything about Expo, from Buckminster Fuller's geodesic American pavilion and the monorail that pierced it, to Moshe Safdie's futuristic housing complex Habitat, proclaimed that a dour former colony like Canada could be as cool as swinging London or hippy San Francisco. As he walked around the exhibition grounds that summer, the critic Robert Fulford felt Jarvis' presence and influence strongly. Over the summer, Jarvis chaired an event for young people and a conference session on "Canada in Today's World" but his personal Expo "passport" – which visitors were meant to fill with stamps from the various national pavilions – was blank. He never saw much of the fair.[174]

His earnings fell apace; he made about $5,500 that year, almost all of which came from Rothmans. It was a decent wage, but only about one third of what he had been paid at the start of the decade.[175] More telling evidence of Jarvis' decline was his absence from another major Centennial project, which also foreshadowed the oblivion into which he has fallen since his death. During

that summer of love beads and miniskirts, the first appointments were made to a national honours system, the Order of Canada. British titles and distinctions had long since been discarded by Canada, while the creation of a specifically national system had often been mooted, most notably by the Massey Commission in 1951. Appointment to the Order honoured Canadians who had distinguished themselves in a particular field. Jarvis was not among the ninety people in the first group invested that July, nor was he ever invited to join, unlike his contemporaries Claude Bissell, Northrop Frye, and Robertson Davies. During his English days, Jarvis had repeatedly joked to his mother that he would be knighted by age thirty. Now, as the incident with Sir Frederick Ashton showed, Jarvis' sense of shame and failure was confirmed by his lack of either British of Canadian honours. The Order of Canada was closed to him, as he knew were most other opportunities in his native country.

CHAPTER
THIRTEEN

"We Have Lost Our Sheep Dog"
The Last Years, 1968–1972

New opportunities for Jarvis appeared in early 1968, in the form of a February grant from the Canada Council to restart his sculpting practice.[1] While waiting for the council to judge his application, Jarvis observed, but did not actively participate in a four-day Toronto seminar exploring the question "Are art galleries obsolete?"[2] A decade earlier he would have been offered, and relished, a central role in such a palaver. No longer.

His work for Rothmans continued, but he wanted to be an artist. Once the seminar ended, he set out on a rare, nostalgia-laden holiday. He saw his onetime love Fanny Myers in Manhattan, before heading to Mexico City's sun and the hospitality of his University of Toronto and Oxford contemporary Saul Rae, who was the Canadian ambassador. He tried to put his life in order before leaving by instructing the Canadian Conference of the Arts to forward any papers regarding his divorce, or messages from his elderly mother.[3]

The trip was only a short tonic, as formative chapters in Jarvis' life continued to close. Most importantly, the sixty-six-year-old Douglas Duncan died in Toronto on 26 June. Executors struggled to catalogue this compulsive collector's incomparable horde of Canadian works that overflowed from the Picture Loan Society and a pair of adjoining apartments. He and Jarvis had not been in regular contact for a couple of decades, though Duncan's $2,500 bequest to his former lover was a sign of ongoing affection.[4] The legacy made

little difference to Jarvis' increasingly chaotic finances. In October he was kicked out of the Athenaeum, which had been trying to collect dues for two years.[5] Mervyn Stockwood and Alan Don had proposed Jarvis' election to this extremely exclusive London club in 1954, but he had not crossed its threshold in years, and now hardly ever communicated with English friends. So, like Duncan's death, the expulsion symbolized his isolation from happier, more successful days.

Above all else, 1968 was the year in which drinking caused Jarvis' health to begin failing permanently. In August he slipped in his room at the King Edward Hotel and lay on the floor for hours with a broken hip. By the time the ambulance reached the hospital, he was gravely ill and pneumonia soon set in.[6] Such was Jarvis' public profile that the accident was reported on the front page of the *Toronto Star*. Dorothy Cameron gave the newspaper what she must have believed was a eulogy, by asserting that Jarvis "really belongs to the Trudeau Era," which was just dawning, and which saw the country headed by a prime minister with similar *élan*.[7] Former Liberal cabinet minister Judy LaMarsh, whom Jarvis had recently befriended, joked to him in a private letter that "there are no other Alan Jarvises in Canada and we just can't have anything happen to the one we have."[8] Visitors like Barbara Moon and Arthur Gelber decorated Jarvis' hospital room with flowers and a large hand-painted get-well-soon poster. Amid this rather forced gaiety, they looked anxiously at a frail, prematurely aged man who was being fed through tubes. When Jarvis regained consciousness, he refused to acknowledge his drinking, readopting his blithe and charming persona for the many friends who stopped by.[9]

After being discharged, Jarvis moved to the Windsor Arms Hotel in an attempt to put the incident behind him. Though he was barely fifty-three, he was so enfeebled that his hip never healed completely and he began relying on a cane and sometimes a wheelchair. In a concession to his worsening physical state, Jarvis hired Stanley Cameron, a young man to whom he had been introduced at the National Gallery, as his general helper. Cameron spent a couple of hours at the hotel each morning, making breakfast, answering mail, and arranging Jarvis' personal papers. Soon after, Jarvis bought a convertible Volkswagen beetle, a suitably stylish design icon, that he could no longer drive. Instead Cameron folded Jarvis into the front seat, tucked the wheelchair in the back, and chauffeured him around the city.

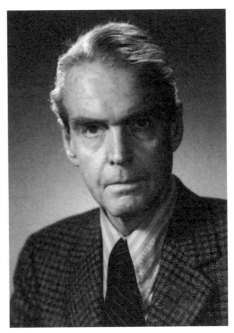

At the end – emaciated, empty, and unhappy,
c. 1972. Alan Jarvis Collection, University
of Toronto.

From time to time they drove up to Muskoka, where the teenaged Jarvis
had worked as a camp counsellor and painted with David Milne. The familiar woods and lakes helped alleviate his increasingly frequent bouts
of despair, for as Cameron recalled, "I think that's the only time I've seen a
really happy flash in Alan's eyes and face."[10] On one occasion Cameron lifted
his emaciated friend into a canoe and watched with joy and amazement as
Jarvis glided it expertly through the waters. In this sense Jarvis was, as Dorothy
Cameron had claimed, very much like Pierre Trudeau in that they both found
meditative solace in paddling. But Jarvis' contentment was not sustained; he
was in constant pain and talked in black moods about not wanting to live
much longer.[11]

With the help and support of Cameron and many admirers, Jarvis continued trying to re-establish himself. The publisher McClelland and Stewart asked him late in the year to write a book commemorating the fiftieth anniversary of the Group of Seven. Such a celebration of Canada's most renowned painters befitted Jarvis' status as a former National Gallery director, but the manuscript had to be completed without delay in order to appear in 1970. The firm's head, Jack McClelland, who had kicked Jarvis out of the Sordsmen's Club for drinking seven years earlier, reinforced the point by writing "that we are bound to take a very tough and rigid line on this one as far as performance is concerned," and made it extremely clear that Jarvis had to meet very tight deadlines.[12] Sensing that the project was too big for him to tackle alone, Jarvis hoped the art historian Peter Mellen would be his co-author. When he decided not to get involved, Jarvis withdrew.[13] The project was eventually entrusted to Mellen alone, and appeared on schedule.[14] At the end of the year Jarvis, was replaced as the Canadian Conference of the Arts' (CCA) national director, the post that had been created for him in 1960, though the group continued looking on him as a "friend, mentor and philosopher."[15]

By 1969 Jarvis was living at the Waldorf Astoria Hotel and using his Canada Council grant to rent a downtown studio with two other artists.[16] He was not happy. When he missed the CCA's annual seminar that January, participants expressed their "deep appreciation of the artists, curators and government representatives and observers for your [Jarvis'] outstanding contribution to the arts in Canada, not only through your activities in various posts which you have held but also through your personal enthusiasm and encouragement of Canadian creativity in print, on the platform, on radio and television."[17] The encomium showed that people understood how much help Jarvis needed. A more public tribute followed in February when Jarvis received the CCA's *diplôme d'honneur* for his career achievements. By now, such ostensibly happy occasions echoed with failure in Jarvis' mind. The award was presented at an Ottawa banquet by Governor General Roland Michener, the dean of Canadian Rhodes Scholars on whom Jarvis had called in his unsuccessful 1941 bid to join the navy, and who, as Speaker of the House of Commons, had presided over the parliamentary furor that preceded Jarvis' dismissal.[18]

Jarvis' deterioration continued unabated and in early summer he was admitted to a Toronto hospital coughing blood. His heart then failed. He

slipped into a coma and it looked as though he would not survive the night. While he recovered, doctors told him that alcoholism had caused his collapse, but he refused to lower his emotional barriers, thereby convincing the attending psychiatrist that he could not be helped.[19] Instead, as Dorothy Cameron recalled, when she first saw him regain consciousness, he looked up at the intravenous bottle through which he was being fed and quipped "I hope that's beefeater" gin.[20] The joke fell flat. Instead of laughing, a group led by Cameron persuaded Jarvis to enter a residential treatment home for alcoholics.

He stayed there until 20 July 1969, the night of the first moon landing. Norman Hay and Dorothy Cameron secured his temporary release so that he could join them to watch the television broadcast of this historic event. The three old friends tried to be gay, in spite of Jarvis' fragility. As Cameron recalled, she and Hay knew that Jarvis was meant to be "on the wagon, and we would not let him have any Gordon's gin so I hid my Gordon's gin."[21] As a comparatively weak alternative, Hay had mixed up a kind of sangria that he called "moon punch" in reference to the occasion and the way the floating pieces of fruit resembled planets in orbit. But the well-intentioned preparations were of little consequence. Jarvis took one sip of Hay's concoction, grimaced, and asked for the gin. So the Gordon's was retrieved and Jarvis was soon drunk. When Neil Armstrong made his famous "giant leap for mankind" onto the moon's surface, Jarvis got down on his knees in a melodramatic gesture of piety and prayer.[22] Hay and Cameron, who cannot have been too sober by this point, were touched by the sight, but Jarvis was now so ill that he only aped his once magnetic persona.

Jarvis suffered a further blow when his mother died in August 1969. Janet Bee left her only child the house in which he had grown up and a considerable investment portfolio, which he began spending at a heady clip. Much of it was given out in magnanimous gestures of support for friends and individual artists. His own circumstances were dire, but Jarvis was generous beyond measure. He also actively pursued attractive young men. At the same time, illness robbed him of any sense about whom to trust. He lent his credit cards indiscriminately, and they were abused by a group of young men who flattered Jarvis with their affections and embroiled him in their quarrels. A stream of bills for clothes from some of Toronto's most expensive stores alerted Jarvis' lawyer and bank manager to what was happening. They knew that his closet was almost empty, but could do little to stop the exploitation

because Jarvis was neither insane nor legally incapacitated. No matter how much was stolen, given away, or squandered, Jarvis was never entirely destitute, thanks mainly to the $5,000 annual retainer he continued to receive from Rothmans.[23]

In return for this small stipend, as mentioned previously, Jarvis gave the company general advice about art and opened exhibitions around the country. The untaxing work allowed him to deliver his well-worn public talks, and to reminisce with old acquaintances. Because he was too feeble to travel by himself, he was accompanied by the director of Rothmans art program, who recalled that "it was one of the few things that kept his [Jarvis'] interest and kept his conversation up." Even as he deteriorated greatly in his last years, Jarvis "had an inner something about him that he pushed himself and made himself" get ready for these appearances by having his shoes shined and his hair trimmed. Having done so, Jarvis would ensure that his public persona was in place by asking his companion "Is my tie straight?" or some other seemingly banal question just before going out to face his audience.[24]

Rothmans did not require much from Jarvis. The daily agendas and calendars he kept during these last years show very few social or professional appointments. A striking and unusual entry was written in his own hand on 2 September 1969 stating simply "NO Gin."[25] It is not clear whether this was a personal challenge to spend one sober day, or a triumphant exclamation that he had done so, but the entry indicates that on some level, and however briefly, Jarvis understood and tried to confront his addiction.

The effort was not sustained and Jarvis' life unravelled further as he squabbled with old friends about the ownership of works in Douglas Duncan's estate. The fight he and Robert Finch carried out in late October prompted Jarvis to beg "I hope you will find it in your heart, for the sake of happier memories to forgive my shocking callousness. After two sleepless nights I will try to write more. Only, please keep the sculpture in its accustomed place. How could I possibly live with such a reproach." Finch could not be placated.[26] Jarvis also argued about several David Milne canvases with Duncan's sister, Frances Barwick. The dispute with Frances, who had befriended Jarvis before the war, and helped him lobby for the National Gallery job, was resolved more amicably when the pair donated them to the nation, along with the bulk of Duncan's huge collection.[27]

With Stanley Cameron's help, Jarvis kept trying to write, though the decreasing scope of the projects showed that he was no longer capable of sustained effort. He contributed three short paragraphs to a brochure that accompanied a Toronto retrospective of the sculptors Frances Loring and Florence Wyle, and then about twice as many words for a travelling Rothmans show of Rodin's works.[28] After this, he embarked on a memorial book about Douglas Duncan, which occupied him until the following year. Because he was too weak to produce a full-length biography, Jarvis called on mutual friends like Northrop Frye, Norman Endicott, Robert Finch, and Rik Kettle to contribute short pieces. As the comedian and art collector Johnny Wayne said, they agreed to take part despite knowing that Jarvis was "very, very sick."[29] The introduction, Jarvis' only contribution, was drafted in Muskoka, where he and Duncan had long ago visited David Milne. It did not reveal much about their relationship, though it included a 1936 photograph of Jarvis, Duncan, and Milne sketching together.[30]

Jarvis revisited this relationship in March 1970, thanks to a $500 commission from the National Gallery to provide an essay for the catalogue of the inaugural exhibition of Duncan's collection. Apart from briefly describing an early visit to Milne's cabin and the chaotic state of the Picture Loan Society, Jarvis revealed virtually no personal sentiments in this rather flat summation of the man who had been his first lover and shown him that a life in the arts was possible.[31] Work on the article brought Jarvis and Stanley Cameron to Ottawa several times. Receipts from these trips show that alcohol accounted for as much as 40 per cent of their expenses. Whatever reins Jarvis had applied to his drinking the year before had slackened.[32]

Now that the essay on Duncan was done, Jarvis began working on a follow-up memorial volume to Donald Buchanan, who had been killed in a 1966 car accident.[33] Once again, private indicators, like the overdue payment to a Toronto gallery for two Inuit carvings, which may well have been bought without Jarvis' knowledge, show how erratic his life had become by the start of the new decade.[34] Yet many people in the arts community still looked on Jarvis as what one admirer called "an inspirer of … life-enhancing experiences," flattering praise given that this was one of Sir Kenneth Clark's favourite phrases.[35] When Jarvis was once again admitted to hospital that autumn, work on the Buchanan book stopped.[36]

Optimism surfaced briefly in late 1970 when Jarvis signed a five-year lease on a small second floor apartment in a converted nineteenth-century house in Clarence Square. Rent was low in this faded district at the foot of Spadina Avenue where once-elegant houses were being replaced by apartment buildings, offices, and industry. Flower pots soon lined the patio on which Jarvis spent happy hours, though he never really settled into his new home. If it were not for the friends who hung a few pictures on the walls, Jarvis would have left them stacked on the floor with his other belongings. He gave away many possessions because material objects might prevent him from decamping once more.[37] After living in hotels for so long, Jarvis could no longer create a permanent home for himself.

As 1971 dawned, the *Toronto Star* published Jarvis' contribution to a column that profiled the city's most prominent residents. What was meant to celebrate life in modern Toronto read like the reminiscences of a man who was trapped in the past. Little of what Jarvis said bore any relation to his current existence, but it played to the public's view of him as an urbane cultural leader. He clung to that persona, despite how little gaiety there was in his life. In the article, Jarvis claimed to spend his money on books and works of art, to read everything from biographies to detective fiction, a host of news magazines, and four American and British daily newspapers. Ideal Sundays were those he spent in the country in the company of artists. He tried to strike a well-worn pose by recounting a fantasy of pulling down offensive buildings, restating as he had done for at least a decade, "If we can obtain an injunction against those industries the smell of which offends, why can't we obtain an injunction against buildings which stink visually?"[38]

The past's grip was evident in the way he counted the 1945 stay on Exmoor with Mervyn Stockwood, and his more recent trip to Israel as his most cherished holidays. "Intense personal relationships," a term Jarvis had once ascribed to Douglas Duncan, were offered as his greatest private satisfaction. But, nothing was more poignant than the men Jarvis identified as his heroes: "In terms of personal encounter I would list the late Sir Stafford Cripps, the later Gerald Murphy and – thank God I do not to have to use the word late – Sir Kenneth Clark."[39] Each of these father-brother substitutes had been important to Jarvis long-ago. Few readers would have remembered Cripps, who had faded into obscurity since his death, while Clark and Jarvis had stopped

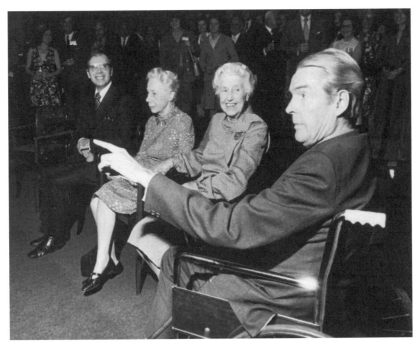

A last radiant moment. A wheelchair-bound Jarvis talks to
William Toye, Maud Brown, and Dorothy Jenkins McCurry
during a final visit to the National Gallery, October 1971.
Alan Jarvis Collection, University of Toronto.

corresponding many years earlier. This was the only public statement Jarvis
ever made about his relationship with Murphy.

Jarvis' reminiscent public mood contrasted with a further cleaving away
from his past. He and Betty were divorced in February, formally ending a
relationship that had begun in early childhood. Jarvis' lawyer advised him to
take a hard line in negotiating the settlement, but too many tender feelings
remained and he allowed Betty to keep the collection of art that he had left
behind when they separated.[40] Another old friend, the sculptor Henry Moore,
visited Toronto in October. He and Jarvis met, but Moore was now one of the
world's most celebrated artists and they had little to share except amiable
stories of earlier days.[41]

The audience with Moore coincided with Jarvis' final visit to the National
Gallery, for the opening of the Group of Seven retrospective. He cut a dapper,

if aged figure in his dark suit. From a wheelchair he chatted animatedly with a semi-circle of admirers. Sitting in the building that he had so largely inspired could not inure Jarvis from feelings of failure over his inability to write the book that accompanied the show. These feelings were heightened in November 1971 when Jarvis sold his London flat at 3a Sydney Close. He had rented it out since returning to Canada, but selling it was an acknowledgment that he would never again recapture the success and optimism of his youthful English days.[42]

At the end of the year, Jarvis was hospitalized for several weeks. He emerged white-haired, emaciated, and with his fingers gnarled by arthritis. Nevertheless, as the warm weather returned, he hosted dinner parties on the terrace at Clarence Square. At these he drank prodigiously, ate next to nothing, and tried to maintain the witty banter and charm that his guests expected. His conversations were now laced with unending references to his days with Cripps and Clark; a fixation with his past that had been hinted at in the *Toronto Star*. The art critic Robert Fulford, who attended one of these events, found it terribly sad to witness the "wreck" of a once-beautiful man, whom he likened to a bombed-out building. Only a battered and derelict facade hinted at Jarvis' previous handsomeness and importance.[43]

In private, Jarvis swayed dramatically between despair and brief periods of apparent contentment during which he tended flowers and worked on his art. He was even listed among the instructors at a rural art school that summer, along with his one-time teacher Carl Schaefer, though he was too feeble to attend and had little fresh wisdom to impart.[44] Hints of a reawakened spirituality, like his attendance at a 1972 Palm Sunday service, also pointed to Jarvis' fluctuating moods.[45]

Friends encouraged Jarvis' artistic efforts because they knew he loved sculpting and sketching even if little real talent remained. They arranged for him to show a group of collages, which Jarvis blithely called "caprices," even if one Toronto painter thought they were simply "god awful."[46] The exhibition opened on 2 December 1972 at Yorktown's Gallery Pascal. An "ashen" Jarvis arrived for the vernissage at about five in the evening.[47] He chatted for an hour or so with Arthur Gelber, Dorothy Cameron, and other friends, before being convinced to go home and rest. There was no answer when Cameron telephoned him the next morning. Gelber reassured her that Jarvis was read-

ing the *New York Times* over Sunday lunch at the King Edward Hotel. When the hotel reported that Jarvis had not come in, Gelber drove to Clarence Square. The apartment was locked. He became very worried and called the police. They forced the door to find Jarvis sitting up in bed with a book in his hand. He had died during the night.[48] He was fifty-seven.

Albert Weisbrot, who had been Jarvis' lawyer for almost a decade, went to the morgue and officially identified the body. This made him ineffably sad because it "seemed to be such a tragic way of ending such a talented, talented human being." Weisbrot described himself as being "really very, very, very upset" by the thought that Jarvis had no close family to perform this duty.[49] Weisbrot's distress grew as he cleaned out Jarvis' apartment and

> found checks that had never been cashed, and return tickets to flights to Ottawa, in other words he obviously must have bought a return ticket to fly to Ottawa and obtained a lift back with somebody and he never bothered to refund it. It was really the classic picture of somebody who didn't care about money at all. It was, most of the cheques were stale dated, they were years old, somebody had paid him for doing something, or royalty cheques which had never been cashed. It was chaos beyond words. It was unbelievable. I couldn't believe that anybody could make such a mess out of their economics as Jarvis had done. There were a lot of outstanding bills, but not large bills, small bills which were put in several drawers to be paid undoubtedly and [he] never got around to it, it was also obvious that people were taking tremendous advantage of this man in terms of, in terms of selling him things that he didn't require.[50]

As Weisbrot discovered, Jarvis had been spending money at such a rate that he would soon have been broke.[51] There was little left beyond this mess of papers, threadbare clothes, old books, and empty bottles. Jarvis' art collection, which had once included works by David Milne, Alexander Calder, Henry Moore, Graham Sutherland, Jacques de Tonnancour, Augustus John, John Gould, and Gordon Smith had been sold or given to Betty in the divorce. The almost complete dilapidation reflected how Jarvis had long ago simply ceased caring about life.

A large trove of personal papers remained. Most of these had been collected by Janet Bee in adoring tribute to her son's earlier, happier, and successful life. Her collection was supplemented by the documents that Stanley Cameron had sorted and filed, a very few of which told the story of Jarvis' last, miserable years. Jarvis bequeathed these to the University of Toronto, with the caveat that the letters he received from Gerald Murphy during their emotionally intense, chaste relationship be held back. The son and daughter of Frank Starr, who were Jarvis' godchildren, inherited what little else remained.[52]

As a boy, Jarvis loved the novels of Thomas Hardy, whose characters are swept away by huge passions only to be punished by tectonic fates. In adulthood Jarvis spent considerable time in and around Hardy's Wessex, so he may well have seen the parallels between his life and that of the title character in *The Mayor of Casterbridge*. Michael Henchard is humbly born, but very talented. As a hard drinking young man, he gambles his wife away in a card game, a shameful secret he carries through ever greater public acclaim. In the climax he is overtaken by his actions and succumbs quickly and miserably to alcohol. His will requests that no funeral or memorial of any kind should mark his passing. Jarvis tried to erase himself in a very similar manner. He donated his body to the University of Toronto's anatomy department. He would not be buried alongside his beloved brother and parents. Most tellingly, this once-religious, extremely sociable and prominent man requested that there be no funeral rites of any kind. Death had lowered the insouciant mask and exposed Jarvis' deep-seated shame at what he perceived to be his own failure.

Dorothy Cameron and Norman Hay would not abide this final request and so they organized a gathering, which as she recalled "must have about it a sense of *joie de vivre*, of fun" that reflected Jarvis' public persona. The event was held in the debates room at Hart House on 7 December. There were no flowers to give it a funereal air, but a garland of intertwined daisies and cedar boughs ringed the walls. Guests were served sandwiches, sherry, and gin martinis, a cocktail that was as much a tribute to Jarvis' suave persona, as an ironic comment on the alcoholism from which he had died. In place of a eulogy,

short tributes were delivered by the National Gallery of Canada's director Jean Sutherland Boggs, the painter Alex Colville, and the comedian Johnny Wayne. Colville likened Canada's artists to a flock of sheep, who had just lost the friendly dog that watched over them.[53] Wayne was less comfortable with the unremitting levity and, as he later recalled, set about reminding the guests of

> an old Talmudic saying that when a great man dies everyone must mourn. And so that we weren't really … it was our duty not to walk around very bravely and saying he was a great guy and lift our sherry glasses to him. The matter of fact was it had to be. We had to say something in a religious sense because it was very important to all of us. I chided them [the other guests] about that but then of course we had a lot of laughs because we, everyone talked about some of the funny things that he [Jarvis] had said.[54]

Tributes were followed by a recording of the English contralto Kathleen Ferrier performing *Blow the Wind Southerly*, a traditional ballad that Jarvis had first heard her sing when they were both weekend guests at an English country house. In it, a woman whose love is at sea implores "blow bonny breeze and bring him safe home." Those gathered hoped that Jarvis had found similar shelter from the gales. It was a last lively gathering of artists, admirers, and friends that he would have adored.

Conclusion

Alan Jarvis was endowed with such glittering gifts of wit, intellect, and artistic skill that one friend summed him up as a "gay kaleidoscope personality."[1] He was as handsome as a movie star and won a Rhodes Scholarship without being an athlete. Innate talent allowed him to sculpt and sketch with some of Canada's best artists, while his charm impressed prime ministers and poets. So it is not surprising that Jarvis' friends, admirers, and colleagues used superlatives to describe him. Until the last years of his life, they believed there was little to which he could not turn his hand. Each of his successes increased their expectations for his far-reaching impact in whatever field he eventually chose to concentrate his energies.

On his twenty-fourth birthday in July 1939, Jarvis looked set to fulfill this destiny. He had completed a year at Oxford, was researching a book about art and war, working with leading English adult educators, and coming to terms with his sexual identity through psychoanalysis. For almost twenty years to the day, his career evolved through a series of important, if short-lived projects until he was fired from the National Gallery of Canada. The blow was shattering and hung over him for the rest of his life.

As Jarvis left the Gallery, his supporters developed romantic ideas that he had been caught in a Manichean conflict between cultured civilization and

unthinking philistinism. They were certain that he would soon take up an equally important new project and they created many opportunities for him. Nevertheless, he fell apart dramatically because the public rejection and humiliation of his dismissal confirmed his innermost fears in ways that very few people anticipated.

As a biographer, it is hard to survey Jarvis' life without foreseeing this tragedy. The persona he adopted as a young man was tremendously attractive to his contemporaries and eased his success. At the same time, it was a protective shell that concealed an innate shyness, and immense anger and grief over the death of his idolized elder brother, Colin. Jarvis' fantasies about Colin's thwarted potential became the standard against which he measured his own talents. Jarvis was very ambitious, but this fundamental sense of inadequacy had a cumulative, withering effect on his confidence. Within this mindset, Jarvis strove for recognition, even though he believed he could never live up to people's praise and expectation, or meet the pressures he put on himself. The blithe insouciance he projected was doubly defeating in that it prevented anyone from peering too closely into his feelings, and isolated him from the many people who were prepared to give emotional and physical help.

Despite his supporters' beliefs, Jarvis' National Gallery career foundered for mundane reasons. By 1957, a series of missteps had eroded the trustees' confidence in him. They were convinced that though he had held important, public positions in England, he had minimal managerial skills and was unnecessarily provocative in public. Much the same view was held by the incoming Conservative administration. These weaknesses undermined his efforts in the Liechtenstein negotiations, which were a delicate balance of art world confidences, politics, bureaucracy, and popular opinion. His mishandling of the deals eventually provoked the government into moving against him.

The humiliation Jarvis felt over his dismissal was immense and inescapable. For the rest of his life, he was invariably identified as the former head of the National Gallery, a title that recalled the events of 1959 and conveyed notions of either martyrdom or incompetence. Throughout his remaining years, Jarvis joked about the end of his Gallery career in an effort to show that he had put it all behind him. A maudlin note rang ever more loudly. Though his last thirteen years were not preordained, they were predictable.

Alcohol was a corrosive mix for this pervasive, and to Jarvis, proven sense of failure. Having grown up in a teetotal Sabbatarian home, he began drinking socially at Oxford. A martini glass soon became a prop for his cosmopolitan persona because cocktails belonged to the jazz age that his beloved *New Yorker* magazine extolled, and conveyed urban sophistication in a way that wine's Gallic pretensions or beer's proletarian associations did not. The reality was less glamorous. By the age of thirty, Jarvis drank steadily. The war had just ended and he, like many others, had used alcohol to ease the exhaustion of unending effort and stress. Within a very few years, signs pointed to debilitating physical and psychological dependence on drink. But these were largely hidden because Jarvis remained slim, handsome, outgoing, and capable of functioning at a high level and under great pressure.

Jarvis further distanced himself from his Presbyterian forebears by relying on his natural abilities, instead of developing a strict work ethic. It was self-defeating. Because he succeeded without ever really exerting himself, he was wildly ambitious about how many tasks he could undertake simultaneously. Jarvis' mother saw this very clearly. Her repeated warnings against taking on too many responsibilities were neither shrill nor shrewish, just evidence of deep concern. Others echoed her pleas, but Jarvis never listened. Like much of the work he undertook throughout his career, Jarvis' Gallery duties were long and unrelenting, but inherently congenial. By the 1960s, when it became necessary for him to forge a career through the dedicated application of his talents, he was too addled by alcohol.

Jarvis never recognized these problems, because as a young man he settled on a career in adult education, which he saw as an intellectual spine for his many interests, and viewed every job through its lens. Most importantly, adult education underlay Jarvis' attraction to the National Gallery, because he knew the government was looking for a charismatic cultural leader rather than an administrator. As he told a friend on the eve of his return home, he dreamed of creating a Gallery that surpassed its physical footprint in Ottawa to reach across the country.[2] Implementing this vision galvanized the arts community and turned Jarvis into the most prominent symbol of Canadian culture.

And yet, what he really wanted to do was to teach the wider population how to critically confront the world by showing them that art was challenging, not sentimental. His success was uneven. For every person he inspired,

another was offended by some seemingly snobbish or cutting remark. Jarvis was never an innately political person, even though his belief in adult education and desire to democratize art were vaguely left-wing. This might eventually have clashed with a Conservative administration, but his outspokenness, flippancy and artistic interests appeared pretentious, whiffed of homosexuality and made him a conspicuous target.

As a young man, Jarvis had aspired to be an artist, and nothing touched him more deeply than sculpting. He turned to it atavistically at the most stressful moments of his life – Colin's death, the failure of Pilgrim Pictures, and his dismissal from the National Gallery. On each occasion, he was discouraged from continuing. First, over his family's fears that sculpting lacked middle-class respectability, and then to take on the structure and stability of Oxford House. Finally, he was told that a professional sculpting practice was unsuitable for the head of a national cultural institution. Self-deprecating quips about his skills conveyed his sense that he had never dedicated himself to the art, while also hinting at deep regret over unfulfilled promise.[3] By the 1960s, when he desperately tried to launch a sculpting practice, his talent was all but gone.

Jarvis enjoyed passionate, casual affairs and longer romances with both men and women. A succession of partners were seduced by his charm and physical beauty only to encounter an impenetrable emotional wall behind which lay insecurity, inadequacy, and fear. Outwardly, these were concealed by glittering connections and success. Throughout most of his life, Jarvis knew that he could attract almost any man or woman he wanted, so he felt little need to restrict himself to a single, exclusive relationship and never learned to foster and sustain a deep emotional bond. What set his long relationship with Norman Hay and marriage to Betty Devlin apart was that they were attempts at monogamy and commitment. Both failed. As age, alcohol, and depression withered his looks and charm, Jarvis could no longer seduce with such assurance. The resulting loneliness left him emotionally and physically vulnerable.

It is pointless to speculate about how Jarvis' life would have unfolded if he had become a sculptor, remained in England, or retired in great esteem from the Gallery. Instead we might consider that the man himself was a walking work of art. The persona that was his greatest creation was initially fresh and

vibrant. People responded emotionally when they met him, and he enjoyed great admiration, success, and renown in his abbreviated life. He played a seminal role in the development of modern Canadian culture by inspiring a group of administrators and artists, who were once collectively identified as the "Jarvis Generation." In a little over two decades, he travelled from Toronto's obscurity to Whitehall's corridors and the heart of the international art world. The breakneck journey had rarely been dull. And yet he died alone, barely five kilometres from the nondescript street on which he had grown up.

Notes

ABBREVIATIONS

AJC Alan Jarvis Collection, University of Toronto

AO Archives of Ontario

BBCWA British Broadcasting Corporation Written Archives

BOT Minutes of the Board of Trustees of the National Gallery
of Canada, National Gallery of Canada Archives

DCA Design Council Archives, University of Brighton

ECC Elspeth Chisholm Collection, Library and Archives Canada

EFB Estate of Fanny Brennan, New York City

FDG Fillipo Del Giudice Collection, British Film Institute

IODE Minutes of the National Executive of the Imperial Order
Daughters of the Empire, Library and Archives Canada

JPC John W. Pickersgill Collection, Library and Archives Canada

LAC Library and Archives Canada

NAUK National Archives of the United Kingdom

NGA National Gallery of Canada Archives

PCC Privy Council Office Collection, Library and Archives Canada

RHC Robert Hubbard Collection, Library and Archives Canada

SCC Sir Stafford Cripps Collection, Bodleian Library, Oxford

THL Tower Hamlets Local History Library, London

UCA University College Archives, Oxford

WCC W.G. Constable Collection, Boston Museum of Fine Arts

CHAPTER ONE

The quote in the chapter title is from Jacques de Tonnancour to Robert Hubbard, 6 March 1956, RHC, box 13.

1 Robert Fulford, "The Jarvis Generation: A Footnote to an Era," *Saturday Night*, January 1973, 9.

2 See for instance Lorna Rodgers to Elspeth Chisholm, 29 September 1975, ECC, box 12.

3 A draft script for the program is found in ECC, box 12.

4 Zena Cherry, "All about Orreries and Astronomical Clocks," *Toronto Star*, 30 November 1978, T3.

5 Kenneth Clark, *The Other Half: A Self Portrait*, 33.

6 Robertson Davies, *What's Bred in the Bone*, 385.

7 Ibid., 419.

8 Ibid., 383–8, 404–5, 414–28.

9 Robert Fulford, "Divine Comedies," *Saturday Night*, October 1985, 6.

10 de Tonnancour to Hubbard, 6 March 1956, RHC, box 13.

11 Douglas Ord, *The National Gallery of Canada: Ideas, Art, Architecture*, 129–56.

12 Norman Hay interviewed by Robert Fulford, 6 May 1981, Fulford collection, accession 30-1992, box 13.

13 For homosexual network, see Robert Fulford, *Best Seat in the House: Memoirs of a Lucky Man*, 111–12. For father-brother substitutes, see Jarvis' diaries for 1945, AJC, box 16. Also Norman Hay to Fanny (Myers) Brennan, 25 September 1987, EFB.

CHAPTER TWO

The quote in the chapter title is from "An Artist in Wardour Street," AJC, box 23.

1 Stanley Cameron interviewed by Elspeth Chisholm, ECC, CD A1 2003-07-0016.

2 For the sake of clarity, I have used the name "Alan" in this chapter. "Jarvis" will be used throughout the rest of the book.

3 *City of Toronto Directory for 1906*, Toronto, 663. The Nottinghams had lived on Shaw Street since at least 1906.

4 *City of Toronto Directory for 1908*, Toronto, 714. For a description of the optical department and the services it offered, see "Optical Goods," *Eaton's Spring and Summer 1908*, Catalogue No. 85, 178.

5 John L. Rawbon to Janet Jarvis, 23 October 1918, AJC, box 55.

6 *City of Toronto Directory for 1910*, Toronto. The McKay family lived at 320 Ossington Avenue.

7 Colin's certificate of baptism, AJC, box 55.

8 Photographs of Charlie and Janet are found in AJC, box 56.

9 Stephen Leacock, *Sunshine Sketches of a Little Town*, 144.

10 Marian MacRae and Anthony Adamson, *Cornerstones of Order: Courthouses and Town Halls of Ontario, 1784–1914*, 176.

11 For "optical expert," see *Brantford City Directory 1913*; for "optometrist and manufacturing optician," see *Brantford City Directory 1914*; for "Dr Charles A. Jarvis," see *Brantford City Directory 1915*; and for "poor eyes," see *Brantford City Directory 1917*.

12 Ethel L. Raymond to Janet Jarvis, 11 October 1918, AJC, box 55.

13 All three quotes are from "Sad Death this Morning of Dr. Jarvis," *Brantford Expositor*, 10 October 1918, 8.

14 Ontario Death Registration 010144/1918, AO, microfilm MS935, reel 241.

15 The quote is from *Toronto City Directory for 1925*, Toronto, 1661. Also Janet and Ed's marriage announcement, 17 June 1925, AJC, box 55.

16 Janet Bee to Alan Jarvis, undated, "Sunday afternoon," AJC, box 55.

17 Betty (Devlin) Jarvis interviewed by the author, 4 June 2003.

18 See for instance Christmas card from "Kitty," December 1938, AJC, box 1; Jarvis to his parents, 28 February 1939, 22 October 1944, and 3 May 1947, AJC, box 11.

19 Norman Hay interviewed by Elspeth Chisholm, ECC, CD A1 2003-06-0045. Photos in AJC, box 57.

20 Steven Maynard, "Through a Hole in the Lavatory Wall: Homosexual Subcultures, Police Surveillance and the Dialectics of Discovery, Toronto, 1890-1930."

21 Betty (Devlin) Jarvis interviewed by the author.

22 Betty (Devlin) Jarvis interviewed by the author. For Janet urging Jarvis to quit smoking, see for instance Janet to Alan Jarvis, 19 July 1946, AJC, box 55.

23 "An Artist in Wardour Street," AJC, box 23.

24 The quote is from Jarvis to his mother, 13 March 1954, AJC, box 11. Also Carol Lindsay to Jarvis, 8 July 1958, AJC, box 3; and Peter C. Newman, "Is Jarvis Mis-Spending Our Art Millions?," *MacLean's*, 22 November 1958, 21–44.

25 Stanley Cameron interviewed by Elspeth Chisholm.

26 Quotes are from Betty (Devlin) Jarvis interviewed by the author.

27 Charles G.D. Roberts to Colin Jarvis, 11 January 1930, AJC, box 55.

28 Undated and unattributed newspaper clippings, AJC, box 55.

29 See playbill for *Romeo and Juliet*, 15–17 November 1932, in which Colin played Paris, and undated review of *Way of the World*, both AJC, box 55. Photographs of the University College and University of Toronto track teams, AJC, box 50.

30 Colin to "Ted," 30 June 1930, 15 August and 6 November 1932, AJC, box 55. Ted was almost certainly a girl.

31 Election card, AJC, box 55.

32 "'Tommy Rot' Opinion of Hollywood Film," *Varsity*, 9 November 1931, 5.

33 "Correspondence," *Varsity*, 10 November 1931, 2.

34 "Nuns" and "Painted Desert," *The Undergraduate* 2, no. 2 (March 1932), unnumbered and 6.

35 Colin to "Ted," 30 June 1930, AJC, box 55. Colin worked at Camp Pine Crest.

36 Julia B. Brockwell to Janet Bee, 24 July 1931. AJC, box 56.

37 Mavor Moore interviewed by the author, July 2004. Giving up an artistic career from Betty (Devlin) Jarvis interviewed by the author.

38 As quoted in Joan Fairley to Ed Bee, 17 March 1933, AJC, box 55.

39 W.J. Feasby to Jarvis, 25 January 1956, AJC, box 3.

40 W. John Maize to the author, 5 December 2006.

41 Rebecca Sisler, *Art for Enlightenment: A History of Art in Toronto Schools*, 93–9.

42 Victoria Baker, *Emanuel Hahn and Elizabeth Wyn Wood: Tradition and Innovation in Canadian Sculpture*, 63, 66.

43 George Brett to Colin Jarvis, 11 February 1933, AJC, box 57.

44 "Student Death," *Varsity*, 6 March 1933, 1.

45 Condolences for Colin's death from friends, employees of Queen City Glass, the president of the University of Toronto, the registrar of University College, and the Optometrical Association of Ontario are found in AJC, box 55.

46 Correspondence with Park Lawn Cemetery regarding the Jarvis family plot, AJC, box 55.

47 Betty (Devlin) Jarvis interviewed by the author.

48 "An Artist in Wardour Street," AJC, box 23. For the candid confessions, see Norman Hay interviewed by Elspeth Chisholm, ECC, CD A1 2003-06-0045. Also

Dorothy Cameron interviewed by Elspeth Chisholm, ECC, CD A1 2003-06-0047. The quote is from Hay.

49 "An Artist in Wardour Street," AJC, box 23.

50 Jarvis' diary for 1945, AJC, box 16, 16.

51 "UC Players' Guild," *Varsity*, 19 October 1933, 2.

CHAPTER THREE

The quote in the chapter title is from Kay Kritzwiser, "Art Collector, Painting Rental Pioneer Duncan Dies," *Globe and Mail*, 27 June 1968, 13.

1 Claude T. Bissell, *Halfway up Parnassus: A Personal Account of the University of Toronto, 1932–1971*, 3, 13; Martin L. Friedland, *The University of Toronto: A History*, 324–6; Charles Morden Levi, *Comings and Goings: University Students in Canadian Society, 1854–1973*, 71.

2 For impressions of UC faculty, see Bissell, *Halfway*, 5, 13; Ernest Sirluck, *First Generation: An Autobiography*, 74–88; M.W. Wallace, "Report of the Principal of University College," *University of Toronto: President's Report for the Year Ending 30th June 1935*, 28; and ibid., *University of Toronto: President's Report for the Year Ending 30th June 1936*, 27. The Regina Manifesto was written in 1933, and set out the left of centre economic and social goals of the Co-operative Commonwealth Federation, a newly formed socialist political party.

3 A.S.P. Woodhouse, "Staff," in Claude T. Bissell, ed., *University College: A Portrait, 1853–1953*, 72–5.

4 Bissell, *Halfway*, 15.

5 Charles Morden Levi, *Where the Famous People Were? The Origins, Activities and Future Careers of Student Leaders at University College, Toronto, 1854–1973*, 7.

6 Bissell, "Opinion," in Bissell, *University College*, 108 (quote), 110.

7 Mary Greey interviewed by the author, 18 February 2005. Greey was a friend of Jarvis' who was one year above him at University College.

8 Jarvis' diary for 1945, AJC, box 16, 26.

9 Undergraduate transcript, Alan Jarvis' student record, UCA.

10 Betty (Devlin) Jarvis interviewed by the author, 4 June 2003. For limerick collecting, see "Anecdotes about Alan Jarvis," ECC, CD A1 2003-06-0042.

11 Norman Berlis to the author, 1 January 2003.

12 G. Hamilton Southam interviewed by the author, November 2002. For Southam's comments, see Peter C. Newman, "Is Jarvis Mis-Spending Our Art Millions," *Maclean's*, 22 November 1958, 42.

13 Francess Halpenny interviewed by the author, 28 November 2003; and Anecdotes about Alan Jarvis, ECC.

14 Anecdotes about Alan Jarvis, ECC, CD A1 2003-06-0042. Also Elspeth Chisholm to Albert D. Sheere, 11 November 1973, ECC, vol. 12.

15 Ian Montaignes, *An Uncommon Fellowship: The Story of Hart House*, 62. This book is based on 1962 interviews with Burgon Bickersteth.

16 See Bickersteth to Schaefer, 9 April 1935, Carl Schaefer collection, box 20, file 6.

17 J.B. Bickersteth, "Report of the Warden of Hart House," *University of Toronto: President's Report for the Year Ending 30th June 1935*, 110. For the quotes from George Johnston, see George Johnston, *Carl: Portrait of a Painter*, 11.

18 Schaefer's course outline is found in Carl Schaefer collection, box 22, file 4.

19 "Art Gallery," *Varsity*, 29 October 1934, 4.

20 Ibid., 6 November 1934, 2; ibid., 8 November 1934, p.2; "Sketch Room," *Varsity*, 12 November 1934, 2.

21 "Sculpture of the Twentieth Century," *The Undergraduate* 5, no. 1 (1935), 35.

22 Undergraduate transcript, Alan Jarvis' student record, UCA.

23 "Notes on Two Canadian Artists," *The Undergraduate* 6, no. 1 (1936), 35–8, quote on 35.

24 "Faculty Art," *The Undergraduate* 7, no. 1 (1937), 17.

25 Undergraduate transcript, Alan Jarvis' student record, UCA. For information about the scholarships, see *University of Toronto Calendar, Matriculation, Curriculum, Scholarships, 1934–35*, Toronto: University of Toronto Press, 1934, 67.

26 "College Journal to Appear Soon," *Varsity*, 24 November 1937, 1; "Women's Press Club Receives Instructions," *Varsity*, 8 December 1937, 1.

27 "Prolegomenon," *The Undergraduate* 8, no. 1 (1937), 7.

28 Anna Hudson, *Art and Social Progress: the Toronto Community of Painters, 1933–1950*, passim, quote on 75.

29 For the quote, see Hudson, *Art*, 107–8; and E. Lisa Panayotidis, "The Department of Fine Arts at the University of Toronto, 1926-1945: Institutionalizing the 'Culture of the Aesthetic,'" 100–25.

30 Jarvis' diary for 1945, AJC, box 16, 16.

31 Duncan to his parents, 11 and 25 March 1927, Barwick/Duncan collection, NGA, file H2.F4.

32 Douglas to Frances Duncan, 10 June 1927, Barwick/Duncan collection, NGA, file H2.F4.

33 Duncan's trust fund paid about $2,300 per year. Norman J. Endicott, "Douglas Moerdyke Duncan: A Memoir," in *Gift from the Douglas M. Duncan Collection and the Milne-Duncan Bequest*, Ottawa: National Gallery of Canada, 1971, 10.

34 John Glassco, *Memoirs of Montparnasse*, 14; "Norman Endicott," in Alan Jarvis, ed., *Douglas Duncan: A Memorial Portrait*, 20. "Magpie" from Douglas Duncan interviewed by Lawrence Sabbath, 14 September 1960, Barwick/Duncan collection, NGA, box 12. Photographs of these tours are found in the Barwick/Duncan collection, NGA, boxes 11a and 11b. Duncan's young lover in 1931 was Jimmy Knights.

35 "Robert Finch," in *Douglas Duncan: A Memorial Portrait*, 33–4.

36 Frances Barwick, "To Alan, Norman, Robert," undated, Barwick/Duncan collection, NGA, file D3.F5.

37 "Alan Jarvis," in *Douglas Duncan: A Memorial Portrait*, 8.

38 Steven Maynard, "Through a Hole in the Lavatory Wall: Homosexual Subcultures, Police Surveillance, and the Dialectics of Discovery, Toronto, 1890–1930," 207–42; and Steven Maynard, "'Horrible Temptations': Sex, Men and Working-class Male Youth in Urban Ontario, 1890–1935," 191–235.

39 G. Hamilton Southam interviewed by the author, November 2002.

40 Kay Kritzwiser, "Art Collector, Painting Rental Pioneer Duncan Dies," *Globe and Mail*, 27 June 1968, 13.

41 "Alan Jarvis," in *Douglas Duncan: a Memorial Portrait*, 10.

42 David P. Silcox, *Painting Place: The Life and Work of David B. Milne*, 259. Milne to Alice Massey, 17 January 1935, Massey family collection. The quote is from William and Nan Angus interviewed by Blodwen Davies, 4 August 1963, David Milne collection, vol. 9.

43 Douglas Duncan interviewed by Lawrence Sabbath.

44 Milne to Alice Massey, 3 December 1935, Massey family collection, vol. 34. For debating artistic ideas, see Duncan interviewed by Lawrence Sabbath.

45 Milne to Alice Massey, 3 December 1935, Massey family collection, box 34; Silcox, *Painting Place*, 259; "Alan Jarvis 2," NGA. A photograph of this sketching trip was published in *Douglas Duncan: A Memorial Portrait*, 9. Four of Jarvis' works are in

a private collection. Several others are found in the National Gallery of Canada collection.

46 For the visit to Ottawa and the first quote, see Milne to Donald Buchanan, 19 January 1937, NGA, file 7.1M. For "majestic six footers," see Milne to Alice Massey, 19 January 1937, Massey family collection, vol. 34.

47 Silcox, *Painting Place*, 256–60.

48 H.G. Kettle, "Pictures in the Home," *Queen's Quarterly*, Autumn 1936, 295–8, quote on 297. Norah McCullough's role is described in "Rik Kettle," in *Douglas Duncan: A Memorial Portrait*, 50.

49 Silcox, *Painting Place*, 260. Also pamphlet for the Picture Loan Society, Carl Schaefer collection, box 13.

50 Picture Loan Society account ledger, Barwick/Duncan collection, file D2.F1.

51 "Alan Jarvis," in *Douglas Duncan: A Memorial Portrait*, 12. And Schaefer to Milne, 3 February 1937, Carl Schaefer collection, box 8.

52 Pearl McCarthy, "Art and Artists," *Globe and Mail*, 18 October 1937, 12. For the roll of members and affiliated artists, and financial accounts, see Picture Loan Society account ledger, Barwick/Duncan collection, file D2.F1.

53 "Alan Jarvis," in *Douglas Duncan: A Memorial Portrait*, 12. Alan and Stacey later moved out of the Picture Loan Society because the expanding business needed the space.

54 The quote is from H.G. (Rik) Kettle interviewed by Elspeth Chisholm, ECC, CD A1 2003-06-0045.

55 Duncan to Jarvis, 21 July 1937, AJC, box 16.

56 See Don Burry, "The Early Pioneers of the Camping Movement" and Kristopher Churchill, "Learning about Manhood: Gender Ideals and 'Manly' Camping," both in Bruce W. Hodgins and Bernadine Dodge, eds, *Using Wilderness: Essays on the Evolution of Youth Camping in Ontario* (Peterborough: Trent University, 1992). Sharon Wall, "Totem Poles, Teepees, and Token Traditions: 'Playing Indian' at Ontario Summer Camps, 1920–1955," 514–20.

57 See for instance "Camp Week," *Toronto Star*, 27 May 1933, unnumbered pages; and "It's Camp Week," *Toronto Star*, 29 May 1933, unnumbered pages.

58 Patrick Fitzgerald to the author, 3 March 2004.

59 Ibid.

60 Ibid.

61 Newman, "Is Jarvis Mis-Spending," 40. The script for a farce entitled *Quick Change*, which included parts for Jarvis and Allen, is found in AJC, box 41.

62 John T. Phair, *Health: A Handbook of Suggestions for Teachers in Elementary Schools*. The handbook was produced by the program on which Jarvis worked.

63 Patrick Fitzgerald to the author, 3 March 2004.

64 See for instance J.L. Granatstein, *The Ottawa Men: The Civil Service Mandarinate, 1935–1957*; and Doug Owram, *The Government Generation: Canadian Intellectuals and the State, 1900–1945*.

65 Anthony Kenny, "The Rhodes Trust and Its Administration," in Anthony Kenny, ed., *The History of the Rhodes Trust*, 1–14.

66 Lord Lothian to J.W. MacDonnell, 29 November 1935, Rhodes Scholarship Trust collection, microfilm A-621. All but two of the eighteen Ontario Rhodes Scholars selected between 1928 and 1936 hailed from the University of Toronto; Martin L. Friedland, *The University of Toronto: A History*, 317.

67 M.W. Wallace, "Report of the Principal of University College," *University of Toronto: President's Report for the Year Ending 30th June 1936*, 28.

68 "Rhodes Deadline Set for Nov. 10," *Varsity*, 4 November 1937, 1.

69 The "pro forma testimonial" is from from H.S. Cody to the Rhodes Scholarship Committee, 2 November 1937. The other quotes are from Jarvis to the Rhodes Scholarship Committee, 10 November 1937, UCA. See also Erskine W. Ireland to Jarvis, 11 November 1937, AJC, box 18.

70 List of essay questions for Rhodes Scholarships, Ontario, 1930, Rhodes Scholarship Trust collection, microfilm A-621.

71 George Brett to Erskine W. Ireland, undated, UCA.

72 Reid MacCallum to Ireland, 13 November 1937, UCA.

73 J.W. Alford to Ireland, 8 November 1937, UCA.

74 John Phair to Ireland, 13 November 1937, UCA.

75 George Carruthers to Ireland, 16 November 1937, UCA.

76 Charles Devlin to Ireland, 29 November 1937, UCA.

77 J.R. Gilley, "Report of the Acting Warden of Hart House," *University of Toronto: President's Report for the Year Ending 30th June 1935*, 122.

78 The interview is described as the key phase of the selection process by Douglas McCalla in "The Rhodes Scholarships in Canada and Newfoundland," in Anthony Kenny, ed., *History of the Rhodes Trust*, 214–15. For the structure and dates of Jarvis' selection, see Peter Oliver, *G. Howard Ferguson: Ontario Tory*, 31–2, 231–42; Jarvis to his parents, 31 October 1946, AJC, box 11; Erskine W. Ireland to Jarvis, 11, 23, 29 November and 6 December 1937, AJC, box 18. For what Jarvis said in his interview, see Kendrick Venables interviewed by Elspeth Chisholm, ECC, CD A1

2003-07-0015; Jarvis to his parents, 5 January 1946, AJC, box 11. The quotes are from Mavor Moore interviewed by the author, July 2004.

79 Erskine W. Ireland to Jarvis, 13 December 1937, AJC, box 18.

80 Kenny, "Rhodes Trust," 34–5.

81 C.K. Allen to Jarvis, 5 February 1938, AJC, box 18.

82 George Brett to Edgar Carritt, 27 December 1937, UCA.

83 Harold M. Gully to Jarvis, 13 December 1937, AJC, box 18.

84 Helen to Jarvis, 14 December 1937, AJC, box 18.

85 "Loving Mother" to Jarvis, Christmas 1937, AJC, box 1.

86 Milne to Alice Massey, 25 January 1938, NGA, file 7.1M.

87 "Rhodes Banquet to Honour Jarvis," *Varsity*, 23 February 1938, 1.

88 "Rhodes Scholar Honoured at Banquet," *Varsity*, 1 March 1938, 1.

89 Anecdotes about Alan Jarvis, ECC, CD A1 2003-06-0042.

90 "Sanderson Distinguishes between Study Methods," *Varsity*, 18 January 1938, 1.

91 John C. Dent, "House Debate Attended by Outstanding Visitors," *Varsity*, 19 January 1938, 1, 4.

92 *Dramatis Personae: An Exhibition of Amateur Theatre at the University of Toronto, 1879–1939*, 15. Jarvis worked alongside George Johnston, a friend from the Hart House Sketch Room and Alan Armstrong, who had acted with Colin Jarvis. A poster for the play is found in AJC, box 14. Alan Armstrong interviewed by Elspeth Chisholm, ECC, CD A1 2003-06-0042. Photographs of the play are found in *Torontonensis, 1938*, 241. For the discovery of Wayne and Shuster, see Johnny Wayne interviewed by Elspeth Chisholm, ECC, CD A1 2003-07-0020, and Alison Ignatieff interviewed by Elspeth Chisholm, ECC, CD A1 2003-06-0044.

93 Tom Daly, "Hart House Gallery," *Varsity*, 1 March 1938, 4; Milne to Alice Massey, 11 February 1938, NGA, file 7.1M.

94 Milne to Carl Schaefer, 16 February 1938, Carl Schaefer collection, box 8.

95 For the quote, see Milne to Alice Massey, 24 May 1938, Massey family collection. For the plan to visit Europe, see "Rhodes Scholar Jarvis to Enter Oxford," *Varsity*, 7 January 1938, 1.

96 Transcript of an interview between Blodwen Davies and William and Nan Angus (the couple who ran the general store at Big Chute, Ontario), 4 August 1963, David Milne collection, vol. 9.

97 "Plan Youth Congress," *Globe and Mail*, 14 January 1938, 5.

98 "Third Canadian Youth Congress in Line with Organized Labor's Policies on Many Problems," *Canadian Congress Journal*, June 1938, 17–18, quote on 18.

99 Transcript of "Youth and Art in Canada," AJC, box 14, 2.

100 Ibid., 7.

101 Ibid., 7, 8.

102 "Kin of Professors Win Many Honours – Special Acclaim for Alan Jarvis and Young 'Einstein,'" *Toronto Star*, 11 June 1938, 27. Young Einstein was Irving Kaplansky, who went on to a distinguished academic career in the United States.

103 Douglas to Frances Duncan, 10 June 1927, Barwick/Duncan collection, file H2.F4.

104 Schaefer to Milne, 5 October 1938, Carl Schaefer collection, box 8.

CHAPTER FOUR

The quote in the chapter title is from Jarvis to his parents, 7 September 1938, AJC, box 17.

1 Jarvis to his parents, undated, AJC, box 11.

2 Jarvis to his mother, 27 June 1938, AJC, box 11.

3 "Alan's Diary of a Trip on the *Ile de France*, June 22 1938," AJC, box 16, 1.

4 Ibid., 1.

5 Ibid., 1, 3.

6 Jarvis to his parents, 27 June 1938, AJC, box 11. The map is in AJC, box 16.

7 For American Express, see Jarvis to his parents, 31 August 1938. Also Jarvis to his parents 20, 24, and 28 July, 17, 20, and 21 August 1938, AJC, box 17.

8 "Alan's Diary of Trip on the *Ile de France*," 3.

9 For croissants, see Jarvis to his parents, 7 July 1938; for French food and cheeses, see Jarvis to his parents, 18 July 1938, both AJC, box 17.

10 Jarvis to his parents, 7 July 1938, AJC, box 11. See also Duncan to Jarvis, 6 October 1938, AJC, box 16.

11 Frances Barwick to her parents, 5 August 1938, Barwick/Duncan collection, file H3.F16. Jarvis to his parents, 16 and 20 July 1938, AJC, box 17.

12 Barwick, "To Alan – Norman – Robert," undated, Barwick/Duncan collection, file D3.F5; Kurt Wagensiel to Frances Barwick, 19 October 1968, NGA, file D3.F6.

13 Jarvis to his parents, 7 August 1938, AJC, box 17. Kurt Wagensiel to Frances Barwick, 28 January 1969, Barwick/Duncan collection, file D3.F6.

14 Jarvis to his parents, 12 August 1938, AJC, box 17.

15 Jarvis to his parents, 7 September 1938, AJC, box 17.

16 Jarvis to his parents, 27 September 1938, AJC, box 11. Duncan's photographs are in the Barwick/Duncan collection, box 11a.

17 Duncan to Jarvis, 6 October 1938, AJC, box 16.

18 Jarvis to his parents, 25 November 1938, AJC, box 11.

19 Gordon Robertson interviewed by the author, October 2001. The sailing dinner is from James Gibson interviewed by the author, June 2003. For a more genral view of the attitude of Canadian students to Oxford during this period, see C.P. Champion, "Mike Pearson at Oxford: War, Varsity and Canadianism."

20 Jarvis to his parents, undated letter beginning "Dad's grand letter," AJC, box 11.

21 Noel Annan, *Our Age: English Intellectuals between the World Wars, A Group Portrait*, 117–18.

22 Alan Jarvis, "The Things We See: Oxford Revisited," *Ottawa Journal*, 10 December 1960, 39.

23 Ralph Glasser, *Gorbals Boy at Oxford*, 81–5.

24 Untitled, *The Oxford Magazine*, 20 October 1938, 63.

25 Jarvis to his parents, 2 October 1938, AJC, box 11. Jarvis was lodged in room 6 on staircase XI.

26 Jarvis to his parents, 11 November 1938, AJC, box 11.

27 Jarvis to his parents, 2 October 1938; and undated letter beginning "Thursday evening," both AJC, box 11.

28 Jarvis to his parents, 2 October 1938, AJC, box 11.

29 Jarvis to his parents, "Thursday Evening," October 1938, AJC, box 11.

30 Jarvis to his parents, 2 October 1938, AJC, box 11.

31 Jarvis to his parents, 21 October 1938, AJC, box 11.

32 Jarvis to his father, 27 January 1939, AJC, box 11. Ashmolean Museum to Jarvis, 12 October 1938; and Martlets' program for 1938–1939, both AJC, box 18.

33 For the Queen, see Jarvis to his parents, 25 November 1938; for Reith, see Jarvis to his parents, 21 April 1939, both AJC, box 11. Also Dorothy Allen, *Sunlight and Shadow*, 51–6.

34 Jarvis to his parents, undated letter, "Thursday evening," AJC, box 11.

35 Edgar Carritt, "Confidential Report on Rhodes Scholar," Michaelmas Term, 1938, UCA.

36 Jarvis to his parents, 25 November 1938, AJC, box 11.

37 Jarvis to his parents, 11 October 1938, AJC, box 11.

38 Jarvis to his parents, 21 October 1938, AJC, box 11.

39 Jarvis to his parents, 11 October 1938, AJC, box 11.

40 Jarvis to his parents, 11 November 1938, AJC, box 11.

41 Jarvis to his parents, 8 November 1938, AJC, box 11.

42 Jarvis to his parents, 15 January 1939, AJC, box 11.

43 For milk and brown bread, see Jarvis to his parents, 21 October 1938; for smoking, see Jarvis to his parents, undated letter beginning "Dad's grand letter," both AJC, box 11.

44 Arthur M. Schlesinger Jr., *A Life in the Twentieth Century: Innocent Beginnings, 1917–1950*, 207.

45 Jarvis to his parents, undated letter beginning "Dad's grand letter," AJC, box 11. Jarvis attended this debate as the guest of Denis Healey, a member of Balliol College who would go on to be a Labour chancellor of the Exchequer.

46 Jarvis to his parents, 25 November 1938, AJC, box 11.

47 Frances Barwick to her parents, 10 January 1938, Barwick-Duncan collection, file H3.F17.

48 Jarvis to his mother, 4 January 1939, AJC, box 11.

49 Frances Barwick to her parents, 10 January 1938, Barwick-Duncan collection, file H3.F17.

50 Jarvis to his parents, 15 January 1939, AJC, box 11.

51 Jarvis to his parents, 27 January and 17 February 1939, AJC, box 11.

52 Alan Lascelles, *King's Counsellor, Abdication and War: The Diaries of Sir Alan Lascelles*, 101.

53 Jarvis to his parents, 17 February 1939, AJC, box 11.

54 Jarvis to his parents, 25 March 1939, AJC, box 11.

55 Edgar Carritt, "Confidential Report on Rhodes Scholar," Trinity Term 1938, UCA.

56 Jarvis to his parents, 3, 30 March, and 13 April 1939, AJC, box 11.

57 See British Newspaper Library reader's ticket for March 1939, AJC, box 18; Jarvis to his parents, 16 May 1939, AJC, box 11.

58 The quote is from Edgar Carritt, "Confidential Report on Rhodes Scholar," Hilary Term 1938, UCA. See also Jarvis to his parents, 30 May 1939, AJC, box 11.

59 Oxford University to Jarvis, 16 June 1939, AJC, box 18.

60 Graham McInnes, *Finding a Father*, 216–19.

61 Ian Montaignes, *Uncommon Fellowship: The Story of Hart House*, 60. McInnes' mother was the novelist Angela Thirkell.

62 Jarvis to his parents, 11 October 1938, AJC, box 11; J.B. Bickersteth to Jarvis, 21 September 1938, AJC, box 18. See also Sir Michael Sadler's diary for 12 October 1938, Sadler collection.

63 Sir Michael Sadler to Jarvis, 17 October 1938, and Christmas card from the Sadlers, both AJC, box 12. The fine is mentioned in Jarvis to his father, 27 January 1939, AJC, box 11.

64 Annan, *Our Age*, 101–3.

65 Jarvis to his parents, 11 November 1938, AJC, box 11. For their sexual relationship, see Duncan to Jarvis, "Green Wednesday" (likely early autumn 1939), AJC, box 16.

66 Patrick Leigh Fermor, "Roger Hinks: A Portrait Memoir," in John Goldsmith, ed., *The Gymnasium of the Mind: The Journals of Roger Hinks, 1933–1963*, ix–xv.

67 Ibid., xi.

68 Hinks to Jarvis, undated, AJC, box 1.

69 Hinks to Jarvis, 2 January, 2 February, 6, 27, 29 April, 4 May, 5, and 11 June 1939, AJC, box 1.

70 The dancer's letters to Jarvis were dated 16, 28 February, 2, 28 March, 8 April, 6 May, 8, 30 June, 9, 13, 17, 31 July, and 8 August 1939, AJC, box 1.

71 Hinks to Jarvis, 11 June 1939, AJC box 1. The Club Liegois was a notorious Paris gay club. Spahis were members of the French army's North African cavalry regiments.

72 Norman Hay interviewed by Robert Fulford, 6 May 1981, Fulford collection, accession 30-1992, box 13.

73 Jarvis to his parents, 21 April 1939, AJC, box 11; Peter Cox, *The Arts at Dartington, 1940–1983*, 10.

74 Michael Young, *The Elmhirsts of Dartington: The Creation of an Utopian Community*, 100.

75 Ibid. For the school's growth, see 131–55; for the prominent supporters who sent their children to Dartington, see 172–4.

76 Annan, *Our Age*, 49.

77 Young, *Elmhirsts*, 98.

78 Jarvis to his parents, 27 June 1939, AJC, box 11.

79 Young, *Elmhirsts*, 162–4.

80 Cox, *Arts at Dartington*, 17.

81 Jarvis to his parents, 2 June 1939, AJC, box 11.

82 Christopher Martin to Jarvis, 29 March 1940, AJC, box 11.

83 Cox, *Arts at Dartington*, 17; and Peter Cox to the author, 25 August 2005. Jimmy Knapp-Fisher, whom Jarvis referred to as "Jimmy Knapp-Fishpaste," was, by coincidence, a friend of Douglas Duncan's former lover Kurt Wagensiel.

84 Cox, *Arts at Dartington*, 10–19; and Peter Cox to the author, 25 August 2005.

85 Hi to Jarvis, undated (likely April) 1940, AJC, box 11.

86 Young, *Elmhirsts*, 209.

87 Jarvis to his parents, 13 and 23 June 1939, AJC, box 11.

88 Jarvis to his parents, 30 June 1939, AJC, box 11.

89 Duncan to Jarvis, undated, AJC, box 16.

90 Jarvis' account is in Jarvis to his parents, 19 June 1939, AJC, box 11. For Honoria Murphy's account of the events, see Honoria Murphy Donnelly and Richard N. Billings, *Sara and Gerald: Villa America and After*, 199.

91 As quoted in Amanda Vaill, *Everybody Was So Young: Gerald and Sara Murphy: A Lost Generation Love Story*, 294.

92 Jarvis to his parents, 23 and 30 June 1939, AJC, box 11.

93 Jarvis to his parents, 11 and 18 August 1939, AJC, box 11.

94 Oswald Schwarz, *The Psychology of Sex*, 45–8.

95 Jarvis confessed his exhaustion in Jarvis to Fanny Myers, 2 May 1940, EFB.

96 Jarvis' diary for 1939, AJC, box 16. "Betty" referred to Betty Devlin, Jarvis' childhood sweetheart. "Pat" was Pat Fitzgerald, a friend from Camp Glenokawa. "Lloyd" was Lloyd Bowers.

97 Oswald Schwarz to Jarvis, undated letter (almost certainly September 1939), AJC, box 12.

98 Duncan to Jarvis, 1 June 1939, AJC, box 16. The "explorer" mentioned in this letter is likely the same person with whom Jarvis had the seaside rendezvous.

99 Duncan to Jarvis, undated letters, AJC, box 16.

100 Duncan to Jarvis, undated letter headed "Friday Noon," AJC, box 16.

101 Jarvis to his parents, 22 August 1939, AJC, box 11.

102 Fourteen of the twenty-one Canadian and Newfoundland scholars already at Oxford elected to stay for the academic year. The philosopher George Grant was one of the four who arrived in Oxford for the first time that autumn. Douglas McCalla, "The Rhodes Scholarships in Canada and Newfoundland," in Anthony Kenny, ed., *The History of the Rhodes Trust 1902–1999*, 229. Southam, who was not a Rhodes Scholar, remained at Oxford for a short time before joining the British Army. G. Hamilton Southam interviewed by the author, November 2002.

103 C.K. Allan to Jarvis, 1 September 1939; and Roland Michener to Jarvis, 27 October 1939, both AJC, box 18.

104 Jarvis to his parents, 8 September 1939, AJC, box 11; Jarvis never filled out the civil service application form, AJC, box 18.

105 For the decision to visit the World's Fair, see Jarvis to his parents, 19 September 1939, AJC, box 11. See also Duncan to Jarvis, 1 June 1939, AJC, box 16.

The quote in the chapter title is from Jarvis to his parents, 28 April 1942, AJC, box 11.

1 Stanley Cameron interviewed by Elspeth Chisholm, ECC, CD A1 2003-07-0016. Jarvis entrusted this correspondence to Cameron in the late 1960s on condition that the letters be excluded from his bequest to the University of Toronto. The letters have since vanished, though Cameron read several excerpts into Chisholm's tape recorder. The photos and letter that were found at the University of Toronto Library are now in NGA, file 9.9J.

2 Amanda Vaill, *Everybody Was So Young: Gerald and Sara Murphy, a Lost Generation Love Story*, 313–14.

3 Brendan Gill, *A New York Life: Of Friends and Others*, 324.

4 Vaill, *Everybody*, 357–8.

5 Calvin Tomkins, *Living Well Is the Best Revenge*.

6 Vaill, *Everybody*, 257.

7 Honoria Murphy Donaldson with Richard N. Billings, *Sara and Gerald: Villa America and After*, 200.

8 Vaill, *Everybody*, 314.

9 Ibid.

10 Hi to Jarvis, 4, 14, 21, 30 January, and 19 February 1940, AJC, box 12.

11 Christopher Martin to Jarvis, 26 March 1940, and Hi to Jarvis, 19 February 1940, AJC, box 12.

12 Martin to Jarvis, 21 June, 5, 12, and 16 July 1940, AJC, box 1.

13 Duncan to McCurry, 1 January 1940, NGA, file 5.4W.

14 See for instance Duncan to Jarvis, 2 February 1939, AJC, box 16.

15 David P. Silcox, *Painting Place: The Life and Work of David B. Milne*, 294–5. The account includes a photograph of Jarvis, clad in black and wearing his customary beret, placing canvases on the fire. Jarvis had related this story, hoping, disingenuously, that Silcox would not publish it. David Silcox interviewed by the author, 30 June 2003.

16 Jarvis to Fanny Myers, undated but likely autumn 1939, EFB.

17 William Robert Young, *Making the Truth Graphic: The Canadian Government's Home Front Information Structure and Programmes During World War II*, 7–17.

18 Young, *Making the Truth*, 27–9.

19 Jarvis to McCurry, 27 November 1939, NGA, file 5.4w.

20 Donald W. Buchanan, *James Wilson Morrice: a Biography*; Graham McInnes, *A Short History of Canadian Art*. McInnes related an anecdote about how he and Buchanan first met while at the Gallery in his memoirs *Finding a Father*, 166. For an insightful analysis of the Carnegie Corporation's decision to fund the arts in Canada and to use the National Gallery as the instrument through which this funding would be dispersed, see Jeffrey Brison, *Rockefeller, Carnegie and Canada: American Philanthropy and the Arts and Letters in Canada*.

21 Duncan McCalla, "The Rhodes Scholarship in Canada and Newfoundland," in Anthony Kenny, ed., *The History of the Rhodes Trust, 1902–1999*, 226.

22 Alan Jarvis, "Elizabeth Wyn Wood," AJC, box 41, and Jarvis to Fanny Myers, 19 February 1940, EFB.

23 Jarvis to McCurry, 21 January 1940, NGA, file 5.4w.

24 McCurry to Jarvis, 23 January 1940, NGA, file 5.4w.

25 The Canadian Association of Adult Education and Legion War Service program was officially endorsed on 27 January 1940. See "The Educational Programme of the Canadian Army Overseas, 1940–41," LAC, RG24, vol. 6917, file 53.

26 Jarvis to McCurry, 30 January 1940, NGA, file 5.4w.

27 Hi to Jarvis, 30 January 1940, and Roger Hinks to Jarvis, 18 February 1940, AJC, box 11.

28 Jarvis to McCurry, 10 February 1940, NGA, file 5.4W.

29 McCurry to Jarvis, 13 February 1940, NGA, file 5.4W.

30 Jarvis to Fanny Myers, 2 May 1940, EFB.

31 Jarvis to Fanny Myers, 19 February and 6 June 1940, EFB.

32 Peter Stansky and William Abrahams, *London's Burning: Life, Death and Art in the Second World War*, 17, 89–90; and Bevis Hillier, *John Betjeman: New Fame, New Love*, 158.

33 Kenneth Clark, *The Other Half: A Self Portrait*, 31–2.

34 Hi to Jarvis, 19 February 1940, AJC, box 1; Meryle Secrest, *Kenneth Clark: A Biography*, 132.

35 Jarvis to his parents, 28 April 1942, AJC, box 11.

36 Jarvis to Fanny Myers, 15 March 1940, EFB.

37 The quote is from Jarvis to Fanny Myers, March 1940. See also Jarvis to Myers, 29 February and 15 April 1940, EFB.

38 Jarvis to Myers, 24 May and 26 June 1940, EFB.

39 Jarvis to Fanny Myers, 26 June 1940, EFB.

40 The quote is from Christopher and Cecily Martin to Jarvis, 21 June 1940, AJC, box 1. See also Christopher Martin to Jarvis, 5, 12, and 16 July 1940, AJC, box 1.

41 Janet Bee to Jarvis, 2 July 1946, AJC, box 55.

42 Betty (Devlin) Jarvis interviewed by the author, 4 June 2003.

43 An extract of this letter was read in Stanley Cameron interviewed by Elspeth Chisholm, ECC, CD A1 2003-07-0016.

44 Stanley Cameron interviewed by Elspeth Chisholm. The introduction to MacLeish is found in Gerald Murphy to MacLeish, 10 May 1940, AJC, box 12. Jarvis mentioned his agent in Jarvis to Fanny Myers, 15 March 1940, EFB.

45 Jarvis to Fanny Myers, 26 June 1940, EFB.

46 *War in Western Art*, five-page draft, AJC, box 13.

47 Ibid., miscellaneous notes, AJC, box 13.

48 Jarvis to Fanny Myers, 5 March 1940, EFB.

49 Ibid.

50 Vaill, *Everybody*, 314–15.

51 Jarvis to Fanny Myers, postmarked 6 June 1940, EFB.

52 Stanley Cameron interviewed by Elspeth Chisholm.

53 Vaill, *Everybody*, 314–15.

54 Jarvis to Fanny Myers, 26 June and letter postmarked 27 August 1940, EFB.

55 John Alford to Jarvis, 10 September 1940, AJC, box 1. The meaning of "WFA" remains obscure.

56 Anecdotes about Alan Jarvis, ECC, CD A1 2003-06-0042.

57 Ben Yagoda, *About Town: The New Yorker and the World It Made*, 30–1. Also Barbara Moon interviewed by Elspeth Chisholm, ECC, CD A1 2003-07-0020.

58 Norman Hay to Fanny Myers, 25 September 1987, Myers collection, New York City. Also quoted in Vaill, *Everybody*, 315.

59 Fanny Myers, as quoted in Vaill, *Everybody*, 315. See also Jarvis to Fanny Myers, 30 August 1942, EFB.

60 Jarvis' NYU grades were told to the author by Jean Sutherland Boggs, December 2003; Alan Jarvis, "David Hume," thirty-page draft, 25 March 1941, AJC, 14.

61 Jarvis to his parents, 27 February 1944, AJC, box 11; and Alan Armstrong interviewed by Elspeth Chisholm, ECC, CD A1 2003-06-0042.

62 Alan Armstrong interviewed by Elspeth Chisholm. The quote is from Alice Armstrong in Anecdotes about Alan Jarvis, ECC, CD A1 2003-06-0042.

63 Reid MacCallum to Jarvis, 8 December 1940, AJC, box 12.

64 Jarvis to his parents, 5 April 1943, AJC, box 11.

65 Hi to Jarvis, April 1940, AJC, box 1.

66 Robert Calder, *Beware the British Serpent: The Role of Writers in British Propaganda in the United States, 1939-1945,* passim.

67 Nicholas John Cull, *Selling War: The British Propaganda Campaign Against American "Neutrality" in World War II,* 97–137.

68 Cull, *Selling War,* 127.

69 Kendrick Venables interviewed by Elspeth Chisholm, ECC, CD A1 2003-07-0015. For Jarvis' state of mind in the spring of 1941, see Vaill, *Everybody,* 315–16.

70 Norman Hay, as quoted in Vaill, *Everybody,* 316.

71 Jarvis' motivations were related in Alan Armstrong interviewed by Elspeth Chisholm, and Mary (Greey) Graham interviewed by the author, 18 February 2005. See also Bob Borley to Jarvis, 17 March 1941, AJC, box 1.

72 Roland Michener to Jarvis, 4 November 1941, AJC, box 1. Norman Hay speculates about medical reasons in Norman Hay interviewed by Elspeth Chisholm, ECC, CD A1 2003-06-0038.

73 Hi to Jarvis, undated letter beginning "Your letter, 7 October," (likely October or November 1941), AJC, box 11.

74 For the salary, see Hi to Jarvis, 6 September 1941, AJC, box 1. For Clark and Massey, see Jarvis to his parents, 20 March 1942, AJC, box 11.

75 Hi to Jarvis, October 1941; and for Curtis Brown, see Naomi Burton to Jarvis, 3 December 1941, both AJC, box 1.

76 Quotes are from Christopher Martin to Jarvis, 10 November 1941, AJC, box 12. Despite numerous references to Hots in Jarvis' archives, the author was unable to identify him conclusively. Hein Heckroth was a set and costume designer who worked in Dartington's theatre department. The exact meaning of "Oliverisms" remains obscure.

77 Jarvis to his parents, undated (certainly December 1941), AJC, box 11.

CHAPTER SIX

The quote in the chapter title is from Jarvis to his parents, 8 February 1942, AJC, box 11.

1 Roger Berthoud, *Graham Sutherland: A Biography,* 96.

2 Jarvis to his parents, 18 July 1945, AJC, box 11.

3 David Reynolds, *Rich Relations: The American Occupation of Britain, 1942–1945,* 146.

4 Winston S. Churchill, *The Second World War: The Gathering Storm*, 338.

5 Mark Benney, *Over to Bombers*, 177–93.

6 Jarvis to his parents, 8 February 1942, AJC, box 11.

7 Angus Calder, *The People's War: Britain 1939–45*, 444–54.

8 Jarvis to his parents, 21 August 1943, AJC, box 11.

9 Jarvis to his parents, 3 January 1942. "Hire and Fire em" is found in Jarvis to his parents, 14 April 1943, both AJC, box 11.

10 Jarvis to his parents, 10 January 1943(incorrectly dated 1942), 28 March 1942 and 27 March 1943, all AJC, box 11.

11 Jarvis to his parents, 8 February 1942, AJC, box 11.

12 For the education scheme, see Jarvis to his parents, 10 August 1942; for the Nuffield conference, see Jarvis to his parents, 27 June 1942; for the report on women workers, see Jarvis to his parents, 17 November 1942 and 27 March 1943, all AJC, box 11.

13 Jarvis to his parents, 28 February and 27 March 1943, both AJC, box 11.

14 Jarvis to the *Times*, 17 February 1943, AJC, box 9; Jarvis to his parents, 28 February 1943, AJC, box 11.

15 Jarvis to his parents, 8 April, 9, 21 May, 3 June, 25 August, 28 September, and 14 October 1942; 25 January and 1 February 1943, all AJC, box 11. Also Kenneth Clark, *The Other Half: A Self Portrait*, 32.

16 Patrick Fitzgerald to the author, 3 March 2004.

17 Advertisement, *Globe and Mail*, 9 April 1934, 511.

18 Israel Sieff, *Memoirs*, 164. Sieff was chairman of Marks and Spencer and one of PEP's staunchest supporters.

19 Hugh Massingham, "The Man Cripps," *Picture Post*, 10 May 1952, 25.

20 Paul Addison, *The Road to 1945: British Politics and the Second World War*, 190; Winston Churchill, *The Second World War: The Hinge of Fate*, 63–86, 554–60.

21 For the creation of the ABCA, see S.P. MacKenzie, *Politics and Military Morale: Current-Affairs Citizenship Education in the British Army, 1914–1950*, 85–117. For Bickersteth's role, see "The Educational Programme of the Canadian Army Overseas, 1940-41," LAC, RG24, vol. 6917, file 53. See also Lord Wigg, *George Wigg*, 88–95; and Alan Jarvis, "Education by Discussion," 30.

22 MacKenzie, *Politics*, 107–8, quote on 108.

23 Ibid., 126–8.

24 David Wiseman, "Informal Education," in N. Hans and J.A. Lauwerys eds, *The Yearbook of Education, 1948*, 109–16.

25 Jarvis to his parents, 28 April, 10 November, 6, and 14 December 1942, AJC, box 11.

26 Jarvis to his parents, 7 January 1943; for broadcasting, see Jarvis to his parents, 26 December 1942; for Cripps and PEP, see Jarvis to his parents, 10 January 1943(incorrectly dated 1942), all AJC, box 11.

27 Alan Jarvis, as quoted in Eric Estorick, *Stafford Cripps: Master Statesman*, 292.

28 Jarvis, "Education by Discussion," 32.

29 Alan Jarvis, Amabel Williams-Ellis, and Michael Young, *An Experiment with Discussion Groups in War Factories July and August 1943*, AJC, box 20. J. Arthur Rank to Jarvis, 11 February 1946, and Samuel Courtauld to Jarvis, 21 March 1945, AJC, box 1. For Murrow and Shirer, see Jarvis to his parents, 13 July 1943, AJC, box 11.

30 Amabel Williams-Ellis, *All Stracheys Are Cousins*, 161, 171. Clough Williams-Ellis built the fantasy town at Portmeirion on the north Welsh coast that was used as the setting of the 1960s television series *The Prisoner*. Amabel Williams-Ellis, *Women in War Factories*. Isobel Cripps wrote the introduction to this book.

31 Jarvis to his parents, 20 May, 1, 6 June, 2 and 4 July 1943, AJC, box 11.

32 Jarvis, Williams-Ellis, and Young, *An Experiment with Discussion Groups*.

33 See for instance Jarvis to his parents, 8 March 1942 and 5 April 1943, AJC, box 11.

34 Jarvis to his parents, 20 June 1943; for the quote, see Jarvis to his parents, 21 August 1943, both AJC, box 11.

35 Jarvis, "Education by Discussion," 33.

36 For "jam sessions," see Jarvis to his parents, 6 December 1942, AJC, box 11.

37 The quote is from Jarvis to his parents, 30 August 1943; while the distribution list is from Jarvis to his parents, 21 August 1943, both AJC, box 11.

38 Honor Balfour, "A New Idea in Industry: The Factory Discussion Group," *Picture Post*, 23 October 1943, 20–1.

39 Jarvis to his parents, 2 October 1943, AJC, box 11.

40 Jarvis to his parents, 5 December 1943, AJC, box 11. Graham Spry interviewed by Elspeth Chisholm, ECC, CD A1 2003-06-0038.

41 Jarvis to his parents, 26 December 1943, AJC, box 11.

42 Jarvis to his parents, 5 December 1943, AJC, box 11.

43 Jarvis to his parents, 8 December 1943, AJC, box 11.

44 Jarvis to his parents, 26 December 1943 and 2 May 1944, AJC, box 11.

45 Jarvis to Isobel Cripps, 16 June 1944, SCC, file SC26.

46 Jarvis to his parents, 15 June and 30 August 1944, AJC, box 11.

47 Jarvis' diary for 1945, 15 January 1945, 10, AJC, box 16.

48 Jarvis to his parents, 30 May 1944, AJC, box 11.

49 Kendrick Venables interviewed by Elspeth Chisholm, ECC, CD A1 2003-07-0015. Asdic, a precursor to modern sonar, was used to locate submerged submarines. For the timing of this visit, see Jarvis to his parents, 11 October 1944, AJC, box 11.

50 Venables interviewed by Elspeth Chisholm.

51 John Devlin interviewed by Robert Fulford, undated, Fulford collection, box 13, file F.22.

52 Jarvis to his parents, 13 October, 8, 14 November, 5 and 26 December 1943, AJC, box 11. The quote is from 14 November.

53 Anecdotes About Alan Jarvis, ECC, CD A1 2003-06-0042.

54 *Discussion Clubs in Factories*, IDCE pamphlet, AJC, box 20.

55 Ibid.

56 Jarvis to his parents, 25 January 1944, AJC, box 11. A list of delegates to the conference is found in AJC, box 20, file 7. For his private impressions, see Jarvis' diary for 1945, 15 January 1945, AJC, box 16.

57 Stafford Cripps to Jarvis, 15 March 1944, AJC, box 1.

58 Honor Balfour, "Jam Session on the Production Line," 52. This was a revised version of Balfour's earlier piece, "A New Idea in Industry."

59 Jarvis to his parents, 15 June 1944, AJC, box 11.

60 Drusilla Scott, *A.D. Lindsay: A Biography*, 260–75. Lindsay had directed army education in the First World War, after which he opened his college to students from wider social backgrounds, and worked with Kurt Hahn, the founder of Outward Bound. His volume on current affairs was *The British Way and Purpose*, London: Directorate of Army Education, 1944.

61 See for instance, Jarvis to his parents, 27 June 1942; 9, 26 July, 30 August, 27 September, 3 October, 7 December 1944; and 9 January 1945, all AJC, box 11. The quote is from Jarvis to his parents, 16 August 1944, AJC, box 11.

62 William Rootes to Isobel Cripps, 1 February 1944, SCC, file SC26.

63 Jarvis to Isobel Cripps, 16 June 1944, SCC, file SC26.

64 William Robertson, *Welfare in Trust: A History of the Carnegie United Kingdom Trust, 1913–1963*, 168.

65 Jarvis to Dorothy Elmhirst, 26 April 1945, Dartington Hall Trust Archive, file DWE/G/S2/D.

66 The quote is from Jarvis to Dorothy Elmhirst, 25 May 1945, Dartington Hall Trust Archive, file DWE/G/S2/D. The photograph appears in Eric Estorick, *Stafford Cripps: A Biography*, unnumbered pages.

67 Jarvis to his parents, 6 September 1942, AJC, box 11.

68 Jarvis to his parents, 1 January 1943, AJC, box 11.

69 The inscription is recalled in Jarvis to his parents, 15 April 1945, AJC, box 11. *The Holy Bible: Authorized King James Version*, London: Collins, 1937.

70 Jarvis to his parents, 1 October 1944, AJC, box 11.

71 Jarvis to his parents, 27 February 1944, AJC, box 11.

72 Jarvis to his parents, 3 October 1944, AJC, box 11.

73 Stockwood to Jarvis, 14 March 1945, AJC, box 1.

74 Stockwood, *Chanctonbury Ring: an Autobiography*, 33–45; for Comedy of Errors, see Stockwood to Jarvis, 18 February 1945, AJC, box 1. For being outed in late life, see Richard Harries, "The Great and the Fairly Tipsy," *The Times Higher Educational Supplement*, 2 August 2002.

75 Stockwood to Jarvis, 18 February 1945, AJC, box 1.

76 Michael De La Noy, *Mervyn Stockwood: A Lonely Life*, 44.

77 Ibid., 38.

78 Stockwood, *Chanctonbury Ring*, 42–4, quote on 43.

79 De La Noy, *Stockwood*, 33.

80 Adrian Hastings, *A History of English Christianity, 1920–1985*, 375–392.

81 De La Noy, *Stockwood*, 43.

82 The quote is from Jarvis to his parents, 26 May 1945, AJC, box 11. See also Jarvis' Labour Party membership, dated 16 June 1944, AJC, box 21.

83 All quotes come from Stockwood to Jarvis, 18 February 1945, AJC, box 1.

84 Stockwood to Jarvis, 18 February 1945, AJC, box 1.

85 Jarvis to Stockwood, 3 May 1945, AJC, box 21.

86 Jarvis to Stockwood, 19 May 1945, AJC, box 21. For "life denying" and "inflexibility," see Stockwood interviewed by Elspeth Chisholm, ECC, CD A1 2003-07-0016.

87 Jarvis to his parents, 15 May 1945, AJC, box 11.

88 For the sermon, see Stockwood to Jarvis, 12 April and 2 May 1945, AJC, box 1, and Jarvis to his parents, 15 April 1945, AJC, box 11. For the quote, see Stockwood to Jarvis, undated but almost certainly from this period, AJC, box 12.

89 Neville Gorton to Jarvis, 5 March 1945, AJC, box 1.

90 Jarvis to his parents, 9 March 1945, AJC, box 11.

91 Jarvis to his parents, 15 April 1945, AJC, box 11.

92 Jarvis to his parents, 15 April 1945, AJC, box 11.

93 Jarvis' diary for 1945, 22 January 1945, AJC, box 16.

94 Peggy (Cripps) Appiah to the author, 24 August 2003.

95 Jarvis' diary for 1945, 23 January 1945, AJC, box 16.

96 Isobel Cripps to Jarvis, 19 April 1945, AJC, box 21.

97 For the euphemisms, see Norman Hay to Robert Fulford, 30 March 1981, Fulford collection, box 13, file F.22. Morocco was a well-known gay holiday destination. For David Webster, see "The Letters of John Gielgud," unsigned review, *The Economist*, 10 April 2004, 79.

98 Jarvis' diary for 1945, 18 January 1945, AJC, box 16.

99 Jarvis to his parents, 17 August 1942 and 13 October 1943, AJC, box 11.

100 Jarvis to Fanny Myers, 26 December 1943 and 8 May 1944, EFB.

101 Jarvis to his parents, 15 February 1944, AJC, box 11.

102 Jarvis to his parents, 27 February 1944, AJC, box 11.

103 Linda Fitzgerald to the author, 6 March 2004.

104 Jarvis to his parents, 20 March 1944, AJC, box 11.

105 The photograph is in AJC, box 57.

106 Jarvis to his parents, 22 October 1944, AJC, box 11.

107 Jarvis' diary for 1945, AJC, box 16. The first quote is from the entry dated 1 January 1945; the other two are from undated entries.

108 Jarvis to his parents, 9 April 1945, AJC, box 11.

109 Stockwood to Jarvis, 14 March 1945, AJC, box 1.

110 Stockwood to Jarvis, 16 March 1945, AJC, box 1.

CHAPTER SEVEN

The quote from the chapter title is from a sermon given by Jarvis at St Matthew Moorfields, 29 April 1945, AJC, box 21.

1 Michael Young, *Let Us Face the Future: A Declaration of Labour Policy for the Consideration of the Nation*, London, 1945.

2 Kenneth O. Morgan, *Labour in Power: 1945–1950*, 362–3.

3 Ibid., 363–4.

4 Jean Stewart Gunn interviewed by Elspeth Chisholm, ECC, CD A1 2003-07-0020.

5 Jarvis to his parents, 8 July 1945, AJC, box 11.

6 Jarvis to his parents, 1 September, 30 October, 6 and 11 November 1945, AJC, box 11.

7 Jarvis to his mother, 5 January 1946, AJC, box 11.

8 Jarvis to his parents, 4 November 1945, AJC, box 11.

9 Jarvis' diary for 1945, AJC, box 16.

10 Stockwood to Jarvis, 11 April 1945, AJC, box 1.

11 Mervyn Stockwood interviewed by Elspeth Chisholm, ECC, CD A1-2003-07-0016.

12 See for instance Robert McKinstry to Jarvis, 6 May 1945, AJC, box 1. For details about Jarvis and Webster, see Jarvis to his parents, 1 June 1947, AJC, box 11.

13 Diana Collins, *Partners in Protest: Life with Canon Collins*, 91–2, quote on 91.

14 Ibid., 112–23.

15 Isobel Cripps to Jarvis, 19 April 1945, LAC, box 21. Also Collins, *Partners*, 136–7.

16 For the assessment of Bell, see Adrian Hastings, *A History of English Christianity, 1920–1985*, 399.

17 The list of those who were considered for appointment to the committee is found in an undated, handwritten list, Lewis John Collins collection, vol. 3288, document 221. Lord Hambleden was the heir to the bookseller W.H. Smith.

18 For the group members taking it as a given that the Church needed reform, see Lewis John Collins, *Faith Under Fire*, 102.

19 "Synopsis of 13 September," Lewis John Collins collection, vol. 3288, document 267.

20 Lewis John Collins, "The Need for Reformation of the Church of England: A Memorandum of Agreed Views on Basic Minimum Principles of Reformation and on Primary Tasks and Policy to Execute Them," 26 October 1945, Lewis John Collins collection, vol. 3288, document 328.

21 Michael De La Noy, *Mervyn Stockwood: A Lonely Life*, 54. For the longer quote, see Collins, *Faith*, 102. After retreating to Oxford to lick his wounds, Collins channelled the impulses that lay behind this group into Christian Action, the Committee for Nuclear Disarmament, and some of the earliest protests against apartheid.

22 Patrick J. Maguire, "Introduction," in Patrick J. Maguire and Jonathan M. Woodham, eds, *Design and Cultural Politics in Postwar Britain*, 8–11. The roles played by individual politicians, civil servants, and arts figures in the creation of the Council are detailed in Lesley Whitworth, "Inscribing Design on the Nation: The Creators of the British Council of Industrial Design," 1–14.

23 See for instance "To the President of the Board of Education and Trade," 27 January 1943, and "Proposals for a Central Design Council and Industrial Design Centres," 27 January 1943, DCA, file 4. Also Jonathan M. Woodham, "Design Promotion: 1946 and After," in Penny Sparke, ed., *Did Britain Make It?: British Design in Context, 1946–1986*, 23.

24 Barlow to Sir Kenneth Clark, as quoted in Jonathan M. Woodham, "Managing British Design Reform I: Fresh Perspectives on the Early Years of the Council of Industrial Design," 56.

25 *Annual Report of the Council of Industrial Design, 1945–46*, 6.

26 Extract from *Hansard* for 19 December 1944, NAUK, file BT13/204; Alix Kilroy to Clement Leslie, 19 June 1945, NAUK, file BT64/3647; Woodham, "Managing British Design Reform I," 57.

27 Isobel Cripps to Jarvis, 11 July and 9 August 1945, AJC, box 21. For the two-year commitment, see Jarvis to his mother, 17 May 1947, AJC, box 11.

28 Jarvis to his parents, 16 April 1947, AJC, box 11.

29 Sir Stafford Cripps, *Democracy Alive: A Selection from Recent Speeches*, with an introduction by Alan Jarvis.

30 Clement Leslie to Alix Kilroy, 9 November 1944, NAUK, file BT64/3647.

31 Jarvis to his parents, 11 September 1945, AJC, box 11.

32 Jarvis to his parents, 15 December 1945, 27 April 1946, 26 January and 16 June 1947, AJC, box 11.

33 "Suggestions for the Formation of Design Centres," 15 January 1945, DCA, file DC1.

34 Clement Leslie to Jarvis, 9 September 1945, AJC, box 1.

35 *Annual Report of the Council of Industrial Design, 1945–46*, 7–8.

36 Patrick J. Maguire, "Patriotism, Politics and Production," in Maguire and Woodham, *Design and Cultural Politics*, 29.

37 "The British Exhibition of 1946," 22 August 1945, DCA, file ID 312.

38 Gordon Russell, undated memo, DCA, file ID 312. The other dissenter was Francis Meynell.

39 Sir Stafford Cripps to Leslie, 10 August 1945, DCA, file ID 312.

40 Press Release, 3 October 1945, DCA, file ID 312.

41 "Brief Notes on Organisation," 6 September 1945, DCA, file ID 312; also Board of Trade Circular, 31 May 1946, NAUK, file BT13/204.

42 Untitled memorandum, 17 October 1945, DCA, file ID 312.

43 Minutes of the Council of Industrial Design, 25 October 1945, DCA, file 361.

44 J. Wilkie to Jarvis, 5 February 1946, AJC, box 1.

45 Jarvis to his parents, 26 January 1946, AJC, box 11.

46 Jarvis to his parents, 8 December 1945, AJC, box 11.

47 Jarvis to his parents, 3 March 1946, AJC, box 11.

48 Untitled memo, 22 February 1947, NAUK, file BT64/2167; also Jarvis to his parents, 3 March 1946, AJC, box 11.

49 *Annual Report of the Council of Industrial Design, 1945–46*, 20.

50 Jarvis to his parents, 3 March 1946; for the knighthood, see Jarvis to his parents, 3 April 1946, both AJC, box 11.

51 Jean (Stewart) Gunn interviewed by Elspeth Chisholm.

52 Paul Reilly, *An Eye on Design: An Autobiography*, 62.

53 "Minutes of the Public Relations Committee," 24 July 1946, DCA, file 189.

54 For the edited series, see Jarvis to his mother, 5 January, 9 and 16 October 1946, AJC, box 11. Also Penguin to Jarvis, 13 March 1946, AJC, box 1. Alan Jarvis, *The Things We See I: Inside and Out*.

55 Alan Jarvis, *Things We See*. "D.M.D." refers to Douglas M. Duncan. The quote about the Englishman's home is on 16.

56 "Design in a New Democracy," 20 July 1946, AJC, box 24.

57 The quotes are from "Radio Theatre," 19–20; "Foreground, Background or Middle Distance?," 43–4; "Productions for Production," 67–8; "Raising Public Taste," 90–1.

58 Robert Waller to Jarvis, 27 August 1946, BBCWA.

59 Reilly, *Eye on Design*, 62.

60 All three quotes are from Amanda Vaill, *Everybody Was So Young: Gerald and Sara Murphy, A Lost Generation Love Story*, 321.

61 Jarvis to his parents, 27 April 1946, AJC, box 11.

62 Jarvis to his parents, 11 May 1946, AJC, box 11; and Donald Buchanan to James A. MacKinnon, 7 June 1946, AJC, box 1. For the show *Design in Industry*, see *The National Gallery of Canada, Annual Report, 1946–1947*, 4–5.

63 Jarvis to his parents, 25 August 1946, AJC, box 11.

64 Mary Alexander, "British Product Design 1946–86: The Changing Relationship between Designer and Manufacturer – a Personal View," in Sparke, *Did Britain Make It?*, 97.

65 For the Design Quiz, see "Minutes of the Public Relations Committee," 24 July 1946, DCA, file 189.

66 James Gardner, *The Artful Designer*, 134.

67 Woodham, "Design Promotion," 25.

68 Mass Observation interim report, undated, DCA, file 903.

69 For the Council's fitful attention to film, see Johnathan Woodham, "Managing British Design Reform II: The film *Deadly Lampshade* – an Ill-fated Episode in the Politics of 'Good Taste,'" 102.

70 "Council Films," undated (likely June 1948), DCA, file 750/1.

71 For Potter's connections to the Council, see Woodham, "Managing Design II," note 13. For Grenfell, see Jean Stewart Gunn interviewed by Elspeth Chisholm.

72 Humphrey Carpenter, *The Envy of the World: Fifty Years of The BBC Third Programme and Radio 3*, 27–9; and Joyce Grenfell, *In Pleasant Places*, 118.

73 *Designing Women*, c. 1947, DCA.

74 As quoted in Woodham, "Managing Design II," 103.

75 Woodham, "Managing Design II," 103–4.

76 For human stories, see Jarvis to Clement Leslie, 27 February 1947, DCA, file 750.

77 Jarvis to Leslie, 1 April 1947, DCA, file 750.

78 Leslie to Jarvis, 31 May 1947, DCA, file 750.

79 For the total annual budget, see Woodham, "Managing Design II," 101.

80 "Minutes of a Meeting to Discuss the Film," 18 September 1947, DCA, file 750/1. Also *Deadly Lampshade*, 1947, DCA.

81 Woodham, "Managing Design II," 111–14. Also Woodham, "Managing Design I," 60. The title of the abbreviated version suggests it was conceived of as the first film in a series.

82 Jarvis to his parents, 3, 8, 17 May, and 26 June 1947, AJC, box 11. The quote is from 26 June. For consulting about Leslie's replacement, see Confidential Minute, 15 July 1947, NAUK, file BT64/2167.

83 Jarvis to his parents, 24 October 1946, 28 May, 1, 2 and 26 June 1947, AJC, box 11. Also Jarvis to Sir Kenneth Clark, "Wednesday," Sir Kenneth Clark collection.

84 Jarvis to his mother, 13 August 1947, AJC, box 11.

CHAPTER EIGHT

The quote in the chapter title is from Jarvis to his mother, 2 September 1947, AJC, box 11.

1 Jarvis to his parents, 15 September 1946, AJC, box 11.

2 Mervyn Stockwood interviewed by Elspeth Chisholm, ECC, CD A1 2003-07-0016.

3 "An Artist in Wardour Street," AJC, box 23. This is a press release about Jarvis that was written in the spring of 1950.

4 For Stockwood, see Jarvis to his parents, 1 April 1947, 18 and 25 November 1948. For Hi, see Jarvis to his parents, 8, 17 May, 25 August 1947, and 7 October 1948, AJC, box 11.

5 Margaret Dickinson and Sarah Street, *Cinema and State: The Film Industry and the Government, 1927–84*, 5, 94.

6 Michael Balcon, "The British Film During the War," 72–3; and Robert Murphy, "Rank's Attempt on the American Market, 1944–9," 167–9.

7 Dickinson and Street, *Cinema and State*, 94; Geoffrey MacNab, *J. Arthur Rank and the British Film Industry*, 43–6; Murphy, "Rank's Attempt," 168–9; and "Films," undated memo, NAUK, BT64, file 4530.

8 Dickinson and Street, *Cinema and State*, 150.

9 William Shakespeare, *King Henry V*, 111.

10 Dickinson and Street, *Cinema and State*, 153.

11 Sir Stafford Cripps, "Films – Note by the President," 19 November 1945, NAUK, BT64, file 2188.

12 Vincent Porter, "All Change at Elstree: Warner Bros., ABPC and British Film Policy, 1945–1961," 9. The actual amount was £1.8 million.

13 Ian Jarvie, "British Trade Policy Versus Hollywood, 1947–1948: 'Food before Flicks?,'" 29.

14 Kenneth O. Morgan, *Labour in Power: 1945–1950*, 360–4. See also Jarvie, "British Trade Policy," 27.

15 MacNab, *J. Arthur Rank*, 173; Jarvie, "British Trade Policy," 19.

16 Jarvie, "British Trade," 33–8; and MacNab, *J. Arthur Rank*, 179–82.

17 George Perry, *The Great British Picture Show*, 112.

18 Del to Rank, 17 December 1943; and Hugh Gaitskell, untitled memo, 26 February 1944, both NAUK, BT64, file 4530.

19 Rank to Hugh Gaitskell, 18 July 1944, and Gaitskell to Rank, 26 July 1944, NAUK, BT64, file 4530. Also Charles Drazin, *The Finest Years: British Cinema of the 1940s*, 25.

20 Drazin, *Finest Years*, 26.

21 Fillipo Del Giudice, *Leader* magazine, 21 June 1947.

22 "The Divorce of Production from the Sales Organization," *Kinematograph Weekly*, 18 September 1947, 6.

23 For "talents," see "Divorce of Production," 6. For "butler" see, Kevin Brownlow, *David Lean: A Biography*, 152.

24 Peter Ustinov, *Dear Me*, 154.

25 Brownlow, *David Lean*, 152.

26 As quoted in Drazin, *Finest Years*, 24.

27 Drazin, *Finest Years*, 24.

28 Jarvis to his parents, 7 December 1946, AJC, box 11.

29 Jarvis to his parents, 26 January and 25 April 1947, AJC, box 11.

30 Murphy, "Rank's Attempt," 170. "Long Shots," *Kinematograph Weekly*, 17 April 1947, 4; "'Del' forms £100,000 Company," *Kinematograph Weekly*, 19 June 1947, 3. Also Jarvis to Fanny Myers, 1 June 1947, EFB.

31 "The Divorce of Production from the Sales Organisation," *Kinematograph Weekly*, 18 September 1947, 5. Laurence Olivier suggested that Del use the title "administrator." See Del to Sir Stafford Cripps, 18 August 1947, SCC.

32 Del to John and Roy Boulting, 6 November 1947, scc.

33 "Memorandum – Pilgrim Pictures," 5 September 1947, scc.

34 Del repeated this idea ad nauseam. See for instance Del to Sir Stafford Cripps, 18 August 1947, scc. The quote is from this letter.

35 "Long Shots," 4.

36 The quote is from Jarvis to his parents, 16 June 1947, ajc, box 11; See also Jarvis' marginal annotations on Del to Sir Stafford Cripps, 18 August 1947, scc.

37 Jarvis to his mother, 18 August 1947; for the yacht, see Jarvis to his mother, 22 August 1947, both ajc, box 11.

38 "An Artist in Wardour Street," ajc, box 23.

39 For Hi, see Jarvis to his mother, 7 October 1948, ajc, box 11. Also Mervyn Stockwood interviewed by Elspeth Chisholm, ecc, cd a1 2003-07-0016.

40 Jarvis to his mother, 17 December 1948, ajc, box 11.

41 Jarvis to his mother, 24 September 1947, ajc, box 11.

42 Jarvis to his mother, 25 October 1947, ajc, box 11.

43 Bill Riley to Isobel Cripps, 12 April 1948, scc.

44 See for instance the marginal comments Jarvis wrote on Del to Sir Stafford Cripps, 18 August 1947, scc; and Jarvis to his mother, 24 September 1947, ajc, box 11.

45 Jarvis to his mother, 21 September 1947, ajc, box 11; for Samuel Courtauld, see Jarvis to Isobel Cripps, undated, scc.

46 Isobel Cripps to Lord Hambleden, 20 July 1947, scc.

47 Jarvis to his mother, 21 September 1947, ajc, box 11.

48 Del to Isobel Cripps, 1 October 1947, scc.

49 Jarvis to Isobel Cripps, "Sunday Night" (likely mid-October 1947), scc.

50 Jarvis to his mother, 4 and 25 October 1947, ajc, box 11.

51 Del to Rank, 18 August and 2 September 1947, and Rank to Del, 26 August 1947, scc. The quote is from Rank to Del, 9 September 1947, scc.

52 Sydney Wynne to Jarvis, 16 September 1947; "very real friend" quote is from Keeling to Del, 6 October 1947, both scc, file sc23.

53 Del to Isobel Cripps, 18 November 1947, scc, file sc22.

54 Del to Keeling, 9 October 1947, scc, file sc23.

55 "Meeting with Jack Keeling, 20ᵀᴴ October 1947," scc. The peers were Lord Hambleden and Lord Luke, who had inherited the Bovril fortune.

56 Alan Jarvis, "Film Crisis," 16 March 1949, ajc, box 23.

57 Jarvis to Isobel Cripps, "Thursday Morning at Home," undated; Alan Jarvis, "Notes on W. Jacob's Phone Conversation," 10 November 1947; and William Riley, "Pilgrim Pictures Limited – Memorandum on Events Between 15th – 19th January," all scc.

58 Del to John and Roy Boulting, 6 November 1947, scc.

59 Jarvis to Dorothy Elmhirst, 16 December 1947; Alan Jarvis, "Notes on W. Jacob's Phone Conversation," 10 November 1947; and William Riley, "Pilgrim Pictures Limited – Memorandum on Events Between 15th – 19th January," all scc.

60 Riley, "Diary Notes," 22 December 1848, scc; for the insidious war quote, see Riley, "Pilgrim Pictures Limited – Memorandum on Events Between 15th – 19th January," scc.

61 Riley, "Films and The Film Agreement," 15 July 1948, scc. For ABPC's financing of *The Guinea Pig*, see Del to Robert Clark, 3 June 1948, NAUK, BT64, file 2366; Riley to Harold Wilson, 12 April 1948, NAUK, BT64, file 2366; Riley to Isobel Cripps, April, scc; and Porter, "All Change," 6–7.

62 "Del Giudice May Move Pilgrim Studio Here," *New York Times*, 10 December 1947, 42.

63 Paul F. Kennedy, "Portrait of an Expatriate," *New York Times*, 11 January 1948, x5.

64 Ibid.

65 Treasury to Del, 2 January 1948, FDG, item 6. Also Jarvis to his mother, 17 and 25 December 1947, AJC, box 11.

66 Jarvis to his mother, 9 September 1947, AJC, box 11.

67 Del to Isobel Cripps, 10 January 1948, scc.

68 Jarvis to his mother, undated from the Beverly Hills Hotel, "Thursday evening," AJC, box 11.

69 Jarvis to his mother, undated from the Beverly Hills Hotel, "Thursday." The quote is from Jarvis to his mother, undated from the Beverly Hills Hotel, "Thursday evening", both AJC, box 11.

70 Both quotes are from Jarvis to Isobel Cripps, 16 January 1948, scc.

71 Jarvis to his mother, 27 January 1948, AJC, box 11.

72 Jarvis to Isobel Cripps, 16 January 1948; Del to Riley, 20 January 1948; telegram from Jarvis and Del to Riley, 21 January 1948; and Alan Jarvis, "Memorandum," 24 January 1948, all scc.

73 Jarvis to Isobel Cripps, 20 January 1948, and Alan Jarvis "Memorandum," 24 January 1948, scc.

74 Alan Jarvis, "Draft Memorandum on Anglo-American Films Trade and Policy for British Film Production," 20 February 1948, SCC.

75 William Riley, "Pilgrim Pictures Limited – Memorandum on Events Between 15th – 19th January," SCC. "Learn Del Giudice Backer," *New York Times*, 17 January 1948, 11.

76 William Riley, "Memorandum on Events"; also Riley to Isobel Cripps, 1 and 2 February 1948, SCC.

77 Jarvie, "British Trade Policy," 34–5; for an American perspective, see Morris Ernst to Del, 6 August 1947, SCC.

78 William Riley, "Films and the Film Agreement," 15 July 1948, SCC. Also Jarvie, "British Trade Policy," 35, 86.

79 Jarvis to Isobel Cripps, 4 May 1948, and Jarvis, untitled memo beginning "Since this will be in effect," 24 May 1948, SCC.

80 Riley to Harold Wilson, 12 April 1948, NAUK, BT64, file 2366.

81 Treasury to R.C.G. Somervell, 8 April 1948; and Somervell, untitled memo, 15 April 1948, both NAUK, BT64, file 2366.

82 Riley to Harold Wilson, 23 April 1948, NAUK, BT64, file 2366.

83 Jarvis to his mother, 21 April 1948, AJC, box 11.

84 Riley to Wilfrid Eady, 12 April 1948, NAUK, BT64, file 2366.

85 Wilfrid Eady to R.C.G. Somervell, 14 April 1948, NAUK, BT64, file 2366.

86 Del, "Notes on the Brilliant Speech by Mr Harold Wilson in the Commons – Thursday, 29th April, 1948," NAUK, BT64, file 2366.

87 Untitled memo written by Jarvis, 24 May 1948, SCC.

88 Riley to Wilson, 23 April 1948, NAUK, BT64, file 2366.

89 Del, "Cri de Coeur," 28 May 1948, NAUK, BT64, file 2366.

90 Untitled memo written by Jarvis, 24 May 1948, SCC.

91 Jarvis to Wilson, 18 August 1948, SCC.

92 Janet Bee's Diary of her trip to England, 1948, AJC, box 55.

93 Del to Isobel Cripps, 4 May 1948, SCC.

94 Del to Robert Clark, 3 June 1948, NAUK, BT64, file 2366. The prices Del hoped to get were £200,000 for *Private Angelo*, £300,000 for an as yet unmade Boulting brothers' film of Paul Gallico's novel *The Lonely*, and a further £300,000 for an unspecified Noël Coward film. See also "Cri de Coeur," 28 May 1948, NAUK, BT64, file 2366; "Film Finance," 28 July 1948, SCC; and "Meeting in the President's Office, House of Commons, at 2:30 pm., July 28th 1948," NAUK, BT64, file 5155.

95 Del to Wilson, 4 June 1948, NAUK, BT64, file 2366.

96 Wyatt to Wilson, 7 June 1948, NAUK, BT64, file 2366.

97 "Sir Wilfrid Eady's Lunch with Del Giudice," 13 July 1948, NAUK, BT64, file 2366; Pilgrim's case was discussed explicitly in late July; "Meeting in the President's Office."

98 "Meeting in the President's Office"; and Somervell to C.M.P. Brown, 6 July 1948, NAUK, BT64, file 2366.

99 Wyatt to Wilson, marked "Urgent, Personal and Confidential," 8 July 1948, NAUK, BT64, file 2366.

100 Somervell, untitled memo beginning "I understand from Eady," 9 July 1948, NAUK, BT64, file 2366.

101 W.G. Riley, "Films and the Film Agreement," 15 July 1948, SCC, file SC23.

102 Somervell, untitled memo beginning "Mr Shillito of the Treasury," 26 August 1948, NAUK, BT64, file 5155.

103 Eady to Sir John Woods, 22 July 1948, NAUK, BT64, file 5155.

104 Del to Wilson, 10 August 1948, FDG, item 10; and Del, untitled memo, 2 September 1948, FDG, item 11.

105 Somervell, untitled memo, 13 September 1948, NAUK, BT64, file 2366. The marginal notations on this document indicate that Wilson read it.

106 For Harvard, see Del to Robert Clark, 2 June 1948, NAUK, BT64, file 2366. For the quote about tickets, see Extract of a memo from Del to Jarvis, 2 September 1948, FDG, item 12.

107 The "ticking over" quote is from Jarvis to his mother, 7 October 1948; see also Jarvis to his mother 1, 6 November, 12 December 1948, all AJC, box 11.

108 All quotes are from "Diary Notes, WGR [William G. Riley]," 22 December 1948, SCC.

109 Del, "Technical Testament," November 1948, Del Giudice collection, item 13.

110 The quote comes from Jarvis to (illegible) Brown, 26 January 1949; Jarvis to Harold Wilson, 25 January 1949; and (illegible) to Jarvis, 1 February 1949, all NAUK, BT64, file 5155. For Jarvis' rewritings, see FDG, item 14; and Jarvis to his mother, 3 December 1948, AJC, box 11.

111 Anonymous memorandum to Wilson, 13 January 1949, SCC.

112 Bosley Crowther, "*The Guinea Pig*, English Film About Public School System, Opens at Little Carnegie," *New York Times*, 2 May 1949.

113 Jarvis to his mother, 22 January 1949, AJC, box 11.

114 Alan Jarvis, "Film Crisis," 16 March 1949, AJC, box 23.

115 Jarvis to his mother, 16 March 1949, AJC, box 11.

116 Isobel Cripps to Del, 20 June 1949, SCC.

117 Del to Wyatt, 20 October 1949, AJC, box 23.

118 Unsigned memorandum (almost certainly written by Jarvis), "Pilgrim Pictures Limited: Proposed Reconstruction," 21 June 1949, SCC.

119 Jarvis to his mother, 11 July 1949, AJC, box 11.

120 Jarvis to his mother, 27, 31 August and 7 September 1949, AJC, box 11; and Riley to Jarvis, 7 September 1949, AJC, box 23.

121 Wyatt to Jarvis, 21 November 1949, and Del to Jarvis, 27 November 1949, AJC, box 23.

122 The quotes are from, respectively, Wyatt to Del, 18 October 1949, and Del to Wyatt, 20 October 1949, AJC, box 23.

123 Del to Jarvis, 9 November 1949, SCC.

124 Jarvis to Del, 22 November 1949, SCC.

125 Alan Jarvis, "An Artist in Wardour Street," AJC, box 23.

126 Sir Arthur Jarratt to A.G. White, 4 January 1950, NAUK, BT64, file 4466.

127 Jarratt to Miss Ward, 3 January 1950, and Bernard Miles to Wilson, 4 January 1950 (incorrectly dated 1949), NAUK, BT64, file 4466.

128 Minutes of the Film Selection Committee Meeting, 7 February 1950, NAUK, BT64, file 4466. Alan Jarvis "Chance of a Lifetime – From Then Til Now," 16 May 1950, AJC, box 23. The Selection Committee was composed of Lord Drogheda, David Bowes-Lyon, Elizabeth Bowen, C.J. Geddes, and Margaret Stewart. John Davis, Mark Ostrer, and Jack Gooddale represented the cinema chains. *Daily Express*, 23 February 1950, 7.

129 Godfrey Ince to Sir John Woods, 17 March 1950, NAUK, BT64, file 4466.

130 Somervell, untitled memo beginning "I think Sir Godfrey," 21 March 1950; Godfrey Ince to Sir John Woods, 31 March 1950; and (illegible) Ministry of Labour to Wilson, 31 March 1950, all NAUK, BT64, file 4466.

131 Untitled report, FDG, item 26.

132 "Chance of a Lifetime – From Then Til Now," 16 May 1950; and "They Know What *We* Like," both AJC, box 23, and SCC. The latter was published in *The National Film Association Journal*, April 1950, 7–10.

133 Jarvis to his mother, 12 November 1949, AJC, box 11; also Somervell, "Chance of a Lifetime," 17 April 1950, NAUK, BT64, file 4466.

134 David Lewin, "Big 3 Told 'Show This Picture,'" *Daily Express*, 23 February 1950, 7; Harold Conway, "Cinema Big 3 Ordered 'Must Show This Film,'" *Evening Stan-*

dard, 22 February 1950, 3; and Jarvis to his mother, 23 February 1950, AJC, box 11. For newspaper pressure, see untitled report, FDG, item 26.

135 Jarvis to his mother, 27 March 1950, AJC, box 11. There is no evidence about the identity of these stocks.

136 Alan Jarvis, "An Artist in Wardour Street," AJC, box 23.

CHAPTER NINE

The quote in the chapter title is from Jarvis to his mother, 1 January 1950, AJC, box 11.

1 Jarvis to his mother, 1 January 1950, AJC, box 11.

2 Jim Tomlinson, "Reconstructing Britain: Labour in Power 1945–1951," in Nick Tiratsoo, ed., *From Blitz to Blair: A New History of Britain Since 1939*, 92–101.

3 Mary (Greey) Graham interviewed by the author, 18 February 2005.

4 Jarvis to his mother, 15 September 1949, AJC, box 11.

5 Mervyn Stockwood interviewed by Elspeth Chisholm, ECC, CD A1 2003-07-0016.

6 Isobel Cripps to Stockwood, 5 March 1950, SCC.

7 Stockwood to Isobel Cripps, 2 March 1950, SCC.

8 Isobel Cripps to Stockwood, 5 March 1950, SCC.

9 Stockwood to Isobel Cripps, 15 March 1950, SCC.

10 Jarvis to his mother, 6 February, 27 March 1950, and 14 July 1952, AJC, box 11. Stockwood to Isobel Cripps, 23 March 1950, SCC.

11 Stockwood to Isobel Cripps, 23 March 1950, SCC.

12 The story is recounted in Alison Ignatieff interviewed by Elspeth Chisholm, ECC, CD A1 2003-06-0044.

13 Stockwood to Isobel Cripps, 30 March 1950, SCC. For another pledge from Jarvis to cut down, see Jarvis to his mother, 29 January 1953, AJC, box 11.

14 Isobel Cripps to Jarvis, undated "Saturday," AJC, box 21. The punctuation is by Cripps.

15 For the list of qualities asked for by the dean, see Stockwood to Isobel Cripps, 1 April 1950, SCC. For Jarvis and the dean's friendly relations, see Jarvis to his mother, 21 September 1952, 17 January and 3 August 1953, AJC, box 11.

16 Jarvis to his mother, 3 April 1950, AJC, box 11.

17 "Group Theatre," in Phyllis Hartnoll, ed., *The Oxford Companion to the Theatre*, 418. Also Group Theatre memorabilia, AJC, box 23.

18 Mary (Greey) Graham interviewed by the author.

19 "The Oxford House," *The Times*, 15 June 1950. For the two-year commitment, see Jarvis to his mother, 27 February 1954, AJC, box 11.

20 Gareth Stedman Jones, *Outcast London: A Study in the Relationship between Classes in Victorian Society*, passim.

21 As quoted in Stedman Jones, 222.

22 *It Always Rains on Sundays*, 1947, Robert Hamer director, Ealing Studios.

23 As quoted in Mandy Ashworth, *The Oxford House in Bethnal Green: 100 Years of Work in the Community*, 7–10.

24 The quotes are in "Head's Report," *Oxford House Annual Report for 1947*, 2, 3. The Community Association is in "Introduction," *Oxford House Annual Report for 1948/9*, 2.

25 "Head's Report," 3.

26 Ashworth, *Oxford House*, 46.

27 Minutes of the Oxford House Council, 14 January; the quote is in 19 October 1948, THL.

28 Minutes of the Oxford House Council, 12 May 1949, THL.

29 Minutes of the Oxford House Council, 9 September 1952, THL, file 8209/54.

30 Robert Draper, Warden Oxford House Community Association, 2 October 1950, THL, file TH8209/54.

31 Oxford House Community Association Constitution, THL; "Report to the Special General Meeting of the Community Association," 11 March 1952, THL, file 8209/55.

32 "Introduction," *The Oxford House Annual Report for 1948/9*, 3.

33 Jarvis to Sir Kenneth Clark, 21 September 1951, and Clark to Jarvis, 26 September 1951, both Sir Kenneth Clark collection.

34 Jarvis to his mother, 28 December 1951, AJC, box 11.

35 Minutes of the Oxford House Community Association, 27 February 1951, and Minutes of the Oxford House Community Association, 13 November 1951, THL.

36 Minutes of the Oxford House Council, 20 March 1954, THL. Jarvis to his mother, 29 January 1952, AJC, box 11; for the embassy scheme, see Jarvis to his mother, 14 November 1953, AJC, box 11. Alan Jarvis, "A Change of Job," script of a BBC radio broadcast given by Jarvis, 1 April 1952, AJC, box 25.

37 "The Music Group and the Discussion Group," *Oxford House Annual Report, 1950–51*, 6; "The Studio Group," *Oxford House Annual Report, 1951–52*, 9; and Jarvis to his mother, 28 June 1953, AJC, box 11.

38 Geoffrey Reeve interviewed by the author, 24 December 2003. Thanks in part to

Jarvis' encouragement, Reeve became a successful producer, working often with Michael Caine.

39 Michael Brown to the author, 2 January 2004.

40 Jarvis to his mother, 24 October 1950, AJC, box 11. the punctuation is by Jarvis. This is the only reference to problems with his hands, the exact nature of which remains obscure.

41 Jarvis to his mother, December 1951, 8 February 1953; for religious feelings, see Jarvis to his mother, 17 April 1954, all AJC, box 11. For Pilgrim, see Crawley and de Reya solicitors to Jarvis, 4 and 6 March 1953; and Barrington Gain to Jarvis, 1 April 1953, all AJC, box 2. Also Minutes of the Directors' Meeting, 25 March 1953, AJC, box 23.

42 Jarvis to his mother, 29 October 1950, AJC, box 11.

43 See for instance Bevis Hiller and Mary Banham, eds, *A Tonic to the Nation*, passim.

44 Jarvis to his mother, 24 October 1950, AJC, box 11.

45 Memorandum, "British Youth Organisations and the Festival of Britain," 22 February 1951, NAUK, Work 25/40. The contact telephone number for the Festival Fires was Jarvis' office at Oxford House.

46 See the Press Release and Janet Bee's ticket to the opening of the Festival Centre for Youth, AJC, box 22.

47 Jarvis to his mother, 3 May 1952, AJC, box 11.

48 Press Release, "For Bill and Betty – Or Setting up Home," May 1952, THL.

49 Minutes of the Oxford House Council, 29 January 1952, THL. Press Release, "For Bill and Betty."

50 For the quote, see Alan Jarvis, *A Letter to Bill and Betty*, unnumbered pages. Also "For Bill and Betty," *Oxford House Annual Report 1952–53*, 4–5; Minutes of the Oxford House Community Association 13 May 1952, THL, file, 8209/54; and Piers Nicholson interviewed by the author, October 2003.

51 For the Queen, see Michael Parker to Jarvis, 17 March 1952, and Mark Cratens to Jarvis, 20 March 1952, AJC, box 2. For Attenborough and Sim, see "For Bill and Betty," 4.

52 Jarvis, *Letter to Bill and Betty*, unnumbered pages.

53 Press Release, "For Bill and Betty – Or Setting up Home." Approximately 1,000 people visited the show each day.

54 Notes for Jarvis' speech to the Rotary Club of London, 24 January 1951, AJC, box 24.

55 *Directory of Social Services in Bethnal Green*, 1951, AJC, box 24.

56 Hull House Association to Jarvis, 30 October 1951, AJC, box 2; for Scotland Yard, see Jarvis to his mother, 16 March 1953, AJC, box 11.

57 Minutes of the Oxford House Council, 24 October 1952, THL. Jarvis to his mother, 21 September 1952, 17 January and 3 August 1953, AJC, box 11. The quote is from 17 January 1953.

58 Both quotes are from Alan Jarvis, "Social Research and Residential Settlements," AJC, box 24.

59 All quotes are from untitled report for the Carnegie Trust, almost certainly 1953, AJC, box 21; see also Jarvis to his mother, 22 August 1953, AJC, box 11.

60 Jarvis to his mother, 5 September 1953, AJC, box 11; and Minutes of the Oxford House Council, 10 October 1953, THL.

61 Minutes of the Oxford House Council, 10 October 1953, THL. The proposal for Michael Young's group to join Oxford House is found in Jarvis' untitled report to the Carnegie Trust, 1953, AJC, box 21.

62 Jarvis to his mother, 14 November 1953, AJC, box 11; Asa Briggs, *Michael Young: Social Entrepreneur*, 6.

63 Minutes of the Oxford House Council, 10 October 1953, THL.

64 Michael Young and Peter Willmott, *Family and Kinship in East London*.

65 Jarvis to his mother, 17 January and 19 September 1953; the quote is from Jarvis to his mother, 21 January 1953, all AJC, box 11. See also Minutes of the Oxford House Council, 12 December 1953, THL.

66 Jarvis to his mother, 3 August 1953, AJC, box 11.

67 Jarvis to his mother, 3 October 1953, AJC, box 11; also the card informing Jarvis of his election to the Athenaeum as of 15 February 1954, AJC, box 12. "Evening Literary Party at Lady Norman's Home," *Tatler*, 21 May 1952, 437.

68 Jarvis to his mother, 22 July 1952, 19 September, 21 November 1953, and 13 March 1954, AJC, box 11.

69 "Group Theatre," *Oxford Companion*, 418. Jarvis to his mother, 21 February 1953, AJC, box 11.

70 C. Walter Hodges and Michael Stringer, "Designing Mermaids," 13; and Sally Miles, "From St John's Wood to the City: An Eight Year Dream Come True," both in *The Mermaid Theatre Review 1959*, 14. Also Kirsten Flagstad, *The Flagstad Manuscript*, 230. The bust of Flagstad is mentioned in Jarvis to his mother, 4 September 1952, AJC, box 11. The theatre moved to Puddle Dock on the Thames in 1959.

71 Jarvis to his mother, December 1951, AJC, box 11.

72 As quoted in Robert Fulford, *Best Seat in the House: Memoirs of a Lucky Man*, 111.

73 Jarvis to his mother, 14 October 1952, AJC, box 11. The government eventually chose a bust by Sir Jacob Epstein.

74 Jarvis to his mother, 15 December 1951, AJC, box 11.

75 The quote is in Jarvis to his mother, 11 February; pewter is in Jarvis to his mother 27 March 1952, both AJC, box 11.

76 Jarvis to his mother, 23 April, 17 June, 5 July 1952, and 8 February 1953, AJC, box 11.

77 Jarvis to his mother, 7 March, 14, 21 February, and 15 July 1953, AJC, box 11; also Jean Stewart Gunn interviewed by Elspeth Chisholm, ECC, CD A1 2003-07-0020. The Irish grandee had been Jean Gunn's wartime boss. She almost certainly arranged the commission for Jarvis.

78 Jarvis to his mother, 10 and 22 August 1953, AJC, box 11.

79 Jarvis to his mother, 19 September 1953 and 22 May 1954, AJC, box 11.

80 Jarvis to his mother, 3 October 1953, AJC, box 11.

81 Jarvis to his mother, 6 March 1954, AJC, box 11.

82 Leonard W. Brockington to Samuel Bronfman, 1 October 1954, AJC, box 2. Jarvis worked on the bust of James until it was delivered in June 1954. Jarvis to his mother, 27 February and 12 May 1954, AJC, box 11. The sculpture of James still stands in McGill's Redpath Library.

83 Sir Eric Bowater to Jarvis, 9 April 1954, and 20 April 1955, AJC, box 2; Jarvis to his mother, 27 February and 3 April 1954, AJC, box 11. Jarvis celebrated these commissions by a short holiday in Paris. Jarvis to his mother, 2 May 1954, AJC, box 11.

84 Programs for the 4th and 5th International Congresses on Mental Health at the University of Toronto, AJC, box 24.

85 H.G. (Rik) Kettle interviewed by Elspeth Chisholm, ECC, CD A1 2003-06-0045. For "VIPs," see Jarvis to his mother, 4 July 1954, AJC, box 11.

86 Keeling to Jarvis, 4 August 1954, and Leonard Brockington to Samuel Bronfman, 1 October 1954, AJC, box 2.

87 Jarvis to his mother, 4 July and 2 August 1954, AJC, box 11; Kettle interviewed by Elspeth Chisholm.

88 Jarvis to his mother, 2 May 1954, AJC, box 11.

89 Richard Keen to Patrick Harvey, 30 June 1954, BBCWA.

90 For the talk about Oxford House, see "Talks Booking Requisition," 13 December 1950; for the under twenty panel, see "School Broadcasting Department Booking Form," 12 October 1951; W. Hodgson to Jarvis, 12 October 1951; for a change of job, see R.E. Keen to D.F. Boyd, 31 December 1951; Boyd to Keen, undated; "Talks

Booking Requisition," 21 January 1952; and Ronald Boswell to Jarvis, 29 February 1952, all BBCWA.

91 "Talks Booking Requisition," 5 September 1952; Jack Singleton to Jarvis, 17 October 1952; "Talks Booking Requisition," 26 January 1953; ibid., 7 September 1953, all BBCWA.

92 "Talks Booking Requisition," 6 November 1953; ibid., 5 May 1954; for the quotes, see Tony Gibson to Jarvis, 22 September 1953, all BBCWA.

93 Jarvis to his mother, 14 February 1953, AJC, box 11.

94 Jarvis to his mother, 21 November 1953 and 10 May 1954, AJC, box 11.

95 "Talks Booking Requisition," 23 March 1955; ibid., 28 March 1955; ibid., 29 March 1954, all BBCWA. Also Jarvis to his mother, 27 March 1954, AJC, box 11.

96 Colin Cooke, *The Life of Richard Stafford Cripps*; Jarvis to his mother, 8 February 1953 and 20 February 1954, AJC, box 11. Jarvis had helped to secure a £5,000 contract for the book. Penguin Books to Jarvis, 20 February 1953, AJC, box 2. Between 1947 and 1952, Jarvis earned £250 in royalties on 28,352 sales of his book *The Things We See*. For the book on furnishing, see Jarvis to his mother, 7 March 1953, AJC, box 11. The book was published as *How to Furnish Your Home*. For his thoughts on becoming an author, see Jarvis to his mother, 6 March 1954, AJC, box 11.

97 "Our Help Sought to Restore Abbey," *New York Times*, 4 March 1954, 4; Jarvis to his mother, 2 May 1954, AJC, box 11. The New York lectures were sponsored by the English Speaking Union. For dangling a knighthood, see Kendrick Venables interviewed by Elspeth Chisholm, ECC, CD A1 2003-07-0015.

98 Norman Hay interviewed by Elspeth Chisholm, ECC, CD A1 2003-06-0045; Jarvis to his mother, 21 January 1953, AJC, box 11; and David P. Silcox interviewed by the author, May 2003.

99 Jarvis to his mother, 19 March 1952, AJC, box 11.

100 Quotes are from Hay interviewed by Elspeth Chisholm.

101 Hay interviewed by Robert Fulford, 6 May 1981, Fulford collection, accession 30-1992, box 13.

102 Hay interviewed by Elspeth Chisholm. Also Marjorie Harris interviewed by the author, 17 August 2004, and "Staff," *The Oxford House Annual Report for 1952/3*, 28.

103 Hay interviewed by Robert Fulford. Also Jarvis to his mother, 10 June 1952, AJC, box 11.

104 For the trip, see Jarvis to his mother, 11 April and 30 May 1954, AJC, box 11. For the postcard, see Jarvis to Hay, 26 June 1954, AJC, box 9.

105 Chris Waters, "Disorders of the Mind, Disorders of the Body Social: Peter Wilde-

blood and the Making of the Modern Homosexual," in Becky Conekin, Frank Mort, and Chris Waters, eds, *Moments of Modernity: Reconstruction Britain, 1945–1964*, 134–151, passim. The number of prosecutions rose from about 400 per year in the early 1930s to more than 2,000 in 1953.

106 See the wedding invitation in AJC, box 12. Also Jarvis to his mother, 25 January and 15 February 1955, AJC, box 11.

107 The quote is from Jarvis to his mother, 6 March 1954. The punctuation is by Jarvis. See also Jarvis to his mother, 11 February 1952, both AJC, box 11.

108 Jarvis to his mother, 3 August 1942, 8 September 1948, 4 January 1949, 3 April 1950, 22 July 1952, 16 March 1953, 13 March 1954, 24 April 1954, 12 July 1954; and Jarvis to Frances Barwick, 7 December 1954, all AJC, box 11. "F" to Jarvis, January 1955, and Jean Stewart Gunn to Jarvis, 15 May 1955, both AJC, box 2. Also Betty (Devlin) Jarvis interviewed by the author, 4 June 2003.

109 Jarvis to his mother, 17 May 1954, AJC, box 11. The punctuation is by Jarvis.

110 Jarvis and his mother discussed his Gallery prospects for several months. Jarvis to his mother, 25 October, 18 November, 7 December 1954, and 17 January 1955, AJC, box 11.

CHAPTER TEN

The quote in the chapter title is from E.J. Walker, "About Alan Jarvis, Director of the National Gallery," *Highlights*, December 1955, 4. The concept of a "museum without walls" was first articulated by André Malraux.

1 As quoted in Wilfrid Eggleston, *The Queen's Choice*, 184.

2 Eggleston, *Queen's Choice*, 185–205.

3 Charles Ritchie, *Diplomatic Passport: More Undiplomatic Diaries, 1946–1962*, 51, 55, quote on 51–2.

4 Norman Levine, *Canada Made Me*, 55.

5 Hay to Jarvis, 15 March 1955, AJC, box 2.

6 J.L. Granatstein, *The Ottawa Men: The Civil Service Mandarins, 1935–1957*, passim.

7 Douglas McCalla, "The Rhodes Scholarships in Canada and Newfoundland," in Anthony Kenny, ed., *The History of the Rhodes Trust, 1902–1999*, 223. This was out of a total of 428 living Canadian and Newfoundland scholars. Toronto and Montreal, with forty-nine Rhodes scholars each, had the next highest concentrations.

8 Jarvis to his mother, 27 February 1954, AJC, box 11.

9 *An Act to Incorporate the National Gallery of Canada*, 3-4 George, Chap 33, Ottawa: King's Printer, 339–41.

10 Jean Sutherland Boggs, *The National Gallery of Canada*, 31; Ann Davis, "The Wembley Controversy in Canadian Art."

11 Boggs, *National* Gallery, 39.

12 "Coast to Coast in Art," *Canadian Art* 1, no. 1 (October–November 1943): 27.

13 Joyce Zemans, "Envisioning Nation: Nationhood, Identity and the Sampson-Matthews Silkscreen Project: The Wartime Years."

14 Jeffrey D. Brison, *Cultural Interventions: American Corporate Philanthropy and the Construction of the Arts and Letters in Canada, 1900–1957*, 114.

15 Jeffrey D. Brison, "The Kingston Conference, the Carnegie Corporation and a New Deal for the Arts in Canada," passim, quote on 515.

16 Elizabeth Wyn Wood, "A National Plan for the Arts in Canada," p.94.

17 Special Committee on Reconstruction and Reestablishment, *Minutes of Proceedings and Evidence, No 10, Wednesday, June 21, 1944*, Ottawa: King's Printer, 1944, 328–38.

18 "An Acorn on Parliament Hill," *passim*.

19 Lawren Harris, "Reconstruction through the Arts," 185–6, and Elizabeth Wyn Wood, "Art Goes to Parliament," 42.

20 Jarvis to his mother, 11 February 1952, AJC, box 11; Louis St-Laurent collection, vol. 125, file N-20-2, passim; McCurry to Pickersgill, 29 November 1954, JPC, vol. 20; and Humphrey Carver, "The Design Centre – The First Year," passim. Claude Bissell, *The Imperial Canadian: Vincent Massey in Office*, 27–8. Massey acquired the paintings while Canadian high commissioner in London. He became a Tate Gallery and National Gallery trustee in 1941 and chairman two years later.

21 Bissell, *The Imperial Canadian*, 161–96. Also "New Gallery Head Anxious to See Adequate Building," *Ottawa Journal*, 2 May 1955, 16.

22 Paul Litt, *The Masses, the Muses and the Massey Commission*, 26–7.

23 *Report of the Royal Commission on National Development in the Arts, Letters and Sciences, 1949–1951*, Ottawa: King's Printer, 1951, quote on 77. See also 314–16. For the Trustees' reaction see BOT, 22 May 1952.

24 "control and supervision" is from BOT, 2 October 1951; *National Gallery of Canada Act*, 15–16 Geo VI, Ottawa: King's Printer, 175–7.

25 Vincent Massey, *What's Past Is Prologue: The Memoirs of Vincent Massey*, 470–90.

26 For Gallery conditions, see Robert Winters to Pickersgill, 27 December 1954, JPC, vol. 20. For the architectural competition, see Louis St-Laurent to Vincent Massey, 8 November 1951, JPC, vol. 19. The other members of Saarinen's committee were Alfred Barr, director of New York's Museum of Modern Art, and John Bland.

Professor Eric Arthur of the University of Toronto was the architectural expert. Vincent Massey's architect son Hart, an architecture student, won a prize for his model for a new National Gallery. See *Ottawa Citizen*, 29 June 1951; and Louis St-Laurent to Hart Massey, 30 June 1951, St-Laurent collection, vol. 125, file N-20-2.

27 Memorandum from Eric Arthur, 19 October 1952, JPC, vol. 18.

28 See for instance McCurry to Pickersgill, 27 March 1953, JPC, vol. 18.

29 McCurry to Pickersgill, 18 August 1954, JPC, vol. 19.

30 McCurry to Pickersgill, 9 March 1955; H.R. Cram to Howard Kennedy, 2 March 1955; Pickersgill to Fell, 14 March 1955; Memorandum from H.R. Cram, 7 March 1955, all JPC, vol. 19. "National Gallery on Elgin Street," *Ottawa Journal*, 15 February 1955, in JPC, box 19.

31 See for instance, Laval Fortier to Walter Harris, 10 November 1952, Department of Citizenship and Immigration collection, LAC, vol. 76. So-called Blocked Funds were Canadian investments held in foreign countries at the end of the Second World War. They could only be withdrawn at the risk of destabilizing the economy of the country in which they were held.

32 For the quote, see McCurry to Blunt, 17 June 1949, NGA, file 1.11B; and McCurry to Blunt, 8 July 1949, NGA, file 1.11B.

33 For Morgan's visit, see Morgan to the Prince, 4 January 1950; for the rumours, see Schab to McCurry, 30 March 1951, both NGA, file 1.11L.

34 BOT, 1 June 1951.

35 For an expression of the government's ultimate aim of acquiring the da Vinci, see BOT, 21–22 April 1954; and Jarvis to Pickersgill, 4 November 1955, JPC, vol. 19. For the Polish da Vinci, see Agnew to McCurry, 12 October 1954, NGA, file 1.11L.

36 H.S. Southam to Dr Gustav Wilhelm, 22 October 1952, NGA, file 1.11L.

37 W.G. Constable, "Memorandum to the Minister," 18 December 1952; for Massey's support, see M.H. to Walter Harris, 30 January 1953, both JPC, vol. 19. The latter was subsequently submitted to cabinet as Cab Doc 562.

38 Schab to McCurry, 19 December 1952, NGA, file 1.11L. The exact figures were $10,696,000 and $13,196,000.

39 Martha J. King, "The National Gallery of Canada at Arm's Length from the Government of Canada: A Precarious balancing Act," 45. Also Cabinet Conclusion, 6 February 1953, LAC. Constable to McCurry, 19 February 1953, NGA, file 1.11L.

40 The quote is from BOT, 11–12 March 1953. Also Morgan to McCurry, 3 February 1953, NGA, file 1.11L.

41 Geoffrey Agnew to McCurry, 9 February, 6 March 1953; McCurry to Agnew, 13 February 1953; both quotes are from Morgan to McCurry, 30 March 1953, all NGA, file 1.1L.

42 Schab to McCurry, 6 October 1953, NGA, file 1.11L.

43 King, "National Gallery," 46, and Cabinet Document 244/53 7 October 1953 PCC, vol. 226, file N-12-2.

44 McCurry to Agnew, 16 December 1953, NGA, file 1.11A.

45 Agnew to McCurry, 28 July 1954, NGA, file 1.11L.

46 Agnew to McCurry, December 1953 and 24 February 1954, NGA, file 1.11L.

47 S.F. Bowman, Chief Treasury Officer to McCurry, 17 December 1953, and Laval Fortier to the Secretary of Treasury Board, 11 December 1953, Department of Citizenship and Immigration collection, vol. 76, file 1-6-30.

48 *National Gallery Annual Report for 1954–55*, Ottawa: Queen's Printer, 1955, 13.

49 BOT, 21–22 April 1954.

50 Walter Harris to the Secretary of the Treasury Board, 29 April 1954, Department of Citizenship and Immigration collection, vol. 1; and J.J. Deutsch to Laval Fortier, 6 May 1954, NGA, file 1.11L.

51 McCurry to Agnew, 22 June 1954, NGA, file 1.11L.

52 McCurry to Agnew, 4 August 1954, NGA, file 1.11L.

53 Agnew to McCurry, 12 October 1954, NGA, file 1.11L; and BOT, 20–21 October 1954.

54 Agnew to McCurry, 9 November and 17 December 1954, NGA, file 1.11L.

55 McCurry to Agnew, 11 January 1955, NGA, file 1.11L.

56 *Debates of the House of Commons,* Session 1959, vol. I, Ottawa: Queen's Printer, 1959, 4 February 1955, 847.

57 J.W. Pickersgill, *Seeing Canada Whole: A Memoir,* 447.

58 Senator Norman P. Lambert to Louis St-Laurent, 19 March 1953, and St-Laurent to Lambert, 20 March 1953, both St-Laurent collection, vol. 125, file N-20-1.

59 Fell to Walter Harris, 6 May 1953, JPC, vol. 18.

60 J.W. Pickersgill interviewed by Elspeth Chisholm, ECC, CD A1 2003-06-0044.

61 Fell to Walter Harris, 12 May 1954, JPC, vol. 18.

62 Pickersgill interviewed by Elspeth Chisholm; Graham McInness, *Finding a Father,* 166.

63 McCurry to Fell, 19 August 1953, NGA, file 9.2F.

64 Frances Barwick to Jarvis, 19 February 1955, AJC, box 2.

65 The quote is from Jarvis to Jack and Frances Barwick, 22 January 1953, AJC, box 9;

Jack Barwick to Fell, 19 February 1954, AJC, box 2, and Jarvis to his mother, 29 January 1953, AJC, box 11.

66 Jarvis to Fell, 4 January 1954, JPC, vol. 18. This file contains a copy of Jarvis' curriculum vitae.

67 Fell to Walter E. Harris, Minister of Citizenship and Immigration, 5 January 1954, JPC, vol. 18.

68 Jarvis to his mother, 27 February 1954, AJC, box 11.

69 Jarvis to his mother, 6 March 1954, AJC, box 11.

70 Fell to McCurry, 17 August 1954, NGA, file 9.2F.

71 For the trustees' decision to make Buchanan the deputy director, see Fell to McCurry, 17 August 1954, NGA, file 9.2F. Also Fell to E.O. Ault, 16 February 1955, and Fell to Jarvis, 28 March 1955, AJC, box 2.

72 Fell to Jarvis, 22 October and 5 November 1954, AJC, box 2. The quote is from 22 October.

73 Jarvis to his mother, 25 October 1954, AJC, box 11.

74 Alan Jarvis, Civil Service Personnel file, LAC.

75 Fell to Pickersgill, 22 September 1954, JPC, vol. 18, file N-23-2.

76 For the number of applicants, see M.H. to Pickersgill, 29 November 1954, JPC, vol. 18, file N-23-2. Charles Fell interviewed by Elspeth Chisholm, ECC, CD A1 2003-06-0045.

77 Pickersgill to Norman Robertson, 25 October 1954, JPC, vol. 18, file N-23-2.

78 Sir Kenneth Clark to Fell, 3 November 1954, JPC, vol. 18, file N-23-2.

79 Fell to Pickersgill, 9 November 1954, JPC, vol. 18, file N-23-2. Also "Dr. A.H. Jarvis May Be New Gallery Director," *Ottawa Citizen*, 30 November 1954, 20.

80 Jarvis to Fell, 9 November 1954, JPC, vol. 18, file N-23-2.

81 For Cripps and Don, see Jarvis to Fell, 9 November 1954; for Andras, see Fell to Pickersgill, 12 November 1954, JPC, both vol. 18, file N-23-2. For Jarvis' account of this meeting to his mother, see Jarvis to his mother, 11 November 1954, AJC, box 11. Frederic Hudd was an English-born bachelor who struck colleagues as "an extraordinary creature from a different era." His endorsement may not have carried much weight. J.L. Granatstein, *A Man of Influence: Norman A Robertson and Canadian Statecraft, 1929–1968*, 207.

82 Norman Robertson to Pickersgill, 8 November 1954. JPC, vol. 18, file N-23-2. For Spry's more general feelings about Jarvis, see Graham Spry interviewed by Elspeth Chisholm, ECC, CD A1 2003-06-0038.

83 Robertson to Pickersgill, 4 and 8 November 1954, JPC, vol. 18, file N-23-2. Jarvis was aware that a francophone might be appointed; Jarvis to his mother, 27 February 1954, AJC, box 11.

84 For sharing information between Fell and Pickersgill, see Sybil Rump to Pickersgill, 5 November 1954, JPC, vol. 18. For Duncan, see Jarvis to his mother, 30 November 1954, AJC, box 11. For Massey, see Charles Fell interviewed by Elspeth Chisholm.

85 Jarvis to his mother, 18 November and 7 December 1954, AJC, box 11.

86 Untitled notebook, AJC, box 14. "Kenny" was the ballet dancer who infatuated Jarvis during his time in New York City. Richard "Dicky" Myers was Fanny Myers' brother. Jarvis knew him well in New York and during the war in England, where he was killed while serving with the Royal Air Force.

87 Jarvis to his mother, 25 January and 1 February 1955, AJC, box 11.

88 Fell to McCurry, 11 February 1955; for McCurry's failure to communicate, see Fell to Jarvis, 28 March 1955, both AJC, box 2.

89 McCurry to Jarvis, 25 February 1955, AJC, box 2.

90 "Persona Grata – Is Art Really Necessary," *Saturday Night*, 21 January 1956, 11; "He Liked to Say What He Pleased," *Ottawa Citizen*, 10 September 1959, 29. See also Jarvis' civil service personnel file, LAC.

91 Betty (Devlin) Jarvis interviewed by the author, 4 June 2003.

92 Jarvis to his parents, 27 June 1938, 3 August 1942, 8 September 1948, 4 January 1949, 3 April 1950, 22 July 1952, 16 March 1953, 13 March 1954, 24 April 1954, and 12 July 1954, AJC, box 11.

93 Jarvis to Frances Barwick, 7 December 1954, AJC, box 9. "F" to Jarvis, undated (certainly January 1955), and Jean Gunn to Jarvis, 15 May 1955, AJC, box 2. Jarvis proposed marriage in Jarvis to Betty Devlin, 15 March 1955, private collection.

94 Pavitt to Jarvis, March 1955, AJC, box 2.

95 Norman Hay to Jarvis, 27 and 31 March 1955, AJC, box 2.

96 See Janet Bee to Jarvis, "Mother's day 1955," and 4 May 1955, AJC, box 55.

97 Betty (Devlin) Jarvis interviewed by the author, 4 June 2003.

98 Fell to Jarvis, 22 October 1954, AJC, box 2.

99 Michael Young to Jarvis, 4 March 1955, AJC, box 2.

100 Stephen Andrews to Jarvis, 27 April 1956, AJC, box 3.

101 Robert Fulford interviewed by Elspeth Chisholm, ECC, CD A1 2003-06-0047. Also Robert Fulford interviewed by the author, 29 June 2003.

102 Fulford interviewed by Elspeth Chisholm.

103 Betty (Devlin) Jarvis interviewed by the author, 4 June 2003; and Piers Nicholson interviewed by the author, October 2003. Jarvis was Nicholson's godfather.

104 "New Gallery Head Anxious to See Adequate Building," *Ottawa Journal*, 2 May 1955, 16; Carl Weiselberger, "New Gallery Director Finds Standards High," *Ottawa Citizen*, 2 May 1955, 16.

105 "Alan Jarvis Appointed Director of the National Gallery of Canada," *Canadian Art* 12, no. 3 (spring 1955): 130.

106 "New Fixture," *Time*, 1 August 1955.

107 Hank Brennan to Jarvis, 22 March 1955, AJC, box 2. Also Brennan to Jarvis, 11 April 1955, NGA, file 9.9J.

108 The quote is from Hay to Jarvis, 15 March 1955; Frances and Jack Barwick to Jarvis, 19 February and 4 April 1955, all AJC, box 2. Robert Hubbard interviewed by Elspeth Chisholm, ECC, CD A1 2003-07-0016.

109 Hulme to Fell, 26 April 1955, NGA, file 9.2F.

110 The quotes is from Jarvis to Hubbard, 8 March 1955, AJC, box 9. Also Hay to Jarvis, 15 March 1955, AJC, box 2.

111 Betty (Devlin) Jarvis interviewed by the author, 4 June 2003.

112 Fell to Jarvis, 28 March 1955, AJC, box 2.

113 For board meetings, see Boggs, *National Gallery*, 52. Barbara Moon interviewed by Elspeth Chisholm, ECC, CD A1 2003-07-0020, and Robert Fulford interviewed by Elspeth Chisholm. Norman Hay interviewed by Elspeth Chisholm, ECC, CD A1 2003-06-0046. For publicly lauding the staff, see "Persona Grata – Is Art Really Necessary?," *Saturday Night*, 21 January 1956, 12. Nicknames are from David Silcox interviewed by the author, May 2003. The nickname referred to the nursery rhyme "Old Mother Hubbard."

114 Robert Hubbard interviewed by Elspeth Chisholm; Hubbard to Peg Wharton, 12 April 1956, RHC, vol. 13; BOT, 7–8 January 1957.

115 Boggs, *National Gallery*, 48. For a personal anecdote, see Robert Hubbard interviewed by Elspeth Chisholm.

116 *National Gallery Annual Report for 1955–1956*, Ottawa: Queen's Printer, 1956, 13–23, 30–46; *National Gallery Annual Report for 1956-1957*, Ottawa: Queen's Printer, 1957, 10–13, 18–20, 26–44.

117 *National Gallery Annual Report for 1955–1956*, Ottawa: Queen's Printer, 1956, 26. Also BOT, 23 April 1956.

118 Boggs, *National Gallery*, 47. BOT, 23 April 1956, 17–18 October 1956. It is interesting to note that when Jarvis first met Paul Arthur in 1947 he declared him to be "a very bright lad but talks too much for me." Jarvis to his mother, 18 August 1947, AJC, box 11. Pearl McCarthy, "Gallery Attendance Aided by Good Public Relations," *Globe and Mail*, 20 August 1955, 8.

119 See for instance undated speaking notes, NGA, file 7.4J.

120 Jarvis to R.M. Donovan, 22 May 1956, AJC, box 9; "Thank You Mr Jarvis," *Brantford Expositor*, 2 October 1956, 4.

121 *National Gallery Annual Report for 1955–1956*, Ottawa: Queen's Printer, 1956, 28.

122 "Extract of Draft Minutes of a Meeting of the National Capital Planning Committee Held at Ottawa on Monday January 17, 1955," and H.R. Cram to members of the Federal District Commission, 16 February 1955, both National Capital Commission collection, vol. 280, file 211-C-7(1); "Memorandum re: New National Gallery," 7 March 1955, JPC, vol. 19; Pickersgill to Howard Kennedy, 4 December 1954, JPC, vol. 19; Pickersgill to Howard Kennedy, 20 January 1955, JPC, box 20. Also Fell to Jarvis, 28 March 1955, AJC, box 2.

123 Kendrick Venables interviewed by Elspeth Chisholm, ECC, CD A1 2003-07-0015. The size of the cafeteria is found in E. Davie Fulton interviewed by Elspeth Chisholm, ECC, CD A1 2006-06-0039.

124 "Closing of National Gallery" and "Réouverture de la gallerie nationale du Canada," JPC, vol. 19. Carl Weiselberger, "Reopened Gallery Has Wealth of Purchases," *Ottawa Citizen*, 22 March 1956, 18. The quote is from Gail Dexter, "Alan Jarvis: Unfortunate Interlude," *Toronto Star*, 21 August 1968, 73.

125 Herbert to Jarvis, 1 March 1955, AJC, box 2.

126 Herbert to Jarvis, 22 February 1955, NGA, file 7.4J; also James Gibson interviewed by the author, June 2003.

127 "'Be Idealists, Revolutionaries' Carleton College Grads Told," *Ottawa Journal*, 21 May 1955. For "style" see James Gibson to Elspeth Chisholm, 17 September 1973, ECC, box 12.

128 J.A. Corry to Jarvis, 23 February 1955, and John C. Parkin to Jarvis, 4 May 1955, NGA file 7.4J.

129 The quote is from Fell to Jarvis, 12 July 1955, NGA, file 9.2F. Also Jarvis to Fell, 13 July 1955, NGA, file 8.1B.

130 Jarvis to A.F. Key, 19 and 22 July 1955, NGA, file 7.4J.

131 Jarvis to Ben Sonnenberg, 21 Sept 1955, NGA, file 5.5H.

132 Kenneth Lochhead interviewed by the author, 29 July 2003.

133 Ronald Bloore interviewed by the author, December 2003. Kenneth Lochhead interviewed by the author.

134 Doris Shadbolt interviewed by Elspeth Chisholm, ECC, CD A1 2003-06-0042.

135 Key to Jarvis, 22 July 1955, NGA, file 7.4J.

136 Ronald Bloore interviewed by the author.

137 Sir Kenneth Clark to Jarvis, 19 January 1955, AJC, box 2. Jarvis claimed that the title referred to James Thurber's book *Is Sex Necessary?*

138 The quotes are from Jarvis' Undated speaking notes, NGA, file 7.4J. Also Alan Jarvis, "A World without Frontiers," 6 December 1956, *The Empire Club of Canada Speeches, 1956–1957,* Toronto: Empire Club Foundation, 1957, 111–22.

139 "Persona Grata – Is Art Really Necessary?," *Saturday Night,* 21 January 1956, 11.

140 For audience reactions, see for instance John C. Parkin to Jarvis, 22 June 1955, NGA, file 7.4J. Jarvis' ability to convey complex ideas is from Ronald Bloore interviewed by the author.

141 Jacques de Tonnancour to Hubbard, 6 March 1956, RHC, vol. 13.

142 E.J. Walker, "About Alan Jarvis, Director of the National Gallery," *Highlights,* December 1955, 4.

143 "Public Opinion Expects Ottawa Support Arts," *Globe and Mail,* 13 November 1956, 7.

144 Dorothy Cameron interviewed by Elspeth Chisholm, ECC, CD A1 2003-06-0047.

145 David Silcox interviewed by the author, May 2003.

146 Front page photograph captioned "Alan Jarvis: A Blueprint for the Visual Arts," *Saturday Night,* 21 January 1956.

147 "Persona Grata – Is Art Really Necessary?," 11.

148 Robert McKeown, "Is Art Necessary?," *Weekend* magazine, 19 May 1956, 2–5, 36, 39.

149 H.A. Young to Jarvis, 7 June 1956, AJC, box 3.

150 "City Museum Called Pompous," *Regina Leader Post,* 29 May 1956, 3.

151 *Debates of the House of Commons,* Session 1956, vol. I, Ottawa: Queen's Printer, 1956, 1 June 1956, 4546.

152 Martin Baldwin to Jarvis, 25 May 1956, and Steegman to Jarvis, 31 May 1956, AJC, box 3.

153 W.G. Davies of Moose Jaw to Jarvis, 24 May 1956, Sheila McManus of Halifax to Jarvis, 30 May 1956, and Evelyn R. Wright of Fredericton to Jarvis, 4 June 1956, AJC box 3.

154 Leslie Loomer to Jarvis, 30 May 1956, AJC, box 3.

155 BOT, 2–3 November 1955.

156 Pickersgill to Jarvis, 3 March 1956, and Fell to Jarvis, 29 March 1956, both Alan Jarvis, civil service personnel file, LAC.

157 *Annual Report for the National Gallery of Canada, 1955–1956*, Ottawa: Queen's Printer, 1956, 28.

158 B.C. Binning to Jarvis, 5 January and 10 February 1956, and Jarvis to Binning, 23 February 1956, NGA, file 7.4V. For a detailed plan for the Gallery's national activities devised by trustees Dorothy Dyde and Lawren Harris, see "Suggestions for a Plan for the Extension Services of the National Gallery," 25 July 1954, JPC, vol. 19. Also BOT, 23 April 1956.

159 *Annual Report for the National Gallery of Canada, 1955–56*, 7.

160 John Steegman's diaries, 14 and 17 August 1956, Steegman collection, King's College, Cambridge.

161 Survey form, dated 31 March 1955, Canadian Museums Association collection, box 21.

162 BOT, 18–19 May 1955.

163 "Memorandum of a Meeting of Representatives of the Fine Arts Departments of Canadian Universities," BOT, 3–4 April 1956.

164 Betty (Devlin) Jarvis interviewed by the author, 4 June 2003.

165 Charles Fell interviewed by Elspeth Chisholm, ECC, CD A1 2003-06-0045.

166 BOT, 23 April, and 17–18 October 1956. Also, Fell to Blunt 20 June 1956, and Fell to Jarvis, 27 June 1956, AJC, box 3.

167 *Debates of the House of Commons*, Session 1955, Ottawa: Queen's Printer, 1955, 1 June 1955, 4315–16.

168 Jarvis to Constable, 16 June and 2 August 1955, and Constable's notes on a telephone conversation with Jarvis, 17 June 1955; also Constable's marginal notes dated 9 August, all WCC.

169 BOT, 2–3 November 1955.

170 The quote and discussions are from BOT, 3 February 1956.

171 *Debates of the House of Commons*, Session 1956, Ottawa: Queen's Printer, 1956, 8 February 1956, 962.

172 *Debates of the House of Commons*, 8 February 1956, 965.

173 BOT, 3 February 1956.

174 *Debates of the House of Commons* 5 March 1956, 1827.

175 "What the National Gallery Buys," *Montreal Gazette*, 28 March 1956, 8; "Masterpieces on the Move," *The Times*, 19 March 1956, 3. Jarvis' comment about "hardware merchants" is mentioned in J.A. Hume, "Approve Payment of $885,000 for

4 National Gallery Paintings," *Ottawa Citizen*, 23 March 1956, 4. Also LeRoux
Smith LeRoux to Jarvis, 28 March 1956, AJC, box 3. LeRoux was an art advisor
to Lord Beaverbrook.

176 *Debates of the House of Commons*, 14 March 1956, 2125.

177 *Debates of the House of Commons*, 21 March 1956, 2479–80.

178 J.A. Hume, "Approve Payment."

179 Boggs, *National Gallery*, 51; and *Debates of the House of Commons,* Session 1956,
Ottawa: Queen's Printer, 1956, 22 March 1956, 2486–95.

180 *The Letter Review* (Fort Erie, Ontario), 16 April 1956, unnumbered pages.

181 *Annual Report for the National Gallery of Canada for 1956-1957*, Ottawa: Queen's
Printer, 1957, 10. See also BOT, 23 April 1956.

182 W.G. Constable, *National Gallery of Canada*, 20 April 1956, JPC, vol. 19; *National
Gallery of Canada Annual Report for 1955-56*, Ottawa: Queen's Printer, 1956, 28;
National Gallery of Canada Annual Report for 1956–1957, Ottawa: Queen's Printer,
1957, 10; and BOT, 23 April 1956.

183 Jarvis to Fell, 30 July 1956, and Fell to Jarvis, 10 September 1956, NGA, file 9.2F.

184 *Debates of the House of Commons,* Session 1956, Ottawa: Queen's Printer, 1956,
5 July 1956, 5673. Press release, 6 July 1956, NGA, file 1.11L.

185 Buchanan to Hubbard, 13 July 1956, NGA, file 1.11L.

186 Fell to Jarvis, 13 July 1956, AJC, box 3.

CHAPTER ELEVEN

The quote in the chapter title is from J.A. Hume, "Approve Payment of $885,000
for 4 National Gallery Paintings," *Ottawa Citizen*, 23 March 1956, 4. The charge
was levelled at Jarvis directly in December 1957 on the CBC television program
Close Up.

1 *National Gallery Annual Report for 1956–1957*, Ottawa: Queen's Printer, 1957, 7.

2 A.Y. Jackson to Dorothy Dyde, 13 and 22 June 1957, Dorothy Dyde collection. For
English friends, see W.H. Hodgson to Jarvis, 24 June 1957, AJC, box 3.

3 Jarvis to Eric Morse, 10 April 1957, NGA, file 7.4J.

4 Mudgie to Jarvis, 14 May 1957, AJC, box 3; Janet Bee to Jarvis, "Mother's day," and
4 May 1955, AJC, box 55.

5 George Y. Masson to Jarvis, 19 February 1957, and Clifford Wilson to Jarvis,
21 November 1958, AJC, box 3. For concerts, see Anecdotes about Alan Jarvis, ECC,
CD A1 2003-06-0042.

6 Betty (Devlin) Jarvis interviewed by author, 4 June 2003. Jarvis also confided that he was an "old bachelor" who had no idea about raising children to Alison Ignatieff. See Alison Ignatieff interviewed by Elspeth Chisholm, ECC, CD A1 2003-06-0044.

7 Jarvis to Claude Bissell, 4 January 1957, AJC, box 9; Bissell to Jarvis, 30 May 1957, AJC, box 3.

8 Jarvis made no contributions to one of the few meetings he did attend on 16 July 1958. "Minutes of a Joint Meeting of the Building Committee and the Executive Committee," Carleton University Special Collections and Archives. For his resignation, see Jarvis to H.H.J. Nesbitt, 23 May 1961, AJC, box 9.

9 *National Gallery Annual Report for 1958–1959*, Ottawa: Queen's Printer, 1959, 7, 33.

10 Fell to Jarvis, 14 June 1957, AJC, box 3. Also Robert Hubbard interviewed by Elspeth Chisholm, ECC, CD A1 2003-07-0016.

11 Fell to Jarvis, 24 June 1957, AJC, box 3.

12 See Newsletter no. 1, 18 July 1955, NGA, file 9.2F; Fell to Jarvis, 6 July 1956, AJC, box 3; and Fell to Jarvis, 8 April 1959, AJC, box 4. For the by-laws, see BOT, 7–8 January 1957.

13 *National Gallery Annual Report for 1957–1958*, Ottawa: Queen's Printer, 1958, 34.

14 Benjamin Sonnenberg to Jarvis, 1 September 1956, and Jarvis to Sonnenberg, 8 and 21 September 1956, NGA, file 5.5H. For Pickersgill's impression of the visit, see Jack Pickersgill interviewed by Elspeth Chisholm, ECC, CD A1 2006-06-0044.

15 Jarvis to Philip Surrey, photo editor of *Weekend* magazine, 31 October 1956, NGA, file 5.5H.

16 *National Gallery Annual Report for 1957–1958*, 9–13, 34–5, 44–59. *National Gallery Annual Report for 1958–1959*, 10–13, 33–6, 44–53. *A Loan Exhibition of Paintings and Sculpture from the Niarchos Collection*. For Jarvis and Governor General Vincent Massey, see Mayfair Personalities," *Mayfair* magazine, June 1959, 27.

17 The quote is taken from 1957 Second Biennial Exhibition of Canadian Art; see also The Third Biennial Exhibition of Canadian Art, 1959, Organized and Circulated by the National Gallery, both Canada Foundation collection, box 79.
National Gallery Annual Report for 1958–1959, 33.

18 As quoted in Hume, "Approve Payment," 4.

19 *National Gallery Annual Report for 1958–1959*, 7, 33.

20 Lorne Pierce to Jarvis, 28 January and 10 February 1959, AJC, box 4. Jarvis to Pierce, 19 February 1959, AJC, box 9.

21 "National Gallery Association, Annual Meetings, 1959–1960, Constitution, dated 8 June 1959," G.H. Southam collection.

22 The quote is from Pearl McCarthy, "This Plan Will Help Art Live," *Globe and Mail*, 22 November 1958, 22. See also BOT, 22 October 1958.

23 McCurry to Martin Baldwin, 29 March 1950, NGA, file 5.5Q. Press release, NGA, file 5.55Q. For underwhelming interest, IODE, 14 June, 5 July, 6 September 1950, box 7.

24 IODE, 4 October, 6 December 1950, box 7.

25 Ibid., 16 November 1950, box 7.

26 Ibid., 4 October 1950, box 7.

27 Ibid., 5 April 1950, box 7.

28 "Princess Elizabeth Will Present Carpet," *Echoes*, autumn 1951, 24.

29 Kathleen Fenwick, press release, 25 October 1951, NGA, file 5.55Q.

30 Robert Hubbard, memo, 18 June 1952, NGA, file 5.55QQ.

31 Helen E. Chapman to McCurry, 7 January 1953, NGA, file 5.5Q.

32 McCurry to Chapman, 8 January 1953, NGA, file 5.5Q.

33 BOT, 11–12 March 1953.

34 Pauline McGibbon to Vincent Massey, 15 July 1954, NGA, file 5.5Q.

35 Massey to Fell, 3 August 1954, NGA, file 5.5Q.

36 Fell to Massey, 9 August 1954, NGA, file 5.5Q. Fell described how he would see Massey at the end of each meeting of the board of trustees in Charles Fell interviewed by Elspeth Chisholm, ECC, CD A1 2003-06-0045.

37 McCurry to Fell, 9 August and 26 October 1954, NGA, file 5.5Q.

38 Pauline McGibbon to Jarvis, 14 April 1955; the quote is from Fell to Jarvis, 4 May 1955, both NGA, file 5.5Q.

39 Jarvis to Kathleen Drope, 5 May 1955, NGA, file 5.5Q. See also Anecdotes about Alan Jarvis, ECC, CD A1 2003-06-0042.

40 Doug Owram, *Born at the Right Time: A History of the Baby Boom Generation*, 88–90.

41 "Persona Grata – Is Art Really Necessary?," *Saturday Night*, 21 January 1956, 11.

42 *National Gallery Annual Report for 1956–1957*, Ottawa: Queen's Printer, 1957, 22. The episode with Jarvis was entitled *This Is the National Gallery*.

43 Sir Allen Lane to Jarvis, 5 April 1957, AJC, box 3.

44 *The Things We See*, episode 1, NGA.

45 Ibid., episode 2, NGA.

46 Ibid., episode 3, NGA.

47 Ibid., episode 5, NGA

48 Ibid., episodes 6, 7, 8, NGA. Jarvis' idea of a documentary that showed how sculptures were made dated as far back as 1940. Jarvis to Fanny Myers, 5 March 1940, EFB.

49 *The Things We See*, episode 10, NGA.

50 Ibid., episode 12, NGA.

51 Pearl McCarthy, "Use Your Own Eyes Alan Jarvis Advises," *Globe and Mail*, 6 July 1957, 20.

52 *Close-up*, December 1957, LAC.

53 The columns appeared in the *Star Weekly* under the heading "Canadian Paintings." They were "*The Ferry Quebec*, James Wilson Morrice," 4 January 1958, 22; "*Gleam on the Hills*, J.E.H MacDonald," 11 January 1958, 26–7; "*Indian Church*, Emily Carr," 18 January 1958, 23; "*Water Lillies*, David Milne," 25 January 1958, 22–3; "*Ghost Ships*, B.C. Binning," 1 February 1958, 26–7; "*Sous le vent de l'ile*, Paul-Émile Borduas," 8 February 1958, 24–5; "*Boy and His Dog*, Goodridge Roberts," 22 February 1958, 26–7; "*Landscape, Northwestern Ontario*, Jacques de Tonnancour," 1 March 1958, 26–7; and "*Coup sur coups*, Jean-Paul Riopelle," 8 March 1958, 28–9.

54 Vincent Tovell to Jarvis, 9 and 15 December 1958, AJC, box 3.

55 *Explorations: The Mask*, 5 February 1959, LAC.

56 Tovell to Jarvis, 15 December 1958, AJC, box 3.

57 Vincent Tovell, "Explorations," 25. For the other series, see M.E. Lafontaine to Jarvis, 31 March and 5 June 1959, AJC, box 4.

58 Tovell to Jarvis, 16 January 1959, AJC, box 3. The quote is from Tovell, "Explorations," 24.

59 *Explorations: The Renaissance*, episodes 1–3, 1959, LAC.

60 Tovell interviewed by Elspeth Chisholm, ECC, CD A1 2003-07-0015.

61 Alan Jarvis, "A World without Frontiers," 6 December 1956, *The Empire Club of Canada Speeches 1956–1957*, Toronto: Empire Club Foundation, 1957, 111–22.

62 John Steegman's diaries, 31 March 1958, Steegman collection, King's College, Cambridge.

63 *National Gallery Annual Report for 1957–1958*, Ottawa: Queen's Printer, 1958, 9.

64 Martha J. King, "The National Gallery of Canada at Arm's Length from the Government of Canada: A Precarious Balancing Act," 60.

65 Hubbard to Jarvis, 14 July 1957, AJC, box 3; and BOT, 7–8 January 1957.

66 Kathleen Fenwick as quoted in BOT, 7–8 January 1957.

67 BOT, 7–8 January 1957.

68 Pickersgill interviewed by Elspeth Chisholm, ECC, CD A1 2003-06-0044.

69 E. Davie Fulton interviewed by Elspeth Chisholm, ECC, CD A1 2003-06-0039.

70 Agnew to Jarvis, 16 August and 16 October 1957, NGA, file 1.11L.

71 Cabinet Conclusions, 5 February 1958, LAC.

72 Jackson to Dyde, 13 February 1958, Dorothy Dyde collection.

73 Jarvis to Fulton, 18 April 1958, NGA, file 9.1C.

74 Cabinet Conclusions, 2 May 1958, LAC.

75 Cabinet Conclusions, 7 May 1958, LAC.

76 Fulton interviewed by Elspeth Chisholm.

77 Geoffrey Agnew, "*Madonna Annunciate* by Lorenzo Monaco, (from the collection of the Prince of Liechtenstein)," as transcribed in BOT, 3–4 June 1959.

78 Ellen Louks Fairclough, *Destiny's Child: Memoirs of Canada's First Female Cabinet Minister*, 109; The critical assessment is in Peter C. Newman, *Renegade in Power: The Diefenbaker Years*, 99–100.

79 Kendrick Venables interviewed by Elspeth Chisholm, ECC, CD A1 2003-07-0015.

80 Fairclough interviewed by Elspeth Chisholm, ECC, CD A1 2003-06-0044; Fairclough, *Destiny's Child*, 109–10; and "Ellen Fairclough, MP," *Echoes*, summer 1950, 44.

81 Cabinet Conclusions, 27 May 1958, LAC.

82 George Ignatieff interviewed by Elspeth Chisholm, ECC, CD A1 2003-06-0044.

83 Pavitt to Alan Jarvis, 15 October 1961, AJC, box 5.

84 Von Polnitz to the Board of Trustees, 25 May 1959, as transcribed in BOT, 2–4 June 1959. His subsequent letters were dated 16 July, 16 August, 16 September, 16 October, 16 November, and 20 December, 1958; all NGA.

85 BOT, 3–4 June 1959.

86 Cabinet Conclusions, 10 July 1958, LAC.

87 Cabinet Conclusions, 14 July 1958, LAC.

88 Cabinet Conclusions, 9 August 1958, LAC.

89 John Steegman's diary, 6 September 1958, Steegman collection, King's College, Cambridge.

90 BOT, 22 October 1958.

91 Fell to Jarvis, 16 October 1958, AJC, box 3.

92 Peter C. Newman, "Is Jarvis Mis-Spending Our Art Millions?," *MacLean's*, 22 November 1958," 20–44, quote on 41.

93 McCullough to Jarvis, 4 November 1958, AJC, box 3.

94 For "boiling mad," see Hirshhorn to Jarvis, 17 November 1958; for the letter to *Maclean's*, see Hirshhorn to Ralph Allen, 17 November 1958, both AJC, box 3.

95 Gilles Leclerc to Jarvis, 16 November 1958, AJC, box 3.

96 Agnew to Jarvis, 5 December 1958, as transcribed in BOT, 3–4 June 1959.

97 "Gallery Board May Quit," *Ottawa Journal*, 16 December 1958, 1. Further confidential details about the negotiations "from a member of the board of Trustees" appeared in "Claim PCs Welched in $440,000 Art Deal, 7 May Quit Board," *Toronto Star*, 16 December 1958, 27–8.

98 The quote is from "Cabinet Didn't OK $440,000 Art – Fulton," *Toronto Star*, 17 December 1958, 2. Also "Canada Picture Deal Goes Awry," *The Times*, 18 December 1958, 10.

99 "Cabinet in Crisis Over Spending, Fear 'Runaway Inflation,'" *Toronto Star*, 17 December 1958, 31; for the unemployment figures, see "December Jobless at 440,000," *Montreal Gazette*, 21 June 1959, 3.

100 For Jarvis' refusal to comment, see "Cabinet Didn't OK."

101 "Canada Picture Deal Goes Awry"; Cabinet Conclusions, 17 December 1958, LAC; Jackson to Dorothy Dyde, 29 December 1958, Dorothy Dyde collection; "No Vision Here," *Toronto Star*, 27 December 1958, 29; Tania Long, "Debate about Art Looms in Ottawa," *New York Times*, 4 January 1959, 2.

102 Paul Duval, "Don't Buy the Prince of Liechtenstein's Pictures Until We Can Afford His Best," *Toronto Telegram*, 20 December 1958.

103 John Steegman's diary, 7 January 1959, Steegman collection, King's College, Cambridge.

104 *Debates of the House of Commons,* Session 1959, 19 January 1959, Ottawa: Queen's Printer, 1959, 48.

105 Fell to Jarvis, 21 January 1959, AJC, box 4.

106 *Debates of the House of Commons,* 11 February 1959, 904–5; for an example of Murphy's earlier scrutiny of the Gallery, see the list of purchases in *Debates of the House of Commons,* Session 1957, Ottawa: Queen's Printer, 1959, 554–5.

107 "Art Authorities Reach Stalemate on Value of Modern Expressionism," *Ottawa Citizen*, 17 February 1959, 3.

108 *Debates of the House of Commons*, 25 February 1959, 1364.

109 "Art Authorities Reach Stalemate on Value of Modern Expressionism."

110 Cabinet Conclusions, 24 February 1959, LAC.

111 *Debates of the House of Commons,* 25 February 1959, 1364.

112 *Debates of the House of Commons,* 11 March 1959, 1856–7. The member was Hazen Argue of the Co-operative Commonwealth Federation.

113 *Debates of the House of Commons,* 12 March 1959, 1903–5, quote on 1905.

114 *Debates of the House of Commons,* 13 March 1959, 1915–21, quotes on 1915.

115 A.L., "Memorandum for Mr Bryce Re: Brueghel and Monaco Paintings," 13 May 1959, PCC, vol. 226, file N-12-2.

116 Douglas Ord, *The National Gallery of Canada: Ideas, Art, Architecture,* 162; BOT, 3–4 June 1959.

117 Imperial Order Daughters of the Empire to Jarvis, 22 April 1959, AJC, box 4. The article had appeared in the 17 April edition of the *Toronto Telegram.* See also Alison Ignatieff interviewed by Elspeth Chisholm, ECC, CD A1 2003-06-0044.

118 Confidential interview with the author.

119 "Queen Mary's Carpet Not 'Art,' Is Hidden," *Toronto Star,* 17 April 1959, 1.

120 *The Times of London,* 18 May 1959. Women's Voluntary Services of London, England, to Jarvis, 20 April 1959; Imperial Order Daughters of the Empire to Jarvis, 22 April 1959; and Lady Cynthia Colville to Jarvis, 24 April 1959, all AJC, box 4.

121 *Debates of the House of Commons,* 20 April 1959, 2832, 2912.

122 Cabinet Conclusions, 24 February and 20 May 1959, LAC.

123 Von Polnitz to the Board of Trustees, 25 May 1959, as transcribed in BOT, 3–4 June 1959. Also Cabinet Conclusions, 14 May 1959, LAC.

124 A.L. "Memorandum for Mr Bryce re Brueghel Painting."

125 Cabinet Conclusions, 20 May 1959, LAC.

126 Fell to Diefenbaker, 29 June 1959, PCC, vol. 226, file N-12-1-1.

127 Cabinet Conclusions, 21 July 1959, LAC.

128 Cabinet Conclusions, 22 July 1959, LAC.

129 Cabinet Conclusions, 31 July 1959, LAC.

130 Jarvis to Hirshhorn, 3 August 1959, AJC, box 9.

131 Norman Hay interviewed by Elspeth Chisholm, ECC, CD A1 2003-06-0038.

132 Jarvis to Fairclough, 24 August 1959, AJC, box 9; two versions of his resignation letter exist in Jarvis' archives. Fairclough to Jarvis, 26 August 1959, AJC box 4.

133 Cabinet Conclusions, 27 August 1959, LAC. Also National Gallery: Settlement with Agnew on Monaco painting, 26 October 1959, PCC, vol. 226, file N-12-2.

134 Ellen Fairclough interviewed by Elspeth Chisholm, ECC, CD A1 2003-06-0044.

135 Kendrick Venables interviewed by Elspeth Chisholm, ECC, CD A1 2003-07-0015.

136 Morgan to Diefenbaker, 2 October 1959, PCC, vol. 226, file N-12-1.

137 Diefenbaker to Morgan, 17 October 1959, PCC, vol. 226, file N-12-1; and "Too Much Interference," *Montreal Star*, 28 October 1958, 8.

138 William McGuffin, "Artist Won't Quit Post: 'Tories Never Show Interest in Art,'" *Toronto Star*, 28 October 1959 28.

139 Jane Clark to Jarvis, "Sunday" September 1959, AJC, box 4.

140 Sir Kenneth Clark to Jarvis, 23 September 1959, AJC, box 4.

141 Norman Berlis to Jarvis, 10 September 1959, AJC, box 4.

142 Watson Balharrie to Jarvis, 10 September 1959, and Marius Plamondon to Jarvis, 22 September 1955, AJC, box 4.

143 Frances Loring to Jarvis, 9 September 1959, AJC, box 4.

144 Brown to Jarvis, 11 September 1959, AJC, box 4.

145 McInnes to Jarvis, 23 September 1959, AJC, box 4.

146 Pavitt to Jarvis, 12 September 1959, AJC, box 4.

147 Richard Gwyn radio script, 10 September 1959, AJC, box 2.

148 Robertson Davies, "Jarvis Falls: Long Live Attila," *Peterborough Examiner*, 11 September 1959, 4. Judith Skelton Grant, *Robertson Davies: Man of Myth*, 568.

149 Blair Fraser, "The Growing List of 'Resignations,' Alan Jarvis Goes: Who's Next?," *Maclean's*, 10 October 1959, 2.

150 "Canada Troubled by Art Gallery," *New York Times*, 8 November 1959, 128.

151 Stuart Tweedie interviewed by Elspeth Chisholm, ECC, CD A1 2003-06-0039.

152 Richard Simmins to Jarvis, 13 August 1959, AJC, box 4.

153 Jarvis to Hubbard, 4 October 1959, Alan Jarvis Civil Service personnel file, LAC.

154 Hubbard to Blunt, 7 October 1959, RHC, vol. 13. Blunt had been knighted in May 1956.

155 Robert Wark to Hubbard, 19 October 1959; Alan Gowans to Hubbard, 21 Oct 1959; Jean Sutherland Boggs to Hubbard, 3 November 1959. In addition to these personal correspondences, on 23 October 1959, Hubbard wrote David Baxendall of the National Gallery of Scotland; Sir John Rothenstein, director of the Tate Gallery; Sir Philip Hendy, of the National Gallery, London; and Trenchard Cox, of the Victoria & Albert Museum, asking them to identify suitable candidates for the job, RHC, box 13.

156 "Comfort Accepts Art Job," *Toronto Star*, 11 January 1960, 1.

157 "Saturday Hoax Painting Prize Winner," *Toronto Star*, 26 December 1959, 2.

The quote in the chapter title is from Gail Dexter, "Alan Jarvis: Unfortunate Interlude," *Toronto Star*, 21 August 1968, 73.

1 *Debates of the House of Commons*, Session 1960, Ottawa: Queen's Printer, 1960, 548.

2 "2500 Crowd New Gallery for Official Opening by PM," *Ottawa Journal*, 18 February 1960, 16; Shirley Gillespie, "Mothballs Mingle with Chanel No. 5," *Ottawa Journal*, 18 February 1960, 23; Bruce MacDonald, "White Tie Proves to Be Flimsy," *Toronto Star*, 18 February 1960, 21.

3 Eileen Turcotte, "Gallery Head Stands Firm: No Controversy for Him," *Ottawa Journal*, 17 February 1960, 3.

4 Robert Fulford, "Gallery Drab and Dull," *Toronto Star*, 18 February 1960, 33.

5 Betty (Devlin) Jarvis, interviewed by the author, 4 June 2003.

6 "Gallery Row: Comfort Denies Quitting," *Toronto Star*, 20 February 1960, 1.

7 "Art Gallery Rebels Protest Jarvis Snub," *Toronto Star*, 24 February 1960, 1. The abstainers were Donald Buchanan and the Gallery's business manager John Veit.

8 Greg Connolly, "Jarvis Was Fired – Former Trustee," *Ottawa Citizen*, 18 February 1960, p.1.

9 *Debates of the House of Commons*, 22 February 1960, 1294.

10 Fell to Buchanan, 22 February 1960, RHC, vol. 14.

11 "Are Canadians Snobbish about Art?," *Chatelaine*, May 1960, 8.

12 *Debates of the House of Commons*, Session 1960, vol. 7, Ottawa: Queen's Printer, 1960, 7326, 7389; Robert Fulford, "Associate Director Resigns: New Crisis Threatens National Gallery," *Toronto Star*, 30 July 1960, 19, 25.

13 Norman Hay interviewed by Elspeth Chisholm, ECC, CD A1 2003-06-0046; Dorothy Cameron interviewed by Elspeth Chisholm, ECC, CD A1 2003-06-0047; and Philip Torno interviewed by Elspeth Chisholm, ECC, CD A1 2003-06-0039.

14 For the Fairclough comment, see Paul Russell interviewed by Elspeth Chisholm, ECC, CD A1 2003-07-0015. For the Diefenbaker comment, see Doris Shadbolt interviewed by Elspeth Chisholm, ECC, CD A1 2003-06-0042.

15 Alan Jarvis, "The Arts: Walking on Eggs," *The Journal of Liberal Thought*, summer 1965, 79–80, quote on 79.

16 "Alan Jarvis Seriously Ill," *Toronto Star*, 19 August 1968, 1.

17 Jean (Stewart) Gunn to Jarvis, 2 February 1961, AJC, box 5.

18 Alan Toff interviewed by Elspeth Chisholm, ECC, CD A1 2003-06-0038.

19 Documents incorporating Alan Jarvis Associates on 1 June 1961 are found in AJC, box 33. The quote is taken from the firm's 1962 corporate income tax return, AJC, box 59.

20 T1 Income Tax form for 1961, AJC, box 61.

21 Audrey Hay to Jarvis, undated, AJC, box 12. Audrey was Norman Hay's wife.

22 Mary Nicholson to Jarvis, 10 March 1962, AJC, box 5.

23 Mervyn Stockwood interviewed by Elspeth Chisholm, ECC, CD A1 2003-07-0016.

24 Burnet Pavitt to Jarvis, 8 December 1962, AJC, box 5; Pavitt to Jarvis, 18 November 1963, AJC, box 6; and Mary Nicholson to Jarvis, 10 March 1962, AJC, box 5. Gelber and Torno's attempts to help were related to the author by David Silcox and Betty (Devlin) Jarvis.

25 Hay interviewed by Elspeth Chisholm. Also Robert Fulford interviewed by the author, 29 June 2003.

26 Alan Hanlon interviewed by Elspeth Chisholm, ECC, CD A1 2003-07-0020. Hanlon directed Rothmans' art program.

27 Sordsmen's Club to Jarvis, 1 and 21 November 1961, AJC, box 5. Jarvis was to have been paid $125 to speak at the lunch.

28 For the Calder sculpture, see Martha Jackson to Jarvis, 27 November 1962. The sculpture was sold for $400. Eaton's to Jarvis, 13 August 1962, G.A. Halliday to Jarvis, 28 December 1962, 28 January 1963, AJC, box 5. For the performers' union, see ACTRA to Jarvis, 1 October 1963, AJC, box 6; ACTRA to Jarvis, 20 February 1964, AJC, box 7. Eleanor Lipson to Jarvis, 22 March 1963, AJC, box 6.

29 Jarvis to P.S. Dodd, 7 November 1963, AJC, box 10.

30 Cable from Scandinavian Airlines, 23 October 1963, and John A. Kelly to Jarvis, 18 November 1963, AJC, box 6.

31 Jarvis to Pavitt, 14 November 1963, AJC, box 6.

32 Jarvis to Hubbard, 9 January 1964, AJC, box 10; Gunn to Jarvis 26 February 1964, AJC, box 7.

33 Norman Hay to Jarvis, 8 December 1963, AJC, box 6.

34 Gunn to Jarvis, 26 February and 20 August 1964, AJC, box 7. Also Grenfell to Jarvis, undated but almost certainly from this time, AJC, box 12.

35 Marjorie Harris interviewed by the author, 17 August 2004. Harris worked for Dorothy Cameron.

36 Barbara Moon interviewed by Elspeth Chisholm, ECC, CD A1 2003-07-0020.

37 Johnny Wayne interviewed by Elspeth Chisholm, ECC, CD A1 2003-07-0020.

38 Robert Fulford, "The Jarvis Generation: A Footnote to an Era," *Saturday Night*, January 1973, 9.

39 Parkin to C.S. Band, 6 October 1959, and Band to Jarvis, 30 October 1959, AJC, box 4.

40 For Minneapolis, see Richard S. Davis to Jarvis, 2 November 1959; for Carolina, see E.L. Davis to Jarvis, 12 January 1960, and Robert Lee Harter to Jarvis, 27 July 1960; for Seattle, see Norman Davis to Jarvis, 2 August 1960, all AJC box 4.

41 Dorothy Cameron interviewed by Elspeth Chisholm.

42 Gordon Washburn to Jarvis, 7 June 1962, AJC, box 5. Washburn knew Jarvis through working on the Biennial of Canadian Art. Also Evan Turner to Jarvis, 7 June 1962, AJC, box 5.

43 Gordon Washburn to Jarvis, 21 June 1962, James M. Bovard to Jarvis, 21 June 1962, Bovard to Jarvis, 12 July 1962, AJC, box 5. Also Jarvis to Bovard, 24 July 1962, AJC, box 9.

44 Jarvis to Bovard, 24 July 1962, AJC, box 9.

45 Bovard to Jarvis, 25 September, 26 October, and 26 November 1962, AJC, box 5.

46 For Dallas, see Stanley Marcus to Jarvis, 1 November 1963, AJC, box 6; for the Frick, see Hank Brennan to Jarvis, 27 January 1964, AJC, box 7. Brennan was married to Jarvis' onetime love Fanny Myers.

47 Arthur Gelber interviewed by Elspeth Chisholm, ECC, CD A1 2003-06-0047.

48 Jarvis to Gelber, undated, AJC, box 9; also CCA newsletter, 24 February 1960, Canada Foundation collection, box 26.

49 Gelber interviewed by Elspeth Chisholm.

50 For "Ali Jar," see Silcox to Jarvis, 30 March 1963, AJC, box 6. Also, the letters from Silcox to Jarvis found in AJC, box 12.

51 Press release, 17 February 1961, Canada Foundation collection, box 26.

52 Canadian Conference of the Arts Newsletter, 30 July 1960, Canada Foundation collection, box 26.

53 See for instance press release, 17 February 1961, and Conference poster, both Canadian Foundation collection, box 26.

54 Vincent Tovell interviewed by Elspeth Chisholm. ECC, CD A1 2003-06-0039.

55 Reinhold Kramer, *Mordecai Richler: Leaving St Urbain*, 161–2.

56 "Tastemakers' Toronto Tea Party," *Saturday Night*, 27 May 1961, 5.

57 Mitchell Sharp to Jarvis, 12 August 1960, AJC, box 4. Also Mitchell Sharp, *Which Reminds Me: A Memoir*, 273. Jarvis was paid $200 for the appearance.

58 C.F. Carsley to Jarvis, 10 April 1963, AJC, box 6.

59 Carsley to Jarvis, 31 May 1963, and G. Hamilton Southam to Jarvis, 27 May, 2 and 29 October 1963, AJC, box 6. Robbins Elliot to Jarvis, 27 February 1964, AJC, box 7. For the per diem, see Jarvis to John W. Fisher, undated, AJC, box 9.

60 G.G.E. Steele to Jarvis, 30 April 1965, AJC, box 7; and Jarvis to Steele, 25 August 1965, AJC, box 10

61 Maurice Lamontagne keynote address, 19 January 1965, Canada Foundation collection, box 74.

62 Jarvis, "Walking on Eggs," 82. *Seminar 65: Agenda and Notes*; and *Seminar 65: Report*, both Canada Foundation collection, box 26.

63 Tovell interviewed by Chisholm.

64 Ibid.

65 Jarvis is quoted in Bruce Lawson, "What Really Happened at That Artists' Conference," *Globe and Mail*, 2 April 1966. Also Robert Fulford, "What Happened at Seminar 66," *Toronto Star*, 28 March 1966.

66 "The Way We Are / Alan Jarvis, Sculptor and Writer," *Toronto Star*, 6 February 1971, 14.

67 "Jarvis Hired Minutes after Quitting Gallery," *Ottawa Citizen*, 10 September 1959, 28l. Also Philip Torno interviewed by Elspeth Chisholm, ECC, CD A1 2003-06-0039.

68 Walter Herbert to Paul Arthur, 9 September 1959, Canada Foundation collection, box 23.

69 Jarvis to Walter Herbert, 3 March 1961, and Herbert to Paul Arthur, 9 September 1959, Canada Foundation collection, box 23.

70 John C. Parkin, Memorandum re *Canadian Art* Magazine, 6 May 1960, Canada Foundation collection, box 23; Jarvis to various people in December 1959, AJC, box 9.

71 Jarvis to Robertson Davies, 21 January 1960, Paul Arthur to Jarvis, 17 July 1963, and Jarvis to Sir Kenneth Clark, undated, AJC, box 6.

72 Paul Arthur to Jarvis, 26 September 1963, AJC, box 6. Philip Torno interviewed by Elspeth Chisholm. "Journalism: Artful Austerity," *Time*, 17 May 1963, p.18.

73 Author's collection. It is unclear when this was given away with the magazine.

74 Arthur to Jarvis, 5 March 1963, and Barbara Kilvert to Arthur, 22 March 1963, AJC, box 6. Jarvis to Arthur, 12 November 1963, AJC, box 5.

75 Jarvis to McConnell, 16 July 1964, AJC, box 10; Walter Herbert to McConnell, 4 June 1964, Canada Foundation collection, box 23. "Journalism: Artful Austerity," 18.

76 R. Keith Sullivan to Jarvis, 15 July 1964, AJC, box 7.

77 Paul Arthur to the Society for Art Publications, 8 August 1967; for the Canada Council, see Jean Boucher to Jarvis, 13 September 1967, both AJC, box 8.

78 Wilmat Tennyson to Jarvis, 14 February 1963, 29 October 1965, AJC, box 7. Also Alan Hanlon interviewed by Elspeth Chisholm.

79 Tennyson to Jarvis, 4 April 1963, AJC, box 6.

80 Alan Hanlon interviewed by Elspeth Chisholm. Tennyson to Jarvis, 18 July 1963, AJC, box 6; Tennyson to Jarvis, 4 and 14 February 1964, AJC, box 7. Jarvis to Victor C. Polley, 24 October 1963, AJC, box 10.

81 Unsigned from Rothmans, 10 March 1965, and John G. McConnell to Jarvis, 6 August 1965, AJC, box 7.

82 Samuel Zacks to Albert Trueman, AJC, box 6.

83 The grant was for $7,500. See Canada Council press release, 8 July 1963, Canada Foundation collection, box 75.

84 *Fifteen Canadian Painters*, exhibition catalogue, no publication data, Canada Foundation collection, box 75. Also Alban Lerner, Curator of the Hirshhorn Collection to Jarvis, 12 November 1963, AJC, box 6.

85 Victor C. Polley to Jarvis, 11 January and 15 February 1963, AJC, box 6.

86 Jarvis to Clair Bice, 29 April 1963, AJC, box 10.

87 See for instance Jarvis to Alex Colville, 15 May 1963, and Jarvis to Samuel Zacks, 17 May 1963, AJC, box 5. Also Charles Comfort to Jarvis, 13 March 1963, and Richard Simmins to Jarvis, 12 March 1963, AJC, box 6.

88 M.F. Chambers to Jarvis, May 1963, AJC, box 6. For the wheelchair, see Paul Russell interviewed by Elspeth Chisholm.

89 Polley to Jarvis, 15 February 1963, Richard Simmins to Jarvis, 12 March 1963, Comfort to Jarvis, 13 March 1963, and Wilmat Tennyson to Jarvis, 18 July 1963, AJC, box 6. Also David Rae to Jarvis, 19 August 1963, AJC, box 6, and Jarvis to Rae, 22 August 1963, AJC, box 5. Paul Russell interviewed by the author, March 2003.

90 Elizabeth Kilbourn, "Art and Artists," *Toronto Star*, 27 June 1964, 10.

91 Polley to Jarvis, 28 April and 17 June 1965, AJC, box 7.

92 "Toronto Sculpture Will Dot Theatre Lawns," *Toronto Star*, 10 June 1965, 22.

93 Polley to Jarvis, 17 June and 22 September 1965, AJC, box 7. The quote is found in the second letter.

94 Tennyson to Jarvis, 29 October 1965, AJC, box 7. Also "Stratford Art Gallery to Get $100,000," *London Free Press*, 16 November 1966, 4.

95 David Silcox interviewed by the author, 30 June 2003. Robert Fulford, "World

of Art," *Toronto Star*, 25 February 1961, 30. Donald Harvey to Jarvis, 2 November 1960, AJC, box 4. Douglas J. Horan to Jarvis, 17 May 1961, AJC, box 5.

96 Nathan Cohen, "Sneak Hit: Celebrities Satirised," *Toronto Star*, 6 March 1961, 6.

97 The other speakers in this series were Members of Parliament Lester Pearson and Stanley Knowles, and the journalist Wilfrid Eggleston, AJC, box 42.

98 Mary Scullion O'Neill to Jarvis, 29 February 1960, AJC, box 4.

99 Louise de Brouin to Jarvis, unknown date, AJC, box 4; Kate Aitken to Jarvis, AJC, box 4. Untitled, *Toronto Star*, 28 May 1960, 31. "Special Events," *Toronto Star*, 5 October 1960, 40.

100 Polly Holden to Jarvis, 3 June 1960, AJC, box 4. The event was sponsored by the Canadian Association of Adult Education.

101 Holden to Jarvis, 6 October 1960, AJC, box 11.

102 For Hebrew Association, see Advertisement, *Globe and Mail*, 11 November 1961, 14. "Coming Events for Thursday," *Globe and Mail*, 21 January 1961, 13. "Jarvis Terms Canada Adult in Art World," *Globe and Mail*, 21 February 1961, 22. Also Olive Dickason, "Berates Unoriginal Canadians," *Globe and Mail*, 23 June 1961, 14.

103 Mike Tytherleigh, "Let's Organize the Anti-Uglies," *Vancouver Province*, 29 July 1961, 4.

104 P. Godt to Jarvis, 26 October 1961, AJC, box 5.

105 For Queen's, see J.A. Corry to Jarvis, 6 February 1962, AJC, box 5. "Plaque to Honour Famous Canadian Artist David B. Milne," *Collingwood Enterprise-Bulletin*, 23 August 1962, 8.

106 Jean Brunton, "The Social World," *Globe and Mail*, 25 January 1962, 12.

107 "Arts-Deprived People Seen Needing Psychological Aid," *Kitchener-Waterloo Record*, 22 October 1962, 3; "Art Must Fill Leisure Void, Jarvis Believes," *Globe and Mail*, 22 October 1962, 8.

108 P. Lester of the University Travel Club to Jarvis, 29 March 1966, AJC, box 8. The quotes are taken from the brochure for the tour which is found in AJC, box 42. Frank Starr worked for the University Travel Club. For the Starrs' hospitality, see Michael Starr to the author, 8 October 2008.

109 Sheridan Morley, *A Talent to Amuse: A Biography of Noël Coward*, 308–9. Noël Coward, *The Noël Coward Diaries*, 626–8.

110 Paul Russell interviewed by the author, March 2003.

111 F.R. Crawley to Jarvis, 7 December 1959, AJC, box 4.

112 Crawley to Jarvis, 26 January 1960, AJC, box 4.

113 Jarvis to Crawley, 12 April 1960, AJC, box 4.

114 Crawley to Jarvis, 15 June 1960, AJC, box 4.

115 Jarvis to Hambleton, 5 July 1960, and Hambleton to Jarvis, 17 July and 7 August 1960, AJC, box 4.

116 Jarvis to Crawley, 19 October 1960, AJC, box 9. The interview had been taped for Jarvis' new series of *The Things We See*.

117 Crawley to Jarvis, 28 October 1960, AJC, box 4.

118 R.C. Hilborn to Jarvis, 11 November 1960, and Charles Comfort to Jarvis, 10 November 1960, AJC, box 4.

119 Colleen Zaharuk to Jarvis, 11 February 1960, AJC, box 4.

120 Hambleton to Jarvis, 7 January 1961, and Crawley to Jarvis, 17, 22 February and 15 June 1961, AJC, box 5.

121 John Bassett to Jarvis, 25 March 1960, AJC, box 4. See also Susan Gittins, *CTV: The Television Wars*, 7–26.

122 R.A.I. Purdey to Jarvis, 11 July 1960, AJC, box 4.

123 For the quote, see untitled, *Toronto Star*, 10 September 1960, 22. For the National Film Board, see Jarvis to Guy Roberge, 31 October 1960, AJC, box 9.

124 "Man-of-Many-Arts Jarvis Joins Tely," *Toronto Telegram*, 22 October 1960, 49.

125 "World of Art," *Toronto Star*, 21 January 1961, 30.

126 Vincent Tovell interviewed by the author; and Johnny Wayne interviewed by Elspeth Chisholm.

127 Contract for *The Things We See*, 25 October 1961, and Murray Cherkover to Jarvis, 8 January 1962, AJC, box 5. Also Colin Clark to Jarvis, 17 and 20 February 1964, AJC, box 7.

128 Bassett to Jarvis, 3 November 1961, AJC, box 10. As was common practice in the 1960s, CFTO reused the tapes on which Jarvis' shows had been recorded. See Bassett to Jarvis, 22 March 1971, AJC, box 8.

129 Mary Nicholson to Jarvis, 16 February and 10 March 1962, AJC, box 5. Jarvis to Nicholson, 25 January 1963, Helga Green to Jarvis, 22 March 1963, and Mary Nicholson to Jarvis, 6 May 1963, AJC, box 6.

130 Jarvis to The Washington Square Press, 11 March 1963, AJC, box 10; and Cynthia White of Pocket Books to Jarvis, 22 March 1963, AJC, box 6.

131 Jarvis to Dorothy MacPherson, 10 May 1963, AJC, box 5; Joel W. Aldred to Jarvis, 29 May 1963, AJC, box 6. See also UNESCO *Festival and Seminar on Art*, pamphlet, Canada Foundation collection, box 36.

132 ACTRA to Jarvis, 1 October 1963, AJC, box 6; ACTRA to Jarvis, 20 February 1964, AJC, box 7. Eleanor Lipson to Jarvis, 22 March 1963, AJC, box 6; Jarvis to Max Stern, 27 March 1963, AJC, box 10.

133 Colin Clark to Jarvis, 17, 20 February and 4 May 1964, AJC, box 7.

134 Reeves and Sons Artists' Materials to Jarvis, 26 October 1959, AJC, box 4.

135 H.T. to Jarvis, 7 January 1961, AJC, box 5.

136 Jarvis to Louis Rasminsky, 13 October 1961, Jarvis to Mrs F.K. Venables, 13 October 1961, AJC, box 9.

137 Max Stern to Jarvis, 28 February 1961, Dominion Gallery collection, file 4. Also Stern to Jarvis, 7 March 1961, and Freda Levine to Jarvis, 18 April 1961, AJC, box 5.

138 Jarvis eventually earned $2,135 for his work. The quote is from Jarvis to Freda Levine, 10 March 1960, AJC, box 9. Freda Levine to Jarvis, 10 October and 21 November 1961, AJC, box 5; and Jarvis to Max Stern, 10 March 1961, Dominion Gallery collection, file 4.

139 Jarvis to Stern, 19 September 1961, and Stern to Jarvis, 23 September 1961, Dominion Gallery Collection, file 4.

140 Cameron to Jarvis, 4 October 1960, AJC, box 4.

141 Jarvis to Philip Surrey, 27 November 1961, AJC, box 9. The quote is from Jarvis to Max Stern, 13 November 1961, Dominion Gallery collection, file 4.

142 The Robertson gallery was owned by a former employee of the National Gallery. John Robertson interviewed by Elspeth Chisholm, ECC, CD A1 2003-06-0047.

143 Jarvis to Stern, 20 January 1962, Dominion Gallery collection, file 4. The photographs were of an unnamed Singhalese girl, Justin Hillgarth, Emil Harrell, Sir Keith Hancock, Cyril James, Edgar Carritt, Sir Stafford Cripps, Colin Clark, Peter Ustinov, Kirsten Flagstad, Vera Lindsay, and Lady Bowater.

144 Cameron to Jarvis, 16 May 1961, AJC, box 5.

145 Robert Fulford interviewed by Elspeth Chisholm, ECC, CD A1 2003-06-0047. For the guest lists, see Wendy Darroch, "Alan Jarvis Sculptures on Show," *Toronto Star*, 4 January 1962, 46. A photograph of the actress Barbara Chilcott posing with one of Jarvis' busts was published in the *Newmarket Era and Express*, 18 January 1962, 16. According to Norman Hay, Jarvis had often used this quip in his English days; see Hay interviewed by Robert Fulford, 6 May 1981, Fulford collection, accession 30-1992, box 13.

146 Touche, Ross and Bailey to Jarvis, 24 September 1962, AJC, box 59.

147 Stern to Jarvis, 14 September 1962, Dominion Gallery Collection, file 4.

148 Jarvis to Stern, 21 September 1962, Dominion Gallery Collection, file 4.

149 Jarvis to Stern, 11 December 1962, and Stern to Jarvis, 18 December 1962, Dominion Gallery collection, file 4.

150 "Domestic reasons," are cited in Jarvis to Max Stern, 5 March 1963; "Les Jeux sont

fait," is found in Jarvis to Stern, 27 March 1963, both AJC, box 10 and Dominion Gallery collection, NGA, file 4. See also Jarvis to Stern, 12 February 1963, Dominion Gallery collection, file 4; and Stern to Jarvis, 14 February 1963, AJC, box 6.

151 Jarvis to Phillip Surrey, 27 February 1964, AJC, box 10. For the National Trust building, see untitled, *Toronto Star*, 9 August 1965, 18. For the Worthington sculpture, see J.A. McGuinness to Jarvis, undated, AJC, box 7.

152 Jarvis to Morris Kestleman, 11 August 1965, AJC, box 10.

153 Walter O'Hearn to Jarvis, 15 January 1960, and Fred Dank to Jarvis, 26 January 1960, AJC, box 4.

154 McCarthy to Jarvis, 15 August 1960, AJC, box 4. For his columns, see for instance Alan Jarvis, "Our Cities Are Sick," *Ottawa Journal*, 19 March 1960, 35; "The Aeroquay Concept," *Ottawa Journal*, 3 April 1960, 30; and "Oh Those Bunnies," *Ottawa Journal*, 23 April 1960, 35.

155 Jarvis to John Bassett, 10 June 1960, and Bassett to Jarvis, 13 June 1960, AJC, box 4.

156 "Man-of-Many-Arts Jarvis Joins Tely," *Toronto Telegram*, 22 October 1960, 49.

157 Jarvis to Philip Surrey, 4 April 1960, AJC, box 9.

158 David Legate to Jarvis, 24 September 1962, AJC, box 5.

159 David Legate to Jarvis, 27 November 1964 and 27 January 1965, AJC, box 7.

160 Francess Halpenny to Jarvis, 7 March, 1 June, 5 July and 2 August 1961, AJC, box 5; and Halpenny interviewed by the author, 28 November 2003. Anne Whitelaw, "To Better Know Ourselves: J. Russell Harper's *Painting in Canada: A History*," 12–13.

161 Robert Hubbard to Jarvis, 29 September 1961, Kathleen Fenwick to Jarvis, 5 October 1961, Jean Paul Morisset to Jarvis, 5 October 1961, Marsh Jeanneret to Jarvis, 26 October 1961, and Jeanneret to Jarvis, 7 December 1961, AJC, box 5.

162 Jeanneret to Jarvis, 12 April 1962, Hubbard to Jarvis, 3 December 1962, Halpenny to Jarvis, 11 December 1962, AJC, box 5. Jarvis to Hubbard, 14 December 1962; the quote is from Jarvis to Jeanneret, 14 December 1962, both AJC, box 9.

163 Jeanneret to Jarvis, 28 February 1963, AJC, box 6; and Halpenny interviewed by the author, 28 November 2003. The book was eventually published as J. Russell Harper, *Painting in Canada: A History*, University of Toronto Press, 1966. Anne Whitelaw, "To Better Know Ourselves: J. Russell Harper's *Painting in Canada: A History*," passim.

164 *Grolliers Encyclopedia* to Jarvis, 17 April 1961, and *Harpers* to Jarvis, 13 September 1961, AJC, box 5. *The Atlantic* to Jarvis, 6 October 1964, AJC, box 7. Also Alan Jarvis, "Art in Canada," *The Atlantic*, November 1964, 124–6.

165 *Student's Guide to Canadian Industry*, Toronto: Copp Clark, 1960, 39–40. A.G.S.

Griffin to Jarvis, 5 February 1962, AJC, box 5. For Gradgrind, see Robert Fulford, "Fulford on Books," *Toronto Star*, 19 May 1961, 27.

166 Elizabeth Kilbourn, "Art and Artists," *Toronto Star*, 24 November 1962, 30.

167 Jarvis to John G. McConnell, 6 July 1965, AJC, box 10. For the comic novel, see Earle Toppings of Ryerson Press to Jarvis, 15 June 1966, AJC, box 8.

168 Jarvis to Gordon Roy, 16 February 1965, AJC, box 10.

169 Press release, "Dorothy Cameron Gallery Closing Announcement," 3 September 1965; and "Notes for Alan for his role in the last supper of the Dorothy Cameron Gallery," by Jack McClelland, 10 November 1965, both AJC, box 42. For Jarvis' impersonations, see Kay Kritzwiser, "Friends Honour Dorothy Cameron with Mixture of Laughs and Tears," *Globe and Mail*, 12 November 1965, 15.

170 Dorothy Cameron to Jarvis, 17 July 1966, AJC, box, 10.

171 R. MacDonald to Jarvis, 12 July 1965, AJC, box 7.

172 Gershon Avner to Jarvis, 12 April 1965, AJC, box 7. For the British diplomat, see Henry J. Seddins to Jarvis, 8 July 1965, AJC, box 7.

173 Cameron interviewed by Elspeth Chisholm, ECC, CD A1 2003-06-0047. Also Nathan Cohen, "Discipline Makes Fine Giselle," *Toronto Star*, 11 June 1965, 20.

174 Robert Fulford interviewed by the author, 29 June 2003. Jarvis' Expo pass is found in AJC, box 35. For the young people's forum, see Graham McInnes to Jarvis, 10 July 1967, AJC, box 8.

175 Income Tax form T1 for 1967, AJC, box 61. See also the pamphlet for the English Speaking Union 1967 Summer School, "Canada in Today's World," AJC, box 42.

CHAPTER THIRTEEN

The quote in the chapter title is from an interview with Alex Colville by the author, 18 January 2004.

1 "69 Artists Share $487,670 Awards," *Toronto Star*, 28 February 1968, 43.

2 Duncan F. Cameron, ed., *Are Art Galleries Obsolete?*

3 University Travel Club Itinerary, 26 January 1968, AJC, box 8. For Jarvis' instructions about forwarding his mail, see undated memo, Canadian Conference of the Arts collection, box 40.

4 P.H. Currie to Jarvis, 22 December 1969, AJC, box 37. A copy of Duncan's will is found in the Barwick/Duncan collection, NGA.

5 A.C. Peebles to Jarvis, 6 December 1967 and 8 October 1968, AJC, box 8.

6 "Alan Jarvis Seriously Ill," *Toronto Star*, 19 August 1968, 1; and Kay Kritzwiser, "Alan Jarvis Is Reported Seriously Ill," *Globe and Mail*, 20 August 1968, 11.

7 Gail Dexter, "Alan Jarvis: Unfortunate Interlude," *Toronto Star*, 21 August 1968, 73.

8 Judy LaMarsh to Jarvis, 20 August 1968, AJC, box 8.

9 Barbara Moon interviewed by Elspeth Chisholm, ECC, CD A1 2003-07-0020.

10 Stanley Cameron interviewed by Elspeth Chisholm, ECC, CD A1 2003-07-0016.

11 Stanley Cameron interviewed by Elspeth Chisholm.

12 Jack McClelland to Jarvis, 29 November 1968, AJC, box 8.

13 Peter Mellen to Jarvis, 4 December 1968, AJC, box 8.

14 Peter Mellen, *The Group of Seven.*

15 Duncan F. Cameron to Jarvis, 23 December 1968, Canadian Conference of the Arts collection, box 40.

16 Micheline de Bruyn to the *Montreal Star*, 6 May 1969, Canadian Conference of the Arts collection, box 40; Toronto City Directory, 1969 and 1970. The studio was located at 8 Market Street.

17 Duncan F. Cameron to Jarvis, 20 January 1969, Canadian Conference of the Arts collection, box 40.

18 Canadian Conference of the Arts to Jarvis, 13 March 1969, AJC, box 8.

19 Paul Russell interviewed by Elspeth Chisholm, ECC, CD A1 2003-07-0015.

20 Dorothy Cameron interviewed by Elspeth Chisholm, ECC, CD A1 2003-06-0047. Beefeater was a popular brand of gin.

21 Ibid.

22 Ibid.

23 Albert Weisbrot interviewed by Elspeth Chisholm, ECC, CD A1 2003-07-0021. For instance, Jarvis' gross income for 1970 was $5,650, of which $5,000 came from his retainer from Rothmans, $150 from the *Toronto Star*, and $500 from the National Gallery of Canada. Janet left her son a portfolio of shares in Bell, Domtar, Dominion, Loblaws, Toronto Dominion Bank, Abita Paper, and Consumers Gas worth $4,443.

24 All of the quotes are from Alan Hanlon interviewed by Elspeth Chisholm, ECC, CD A1 2003-07-0020.

25 Pocket agenda for 1969, AJC, box 39.

26 The quote is from Jarvis to Robert Finch, 1 November 1969, AJC, box 10; also Finch to Jarvis, 10 November 1969, AJC, box 8.

27 Paul Russell interviewed by Elspeth Chisholm, ECC CD A12003-07-0015.

28 Alan Jarvis, introduction to *Francis Loring – Florence Wyle*; and Alan Jarvis, introduction to *Rodin and His Contemporaries Presented in Canada by Rothmans of Pall Mall Canada Limited.*

29 Johnny Wayne interviewed by Elspeth Chisholm, ECC, CD A1 2003-07-0020.

30 Alan Jarvis, *Douglas Duncan: A Memorial Portrait*, 7–13.

31 Jean Boggs to Jarvis, 31 March 1970, AJC, box, 8. Jarvis to Lester B. Pearson, 18 March 1971, AJC, box 10. Alan Jarvis, "Douglas Duncan," *A Gift from the Douglas M. Duncan Collection and the Milne-Duncan Bequest*, 26–34.

32 See the various receipts found in AJC, box 61, file 9.

33 Wayne interviewed by Elspeth Chisholm.

34 Lippel Gallery to Jarvis, 5 January 1970, AJC, box 8. The sculpture had cost $1,600, a huge portion of Jarvis' annual income.

35 Dorothy McPherson to Jarvis, 6 April 1970, AJC, box 34.

36 Jarvis to Robert Hubbard, from Wellesley Hospital, 2 September 1970; and Hubbard to Jarvis, 2 September 1970, RHC, box 15.

37 David Silcox interviewed by Elspeth Chisholm, ECC, CD A1-2003-07-01.

38 "The Way We Are / Alan Jarvis, Sculptor and Writer," *Toronto Star*, 6 February 1971, 14. An almost identical quip about visual "stink" appeared in Peter C. Newman, "Is Jarvis Misspending Our Art Millions?," *Maclean's*, 22 November 1958, 41.

39 "The Way We Are," 14.

40 Weisbrot interviewed by Elspeth Chisholm.

41 A postcard of Moore's reclining woman, inscribed "For Alan with warmest regards, Henry Toronto Oct 15th 1971," AJC, box 47.

42 Correspondence regarding the sale of the flat is found in Susan Allison to Jarvis, 30 March, 2 June, 5 July, 28 November, and 7 December 1971, AJC, box 8. For Jarvis' last trip to the Gallery on 27 October 1971, see Ord, *National Gallery*, 328.

43 Robert Fulford interviewed by the author, 29 June 2003.

44 Advertisement for the Schneider School of Fine Art, Actinolite, Ontario, *Globe and Mail*, 15 April 1972, 30.

45 Order of Service, AJC, box 42. The service was on 26 March 1972.

46 Ronald Bloore interviewed by the author, December 2003.

47 Dorothy Cameron interviewed by Elspeth Chisholm, ECC, CD A1 2003-06-0047. The "ashen" quote is also taken from Cameron's interview. For the "god awful" comment, Ronald Bloore interviewed by the author.

48 Dorothy Cameron interviewed by Elspeth Chisholm; Arthur Gelber interviewed by Elspeth Chisholm, ECC, CD A1 2003-06-0047; and Stanley Cameron interviewed by Elspeth Chisholm, ECC, CD A1 2003-07-0016.

49 Weisbrot interviewed by Elspeth Chisholm.

50 Ibid. Also Michael Starr to the author, 8 October 2008.

51 Weisbrot interviewed by Elspeth Chisholm.

52 The disposition of the letters from Gerald Murphy is mentioned in Stanley Cameron interviewed by Elspeth Chisholm. Also Last Will and Testament of Alan Hepburn Jarvis, 14 January 1972, Superior Court of Ontario.

53 Colville interviewed by the author, 18 January 2004.

54 Wayne interviewed by Elspeth Chisholm.

CHAPTER FOURTEEN

1 Mervyn Stockwood to Jarvis, 13 June 1945, AJC, box 11.

2 Jean (Stewart) Gunn interviewed by Elspeth Chisholm, ECC, CD A1 2003-07-0020.

3 Betty (Devlin) Jarvis interviewed by the author, 4 June 2003.

Bibliography

SOURCES BY ALAN JARVIS
Personal Archives
Alan Jarvis collection. University of Toronto

Published
A Letter to Bill and Betty. London: Oxford House 1952.
"An Experiment with Factory Discussion Groups." *Labour Management*,
 October–November 1943.
Canada Year Book entries, 1959–1963.
(Sir Stafford Cripps) *Democracy Alive: A Selection of Recent Speeches by the Right
 Honourable Sir Stafford Cripps*. Introduced by Alan Jarvis. London: Sidgwick
 and Jackson, 1946.
"Did You Know That There Are Factory Discussion Groups Too?" *Target: the* RAF
 Review of Current Affairs and Topics, no. 15 (1 August 1944).
Douglas Duncan: A Memorial Portrait. Toronto: University of Toronto Press, 1974.
"Education by Discussion." *Pilot Papers*, no. 1.2 (April 1946).
"Foreground, Background or Middle-Distance." *Further Education: A Monthly
 Review of Planning and Progress*, no. 1.2 (May 1947).
Francis Loring – Florence Wyle. Toronto, 1969.
"Henry Moore Sculpture in Canada." *Canadian Art*, spring 1959: 82–87, 147.

(With Gordon Russell) *How to Furnish Your Home… With a Shopping Guide by Veronica Nisbet*. London: Newman Neame, 1953.

"Production for Production." *Further Education: A Monthly Review of Planning and Progress*, no. 1.3 (June 1947).

"Radio Theatre." *Further Education: A Monthly Review of Planning and Progress*, no. 1.1 (April 1947).

Rodin and His Contemporaries Presented in Canada by Rothmans of Pall Mall Canada Limited. N.d. (probably 1970).

(With Malcolm Ross, ed.) *The Arts in Canada: A Stocktaking at Mid-century*. Toronto: MacMillan, 1958.

"The Things We See," syndicated newspaper column, 1960–64.

The Things We See I: Indoors and Out. Harmondsworth: Penguin, 1947.

Television Appearances

Close-up, CBC television, December 1957.

The Mask, CBC television, February 1959.

The Renaissance, three-part CBC television series, 1959.

The Things We See, twelve-part CBC television series, 1959.

OTHER SOURCES

Archival Collections – Personal

Frances Barwick / Douglas Duncan. National Gallery of Canada Archives

J. Burgon Bickersteth. Bodleian Library

Estate of Fanny Brennan. New York City

Eric and Maud Brown. Library and Archives Canada

Esmond Butler. Library and Archives Canada

Elspeth Chisholm. Library and Archives Canada

Sir Kenneth Clark. Tate Gallery Archives

Lewis John Collins. Lambeth Palace Archives

William G. Constable. Boston Museum of Fine Arts Archives

Sir Stafford Cripps. Bodleian Library

Fillipo Del Giudice. British Film Institute

John Diefenbaker. Library and Archives Canada

Alan Don. Lambeth Palace Archives

Dorothy R. Dyde. Library and Archives Canada

Robert Fulford. McMaster University
Grant family. Library and Archives Canada
Robert Hamilton Hubbard. Library and Archives Canada
A.Y. Jackson. Library and Archives Canada
Maurice Lamontagne. Library and Archives Canada
Newton McTavish. Library and Archives Canada
Harry Orr and Dorothy Jenkins McCurry. Library and Archives Canada
Massey family. Library and Archives Canada
David Milne. Library and Archives Canada
John W. Pickersgill. Library and Archives Canada
Adrian Pryce-Jones. British Film Institute
Sir Michael Sadler. Bodleian Library
Carl Schaefer. Library and Archives Canada
G. Hamilton Southam. Library and Archives Canada
Graham Spry. Library and Archives Canada
John Steegman. King's College, Cambridge
Max Stern / Dominion Gallery. National Gallery of Canada Archives
Louis St-Laurent. Library and Archives Canada
Samuel Zacks. Library and Archives Canada

Archival Collections – Institutional
Board of Trade. National Archives of the United Kingdom
Boston Museum of Fine Arts
British Broadcasting Corporation Written Archives
"Britain Can Make It." Design Archives. University of Brighton
Cabinet. Library and Archives Canada
Canada Foundation. Library and Archives Canada
Canadian Conference of the Arts. Library and Archives Canada
Canadian Museums Association. Library and Archives Canada
Carleton University Special Collections and Archives
Civil Service Commission. Library and Archives Canada
Department of Citizenship and Immigration. Library and Archives Canada
Dartington Hall Archives
Council of Industrial Design. National Archives of the United Kingdom
Council of Industrial Design. Design Archives. University of Brighton
Expo 67. Library and Archives Canada

Department of External Affairs. Library and Archives Canada
Festival of Britain. National Archives of the United Kingdom
Imperial Order Daughters of the Empire. Library and Archives Canada
Ministry of Aircraft Production. National Archives of the United Kingdom
National Capital Commission. Library and Archives Canada
National Gallery of Canada Archives
Oxford House. Tower Hamlets Local History Library, London
Parkdale Collegiate Library, Toronto
Privy Council. Library and Archives Canada
Rhodes Scholarship Trust. Library and Archives Canada
Sculptors' Society of Canada. Library and Archives Canada
Secretary of State. Library and Archives Canada
Society for Art Publications. Library and Archives Canada
Toronto Public Library Special Collections
Treasury Board. Library and Archives Canada
University College Archives, Oxford
University of Toronto Archives

Interviews

From the Elspeth Chisholm collection, Library and Archives Canada, interviews with the following people conducted by Chisholm during the early 1970s for a CBC radio documentary about Alan Jarvis:

Alan Armstrong
Dorothy Cameron
Stanley Cameron
Sir Kenneth Clark
Ellen Fairclough
Charles P. Fell
E. Davie Fulton
Arthur Gelber
Joyce Grenfell
Jean (Stewart) Gunn
Norman Hay
Allison Ignatieff
George Ignatieff

H.G. (Rik) Kettle
Barbara Moon
John W. Pickersgill
John Robertson
Paul Russell
Doris Shadbolt
David Silcox
Bruno Spici
Graham Spry
Sarah Stalley
Bishop Mervyn Stockwood
Alan Toff
Phillip Torno
Vincent Tovell
Stuart Tweedie
Kendrick Venables
Johnny Wayne
Albert Weisbrot

Interviews conducted and correspondence received by the author in support of this project:

Norman Berlis
Bishop John Bickersteth
Ronald Bloore
Jean Sutherland Boggs
Richard Brennan
Michael Brown
Alex Colville
Alistair Cooke
Peter Cox
Peggy (Cripps) Appiah
Linda Fitzgerald
Patrick Fitzgerald
Robert Fulford
James Gibson

Mary (Greey) Graham
Francess Halpenny
Marjorie Harris
Betty Jarvis
Kenneth Lochhead
Robert McKinstry
Barbara Moon
Mavor Moore
Piers Nicholson
Geoffrey Reeve
Gordon Robertson
Paul Russell
Gyde Shepperd
David Silcox
Gordon Smith
G. Hamiltob Southam
Michael Starr

Newspapers & Magazines

Atlantic (Boston)
Brantford Expositor
Canadian Art
Canadian Congress Journal
Canadian Forum
CBC Times
Council of Industrial Design *Annual Reports*, 1945–1948
Daily Telegraph
Echoes (Toronto)
Evening Standard
Globe and Mail
Harpers (New York)
Highlights (Alberta Society of Artists)
Illustrated London News
Isis (Oxford University)

Kinematograph Weekly (London)

Leader (London)

Letter Review (Fort Erie, Ontario)

Lethbridge Herald

London Free Press (Ontario)

Maclean's

Magazine Digest (Toronto)

Mayfair (Toronto)

Montreal Gazette

Montreal Star

National Gallery of Canada *Annual Reports,* 1940–1960

New York Times

Ottawa Citizen

Ottawa Journal

Oxford University Magazine

Peterborough Examiner

Picture Post (London)

Queen's Quarterly

Regina Leader Post

Rotary Voice (Toronto)

Saturday Night

Target (London)

Tatler (London)

Time

The Times (London)

Toronto Star

Toronto Telegram

Torontonensis (University of Toronto)

The Undergraduate (University of Toronto)

University of Toronto *Annual Reports,* 1933–1939

University of Toronto Quarterly

Vancouver Province

Varsity (University of Toronto)

Weekend (Montreal)

Secondary Works

Addison, Paul. *Now the War Is Over: A Social History of Britain*. London: Cape, 1985.

– *The Road to 1945: British Politics and the Second World War*. London: Cape, 1975.

Allen, Dorothy. *Sunlight and Shadow: An Autobiography*. London: Oxford University Press, 1960.

"An Acorn on Parliament Hill." *Canadian Art* 2, no. 1 (October/November 1944): 15–18.

Annan, Noel. *Our Age: English Intellectuals between the World Wars, A Group Portrait*. New York: Random House, 1990.

Armes, Roy. *A Critical History of the British Cinema*. New York: Oxford University Press, 1978.

Arthur, Eric. *Toronto: No Mean City*. Toronto: University of Toronto Press, 1964.

Ashworth, Mandy. *The Oxford House in Bethnal Green: 100 Years of Work in the Community*. London: Oxford House, n.d.

Attlee, Clement. *A Prime Minister Remembers*. London: Heinemann, 1961.

Averill, Harold A. *Dramatis Personae: An Exhibition of Amateur Theatre at the University of Toronto, 1879–1939*. 17 February – 29 May 1992. Toronto: Thomas Fisher Rare Book Library, 1992.

Axelrod, Paul. *Making a Middle Class: Student Life in English Canada During the Thirties*. Montreal and Kingston: McGill-Queen's University Press, 1990.

Ayre, John. *Northrop Frye: A Biography*. Toronto: Random House, 1989.

Baker, Victoria. *Emanuel Hahn and Elizabeth Wyn Wood: Tradition and Innovation in Canadian Sculpture*. Ottawa: National Gallery of Canada, 1997.

Balcon, Michael. "The British Film during the War." *The Penguin Film Review*, vol. 1, London: Penguin, 1946.

Balfour, Honor. "Jam Sessions on the Production Line." *Magazine Digest*, April 1944: 49–52.

Barwick, Frances Duncan. *Pictures from the Douglas M. Duncan Collection*. Toronto: University of Toronto Press, 1975.

Baxter, R.K. Neilson. "The Structure of the British Film Industry." *Penguin Film Review*, vol. 7. London: Penguin, 1948: 83-90.

Beaulieu, Lord Montagu. *Wheels Within Wheels: An Unconventional Life*. London: Weidenfeld and Nicolson, 2000.

Berthoud, Roger. *Graham Sutherland: A Biography*. London: Faber, 1982.

Betjeman, John. *John Betjeman's Oxford*. Oxford: Oxford University Press, (1938) 1990.

Beasley, David. *Douglas MacAgy and the Foundations of Modern Art Curatorship*. Simcoe: Davus, 1998.

Benney, Mark. *Over to Bombers*. London: George Allen and Unwin, 1943.

Berton, Pierre. *1967: The Last Good Year*. Toronto: Doubleday, 1997.

Betts, Ernest. *The Film Business: A History of British Cinema, 1896–1972*. London: George Allan and Unwin, 1973.

Bissell, Claude. *Halfway up Parnassus: A Personal Account of the University of Toronto, 1932–1971*. Toronto: University of Toronto Press, 1974.

– *The Imperial Canadian: Vincent Massey in Office*. Toronto: University of Toronto Press, 1986. ed. *University College: A Portrait, 1853–1953*. Toronto: University of Toronto Press, 1953.

– *The Young Vincent Massey*. Toronto: University of Toronto Press, 1991.

Blythe, Ronald. *The Age of Illusion: England in the Twenties and Thirties, 1919–1940*. London: Phoenix, (1963) 2001.

Boggs, Jean. *The National Gallery of Canada*. Toronto: Oxford University Press, 1971.

Brandon, Laura. *Pegi by Herself: The Life of Pegi Nicol MacLeod, Canadian Artist*. Montreal and Kingston: McGill-Queen's University Press, 2005.

Briggs, Asa. *Michael Young: Social Entrepreneur*. London: Palgrave, 2001.

Brison, Jeffrey, "Cultural Interventions: American Corporate Philanthropy and the Construction of the Arts and Letters in Canada, 1900–1957," PhD, Queen's University, 1998.

Brison, Jeffery D. "The Kingston Conference, the Carnegie Corporation and a New Deal for the Arts in Canada." *American Review of Canadian Studies* 23, winter 1993: 503–22.

– *Rockefeller, Carnegie and Canada: American Philanthropy and the Arts and letters in Canada*. Montreal and Kingston: McGill-Queen's University Press, 2005.

Brown, F. Maud. *Breaking Barriers: Eric Brown and the National Gallery*. Toronto: Society for Art Publications, 1964.

Brownlow, Kevin. *David Lean: A Biography*. London: Richard Cohen, 1996.

Bryant, Chris. *Stafford Cripps: The First Modern Chancellor*. London: Hodder and Stoughton, 1997.

Buchanan, Donald W. *James Wilson Morrice*. Toronto: Ryerson, 1947.

Bury, Don. "The Early Pioneers of the Camping Movement." In Bruce W. Hodgins and Bernadine Dodge, eds, *Using Wilderness: Essays on the Evolution of Youth Camping in Ontario*. Peterborough: Trent University, 1992.

Calder, Angus. *The People's War: Britain 1939–45*. London: Pimlico, (1969) 1994.

Calder, Robert. *Beware the British Serpent: The Role of Writers in British Propaganda in the United States, 1939–1945*. Montreal and Kingston: McGill-Queen's University Press, 2004.

Cameron, Duncan F., ed. *Are Art Galleries Obsolete?* Toronto: Art Gallery of Ontario, 1969.

Cameron, Elspeth. *Hugh MacLennan: a Writer's Life*. Toronto: University of Toronto Press, 1981.

Carpenter, Humphrey. *The Envy of the World: Fifty Years of The BBC Third Programme and Radio 3*. London: Weidenfeld and Nicolson, 1996.

Carritt, E.F. *The Theory of Beauty*. London: Methuen, n.d.

Carter, Miranda. *Anthony Blunt: His Lives*. London: Macmillan, 2001.

Carver, Humphrey. "The Design Centre: The First Year." *Canadian Art* 11, no. 3 (spring 1954): 104–8.

Champion, C.P. "Mike Pearson at Oxford: War, Varsity and Canadianism." *The Canadian Historical Review* 88, no. 2 (2007): 263–90.

Chauncey, George. *Gay New York: Gender, Urban Culture, and the Makings of the Gay Male World, 1890–1940*. New York: Basic Books, 1994.

Christian, William. *George Grant: a Biography*. Toronto: University of Toronto Press, 1993.

Churchill, Kristopher. "Learning about Manhood: Gender Ideals and 'Manly' Camping." In Bruce W. Hodgins and Bernadine Dodge, eds, *Using Wilderness: Essays on the Evolution of Youth Camping in Ontario*. Peterborough: Trent University, 1992.

Churchill, Winston S. *The Second World War: The Gathering Storm*. Boston: Houghton Mifflin, 1948.

Clark, Kenneth. *The Other Half: a Self Portrait*. Don Mills: Longmans, 1977.

Clarke, Nick. *Alistair Cooke: A Biography*. New York: Arcade, 1999.

Clarke, Peter. *The Cripps Version: The Life of Sir Stafford Cripps, 1889–1952*. London: Allen Lane, 2002.

Collingwood, R.G. *The First Mate's Log of a Voyage on the Schooner Yacht* Fleur de Lys *in 1939*. London: Oxford University Press, 1940.

Collins, Diana. *Partners in Protest: Life with Canon Collins*. London: Gollancz, 1992.

Collins, Lewis John. *Faith Under Fire*. London: Leslie Frewin, 1966.

Conekin, Becky. *The Autobiography of a Nation: The 1951 Festival of Britain*. Manchester: Manchester University Press, 2003.

Cooke, Colin. *The Life of Richard Stafford Cripps*. London: Hodder and Stoughton, 1957.

Corry, J.A. *My Life and Work: A Happy Partnership*. Kingston: Queen's University, 1981.

Costello, John. *Love, Sex and War: Changing Values, 1939–1945*. London: Collins, 1985.

Cotter, Charis. *Toronto between the Wars: Life in the City, 1919–1939*. Toronto: Firefly, 2004.

Coward, Noël. *The Noël Coward Diaries*. Ed. Graham Payne and Sheridan Morley. Toronto: Little Brown, 1982.

Cox, Peter. *The Arts at Dartington, 1940–1983: A Personal Account*. Exeter: Dartington Hall Trust, 2005.

Creighton, Donald G. "Charles Perry Stacey." In Michael Cross and Robert Bothwell, eds, *Policy by Other Means: Essays in Honour of C.P. Stacey*. Toronto: Clarke, Irwin, 1972.

Cull, Nicholas John. *Selling War: The British Propaganda Campaign against American 'Neutrality' in World War II*. Oxford: Oxford University Press, 1995.

Davies, Blodwen. *The Charm of Ottawa*. Toronto: McClelland Stewart, 1932.

– *Storied York, Old and New*. Toronto: Ryerson, 1931.

Davies, Robertson. *What's Bred in the Bone*. Harmondsworth: Penguin, 1985.

Davis, Ann. "The Wembley Controversy in Canadian Art." *Canadian Historical Review* 54, no. 1 (1973): 48–74.

De La Noy, Michael. *Mervyn Stockwood: A Lonely Life*. London: Mowbray, 1996.

Dickinson, Margaret and Sarah Street. *Cinema and State: The Film Industry and the Government, 1927–84*. London: British Film Institute, 1985.

Diefenbaker, John. *One Canada: Memoirs of the Right Honourable John G. Diefenbaker*. Toronto: Macmillan, 1975.

Donelly, Honoria Murphy. *Gerald and Sara, Villa America and After*. New York: New York Times Books, 1982.

Drazin, Charles. *The Finest Years: British Cinema of the 1940s*. London: Andre Deutsch, 1998.

Edinborough, Arnold. *An Autobiography.* Toronto: Stoddart, 1991.

Eggleston, Wilfrid. *The Queen's Choice: A Story of Canada's Capital.* Ottawa: Queen's Printer, 1961.

English, John. *Shadow of Heaven: The Life of Lester Pearson, Volume One, 1897–1948.* Toronto: Lester, Orpen and Dennys, 1989.

Estorick, Eric. *Stafford Cripps: A Biography.* London: Heinemann, 1949.

– *Stafford Cripps: Master Statesman.* New York: John Day, 1949.

Fairclough, Ellen Louks. *Destiny's Child: Memoirs of Canada's First Female Cabinet Minister.* Toronto: University of Toronto Press, 1995.

Faris, Ron. *The Passionate Educators: Voluntary Associations and the Struggle for Control of Adult Educational Broadcasting in Canada, 1919–1952.* Toronto: Peter Martin, 1975.

Finlay, Karen A., "The Force of Culture: Vincent Massey and Canadian Sovereignty," PhD, University of Victoria, 1999.

– *The Force of Culture: Vincent Massey and Canadian Sovereignty.* Toronto: University of Toronto Press, 2004.

Flagstad, Kirsten. *The Flagstad Manuscript.* New York: Putnam, 1952.

Forsey, Eugene. *A Life on the Fringe: the Memoirs of Eugene Forsey.* Toronto: Oxford University Press, 1990.

Foster, Peter. "J. Arthur Rank and the Shrinking Screen." In Michael Sissons and Philip French, eds, *Age of Austerity.* Westport, Connecticut: Greenwood, 1963.

Friedland, Martin L. *The University of Toronto: A History.* Toronto: University of Toronto Press, 2002.

Frye, Northrop. *The Diaries of Northrop Frye, 1942–1955.* Ed. Robert D. Denham. Toronto: University of Toronto Press, 2001.

Fulford, Robert. *Best Seat in the House: Memoirs of a Lucky Man.* Toronto: Collins, 1988.

Gardner, James. *The Artful Designer.* London: Centurion Press, 1993.

Gill, Brendan. *A New York Life: Of Friends and Others.* New York: Poseidon, 1990.

Gittins, Susan. *CTV: The Television Wars.* Toronto: Stoddart, 1999.

Glassco, John. *Memoirs of Montparnasse.* Toronto: Oxford University Press, 1970.

Glasser, Ralph. *Gorbals Boy at Oxford.* London: Pan, 1988.

Goldsmith, John, ed. *The Gymnasium of the Mind: the Journals of Roger Hinks, 1933–1963.* Salisbury: Michael Russell, 1984.

Granatstein, J.L. "Culture and Scholarship: The First Ten Years of the Canada Council." In Beverley Diamond and Robert Witmer, eds, *Canadian Music: Issues of Hegemony and Identity*. Toronto: Canadian Scholars' Press, 1994.

– *A Man of Influence: Norman A. Robertson and Canadian Statecraft, 1929–1968*. Ottawa: Deneau, 1981.

– *The Ottawa Men: The Civil Service Mandarins, 1935–1957*. Toronto: Oxford University Press, 1982.

Greenhorn, Beth, "An Art Critic at the Ringside: Mapping the Public and Private Lives of Pearl McCarthy," MA, Carleton University, 1996.

Grenfell, Joyce. *In Pleasant Places*. London: MacDonald Futura, (1979) 1982.

Harris, José. *William Beveridge: A Biography*. Oxford: Clarendon, 1977.

Harris, Lawren. "Reconstruction through the Arts." *Canadian Art* 1, no. 5, (June–July 1944): 185–6, 224.

Hartnoll, Phyllis. *The Oxford Companion to the Theatre*. 3rd ed. Oxford: Oxford University Press, (1967) 1975.

Hastings, Adrian. *A History of English Christianity, 1920–1985*. London: Collins, 1986.

Hillier, Bevis. *John Betjeman: New Fame, New Love*. London: John Murray, 2002.

Hillier, Bevis and Mary Banham, eds. *A Tonic to the Nation*. London: Thames and Hudson, 1976.

Hinks, Roger. *The Gymnasium of the Mind: the Journals of Roger Hinks, 1933–1963*. Ed. John Goldsmith. London: Michael Russell, 1984.

Hudson, Anna, "Art and Social Progress: The Toronto Community of Painters, 1933–1950," PhD, University of Toronto, 1997.

Hyde, H. Montgomery. *The Other Love: An Historical and Contemporary Survey of Homosexuality in Britain*. London: Heinemann, 1970.

Ignatieff, George. *The Memoirs of George Ignatieff: The Making of a Peacemonger*. Toronto: University of Toronto Press, 1985.

Ignatieff, Michael. *Isaiah Berlin: A Life*. London: Viking, 1998.

Jackson, A.Y. *A Painter's Country: The Autobiography of A.Y. Jackson*. Toronto: Clarke, Irwin, 1958.

Jackson, Paul, "Male Lovers: Homosexuality in Canada, 1930–1950," MA, University of Toronto, 1994.

Jarvie, Ian. "British Trade Policy Versus Hollywood, 1947–1948: 'food before flicks'?" *Historical Journal of Film, Radio and Television* 6, no. 1 (1986): 19–41.

Johnston, George. *Carl: Portrait of a Painter*. Moonbeam, Ontario: Penumbra, 1986.

Kenney, Anthony, ed. *The History of the Rhodes Trust, 1902–1999*. Oxford: Oxford University Press, 2001.

Kettle, H.G. "Pictures in the Home." *Queen's Quarterly*, autumn 1936: 295–8.

King, James. *Jack: A Life with Writers: The Story of Jack McClelland*. Toronto: Knopf, 1999.

– *The Last Modern: The Life of Herbert Read*. London: Weidenfeld and Nicolson, 1990.

King, Martha J., "The National Gallery of Canada at Arm's Length from the Government of Canada: A Precarious Balancing Act," MA, Carleton University, 1996.

Kinsman, Gary. "'Character Weaknesses' and 'Fruit Machines': Towards an Analysis of the Anti-Homosexual Security Campaign in the Canadian Civil Service." *Labour/Le Travail* 35 (spring 1995): 133–61.

– *The Regulation of Desire: Sexuality in Canada*. Montreal: Black Rose, 1987.

Kramer, Reinhold. *Mordecai Richler: Leaving St Urbain*. Montreal and Kingston: McGill-Queen's University Press, 2008.

Kristmanson, Mark. *Plateaus of Freedom: Nationality, Culture and State Security in Canada, 1940-1960*. Don Mills, Ontario: Oxford, 2003.

Laing, G. Blair. *Memoirs of an Art Dealer*. Toronto: McClelland and Stewart, 1979.

LaMarsh, Judy. *Memoirs of a Bird in a Gilded Cage*. Toronto: McClelland and Stewart, (1968) 1969.

Lascelles, Alan. *King's Counsellor, Abdication and War: The Diaries of Sir Alan Lascelles*. Ed. Duff Hart-Davis. London: Weidenfeld and Nicolson, 2006.

Leacock, Stephen. *Sunshine Sketches of a Little Town*. Harmondsworth: Penguin, (1912) 1942.

Levi, Charles, "Where the Famous People Were? The Origins, Activities and Future Careers of Student Leaders at University College, Toronto, 1854–1973," PhD, York University, 1998.

Levi, Charles Morden. *Comings and Goings: University Students in Canadian Society, 1854–1973*. Montreal and Kingston: McGill-Queen's University Press, 2003.

Levine, Norman. *Canada Made Me*. London: Putnam, 1958.

Limbos-Bomberg, Natalie, "The Ideal and the Pragmatic: The National Gallery of

Canada's Biennial Exhibitions of Canadian Art, 1953–1968," MA, Carleton University, 2000.

Litt, Paul, "The Donnish Inquisition: The Massey Commission and the Campaign for State-sponsored Cultural Nationalism in Canada, 1949–1951," PhD, University of Toronto, 1990.

– *The Muses, the Masses and the Massey Commission*. Toronto: University of Toronto Press, 1992.

A Loan Exhibition of Paintings and Sculpture from the Niarchos Collection. New York: Knoedler, 1958.

Mackenzie, S.P. *Politics and Military Morale: Current-Affairs and Citizenship Education in the British Army, 1914–1950*. Oxford: Clarendon, 1992.

MacNab, Geoffrey. *J. Arthur Rank and the British Film Industry*. London: Routledge, 1993.

MacRae, Marian and Anthony Adamson. *Cornerstones of Order: Courthouses and Town Halls of Ontario, 1784–1914*. Toronto: Clarke Irwin, 1983.

Maguire, Patrick J. and Jonathan M. Woodham, eds. *Design and Cultural Politics in Postwar Britain*. London: Leicester University Press, 1997.

Manion, James P. *A Canadian Errant: Twenty-five Years in the Canadian Foreign Service*. Ed. Guy Sylvestre. Toronto: Ryerson, 1960.

Massey, Vincent. *On Being Canadian*. Toronto: Dent, 1948.

– *What's Past Is Prologue: Memoirs of Vincent Massey*. Toronto: MacMillan, 1963.

Maynard, Stephen. "'Horrible Temptations': Sex, Men and Working-class Male Youth in Urban Ontario, 1890–1935." *Canadian Historical Review* 78, no. 2 (June 1997): 191–235.

– "Through a Hole in the Lavatory Wall: Homosexual Subcultures, Police Surveillance and the Dialectics of Discovery, Toronto, 1890–1930." *Journal of the History of Sexuality* 5, no. 2 (October 1994): 207–42.

McCalla, Douglas. "The Rhodes Scholarships in Canada and Newfoundland." In Anthony Kenny, ed., *The History of the Rhodes Trust 1902–1999*. Oxford: Oxford University Press, 2001.

McInnes, Graham. *A Short History of Canadian Art*. Toronto: MacMillan, 1939.

– *Finding a Father*. London: Hamish Hamilton, 1967.

The Mermaid Theatre Review 1959. Westerham, Kent: Westerham Press, 1959.

Mellen, Peter. *The Group of Seven*. Toronto: McClelland and Stewart, 1970.

Minnifie, James M. *Expatriate*. Toronto: Macmillan, 1976.

Montaignes, Ian. *An Uncommon Fellowship: The Story of Hart House.* Toronto: University of Toronto Press, 1969.

Moore, Mavor. *Reinventing Myself: Memoirs.* Toronto: Stoddart, 1994.

Morgan, Kenneth O. *Labour in Power: 1945–1950.* Oxford: Clarendon, 1984.

Morley, Sheridan. *John Gielgud: The Authorized Biography.* New York: Simon and Schuster, 2002.

– *A Talent to Amuse: A Biography of Noël Coward.* London: Heinemann, 1969.

Mumford, Lewis. *The Culture of Cities.* New York: Harcourt Brace, 1938.

– *Technics and Civilization.* New York: Harcourt Brace, 1934.

Murphy, Robert. "Rank's Attempt on the American Market, 1944–9." In James Curran and Vincent Porter, eds, *British Cinema History*, Totowa, New Jersey: Barnes and Noble Books, 1983.

Newman, Peter C. *Renegade in Power: The Diefenbaker Years.* Toronto: McClelland and Stewart, 1963.

Nicholson, Mary. *Worlds on Worlds: The Unfinished Autobiography of Mary Nicholson (1908–1995).* Epsom: Sunshade Press, 1997.

Oakley, C.A. *Where We Came In: Seventy Years of the British Film Industry.* London: George Allen and Unwin, 1964.

Oliver, Peter. *G. Howard Ferguson: Ontario Tory.* Toronto: University of Toronto Press, 1977.

Ord, Douglas. *The National Gallery of Canada: Ideas, Art, Architecture.* Kingston and Montreal: McGill-Queen's University Press, 2003.

Owram, Doug. Born at the Right Time: A History of the Baby Boom Generation. Toronto. University of Toronto Press, 1996.

– *The Government Generation: Canadian Intellectuals and the State, 1900–1945.* Toronto: University of Toronto Press, 1986.

Panayotidis, E. Lisa. "The Department of Fine Arts at the University of Toronto, 1926–1945: Institutionalizing the 'Culture of the Aesthetic.'" *Canadian Journal of Art History* 25 (2004): 100–25.

Parr, Joy. *Domestic Goods: the Material, the Moral, and the Economic in the Postwar Years.* Toronto: University of Toronto Press, 1999.

Pearson, Lester B. *Mike: The Memoirs of the Right Honourable Lester B. Pearson.* Toronto: University of Toronto Press, 1972.

Pelling, Henry. *Britain and the Second World War*. London: Collins, 1970.

Perry, George. *The Great British Picture Show*. London: Hart-Davis, 1974.

Petley, Julian. "Cinema and State." In Charles Barr, ed., *All Our Yesterdays: 90 Years of British Cinema*. London: British Film Institute, 1986.

Phair, John T., Mary Power, and Robert H. Roberts. *Health: A Handbook of Suggestions for Teachers in Elementary Schools*. Toronto: Ryerson Press, 1938.

Pickersgill, J.W. *My Years with Louis St-Laurent: A Political Memoir*. Toronto: University of Toronto Press, 1975.

– *Seeing Canada Whole: A Memoir*. Markham: Fitzhenry and Whiteside, 1994.

Pimlott, Ben. *Harold Wilson*. London: Harper Collins, 1993.

Porter, Vincent. "All Change at Elstree: Warner Bros., ABPC and British Film Policy, 1945–1961." *Historical Journal of Film, Radio and Television* 21, no. 1 (2001): 9.

Potvin, Rose. *Passion and Conviction: The Letters of Graham Spry*. Regina: Canadian Plains Research Centre, 1992.

Reilly, Paul. *An Eye on Design: An Autobiography*. London: Reinhardt, 1987.

Report of the Commission on National Development in the Arts and Sciences. Ottawa: King's Printer, 1951.

Reynolds, David. *Rich Relations: The American Occupation of Britain, 1942–1945*. New York: Random House, 1995.

Ritchie, Charles. *Diplomatic Passport: More Undiplomatic Diaries, 1946–1962*. Toronto: Macmillan, 1981.

– *The Siren Years: A Canadian Diplomat Abroad, 1937–1945*. Toronto: MacMillan, 1974.

Robertson, Gordon. *Memoirs of a Very Civil Servant*. Toronto: University of Toronto Press, 2000.

Robertson, William. *Welfare in Trust: A History of the Carnegie United Kingdom Trust, 1913–1963*. Dunfermline: Carnegie United Kingdom Trust, 1964.

Rooke, Paricia T. "Public Figure, Private Woman: Same-sex Support Structures in the Life of Charlotte Whitton." *International Journal of Women's Studies* 6, no. 5 (November–December 1983): 412–28.

Rutherford, Paul. *When Television Was Young: Prime Time Canada, 1952–1967*. Toronto: University of Toronto Press, 1990.

Saddlemyer, Ann and Richard Plant, eds. *Later Stages; Essays in Ontario Theatre from the First World War to the 1970s*. Toronto: University of Toronto Press, 1997.

Schlesinger Jr., Arthur M. *A Life in the Twentieth Century: Innocent Beginnings, 1917–1950*. Boston: Houghton Mifflin, 2000.

Scott, Drusilla. *A.D. Lindsay: A Biography*. Oxford: Blackwell, 1971.

Scott, Ian with Neil McCormick. *To Make a Difference: A Memoir*. Toronto: Stoddart, 2001.

Sharp, Mitchell. *Which Reminds Me: A Memoir*. Toronto: University of Toronto Press, 1994.

Schwarz, Oswald. *The Psychology of Sex*. Harmondsworth: Penguin, (1949) 1965.

Secrest, Meryle. *Kenneth Clark: A Biography*. New York: Fromm, 1986.

Selman, Gordon. *Adult Education in Canada: Historical Essays*. Toronto: Thompson Educational, 1995.

Shakespeare, William. *King Henry V*. Ed. J.H. Walter. London: Routledge, 1993.

Sieff, Israel. *Memoirs*. London: Weidenfeld and Nicolson, 1970.

Silcox, David P. *Painting Place: The Life and Work of David B. Milne*. Toronto: University of Toronto Press, 1996.

Sirluck, Ernest. *First Generation: An Autobiography*. Toronto: University of Toronto Press, 1996.

Sisler, Rebecca. *Art for Enlightenment: A History of Art in Toronto Schools*. Toronto: Fitzhenry and Whiteside, 1993.

Sissons, Michael and Philip French. *Age of Austerity*. Westport, Connecticut: Greenwood, 1963.

Skilling, H. Gordon. *The Education of a Canadian: My Life as a Scholar and Activist*. Montreal and Kingston: McGill-Queen's University Press, 2000.

Smith, Frances K. *André Bieler: An Artist's Life and Times*. Toronto: Merritt, 1980.

Sparke, Penny, ed. *Did Britain Make It?: British Design in Context, 1946–86*. London: Design Council, 1986.

Skelton Grant, Judith. *Robertson Davies: Man of Myth*. Toronto: Viking Penguin, 1994.

Sperdakos, Paula. *Dora Mavor Moore: Pioneer of the Canadian Theatre*. Toronto: ECW Press, 1995.

Stansky, Peter. *London's Burning: Life, Death and Art in the Second World War*. London: Constable, 1994.

Stedman Jones, Gareth. *Outcast London*. Harmondsworth: Penguin, 1971.

Stockwood, Mervyn. *Chanctonbury Ring: An Autobiography*. London: Hodder and Stoughton, 1982.

Sullivan, Rosemary. *By Heart: Elizabeth Smart: A Life*. Toronto: Viking, 1991.

Théberge, Pierre. *Gift from the Douglas M. Duncan Collection and the Milne-Duncan Bequest: An Exhibition at the National Gallery of Canada, 5 March–4 April 1971*. Ottawa: The Gallery, 1971.

Tippett, Maria. *Making Culture: English Canadian Institutions and the Arts before the Massey Commission*. Toronto: University of Toronto Press, 1990.

Tomlinson, Jim. "Reconstructing Britain: Labour in Power 1945–1951." In Nick Tiratsoo, ed., *From Blitz to Blair: A New History of Britain Since 1939*. London: Weidenfeld and Nicolson, 1997.

Tompkins, Calvin. *Living Well Is the Best Revenge: Two Americans in Paris, 1921–1933*. New York: Viking, 1971.

Tovell, Vincent. "Explorations." *Waterloo Review* 2, no. 2 (winter 1960): 23–9.

Trueman, Albert W. *A Second View of Things: A Memoir*. Toronto: McClelland and Stewart, 1982.

Ustinov, Peter. *Dear Me*. Toronto: Little, Brown, 1977.

Vaill, Amanda. *Everybody Was So Young: Gerald and Sara Murphy, A Lost Generation Love Story*. New York: Houghton Mifflin, 1998.

Vipond, Mary. "The Nationalist Network: English Canada's Intellectuals and Artists in the 1920s." *Canadian Review of Studies in Nationalism* 7, no. 1 (spring 1980): 32–52.

Waite, P.B. *Lord of Point Grey: Larry MacKenzie of UBC*. Vancouver: UBC Press, 1987.

Wakelin, Michael. *J. Arthur Rank: The Man Behind the Gong*. Oxford: Lion, 1996.

Wall, Sharon. "Totem Poles, Teepees and Token Traditions: 'Playing Indian' at Ontario Summer Camps, 1920–1955." *Canadian Historical Review* 86, no. 3 (September 2005): 513–44.

Wallace, R.C. "Canadian Rhodes Scholars." *Canadian Geographical Journal* 19, no. 6 (December 1939): 318–29.

Waters, Chris. "Disorders of the Mind, Disorders of the Body Social: Peter Wildeblood and the Making of the Modern Homosexual." In Becky Conekin, Frank Mort and Chris Waters, eds, *Moments of Modernity: Reconstruction Britain, 1945–1964*. London: Rivers Oram Press, 1999: 134–51.

Weeks, Jeffrey. *Coming Out: Homosexual Politics in Britain*. London: Quartet, 1977.

Whitelaw, Anne. "To Better Know Ourselves: J. Russell Harper's *Painting in Canada: A History*." *Canadian Journal of Art History* 26 (2005): 8–30.

Whitworth, Lesley. "Inscribing Design on the Nation: The Creators of the British Council of Industrial Design." *Business and Economic History Online* 3 (2005): 1–14. http://www.thebhc.org/publications/BEHonline/2005/whitworth.pdf

Wigg, George. *George Wigg*. London: Michael Joseph, 1972.

Wildeblood, Peter. *Against the Law*. London: Weidenfeld and Nicolson, (1955) 1999.

Williams-Ellis, Amabel. *All Stracheys are Cousins*. London: Weidenfeld and Nicolson, 1983.

– *Women in War Factories*. London: Gollancz, 1943.

Wiseman, David. "Informal Education." In N. Hans and J.A. Lauwerys, eds, *The Yearbook of Education, 1948*. London: Evans Brothers, 1948.

Woodham, J. M. "Managing British Design Reform I: Fresh Perspectives on the Early Years of the Council of Industrial Design." *Journal of Design* History 9, no. 1 (1996): 55–65.

Woodham, J. M. "Managing British Design Reform II: The Film *Deadly Lampshade* – An Ill-fated Episode in the Politics of 'Good Taste.'" *Journal of Design History* 9, no. 2 (1996): 101-15.

Wyatt, Honor. "Bill and Betty." *Woman's Hour*. BBC Radio, 6 June 1952.

Wyatt, Woodrow. *Confessions of an Optimist*. London: Collins, 1985.

Wyn Wood, Elizabeth. ""A National Plan for the Arts in Canada." *Canadian* Art 1, no. 3 (February–March 1944): 93–5, 127–8.

– "Art Goes to Parliament." *Canadian Art* 2, no. 1 (October–November 1944): 3–5, 41–2.

Yagoda, Ben. *About Town: The New Yorker and the World It Made*. New York: Scribner, 2000.

Young, Michael. *The Elmhirsts of Dartington: The Creation of an Utopian Community*. London: Routledge and Kegan Paul, 1982.

Young, Michael and Peter Willmott. *Family and Kinship in East London*. Harmondsworth: Penguin, 1957.

Young, William Robert, "Making the Truth Graphic: The Canadian Government's Home Front Information Structure and Programmes During World War II," PhD, University of British Columbia, 1978.

Zemans, Joyce. "Envisioning Nation: Nationhood, Identity and the Sampson-Matthews Silkscreen Project: The Wartime Years." *Journal of Canadian Art History* 19, no. 1 (1998): 6–51.

Index

Bickersteth, J. Burgon, 29–30, 32, 42, 45, 48, 72, 74–5, 113, 117–18, 121

Binning, B.C., 255

Bissell, Claude, 28, 266, 312, 324, 336

Black, Misha, 152, 155

Bloore, Ronald, 403n136, 424n47

Blunt, Anthony, 226, 257, 297

Boggs, Jean Sutherland, 315, 349

Borley, Bob, 105, 134

Boulting, John and Roy, 172, 179, 181

Bovey, Wilfrid, 92

Bowater medallions, 209–10

Bowers, Lloyd, 77–9, 79 (photo), 86

Bowra, Maurice, 62, 121

Brains Trust. *See* adult education

Brantford, Ontario, 8, 12–15, 158

Brennan, Hank, 174, 238, 244, 415n46

Brett, George, 24, 27–8, 34, 47, 49–50, 53

Britain Can Make It (exhibition), 151–3, 276

Brockington, Leonard, 209

Bronfman, Samuel, 209, 324, 328

Brown, Eric, 220–1, 226, 256

Brown, Maud, 296, 345 (photo)

Brussels World's Fair (1958), 245, 266

Buchanan, Donald, 39, 92, 151, 215, 232, 234–5, 237, 239, 244–5, 270, 299, 301–2, 316, 343

Calder, Alexander, 33, 306, 330, 347

Calgary, 251

Calling of Saint Peter, Peter Brueghel the Elder, 281–5

Cameron, Dorothy, 308, 328, 334–5, 338–9, 341, 346, 348

Cameron, Stanley, 338–40, 343

Camp Glenokawa, 42–4, 44 (photo), 48, 61, 95, 98, 109, 199, 306

Canada Council, 256, 310, 316–18, 337

Canada Foundation, 233, 249, 316

Canadian Art magazine, 221, 244, 309, 316–17, 334

Canadian Clubs, 250, 252, 321

Canadian Conference of the Arts, 308, 311, 314, 340

Canadian Museums Association. *See* National Gallery of Canada

Canadian Rhodes Scholars Association, 220

Carleton (College) University, 218, 250, 266–7

Carnegie Foundation, 35, 91–3, 221–2, 256

Carnegie Institute, Pittsburgh, 309–10, 332

Carnegie Trust (UK), 124, 147, 203–4, 206

Carritt, Edgar, 34, 49, 65–6, 70, 71 (photo)

Central School of Art, London, 331

Central Technical School, 23–4

Chance of a Lifetime (film), 183, 186–8

chief medical officer of health of Ontario, 44, 47, 94

Chisholm, Elspeth, xi

Church of England. *See* Alan Jarvis, religious beliefs

Churchill Club, 120–1

Citizenship and Immigration, Department of, 224, 228, 230–1,

Civil Service Commission, 231, 234, 239, 287, 293–4

Harris, Tony, 76, 89, 104, 106 (photo)

Harris, Walter, 228, 230, 233

Hart House, 29–32, 35, 45, 48, 50–2, 204, 241, 304, 311, 348

Hay, Norman, 212–15, 213 (photo), 219, 234, 244, 247, 266, 294, 302, 305–7, 318, 335, 341, 348

Herbert, David, 214

Herbert, Walter, 233, 249

Hi. *See* Winterbotham-Hague-Winterbotham, Arthur Hiram

Hinks, Roger, 73–4, 97

Hirshhorn, Joseph, 268–9, 288, 294, 319, 324

homosexual circles: England, 62–3, 76–7, 104, 132, 159, 207; Toronto, 37

homosexual prosecutions (UK), 214

Howard, Leslie, 110, 162, 164

Hubbard, Robert, 232, 235, 245, 262, 268–71, 281, 282, 292, 297–8, 333

Hulme, George, 244

Huxley, Julian, 110, 311–13

Ignatieff, Alison (Grant), 61, 389n12, 236–7

Ignatieff, George, 285

Imperial Order Daughters of the Empire (IODE), 271–4, 284, 292

Industrial Bureau of Current Affairs, 118

industrial design, 142–50, 276

Industrial Discussion Clubs Experiment, 114–18

Institute of Community Studies, London, 205–6, 242

Is Art Necessary? See Alan Jarvis, public speaking

Israel Museum, opening of, 334–5

Isaacs, Av, 312

It Always Rains on Sundays (film), 195–96

Jackson, A.Y., 21, 265, 271, 272 (photo), 283, 289

Jarratt, Sir Arthur, 178, 181

Jarvis, Alan: acting and theatrical activities, 26, 50, 69, 194, 207, 334–5; and adult education, 42–5, 81–2, 91–3, 94, 97–8, 108–9, 113–18, 121–4, 127, 147, 222, 233, 238, 247, 249; aesthetics, study of, 28, 33, 34–5, 47, 49, 53, 70, 78; Alan Jarvis Associates, 305, 333; Alan Jarvis Limited, 188; alcoholism, 66–7, 100–1, 135, 159, 168–9, 190–1, 193–4, 208–9, 212, 257, 292, 294, 302–3, 305–6, 308, 338, 341–3, 352; Archives, xi, 85, 88–9, 96–7, 348; Art Odyssey for Connoisseurs, 322, 323 (photo); artistic talent, 20, 23–4, 51–2 (photo), 70, 192; in broadcasting, 52–3, 150, 153 (photo), 211–12, 235, 255, 274–8, 279–80, 285, 306, 308, 310, 324–7, 325 (photo); brother, relationship with and feelings of inability to match, 18–21, 25–6, 29, 30, 38, 43, 49, 59, 77, 192–3, 214, 327, 331, 351–2; Canada, views about and knowledge of, 60, 62, 65, 93, 111, 134, 138, 189, 190, 209, 231, 251; Canadian Youth Congress, 51–3; childhood, 14–16; colourblindness, 20, 103; death, 346–8; diaries, 79–80, 132; dismissal from National Gallery, 293–7; divorce, 345,

79 (photo), 86, 95, 98, 100, 132–3, 174, 179, 208, 238, 244, 337

National Gallery of Canada: use of adult education techniques while Jarvis director of, 245, 247–8, 274–7; annual reports, 248, 264, 281; blocked account purchases, 226; Canadian Museums Association training scheme, 256, 270; exhibitions, 246–8, 268–70; history of, 220–2; industrial design division, 151, 215, 223, 299; legislation, 220, 224–5, 231, 234; Liechtenstein collection, 226–7; Liechtenstein negotiations and purchases, 228–30, 239, 257; National Gallery Association, 270–1; National Gallery Conference (1956), 256–7; network of galleries created under Jarvis, 255–6; new gallery building, 218, 224–6, 227, 249, 268, 269 (photo), 299, 300 (photo); Parliamentary debates about Jarvis and, 231, 254, 258, 259–61, 262, 290–1, 301–2; purchases under Jarvis' directorship, 245–6, 258–60, 268; recruitment of new director, 231–3; speaking tours, *see* Alan Jarvis
National Trust Mural, 330
Nesbitt, Wally, 231, 260–2
New York Times, 289, 296
New York University, 57, 98–100
New Yorker magazine, 30, 34, 87, 99, 100
Newman, Peter C., 287
Nicholson, Mary, 121, 180, 414n22, 327

North Carolina Museum of Art, 309
Nuffield Conferences, 109, 122
Nureyev, Rodolf, 335

Olivier, Laurence, 110, 162, 164, 168, 172,
Order of Canada, 336
Ostiguy, Jean-René, 247, 270
Ottawa Citizen, 236
Ottawa Journal, 288
Oxford House, 191, 193–9, 198 (photo)
Oxford University, 62–3, 196

Painting in Canada (book), 332–3
Parkdale Collegiate, 23
Parkin, John C., 309, 311
Parnall Aircraft Limited, 103, 107–10, 121, 124
Patterson, Tom, 327
Pavitt, Burnet 207, 241, 285, 296, 305, 307
Pearson, Lester B., 265, 280, 289, 291–2, 313, 315, 334
Pickersgill, J.W. (Jack), 230–2, 234–5, 237, 239, 250, 258–60, 262, 265, 268, 282, 290–1, 311, 313
Picture Loan Society, 40–1, 50, 302
Pilgrim Pictures, 166–88, 200, 302
Plamondon, Marius, 295
political and economic planning, 112, 144
Potter, Stephen, 154
Private Angelo (film), 179, 181, 185,
Provincial Museum, Regina, 251, 254

Queen Mary's Carpet, 271–4, 284, 287, 292, 301